Framing
Feminism

Rozsika Parker studied European Art History at the Courtauld Institute, London. She formed the Women's Art History Collective with Griselda Pollock and others in 1973-5 and was one of the original members of the editorial collective of the British feminist monthly *Spare Rib*, working with them from 1972 to 1980. She has since trained as a psychotherapist and is currently in practice in London. She is the author of *The Subversive Stitch: Embroidery and the Making of the Feminine* (The Women's Press, 1984).

Griselda Pollock studied History and Art History at Lady Margaret Hall, Oxford, and the Courtauld Institute, London. She is now Professor of Social and Critical Histories of Art at the University of Leeds. She was a member of the Women's Art History Collective 1973-5, and is the author of *Millet* (Oresko, 1977), *Van Gogh* (with Fred Orton, Phaidon, 1978), *Mary Cassatt* (Jupiter Books, 1980), *Van Gogh: His Dutch Years* (Huig, Amsterdam, 1980) and *Vision and Difference* (Routledge, 1988).

Rozsika Parker and Griselda Pollock are the authors of *Old Mistresses: Women, Art and Ideology* (RKP, 1981; Pandora Press, 1986) and the editors of *The Journal of Marie Bashkirtseff* (Virago, 1985).

Framing Feminism

Art and the Women's Movement 1970-85

edited and introduced by

Rozsika Parker and Griselda Pollock

An Imprint of HarperCollins*Publishers*

Pandora
An Imprint of HarperCollins*Publishers*
77–85 Fulham Palace Road,
Hammersmith, London W6 8JB

Published by Pandora 1987
1 3 5 7 9 10 8 6 4 2

This selection and introductory and editorial material
© Rozsika Parker and Griselda Pollock 1987

Rozsika Parker & Griselda Pollock assert the moral
right to be identified as the editors of this work

A catalogue record for this book
is available from the British Library

ISBN 0 86358 179 X

Typeset in Ehrhardt, Rockwell and Plantin
by Columns of Reading
Printed and bound by
The Guernsey Press Co Ltd,
Guernsey, Channel Islands

Contents

Contents

Contents

Contents

Illustrations

Introduction II Feminism and modernism

Preface

Feminism has had enormous impact on the visual arts today. Whereas the majority of political movements have employed art and artists for propaganda purposes, feminism has worked to transform art – and artists themselves. The emancipatory effect of the Women's Liberation Movement is particularly evident in the energy and variety of art being made by women today. Women's sense of themselves as artists has altered. Whether consciously influenced by feminism or simply responding to the new sense of confidence generated by the Women's Liberation Movement, women artists have gained an extraordinary momentum during the decades spanned by the texts in this anthology. The contrast with women's experiences in the 1960s and early 1970s to be found in the personal testaments included here is remarkable. Up to the late 1960s few women would overtly situate themsleves as *women* artists, and most fought shy of feminism, though not going as far as Bridget Riley who declared that 'At this point in time, artists who happen to be women need this particular form of hysteria like they need a hole in the head.'[1] During the mid–1970s many women still hesitated to acknowledge the impact of their gender on their work, but by the end of the decade few viewed it as an impediment and some positively identified as women, drawing on the insights of feminism in their art practice. This represents considerable change in a brief space of time.

Behind the shift in women artists' 'self-image' lies the feminist challenge to the denigration of women's art as second rate and innately inferior to that of men. The Women's Liberation Movement initiated a flood of publications dedicated firstly to revealing the existence of women artists of the past, for so long 'hidden from history', and then to discovering why and how women's art has been viewed as stereotypically feminine.[2] Feminist art historians and critics did not simply assert that women were as significant as men artists, rather we analysed the under-pinnings of art practice today; the conventional view of the artist as untramelled genius and art's current preoccupations with its own procedures and protocols (Modernism). We established that there was a correlation between the value system that sustains the institutions of art and the sexual division that structures our society; the notion of genius is gender specific.

The feminist challenge to accepted ideas of what constitutes great art and great artists was part of a broad attack on the art establishment. The 1970s saw the birth of cultural studies in universities and polytechnics, the boom in community art projects

and the beginning of radical artists groups, for example the Artists' Union and Artists for Democracy.

Feminism was thus both a catalyst and a component of a broad front. The feminist critique is comparable with, but not reducible to, these concerted attacks on Modernist paradigms. In the 1970s economic and ideological transformations in the sphere of artistic production as well as larger social fields, facilitated a coalescing of radical developments in cultural politics with vital forces for social change within the Women's Movement.

Raising the question of women and art had an impact on the art establishment and its institutions because they are structurally sexist. The history traced in this collection of writings on the period reveals the tenacious resistance which feminist activity produced by threatening male privilege. Feminist artist Susan Hiller, interviewed in 1978, illustrated this dynamic clearly. She described a male colleague's response to the students' demand for more women staff in the art college where they both taught: 'he totally agreed . . . he thought we should have at least 50 per cent women and ended up by saying, 'of course that would mean the end of art education as we know it. He's absolutely right." Those with class and gender power who write about art, exhibit it, publicise it and award its prizes have systematically worked to ensure the continuation of male dominance in the field. Thus, the Arts Council of Great Britain 1980 award selection panel made no secret of its intention to disregard women artists' demand for proportional representation of women in the awarding of grants. A member of the all-male panel declared, 'this thing (referring to the representation of women) has gone too far and it's time to draw the line', adding for good measure, 'women don't have enough depth to be artists'. (*Spare Rib*, 1980, no. 100)

In the face of such attitudes the artists who made the women's art movement proclaimed their feminism at tremendous cost in real terms – both economic and personal. We are therefore not engaging here with an academic issue, with a mere concern to put the record straight and ensure appropriate historical recognition. Rather we are confronted with the fact that the material and practical position of women artists is precarious. Admittedly it is difficult enough for anyone to make a living or reputation as an artist. But the insecurity of women who are artists is intensified by the continuing discrimination against them at all levels of funding, patronage, exhibition and employment.

One of the major issues facing women artists in Great Britain is the lack of systematic attention given to their work by national art critics. In addition there is an absence of specifically feminist apologists to mediate between feminist art and the public, when as Mary Kelly has pointed out, the dominant form of knowledge about art is provided by written texts:

Artists generally maintain that the catalogue is more important than

the exhibition itself. It gives particular permanence to temporary events, an authenticity in the form of historical testimony. Together with art books and magazines, exhibition catalogues constitute the predominant forms of receiving, and, in a certain sense, possessing images of art.[3]

The dearth of writing about feminist art and the fact that much that exists appeared in fringe or ephemeral publications has rendered feminist work invisible. What writing there has been on feminist art has frequently been produced by artists themselves. In the absence of critics, artists have had to become their own apologists, curating their own shows, collating catalogues and recording each other's work.

We have been involved with the feminist art movement for the past decade. Our chief contribution has been in terms of feminist art history. We were amongst the founders of the London Women's Art History Collective which in 1972 initiated group teaching, study and research projects. After the group disbanded we continued the work and jointly wrote *Old Mistresses: Women, Art and Ideology* (Routledge & Kegan Paul 1981). In our exploration of women's place in the history of art we focused upon women's relation to artistic and social structures – to institutions such as academies of art, to the development of the language and codes of art, and to the changing concept of the artist. However the inspiration behind the book was not merely a historiographic interest but a concern for the immediate context of women's art practice. An understanding of the historical process and practices that have determined the current situation of women artists is crucial if we are to change the role of art in contemporary systems of sexual domination and power. Here we have selected a series of texts and arranged them according to the categories of analysis established in *Old Mistresses: Women, Art and Ideology*, trying to reassemble such feminist reviews, letters, documents, essays and articles as might constitute the necessary textual framework for the 're-possession' of the feminist art of the 1970s.

We have tried to amass as consistent a record as possible from the diverse sources in which feminists have aired their aims and constructed their theories. Yet we are aware of our ambiguous position in this. We are neither critics nor historians claiming superior knowledge of events and issues. We cannot be detached. We are evidently partisan – in ways that may be more visible to our readers than to ourselves. Nevertheless we have attempted to be representative, selecting material which relates to major events and developments. Equally, we have been concerned to retrieve articles which were decisive in the evolution of our thinking about the issues. We have also included our own contributions as they were a consistent attempt to support and participate in the cultural politics of the Women's Movement.

Too often anthologies wrench their materials from the original site of their production. By reproducing articles in facsimile form and by supplementing them with cuttings and letters we want to give a concrete representation of the time, space, intentions and constraints that initially determined the texts. The fascimile form allows us to discern in residual form the living movement of history.

Undoubtedly the history of 1970s feminism could be written in terms of individual artists who have contributed so much, for example Margaret Harrison, Susan Hiller, Alexis Hunter, Tina Keane, Mary Kelly, Hannah O'Shea or Kate Walker. But the purpose of this anthology is to reconstruct some of the context in which feminist interventions have functioned. This may well be read as a betrayal by individual woman – as a refusal to provide the kind of critical endorsement which they genuinely need and deserve. However the feminist art movement has to be seen as a historical project which was part of a socio-political movement. A confluence of conditions and factors occurred which shaped feminism, and which feminists in turn shaped and acted upon, to produce the distinctive work for which they must be recognised. But if that recognition functions only in terms of individual artists or great women or leading feminists it will do an injustice to the whole community of women who produce art, or intend to.

Nevertheless, the situation facing women artists as individuals is profoundly paradoxical. Women whose situation had they been men and mainstream Modernists would have ensured that they made a marginal but secure living, find themselves overlooked and ignored. Because of their positive identification with feminism and a radical intervention in artistic practice, their future in the face of the current conservatism and retrenchment in cultural life is deeply uncertain.

A few feminists are selected for publicly funded exhibitions because they are undeniably major British artists – but the prospect for them is precarious because recognition of their stature as artists is implicated in feminism, a political movement demanding radical changes in our notions of art and artist.

Feminist artists are thus denied the reputation and recognition they have earned by the establishment on the one hand, and on the other hand by feminists fighting to prevent the women's art movement being subsumed by 'token women' selected by the establishment. Yet these artists who have struggled to sustain feminism in art during the last decade do deserve recognition from the Women's Movement. Thanks to their efforts in teaching, writing and organising exhibitions, feminist art groups are continually springing up throughout the British Isles, leading us to hope that recent feminist events will not be 'hidden from history'.

Notes

1 Bridget Riley, in E.C. Baker and T.B. Hess eds, *Art and Sexual Politics*, London 1973, p. 83.
2 For a bibliography, see R. Parker and G. Pollock, *Old Mistresses: Women Art and Ideology*, London, 1981.
3 Mary Kelly, 'Reviewing Modernist Criticism', *Screen*, 1981, vol. 22 no. 3, pp. 59-60.

Acknowledgments

This book is the product of the Women's Movement. In assembling the texts and preparing the introductory essays we have had much encouragement and practical help from many women. We would like to thank personally for their time and labour: Pauline Barrie, Elona Bennett, Cate Elwes, Phil Goodall, Margaret Harrison, Susan Hiller, Alexis Hunter, Mary Kelly, Sarah Kent, Cathy Nairne, Monica Ross, Hannah O'Shea, Marie Yates. For support and constructive comment during the writing we would like to acknowledge Heather Dawkins and Ruthie Petrie. Above all we would like to thank the women who have agreed to have their work published or illustrated in this collection.

The authors and publisher would like to thank the following for permission to reproduce material in this anthology:

Judith Barry and Sandy Flitterman, and The Society for Education in Film and Television for "Textual Strategies: The Politics of Art Making", from *Screen*, 1980, vol. 21 no. 2; Tricia Davis and Phil Goodall, and *Feminist Review* for "Personally and Politically: Feminist Art Practice", from *Feminist Review*, 1979, no. 1; Phil Goodall for "Growing Point/Pains in Feministo", from Mama Women Artists Together, 1977; Phil Goodall and *Spare Rib* for "Feministo: Portrait of the Artist as a Young Woman", from *Spare Rib*, 1976, no. 49; Pen Dalton for "What is Art Education For?", from *Feminist Art News*, 1980, no. 1; Su Braden and *Time Out* for "Self-Exposure", from *Time Out*, 1975; Mary Kelly and the Winchester School of Art for "Sexual Politics", from *Art and Politics*, edited by Brandon Taylor, Winchester School of Art, 1980; Mary Kelly for "Beyond the Purloined Image", from *Block*, 1983, no. 9; Rosalind Coward and *Time Out* for "Underneath We're All Angry", from *Time Out*, 1980, no. 567; Monica Ross for "Portrait of the Artist as a Young Woman: A Postal Event", from Mama Women Artists Together, 1977; Monica Ross, Suzy Varty and Kate Walker for their extracts from *Fenix*, 1978; Caroline Tisdall and *The Guardian* for "Women's Art: The Women's Free Arts Alliance", from *The Guardian*, 3 March 1975; Natasha Morgan and *Spare Rib* for "Shadow Woman" and "A Litany for Women Artists: Hannah O'Shea", both from *Spare Rib*, December 1977, no. 65; Laura Mulvey and *Spare Rib* for "You Don't Know What Is Happening, Do You, Mr Jones?" and "*Post Partum Document* by Mary Kelly", from *Spare Rib*, 1973, no. 8 and 1976, no. 53

respectively; Sally Potter and the Institute of Contemporary Arts for "On Shows", from *About Time*: Video, Performance and *Installation by 21 Women Artists*, Institute of Contemporary Arts, London, 1980; Anthea Callen, Mary Crokett, Linda Newington, Wendy Holmes and *Spare Rib* for "A Beginning", from *Spare Rib*, 1976, no. 44; Lisa Tickner and Routledge and Kegan Paul for "The Body Politic: Female Sexuality and Women Artists since 1970", from *Art History*, 1978, vol. 1, no. 2; *Art Monthly* for the correspondence between Lisa Tickner and the editor of *Apollo*, originally published under the title "Attitudes to Women Artists" in *Art Monthly*, 1979, no. 23; Rosetta Brooks and *Studio International* for "Woman Visible: Women Invisible", from *Studio International*, 1977, vol. 193, no. 987; Sarah Kent and *Time Out* for "Pretty Promises, Happy Traps", from *Time Out*, 1980, no. 550; Suzanne Davies and *LIP Feminist Arts Journal* for "Private and Public: Points of Departure – The Work of Margaret Harrison", from *LIP Feminist Arts Journal*, 1984, vol. 8; Jannis Jeffries and *CRAFTS Magazine* for "Women and Textiles", from *CRAFTS Magazine*, March/April, 1984; Elona Bennett and *Time Out* for "Venus de Milo: Virgin on the Rocks", from *Time Out*, 1972; Monica Sjoo and Roslyn Smythe for "Some Thoughts About Our Exhibition of Women's Art at the Swiss Cottage Library in London, 7-28 April 1973"; Cate Elwes and Rose Garrard for "About Time at the ICA", from *Primary Sources*, 1980, no. 6; Ann Cullis for "Sculpture by Women at Ikon, Power Plays at Pentonville", from *Artscribe*, December 1983, no. 44; Roberta McGrath for "Sculpture by Women", from *Aspects*, Winter 1983/4, no. 25; Maud Sulter and *Spare Rib* for "Houria Niati, Black Woman Time Now", from *Spare Rib*, April 1984, no. 141; Moremi Charles and *City Limits* for "Five Black Women Artists", from *City Limits*, 1983, no. 103; Anne-Marie Sauzeau-Boetti and *Studio International* for "Negative Capability as Practice in Women's Art", from *Studio International*, 1976, vol. 191, no. 979; Alexis Hunter and Ana Godel and *Art Monthly* for "Object of Fetishism", from *Art Monthly*, 1982/83, no. 52; Alexis Hunter for the Photographic Narrative Sequences and Drawings originally published in *The Auckland Star*, 22 March 1982; Chila Kumari Burman and Bhajan Hunjan, and *Spare Rib*, for their discussion of their art, originally published in *Spare Rib*, March 1983, no. 128; Rosalind Delmar and *Spare Rib* for "Women and Work: A Document on the Division of Labour in Industry", from *Spare Rib*, 1975, no. 40; Margot Waddell and Michelene Wandor, and *Spare Rib*, for "Mystifying Theory", from *Spare Rib*, 1977, no. 55; Joanna Klaces and *Spare Rib* for "Phoenix Arising", from *Spare Rib*, 1978, no. 76; Parveen Adams, Rosalind Delmar and Sue Lipchitz, and *Spare Rib*, for "Using Psychoanalyic Theory", from *Spare Rib*, 1977, no. 56; Rozsika Parker and *Spare Rib* for "Women Artists Take Action", "Art Has

No Sex. But Artists Do", "Body Works", "Housework", "Portrait of the Artist as a Housewife", "Dedicated to the Unknown Artist (Interview with Susan Hiller)", "The Story of Art Groups" and "Images of Men", respectively from *Spare Rib*, 1973, vol. 13; 1974, vol. 25; 1974, vol. 23; 1975, vol. 26; 1977, vol. 60; 1978, vol. 72; 1980, vol. 95; and, 1980, vol. 99; Rozsika Parker and Margaret Priest, and *Spare Rib*, for "Still Out of Breath in Arizona and Other Picture", from *Spare Rib*, 1974, no. 24; Rozsika Parker and *Art Monthly* for "Feminist Art Practices in 'Women's Images of Men', 'About Time' and 'Issue'", from *Art Monthly*, 1981, no. 43; Griselda Pollock and *Screen Education* for "What's Wrong with 'Images of Women'?", from *Screen Education*, 1977, no. 24; Griselda Pollock and *Feminist Review* for "Feminism, Femininity and the Hayward Annual Exhibition, 1978", from *Feminist Review*, 1979, no. 2; Griselda Pollock and *Spare Rib* for "An Exhibition of Social Strategies by Women Artists", from *Spare Rib*, 1981, no. 101; *The Guardian* for "Porn Squad eyes Women's Lib art" by Peter Cole, from *The Guardian*, 19 April 1973; *The Times* for "Police see Women's Lib art show" from *The Times*, 19 April 1973. Unpublished letter to the Editor of *The Guardian*, "Femininity" and "Theory and Pleasure" © Griselda Pollock, 1974, 1982 and 1982, respectively.

Introduction

Rozsika Parker
and
Griselda Pollock

I Fifteen years of feminist action: From practical strategies to strategic practices

In the early years of the 1970s there was an explosion of political energy, accompanied by a growth of political movements. One of the most vital of these was the Women's Movement. Out of the meeting together of women emerged new kinds of art, new forms of practice, and, for the women, positive self-consciousness as feminist artists. No political movement of the 1970s other than the Women's Movement had a comparable effect on the visual arts. The Women's Art Movement has remained closely allied with the Women's Movement. The identification of artists with the political movement has forced feminists to confront new and complex issues, even contradictions, which have generated diverse actions and important debates within feminist art practice.

One of the earliest groups of women artists to organise – The Women's Workshop of the Artists' Union – summarised why they decided to form as a collective:

> We formed as a collective of women artists because of our common situation/condition. We share similar, if not identical problems of isolation; both from other women artists and the general isolation of artists in a society which is alien to collective creative activity.[1]

Their statement illustrates the double-edged assault of feminism both against the myth of individual creativity which, in practical terms, results in isolation and exploitation for artists, and against the particular experience of women, cut off from each other and from public acknowledgement as artists. Working collectively is both a reaction against an oppressive condition and a progressive critique of it.

Since 1970 feminist artists in Europe, North and Central America, Australia and elsewhere have been initiating collective projects, organising all-women exhibitions and intervening in many related cultural and political spheres. For instance in New York an Ad Hoc Committee of Women Artists was formed in

1970 to protest the meagre 5 per cent of women exhibited in the annual survey held at the Whitney Museum of American Art. Demanding 50 per cent representation for women, the campaigners picketed the museum, deploying Tampax and uncooked eggs in their demonstrations. Other protests led to the formation of Women in the Arts which organised an all-women exhibition, 'Women Choose Women', shown at the New York Cultural Centre in 1973. American women's activism in organising protests, exhibitions, all-women galleries and education programmes, and researching into women artists has been inevitably influential, but there is also active exchange of ideas and personnel on an international basis. Feminism is an international movement, but in each country or region of the world where women struggle, the movement is shaped by local socio-economic and ideological features. The pattern of development in each area is particular but shares common features which make those particularities relevant as part of the totality of feminist activity. What we provide here is not an exhaustive list encompassing all feminist actions in Britain of the 1970s and 1980s but rather an outline of the major developments, a sense of the central debates and a map of the important landmarks. While having an immediate use value for British women, our concentration on what has happened in Britain is conceived of as a contribution to the history of an international movement and a continuing struggle which is taking place in so many parts of the world.[2]

First moves

The first 'Women's Liberation Art Group' exhibition was held in March 1971 at the Woodstock Gallery in London. Included were works by Valerie Charlton, Ann Colsell, Sally Frazer, Alison Fell, Margaret Harrison, Liz Moore, Sheila Oliver, Monica Sjoo and Rosalyn Smythe. A statement written by Liz Moore conjures up the feelings generated by women's decision to show together, with their growing ambitions to change art by their collective presence:

> Women artists are making contact with each other, coming out of their isolation. We are beginning to acknowledge the validity of our own and of each other's work; to learn to do without male approval, to be proud to show in company with each other. We are learning to provide each other with the confidence to explore and develop our own vision of a new consciousness: and we believe that the existing male-oriented art world, distorted as it is into a sort of international stock market, needs the transfusion of this new vision and new consciousness in order to survive.[3]

The following year, 1972, Liz Moore together with Monica Sjoo exhibited work at the National Women's Liberation

Conference at Acton Town Hall in London. One of us attended and remembers the vigorous debate provoked by those artists who asserted that figurative painting was the only appropriate style for feminist artists. Monica Sjoo, who put forward the anti-abstraction position, elaborated her ideas in a pamphlet, 'Towards a Revolutionary Feminist Art', which was produced to accompany the 1973 exhibition 'Womanpower' at London's Swiss Cottage Library. She wrote:

> We regret the abstract researches, playful gimmicks characteristic of contented and successful male artists. Although aware that these are not entirely without purpose and interest, we feel that it is not possible as members of an oppressed group – half of the human race – and with a powerful means of communication in our hands to sit around playing games with surface reality.[4]

As a tactical opposition to the orthodoxy of formalist abstraction in painting in the early 1970s, a revival of figurative painting had a powerful impact. However the position is not straightforward. Figurative painting is burdened with a history of meanings, uses, associations. For example, painting a figure of a naked woman to celebrate women's power and fertility or sexuality, can easily be misrepresented and recuperated for the voyeuristic representation of the female nude. A debate also developed between those who argued for the accessibility of figurative art and those who insisted that there can be no authentic women's discourse in current or traditional artistic language. Following recent trends towards figuration in mainstream painting in the 1980s in which feminists have been involved (for example Alexis Hunter and Lys Hansen) the debate has shifted towards a more strategic assessment of the implications of different media and forms. It is not a matter of choosing between figuration or abstraction, conceptual or scripto-visual forms, only one of which can be authorised as appropriate. It is a matter of calculating what effect any particular procedure or medium will produce in relation to a given audience, a particular context and the actual historical moment. This has become a decisive feature of feminist art practice which radically breaks with movement-, style- or content-defined categories of art making.

In April 1973, Monica Sjoo with other figurative artists, Liz Moore, Beverley Skinner and Ann Berg, organised 'Woman-power'. The artists initially approached the Serpentine Gallery for a venue. They were rejected – perhaps fortuitously – because they were forced to seek an alternative to a conventional gallery. They chose to exhibit in Swiss Cottage Library, initiating a policy pursued by many later feminist artists who have sought spaces which attract sectors of the public that normally do not visit art galleries. During the exhibition a painting by Monica Sjoo inspired by Goddess-worshipping religion and titled 'God Giving

Introduction

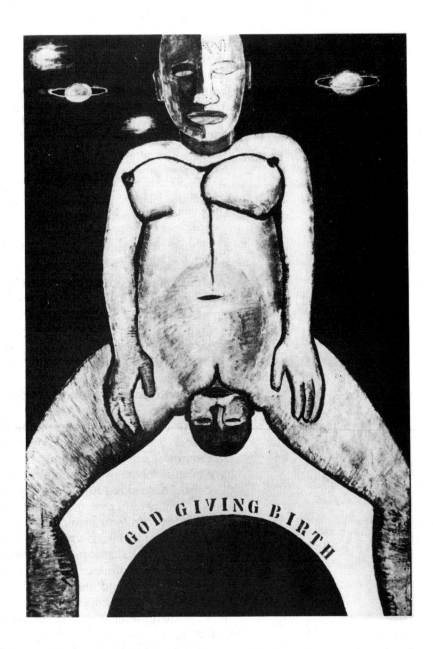

1 Monica Sjöo 'God giving birth', 1969, oil on canvas

Birth' aroused vitriolic controversy and the artist was threatened with legal proceedings on charges of blasphemy and obscenity (see Section III, 1 and 2): the painting showed a woman giving birth.

These artists set another important precedent for later feminist exhibitions by calling a meeting to discuss the public's objections to their work and the issues they believed the exhibition raised about women and art.

Artists' Union

A good indication of the pluralism of the women's art movement is that while some women were exploring the possibilities of the figurative tradition and imagery drawn from goddess cults and mythology, others were pursuing their feminism within the contemporary political struggles such as the Artists' Union. In 1971 the 'Art Spectrum' show at Alexandra Palace brought together many artists including many women in a large exhibition which exposed their common plight, facing economic deprivation and isolation. Discussions began which led to the formation of the Artists' Union in 1972. A women's working party was organised which considered ways to establish parity for women within the emergent union. At a meeting on 29 April 1972 the women came prepared to nominate women for the offices of the Union. As Elona Bennett, a founder member recalled:

> We decided as a group of women that we would have to be well organised: we had to have nominees for all the posts to be elected. So we went into the meeting with a nominee and a seconder for all the offices. All got voted in. Mary Kelly was chairperson, Margaret Harrison and Carol Kenna were elected to the secretariat. I was elected to the membership group. Women took some key positions and this took everyone by surprise.[5]

In the constitution of 9 May 1972 the Union ratified a Women's Workshop:

Women's Workshop

The Artists' Union recognises that women in art have at the present time problems which while they inevitably relate to problems of our civilisation as a whole, nevertheless need resolution and clarification through a special dialectic. The Women's Workshop has emerged in recognition of this position.

The Women's Workshop has already been in contact with three situations in the Trade Union Movement which have special lessons and relevance for women; the Strike at Brannan's, the Fakenham Occupation by women and the Women Night Cleaners Campaign for unionisation.

The workshop has started research on women art students who have not continued their work since leaving college and the relationship to the ratio of men who have continued to practise art since leaving college. The workshop sees a major role in helping to end the comparative artistic isolation of women who have left college and who have families. A related aim is to make the art world aware to the point of action on these issues and to raise consciousness to a level where creches and facilities for children and mothers are a normal state of affairs rather than as at present an afterthought if the thought is there at all. Participation in and initiation of exhibitions and a weekend conference are currently under discussion.

The education system is being considered with the recognition that

in Further Education the number of women teachers becomes proportionally smaller with the consequent effects on women's education leading to an inability to identify with the role of the artist.

Women in art are subject to conscious and unconscious discrimination and the art world in all its manifestations from gallery systems to educational systems is based totally upon a masculine identity. Women do not wish to simply replace men in art; women want something much more radical. Women need to redress the massive dis-balance which history has created. We do not wish to merely invent a new set of rules but rather to create a fluid society capable of responding to the needs and aims of artists, and to this end members of the women's workshop attend all other meetings of union workshops.

We seek links with other women's groups and invite women artists to join us in our efforts and to develop with us an ethic for a society and an art which does not discriminate against women for sexist reasons.

The Workshop met regularly, its members discussed each other's work and general issues relating to the situation of women artists, and planned a group of projects. They researched women artists of the past, familiarised themselves with contemporary feminist work in other parts of the world, notably the USA, and organised day schools at universities and art colleges. Concerned that the structure of art education discriminated against women, the Workshop demonstrated at the National Conference on Art Education organised by the Artists' Union in June 1973, demanding that women should comprise 50 per cent of the staff in art colleges given that 50 per cent of students were women (see Section II, 4).

The campaign for equality in art education has continued to be waged into the 1980s. Despite the fact that over 50 per cent of art students are women there remain many colleges and polytechnic departments of Fine Art in which there are no women full-time members of the studio staff. The few women working in such departments are exploited by part-time work which is increasingly difficult to find, offers no security of tenure and usually means that women do not participate in any decision or policy making meetings; and quite often, although they teach in the studios, they are not part of the examination boards. Between 12-14 November 1982 the Women Artists' Slide Library organised a conference on Women and Art Education. The idea had emerged out of discussions of the position of women in art education occasioned by the 'New Contemporaries' exhibition at the Institute of Contemporary Arts, London, in May and June of 1982. One of the resolutions passed at the conference was to press, through students and national teachers unions, motions which committed the unions to campaign for parity for women in colleges and other

educational institutions. In *FAN* No. 10 a resolution formulated by Pam Skelton and put through the Birmingham Branch of NATFHE (National Association of Teachers in Further and Higher Education) was published as an example for others to follow:

This branch notes that:

1 50 per cent of art school students are women, yet only a tiny minority of full-time tutors are women.

2 The National Council of NATFHE agreed in July 1981 to the creation of a positive action programme for women within NATFHE.

3 The Conference of Women in Art Education resolved at its November 1982 meeting to press for affirmative action to ensure that there is in future a balance between female and male tutors, and calls upon NATFHE at regional and national levels to adopt a positive action policy to achieve an end to the long history of discrimination in art school employment.

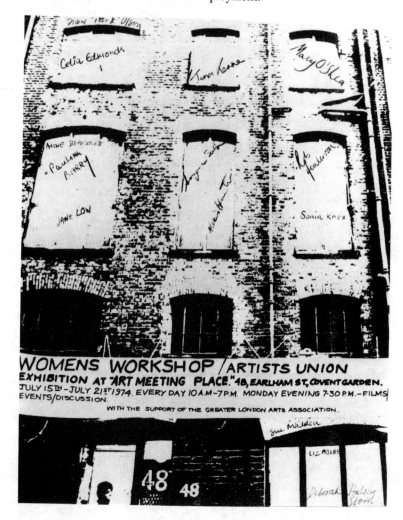

2 Poster of Women's Workshop of the Artists' Union exhibition at the Arts Meeting Place, 1974

3 Composite showing work by (starting at top left) Tina Keane, 'Collapsed Dream', Jane Low 'Madonna of Mercy'; Deborah Halsey Stern; Roberta Henderson

Tina Keane: *Collapsed Dream*. image/dream/illusion
image/language/illumine
Mirrorboard, bamboo poles and string. 9ft. high by 7ft. wide, 4ft. projection. The mirrorboard the illusion of water, the bamboo poles elegence, the string a tangled web.

Jane Low: *The Madonna of Mercy*. Two perspex discs, canvas, polythene fixing to attach bamboo pole to support.

DEBORAH HALSEY STERN

If women are defined as "being confined" by pregnancy, are they not confined to being defined by pregnancy?

If art is defined (as investment or shareout)? people are contained by this confinement; but when art is *theirs* confined who can define people?

Question WOMEN

Question ART

Rob Henderson.

A campaigning organisation was formed at the end of the 1982 conference, co-ordinated by Gillian Elinor and based at the Women Artists' Slide Library; it was called Women's Art Change. It has held conferences in Stourbridge, Liverpool, Nottingham, London, Cardiff, and Leeds, and it also circulated a questionnaire in order to gather precise and up-to-date information on the condition of women's employment in art schools from both students and the – still very few – women employed there.

Within the Women's Workshop of the Artists' Union in the early years the projects planned by the women reveal their commitment to making art more accessible and socially relevant

4 Pauline Barrie, 'Menstruation'

and to working collectively, rather than in isolation. Tina Keane and Jane Low worked on 'Playground Projects'. Jane Low designed an environmental piece for children at Dartmouth Park Hill nursery, while Tina Keane planned a piece for Victoria Park in London. Mary Kelly, Margaret Harrison and Kay Hunt collaborated on a documentary exhibition called 'Women and Work' (1975) (see Section III, 8) on women workers in a Metal Box Company factory in Southwark. An idea that was explored but not executed was to emulate the work of women in Los Angeles on the Feminist Art Program who had produced 'Womanhouse'. The artists intended to take over a derelict house, using it as a studio and meeting place, redecorating it with art forms expressive of women's lives, and finally opening it to the public. The project was only to be realised in 1974 by the then South London Women's Art Group (see Section III, 7).

In 1974 the Women's Workshop of the Artists' Union organised two all-women exhibitions. In July, Diane Olson, Priscilla Trench, Alene Strausberg, Mary O'Shea, Liz Moore, Sue Madden, Jane Low, Sonia Knox, Mary Kelly, Pauline Barrie, Susanne Solon, Margaret Harrison, Tina Keane and Roberta Henderson exhibited at the Arts Meeting Place. This was a large Covent Garden warehouse organised by artists themselves and available to whomsoever applied for space. That the Workshop exhibited at the Arts Meeting Place is an indication of feminist artists' contact and co-existence with the numerous radical artists' organisations that developed during the 1970s. In November and December many of the same artists exhibited as part of the Women's Workshop of the Artists' Union at the Almost Free Theatre to coincide with a women's theatre festival. Weekly meetings were held by the artists throughout the festival. The event signified the feminist belief in the importance of multi-media, cross-discipline work, and once again the search for venues outside the usual run of exhibition spaces.

All-women shows and the art world

In May 1974 an exhibition organised by the American critic Lucy Lippard was finally put on at the Warehouse in Earlham Street, London. The show 'Ca.7,500' comprised the work of 26 American and European artists and had been exhibited at many

prestigious galleries in the USA. It had originally been intended for the Royal College of Art Gallery in London but, at the last minute, the gallery refused to house the show, providing another example of the still pervasive hostility to an all-women show in Britain. The exhibition presented an unfamiliar range of work which was labelled 'conceptual art', that is, 'art in which the idea is paramount, in which permanence, formal or decorative values, are secondary if of any concern at all.'[6] Few of the artists had yet established reputations but, in a variety of new forms, including photography, video, tape-slide and reworked images from contemporary art, art history or media, the artists involved were exploring the means to address the issues of the social and personal experiences of women, in love, in the family, in the street, at work, in art, in the body. During the course of the exhibition, British feminists organised a series of events to highlight the issues handled in the show, to draw attention to the problems of bringing the show to London at all, and to assess the reception of the show itself. There were sessions about women's art and about criticism. Women from the Artists' Union and members of the Women's Art History Collective organised lectures, talks and discussions on many related issues of women and art (see Section III, 4, 5 and 6).

The incomprehension of, and hostile attitude to women's exhibitions which were so evident around the 'Ca.7,500' event were explored in an issue of *Spare Rib* where artists answered some of the commonplace questions they were asked.

Why have a women's exhibition?
Why does a women's exhibition always create that response? Most exhibitions are single sexed ones (i.e. all male) and for as long as that holds true we have to promote ourselves and each other in a very conscious way. We chose, and feel it is necessary to exhibit together – though some of us exhibit individually and in other contexts – to counter prejudice against women artists. Nobody else is going to do it for us.

Your exhibition does not seem particularly feminist.
Feminism can be expressed in many levels – not just by the use of explicit imagery. And, as in any group of people, there will be varying levels of commitment and consciousness which will be reflected in the work. We convey feminism not only in the content of our work but also in its context, in terms of how we go about finding a space in which to exhibit, finding and sharing financial support[7]

While it is perfectly correct to state that a feminist exhibition is created by a feminist mode of organising as well as by feminist content, in 1974 feminist artists were struggling to bring together the politics of feminism and their aesthetic concerns. Future feminist exhibitions would show a synthesis of the two that had been achieved as yet by few artists.

A dominant concern of women artists both inside and outside the Artists' Union was the male monopoly on exhibition space, not only within the establishment but in the new alternative galleries then opening in London. During the summer of 1973 Susan Hiller, Carla Liss and Barbara Schwartz persuaded Gallery House to show their work in an exhibition titled 'Three Friends' (see Section III, 3). In its two-year history not more than three women had had work in Gallery House and in a survey of about 100 artists of the avant-garde only one woman had been included. Soon after 'Three Friends', Gallery House closed; typically male-dominated organisations open doors to women only after their power is on the wane. Susan Hiller and Carla Liss continued to work together and joined by Helen Dracup, Marilyn Halford, Signe Lie, Christina Toren, they organised a project called 'Women's Work'. It was to be an open exhibition of extraordinary and special objects, events, artworks, baked works, music, dance, films, works of love, documentations (scrap books), journals, research projects, albums, 'in short, anything which a woman may consider to be looked at, or participated in, for the sake of its aesthetic rather than its purely practical relevance to her own life and the lives of others.'[8]

The organisers felt that too many women were 'secret artists', unwilling to show their work in public and to submit it to judgement by alien 'masculine commercial standards'. Regrettably the exhibition never took place, but the idea that women's domestic art was worthy of serious consideration and the belief that women needed a specific and different form of exhibition were realised in future feminist projects.

'Women's Work' highlighted a debate in the feminist art community which reflected a similar division in the wider Women's Liberation Movement. Should women seek to establish themselves as professionals, or should the trappings of professionalism be rejected in favour of the wholesale recognition as art of whatever women make. On the one hand there was the Women's Workshop of the Artists' Union fighting to revolutionise the conditions of professional work, and on the other there were those who felt that in order for skills traditionally associated with women to be recognised and valued, hierarchies – professional/amateur, public/private, fine/decorative arts – had to be demolished. The lines of the argument were, of course, never so crudely drawn. The protagonists were not rigidly set in their positions. Rather, in 1973 all were involved in an urgent search for priorities and pathways which would give women the confidence to trust in their own abilities, in order to overcome the negative evaluation resulting from pervasive discrimination against women.

Women and the press Questions raised by women about their historical and current position in the arts led to the publication of special issues of art magazines focusing on women, or to the foundation of magazines devoted to coverage of women's activities and debates. In the USA the *Feminist Art Journal* and *Womanart* appeared in the early 1970s followed in 1975 by the *Women Artists' News*. *Heresies* and *Chrysalis* are substantial quarterly journals produced respectively in New York and Los Angeles. In 1976 an Australian journal, *Lip* appeared. In Britain the initial intervention occurred in the form of special issues of existing magazines, for instance, Carla Liss, one of the organisers of 'Women's Work' edited the 'women's issue' of *Art and Artists* which appeared in October 1973, and which was intended as 'another step towards a more equitable representation (of women) and a new consciousness.'

In the opening article the American critic Lucy Lippard addressed the questions that haunted the early 1970s: 'Why women only?' 'Is there a female sensibility?' In response to the latter Lippard wrote,

> I for one am convinced that differentiation exists, but for every time I can be specific about it there are endless times in which it remains just out of reach. Perhaps it is impossible to pin it down or draw any but the most personal conclusions until women's place in society is indeed equalised and women's work can be studied outside the confines of oppressive conditions.[9]

These special issues of journals have played an important role in generating feminist criticism and art history, and in providing visibility for the issues and the work by women. They have been used extensively in teaching and debate.

After nine months out of circulation *Studio International* came back into print in 1978 with an issue on women's art (No. 3, 1977). Written by women and introduced by a long historical article from the American art historian Linda Nochlin, the issue ranged widely through art history, criticism, theory and review. Incorporating original essays on women artists in the UK, Tessa Schneideman, 'Feministo', Mary Potter, Marie Yates, Mary Kelly, Kate Walker, Katherine Gili, Yve Lomax and Rita Donagh, the issue also created several contexts for viewing women's art. First, there was a section by Lucy Lippard on five political artists, Mary Beth Edelson, Adrian Piper, Martha Rosler, Nancy Spero and May Stevens. Second, Pauline Barrie and Margaret Harrison produced a vital resource in the form of a year by year chronology of events, exhibitions and conferences by women. Rosetta Brooks' article on women's place in representation and as consumers is reprinted as item 3 in Section I of this anthology.

In 1980 the *Oxford Art Journal* devoted an issue to 'Women in Art' which included substantial art historical articles and major

contributions to feminist criticism of contemporary work. Valuable as were the individual contributions to this publication, the editorial framework revealed an ambivalence in the enterprise:

> Whilst it is of paramount importance to rescue unduly neglected women artists from obscurity, it seems equally necessary to avoid an uncritical fetishisation of women's art – a process which, in the final analysis benefits nobody but the picture dealer. If women artists – many of whom faced only condescension and neglect during their lifetimes – are finally to receive due attention, such attention must in itself avoid the pitfalls of condescension.[10]

Given how few column inches are usually devoted to women's work compared to men's work, special issues were welcomed by feminists even when hedged around with editorial comment that attacked straw dogs – when has there been an uncritical fetishisation of women's art? More serious was the danger of tokenism. Having 'done' their women's issue, editors could complacently continue to keep women's contributions on the margins. There was clearly a need for a magazine run by women themselves that would answer artists' needs for a place to air their experiences, voice the debates of the movement, and disseminate information and criticism.

The first attempt to launch such a publication in Britain was made in January 1977. *MaMa* – *Women Artists Together* documented the experiences of the postal event *Feministo* (see Section III, 12-15) as well as containing articles about feminist activities in Britain. It was compiled by the Birmingham Women Artists' Collective who declared,

> We hope this booklet of our voices and images will be one of many, produced by different groups; perhaps a circulating journal could emerge.[11]

In 1979 the type of journal they envisaged did emerge, *FAN* or *Feminist Art News*. This is a quarterly magazine produced each time by a collective of women from a different part of the country who have focused on a particular theme. Issues so far have covered education (1 and 10), performance (2), Comics (3), Women's Crafts (4), Women's Art History (5), Photography (6), Women's Space (7), Women Working Together (8), Women, Textiles, Fashion (9).

Women's exhibitions and women's spaces

Mention has already been made of the way feminist artists sought to exhibit outside conventional galleries with, for example, 'Womanpower' mounted in Swiss Cottage Library, and the Women's Workshop of the Artists' Union at the Arts Meeting Place. But new venues were desired not only to make art

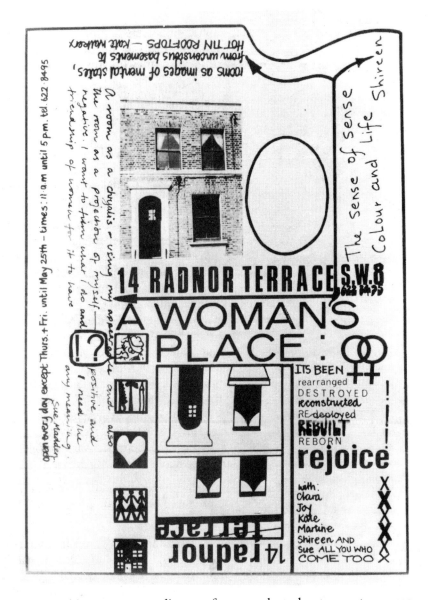

accessible to a new audience of women but also to create spaces
which would complement or contribute to the work itself. In 1974
a Women's Art Group had been formed in South London by Sue
Madden, Catherine Pantley, and Kate Walker. During April and
May six women artists took over a house in Radnor Terrace,
Lambeth, London. Kate Walker used three rooms to make
environmental statements about the expectations and contradic-
tions facing the artist/housewife. Sue Madden working with
mixed media similarly explored the dark side of the domestic
dream and the construction of femininity, in order to 'grow and
transform' by working consciously through activities which 'wipe
away women's identity'; the smoothing, concealing or obliterating

of those aspects of her body which fail to fit the feminine norm. Other artists in the group exhibited paintings and sketchbooks once the women had renovated and decorated the house (see Section III, 7). (Fig. 5)

All of the major groupings of feminist artists recognised the need for a building that would serve as a women artists' centre. In 1974 the Women's Workshop of the Artists' Union declared,

> If we could find the space we would like to start a women's art lab which would house activities in all media (film, theatre, music, dance etc.), where we could pool knowledge, materials, tools and experience.[12]

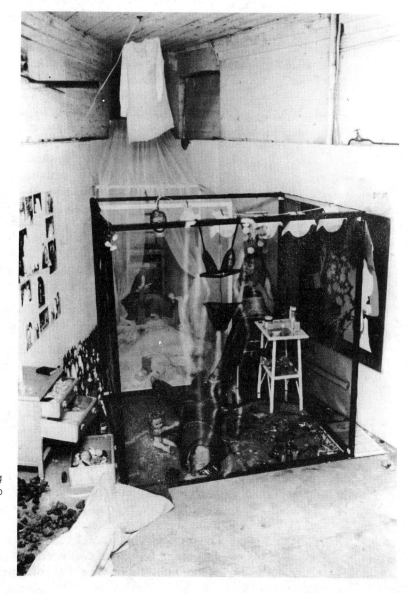

6　Kate Walker Performance still from performance at *'Sweet Sixteen and Never Been Seen'*, Women's Free Arts Alliance, 1975. The artist stated: 'Beginning nude, I performed a reverse strip tease act; dressing in a sexist style (black stockings, underwear, heavy make up); then as a housewife; then as a male artist-hero walking off presumably into the art world.'

The need was answered by the formation of the Women's Free Arts Alliance (see Section II, 6 and 7). The organisation was primarily the brainchild of two women whose area of work had been not the visual arts but theatre, dance and therapy. Kathy Nairne and Joanna Walton began to work towards founding a women's art centre in 1972, registered as a charity in 1974 and opened their first exhibition at premises in King Henry's Road, Chalk Farm, London on Valentine Day in 1975. The exhibition 'Sweet Sixteen and Never Been Shown' was large, and diverse incorporating a range of media from oil paint, to pottery and performance (see Section II, 7). It brought together women who had never been actively involved with feminism and those like Liz Moore who had already participated in several feminist exhibitions (Fig. 6).

In June 1975 the Women's Free Arts Alliance moved to new premises in Cambridge Terrace Mews adjacent to Regents Park, London. Writing classes, self-defence, art classes, African drumming and dance were just a few of the activities available to women at the centre. For a while even a food co-op operated, largely for the benefit of local women. The combination of food co-op and artistic activities indicates the way the Women's Free Arts Alliance in its early incarnation combined different and at times clashing cultural models. There were the convictions characteristic of a specifically American tradition of feminism that every woman had it in her to be creative, once she was liberated from the dominant mode of instruction and exhibition appropriate to men. The feminist belief that the right context would 'free' women's creativity combined with an insistence on self-discovery typical of growth movement therapies then flourishing. Looking back, Kathy Nairne comments:

> We wanted to give ourselves, physically and emotionally, space to develop ourselves and our creativity. If we were not what men said we were, what were we?[13]

The desire to provide a place where women could explore and discover their personal potential co-existed with a more British-based belief in the necessity for democratising art practice by working at a community level. It was the period of the development of community art centres and the expansion of community art projects. Indeed, the centre was directed by the Arts Council to apply to the Community Arts Panel for funding. The organisation tried to be responsive to the needs of local women as well as to the wider population of women. However, as with all community art projects they faced endless contradictions, trying to democratise art in a society which maintains it as an élitist practice.

Perhaps the salient characteristics of the Women's Art Alliance as it became known from 1978 was that the ideology of the centre

remained fluid. During the organisation's lifetime the character of the place changed as one group of organisers was replaced by another. The premises were available for whichever group of women had the energy and inspiration to occupy them.

The first exhibition at Cambridge Terrace Mews, Regents Park, opened in 1976, titled 'Women's Crafts'. A series of group shows, organised by Linda Mallet followed: 'Images of Women', 'Not the Object' (diaries and sketchbooks), and 'Off the Fence' (which had an overtly political content). With Linda Mallet's departure for Scotland in 1977 regular group exhibitions ceased and the gallery became a venue for intermittent one-woman shows, for instance 'Towards a Feminist Perception: Four Years' Work by Alexis Hunter' in 1977. The gallery is no longer in operation.

The year the Women's Free Arts Alliance moved to Regents Park (1975) was one of considerable activity for feminists in art. The Birmingham Women's Art Collective was established. Women organised a demonstration and protest against the Arts Council's discriminatory arts awards and exhibition policies. An exhibition titled 'The World as We See It' opened at Swiss Cottage Library with work by Hilda Bernstein, Maureen Scott, Jean Miller, Mary Wolfard, Liz Moore, Gertrude Elias and Mary Louise Colouris. The exhibition, 'Women and Work' (not to be confused with the project for an open women's show (see p. 13), was a documentary analysis on the impact of Equal Pay legislation on women workers in a South London Metal Box Co. factory. Initiated within the Women's Workshop of the Artists' Union and produced by Kay Hunt, Mary Kelly and Margaret Harrison, it was shown at South London Art Gallery (see Section III, 8). The Women Artists Collective was also formed in this year. The latter consisted of a group of women who had been in the Women's Workshop of the Artists' Union but had felt the need to move away and organise independently as women. Pressures had been building up in the Women's Workshop in part due to the number of projects the women took on. As Tina Keane has remarked, 'I didn't want just to be a researcher'.[14] This had led to the desire to organise the all-women shows of 1974 – a priority for some who needed to be able to produce specific work for a specific context. In the Union the necessity that some women felt for the chance to work together as women on the shows was not fully supported – women's issues were and are still so often dismissed by the male Left as diversionary. Some feminists remained committed to the Union and a broad base of political and cultural campaigns, e.g. Alexis Hunter, Mary Kelly, Margaret Harrison – while others left to form the Women Artists Collective.

In July 1975 the Collective held a week-end conference at the Franklin School in London. It included discussions of feminist art history, a showing of the film of the Feminist Art

Program's 'Womanhouse' and talks and slide shows by women about their own work. The Women Artists Collective continued to meet regularly as a discussion and support group until 1983.

Women and art history

Since 1971 when Linda Nochlin's article 'Why Have There Been No Great Women Artists?' appeared in the American magazine *Art News* feminist art history has rapidly expanded, identifying the massive omissions from standard art history of the heterogeneous traditions of women artists. In the USA prestigious historical exhibitions such as 'Old Mistresses: Women Artists of the Past' at the Walters Art Gallery, Baltimore in 1972 and 'Women Artists 1550-1950' at the Los Angeles County Museum – from whence it travelled in 1976 – represented major feminist interventions into established institutions. There have been no such substantial public demonstrations of women's art in Britain but feminist art work in art history has been developing through individuals' work inside many institutions. In the early 1970s, however, the impulse came from a collective of women within the women's movement – the Women's Art History Collective, another group initially affiliated to the Women's Workshop of the Artists' Union. This involved Rozsika Parker, Griselda Pollock, Alene Straussberg, Pat Kahn, Lisa Tickner, Tina Keane, Denise Cale, Anne de Winter. Since its inception in 1972 after the open meeting organised at Swiss Cottage by the artists of 'Womanpower', the Collective undertook research into and analysis of many aspects of women's history in art. The Collective travelled to talk at colleges and universities about the neglect of women artists in art history, the prejudice evident in contemporary criticism and art education, and the ideological effects of dominant forms of imagery in which women figured. In 1974-5 the Collective taught an evening class at the Holloway Institute for the Inner London Education Authority entitled 'From Patchwork to Painting'.

Believing that methods of teaching determined how knowledge is produced, the Collective attempted to break down the traditional relationship between lecturer and audience. They taught as a group to undermine the notion of the teacher as individual, unchallengeable authority. The ideology of the classroom more often than not swamped their efforts. Despite its avowed intentions, the group was easily perceived by students as merely a corporate authority figure. But the structure did have the advantage of giving those members of the group with no experience of teaching the necessary sense of support to start speaking in public. Moreover the material the group brought to art colleges, their collective research on women artists of the past, had enormous impact on women students with no previous knowledge at all of the history of women artists.

While retrieving knowledge of the work of women artists of the past, feminists have also been active in conserving the evidence of women's work in the present. During 1976 a group formed to establish Women Artists Slide Library, a slide library of art by women, and while they were searching for permanent premises, a nucleus of a slide library was operated from the Women's Arts Alliance, the Women's Research and Resources Centre and A Woman's Place by Annie Wright, Pauline Barrie, Flick Allen, Debbie Dear. Several members left, but soon Pauline Barrie and Flick Allen were joined by Gillian Elinor. In May 1982 permanent and accessible premises were found at Battersea Arts Centre in the Old Town Hall. The group was now an executive committee composed of Janis Jeffries, Clare Rendell, Gillian Elinor, Joanna Banham, Clare Torvey, Elizabeth Shepherd and Pauline Barrie. All women are welcome to submit slides of their work and the library is open for reference purposes regularly for six hours a week. Not only does the library function as an archive for contemporary and historical work but the executive committee has organised and hosted conferences and exhibitions in the arts centre. Workers were, for example, involved in the Women and Art Education conference in October 1982 and in the exhibition 'Women and Textiles – Their Lives and Their Work' in November 1983.

Feminist art history in Britain has never won so high a profile within the academic and museum establishment as in the USA for instance. None the less there has been a constant feminist voice at the annual conferences of the Association of Art Historians (one of the earliest papers given in 1978, 'The Body Politic: Female Sexuality and Women Artists' is reprinted in Section IV, 1). It took fourteen years after the foundation of the Women's Art History Collective for a Feminist Event to be organised for the AAH conference held in Brighton in 1986. The opening session was addressed by Linda Nochlin, Lisa Tickner and Griselda Pollock and they discussed the questions, 'What is feminist art history?,' 'What has it achieved?', 'Where should it go now?'; while workshops opened out discussions on art history and the woman artist, painting and the construction of gender, women and advertising. Despite the academic setting both participants and speakers consistently emphasised the political purpose of feminist art history. Feminist art history was positioned as both part of the women's movement and one instance of the movement's current vitality.

Four hundred people attended these sessions. The purpose of the Event was not an internal improvement of an ailing discipline. Its project is political, dealing in the politics of knowledge, and thus of power.

The feminist problematic in art history is shaped by the terrain on which we work but it is ultimately defined within that collective

Women and official Culture

critique of social and economic power which is the women's movement. (Panel statement by Griselda Pollock.)

In the USA the first signs of a movement amongst women artists were the protests against the exclusion of women from public exhibitions and collections of contemporary art. After the protests outside the Whitney Museum of American Art in New York in 1970, there followed organised demonstrations against other institutions which included no women in their exhibitions, such as the Los Angeles County Museum in 1970, the Corcoran Art Gallery, Washington in 1971 and the Museum of Modern Art in 1972. The institutions of official culture in Britain are more limited and they are publicly owned, financed and administered. Most museums in the USA are private corporations. In the first half of the 1970s feminist activity was concentrated in alternative spaces such as the Women's Free Arts Alliance, and the Women's Workshop of the Artists' Union. It was, however, increasingly obvious that an intervention had to be made into the official and public institutions which were responsible for shaping the public's ideas about the state of the art, and for awarding grants to artists and buying works for a national collection. It was vital on many fronts to bring attention to the discrimination against women artists.

In 1975 members of the Women's Workshop of the Artists' Union had organised a protest outside the Arts Council's main London venue, the Hayward Gallery, which was then housing a large show, 'The Condition of Sculpture', which included only four women out of a total of forty exhibitors. The intention was to highlight the discrimination against women in the sphere of publicly funded and promoted exhibitions. A petition was subsequently handed in to the Arts Council's offices in Piccadilly demanding parity for women in exhibition and funding. Pressure of this order and agitation by other individuals led to five artists, Tess Jaray, Liliane Lijn, Kim Lim, Rita Donagh and Gillian Wise Ciobotaru being invited to select the second Hayward Annual Exhibition in 1978. Like the Whitney Annuals in the USA (see page 4), the Hayward Annuals were to be comprehensive surveys of current British art. The first exhibition had included only one woman. The women selectors for the second Annual invited twenty-three artists to participate, of which sixteen were women. 'I think we're fairer to men than they were to us', said Tess Jaray in an interview with Suzanne Hoggart of *The Sunday Times*.[15] Although none of the selectors were actively involved in the Women's Movement or declared themselves publicly to be feminists, the experience of preparing this exhibition changed their consciousness. 'We weren't part of a feminist group, but doing this had made us one.'[16] The complicated history and

implications of this event are analysed in an article in this anthology (Section II, 8) but the Hayward Annual II 1978 remains the major breach into official culture on behalf of women in Britain. The event raised major questions about women's place in contemporary art institutions and practices and about the relationship between feminist art practices and both art by women and official art in general. The optimism felt by the organisers that the exhibition would have a telling effect – 'Women won't be pushed into the background as they have been'[17] – has yet to be proven. The exhibition also marked a major moment of dialogue across the community of women involved in art between women in different spaces in art and in different relationships to the Women's Movement.

Feministo

Although London was the centre of feminist art activity in the 1970s, as early as 1972 a women artists' group had formed in Bristol and during the decade groups proliferated throughout the provinces. A determination to 'decentralise' is part of the politics of the Women's Liberation Movement. Thus annual conferences would circulate around provincial cities throughout the country giving different groups of women the chance to learn about organising such events and enabling many women, especially with children, to attend who would otherwise not be able to travel to London. Individual galleries and art centres have been sympathetic to feminism, for example the Chapter Arts Centre in Cardiff, the Arnolfini Gallery in Bristol, the Bluecoat Gallery in Liverpool, Richard Demarco in Edinburgh, Rochdale Art Gallery, and the Midland Group Gallery in Nottingham. These and others have housed touring feminist exhibitions.

The event which was of crucial importance for the dissemination of feminist art was 'Feministo'; the postal event exhibited as 'Portrait of the Artist as Housewife'. In 1974 Kate Walker and Sally Gollop began exchanging art works through the post. The pieces functioned as links between the two women at home with small children, and as a medium for conveying the artists' feminist critique of conventional definitions of art and artist. The small-scale works, often utilising domestic objects and household skills, created a dialogue on the ideology of domesticity and femininity. The numbers of women involved expanded and in 1976 the artists began to exhibit their work in provincial galleries; during May in Manchester, then in Birmingham, Edinburgh, Liverpool, and ending in November at Coventry Women's Aid Centre. In June 1977 'Portrait of the Artist as Housewife' opened in London at the ICA. The artists deliberately transformed the impersonal, empty spaces of the ICA into a more domestic environment emphasising that they were inserting works from the private personal sphere into a professional, public setting. Theirs

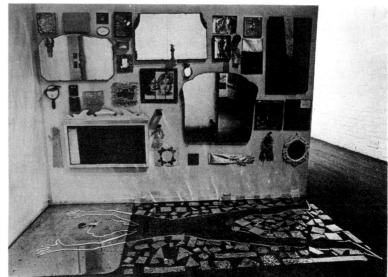

7, 8, 9 Feministo: 'portrait of the Artist as Housewife', London Institute of Contemporary Arts, 1977. (Photographs by Michael Ann Mullen.) Mixed media installation of postal works and environments

was a political act, highlighting the hierarchical separation of the two spheres – a separation which works to devalue everything women produce.

After 'Feministo' came to an end, several of the artists involved teamed up with each other to continue creating works which revealed the contradictions besetting women who wished to combine art making with the specific demands facing women as mothers and housewives.

10 'Feministo' contd.

11, 11a Sue Richardson, Monica Ross, Kate Walker, 'Fenix' 1978, mixed media installation produced in the gallery

 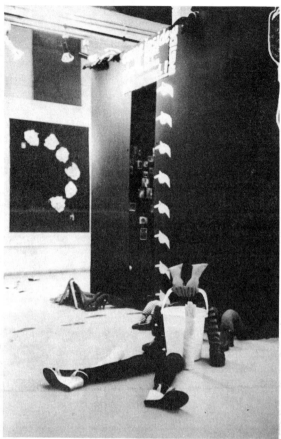

12, 13, 14 'Fenix' 1978 cont'd

In 1978 Kate Walker, Sue Richardson and Monica Ross began the travelling exhibition 'Fenix Arising' (see Section III, 16, 17) which they worked on *in situ*. By showing work in process the artists were pursuing a feminist practice aimed at both demystifying the role of the artist and at attacking the commodification of art work for the market place. A high degree of professionalism and finish can contribute to the work's being treated as a commodity, as an art object or object of art, whereas the refusal of 'finish' or closure at the level of content forces the spectator to engage with the politics of the work and the process of its production as an object *and* as a meaningful text. Other radical art movements have similarly placed a high premium on exposing the process of art making – but for feminists the act had specific implications. The 'Fenix' artists in particular wanted to demonstrate the working conditions of so many women artists – not insulated in studios but constantly interrupted by the demands of life, domesticity and childcare. The exigencies of their environment were shown to be, in 'Fenix', an integral part of the creative process – an enrichment.

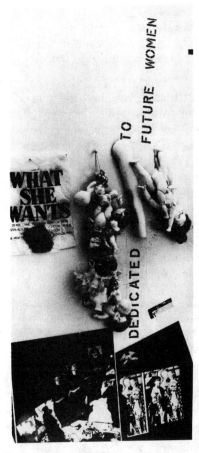

The social body of woman

'Mother's Pride: Mother's Ruin' (1977-8) also developed out of 'Feministo' (see Section IV, 9). Phil Goodall and Tricia Davis collaborated to produce a mixed media exhibition which travelled the country. Using material from their everyday lives – diaries, photographs, clothing and domestic objects – they presented different stages in a woman's life. For example, a girl's gym slip and a school desk edged with lace carry quotations from educational reports on the importance of training a girl for her main role in life as a future wife and mother.

Reviewing the exhibition Trisha McCabe commented:

> 'Mother's Pride: Mother's Ruin' manages the tightrope between being entertaining and depressing because it doesn't only go round in circles; the cyclical suggestions are there, birth, education, birth, work . . . but it ends with positive images of women, not idealistically throwing off the shackles, but struggling against them. The final image is a woman covered in campaign badges – a 'where we go from here' image, not free from pressure because contextualised by the personal life portrayed around it.[18]

Trisha McCabe's review alludes to the debate that developed early in the Women's Liberation Movement around the theme of positive images of woman. It was argued that the denigratory or 'false' images of women which surround and shape us could be encountered by producing positive, heroic, feminist realist images. This idea was found to be extremely problematic (see the Introduction to Section I). However, to produce representations of women that conveyed our oppression alone was similarly inadequate. McCabe felt that in 'Mother's Pride: Mother's Ruin' the artists successfully negotiated their way between documentation and inspiration by exposing and analysing the conditions of women's lives in conjunction with their political resistance:

> The exhibition as a whole complements and supports the politics it presents because the women include diary entries recording working on the show, and the difficulties they encountered finding child-free time *they've* had to organise, 'no-one will do it for us', and finding positive things to say about women's lives, and more than anything, about our future.[19]

A very different form of 'positive images of women' was produced by those artists involved in a touring exhibition of 1978, 'Womanmagic' – Marika Tell, Monica Sjoo and Beverley Skinner. They present and celebrate the power and dignity of women's sexuality and fertility–creativity. As Monica Sjoo had written in *Towards a Revolutionary Feminist Art* (1972):

> In fact it was after giving birth to a child that I started to develop a 'feminist consciousness' because I could not reconcile this experience

of extreme strength, dignity and violence with the feebleness, weakness, and lack of creativity which is expected of women in this society. In fact, to give birth is an 'unfeminine' act, the way femininity is defined in our society.[20]

Whereas 'Mother's Pride: Mother's Ruin' represented the stages of women's lives as socially constructed and politically resisted, the artists involved in 'Womanmagic' celebrate universal aspects of womanhood, transhistorical, transcultural, multi-racial, reaching back through ignored traditions, religions, and mythologies to goddess worship and a recognition of women's biological and spiritual value. The exhibition contained batiks by Marika Tell, and paintings by Monica Sjoo and Beverley Skinner. Monica Sjoo's famous painting 'God Giving Birth' (see Fig. 1 on page 6) was included (see Section III, 1, 2). Joanna Klaces enthusiastically reviewed the exhibition, concentrating on the mythological content and offering particular praise to Marika Tell's batiks:

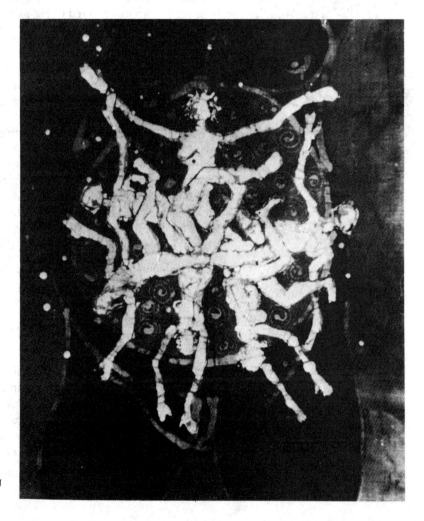

15 Marika Tell, 'Woman Giving Birth to Herself', 1978, batik

The small batiks hung from the ceilings and in windows, like flags printed with figures gushing life blood, indeed 'flying the flag', the old euphemism for menstruation is given new, unembarrassed and jubilant meaning. Marika Tell talks of her designs expressing 'The rhythms of birth, death, re-birth in our woman-selves, the rhythm of menstruation, the wisdom of the womb, the power and influence of the moon' – and they do.[21]

The tradition of feminist theory to which 'Womanmagic' belongs raises the issues of a feminine sensibility or a female aesthetic. The positive pleasure of such a belief is the celebration of the specificity of women's identity, life and experiences. This can, however, easily slide into an assertion of an essence of womanhood, suppressed or distorted in male society which it is the feminist project to liberate. There has been considerable criticism of these claims, for instance in the collective paper given at the Socialist Feminist Conference in 1979. The authors reviewed current feminist tendencies in art practice but argued against an essentialist feminist position. Discussing the feminist celebration of traditional 'feminine' skills, for example, patch-working, and the focus on female reproduction and sexuality as the basis for a female aesthetic, they commented:

> But in celebrating what is essentially female we may simply be reinforcing oppressive definitions of women, e.g. women as always in their separate sphere, or women as defining their identities exclusively, and narcissistically, through their bodies.[22]

It is easy to overemphasise a conflict of opinion. Both those who believe that there is an essential feminine sensibility and those who insist that femininity is socially and historically constructed, support the tactical importance of revealing and analysing aspects of women's lives that have been veiled in shame and silence – childbirth and menstruation, for example. Acknowledging the importance of events of the body, as do all feminists, is not reducible to biological essentialism, a facet of patriarchal ideology which supposes a primordial difference between the sexes determined by anatomical and specifically genital structures. How the body is lived in and experienced is implicated at all levels in social or socially determined psychic processes.[23] The radically different ways in which these issues are approached underline the diversity of positions held by feminist artists, and the major differences of effect which both the theoretical and the artistic frameworks produce.

In her piece entitled '10 Months' (1977-9) Susan Hiller analysed a woman's (her own) consciousness during pregnancy. She displayed photographs she had taken of the body during pregnancy which documented the gradual swelling of the growing child inside. These photographs were arranged in sequences of

16 Susan Hiller, '10 Months',
1977-9, 10 composite
monochrome photographs
with captions

twenty-eight, one sequence for each of the ten lunar months of
pregnancy, and these images were juxtaposed to a written
discourse drawn from a diary covering the same span of time.
Writing about the work for a special publication of it in *Block*
magazine, Lisa Tickner observed that,

> The sentimentality associated with images of pregnancy is set tartly
> on edge by the scrutiny of the woman/artist who is acted upon, but

17 Detail

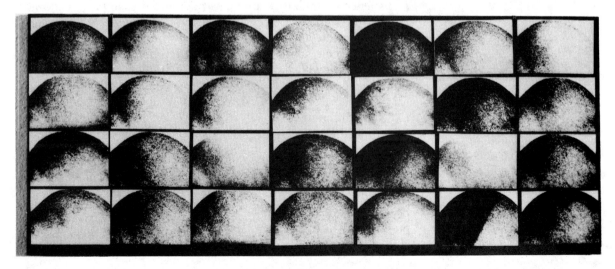

who also acts; who enjoys a precarious status as both the subject and the object of her work. ('She is the content of a mania she can observe.') The belly swells and rises like a harvest moon – but the echoes of a landscape, the allusions to ripeness and fulfilment, are refused by the anxieties of the text, and by the methodical process of representation. The conflict between a need to speak, and the difficulty of speaking, is exacerbated at this moment when the self is 'engrossed' and identity peculiarly uncertain. ('She now understands that it is perfectly possible to forget who one has been and what one has accomplished.')[24]

Take also for example two contrasting works on the theme of menstruation. 'Menstruation II' (1979) was a three-day perform-ance by Cate Elwes. It coincided with the duration of a menstrual period. Enclosing herself dressed in white seated in a white, glass-fronted box, she could be observed bleeding and writing answers to questions on the walls and windows of the box. The work confronts the cultural non-existence of menstruation, which as a natural and regular part of women's lives is none the less a source of shame and an excuse for quite violent repression of women.

Cate Elwes used performance as a means of breaking the taboo because she argues that 'the "material" of women's experience does not work with a masculine structure, and painting and

18, 19 Cate Elwes, 'Menstruation II', photographic documentation of a three day performance at the Slade School of Art, 1979

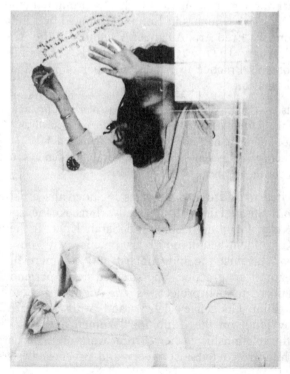 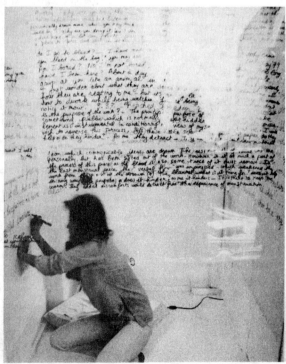

sculpture are too loaded for illicit imagery'. The artist has written about her work in these terms:

> The work reconstitutes menstruation as a metaphorical framework in which it becomes the medium for the expression of ideas and experiences by giving it the authority of cultural form and placing it within an art context.[25]

By contrast Judith Higginbottom has concentrated on the 'relationship between the menstrual and lunar cycles, between menstruation and dreaming, and between the menstrual cycle and creativity'.[26] Her installation 'Water into Wine' for the exhibition 'About Time' in 1980 was based on letters she wrote to women all over the country inviting them to document creative activity and dreams in accordance with lunar and menstrual cycles. Although this work is based on a belief in an essential femaleness located in the body, it can also be read as an attempt to produce a symbolism for women, using the body or bodily processes of women as a prop for representing as creativity what has hitherto been experienced by women as the mark of their physicality, their biological destiny. Feminist work, as these examples demonstrate, cannot be classified in terms of content. But a feminist consciousness of women's oppression does not of itself prescribe the forms of response or resistance, or of political analysis and artistic strategy.

An awareness of the increasingly intricate issues facing women artists, and their varying responses to them, prompted the organisation of a series of seminars in London arranged by Linda Mallett of the Women's Free Arts Alliance. A seminar at the AIR Gallery on 20 February 1977 was titled 'Towards a Feminist Perception of Women's Practice in Art'. A number of questions were posed for discussion:

> Do women artists face basic conflicts? What has women's art practice been in the past and what is it now? Is there, in fact, an especially female art practice and if so, how does it relate to the masculine mainstream? Is there an equivalent female aesthetic, either feminist or non-feminist? Is our theory ahead of our practice?

The panelists invited to address such issues included the artists Margaret Harrison, Susan Hiller, Mary Kelly, Tina Keane and the critics Jane Kelly, Caroline Tisdall and Sarah Kent. In her remarks Mary Kelly identified feminist art practice with other radical interventions against the individualist and commercially oriented mainstream of art practice. She stressed her experience of working collectively in such projects as *The Nightcleaners* film (Berwick Street Film Collective, 1975) and with Margaret Harrison and Kay Hunt on the exhibition 'Women and Work' (1975), but also the relationship of her current work on maternal femininity and childcare to feminist theory and psychoanalysis.

Margaret Harrison emphasised in her talk the need for women to confront the discrimination against women of the institutions of art education, exhibition and public funding and to develop a strategy for intervention. Susan Hiller's primary concern was with the exclusiveness of language in a masculine-oriented culture which means that women lack a suitable or authentic mode of public discourse. While trying to develop an appropriate form of language, she argued that there was the problem of the work of women being misread by critics and thus marginalised (see also Section IV, 5). Tina Keane spoke of the importance to her of the psychological support and solidarity of women's groups such as the Women Artists Collective which had come out of the Artists' Union. This point was reinforced by the critic Sarah Kent who, in a review of the seminar for the magazine *Readings* provided this revealing insight into how attending the seminar had altered her suspicions of feminism and her attitude towards women's 'problems':

> although in general I feel sympathy with women artists and believe their problems to be genuinely more acute than those of their male counterparts, when it actually came down to defining these, I discovered a very strong resistance to an activity that seemed filled with indulgent self-pity. To recognise one's problems seemed to confer upon them a status more important than they merited, in fact to acknowledge their existence at all implied, for me, a passive, though complaining, acquiescence One result of the seminar for me, and I guess for others, was the realisation that sharing difficulties may be a step towards eradicating or, at least, ameliorating them, and need not appear like an admission of weakness or defeat, nor an excuse for failure.[27]

Regional activity

By 1980 there were women artists' groups through the country, with particularly active groups in Manchester, Sheffield, Leeds, Birmingham, Nottingham and Bristol (see Section II, 9). For instance in 1981 the Sheffield Feminist Arts Group put on an open exhibition of Sheffield women's art called 'With One Hand Tied Behind Us'.[28] Housed in an unused shop in the city centre, the show demonstrated the possibilities and difficulties of bringing together a variety of work by women in many media in a context which was nevertheless evidently feminist in the supportive freedom available to all the women to make a statement.

In 1981, as part of a campaign to start the first feminist photography and arts centre in Britain, the Leeds Women's Art Programme, inspired by the example of the Feminist Art Program in California in 1970-1, was started as a means to co-ordinate women's activities and to initiate courses in art history and

Introduction

20 'Anonymous: Notes towards a show on self-image', Leeds St Paul's Gallery, 1982, 10 panels, installation shot

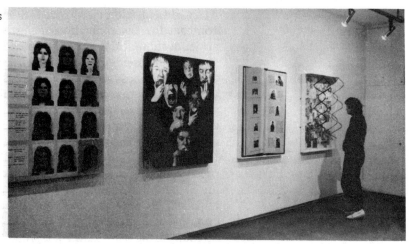

21, 22 Details

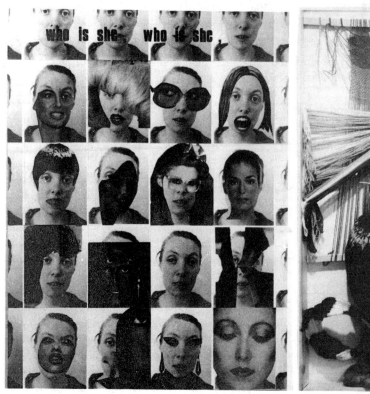

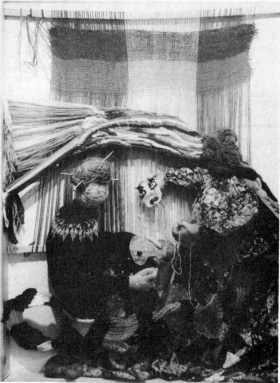

practical art work. Based in the local Workers Education Association, several courses were run, one of which led to the formation of a collective which mounted an exhibition, 'Notes Towards a Show on Self Image' which was first exhibited at St Paul's Gallery in Leeds in February, 1982. It was also shown at Sheffield Polytechnic, the Fine Art Department at Leeds University and the Art Centre in York. During its initial showing

at St Paul's Gallery, there were more visitors than had been recorded by any other of the gallery's previous exhibitions.

In the accompanying catalogue the collective explained the exhibition:

> This show is the result of work which a group of women began at a Saturday morning art class at the Swarthmore Centre run by Caroline Taylor as part of the Leeds Women's Art Programme. The work is on the theme of self-image, a concept which appeared to us more and more complex as the course progressed. We chose the theme because of the paradoxes which have to be negotiated for a woman to identify herself as an artist, a term which is in our culture (publicly) gender specific, i.e. male.[29] (Figs 20-22)

All-women galleries such as AIR in New York and feminist centres such as the Women's Building in Los Angeles have provided a continuing organisational backbone for generations of women artists in the USA. The difference of funding possibilities and of general attitudes on the part of official art support bodies such as the Arts Council of Great Britain are revealed in the fact that the first feminist gallery to be opened with public financial support did so only in 1983. The Leeds Women's Photography Project opened The Pavilion, a gallery and darkroom, in May 1983 in a once-derelict refreshment centre in the middle of Leeds. Run as a collective by and for women to gather and discuss the exhibitions, see films and other events, it has had to counter the suspicion of funding bodies about its management structure and about women-only events. The argument that because women are a disadvantaged minority in terms of cultural resources and opportunities, they deserve some of the financial aid for arts activities, is hardly won before anxieties generated by women working on their own behalf lead to financial cutbacks.[30]

In 1981, there was a group exhibition by the Nottingham Women's Art Group at the Midland Group Gallery. Seventeen women showed work; some were trained as artists, others were self-taught. Included was a joint project initiated by Carol Crowe. A set of boxes was exhibited, each painted by a different woman; three sides having a linking theme and three are random. The brightly coloured cubes, some abstract, one quilted, were placed in the gallery and visitors were invited to arrange them. The group explained, 'It is intended as temporary art, and should be easily accessible to the public.'

In 1983 the Nottingham women organised a more ambitious event of over seventy works, films and performance by the feminist art group. The show was divided between the Midland Group Gallery, the Castle Museum and Queens Medical Centre University Hospital main reception area. A day school was arranged to discuss the shows.

The Institute of Contemporary Art 1980

A series of events in the Autumn of 1980 represents the outcome of ten years of action by women artists. Between September and December the Institute of Contemporary Art in London hosted three major exhibitions of women's work. In 1970 no major gallery would have dreamt of providing a venue for an all-women, overtly feminist show, let alone a series of consecutive all-women, overtly feminist exhibitions. The first show which opened in September 1980 was called 'Women's Images of Men' (see Section III, 18). It had complex origins. A group of women had been meeting at the Women's Arts Alliance to discuss the necessity for finding a space for a co-operative gallery in which women could exhibit their work. Then Nina Jennings called a meeting at the Alliance to protest against a current exhibition at the ICA of the work of Allen Jones (July to August 1978) in which female figures were exhibited as pieces of furniture and in other degraded poses. It was decided to 'claim from the ICA the right to intervene by presenting a show of women's attitudes towards men'. A committee was established comprising Joyce Agee, Cate Elwes, Jacqueline Morreau and Pat Whiteread who advertised for submissions for a proposed exhibition of 'Women's Images of Men'. So overwhelming was the response that two exhibitions were decided upon – one of painting, drawing, sculpture and photography and another devoted to work in performance and video. The latter, called 'About Time', was organised by Cate Elwes and Rose Garrard in conjunction with the new exhibitions director of the ICA, Sandy Nairne. It revealed how time-based work in general and performance in particular had become an important area for feminist work.

In the catalogue essay for the exhibition Lynn MacRitchie

23 Elena Samperi, 'Madonna', 1979

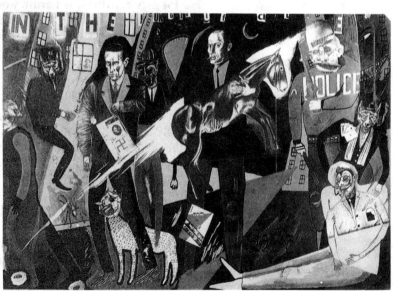

24 Sue Coe 'In the Jungle of the Cities', 1980. (Courtesy of the Thumb Gallery.)

provided an outline history of performance by women associated with the women's art movement since 1970. Prior to 1970 some women were involved in the happenings associated with the two London Arts Labs at Robert Street and Drury Lane. Carlyle Reedy who was to contribute to later feminist events performed there, although Kate Walker, reminiscing about the late 1960s performance, happenings and events, recalls that 'women were incidental to the whole process.'[31]

With the politicisation of performance in the 1970s women's performance work developed rapidly. In 1971 Shirley Cameron abandoned sculpture to take up performance as a more immediate and effective means of artistic communication and she has developed performances which explore the specific qualities of women's lives and relationships. 'Naming Our Vision' (1973) concerned the relationship between making art works and producing children (she worked with Roland Miller), and '30th Birthday Project' was a study of units of time over the period of one year leading up to her thirtieth birthday, considering the texture of a day, a week, a month, a year and a decade through diaries, photographs, records of food bought, earnings, chores done and so forth. After the birth of twins Shirley Cameron incorporated her babies into performances to underline the reality of women's dual working lives. She has collaborated with the novelist Angela Carter and since 1981 with Evelyn Silver in a series of performances about reclaiming negative female imagery such as the Bride, the Virgin Mother, and most recently Britannia (Waives the Rules). Humour is a crucial element and these performances are not oriented exclusively to art venues, but Cameron has worked at festivals, factories and agricultural fairs using performance to reach a broad and diversified audience.

Another artist involved in the accessibility of performance was Susan Hiller. In 1973/4 she worked on large scale 'street pieces', such as 'Street Ceremonies' and 'Dream Mapping' which demanded the collective involvement of large numbers of participants. In the same years Tina Keane moved from presenting light shows to performance art with 'Rain Painting' and 'Playing Cards'. In 1975 during the Women's Day at the Video Show which took place at the Serpentine Gallery, London, members of the Women's Workshop of the Artists' Union produced a video/performance titled 'Hands'. The following year a Performance Art Festival was mounted at the Serpentine Gallery and a group of women performance artists took part, Rose English, Judith Katz, Lyn MacRitchie and Sylvia Stevens. Since then women have been well represented at all significant performance events.

Today it would be the rare feminist art show which did not include a performance section. In 1977 British women performance artists Tina Keane, Rose Finn-Kelcey, Sonia Knox, Hannah O'Shea and Jane Low were invited to perform at *Kunstlerrinnen*

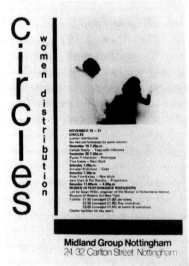

25 'Circles Women's
Distribution' Nottingham,
Midland Group, 1981

International, an international exhibition of women artists in Berlin. Increasingly, however, events focusing only on performance are being organised. In 1981 (19-21 November) a performance festival of women's work was organised at the Midland Group in Nottingham by Circles, Women's Work in Distribution with a catalogue introduction by Susan Hiller. The women involved included Tina Keane, Carlyle Reedy, Rose Finn-Kelcey, Annabel Nicolson, Pat Murphy, Rachel Finkelstein and Jane Clark. In the introduction Susan Hiller noted the tendency to falsify the history of performance art in current writing which favours American and European antecedents over British and explicitly ignores the early contributions by women. She concludes:

> The second of these tendencies is particularly remarkable, given that it is precisely in this area of work that many of our best women artists have been seen to make their mark, though significantly their work remains absent from the major public art collections which are of course object-biased.[32]

Hiller also jointly curated a season of performance by British women in New York in 1981 L.A./London Lab at the Franklin Furnace Gallery. 'A Room of One's Own' was the name of an exhibition of performance work at the Bracknell Arts Centre which lasted for three weeks in 1980. Taking part were Jeanette Iljon, Sarah Breen, Judy Child, Jane Warrick, Carrie Born, Annabel Nicholson and Pam Marre plus other women friends.

26 Rose Finn-Kelcey, 'Live, Neutral and Earth', performance documentation

"LIVE, NEUTRAL and EARTH"

– A VACATED PERFORMANCE. Rose Finn-Kelcey

'About Time' at the ICA in 1980 was a major breakthrough (see Section III, 19, 20).

> The present exhibition is the first group show of women's work in this area to be presented by a publicly funded gallery in this country. And this is after ten years of the women's movement. This is not to say that there has been no art by women. On the contrary, the present show is of selected works, a mere drop from the pool available. Thus the unfamiliarity of work by women does not lie in its rarity. It lies in its suppression.[33]

Performance has become an important area for feminists. One of its attractions is the possibility of escaping from the traditions of fine art which are already loaded with meanings, both in terms of the connotations of imagery and the social meanings of the actual practices, paintings and sculpture, for instance. Susan Hiller claimed for the artists in 'Circles' 1981:

> In an era when artistic versatility is rare, since most artists are busily producing easily labelled products required by the market, the artists in this exhibition present an alternative model of artistic behaviour, one in which formal means are radically adjusted or abandoned in favour of new solutions as the development of their ideas requires.[34]

Performance offers possibility for women to make new meanings because it is more open, without an overwhelming history, without prescribed materials, or matters of content. It implies an active relationship between performer and audience which can render the activity and experience more collective and social, more immediate, communicative and also open-ended. It is more mobile than other forms which are restricted by their media and tradition to only one level of operation (paintings don't talk) while performance gives the producer options on all sorts of activities, sound, slides, bodily presence, real objects in real space and so forth. The range of materials and unlimited possibilities for combination offers an art form whose potential complexity of subject and form and address can match the complexity of feminist analysis, itself demanded by the totality of forces and determinations which shape and condition our lives.

In an interview (1982) Tina Keane discussed the reasons why she became involved with performance in 1974 after practising as a painter and producing light shows. In addition to the appeal of the 'of the moment' quality, and the feedback characteristic of the work, Tina Keane argued that performance provided women with a significant tool for discovering the meanings of being a woman. Performance can be a learning process. It can be transforming because it demands putting 'oneself on the line' with often emotional or intimate material, revealing to both performer and audience that which is dimly perceived but never publicly acknowledged. Performance is accessible to women; it needs few

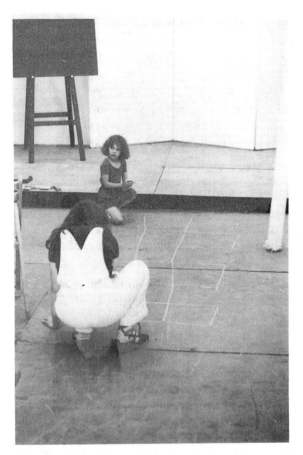

27, 28 Tina Keane, 'Hopscotch',
two photographs documenting a
performance based on the
children's games. Guy Brett
wrote; 'Her Hopscotch
performances suggested that,
although the figures are hurriedly
chalked on the pavement and
soon abandoned, the game is a
memory going back into neolithic
times.'

resources, a voice, possibly props, and something to say. Therefore, Tina Keane suggests, 'women in performance have been more important in the development of feminist art than any other media or area because it really cuts through.'

One of the central problems, however, that arise in performance is the status of the body of the woman, given the traditional ways in which a female figure is viewed and made into an object. In her excellent article on performance written for the 'About Time' catalogue (see Section IV, 8) Sally Potter addresses this difficult relationship which women have to negotiate between the presence of the woman as performer, as subject of the activity, and the spectacle of woman as the object of an audience's voyeuristic and fetishising gaze. The work of feminists in performance becomes a matter of dismantling Woman as Image by using the potential of performance to constitute different relations between woman and audience.

There was considerable concern about the organisation of these shows, 'Women's Images of Men' and 'About Time', precisely because the submissions were subjected to a selection

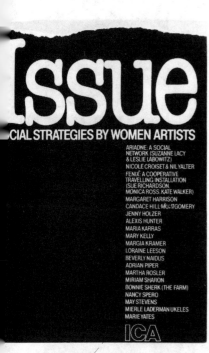

29 Issue Social Strategies by
Women Artists, London Institute
of Contemporary Art, 1980

procedure. In the former, works by only forty artists were chosen. A 'Salon des Refusées', called 'The Extended (or Alternative) Women's Images of Men' was organised by Chick Hill, Rosemary Mountford and Cathy Nicholson of the South London Women's Art Group at the Bakehouse Gallery in Blackheath, and works by twenty artists which had been offered to the ICA but not accepted by the committee, were shown with works by twenty local artists. (It was reviewed in *FAN* no. 3.) None the less, the response to 'About Time' and 'Women's Images of Men' was tremendous, and both went on tour through Britain, the latter attracting huge audiences wherever it was exhibited.

Following these two shows at the ICA came an exhibition selected by the American critic Lucy Lippard. It was an international feminist art show called 'Issue: Social Strategies by Women Artists'. It scrutinised that branch of contemporary feminist art which is 'moving out' into the world, placing so-called women's issues in a broader perspective or utilising mass production techniques to convey its message about global traumas such as racism, imperialism, nuclear war, starvation and inflation to a broader audience. The exhibition contained the work of twenty-one artists from the USA, France, Turkey, Israel and Britain. The British artists included the Fenix co-operative – Sue Richardson, Monica Ross and Kate Walker (Figs. 11-14), Margaret Harrison (Figs. 32, 48), Alexis Hunter (who was born in New Zealand but works in London) (Fig. 31), Mary Kelly (born in the USA but working in London) (Fig. 49), Lorraine Leeson (Fig. 30), and Marie Yates (Fig. 51). Lippard stressed the common source in the theoretical vitality of the International Women's Movement while noting the different uses to which women from different national, racial and class backgrounds put this common material. The combination predominantly of American and British artists revealed important differences between the two countries where feminism and art of the 1970s was concerned.

> For example, this ICA series is the first establishment – approved women's show in London, while New York has had women's shows but has never had a 'political art show' on the order of London's 'Art For Whom', 'Art For Society' and others. In mainstream America, social art is basically ignored; in England it enjoys the attention of a small but vocal (and often divided) group with a certain amount of visibility and media access. In America, artist-organised tentatives towards a socialist art movement are marginal and temporary, waxing and waning every five years or so with only a few tenacious recidivists providing the continuity. In England there are actually left political parties artists can join and even work with – and the more advanced level of theoretical discussion reflects this availability of practice.[35]

The ICA also mounted a concurrent film and television festival

30 Lorraine Leeson, 'Women Beware of Man-made Medicine', poster made as part of the East London Health Project

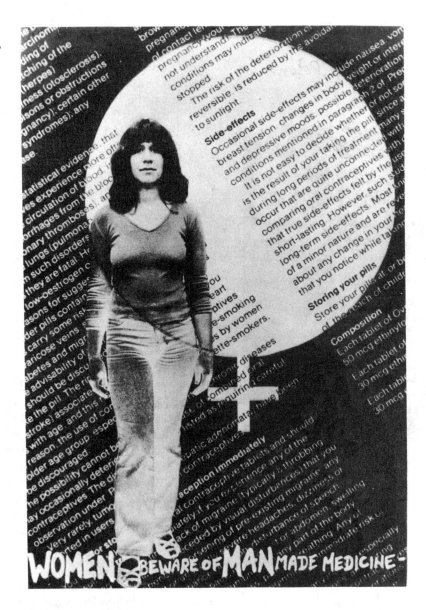

surveying eighty years of work by women in these media and their institutions. At the Acme Gallery in London 'Eight Artists: Women 1980' was shown in three parts. The work by Claire Smith, Shelagh Cluett, Emma Park, Jozega Rogocki, Mikey Cuddihy, Sarah Greengrass, Margaret Organ and Alison Wilding, showed abstract paintings in an all-women show, designed to help redress an existing imbalance in opportunities for exhibition for women artists. The catalogue introduction was written by Fenella Crichton. The conjunction of the three shows with other events of autumn 1980 demonstrated the diversity and complexity of current feminist practices.

31 Alexis Hunter, 'The Marxist's Wife Still Does the Housework', detail of multipanelled piece, 1978, colour Xerox

32 Margaret Harrison, 'Craftwork', 1980, photographs, painting, objects, installation at the 'Issue: Social Strategies by Women Artists' exhibition, London Institute of Contemporary Art

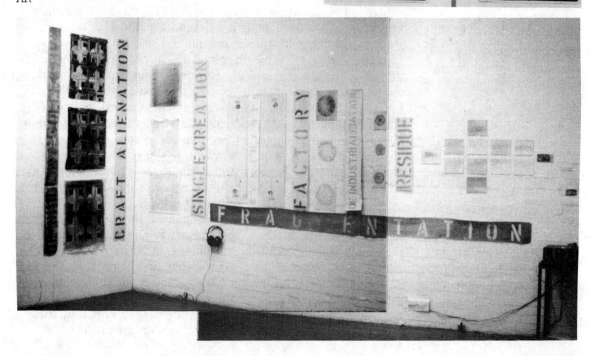

'Questions on Women's Art'

Just after the opening of 'Issue' a conference took place, 'Questions on Women's Art' (November 15-16 1980) enabling artists from all the three ICA shows and those at the Acme Gallery to join in debates with a large audience.

The conference was an historic one. The clash of convictions revealed how difficult were the issues which feminists faced about how to make art, what to make about it, how to relate to conventional or radical practices. In a highly critical review Monica Petzal complained that the conference was dominated by the articulate socialist feminist artists associated with the 'Issue' show:

> With diversity the potential strength but divisiveness and self-promotion the actual downfall of the conference, a pretty complex factionalism was evident. . . . Figurative painting, sculpture, female imagery, the female imagination and sensibility, subjectivity and expressiveness (all concerns widely reflected in the other shows and in previous US shows) were now regarded as inappropriate to the ideological cause and ten years out of date . . . the majority (of the conference) were left thinking that, in context, the 'Issue' concerns, though the most vociferous, were neither innovative nor particularly radical, and were merely part of the intended diversity.[36]

What Petzal found problematic in the seeming confidence of the artists involved in the 'outreach art' of a conceptual type, as opposed to those promoting expressionism and figurative painting, has to be read in historical terms. Against an *internal* dialectic of feminist thought around abstraction/figuration/conceptual art which had been already in evidence in 1972, there was an *external* development. In the late 1970s figurative painting and sculpture were newly being circulated and ratified in a more conservative ideological climate. The diversity of feminist practice by 1980 therefore produced critical debates about artistic practices appropriate to and relevant for *both* the women's movement and the current art world. However, in the context of the ICA conference participants experienced a sense of polarisation more powerfully than at any other previous art event.

One of the major conflicts was over the relationship between the personal and the political in feminist theory and art practice. The slogan 'the personal is political' is one of the keystones of the politics of the women's movement. Focusing on the experiences of everyday life in the realm designated the personal (home, family, sexuality) consciousness-raising groups had identified in these areas the oppressive conditions of women's lives. 'The personal is political' therefore asserts the *political* nature of women's familial oppression. And in place of a preconceived theory, feminism has developed a political understanding through the testament of individual women. Cate Elwes in *FAN*, discussed the effect of this central feminist politics on art practice:

The examination of individual cases of oppression that had perhaps been dismissed by male authority as personal quirk or fundamental inadequacy were now linked to the experiences of other women and de-personalised into an effect of collective oppression. This process produced many autobiographical works which countered the distorted images of femininity in the media and in the arts with explicit expositions of women's actual social, biological and psychological experiences.[37]

Within the domain of art, however, the project of extrapolating the general from the particular and personal collides with conventional notions of the artist which feminists are countering. The feminist principle is refracted by the romantic cult of artistic individualism and the related ideology of art as the direct, personal expression of universally valid meanings by a transcendent human subject. There is considerable danger, therefore, that claims for art as a privileged form of women's self-expression and self-exploration would collapse apolitically back into the artistic ideologies of expressivity. The determinations of the individual by society would thus disappear.

At the conference the debates reflected the contradictions between feminism and conventional notions of art. Feminist theory and art history have criticised the notion of the pure, independent artistic voice. Stressing an understanding of art as representation undercuts the idea of untramelled personal expression. Art defined as a system of signification, moreover, operates within socially and historically produced codes and conventions. Language is not a private vehicle for individually produced meaning, but a social system for the production of socially determined meanings. The feminist project is therefore as much a deconstruction of current orders of meaning as an attempt to make the spaces for the production of women's discourses. The ideological clash is therefore between the fundamental feminist belief in the value of the individual woman and her lived experience and the feminist critique of the ideologies of 'individualism'. 'Individualism' denies that the individual is socially produced and formed, and proposes art as the privileged sphere of the non-social, self-creating, self-possessing fiction – the individual.

The emphasis on the socially formed individual and on art as socially determined representation/signification was viewed by many at the conference as threatening to the traditions of feminist art practice based on art as liberated or liberating self-expression, as a means for women to gain access to the full subjecthood apparently enjoyed by men or at least by some men, depending on their class and race. At issue was the question, 'Is the fact that the art is made by a woman and is claimed to be an authentic personal statement sufficient to render it political?'. It is necessary

to analyse what is meant by 'the personal', what is its history, its ideological implications, and what does political mean or imply, and to ask what is needed to transform the category of the individual from ideological fiction into social reality? Addressing the panel on the question 'Is the personal political?' the American artist Martha Rosler clarified the dialectic of the feminist transformation of both political struggle and the idea of the personal, by answering the question thus:

> YES, if it is understood to be so and if one brings the consciousness of a larger collective struggle to bear on questions of personal life, regarding the two spheres as both dialectically opposed and unitary.

> NO, if the attention narrows to the privileged tinkering with or attention to one's solely private sphere, divorced from any collective struggle or publicly conjoined act and simply names the personal practice as political. For art this can mean doing work that looks like art has always looked, that challenges little but about which one asserts that it is valid because it was done by a woman.

> YES, if one exposes the socially constrained within the supposed realms of freedom of action, namely the personal.

> NO, if one simply insists upon protecting one's right to autonomy and regards this triumph of personal politics as a public emancipatory act.

> YES, if one is sensitive to the different situations of people within society with respect to taking control over their private lives.

> NO, if one simply urges everyone to 'free themselves' or 'change their lives'.

> YES, if we understand how to make these demands for the right to control our lives within the context for the struggle for control over the direction of society as a whole.

It is on this territory of art practice that discourses about individuality and the subject, and feminist theory and politics encounter each other in a massive conflict. This structures the particular intensity of feminist debates, for while the issues matter vitally, the persons, the identities and feelings of women who are living out these issues have also to be handled with the respect and suportiveness which is the fundamental bedrock of the Women's Movement.

At the ICA in the autumn of 1980 it was clear that after ten years of the resurgence of the Women's Movement in Britain, there are profound differences amongst the artists who identify as feminists. There are different needs amongst those feminists who have become involved after the experience of art school, or after several years of working at home, or after years of isolation trying to become 'one of the boys', or after establishing a reputation in conventional areas of practice. These existential

differences militate against reducing diverse positions within feminism to a matter of conflicting theories. In addition there is now the factor of generations, of the accumulated experience of the activities during the 1970s which have shaped the women involved in feminist art making. Younger women or women recently coming into feminism are now encountering a different constellation of art issues and feminist issues, as well as institutional, social and political conditions.

The events of late 1980 therefore mark a turning point. They were the culmination of a decade of struggle to make women's work visible, to establish the pertinence of the heterogeneous culture women participated in and produced. The relevance of this history of the 1970s is twofold. It is important to chart what British women did for the general historical picture of that decade – feminism's contribution to the culture of its time. Moreover, it is crucial that new generations of women are aware that they have a history. Much more than a chronological list of past events, history is a shaping tradition to be understood in terms of the forces which formed it, the issues which it has generated, and the reasons for the debates and their intensity. That history is therefore not one of simple progress or evolution. It is a matter of identifying the contradictions of women's position and their radical potential with regard to political change, and of assessing the political implications of the diverse strategies which have emerged. The history is not only what happened, but how we now understand what has been done and what has been made.

Major feminist events after 1980

In November 1982 'Sense and Sensibility in Feminist Art Practice' opened in the Midland Group Gallery in Nottingham. The exhibition was organised by Carol Jones who had been impressed by the work on show at 'Issue: Social Strategies in Women's Art' at the ICA in 1980. She felt that it was important to exhibit this kind of work outside London and to extend to a wider audience discussion of the issues it raised in feminist art practice. Five artists, Mary Kelly (see Fig. 49), Margaret Harrison (see Figs 32, 48), Alexis Hunter (Fig. 34), Susan Hiller (Figs 52, 53) and Marie Yates (Fig. 51) were invited to exhibit and to choose other artists 'whose work they felt is making an important contribution in the area of women's art practice and in particular work which concerned itself with feminist issues.'[38] In addition to the selectors the artists exhibiting were Anne Newmarch (Australia), Roberta M. Graham, Nancy Spero (USA), May Stevens (USA), Aimee Rankin (USA), Yve Lomax and Sarah MacCarthy (see Figs 33, 50). There was a concurrent programme of video tapes curated by Tina Keane which exhibited works by Tina Keane, Martha Rosler, Susan Parker,

33 Yve Lomax 'Open Rings,
Partial Lines', 1984, new section
of photographic sequence
exhibited at 'Sense and
Sensibility', exhibition, 1982

Susan Stern, Deborah Lowensberg, Marion Urch, Caroline
Stone, Julie Plimmer, Cate Elwes, Tamar Trikorian, Lezli An
Barrett, Maya Deren, Judith Barry, Carla Liss.

The main emphasis of 'Sense and Sensibility' was on a debate
within feminist art practice signalled by the title, which took up
the issues that had shaped the conference at the ICA in 1980.
'Sense and Sensibility' initially indicated a dichotomy between
rational, analytical, theoretical modes of knowledge and questions
of personal understanding. The work exhibited and the artists'
contributions to the catalogue, however, indicated that there had
been an important shift away from general issues of principle as at
the ICA, towards an analysis of the specific processes of artistic
representation – a politics of representation. Much of the work
exhibited was about the problems of representing women or
women's discourse within existing systems of representation.
When we confront images of woman or images in which we
discern what we take to be a woman, the act of interpretation and
recognition often confirms ideologically sexist and patriarchal
meanings for that figure. Thus much feminist work has of
necessity become critical work, a work of negation of those easy
and ideologically bounded pleasures. It is analytical of that
seduction, interrogating simultaneously image making and the
experience of viewing. At the same time such a strategy raises
questions of pleasure, or the specific forms of desire and
fascination from looking in art which are being reorganised so as

34 Alexis Hunter, 'The Silent
Woman', 1981

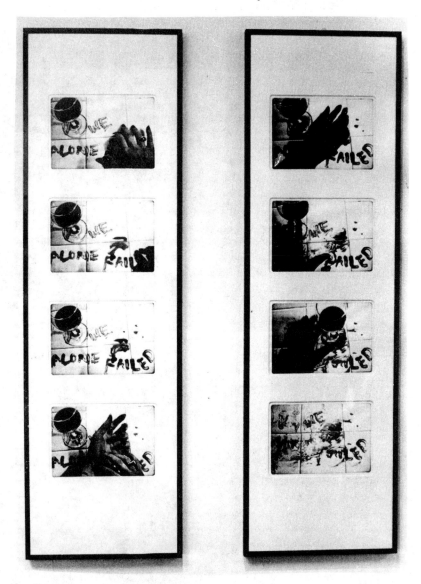

to engage the viewer without inciting sexist responses. Thus the
'politics of representation' is not merely a negative or critical
practice but a constructive and artistically specific procedure. As
Mary Kelly stated in an article republished in the catalogue with
regard to the 'Post Partum Document' (see Fig. 49), which traces
a woman's discourse via mementoes and diaries:

> What I've evacuated at the level of the look (or representational
> image) has returned in the form of my diary narrative. That acts as a
> kind of 'capture' of the viewer which precedes a recognition of the
> analytical texts. For me, it is absolutely crucial that this kind of
> pleasure in the text, in the objects themselves, should engage the
> viewer, because there is no point at which it can become a

35 'Light Reading', B2 Gallery, London, 1982

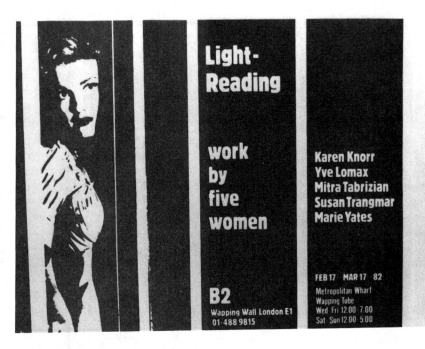

36 Mitra Tabrizian, 'College of Fashion, Modelling Course', 1982, one image from a sequence

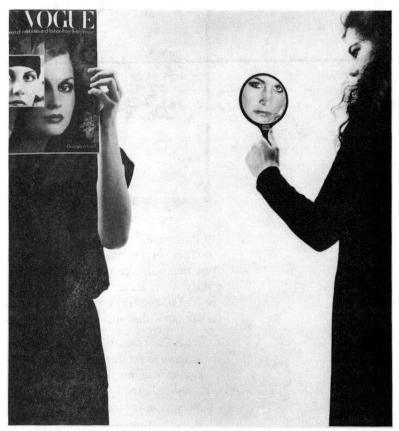

37 Susan Trangmar, 'Tattoo', 1981, from a series of 19 panels

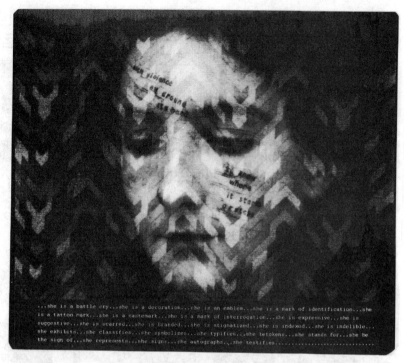

...she is a battle cry...she is a decoration...she is an emblem...she is a mark of identification...she is a tattoo mark...she is a castemark...she is a mark of interrogation...she is expressive...she is suggestive...she is scarred...she is branded...she is stigmatized...she is indexed...she is indelible... she exhibits...she classifies...she symbolizes...she typifies...she betokens...she stands for...she be the sign of...she represents...she signs...she autographs...she testifies..............................

deconstructed political engagement if the viewer is not first – immediately and affectively – drawn into the work.[39]

The introductory essay for the catalogue (which is reprinted in Section III, 24) argued that 'sense and sensibility' could, therefore, be rephrased as 'theory and pleasure' which are currently preoccupations within one of the major tendencies in feminist art practice. Two of the artists exhibiting at Nottingham had shown work together at the B2 gallery in London in February 1982. In addition to Yve Lomax and Marie Yates, Karen Knorr, Susan Trangmar and Mitra Tabrizian produced the show 'Light Reading – Work by Five Women' (Figs 35, 36, 37). The aim of the exhibition was thus stated:

To subvert is to invent, to experiment, to explore, to map. . . . This diverse show of work takes pleasure in mapping and in so doing takes issue with the 'rules' of representation.[40]

In August 1983 at the Riverside Studios in London, Mary Kelly organised 'Beyond the Purloined Image', an exhibition of work by Marie Yates, Yve Lomax, Susan Trangmar, Mitra Tabrizian, Olivier Richon, Karen Knorr, Ray Barrie, Judith Crowle. The show addressed issues of femininity, masculinity and representation. Involved in both debates within feminist art practice and issues in current art practices in general the show raised several new issues. In the early years of the 1970s political strategies were of crucial importance – where to exhibit as

38 'Beyond the Purloined Image', London, Riverside Studios, 1983, showing the work of (top) Karen Knorr, Marie Yates, Susan Trangmar, Mitra Tabrizian, Judith Crowle; (bottom) Oliver Richon, Ray Barrie, Yve Lomax

women, how to get space for working as a woman and how to understand the implications of being a woman involved in art making. As the movement has expanded diverse practices have been generated. Practical strategies have become strategic practices.

In 'Beyond the Purloined Image' several of the artists selected were men, a fact which might be initially surprising for a show that is claimed as feminist. It can be argued that the 'feminist' valency of a work does not inhere in the gender of the author or result purely from the author's intentions. It is the effect of the dynamic context of the work's consumption and reading. The exhibition was open to a feminist reading. The work on show was being constituted as a feminist event – Mary Kelly calls it a discursive event – but it was equally possible for the show to function for some readers in non-feminist ways.[47]

In an extended version of the brief catalogue/poster statement by the show's curator published in *Block* (see Section III, 25), Mary Kelly offered two routes into the show:

Considering that, when I was asked to curate yet another 'women's

show', I saw it instead as an opportunity to go beyond, exactly to re-read the biological canon of feminist commitment and situate the question of gender within a wider network of social and aesthetic debates. Specifically, I wanted to show how recent developments in photographic practice, initiated by artists in London, had gone beyond the more reductive quotational tactics of their New York equivalents, precisely by extending a feminist theory of 'the subject' to a critique of artistic authorship.[42]

Yet another invitation to select a women's show is one kind of success for the feminist art movement. But Kelly suggests that it is time for a different strategy. Women's events can be accommodated – rarely – within the exhibition system and there is the danger of being locked once again into a separate sphere of women's art. One solution is to arrange an exhibition which defies the identity as a women's show, and demands recognition for what feminism means in art at the level of what is represented.

The question of gender as a product of socially, historically and psycho-socially constructed representations has been put on the agenda by the women's movement, by lesbian women and homosexual men in the gay movement. Its relevance as a point of struggle is not restricted to women. Bringing together what Kelly calls 'a group of diverse statements' by women and men, by feminists and non-feminists can be a way of marking the effects of feminism in current cultural practices. There is a thin line, however, between claiming feminism's significance and decentring feminism in a 'wider network of social and aesthetic debates'.

The second context in which the exhibition is positioned is that of current developments in a transatlantic artistic and discursive community. Mary Kelly refers to these New York artists who are critical of Modernism's empty formalist gesturing and are also resistant to the spectacle of visual imagery proferred by consumer capitalism. Post-modernists, or appropriationists, take, or appropriate, their images from the mass media, and from high art. They use found images and

> re-present them in 'visual quotation marks'. Their aim in doing this (the part that interests me), is to contest the ownership of the image, and dispel the aura of genius and madness and originality and maleness that surround the artist auteur.[43]

Mary Kelly's purpose was to mark off a difference from the American Post-modernists and align the British work with a selective group who are politically involved – 'passionately, but critically committed to the contemporary world'. Instead of merely 'pilfering its cultural estate' 'they [the British artists in 'Beyond The Purloined Image'] are exploring its boundaries, deconstructing its centre, proposing the decolonisation of its visual codes and of language itself.'[44]

This set of practices in the show proceeded from theoretical and political work which is not peculiar to feminism but it has a particular purchase for the women's movement. Since Laura Mulvey's decisive arguments in 'Visual Pleasure and the Narrative Cinema' (first published in 1975) we have been preoccupied with a double task. There is the deconstruction of existing managements of pleasure and fascination in looking in film, photography and visual art which have been oppressive to women. We have also to imagine radically new forms of pleasure, the other side of this work of analysis.[45] The problems of a political refashioning of the economies of pleasure are massive.[46] One of the claims for this exhibition was to set forth texts that were both political *and* pleasurable. There must be some form of pleasure for art to function as invitation or engagement, 'to capture' the viewer. But within feminism there are new kinds of pleasure being proposed. Rejecting the conventional gratifications of the successful, complete, finished art object and the voyeuristic spectacle, feminism explores the pleasures of resistance, of deconstruction, of discovery, of defining, of fragmenting, of redefining, all of which is often still tentative and provisional. Feminism constantly questions the identifications of popular and high culture and their pleasures – of being the artist, the special and select, the refined sensibility or inspired or driven creator, as well as the identifications for the viewer, of voyeurism and imaginary suspension from time and place, escape from the banal and real to the fantasies of other personalities, classes, races or genders.[47] Feminist practice entails a collective production of radically different views of the world, different kinds of knowledge and accounts of experience and its determinations. There is, however, a delicate balance to be held in feminist art practice between its commitment to feminism and its specificity as art practice. However necessary is engagement with the issues of representation there is a need to be accessible to the world of women, who may be unfamiliar with feminist theories about the way representations operate in the subordination of women.

'Pandora's Box' an exhibition with this intention opened in June 1984 at the Arnolfini Gallery in Bristol and later it toured to the Rochdale Art Gallery, The Midland Group in Nottingham, the Ferens Gallery in Hull, and the Laing Art Gallery, Newcastle. As late as the early 1980s it was still impossible to find a London venue for such a women's show despite the considerable success of the exhibition which had directly inspired and preceded it, 'Women's Images of Men'. Eventually in October 1985 this show was seen in London at the Chisenhale Works, Bow, but the showing received no official backing and no financial support from any of the public organisations such as the Arts Council. After 'Women's Images of Men' the many women who had been brought together by planning and showing in the event felt

39 Mouse Katz 'Pandora's Box', 1984

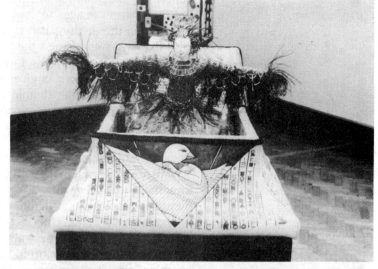

40 Jacqueline Morreau 'Within the Apple – Eve and Adam' oil on board

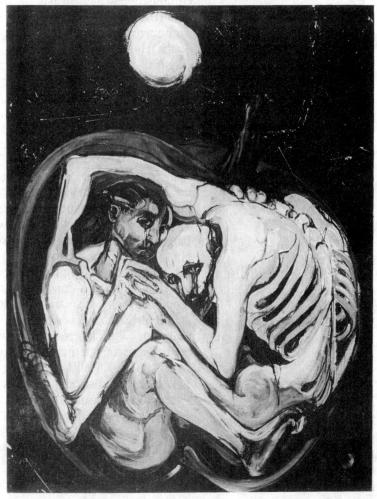

determined to maintain the network and the impetus it had generated and another open submission exhibition was planned around *women's* images of *women*. The theme was narrowed down to focus on the myth of Pandora, a character in Greek mythology who like Eve was blamed for loosing evil on the world. In more ancient rites, however, Pandora had been associated with earth and mother goddesses, a giver of gifts, a life maker, and also a consumer of life. The double image of life and death in earth worshipping religions had given way to a patriarchal rewrite of woman as the source of evil. The theme was selected in order to 're-examine culturally accepted attitudes towards women as seen through traditional clichés, stories and myths'.[48]

Thirty-two artists were finally selected and it would be impossible to categorise all the diverse responses and managements of the theme. Significantly, there was a wide range of media cutting across hierarchies observed in mainstream art. There were paintings, drawings and sculptures but also assemblages, photographs, embroidered works, weavings – a feminist combination which insists on the capacity of all techniques and materials to be used to produce meaning (see Section III, 23). Some work in the exhibition offered a critical view of patriarchal myths about woman as evil, for instance Jane Lewis's bleeding classical statues and her image of a childish thumbsucking Salome with amputated leg, playing on the link between Salome seductress and destroyer and Pandora. By contrast, works by Marisa Rueda countered with an evocation of ancient goddess cultures and women-centred myths of origin such as the Argentinian figure of Akewa, a sungoddess, sole survivor of an original race of women who lived in heaven when men still roamed the earth as furry four-legged beasts. Elena Samperi used the Panamanian myth of the goddess Nu who gave birth to the universe and was shown pinned, butterfly-like in captivity and screaming at the rape of that world. Other participants located Pandora's legacy in the present such as Christine Voge's photographs of pregnant women in stark and isolated settings, or the Hilary Rosen painting 'Hope has Golden Wings'; this poses the women's peace movement as the figure of Hope which alone remained in the box after Pandora had released the evils.

The project of this exhibition has many links with the feminist tradition. The interest in developing alternative and positive readings of fabled meanings corresponds with the concerns of 'Womanpower' (1971 and 1973) as well as 'Womanmagic' (1978). Yet there are also comparisons to be made with the revival of interest in the use of myth in mainstream New Image of Neo-expressionist painting in which however, classical mythology is invoked to support a revamped claim for the heroic (masculine) artist to an unbroken tradition of (masculine) creativity. As Tamar Garb pointed out in a review of 'Pandora's Box',

Few women could engage with patriarchal myth on the heroic scale which their male colleagues seem able to do so unproblematically. Here (in 'Pandora's Box') the mythological is invoked in a questioning rather than a celebratory way and classical myth is often engaged at the level of subversion, the links between Pandora as the source of evil and Eve as the Original sinner/temptress being repeatedly exposed. Such an intervention into Post-modernist art practice is radical in that it calls into question the idea that there is a continuous great tradition which all artists inherit – a disruption of the idea of progress as linear and cumulative.[49]

The critical use of myth also recalls the film *Riddles of The Sphinx* (1977) made by Laura Mulvey and Peter Wollen in which the figure of the Sphinx was used as 'the voice-off' – the questioning voice outside the city gates of a patriarchal ordering of kinship and family which posed the dilemmas women face as mothers and non-mothers in a society which represses the place of the mother and functions in the Name of the Father. There have been dangers in such uses of myth, not least the confirmation of woman's outsiderness, and the association of the feminine with the irrational and unconscious. Both the figures of the Sphinx and Pandora, however, articulate the complex of associations in patriarchal societies between Woman, sexuality and death, and all of it focuses around the question of women's relation to knowledge. Knowledge can stand as a sign for access to the powers effected by knowledge, the power to name, and define the world and its positions, to determine action within it, and it is this which is denied to women. The use of myth with all its attendant dangers can nonetheless serve as a strategy for women in combating the order encoded in mythic excuses such as Eve and Pandora for the continued subjugation of women.

The contrast between 'Pandora's Box' and 'Beyond the Purloined Image' seems initially sharp, the latter using its textual strategies of deconstruction, the former also deconstructing meanings but employing familiar media and familiar modes which audiences find more easily negotiable – if there is some basic familiarity with recent art in the first place, of course. Yet as Sarah Jane Edge asked of this exhibition:

> why is it that women artists are still failing to connect with the important and very relevant advances being made in the area of cultural theory? The problem of the concept of 'making men the object of the female gaze. . .' were met full on in the past show 'Women's Images of Men'. Too much of this work treads a dangerous line in a patriarchal culture where meaning is masculine. Can we really use images as a role reversal?[50]

There is a current opinion in women's art circles, however, which is concerned that theory, valid as it is, may lead to denial of

the pleasure and solidarity of bringing together women's personal experiences for collective reassessment and sharing which has been one of the political principles of the Women's Movement. Angela Partington, in an occasional paper published by the Birmingham Centre for Contemporary Cultural Studies in 1984, made a case for the strategies which directly address women's pleasures and woman as audience in this way. 'Pandora's Box' raises the issue of a necessary dialectic between opening up opportunities for women to exhibit their work with a vivid sense of audience, and, on the other hand, the questioning of the effects and meanings which can accrue to these practices in the institutions of art which they enter and are consumed by.

The difficulty posed by exhibitions such as 'Beyond The Purloined Image' – not with the work so much as the terms in which the event was positioned – is that feminist art practice becomes exclusively addressed to art institutions and art discourses (where at least its seriousness and pertinence may be acknowledged, however marginally). The special historical identity of the feminist art movement is, however, precisely its political base *outside* the art world. There is a case for a politics of representation and a politics of institutions, but not at the price of losing a real relationship to the movement. There has been a movement away from practical strategies – i.e. campaigning for an end to discrimination against women, for exhibition space for all-women shows, for places for women to work, which tend to be inclusive. The new tendency, however, i.e. strategic practices, those diverse negotiations of the processes of making feminist work and intervening in representation and cultural practices, are potentially exclusive. This shift from the former to the latter is now charged as a major political issue within the women's art movement.

The 'Women Artists Conference, Glasgow' held at the Third Eye Centre 9-11 March 1984 showed the other side of the coin. Women artists, students and administrators gathered. The discussions betrayed an uneven understanding of over a decade of feminist political practice and cultural theory. The organisation of the conference was, however, shaped by an awareness of what had happened and this led to the provision of lectures, talks and workshops on vital and pertinent topics. For instance: 'The History and Current Position of the Contemporary Woman Artist', 'Women's Imagery and the Mainstream', 'Education', 'The Uses of Art History', 'Feminist Artists/Artists who are Feminists/Artists who Happen to be Women', 'Problems of Arts Administration', 'Risk-taking/Responsibility/Romance: The Struggling Artist Syndrome,' 'Working the System', 'Criticism,' 'Women's Materials and the Mainstream', 'The Ghettoising of Women's Art'.

There was an intended diversity of opinion and positions among the speakers and leaders of workshops. But in the body of

the conference not all participants recognised the implications of the differences and the reason for the debates. Depoliticised, the issues could easily slip back into romantic notions of art and the artist. The painter, Lys Hansen made this statement:

> Art making at any time is a means of asserting the artist's existence and that existence, whether male or female, cannot be denied. Women's expanded awareness has, and will, find its expression and function through art.

Contrast this statement by the sculptor Elona Bennett:

> The Romantic concept of 'The Artist' was constructed over a hundred and fifty years ago, although it still has currency within artistic circles today. I shall explore how this Romantic myth has become the antithesis of 'woman' and how both these myths have been fabricated within a patriarchal system of capitalism. As feminist artists we have a responsibility to change these ideas, to become cultural pioneers and take the risks involved in exploring the meanings of the signs and symbols in our culture; to reconstruct new meanings in our art.

For historical and strategic reasons Elona Bennett argues for a distinction between 'feminist artist' and both the ideological identities of 'woman' and of 'artist'. Her position points to the dilemma for feminists in art in the necessity of distancing ourselves from the identifications for which we long precisely because they seemed denied to us. For the woman student at art college, discouraged, even ridiculed by a predominantly masculine establishment which seems to possess the rights to self-expression and self-esteem, to a comfortable and powerful presence in the world, to the right to be the Artist, the Women's Movement initially offers solidarity and the confirmation of the desire to claim equal subjecthood and status as artist. It is painful to realise that this is delusive. Access is not permitted to that imaginary ideal and attempts to gain it will be resisted, for there is a lot of power, prestige and money at stake. The only constructive strategy for women is to work to produce a different meaning for art, its producers, its audience, that is to align its social relations of production and use to radical political change. Yet this other vision cannot merely be an alternative, inverted image – needlework in place of painting, a woman's world instead of a man's world. The conference exposed dramatically the contradictions in which women are currently caught. It is easier to perceive oneself as a victim and to be encouraged to find other victims who will sustain the initial consciousness-raising and emergence into combative struggle. But to remain at that point or retreat into creating an alternative world, positing and celebrating some essential, female power is personally and politically unproductive. The issue now is how to make available to the new generations of

young women who attended this conference – and the many others held in 1983-4 – in such numbers, the experience, the debates and the political understanding of how to go beyond the contradiction, to realise the potential of the feminist movement in the domain of culture – the domain of identities, meanings and pleasures.

New histories

Feminist historical writing and teaching throughout the 1970s insistently drew attention to a body of art work that deserved to be made visible. Yet it was not until the 1980s that any major exhibitions of women's art of the past were mounted in Britain. And then, some of the exhibitions chose to distance themselves from the feminism without which they were unthinkable. The acceptable face of feminism – the demand that the neglect of women artists be rectified – was adopted, but the revolutionary face of feminism – the demand that our entire conception of art, artist and the discipline of art history be overhauled and transformed – was eschewed. The exhibitions thus appeared like unfinished sentences, very pleasing but somewhat pointless.

'Quilting, Patchwork and Appliqué: 1700-1982 : Sewing as a Woman's Art', was organised by June Freeman. Opening at the Minories Gallery in Colchester, the exhibition toured the country during 1982–3. Women quilters and embroiderers viewed their own work with new eyes after seeing it in the context of its tradition. The superb historical section answered feminist criticism of previous exhibitions of quilts.[51] Instead of being distanced from their makers and their places of production, and viewed as abstract art, the work was placed in context. June Freeman's stated intention was,

> noting how, behind the development and use of art forms there lies a social world, and that the art produced at any given time reflects that world.[52]

Photographs, tape recordings and explanatory captions anchored the sewing in its conditions of production. We were able to view the quilts in a tradition – a tradition other than the tradition of painting and sculpture – determined by where the textiles were made, and by whom.

There was also a section on contemporary women's quilting, patchwork and appliqué. Whereas in the historical quilts every shape and pattern carried meaning in relation to women's lives, contemporary textile art incorporates 'recognisable old patterns' in works which only seek to emulate the formalist intention of abstract painting.

The contrast between the old and new was a painful reminder that the feminist project has not simply been to validate women's

41 'Women and Textiles – their
Lives and their Works', 1983

Battersea
Arts
Centre

Old Town Hall, Lavender Hill, SW 11 5TF. 01·223·6557

WOMEN AND TEXTILES
THEIR LIVES AND THEIR WORK

An exhibition presented by The Women Artists Slide Library
November 3rd - 27th

Slide/Seminars every Tuesday at 7pm

8th JANIS JEFFERIES	TEXTILE REALITY
15th SARAH BOWMAN	FRENCH EMBROIDERERS 1925, WITH SAMPLES
22nd JUNE FREEMAN	SEWING AS WOMENS ART

A Conference on the 11,12 & 13th November
Fri. 11th Films & Discussion from 3pm

THE ABAKAN TAPESTRY & AWAKE FOR MORNING (followed by a discussion)
7·30 JUDY CHICARGO'S DINNER PARTY (followed by a discussion)

Sat. 12th from 1pm

TERI BULLEN	PATCHWORK; WOMEN, ART & POLITICS
CAS HOLMES	"THE SEX OF THE ARTIST MATTERS"
FAITH GILLESPIE	THE ECONOMICS OF CRAFTWORK
SWASTI MITTA	HOMEWORKERS AND THE EFFECT OF NEW TECHNOLOGY

Sat. from 7·30
An evening with Centre Ocean Stream (Theatre of Colour)

A LECTURE/DEMONSTRATION WITH SLIDES BY BARBARA HARROW, INCLUDING A 15 MINUTE
PERFORMANCE AND A DISPLAY OF COSTUMES.

Sun. 13th from 1pm Informal discussions/workshops

LYNN ROSS	TALKING ON THE DEVELOPMENT OF THE SPINING CO-OP IN ARRAN
PENNINA BARNETT	A SLIDE SEMINAR ON THE ISSUE OF WOMEN WORKING IN TEXTILES
HILARY SLEIMAN	THE EVOLUTION OF KNITTING HAS LED TO IT BEING A PREDOMINANTLY FEMALE OCCUPATION

A GROUP FROM THE BLACKIE DISCUSSING WORKS OF ART MADE BY MORE
THAN ONE PERSON

AUDREY WALKER	TEXTILE EDUCATION

Sun. from 7·30

ELAINE WALLER - SHADOW PUPPETS

BOOKING FORMS & TICKETS FOR THE CONFERENCE NOW AVAILABLE

traditional work in the crafts, but to analyse and criticise the
hierarchy of art forms which led to the domination of painting
and sculpture in the first place. The effects of this domination
could be seen in the way the separate tradition of women's sewing
has been vitiated and subsumed by the fine art tradition.

Had the organisers included contemporary feminist sewn work
which consciously relates the medium of textiles to their lives and
histories as women (for instance, the banners of the international
women's peace movement) the exhibition would have gained
coherence and ended on a more optimistic note. By excising the
critical aspect of feminism and concentrating only on celebrating

women's work, exhibitions are paradoxically impoverished. However, while the historical show toured, an exhibition which well represented feminist work in textiles did open in London at Battersea Town Hall. 'Women and Textiles – Their Lives and Their Work' was organised in conjunction with a conference which explored women's relation to textiles from different class positions and in different techniques (see Section III, 28).

A certain ambivalence towards feminism informed the other major historical exhibition of 1982, 'The Women's Art Show 1550-1970' at Nottingham Castle Museum. A decade after the inception of feminist art historical work, an historical exhibition of women's painting was at last on view in Britain. But in the catalogue Jennifer Fletcher expressed doubts about the entire undertaking: 'I wrote this piece on commission, not out of passion, and with three thousand words for three hundred years I am not even sure that I have a valid art historical subject.'[53]

The first part of the exhibition covered British and European artists pre-nineteenth century. We were able at least to view the paintings we had pored over in reproduction or known only by name. The long feminist fight for the recognition of women artists of the past had borne fruit. But we had not only demanded recognition, we had set out to deconstruct the category 'woman artist', demonstrating that women's art is determined not by their biology but by their specific historical, social and artistic circumstances. By lumping women artists together across the centuries the first section of the show simply shored up the art historical habit of stereotyping and filing women's work away under the denigrated category 'women artists'. The second section on nineteenth-century art in Britain, organised by Pamela Gerrish Nunn, was based on feminist scholarship and did make more sense. It allowed us to see the diversity of women's art, and to gain more insight as to how the individual histories of women intersected with the particular conditions of nineteenth-century British art practice to produce a striking and heterogeneous collection of work.

Feminism was conspicuously absent from the twentieth-century section which ended at 1970. The show was intellectually and aesthetically impoverished by the omission. Deliberately distancing herself from feminism, Jennifer Fletcher wrote in the catalogue that 'Feminist art history suffers from certain stresses, often strong in indignation, it can be weak on facts.'[54] It would be curious if established art historians did not view feminist art history with disquiet. For the feminist project is not primarily the conventional collecting of so-called facts – in Deborah Cherry's words, 'our project is not to add to art history but to change it'.[55]

There was a show in the same year, 1982, which did seek not only to add to our knowledge about women artists but to change the way we see them and comprehend their work. It was an

exhibition which demonstrated the enormous gains to be obtained if a show is not simply inspired by feminist research but shaped by feminist theory. 'Frida Kahlo and Tina Modotti' was conceived by Laura Mulvey and Peter Wollen. Organised by the Whitechapel, London, it opened in March 1982 and subsequently toured to Germany, and the USA.

The decision to show simultaneously a photographer and a painter who both worked in Mexico, circumvented the problems which had bedevilled women's shows. Displaying the work of one woman alone tends to confirm the notion that women who succeed as artists are mysteriously different from 'ordinary' women, working in isolation and under conditions that apply to them alone. But to show women indiscriminately together suggests that their shared biology is the over-riding factor in their art and denies the real differences between women. 'Frida Kahlo and Tina Modotti' actually undermined the notion that there is a recognisable category 'women's art'. The two are remarkable not for what they share but for their different relations to their common territory, which Mulvey and Wollen demarcate as the Mexican Revolution and the Mexican Art Renaissance. A series of essays accompanied by reprints of contemporary accounts in the catalogue compare and contrast the two against different backgrounds and through different eyes, with for example, 'Women, Art and Politics', 'Revolution and Renaissance', 'The Interior and the Exterior' and 'The Discourse of the Body'.

While both Tina Modotti and Frida Kahlo produced work that was recognisably inflected by their experiences as women (Modotti sometimes less than Kahlo), the stance taken up by each artist is very different. Mulvey and Wollen comment:

> Looking at Frida Kahlo's and Tina Modotti's work in relation to their lives and experience as women it is clear that conscious decisions about artistic stance are only to a limited extent the result of conscious, controllable choice. Two other forces are of utmost importance: that of historical heritage and that of individual accident. The relation between these two can be described as that between the necessary and the contingent. The difference between a working class Italian immigrant to California and a Mexican bourgeois intellectual are of great importance. These social historical conditions contribute to the artist's stance, to Kahlo's desire to explore herself and her colonised cultural roots through her art, and to Modotti's desire to change the conditions of exploitation and oppression she saw around her, then to devote herself to the international working class movement.[56]

New spaces

The importance of defining and analysing the differences between women was evident not only in the decision to show Frida Kahlo and Tina Modotti together, but also in the character of contemporary feminist shows of the early 1980s. In the 1970s women's desire to show together had been a product of the determination to cross barriers of race and class in a recognition of shared oppression. It was necessary to group together as women, to be proud to show in each other's company, to make a political point. However, over the decade it became clear that a notion of 'shared oppression' permitted the domination of a white, heterosexual, middle-class definition of that oppression. By the 1980s Black women, lesbian women, working-class women, Jewish women were rightly claiming that their position in a racist and sexist society gave rise to quite specific forms of oppression. Women's shows began to reflect the solidarity and self-consciousness of particular groupings of women.

In December 1981 an exhibition 'Four Indian Women Artists' opened at the Indian Artists United Kingdom Gallery in Mayfair, London. Chila Kumari Burman, Vinodini Ebdon, Bhajan Hunjan and Naomi Iny exhibited paintings, ceramics, prints and sculpture. In Section IV, 14 of this anthology, Chila Kumari Burman and Bhajan Hunjan talk about their lives and work. The latter declares:

> I feel I am between two cultures, yes, and I feel I have every right to be there. I do not know what it feels like to belong to a culture. I was born and brought up in Kenya, as an 'Asian' in Kenya. When I came to England I never felt the need to belong. I wanted to feel comfortable within my own community and the other.[57]

Similar feelings are reflected in the exhibition title 'Between Two Cultures' chosen for the show organised by the Indian Artists United Kingdom collective at London's Barbican Centre later in 1982. Artists from 'Four Indian Women Artists' took part in the extensive exhibition of work by men and women.

The Barbican then housed 'Nova Mulher – Contemporary Women Artists Living in Brazil and Europe' during May 1983. It included work by Ana Maria Pecheco whose sculpture had been part of 'Women's Images of Men'. Reviewing the show for *City Limits* Nigel Pollitt singled out Bette Kalache's work: 'constructed washing lines from which hung muslin nappies, dipped in plaster to take the form of children's toys, a woman's body'.[58]

1983 also saw the organisation of two more highly important shows of Black women's work. 'Five Black Women' at the African Centre, King Street, Covent Garden comprised paintings, drawings and sculpture by Sonia Boyce, Lubaina R.H. Himid, Claudette Johnson, Houria Niati and Veronica Ryan. The artists led a women/only discussion on the special difficulties of being Black women in the art world – and artists in the Black political scene.

42 'Black Woman Time Now', 1983

BLACK WOMAN TIME NOW

Festival

*THEATRE * ART * BOOKS * FILMS * MUSIC*
*DANCE * WORKSHOPS * DISCUSSIONS * SEMINARS*

29 November - 4 December at:

GLC Funded

Battersea Arts Centre, Old Town Hall, London SW11.
Tel. 01 223 8413.

FOR FURTHER DETAILS RING 01 223 8413.

One of the exhibitors, Lubaina Himid, organised a larger show of Black women's work as part of the festival 'Black Woman Time Now' at the Battersea Arts Centre (Section III, 30). Work by fifteen women was exhibited by Houria Niati, Veronica Ryan, Claudette Johnson, Sonia Boyce (see Fig. 44), Chila Burman, Jean Campbell, Andrea Telman, Ingrid Pollard, Margaret Cooper, Mumtaz Karimjee, Elizabeth Eugene, Leslee Wills, Cherry Lawrence, Lubaina Himid (see Fig. 43) and Brenda Agard. Writing in *City Limits* Moremi Charles outlined Lubaina Himid's intentions for the show: 'To her an exhibition of this

43 Lubaina H.R. Himid, 'We Will Be', 1983. (Photo: Anne Cardale.)

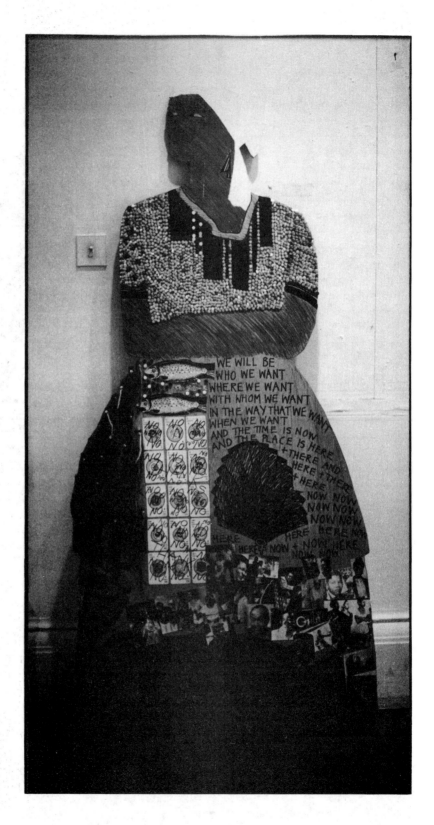

kind is simply a way of countering the racism of the art world
which makes it impossible to exhibit without labels.'[59] By 1985,
however, the sense of Black women's culture was more positively
asserted through the exhibition 'The Thin Black Line' at the
Institute of Contemporary Arts, for which Lubaina Himid wrote:

> All eleven artists in this exhibition are concerned with the politics and
> realities of being Black Women. We will debate upon how and why
> we differ in our creative expression of these realities. Our methods
> vary individually from satire to storytelling, from timely vengeance to
> careful analysis, from calls to arms to the smashing of stereotypes. We
> are claiming what is ours and making ourselves visible. We are eleven
> of the hundreds of creative Black Women in Britain today. We are
> here to stay. (Catalogue statement.)

The artists involved included Veronica Ryan, Chila Burman,
Ingrid Pollard, Marlene Smith, Brenda Agard, Claudette Johnson,
Lubaina Himid, Sutapa Biswas, Sonia Boyce, Jennifer Comrie,
Maud Sulter. It is illuminating to review the reviews of the show
because its meanings varied radically according to the position of
the reviewers in ways which underscore the struggle all women
have to express their particular reality in a white male dominated
society. Writing for *West Africa* M. Ali called the show witty, taut,
protesting, angry, dreamlike at times yet threatening, but it also
exuded an assurance. Ali particularly commended works by
Sutapa Biswas who

> coldly slashes at the system; her images attack not only the oppression
> of black women but the oppression of all black and Asian people. A

woman watches TV whilst peeling Leon Brittan's head. The Hindu goddess Kali – Kalima the one who protects her flock from evil – is summoned to behead the devil. In her hands she holds a blood-stained cleaver, a head, a red flower, and images conceived by an Italian woman painter. Her fourth arm is raised in the traditional Indian sign of peace; round her neck are strung the heads of Heath, Hitler and Trotsky amongst others. It is a powerful image that derives its strength from reference to traditional culture. (16 December 1985, p. 2638.)

This reviewer saw strength and calculated strategy in the making of powerful images which draw upon Indian culture, the repressed of an imperialist culture, while also scything its way through that very culture, its protocols of painting, its modernist theories and its ethnocentric feminism. The work by the Italian woman painter is a copy of a painting from our *Old Mistresses: Women, Art and Ideology*. The *Guardian* reviewer (27 November 1985), however, set his review under the title 'Anger at hand' and found the show almost 'Choking on its own anger' and the word 'anger' recurs several times in the short text. The only other note sounded is 'gentle sadness' of the poetic sculptures by Veronica Ryan. Both responses are trapped within feminine stereotypes of outrageous violence or acceptable softness, and the text registers the difficulty such writers experience in facing up to the nature of women's experience of class, gender and – crucially here – race. As Marlene Smith explains in the catalogue:

As Black women artists our work revolves out of an experience which is our own. As a Black woman I feel a responsibility to address that experience, to embrace it and explore it. In doing so many of my images deal with brutality and violence. It is important to point out here that such work is about the continued *attempt* to dehumanise us. My work is not about a dejected people nor does it portray a degraded Black womanhood. I seek to contribute to the building of a material culture that might have been denied were it not for the struggles of my people.

> the thin black line
> is long
> is slender (but not delicate)
> is cord, not thread,
> is a long slender cord
> taut when stretched.

Of vital significance for the increased presence and visibility of specific groups of women in London during the early 1980s was the opening of new venues for exhibitions, namely the Battersea Arts Centre in Battersea Town Hall, the Africa Centre and the Brixton Gallery in Atlantic Road, Brixton. The latter housed an exhibition of paintings, installations and performance in 1983.

Organised under the working title 'Artists Who Happen to be Lesbian or Gay', the exhibition was part of the September 1983 lesbian and gay arts festival 'In the Pink'.

In December 1983 the gallery mounted a major group exhibition of women's art, 'Women's Work'. The women in the 'Brixton Artists Collective' organised the show. Over two hundred applications from all over Britain poured into Brixton. Although the organisers made the decision to limit exhibiting space to women from South London, more than seventy women exhibited their work. 'Women's Work' provided telling evidence of the effects of over a decade of feminist activities in the arts. The numbers prepared to participate and identify with a women's show is significant. There are enormous numbers of women making art in a variety of forms, materials and circumstances. The women's art movement has created a space for that work to become visible which forms a link in a chain which runs from those who practice in the professionally defined art worlds and those women who make art in other social spaces. The opening out of the art spaces envisaged by the project for an open exhibition 'Women's Work' show of 1973-4 and of 'Feministo', the postal art event has been consolidated and extended. The striking fact about the 1983 'Women's Work' exhibition was the range of age, race and background of those involved. 'The women vary from trained to untrained and from pensioner to student,' commented the organisers in their introduction to the show. A glance at the catalogue confirms this claim. Elizabeth Arnold, for example, writes of herself, 'I am seventy-five years old and until I was seventy-three never had any art experience having left school at fourteen . . .'. In contrast Anne Seagrove writes, 'After a year at art foundation at Trent, in Nottingham, I moved to Brighton and started on the Expressive Arts course at the polytechnic, where I am now in my third year.'

Lynn MacRitchie attended an evening of performance during the exhibition and described the piece by Anne Seagrove:

> The first was a series of extracts by Anne Seagrove from her 'Women Against . . .' series. She used precise, swift movements and impressive physical control in encounters with a shopping basket, a snapping step-ladder and some cellotape to suggest complex little scenarios of constraint and questioning.
>
> 'Provisional No-Fun' (a group of performers in the exhibition) took on major themes – menstruation, marriage, religion, sexism, the war in Ireland – in a series of short items. Often chaotic, the piece won out by its sheer determination to tackle the lot, no matter if things did get a little out of hand.[60]

All media were represented in the show from embroidery, sculpture, painting to video, performance and photography. Some artists addressed feminist issues both in the content and form of

their work, while others, under the impact of feminist recognition of the importance and specificity of the 'gendered voice', spoke as women on particular subjects. Given the current strength of the women's peace movement, it was not surprising that the theme of the nuclear threat was well represented in the work exhibited.

The programme of events accompanying the exhibition was inclusive and international with a slide show from Chile, films, poetry reading, art therapy, a talk on women and education. Mary Kelly and Kate Walker also spoke about their long involvement in the women's movement and the art they had produced. It was a decade and a half of feminist work by such women as Mary Kelly and Kate Walker in conjunction with the women's movement that produced the vitality, and the diversity of the Brixton 'Women's Work' exhibition. The events and those already being planned for the future are the concrete results of the emancipatory and democratic ambitions of the Women's Movement and the cultural history it has generated.

Women and peace

One of the most pressing issues for artists involved in feminism has been the need to establish effective links between the practice of art and the political priorities of the Women's Movement. The largest mass feminist campaign of the early 1980s has been the women's peace movement, focused in Britain through the concrete and symbolic presence of the women's peace camps at the Air Force base which houses the US Cruise missiles at Greenham Common, Newbury, Berkshire. The peace movement has generated a vast range of creativity in which political action and aesthetic celebration of women's concern for life, ecology and peace have been demonstrated in the actions at the peace camp – for instance weaving great webs across the fences, the linked-hands human chain surrounding the base, the placing of children's clothes and photographs on the fences. There has also been a massive growth or revival of women's banner making which incorporates the traditions of textile arts with the aspirations of women to make visible their positive protest against the nuclear threat. The formation of Sister Seven was a direct response to the march from Cardiff to Greenham in 1981, after which the spontaneous decision to set up a camp was made. The group comprises feminist writers, poets, artists, Gillian Alnutt, Shirley Cameron, Liz Hibbard, Mary Michaels, Monica Ross and Evelyn Silver. They have worked together collectively in order to produce a fuller understanding of the complex issues involved in presenting nuclear issues, though they have produced a variety of individual works drawn from their own experiences and lives. Monica Ross has explained the problems of producing a counter imagery:

Current areas of visual representation in the area of anti-nuclear propaganda disquieted us. . . . We felt that images which continue to rely on either visualising nuclear destruction, or even the subversion of military hardware, actually serve to prolong the power of militarism by default. Caught in the language of war, specialising in the tactics of shock and attack, such images serve to arouse fear and helplessness without offering any solution to them. . . . Our aims within this spectrum became an attempt to involve people in an emotional and imaginative space that lies between art and propaganda. We aimed, like the women at Greenham who collaged the fence with children's photographs and clothes, to open up emotional responses, to confront fear and helplessness and to displace them with energy and power. (*FAN* vol. 2 no. 1, p. 9)

Sister Seven aimed to create images that tried to visualise alternatives, a process which is 'vital to creating a concept of peace without the corollary of war' (Monica Ross). They produced an exhibition made of posters, poetry and objects, which has travelled widely in Britain as well as to peace festivals in New Zealand and the USA. They have exhibited in many venues, community centres, libraries, fairs, festivals, conferences and adult education institutions. Live performances have also been part of their work. Shirley Cameron has performed 'Premature Endings' which refers to the premature birth of her twin daughters and her refusal of their premature death. Evelyn Silver performed 'Cruise Tango' and 'Dove Woman Discusses Britain'. Monica Ross has several versions of a tape-slide piece and a performance. Shirley Cameron and Evelyn Silver have jointly developed their work on oppressive imagery of women for

45 Shirley Cameron and Evelyn Silver, 'Brides Against the Bomb', performance at the Campaign for Nuclear Disarmament Festival and Green Gathering, Glastonbury, 1983. (Photo: Sue Stanwell.)

Sister Seven with their performances of 'Brides against the Bomb'. The women dressed as brides take turns in marrying each other to a missile, 'someone with a good job in the Ministry of Defence'. At first the bride is willing but when she resists she finds herself tied to the missile. The audience distributes peace confetti and eventually the bride liberates herself and declares herself strong and free. Taking advantage of the traditional connotations of marriage to subvert the notion of women's passivity by their own actions in making themselves free, the performance also transforms the nuclear debate by suggesting missiles are not necessity but there as a part of a bad marriage, a contract for life which can and must be broken when it endangers life. The need is to present the issues in such a way as to break the spell of inevitability and empower ordinary people to change their futures. In this area particularly the power of imagery in the media to shape what we think and even what we imagine is possible is all-pervasive. Here feminist critique and resistance is most urgent and potentially effective using the processes of communication called art, where immediacy and the possibility of involvement and discussion break through the dominative, unanswerable messages of public media.

Difference: on representation and sexuality

This was the title of an exhibition at the Institute of Contemporary Arts, London in September 1985. It had originated in the New Museum in New York, curated by Kate Linker in December 1984. The event registered and underscored the impact of feminism's radical presence in the art world of the mid-1980s and was received in New York as one of the most important shows of the decade. It was a mixed exhibition dominated none the less by feminist work by women while demonstrating the necessity for both men and women to confront the issues of sexuality and representation. This formulation means going beyond treating gender issues as a matter of content by understanding that sexual difference, or the régime of differentiation which positions us as masculine or feminine subjects is a continual *process*. It structures and is structured by the activities of looking, knowing, desiring and finding pleasure which dominate in the domain of art as elsewhere, in the media for instance.

The exhibition also combined artists from both London and New York and as such set up another difference in opposition to the trends in art history and exhibitions policy towards celebrating fallacious national identities in art (e.g. Italian sculpture, German painting, British art and so forth). The range of media used defied the pronounced revival of recent years of 'born again painting' and sculpture. Thus what was displayed was not a range of objects advertising their medium and its manipulation by the

expressive Artist but texts, combinations of images and writings which produce what Mary Kelly has defined as 'imaged discourse'.[61]

This book spans a decade and a half. During this period the political, economic and cultural practices of the West have shifted decisively. This exhibition was about difference but it was also different from the dominant culture of the moment, dubbed the 'Post-modernism of reaction'. The 'Difference' exhibition presented work generated from the critical concepts of artistic practice and cultural politics developed during the 1970s in contest with the domination of American modernism and multinationalism. By 1984-5 the conditions which fostered the experimental and iconoclastic work of early feminism had been swept away while the theoretical and practical developments of feminist practices now stand out in sharper relief, maintaining a radical posture against massive reaction and retrenchment of traditional ideologies of art and artist which secure a masculine hegemony in culture.[62]

This resistance can be seen at two levels. In practice, in opposition to the conventional ideologies of art which offer a world of natural meanings expressed to a direct, untutored vision, feminist work denaturalises our common sense understandings of art and gender to reveal the mechanisms by which they are produced. These mechanisms are, however, contradictory, unstable and fascinating. Working through and against them is a difficult process for the producers and disturbing for the spectators. The central question is about looking. Structures of looking and especially pleasurable looking have been identified and shown to establish meanings and gender positions for accepting those meanings. In a sexually divided and divisive society dominance in looking is accorded to and secures the masculine position, while the feminine is placed as the passive object of that gaze. For feminists the question is how is it possible to make texts through which women's point of view can be articulated. How can she be positioned as the subject not the object of both vision and discourse. Thus feminists have had to deal with strategies of representation and the sexual positions and meanings they inscribe or unsettle. These necessarily can seem unfamiliar, but they are vital when grasped in relation to the second level of resistance.

The reason for the existence of these kinds of artistic practices seen in the 'Difference' exhibition is the Women's Movement – the powerful desire to explore, voice and empower women's experiences and understandings as a basis for political change by collective action. In 'Interim', a new project by Mary Kelly and 'The Only Woman' by Marie Yates the material is derived from women's experiences of growing older, grieving, being mothers, being daughters, workers.[63] From the beginning feminist artists

had confronted the feminist dictum: 'the personal is political'. But they had to negotiate its meaning across the ideology of art as self-expression, the expression of personal meanings – a theory which excises social and historical concerns and bolsters up the masculinism of Western art ideologies. Feminists have had to find ways to speak the feminine in all its varying forms in differing conditions of race, age and so forth. In doing so we have had to question our desires, what makes us complicit with the present system, what will fuel our resistance, what will make it effective. How is it possible to represent the feminine(s) in cultures where it is repressed, colonised or silenced? The area of feminist activity presented in the 'Difference' show is the interface between fundamental feminist concerns to articulate women's meanings and the theorised understanding of how meanings are produced – how sexed positionalities for meanings are secured in dominant art practices and theories. In distinct ways from the Greenham banners, the work in 'Pandora's Box', the strategies of 'The Thin Black Line', the dialectic of strategic practices and the politics of a broadened Women's Movement is being battled out.

Postscript

Throughout this essay the emphasis has fallen upon the collective activities of feminists in art practice. This is both a reflection of the specific identity of feminism and a deliberate rejection of the dominant form of art history and criticism. The monographic form isolates artists as transcendent individuals. They are extracted from the social world which produced them and shapes their work, its meanings and its audiences.

But there are women who deserve a personal acknowledgement – to name a few who have been active longest in the women's art movement, Mary Kelly, Margaret Harrison, Susan Hiller, Lubaina Himid, Alexis Hunter, Tina Keane, Hannah O'Shea, Kate Walker. Their names recur in this book in terms of both practical activities and their work. They have played a vital role, and continue to do so not only because of their production of art but because of the considerable labour they have expended in teaching, visiting art colleges and introducing younger women to a tradition of feminism and feminist art practice which they have helped to found over the last decade and a half.

Some now have international reputations; their work is held in many collections, and on the strength of the critical standing of their work outside Britain, the Tate Gallery has at last purchased work by Mary Kelly and Susan Hiller. Acknowledgement and greater visibility have also come in the form of major publications. To accompany a retrospective of 'Photographic Narrative Sequences 1976-1981' at the Edward Totah Gallery, a book was published on Alexis Hunter's work with essays by Lucy Lippard

46 Hannah O'Shea, 'Litany for Women Artists', a performance, 1977

and Margaret Richards.[64] In 1984 Susan Hiller had three simultaneous shows. 'New Work' was shown at Gimpels Fils, including the installation 'Belshazzar's Feast/The Writing on Your Wall' (now in the Tate Gallery) and at the same time her work was exhibited at the Orchard Gallery, Derry and the Third Eye Centre in Glasgow. A book *The Muse My Sister* was published to co-incide with the shows with essays by Guy Brett and John Roberts as well as an interview with the artist by Rozsika Parker.[65] Rose Garrard, a performance artist, had an exhibition of performance, sculpture and paintings initiated at the Ikon Gallery in Birmingham, and this travelled to Liverpool, Bristol, Rochdale and Bracknell between January 1984 and January 1985. To mark the tour a book entitled *Rose Garrard Between Ourselves* has been published, with an essay by John Roberts and a conversation with Sue Arrowsmith.

These one-woman shows with accompanying publications do constitute an important breakthrough. The production of a literature on feminist art practice rescues the traces we have here collected of past events, exhibitions or art works and gives them a contemporary currency and circulation. Another aspect of this process is the publication of the artist's book. An early work by Susan Hiller of 1973, 'Sisters of Menon', was also published in 1984. And in 1983 'The Post Partum Document' by Mary Kelly was translated into the form of a book accompanied by an introduction by Lucy Lippard, a foreword by Mary Kelly and an appendix of essays of the work.[6] Since the nineteenth century publication has always played a major role in the social circulation and consumption of art as well as in terms of critical and art historical ratification. Books and catalogues can also serve another function – outside the art world. They provide a wider access to feminist art practices beyond the London or New York or Paris galleries where these artists exhibit as professional artists – and beyond the art magazines in which the exhibitions are occasionally reviewed.

There is, however, a dialectic to be maintained within feminist art practices between the democratic and enabling activities which encourage more women to make art and exhibit it with confidence simply as women, and the specialised, theoretically developed feminist interventions in the official cultural sites and apparatuses. It should not be a matter of either/or, alternative or interventionism, populism or the mainstream. The history of the feminist art movement, and the theory which can now be elaborated for it, reveals a necessary relation and interchange between practical strategies and strategic practices.

Rozsika Parker
Griselda Pollock
London and Leeds
May 1984
revised May 1986

Notes

1 Women's Workshop, Artists' Union, *Spare Rib*, July 1974, no. 29, p. 38.

2 For example, Lucy Lippard is currently preparing a history of the Feminist Art Movement in the United States. Julie Ewington is working on a study of Australian feminist activities.

3 Liz Moore, Statement for the first Women's Liberation Show at the Woodstock Gallery, 1-13 March 1972, in *Towards a Revolutionary Feminist Art*, 1972, no. 1, p. 1.

4 Monica Sjoo, 'Images of Womanpower', *Arts Manifesto*, in *Towards a Revolutionary Feminist Art*, 1972, no. 1, p. 4.

5 Interview with Elona Bennett, 9 July 1982.

6 Lucy Lippard, 'Introduction to Ca. 7,500', May 1973—February 1974. The exhibition showed the work of Renate Altenrath, Laurie Anderson, Eleanor Antin, Jacki Apple, Alice Aycock, Jennifer Bartlett, Hanne Darboven, Agnes Denes, Doree Dunlap, Nancy Holt, Poppy Johnson, Nancy Kitchell, Christine Kozloff, Suzanne Kuffler, Pat Lasch, Bernadette Mayer, Christine Mobus, Rita Myers, N.E. Thing & Co. Ltd, Ulrike Nolden, Adrian Piper, Judith Stein, Athena Tacha, Mierle Ukeles, Martha Wilson.

7 Women's Workshop, Artists' Union, *Spare Rib*, July 1974, no. 29, p. 38.

8 Statement from the Press Release.

9 Lucy Lippard, 'Why Separate Women's Art?' *Art and Artists*, October 1973, p. 8.

10 Preface, by the editors, *Oxford Art Journal*, April 1980, Vol. 3 no. 1, 'Women in Art', p. 3.

11 *MAMA*, January 1977, p. 4

12 *Spare Rib*, July 1974, no. 29, p. 38.

13 Interview with Kathy Nairne, 13 July 1982.

14 Interview with Tina Keane, 9 July 1982.

15 Suzanne Hoggart, 'Preview of the Hayward Annual II', *Sunday Times Magazine*, 20 August 1978.

16 Liliane Lijn, ibid.

17 Tess Jaray, ibid.

18 Trisha McCabe, 'Mother's Pride, Mother's Ruin', *Spare Rib*, March 1979, no. 80, p. 37.

19 ibid.

20 op. cit. p. 14.

21 Joanna Klaces, 'Womanmagic at the Ibis Gallery, Leamington Spa . . .', *Spare Rib*, 1979, no. 81, p. 38.

22 Elizabeth Cowie, Claire Johnston, Cora Kaplan, Mary Kelly, Jaqueline Rose, Marie Yates, 'Representation versus Communication' reprinted in Feminist Anthology Collective, *No Turning Back*, London Women's Press, 1981, p. 240.

23 There is a considerable feminist literature on this point derived from feminist debates with and within psychoanalysis. See for instance Beverley Brown and Parveen Adams, 'The Feminine Body and Feminist Politics', *M/F*, 1979, no. 3, and Mary Ann Doane, 'Woman's Stake : Filming the Female Body', *October*, Summer 1981, no. 17, pp. 23-6.

24 Susan Hiller, '10 Months Piece' (1977-9) *Block*, 1980, no. 3, p. 27.

25 Cited in Alexis Hunter, 'Feminist Perceptions', *Artscribe*, October 1980, no. 25, pp. 27-8.

26 Statement in 'About Time', London Institute of Contemporary Art, 1980.

27 Sarah Kent, 'Towards a Feminist Perception of Women's Practice in Art', *Readings*, 1977, no. 2, p. 11.

28 Reviewed by Dinah Clark, Shirley Moreno and Caroline Taylor in *Spare Rib*, November 1981, no. 112.

29 From *Notes towards a Show on Self Image*, duplicated catalogue, reproduced as Section III, 24.

30 The Pavilion is primarily a centre devoted to feminist photography. Its

existence celebrates the special and radical tradition of feminist interventions in photography. This book is primarily concerned to document the history of feminism in the visual arts of which photography can be accounted as one. But we have not covered specifically photographic events, exhibitions or publications such as *Who's Holding the Baby?* by the Hackney Flashers, *Beyond the Family Album* by Jo Spence or the *Three Perspectives in Photography* at the Hayward Gallery in 1979. Many feminists use photography as a medium of practice, some of whom come from a Fine Art background while others come from a professional and commercial practice in photography. The history of feminism and photography needs its own publication and we have incorporated in this text events or practitioners using photography which have contributed to the development of feminist theory and culture in general in the 1970s and early 1980s.

31 Kate Walker, 'Do you Need Spectacles or are you Wearing Contact Lenses?', *Feminist Art News*, Performance Issue, Summer 1980, no. 2, p. 4.
32 Susan Hiller, 'Introduction', *Circles Women's Work in Distribution*, Midland Group, Nottingham, 1981.
33 Lynn MacRitchie, 'About Time – a Historical Background', *About Time*, London, Institute of Contemporary Art, 1980.
34 Hiller, op. cit.
35 Lucy Lippard, 'Issue and Tabu', *Issue: Social Strategies by Women Artists*, London Institute of Contemporary Art, 1980, p. 3.
36 Monica Petzal, 'Questions on Women's Art', *Art Monthly*, December 1980/January 1981, no. 42, p. 23.
37 Cate Elwes, 'Recent Trends in Art Criticism', Women's Space, *Feminist Art News*, Winter 1982, no.7, p. 38.
38 Carol Jones, Preface, *Sense and Sensibility in Feminist Art Practice*, 5 November—4 December 1982, Midland Group Nottingham, 1982.
39 The catalogue republishes part of a conversation with Paul Smith published in *Parachute*, 1982, no. 26.
40 Publicity Handout for events at *B2* throughout February 1982.
41 See for instance the review by Robert Hamilton, *Artscribe*, October 1983, no. 43, p. 60.
42 Mary Kelly, 'Beyond the Purloined Image', *Block*, 1983, no. 9, p. 68. A section of Marie Yates's piece for the exhibition, *The Missing Woman* is also illustrated in this edition of *Block*.
43 ibid.
44 Mary Kelly, op. cit. 1983, p. 68.
45 Laura Mulvey, 'Visual Pleasure and the Narrative Cinema', *Screen*, 1975, vol. 16, no. 3.
46 For several important discussions of the issues of pleasure see *Formations of Pleasure*, ed. James Donald *et al.*, London, Routledge & Kegan Paul, 1983, notably articles by Cora Kaplan, Frederic Jameson and Colin Mercer.
47 Identification is a term borrowed initially from psychoanalysis in which it means the process by which a person either (a) extends his/her identity *into* someone else, (b) borrows his/her identity *from* someone else, (c) fuses or confuses his identity *with* someone else. In analytical writings it never means establishing the identity of oneself or someone else. Identification has been mobilised to help explain the processes of subject formation and the workings of ideology in which a subject is constituted through identifications with initially a parent, an image reflected in a mirror and later with other proferred representations.
48 Jacqueline Morreau, 'Gaining Ground', *Pandora's Box*, edited Gill Calvert, Jill Morgan and Mouse Katz, 1984, p. 22.
49 Tamar Garb, 'Pandora's Box at the Arnolfini and Rochdale', *Artscribe*, 1984, no. 48, p. 53.
50 Sarah Jane Edge, 'Pandora's Box at Rochdale', *Aspects*, 1984, no. 28, n.p.

51 See Rozsika Parker and Griselda Pollock, *Old Mistresses: Women, Art and Ideology*, London, Routledge & Kegan Paul, 1981, Chapter 2, 'Crafty Women'.

52 June Freeman, *Quilting, Patchwork and Appliqué – Sewing as a Woman's Art*, The Minories, Colchester, 1982, p. 3.

53 Jennifer Fletcher, 'The Glory of the Female Sex – Women Artists ca. 1500-1800', *The Women's Art Show 1550-1970*, Nottingham Castle Museum, 1982, p. 16.

54 ibid.

55 Deborah Cherry, 'Feminist Interventions: Feminist Imperatives', *Art History*, 1982, vol. 5, no. 4, p. 507.

56 Laura Mulvey and Peter Wollen, 'Women, Art, Politics', *Frida Kahlo and Tina Modotti*, London, Whitechapel Gallery, 1982, p. 10.

57 Bhajan Hunjan, 'Mash it Up', *Spare Rib*, March 1983, no. 128, p. 52.

58 Nigel Pollitt, *City Limits*, 1983, no. 84, p. 62.

59 Moremi Charles, 'Beyond Labels, Five Black Women Artists', *City Limits*, 1983, no. 103, p. 13.

60 Lynn MacRitchie, *City Limits*, 16-29 December 1983, no. 115-16, p. 3.

61 Mary Kelly, 'Desiring Images/Imaging Desire', *Wedge*, 1984, no. 6. p. 9.

62 Roszika Parker and Griselda Pollock *Old Misstresses: Women, Art and Ideology*, London, Routledge & Kegan Paul, 1981.

63 For a fuller analysis of this exhibition see Griselda Pollock, 'What's the Difference? Feminism, Representation and Sexuality', *Aspects*, no. 32 1986.

64 Alexis Hunter, *Photographic Narrative Sequences* with essays by Lucy Lippard and Margaret Richards, London, Edward Totah Gallery, 1981.

65 *The Muse, My Sister*, essays on the work of Susan Hiller by Guy Brett, Rozsika Parker and John Roberts, London, Gimpel Fils, 1984.

66 Mary Kelly, *Post Partum Document*, London, Routledge & Kegan Paul, 1983.

Griselda Pollock **II Feminism and Modernism**

What is feminist art?

> Feminist art, for instance, cannot be posed in terms of cultural categories, typologies or even certain insular forms of textual analysis, precisely because it entails assessment of political interventions, campaigns and commitments as well as artistic strategies.
>
> (Mary Kelly, 'Reviewing Modernist Criticism', *Screen*, 1981, vol. 22 no. 3, p. 58.)

During the late 1960s and 1970s Modernism as the dominant paradigm for artistic practice was contested on many fronts. At the same time the political and social upheavals of the 1960s, youth movements, Black consciousness movements, national independence movements, and so forth produced a constellation of new concepts, rhetorics and politics, one of the most important of which was the Women's Movement. The Women's Liberation Movement, as it was initially known, represented a resurgence of the four-centuries old struggle by women for access to full human rights, and the new feminism was shaped and fuelled by the many new and radical forces both political and cultural of the late twentieth century. The conjunction of a new wave of feminism and the challenges in art to Modernism took place with the additional support of an expansion in the field now called cultural studies. A new understanding of the politics of culture was one of the legacies of the New Left Movements of the late 1950s and early 1960s which had been forced to develop a more sophisticated analysis of the complexity and depth of modern forms of social control in advanced societies. The question of the ways in which, in a more affluent society, consent is secured for the maintenance of an unequal and exploitative society led to a reassessment of the effects of advertising, film, television, journalism, as well as literature, fine art and the education system – in short the whole spectrum of those social practices which, producing meaning and images of the world for us, shape our sense of reality and even our sense of our own identities. It is in this sense of an interlocking network of images, values, identities which saturate our daily living so as to appear as a common sense that cultural theorists elaborated Gramsci's notion of hegemony as a means to understand the role of culture in social reproduction. Theorists also began to appreciate that ideologies

were more than mere sets of ideas and beliefs held more or less consciously by certain social groups and classes. Ideology speaks for us, speaks us even, makes us in the images and identities appropriate to the perpetuation of a radically unequal racist and sexist social system.

In introducing the following documents it is necessary to consider the multifarious ways in which women involved in the Women's Movement intervened in the historical conjuncture of the 1970s at the level of cultural practice and cultural politics. In the history that can be written of the last fifteen years feminism has been both shaped – by those historical forces mentioned above – and shaping of the present conditions and possibilities. There are many issues now on the agenda of art making which are the direct result of feminism – questions of sexual difference, gender relations and sexuality and power. There are other areas to which feminism has made a particular modification of a current trend – body art, conceptual art, for example. But the goal of feminism is not to be incorporated as a new -ism to add richness to the pluralism popularly labelled Post-modernism. Its base is a mass movement of women for radical social change and this makes it a revolutionary force. For this reason feminist interventions encounter more than the polite disdain of the establishment. They are resisted with hostility, repression, censorship and ridicule. The women involved are subject to personal abuse and criticism mostly from the men whose 'hegemony' is threatened by the fact that women are beginning to articulate another common sense.

There have to date been several attempts to map out the field of feminist artistic practice.[1] All disdain the idea of answering the question 'What is feminist art?'. There is no such entity; no homogeneous movement defined by characteristic style, favoured media or typical subject-matter. There are instead feminist artistic practices which cannot be comprehended by the standard procedures and protocols of modernist art history and criticism which depend upon isolating aesthetic considerations such as style or media. The somewhat clumsy phrase 'feminist artistic practices' is employed to shift our attention from the conventional ways we consume works of art as *objects* and stress the conditions of production of art as a matter of texts, events, representations whose effects and meanings depend upon their conditions of reception – where, by whom, against the background of what inherited conventions and expectations. In a paper given at the Art and Politics Conference in London in 1977 (see Section IV, 10), Mary Kelly introduced yet another term: the 'feminist problematic in art'. A problematic, borrowed from developments in Marxist philosophy, defines the underlying theoretical or ideological field which structures the forming of concepts and the making of statements.

Thus, for instance, the concept 'feminist art' is the product of a bourgeois problematic in which 'art' is assumed to be discrete and self-evident entity in which a knowing, conscious individual expresses herself in terms of an object which contains – acts as a repository for – a recognisable content called a feminist point of view or feminist ideology. Kelly uses the notion of 'the ideological' developed in structuralist marxism to counter this: 'the ideological is the non-unitary complex of social practices and systems of representation which have political consequences'. Thus feminist artistic practice has initially to begin to define a problematic in relation to an understanding of the ways in which it can be effective – not by expressing some singular and personal set of ideas or experiences but by calculated interventions (often utilising or addressing explicitly women's experiences ignored or obliterated in our culture). Therefore the study of feminist cultural practices leads to a series of tactical activities and strategically developed practices of representation which represent the world for a radically different order of knowledge of it. These interventions occur in the context of established institutions and discourses which circulate the dominant definitions and accepted limits of what is ratified as art and how it should be consumed.

Feminist activities and modes of representation have drawn upon an increasingly complex range of theories which enable women to understand how institutions operate, how ideology works, how images produce meanings for their viewers and thereby construct those viewers. There has been, in addition, a necessary investigation of those areas and modes of practice – video, photo-text, scripto-visual work, performance, street theatre, postal art etc., which offer the maximum flexibility and potential for both a dislocation of existing and dominant regimes of power and knowledge, and a construction of a new multiplicity of powers and knowledges for the diverse communities of the oppressed – women are not a homogeneous group but are fractured by class, race, age. How to undertake this has generated considerable debate in a diversified field of practices, positions and priorities. This essay is intended to cover a selected range of both debates and practices which focus primarily on the historic exchange between feminism and Modernism.

Art, artists and women

A feminist intervention in art initially confronts the dominant discourses about art, that is the accepted notions of art and artist. These involve those typical ideals which popularly circulate and the historical inflections of the terms at any particular time and place. In the late 1960s the paradigm of the artist was unquestionably masculine and the history of art both past and

present offered little space for women (see Section II, 3). The injection of a feminist consciousness raised basic questions for the women involved in art who became part of the emerging Women's Movement. What relationship do women have to art? Could there be a feminist aesthetic? How does art made by women relate to current forms of art? Is there a difference between art made by women and art made by men? Is artistic practice an area women should reclaim, or abandon, and why?

Several books published in the mid-1970s by American artists or critics documented the massive reorientation for women in the arts which the arrival of a new phase of feminism initiated. In *From the Center* (1976) the critic Lucy Lippard provided a biographical introduction to a set of essays written exclusively about art made by women. Lippard explained how the Women's Movement changed her whole approach to criticism and undermined all her inherited certainties about both art and women. In 1977 the artist Judy Chicago published *Through the Flower*, an autobiographical account of her move from being 'one of the boys' making macho, abstract metal sculptures in the late 1960s, through research into the history of women into an involvement with feminist art education and the development of a feminist imagery. Both Lippard and Chicago posed the question of a feminine aesthetic and wondered if there were stylistic features of art made by women in the past, for instance central-core imagery, which could now be consciously employed to express women's pride in themselves, their bodies and their sexuality. Feminism had a considerable impact on both women new to the practice and on established professional artists in the USA. Feminist education programmes and such enterprises as the Women's Building in Los Angeles have offered important points of identification for women through which to orient their feminism to an artistic practice.[2]

The situation has been different in Britain. There is little or none of what Martha Rosler has termed 'art world feminism' (identification with women's struggles by established artists, using the 'woman' question to gain space for their work). On the other hand the Women's Movement in Britain has been suspicious of a culturalist as opposed to political analysis of feminist concerns and therefore only slowly did women active in the arts accommodate their interest in artistic practice with priorities of political movement for the transformation of women's economic and social condition. Several artists working in Britain in the early 1970s attested to the problems they first encountered when they became actively involved in the Women's Movement. Susan Hiller (Sections III, 3; IV, 5) (see Figs 52, 53) told us in an interview in March 1982 that when she joined a consciousness-raising group in 1973 anything to do with art was deemed to be secondary to the discussion of women's issues:

Art seemed to have nothing to do with the way we lived. Women in the group wanted me to give up art and return to anthropology. The movement did not need artists and the only conceivably useful thing I could do was to make posters. I did that. It was difficult for me to assert my right to make art. It was very undermining. ('Interview', March 1982.)

There could be many explanations for this initial suspicion of art's validity or relevance but two main ones can be suggested. In the early 1970s women knew precious little about women's history. As part of the rediscovery of women's history, investigations into art history began to reveal a tradition of women who had participated in cultural production of all kinds. The reclaiming of women's creativity became a part of the positive valorisation of women for which the Women's Movement aimed. Furthermore the generally accepted notions of art – based upon what was being produced and sold then, for example minimalist sculptures and abstract paintings – seemed to be irrelevant to women struggling against economic, sexual and racial exploitation. Elona Bennett (Section III, 26, 27) recalled how difficult it was to find a way through these related problems:

I didn't know anything about women artists at all; maybe Barbara Hepworth and Elizabeth Frink. When I left art school I was in one or two exhibitions and there was talk about a women's history group. There was a conference in Oxford (March 1970). It was the first time women got together on a mass basis. I felt I must find out about women's history and the History Group started from there. Everything took off and flowered. I met Mary Kelly. We'd both been at St Martin's School of Art together but we'd not known each other. Both of us felt we wanted somehow to be involved in feminism and link up our art with it. We both became involved in the Artists' Union [see Section II, 5] and the film *The Nightcleaners*. Both these activities enabled us to work more polemically, in a more direct way. I couldn't immediately see a way through at that time. My art was then very abstract, big steel structures. I had an exhibition at the Birmingham Arts Lab at the same time as the Miss World Protest (November 1970). I was making abstract conceptual works about Time. There was a huge gap between my art work and my involvement with the women's movement. ('Interview', July 1982.)

The closing of this gap was obviously more than a matter of overcoming initial doubt about the usefulness of art to the movement. Feminism forced artists to question many of their assumptions about the character of contemporary art and about the social definition of art and artist in general.

Our commonsensical definitions of the artist today are still a combination of the Romantic notion of the artist as 'Genius' and expressive theories of art. To the artist is attributed a heightened sensibility and even a visionary capacity to see beyond surface

reality and to probe human experiences which are expressed through so great a creative ability that it is assumed that it must be innate. It cannot be learnt. Art is the externalisation of the internal feelings and mental contents of this distinctive type of personality – the artist. Thus the primary object of art becomes in fact the artist whose being is expressed in it.

This idea of the artist developed historically in relation to massive changes in the organisation and evaluation of human labour and social production. In the grand-scale transition to mechanised factory production of goods for exchange and wage labour fundamental changes in the practical division of labour and the definition and purposes of skill were wrought. Certain categories of skill were defensively attributed to a redefined realm of the arts. A new notion of art gained meaning in historical opposition to industry, and in such polarities as fine art against useful arts, art against technology. The representative figure for these differentiated skills and procedures, the artist, was categorically distinguished from the scientist, the artisan and the operative – the latter being the labourer produced by the dominant social relations of capitalism which collaterally redefines the meaning of the activity work. Once work referred to any activity or skill; in modern societies it means being hired, waged. (It is only in this sense that a woman working at home with children is deemed 'not to work'.) Art is idealised as the opposite of work i.e. of wage labour. It retains the idea of work as a self-realising skilful activity which yields a total product, something affirmative of its maker. The artist is mythically idealised as the free agent of this creativity. Yet all production is subject to the laws of capitalism and the freedom the artist mythically celebrates is conditioned in practice by the market economy. Thus as Raymond Williams summarises the results:

> Art and artist acquire general and vague associations while art works are practically treated as marginal commodities and artists function as a category of skilled independent workers producing a marginal commodity in an uncertain market.[3]

The democratic impulse of the Women's Movement undermines the fantasy of the artist as genius, decrying its élitist pretensions and revealing its mystification of the real conditions which facilitate the success of a select few from select class, racial and gender groups. In her essay 'Why have there been No Great Women Artists?' (1971) the American art historian Linda Nochlin exploded the myth of the genius by showing how recurring conventions in artists' biographies shore up the notion that true greatness will always find its recognition. And since genius will always win in the end, those who do not make it are proven to be inevitably second rate, not geniuses; not true artists. Linda Nochlin showed the power of social and economic conventions in

determining who is able to produce art and gain renown.[4] The myth of the artistic genius serves to desocialise the production of art, to disguise the facts of privilege and convention which regulate access to training and advancement. A product of a classed and gender-divided society, this idea of the artist is a veil for the inequalities which sustain its élites.

There is, however, a material underside of the myth – the economics of art, how artists live in a market economy. While the Women's Movement has gradually accepted the idea of a specialist – the professional artist who lives by her practice – there have been as yet no sufficient analyses of the economics of art production. Women artists are left to drift upon the open market, eeking out a precarious living. This problem relates to another. Feminist critiques of current notions of art have also addressed the relationship between art and its audiences. Modern artistic production is typically private production. Artists generate work as independent producers, rarely commissioned, living more often by teaching than by sales. The work that is produced is not made for an audience, but for a market. The market exchange to unknown private consumers is mediated by the operations of cultural managers, museum curators, critics, exhibition organisers and Arts Council officers who attempt to shape a public image of the living culture. Art lacks an audience in the sense of a special group who interacts with the meanings and values being circulated in this form of social exchange mediated by objects. Feminists have tried to explore new constituencies of audience and to articulate the experiences and interests of hitherto culturally dispossessed groups, women, or working people, or cultural minorities, for instance. Yet the financial basis of survival as an artist remains tied to the current market conditions where there is little audience, just consumers and managers. Without alternative systems of financial support those who want to work as artists have to negotiate a relationship with the existing discourses and institutions of art and artist. In an interview Susan Hiller explained the critical attitude in the movement to this practical necessity:

> The idea was that women were creative and their creativity came out in unrecognised ways. And that this was the way of the future. This should be encouraged and one should withdraw from male notions of exhibitions, careers, vast projects and goal-oriented work. Any of these sorts of things were seen as wrong. In the United States the women who had made it are still seen as having sold out.
>
> Of all the political movements feminism above all other demands that we live our ideal feminism in a society that is not feminist in a way that socialists are not required to live their socialism in a non-socialist society, to the same extent. Yet on the other hand we agree that our actions now must presage future social relations. Now we

face the situation of having to live with the struggles and make some peace with them. (March 1982)

Feminist art historians have extended this debate by the historical analysis of the gendering of the mythic artist figure. Art history writes about art and artist when in fact it exclusively refers to work by men. Art made by women is designated by the prefix 'woman' before art or artist. This signifies more than art by female persons; it means art that is different and therefore less good. In our book *Old Mistresses, Women, Art and Ideology* (1981) a history of the meanings of the word artist was traced and compared with the history of the designation 'Woman'. It was suggested that these sets of definitions altered in increasingly antagonistic ways as massive historical changes impinged upon social and gender relations. What changed was not the fact of women's practice. Women have always made art. From the mediaeval period onwards not only did the conditions of women's and men's labour alter but so did the way in which sexual difference was defined and represented. It was argued that a division was established by the late eighteenth century between representations of the artist as a Man of Reason and of Woman as a beautiful object. With the development and consolidation of bourgeois social forms and gender relations the process of opposition between Artist and Woman became subject to an increasingly rigid divide between public and private spheres, between professional activity and self-sacrificing domesticity and procreativity. Across these sets of oppositions a divisive map was drawn of those social spaces and behaviours which were designated as masculine and feminine; 'Artist' and 'Woman' were placed in separate and gendered territories.[5]

In addition, the complex relations between the bourgeoisie and its cultural agents impinged upon the spaces occupied by the artist. The Romantic myth and its urban derivative the Bohemian placed the artist decisively in the sphere of the masculine – in touch with Nature or steeped in the underworld of modern urban life – but this was in an oblique relation to bourgeois norms of masculinity which were lived and regulated in the office, factory or the home. The myth of the freedom of the artist has further gender implications, therefore. In opposition to the Respectable norm of masculinity whereby manliness was achieved by hard work, duty and both economic and sexual thrift, the artist is projected in difference as the figure of freedom from such social regulation. As such, the artist articulated the contradictions of bourgeois ideologies of masculinity. Bourgeois culture generates this fantasy of freedom through which the artist has direct access to Nature and to Truth. The artist is imagined as a free agent outside of society exercising a liberated sexuality which realises some imaginary, primordial, masculine self-determination and

power. One conclusion of this was the Surrealist ambition for total liberation from bourgeois gender norms. Jean Cocteau provided the conceit of the artist as the unity of masculine and feminine wherein art was a kind of parthenogenesis uniting reason and fertility, offering a dream to men of wholeness and confirmation of their universality.[6] In the tradition of Cocteau and the Surrealists the complementary combination of masculine and feminine is possible in a man, unnatural in woman. June Wayne has analysed the feminisation of culture from another perspective in an article 'The Male Artist as Stereotypical Female'. She points out how the artist is viewed as inept in money matters, impractical, absent-minded and in need of managers and housekeepers, manipulated by dealers and collectors. However, if a woman is single-minded and rational she is condemned as aggressive and unwomanly and if passive, impractical or inept the would be taken as proof not of genius but of innate, 'feminine' temperamental weakness.[7] However, with such figures as Jackson Pollock, late twentieth-century myths of the artist reinforce the machismo masculinity of the artist, and in recent developments in contemporary art the 1950s image of the suffering and self-expressing painter-artist is clearly once again in circulation.

Since the nineteenth century, therefore, the notion of the artist has acquired a complex of significations. A complementary type, the woman artist, came into discursive existence side by side with this ideological construction, but it is fractured across the system of gender relations which attempts to establish an absolute and hierarchical difference between masculine and feminine. The woman artist is also marginalised by the appropriation of the term 'artist' and the concept art within discourses on masculinity. Today, as we have already seen, over 50 per cent of students at British art schools are women (see Section II, 1). But the term woman artist is already captured and disfigured as a perverse hybrid struggling to conform to incompatible stereotypes. To define oneself as an artist without the qualifier 'woman' is to repress the important and desirable fact of being a woman. To be labelled a woman artist is to be placed in a separate sphere where only gender matters, where gender is assumed biologically to determine the kind of art that is made. There remains an unsolved contradiction for women who nonetheless justifiably claim that women should be recognised as producers of culture, as artists.

Feminism has only partly been concerned with supporting more women to become artists. It has become increasingly clear that the very structures of the practice, its terminologies and guiding ideologies are sexist. They reproduce in a variety of ways the dominance of men and the subordination of women. It has become a vital necessity to develop, therefore, a political analysis of culture and a political strategy for women's involvement in its sphere.

Art, politics and women

In feminist practice, however, the relationship between art and politics is radically new. The novelty results from the conjunction within feminism of both a revolution in knowledge and theory and a revolutionary struggle in concrete social relations. It is also developed from the conjunction of the special character of feminist politics with the major developments of cultural theory and practice in the last fifteen years.[8]

The project of the Women's Movement is the transformation of all practices and institutions which perpetuate the subordination of women. Feminist politics have to this end revolutionised the traditional terms of reference for politics. To revolt is to believe that change is possible and therefore to recognise that the present situation is socially conditioned. It is not natural or inevitable. Feminism has precisely challenged those areas of social life which were deemed to be non-social, based on human nature, i.e. motherhood, sexuality, childcare, the body. As early as 1971 Juliet Mitchell in *Women's Estate* defined the major area of women's oppression in modern capitalist societies as the sexual division of labour in the family and the psycho-social construction of femininity. In addition to this analysis of the domestic and private sphere as a political site, women have disputed the control of women's bodies, the regulation of women's sexualities. In a major feminist film produced in 1976 by the British film makers Peter Wollen and Laura Mulvey, *Riddles of the Sphinx*, these themes are central. They are presented in terms of the riddles women confront as they live out motherhood, for instance, in a culture which suppresses the mother and is ruled by the father. Using the image of the Sphinx located outside the city, on the margins of patriarchal culture, the massive questions women face are thus posed:

Should women demand special conditions for mothers? Can a childcare campaign attack anything fundamental to women's oppression? Should women's struggle be concentrated on economic issues? Is domestic labour productive? Is the division of labour the root of the problem? Is exploitation outside the home better than oppression within the home? Should women organise themselves separately from men? Can there be a social revolution in which women do not play a leading role? How does women's struggle relate to class struggle? Is patriarchy the main enemy for women? Does the oppression of women work on the unconscious as well as on the conscious? What would a politics of the unconscious be like? How necessary is being a mother to women in reality or imagination? Is the family needed to maintain sexual difference? Are campaigns for childcare a priority for women right now? Question after question arose, revolving in her mind without coming to any conclusion. They led both out into society and back into her own memory. Future and

past seemed locked together. She felt a gathering of strength but no certainty of success.[9]

The problem of feminist politics is aggravated by the fact women feel dispossessed from the culture and its language.[10] We lack the terms and concepts necessary to articulate what is specific to women's condition as well as to challenge the way dominant masculine discourses are asserted as the norm. In another early text of the British Women's Movement *Woman's Consciousness, Man's World* (1973) the historian Sheila Rowbotham explained this phenomenon:

> Every time a woman describes to a man any experience which is specific to her as a woman she confronts his recognition of his own experience as normal. More than this his experience of how he sees the 'norm' is reinforced by the dominant ideology which tells him and the woman that he is right. This inability to find ourselves is true of course for other groups besides women. The working class, Blacks, national minorities within capitalism all encounter themselves as echoes, they lose themselves in the glitter and gloss of the images capitalism projects to them.[11]

Sheila Rowbotham also used the notion of cultural colonisation to underline women's sense of being occupied, dominated and visible to ourselves only through images constructed of and by the oppressor, the dominator, the coloniser – of mind and body.

One of the major developments of critical social theory which has been of great importance for feminist cultural politics has been the expansion of analysis of ideology. At its most limited the word describes a set of ideas and beliefs which, in Marxist theory, have been seen to be characteristic of social groups or classes, determined by the material conditions of social production. As a result of new developments in Western Marxism since the 1960s 'Ideology' is now used to designate the social processes of the production of meanings and identities in general. Informed by other related developments in psychoanalysis and linguistics, 'Ideology' implies not only the production of ideas and beliefs, but the very making of identities, of subjects for those meanings. That is to say, it is by means of social processes that we are produced as subjects, gendered and classed. We are invited to recognise ourselves in identities and images projected to us through dynamic processes of social practices and institutions which constitute who and what (we believe) we are: the family, schooling, the church, advertising, cinema and so forth.[12] These developments have had special purchase for feminism because in rejecting the definitions as natural of femininity, masculinity, women's subjectivities as mother and nourisher, it was vital to develop some analysis of the social *construction* of gendered subjectivities. Feminists have carefully explored the political

implications of these theories of ideology, concerned particularly with related developments in structuralist theories of language and psychoanalysis (see Section III, 9-11). As Rosalind Coward clearly stated the case:

> What is important about psychoanalysis is its potential together with a development of Marxist theory for providing an account of how the categories of masculine and feminine are constructed in a particular society. It is this which will make possible for us to examine the relation between forms of sexual behaviour and forms of social organisation.[13]

In studies of culture informed by this complex of new theoretical impulses the whole domain of culture was subjected to radical revision. In bourgeois ideology art has been treated as a supreme embodiment of culture which is taken to be the sum of great works of art, literature, music and so forth which embody the universal aspirations and ideals of human civilisation. It is both the epitome of humanity and yet autonomous of society. But culture can also refer in the anthropological sense to everyday *ways of life*. Cultural studies as it has evolved since the late 1960s has consistently challenged the first notion of (high) culture and expanded the second to understand culture historically. The practices which compose it are subject to the pressures of specific historical social relations and thus culture is opened up to questions of domination and resistance – to politics. If culture is no longer detached from the social formation but understood as a crucial area of the production of values, beliefs, identities, ways of living, the practices which comprise it can become a legitimate area for political struggle.[14]

Part of the political identity of the women's movement has been constituted by its resistance to the dominant representations of women circulated through the interrelating institutions of culture, schools, advertising, films, television, photography, fine art, literature, journalism and so forth (see Section I, 2, 3). The first march in London to celebrate International Women's Day in March 1971 illustrates the early British Feminist challenges to representations of women in an insistently visual culture. Many of the actions and elements of the march demonstrated the energy, iconoclasm and irreverence of the early days of the movement:

> A group of childcare campaigners brought a twelve foot high Old Woman's Shoe, with the nursery rhyme suitably rephrased and written out in giant letters. Others rigged up an irreverent simulation of childbirth, on a float bedecked with strings of cardboard cut-out babies and sanitary towels. There was a caged woman displayed as 'Misrepresented' and banners appropriating the admen's appropriation of the movement. One carried an ad showing three women striding across the desert clad only in bras and corsetry,

47 Women's Day March, March 1971. (Photo: Chris Davis: Report.)

under the slogan 'Freedom'. 'We want freedom not corsets', said the feminist banner.[15]

In still predominantly agit prop forms these elements none the less encapsulated many of the issues and strategies which were to be handled by feminist artists in the following decade: breaking of taboos – celebrating what had been hitherto areas of shame for women and hence weapons of subjugation; consciousness–raising – as a means of resisting prescriptive images of woman; subversion – changing dominant, man-made images to reveal a sub-text. Imagery functioned in a double space in this march and in the movement in general. On one level, woman-made images are a means to take women's politics to the streets, to interrupt the spectacle, 'the gloss and glitter of the images projected at us', with subversive and politicised visual statements. At another level images are the targets. A mere *use* of art was displaced by the struggle against the dominant images which constitute an additional level of our oppression. Over the years the understanding of the effects of images has changed through the interaction between accumulating work by feminist artists and the theoretical analyses of the ways in which images function – the production and circulation of meanings and of subjects for these meanings.

There has been, therefore, a *tactical* necessity within the women's art movement to produce a public manifestation of women's experiences and a public challenge to the dominant 'régime of truth' about women by means of a self-consciously

91

alternative, woman-made imagery. In the growing tradition of feminist practice in art, however, a more extended *strategy* has emerged. The project involves not merely the substitution of oppressive images by those made by and about women, but rather the deconstruction of the processes by which meanings are produced (signification) and the fixing of sexed subject positions in language (see Section I).[16] Using the idea of a symbolic order developed in structural anthropology feminists have argued that language can be grasped as an ordering of the laws and positions of a given society or culture. Learning to speak is learning to be spoken by the culture to which one is accessed by language. Therefore there has to be a struggle not only about the content of representations but about the signifying systems which are points for the production of definitions, meanings and positions for subjects. In a collective paper given at the Socialist Feminist National Conference in London in March 1979, the authors explained this position and stated that

> It takes artistic practices as a work of production of meanings and in so doing brings into the analysis the question of the position of the subject within the work, the kind of 'reader' and 'author' the text constructs.[17]

It is conventional wisdom that art expresses the individual who makes it. The art object is said to carry the meanings put there by the artist. Thus much art history and criticism is monographic and searches through art works for clues to the personality of the artist which are then read back onto the art work as its meanings.[18] The expressive, or its variant the reflective, theories of art have been substantively criticised in the radical cultural theory which has emerged since 1968. In this work the fact that an individual is socially formed is emphasised. Pure subjectivism is countered by locating the producer of art works within the specific social relations of gender, race, class, within the history of the art form and practice, within ideology. It is furthermore argued that in order for art to be socially recognised as art it must operate within culturally shared, not privately formed codes and conventions. Finally the productivity of the process of reception is stressed. It is claimed that meanings are generated in the dynamic moment of public consumption of the work, which includes the moment of viewing and reading, and the entry of this particular work into a network of other texts upon which its specific meaning, i.e. its difference, depends. In opposition therefore to the bourgeois myth of private, personalised and expressive creativity we are asked to understand the social and productive character of artistic practice in which art works function as part of a social exchange between producers, viewers, commentators, collectors, buyers, etc.. Art works are texts and can be understood as a site of a particular organisation of socially instituted signs

which produce meaning in a field composed of other signs. i.e. other texts and general cultural systems of representation. The viewer must be familiar with these if she is to be able to read the work or text. Knowledges of some sort are always mobilised in looking at and understanding what is looked at. This necessary excess baggage shapes the viewing/reading processes. They and the institutional space in which viewing/reading takes place constitute the ground against which a particular configuration of meaning is possible. Therefore what makes an art work feminist, for instance, is the way in which it intervenes in what can be called the social relations of artistic production and reception, the social relations of signification. Such arguments led Annette Kuhn in her study of feminism and cinema to distinguish between cultural interventions by women and feminist cultural interventions, and she asked:

> Is the feminism of a piece of work there because of the attributes of the author (cultural interventions by women), because of certain attributes of the work itself (feminist cultural interventions), or because of the way it is 'read'?[19]

Cultural interventions by women can be understood to refer to those activities which lead to greater numbers of women being involved in culture – more women film makers, more women artists in public exhibitions etc.. This expansion is certainly a feminist project, or it is inspired by the Women's Movement. But simply more women in a particular field is not the main or even central aim of the Women's Movement. In addition encouraging women to voice or represent their particular and 'personal' experience – speaking with a gendered voice – is also an aspect of feminism. But feminism in culture cannot be reduced to substituting *women's* for men's subjectivities in an otherwise unchanged notion of art as self-expression. It is not, therefore, the fact that activities or representations are undertaken by *women* which renders them feminist. Their feminism is crucially a matter of *effect*. To be feminist at all work must be conceived within the framework of a structural, economic, political and ideological critique of the power relations of society and with a commitment to collective action for their radical transformation. An art work is not feminist because it registers the ideas, politics or obsessions of its feminist maker. It has a political effect as a feminist intervention according to the way the work acts upon, makes demands of, and produces positions for its viewers. It is feminist because of the way it works as a text within a specific social space in relation to dominant codes and conventions of art and to dominant ideologies of femininity. It is feminist when it subverts the normal ways in which we view art and are usually seduced into a complicity with the meanings of the dominant and oppressive culture (see Section I, 4).

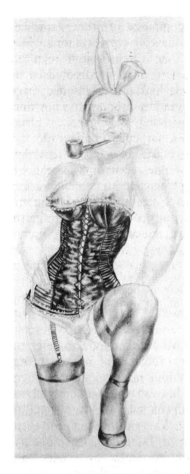

A demonstration of this crucial difference can be drawn from two moments in the work of Margaret Harrison (see Section IV, 15). In 1971 Margaret Harrison had one of the first single-woman, feminist exhibitions at the Motif Editions Gallery in London. She exhibited a set of drawings which tried to use image-reversal in order to subvert the stereotypical images of men and women current in both advertising and soft-core pornography, for example, comic supermen like 'Captain America' as well as 'The Little Woman at Home'. One drawing showed Hugh Heffner of the Playboy Industries as a Bunny Girl, but with a Bunny penis (Fig. 48a). The show was, however, closed within a day of its opening as a result of police pressure because of its so-called 'offensive' material. Instead of subversion, the work was read as contributing towards pornography. The ironic commentary had as yet no context for being read as political, feminist irony and thus it backfired because critique at the level of the image would not alone ensure a recognition of the feminist intention of the works.

Seven years later, in 1978, Margaret Harrison completed a major painting entitled *RAPE* produced after a period of working with a Rape Crisis Centre and of living in an area where the crime was a daily occurrence. The painting tried to address the complex of prejudices and stereotypes which pervade current popular, police and legal attitudes to the offence. The painting

48 Margaret Harrison, (a) 'He's Only a Bunny Boy But He's Quite Nice Really', pencil drawing 1971 (above) (b) 'Rape', oil paint, collage, 1978 (right)

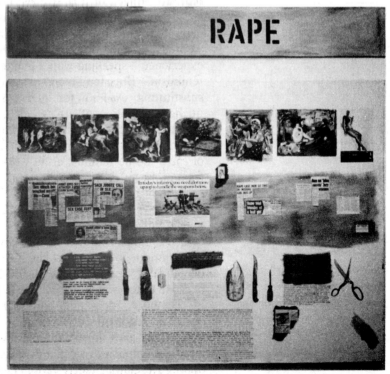

proposes to disrupt the smooth functioning of ideologies which assume that 'women ask for it' and which equate the often very violent crime with an extension of normal heterosexual relations between men and women where a little force is deemed to be desirable or acceptable. The context and associated discourses which create meaning for the current ideas about rape are thus anticipated and then systematically demythicised.

The painting itself is a combination of images, texts and represented objects. A frieze across the top of the painting comprises copies of a selection of famous paintings from 'high culture': 'The Three Graces', by Rubens, 'Ruggiero rescuing Angelica' by Ingres, 'St George and Princess Sabra' by Rossetti, 'The Luncheon on the Grass' by Manet. All of these bear witness to current images of woman as sexually passive, available and on offer to the possessing and fantasising gaze of a presumed masculine viewer. The fine art images are juxtaposed with a contemporary advertisement which displays the body of a woman, equating it in the caption with juicy, tasty food. In shocking contrast to these normalising visions of woman as a sexual, objectified body are painted representations of some common instruments of rape, knives, scissors, broken bottles, razors, which viciously threaten the bodies displayed above. The contrast works to explode the myths of rape as boisterous sexual penetration, and instead they assert its actuality as violence and mutilation. Between these two horrifying incompatible visual discourses Harrison has placed press cuttings in whose reports of rape trials the complicity of the legal profession with violence against women and with the myths of 'women ask for it' (sanctioned by high culture as in the paintings above) is forcefully catalogued.

Reviewing the work when it was exhibited in 1979 as part of the 'Lives', exhibition selected for the Arts Council by Derek Boshier, Caroline Tisdall remarked:

> She adopts a mixture of written work and visual image that we encounter everyday, then uses painting to overcome the deadened muffling of such messages. The overfamiliar once more takes on meaning and urgency while artiness and exclusive aesthetics are kept at bay. (*Guardian* 13 March 1979)

Tisdall thus draws attention to the two strategies which the work '*RAPE*' hinges upon. The first is that of establishing an unexpected relationship between usually separated areas such as high culture, advertising and judicial report in order to show that representations of women circulate across and are sustained by these different sites of meaning. This indexes art and advertising to daily social life, and to politics. The second strategy is that of medium. Harrison uses the craft and tradition of painting – a fine art – as the means to defamiliarise the taken for granted messages of ads and newspaper reports. Painting is coded as not life, as art.

Using it to handle this issue effectively places unexpected materials in a new register through which a different, a feminist reading is produced. The meanings of the work are not dependent on Margaret Harrison's intentions, but they result from the difference this presentation of rape marks out from the mythologies which – from high art to the gutter press – veil the horrors of the daily infliction of male violence on women and children.

Thus a specific kind of 'textual practice', intervening in the institutions and discourses of art, proposes a radically different understanding of political art practice. Political work is done upon those signifying systems and their institutional sites which are shown to be implicated in the oppression of women. By means of these disruptive actions the claims of the signifying systems of our culture merely to mirror reality are shattered.

In their article (Section IV, II) Judith Barry and Sandy Flitterman describe this position:

> The final type of artistic practice situates women at a crucial place within patriarchy which enables them to play on the contradictions which informs patriarchy itself. This position treats artistic activity as a *textual* practice which exploits the existing social contradictions toward productive ends. Accordingly this position takes culture as a discourse in which art as a discursive structure and other social practices intersect.[20]

One example of this kind of work is the 'Post Partum Document' (1975-8) by Mary Kelly (Section III, 9-11). 'Post Partum Document' is not a single work but is composed of six sections which trace a history of a relationship between a mother and a child (see Figs 49a, b and c). It is a history of reciprocal socialisation which contradicts the dominant representations of woman as 'naturally' a mother nurturing her child. What happens in that relationship to both mother and child is determined within social, not natural, relations. The term 'document' is significant. It marks the kind of practice the 'Post Partum Document' adumbrates and realises. 'Document' can imply something written or inscribed; it can also be 'that which serves to show or prove something, evidence or proof'.

The 'Post Partum Document' stands in opposition to a massive array of pictures of mother and child in European art. It does not picture the mother or the child. The relationship, the reciprocal activities, experiences and, at the level of the psychic, the fantasies cannot in fact be pictured or directly represented. What can be 'documented' is the trace of this intersubjective, social practice of childcare through which the child acquires a social and therefore gendered position and the woman is confirmed within the problematic of femininity under patriarchy. The six sections each use different materials – nappy liners, drawings,

49 Mary Kelly, 'Post-Partum Document', 1974-1979
(a) (top left) Documentation I Weaning from the Breast, 1974
(b) (bottom left) Documentation IV On Femininity, 1976 (c) (top right) Documentation VI On the Insistence of the Letter, 1979

96

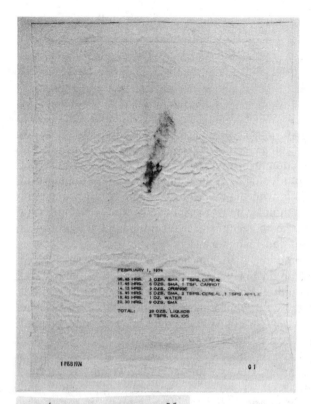

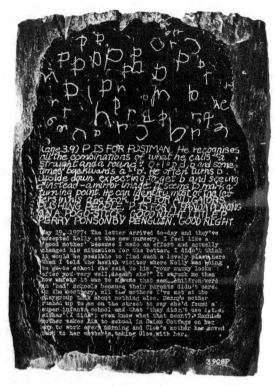

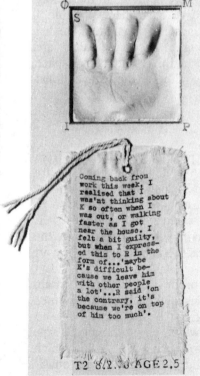

printed words, plaster casts and a comforter, gift objects and a writing slate. The physical objects which form the tokens of exchange between mother and child are present but they are marked, literally, by the inscription of a woman's discourse about that which is precisely obliterated in the conventional representation of mother and child, i.e. the effects of the process on the woman to constitute the condition of mother, that complex of desires, pleasures, fantasies and losses. In order to articulate a woman's discourse about what is in the patriarchal culture invisible and unsaid a complex form is required which offers several levels of reading. Diaries and other writings document the mother's responses. The whole is framed within another discourse which calculatedly traverses several fields of theoretical knowledge (biological, psychoanalytical, linguistic, artistic) in order to produce feminist knowledge of the processes of femininity in the sexual division of labour in childcare, i.e. the interaction of the psychic and the social as a site of women's oppression and complicity. Thus the 'Post Partum Document' attains to the level of document as evidence or proof. In order to attain its multi-levelled meanings the 'Post Partum Document' depends upon relations both internally to artistic conventions and discourses, i.e. as document/inscription and externally to those discourses and practices it invokes, as document/evidence. The sense in which

'Post Partum Document' articulates a woman's discourse does not produce a fixed coherent autobiographical work with an integrated woman as its subject. It functions finally as the discourse of the Other, subversive in the very act of speaking for women and from the position of women. The effect of reconstructing history by means of 'documents' is always one of fissure, fragment, absence. Reading a history from documents requires the active participation of the reader in order to reconstruct the meanings across the traces. As this occurs in the 'Post Partum Document' the reader/viewer must activate the social knowledge of ideologies about women, children, housework, 'who makes art while who makes babies'. Meaning is produced at that point of production by its viewers/readers who in deciphering the documents, come to recognise and understand femininity as social process, founded in historically specific social practices.

Feminist art practices are political, then, because of the relations they do, or do not, sustain to dominant discourses and modes of representation. Politics is not merely a matter of content nor of commitment of the producer. Political effectivity is the product of an intervention in a specific network of discourses and conditions of production and consumption.

The politics of the Women's Movement has identified areas such as subjectivity, sexuality, the sexual division of labour, language and imagery as areas of women's oppression and therefore targets for political change. Developments in the theory of ideology, representation and language have made possible a politics of art, working at the level of the signifying system, textual relations and the institutions through which the texts are produced, circulated and consumed. In this conjunctural space feminist art practices have radically altered the conventional notions of politics and of art.

Official culture and feminism

The primary identity of feminist art practices must derive from the debates and politics of the Women's Movement. Yet they are equally shaped by the current conditions and trends in art practice. This establishes a dialectical relationship between feminism and official culture the distinctive feature of which is the fact that while feminists are making an intervention in the institutions of official culture, their practice is based *outside* the art world in a political movement.

The current conditions of artistic production in Great Britain are dominated by the major institutions such as the Arts Council and the Tate Gallery, art publishing, art education and the art press including the national papers which cover the visual arts. These comprise one of a set of interlocking art worlds which involve the commercial galleries and dealerships, the quasi-

independent organisations such as the Museum of Modern Art at Oxford or the Institute of Contemporary Arts and the Whitechapel Gallery in London, the regional art centres and galleries funded in part by Regional Arts Associations and also the fringe groups and artists' organisations. It is the discourses and practices produced across these institutions that define what is socially produced and ratified as 'art', i.e. that selection from the quantity of works made and sold which are taken to constitute significant high culture.[21] The accepted modalities of art making that these interlocking institutions circulate are limited and impoverished.[22] But they are hegemonic. Not only do they produce the dominant ideas of high culture but this set of attitudes subordinates all others and makes them relative to it. What cannot be accommodated, however, within these definitions, presenting a serious challenge to them, can be, and often is dismissed as not art at all (see Section II, 8). For example in reviewing the exhibition about the sexual division of labour and the impact of Equal Pay legislation on women's employment in a South London factory, 'Women and Work' (1975) by Margaret Harrison, Kay Hunt and Mary Kelly (Section III, 9) the Sunday Times critic was much impressed: 'This is one of the most vivid, vibrant and important exhibitions I have ever seen.' None the less she asked herself, 'I don't know if this is "art".' (Sunday Times, 25 May 1975, p. 27). The press response to the exhibition of Mary Kelly's 'Post Partum Document' at the Hayward Annual in 1978 was in general hostile (see Section II, 8), but one critic stated categorically that the work belonged not in an art gallery but in the foyer of a maternity hospital, the shop Mothercare, or in a woman's magazine.[23]

Alternative activities are, however, always defined in relation to that to which they are counterposed. A 'counterculture' does not exist absolutely outside of that to which it runs counter. The dominant and the alternative in cultural practice exist *interdependently*.[24] This fact has several ramifications, which can be traced historically. In the 1870s in France when an independent movement in painting was formed (better known to us today as Impressionism), both the kinds of artistic practice they formulated and the institutions they founded (i.e. group exhibiting society and a Salon of Independents) were perceived by themselves and by outsiders in difference from what was currently dominant. Significantly, however, for that moment in history and for the present debate, what the Independents (as they and their successors called themselves) were doing can be recognised as the constitution of a form of culture on behalf of the emerging bourgeoisie which, however, was still tied culturally to older forms of art produced for and supported by earlier class formations they were replacing. While Independents' work was shaped in relation to the norm and officially sanctioned

conventions, their revolt against this orthodoxy was very quickly ratified as the favoured culture of the dominant bourgeoisie.

In the late nineteenth century the practices now acknowledged as the founding forms of modern art constituted a marginal and only potential culture (despite the enormous stress given it by Modernist art history to the virtual exclusion of all else). Its adoption by the big bourgeoisie of the early twentieth century marked its victory and its arrival as the effectively dominant cultural form – Modernism. There are still many kinds of art practice in this century but only the selected forms which can be construed within the Modernist protocols are ratified by art criticism and taken to be 'modern art'. Modernism can therefore be called hegemonic since it is in relation to it that all other contemporary practices are defined and classified.[25]

Although the notion of hegemony is usually used of classes and nations it can usefully assist in the analysis of gender relations.[26] One of the most important debates within the women's art movement has centered on this problem of the relationship between feminist practices and the dominant cultural forms and institutions. It is not however, possible to remain 'pure', uncontaminated by contact with the art world. A certain notion of women's art, even a degree of feminist practice has been incorporated as a tolerated and marginalised side line momentarily visible through token women adopted by the Arts Council or mentioned in critics' reviews. For instance, the Arts Council has purchased some pieces of work by Mary Kelly, Margaret Harrison, Susan Hiller, Alexis Hunter, and Marie Yates. Work by Alexis Hunter and Mary Kelly was selected for the British Council's touring show '*Un Certain Art Anglais*' which was first exhibited in Paris at the Musée d'Art Moderne in 1979. As we have already seen (p. 22-23) the second Hayward Annual in 1978 was selected by five women and the exhibition included feminist artists such as Susan Hiller, Alexis Hunter and Mary Kelly. This apparent acceptance should not be overstressed, for such tokens of recognition must be set in the context of more than a decade of struggle to win any degree of parity in the representation of women in officially sponsored exhibitions and bursaries. Take a look at these figures:

1974	British Painting	106 men	16 women
1975	Condition of Sculpture	36 men	4 women
1977	Current British Art Hayward Annual I	34 men	3 women
1978	Hayward Annual II*	7 men	16 women
1979	British Art Show	100 men	12 women
1979	Hayward Annual III	23 men	2 women
1980	John Hoyland's Selection of British Art	32 men	2 women

1981	The New Spirit in Painting	38 men	0 women
1982	Hayward Annual Drawings	55 men	15 women
1984	The British Art Show	72 men	11 women

* Selected by a panel comprising five women.

Specifically feminist practices are subjected to another form of closure. Excluded from publicly sponsored exhibitions they are rarely discussed in art history and criticism. Thus they are rendered invisible. New generations of women in art schools, struggling with the contradictions of their position in so structurally sexist a system of art education are effectively disinformed about the tradition of women in art both past and present.[27] Without that sense of a feminist tradition as it has developed they are condemned endlessly to repeat the same initial stages of resistance which can be easily contained as each generation passes through the educational system – a system which itself remains scandalously dominated by men.

Yet feminism is more problematic for official culture. It is more than a peripheral practice, for its analyses and effects are potentially revolutionary. It is therefore treated as inimical to art itself. What women produce is in our culture not considered as art, but 'women's art'. It is always too much about women, therefore partisan and not universal – so the argument goes. Feminist art practices do not in general subscribe to the myths of essential femininity but are consciously addressed to questions of gender and subjectivity. They are necessarily about women. Therefore merely asserting women's right to make art about women – which is one of the initial stages of a feminist consciousness in art making – falls prey to the already framed subordination of women's art to what is falsely claimed to be the gender free Art of men.

It is, therefore, necessary to intervene in the sites of artistic production and to expose its ideological character and effects in reproducing a gender hierarchy. Intervention does not mean trying to join the establishment. It is impossible, and ultimately disfiguring. Intervention is a complex of related strategies, material, social, institutional and textual, confronting and exposing the sexism which structures the cultural institutions and their endorsed practices, which in turn realise in this specific form the sexual contradictions of the society as a whole.

Modernism and feminism

A relationship between feminism and Modernism as official culture can be posed. It is a historical relationship – Modernism constituted in the late 1960s the dominant paradigm of art, art criticism, and art history. It is an institutional relation – Modernism is still the instituted official culture in terms of

galleries, museums and art education. It is therefore a strategic relation as a result of a cultural politics of intervention. This makes the relation a necessary one in terms of art practice, but what makes it necessary in terms of feminism? Indeed the opposite case has been strongly argued. For instance, in 1980 Lucy Lippard proclaimed that 'Feminism's greatest contribution to the future vitality of art has probably been precisely its lack of contribution to Modernism'.[28] Lippard located feminism in opposition to Modernism and thus posed the issue in terms of overlapping polarities such as Modernist/Anti-modernist, male/female.

> Feminist methods and theories have instead offered a socially concerned alternative to the increasingly mechanical evolution of art about art. The 1970s might not have been pluralist at all if women had not emerged during the decade to introduce the multi-coloured threads of female experience into the male fabric of modern art.[29]

Lippard's remarks must be placed in the context of the debate about Modernism and Post-modernism. The pluralism of the 1970s was a symptom of the disintegration of a core of practices (abstract painting, minimalist sculpture for instance) within Modernism and the new term 'Post-modernism' has been coined to be a catch-all for this break with the unified tradition of Modernism. Feminism is thus claimed not so much as anti-modernist as Post-modernist, part of a complex field of diverse and critical practices which, abjuring formalism and the claims for aesthetic autonomy typical of Modernism, search for ways to index art critically to the social, experiential and the everyday spectacle of modern consumer capitalism.

In order to explore this claim further it is necessary to be clear about what can be meant by the term Modernism. The term has different currencies in the several contexts in which it figures. For practitioners Modernism is identified with a particular kind of painting and sculpture, particularly abstract work which is premissed upon and explicated by the formalist criticism of Clement Greenberg and his followers. It is claimed that that which distinguishes one art from another is fundamentally its medium, and the advance of that art is served by a progressive purification of each art form. So the history of modern painting follows the rejection of narrative and literary content or illusionistic space and the growing concern with the properties of the medium and the two-dimensionality of the painted surface.[30]

Modernism must, however, also be more broadly defined as a system of interpretation of those art practices which, since the late nineteenth century, have been accommodated within such a trajectory. Modernism refers, therefore, to the criticism and art history which classifies paintings, sculpture and other art forms according to stylistic innovations and reactions (Cubism, Abstract

Expressionism etc.) embodied in the masterpieces of great individual geniuses (for instance Picasso, Matisse, Pollock, Johns). Taking both these conceptions of Modernism as symptoms of a larger phenomenon, social historians of art treat Modernism as much more than style or a critical theory. Modernism can be understood as an institution, composed of and realised in a series of practices – painting, sculpting, writing art criticism, curating exhibitions, marketing pictures and careers, lecturing on art history courses, collecting and so forth. These practices circulate an ideology for the making, consuming and ratification of art.[31]

Modernism can therefore be grasped in several dimensions. It refers to the paradigm for the practice of art initially produced in Europe in the 1860s–90s. By the beginning of the twentieth century these marginal activities had become an effective component of a still highly diversified cultural formation. By the 1930s and 1940s, however, these practices were made official, institutionalised, in the Museum of Modern Art, New York and the other museums of modern art which were shaped in its mould, thus having an extensive influence on art history and art education. Modernism was positioned as the living culture of the capitalist West and its position of authority was secured with the economic, political and ideological domination by the metropolitan countries (particularly the United States) and their ruling classes over a world market.

Although as a paradigm of practice, Modernism was an initially European phenomenon whose capital was Paris (the School of Paris) it became transatlantic in the period between the two World Wars. By the 1950s it was exclusively identified with 'American-Type Painting' (Abstract Expressionism) which was circulated in Europe for European acknowledgement during the period in the late 1940s and 1950s when European economies and cultures were increasingly penetrated by American international capital. In the process of 'modernising', the European satellites absorbed along with American norms of manufacture and management the condition of Modernism managed by the International Programme of the Museum of Modern Art.[32]

Modernism is not a coherent set of practices. It also refers to a *representation* of twentieth-century art practices which select some as significant (advancing, avant-garde), while marginalising others as residual, reactionary or historically irrelevant. Modernist criticism and art history have become the shaping and 'selective' tradition of and for twentieth century culture in the West. As Raymond Williams has argued, 'tradition' is not to be understood as merely the surviving past, worthy of record and respect because its value has been proved by time. What is presented as 'tradition' is in fact always selective: 'an intentionally selective version of a shaping past and a preshaped present which is

powerfully operative in the process of social and cultural definitions and identifications.' The selective tradition becomes a powerful force in sustaining the interests of the dominant class, race or gender. 'Tradition is in practice the most evident expression of the dominant and hegemonic pressures and limits.'[33]

Feminist opposition to Modernism has therefore been more complex than the substitution of pluralism for formalism, of critical engagement for abstraction and (apparent) neutrality, of photography, video or scripto-visual art forms for pure painting. It has entailed a political assessment of the relations between a range of potential practices and the sites of their effective deployment within a field contested by official and emergent cultural strategies.

Feminist practices are increasingly being assimilated to debates about Post-modernism,[34] to the sense that Modernism as a practice has been frankly superseded by a diversified and radically different kind of culture. It is, however, timely to compare this labelling with an earlier historical exercise curated by the Museum of Modern Art in 1957 when the term Post-impressionism was given new currency – having been initially coined by Roger Fry and Desmond McCarthy in 1910 – as a means to distinguish the diversified reaction against Impressionism by avant-garde artists. Yet these reactions were none the less institutionally and critically predicated upon the economic, social and artistic practices of the superseded Impressionist moment of the avant-garde. While it is clear that modernist practices as understood in the later 1950s have been overthrown, it is not clear that modernist structures of production and consumption too have been radically altered by, at least many, aspects of current Post-modernist art. Some recent writers on the subject pose Post-modernism as an aesthetic break with the field of Modernism resulting from structural changes in the economic and social forms of late capitalism,[35] others have argued that Modernism as the dominant institution is still structural to our culture.[36] This latter position acknowledges the kinds of institutional continuities which figured in the Post-Impressionist example, while the former alerts us to the necessity to resist the assimilation of all practices to the Modernist embrace.

The formation of feminist practices in the early 1970s was clearly part of a radical reaction against Modernist paradigms for artistic production and as such there are correspondences with other cultural groups. But while being shaped by similar forces and interests, feminist practices have also been active in shaping the character of recent cultural activity, indicating the means for a radical critique not only of Modernist practice but of its institutional and critical structures.

Lucy Lippard represents one position in the spectrum of

feminist opinion on this point. She poses feminism as an alternative to Modernism, an anti-modernism which is also presented in terms of gender difference. While it is true that Modernist art history and criticism have pretty consistently negated women's participation in the Modernist project (for there have been many women engaged therein), and it is true that many of Modernism's heroes mythically celebrate a macho masculinity (think of Picasso and Jackson Pollock for instance, and their legends), it is dangerous to confuse the social and historical reasons for the predominance of men practising and being celebrated in Modernism for some given fact of gender, or some essential feature of Modernism itself.

A second form of the argument has assimilated feminist practice to a notion of the feminine which is held to 'the moment of rupture and negativity which conditions the newness of any practice'. Julia Kristeva's dictum was used as the key note to a text (Section IV, 3) by Anne-Marie Sauzeau-Boetti in which she identifed a feminine avant-garde committed not 'to a positive avant-garde subversion but a process of differentiation. Not the project of fixing meanings, but of breaking up and multiplying them.'[37] Feminism, assumed into a binary opposition of masculine and feminine, inspires an absolute break with masculine culture. To identify all radical rupture with the feminine is, however, to lapse into unhistorical generalities, and to deny the particularity of the historical conditions of femininity and its relative positionalities in a given social system. It is also to deny actual women's historical or politicised agency. In a paper in 1981 on 'Feminism and Modernism: Some Paradoxes' Nicole Dubreuil-Blondin raised this issue of woman–avant-garde as *the* model for rupture, 'the total "Other", the definitive subversion which will finally reconcile art and politics'. On the other hand, she also asked, 'Is it not the avant-garde itself undergoing profound changes in its Post-modernist phase, its new configurations corresponding exactly to the problematics of women's art? Will that art simply be another chapter ... of the dominant art that is now creating history?[38] This poses a more substantive question about the relations of feminism and Modernism. Is feminism the decisive challenge to it or just one of the proliferating Post-modernist alternatives that attest to its practical contradictions?

There is more than theoretical clarity at stake in separating Modernism-as-an-institution from Modernism-as-practice. Modernism is still the dominant institution and it is through its processes and offices that much of what is termed Post-modernism is still ratified and consumed. As a practice, however, Modernism has never been as monolithic as is presently made out in this Post-modernist debate. There have been many radical practices identified within the Modernist project. The famous examples are the Constructivists in the early years after the

Russian Revolution, moments in the history of Dada and Surrealism, some of the German Realists of the 1930s, the Russian cinema of 1920s and the theory, theatre and film work of Bertolt Brecht.[39]

The revived interest manifested in the 1970s in the ways in which Brecht had shown how modernist tactics could be used in a critical and politically progressive intervention in and through art was a symptom of a crisis *within* the Modernist community. Some works produced in the late 1950s, particularly in the Modernist capital of New York, were a guarded exploration of the constraints imposed on artists by the institutional frameworks of Modernist practice – for instance the limitations of audience and accessibility were resisted by staging popular street events, or artists tested the power of galleries to absorb and define as art what they housed, whatever it was.[40] These tactics identified points of contradiction, but they did not enable the producers to break out of them or resolve them into a practice based *outside* the institution. Another trend involved artists in a complex reassessment of the conditions and relations of artistic production. Feminist activities can be located in this area, but its particular and decisive feature was the possibility of breaking out of the contradictions (based on the necessity of doing so in order to function at all). This can be specified crudely thus: the desire for political effectivity for art cannot be realised exclusively in terms of the art world. Yet art practices have to maintain a relation to the art world in order to be accredited as art, to be effective as that specific form of social operation. There has to be an intervention generated from a *social* space. This means being aware of the social nature of cultural activity, and, yet conscious of the larger social issues of which cultural activity is but a part. The intervention must at the same time have the effect of exposing the art world as a social space, breaking down the notion of art as above or separate from society and its political struggles. For instance, feminist interventions have shown how the hierarchical relation between men and women is realised and reproduced in art, through discrimination, through the different ways the different arts are valued, through the dominant values and ideals which are represented in paintings and other images.

Mary Kelly's article 'Reviewing Modernist Criticism' published in *Screen* in 1982 makes a major contribution to the debate about feminism's relation to modernism, counterpointing Lucy Lippard's view of feminism as anti-modernism or Post-modernism. Kelly maps out the conditions of Modernism and the dialectic between that historical moment of the late 1960s and the possibilities for feminist art practices. The argument begins with an account of the condition of Modernism when the recent 'Triumph of American Painting' – Abstract Expressionism – could no longer be sustained.

In the later 1960s the viability of the official Modernist paradigm was subject to growing stresses and corruption as the logical conclusions of an institutionally backed formalism were pushed to the limits. At the same time work which represented a literalist abstraction, for instance the sculpture of Carl Andre, or at times paintings of Frank Stella, seemed to threaten the potent ideological and economic component of Modernism – the idea of art as expressive subjectivity, the emblem of individualism.[41] Gesture had played a major role in the critical elaboration of, for instance, Abstract Expressionism, where, as Mary Kelly has argued, the painterly gesture compensated the viewer for what was no longer offered in terms of content or narrative incident. Gesture signifies the artist whose subjectivity, thus registered by the marks of making a painting, becomes – in both senses – the painting's *subject*.

> Gesture is the term which the proponents of modernism cannot afford (literally in the financial sense) to efface. In the 1960s, when the 'avant-garde' expelled gesture, denied expression, contested the notion of essential creativity, the spectator was called upon to sustain a certain loss: the presence (or rather petrified absence) of the artistic subject. The dealer, too, was threatened with deficit: the authenticating mark which figures so prominently in the art market's peculiar structure of desire and exchange. It is not only a particular work of art which is purchased (title) but also something by a unique individual which is possessed (the name).[42]

(It is important to note that in the recent revival of painting – Neo-Expressionism and the so-called 'New Spirit in Painting' –it is this gesture-commodity with all its macho posturings that has been so warmly welcomed by the desperate market.) Under this stress Mary Kelly points out how alternatives began to proliferate within Modernism:

> Following the paradoxical logic of Modernism's demands for objective purposes as well as transcendental truths, avant-garde practices between 1965 and the mid-1970s initiated areas of work that divided the very field of which they were an effect. The potential of that divergence has not been completely realised.[43]

Kelly offers a dialectical view of what those potentials are and how they can (and have been) refashioned for a feminist, materialist practice.

Kelly identifies three areas: materiality, sociality and sexuality. In the paradigm of Modernism articulated in its transatlantic phases through the writings of Clement Greenberg, materiality is the law of Modernism. In an essay of 1961, 'Modernist Painting', it is claimed that 'the unique and proper area of competence of each art coincided with all that was unique to the nature of its medium.'[44] Thus two-dimensionality (flatness) and opticality

through colour (as opposed to illusion) were the essences of painting.[45] In this form of materialism the material characteristic of materials or objects prescribe the human activity, their meaning inheres. There is, however, another sense of materialism which gives priority to *human* activity within socially and historically produced circumstances. Human, social forms are shaped by real conditions of social existence – labour, reproduction and so forth. In terms of art making such a notion of materialism would propose that art is a social process whereby meanings are produced in concrete social transactions mediated by socially and historically formed signifying systems. The potential here is for a textual politics.

Sociality raises the question of the contexts for art. The contradictions within Modernism itself between its ideological claims of individual self-expression and freedom and the commodification not only of art object but of art personality had in the late 1960s generated several programmes of tactical resistance to the gallery system. Should art be made for the gallery system? What was a space for art? Various artists explored questions like these but from within the system, using galleries as spaces within which to house exhibitions critical of the effect of galleries on art, or to house exhibitions which revealed the determining effect of the gallery space on the identity of objects as art objects. The problem was widespread. As Philip Leider commented in passing in a review of a retrospective of the work Frank Stella in 1970:

> the idea of what to do as artists was up for grabs; for both (current artists and those of the late forties), uncertainty, especially as it pertains to their relationship to the tradition of modern art – not merely the plastic tradition but the social and economic traditions of museums, dealers, collections and collectors– is the fundamental condition of their creative lives.[46]

The resulting experiments with art spaces and with art forms which resisted commodity exchange on the market– body art, art as idea, process art, land art and so forth, were limited in their effectivity because of a lack of any analysis of art as an institutional practice. If institutions such as museums, galleries, owners' homes are merely seen as *contexts of use* which intervene after the discrete moment of private creation, artists could worry away at dreams of making a purer art, uncontaminated by its exploitation in the market place, or dreams of an art which can withstand incorporation and act critically from within the system by virtue of the artist's intention for it to do so. The radically different and necessary approach is premised in the recognition of 'art' as institutionally produced and defined; the studio is not separate from the gallery. They form interdependent moments in the circuits of production and consumption of art under capitalist

relations of production. Therefore the issue of sociality must be 'considered as a question of institutions, of the conditions which determine the reading of artistic texts and the strategies which would be appropriate for interventions (rather than for "alternatives") in that context'.[47]What empowers such interventions must be the location of art and its institutions in a continuum with other social, ideological, political and economic practices. The question is not to be or not to be in the gallery, but rather what relationships can be established (and exposed) between this institutional site of social struggle (the art gallery etc.) and others. Thus, instead of the short-circuited critiques from within Modernism which none the less had useful repercussions, a feminist materialist practice is founded outside the art world, but indexes the art world to the social relations of which it is a constitutive element.

The third issue is sexuality. This has come to the fore in part as a result of the impact of feminism itself in the late 1960s and early 1970s. But it has also been an effect of the expansion of libertarian discourses on sexuality which also characterised those decades. These latter, however, have tended to reify sexuality as a discrete entity, which is, moreover, treated as a touchstone for truth, in Foucault's phrase, the 'truth of our being'. This has contributed to body-based art practice. Feminist critiques of the dominant iconographies of woman in art and the mass media, as sex objects of objectified spectacle have been paralleled by attempts to produce an alternative, so-called positive, non-sexual or sexually redefined imagery for women[48] (see Section IV, 1). This is premissed, however, on both a notion of sexuality as an essence and a positivist view of language as a vehicle for expression of meanings constituted outside of its system. Recent work on the history and theory of sexuality has generated significant reformulations.[49] Instead of treating sexuality as something we have, or even, are – the touchstone of our being, of our gender, corrupted, repressed or misrepresented by patriarchal society, sexuality is defined as a product of society, of its practices and discourses through which we are positioned. Sexuality is therefore not an essence trained through social conditioning or repression; it is an effect of the processes which place us as sexed subjects, subjected to a place in a relation of difference through the acquisition of language and through the reinforcing networks of social practice such as the family, education and so forth. Sexuality is not an attribute of people, to be pictured or re-imaged. It is a set of effects and positions which artistic practices confront, are implicated in, or may dislocate in the way in which they produce positions for viewers and authors for the artistic text.

The way in which Mary Kelly's article reformulates the agenda around these three issues of materiality, sociality and sexuality is

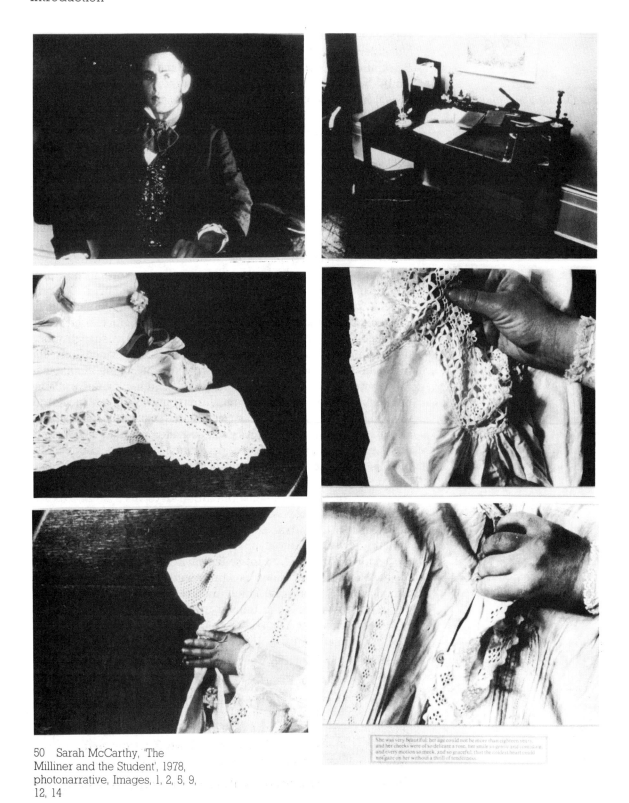

50 Sarah McCarthy, 'The
Milliner and the Student', 1978,
photonarrative, Images, 1, 2, 5, 9,
12, 14

important. It makes it possible to imagine interventions in historically informed and politically effective terms. Kelly's argument also breaks down the myth of Modernism as monolithic entity. She points out the internal contradictions and the minor acts of disobedience they give rise to, as well as identifying the major fissures through which a feminist materialist counterpractice may make its way. However hegemonic, there is much incoherence within Modernism and the important contradictions have to be distinguished from the rebellions which sustain its vitality and renew its novelty (e.g. some aspects of what is now called Post-modernism).

Although Kelly's article seems to be suggesting the possible directions of feminist practice, it is in part informed by those practices which have already begun to exploit the contradictions within Modernism. This can be demonstrated by a few examples of feminist work which touch upon the questions of text, institution and sexuality.

Writing of her photographic narrative 'The Milliner and the Student', (London, Arts Council), (see Fig. 50a-f) exhibited in 1979 at the Hayward Gallery, Sarah MacCarthy described how she constructed scenarios which were then photographed in order to set up a counter-text to extracts from a novel about the seduction of a poor milliner by a middle-class student which was published in a mid-Victorian magazine. The opening shots of Sarah MacCarthy's sequences show a man, a writing table and writing materials. This is followed by a series of photographs of clothes, women's clothes being laid on a table. At some point hands are shown unbuttoning or buttoning a garment. A short text describes a beautiful young woman. After several more scenes of clothes on the table the text makes it clear that these clothes are not being discarded by an unseen woman, undressing, but are in fact the products of the milliner's labour. The original ambiguity of the photographs lays them open to a voyeuristic reading, a sexual reading of a woman undressing, which then becomes impossible for it is displaced by a different set of connotations for the same items; the clothes signify work. Sarah MacCarthy argues:

> The problem of representation of women is not that men and women
> are different, but that difference is inscribed politically and
> ideologically in our society. The meaning of an image always exists
> both as a production of the image, and beyond the image in the
> viewer's culturally constructed interpretation and alongside all other
> images of for instance women. Alternative readings are then not just a
> question of new content or changed 'Consciousness' but the result of
> a different strategy of production of the image in relation to this social
> space inside and outside the image.[50]

Sexual overdetermination is also an issue in the work of Marie

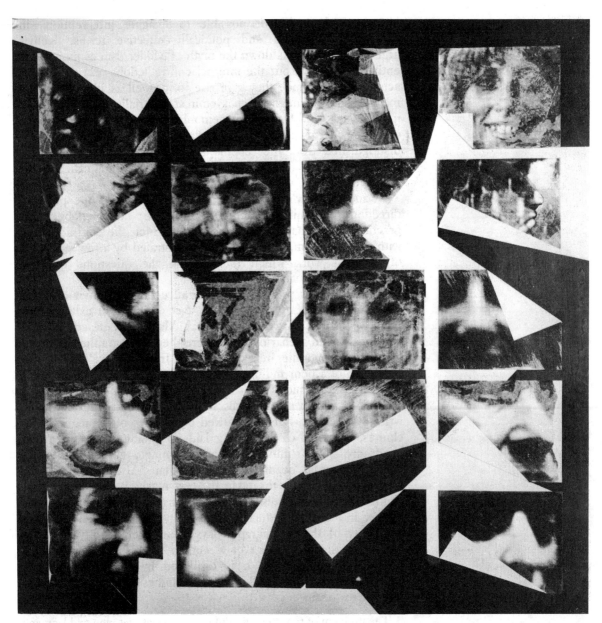

51 Marie Yates,
'Image-Woman-Text', 1980,
two panels (a), (b)

Yates in her work 'Image-Woman-Text', 1980. This piece
comprises two composite panels of photographs. On one panel
photographs have been xeroxed and painted over, reduced to the
minimum of information. What is most striking is therefore the
signs of manufacture or the 'painterly gesture'. The reference is
therefore to Modernist practice and discourse. In the second
panel the same images are printed in high-gloss restoring, but
noticeably, the pleasures and plentitude of the photographic
image. There are captions, 'She feels gloomy', 'She goes to

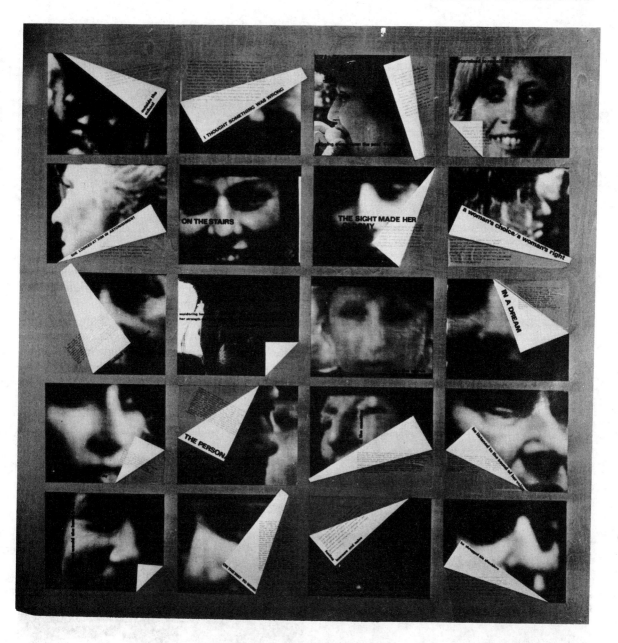

school' and annotations which intrude on the photographs. The juxtaposition aims to reveal the lack in a photograph, what/who is photographed is absent, no longer there. Reduced to pure visibility, it is empty of meaning except of its manufacture. The annotated panel is the more usual way we encounter photographs, with signposts and the illusion of fully visible information. But what is present, as subject and as the product of meaning, is the viewer, entering the space of the image from a social space constituted across differences of gender, of race, of class. In the

notes accompanying the exhibition of this work at the Institute of Contemporary Arts in 1980 Marie Yates pointed out the way in which the viewer is complicit with photography to secure a notion of the natural sexual identity of woman.

> Within these representations we seek woman-ness or man-ness; we locate what we identify as a clue and decide on that basis that we have discovered a 'real' sexual difference located as a property within the discrete person captured in the 'reality' of the photograph. This 'location of difference' then becomes the full presence required by the question of the image (What is it of? What is she?) and narrative takes hold. . . . Because so much personal reference is required in this production of meaning through involvement with the image, we entail ourselves within (what we take to be only) recognition.[51]

Susan Hiller's work, in a very different idiom, also confronts and exposes the social and cultural relations within which texts have meanings or are given value. 'Dedicated to the Unknown Artists', first exhibited in 1976, comprises 305 postcards, 10 charts mounted on fourteen boards (see Fig. 52 a, b and c). The postcards are all photographs of photographs and paintings which picture a coastal scene and have the works 'Rough Sea' in the title. This common phrase indicates the existence of a popular set of pictorial formats and their presentation in Hiller's work is based on the assumption that there is meaning, method and

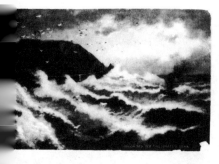

52 Susan Hiller, 'Dedicated to Unknown Artists', 1976, 305 postcards, 10 charts, 1 map; (a) installation shot (facing page); (b), (c) two details

THE ROUGH SEA ART

Order no.	Locale	Caption	Legend (explanatory text, on back of card)	Commentary (first figure in total refers to correspondence about work on image or second figure indicates total cards with correspondence on any subject)	Medium	Format	Color	Presentation	Signature	Type	Catalogue
242	Blackpool	Rough Sea on North Shore Cliffs									
31	Blackpool	Rough Sea, North Shore									
32	Blackpool	Rough Sea, Princess Parade									
33	Blackpool	Rough Sea, North Shore									
241	Blackpool	Rough Sea, South Parade									
35	Blackpool	Rough Sea, North Parade (et al.)									
56	Blackpool	A Rough Sea / The Dog Wave	The air of Blackpool is bracing in the highest degree, and the weather of Blackpool can be remarkably tough. A sight that will never be forgotten is the sudden inrush of some enormous wave, such as this "Dog Wave", against and over the sea-wall and sea-front, which are both whelmed in showers of thundering spray.						7.(?)		
243	Blackpool	A Rough Sea at -									
Subtotal: Blackpool		21	6	1/12	16 5	20 1 3 18	7 14	7 5	0 0 ?	19? 1 3	
37	Bognor	Rough Sea									
38	Bognor	Rough Sea									
39	Bognor	Rough Sea									
40	Bognor	Rough Sea									
41	Bognor	Rough Sea									
42	Bognor	Rough Sea (et al.)									
43	Bognor	Rough Sea (et al.)									
44	Bognor	Rough Sea 11							E. Lawrence Wood		
45	Bognor	Rough Sea at -									
47	Bognor	Rough Sea near the Pier									
48	Bognor	Rough Sea, West Parade									
46	Bognor	Rough Sea at -									
Subtotal: Bognor		12	0	0/11	12 0	11 1 2 10	8 4	0 0 1	0 0 2	6 4 1	
49	Boscombe	Pier & Rough Sea									
Subtotal: Boscombe		1	0	0/1	0 1	1 0 0 1	1 0	0 0 0	0 1 0	0 1	
50	Bournemouth	Pier & Rough Sea	"This I think is a moonlight effect. The wind is rising steadily and we shall soon have it just like it."								
Subtotal: Bournemouth		1	0	1/1	0 1	1 0 0 1	0 1	0 1 0	0 1 0	0 0	
51	Bridlington	Rough Sea at -	"How would you like to stand here. You would get a splendid bathe. Plenty of water for the engine too."								
Subtotal: Bridlington		1	0	1/1	1 0	1 0 0 1	0 1	0 0 0	0 1 0	0 0	
52	Brighton	Rough Sea	"This is something like its been here. I am bringing you some PC's back in exchange for those I've given you. I have got 2 albums for myself, small ones both hold 100 each. One I've got with all musicians and the other, views."								
53	Brighton	Rough Sea									
54	Brighton	Rough Sea									
55	Brighton	Rough Sea									
56	Brighton	Rough Sea	"The weather yesterday was somewhat like the view..."								

commitment to an idea in these artefacts. Such postcards are usually considered lacking all these attributes which are the qualities of art. The artist Susan Hiller occupies several positions in relation to these works by unknown artists. She is a curator collecting these items and by exhibiting them together she confers upon them the status of significant objects of art because they can be placed in a system, a genre of landscape imagery, and a tradition of art forms. Thus they are converted, but at the price of exposing the status of art as something conferred by social action, not inherent in the thing itself. On the other hand, the artist works as analyst, using the skills acquired in a professional training in anthropology to subject the artefacts to a systematic classification.

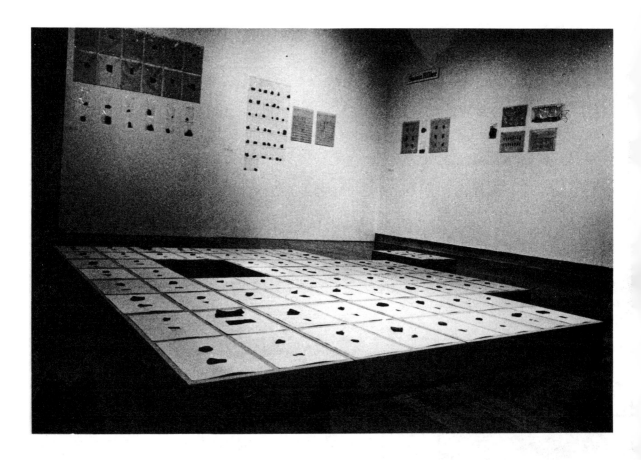

The 'approach' used in this piece has the traditional four stages of 1 preliminary collecting of data, 2 description and classification, 3 analysis, 4 presentation. I would call it a methodical-methodological approach that closes the gap between the piece as *work in the world*, and the piece as *metaphor*, for work in the world. There can be no doubt that a kind of contribution to 'objective' knowledge is involved; I have, after all, claimed academic competence. On the other hand, the initial impetus for the piece was concidence; I was intrigued by the artful pairing of words and images, a pairing or doubling that I have insisted on in every subsequent stage of description, analysis and presentation.[52]

Hiller has also been consistently interested in the historical and cultural specificities which govern the way we know the world. Systems of meaning, particularly language incapacitate as much as they empower the production of meanings. Thus by establishing in her work a relationship between a woman from one culture and artefacts which were produced by women and men from other cultures Hiller points to the social structures which govern the relative degrees of articulacy and inarticulacy. The project 'Fragments' 1978 questions the means available to us

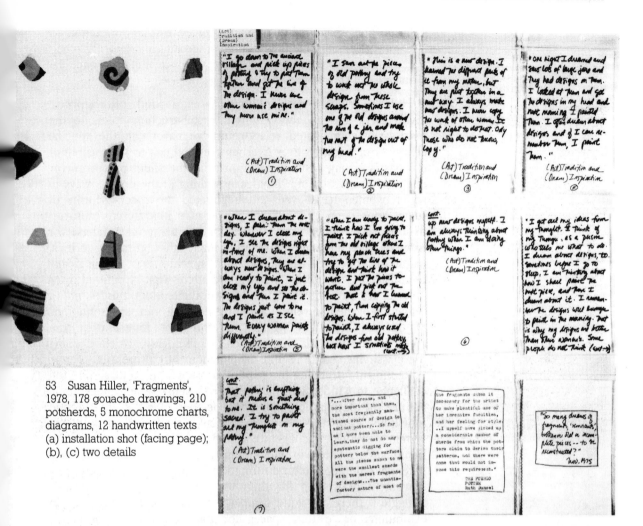

53 Susan Hiller, 'Fragments',
1978, 178 gouache drawings, 210
potsherds, 5 monochrome charts,
diagrams, 12 handwritten texts
(a) installation shot (facing page);
(b), (c) two details

for knowing about the past of another culture. Using fragments of
Pueblo pottery made by Indian women (and often painstakingly
catalogued by women working in the museums which have
preserved these remnants) Hiller cross-referenced the rigid ways
our culture classifies and imposes its order upon the fragmentary
remains of another society and thus, rephrasing its meanings,
silences it. In seeking to know about the context of the pottery
made by women of Pueblo, Hiller confronted the culture- and
gender-bound context in which she herself works. In a catalogue
of 1978 David Elliott wrote:

An introductory section called *(Art) Tradition and (Dream) Inspiration*
outlines and the parameters within which the Pueblo women work in
making and painting designs on their pots, and by implications
suggests that the contemporary artist is bound within the same
restrictions – those of the inherited tradition of art and the personal

117

'inspiration' which leads to the making of art. 'So many dreams of fragments, "remnants" broken or old or incomplete pieces. . . . to be reconstructed'; the artist's note indicates the weight of history and the fragmented knowledge of the world we still have.[53]

Hiller's critical sense of history as a kind of reciprocal involvement and an always partial reconstruction points to the necessarily complicated relationship we have with the specific character of women's lives in other ages and cultures. In search of the past we may easily superimpose on the silent past a mirror image of our world and thus learn nothing of the diverse ways in which women have lived and negotiated the specific forms of social oppression and resistance operative in different cultures, nations, races and classes. While this has a special purchase for women, the point is powerfully made that curators, critics, historians operate within socially specific and ideologically boundaried frameworks. What is included, what is omitted, how objects are presented, defined or evaluated, all this is not a reflection of the inherent qualities or meanings but representations of current meanings which therefore are inflected by the inequalities and social hierarchies of the society which is doing the classifying, curating and management of culture.

Feminism occupies a particular place, therefore, in the challenge to Modernism in an order of sense, as the hegemonic culture of patriarchal capitalist societies. Unlike the limited rebellions against Modernism which remain locked into the system, feminist practices are founded in a political movement. Feminism's relation to Modernism and therefore its force as a potential emergent cultural formation is a result of its relation to a movement of women for their total emancipation. Feminism's struggle is therefore not a campaign to raise quotas of women in exhibitions or to find spaces for the expression of women's experiences, although these are parts of the tactical activity of the movement. It is a struggle about meanings, a fight against dominant and established systems of meaning and the positions and identities which they attempt to secure. To sustain a genuine intervention which can unsettle the dominant 'regime of truth' oppositional practices must articulate with alternative, contrary sets of meanings and social practices, ideologies which are being constructed in terms of historically relevant social struggles. Feminism is the expression of a political movement which is attempting through diverse practices to disarticulate the meanings of the dominant social order and to articulate new meanings for the dominated gender within the subordinated classes and races. This does not imply the simple invention of meanings released suddenly, already formed from the repressed sub-cultures. It will occur and has occurred in the knowing exploitation of the implicated but radical position of women within the institutions

and ideologies of society. It necessitates the negotiation of those forms and practices within the dominant ideologies of art such as Modernism which, shaped within the real and contradictory conditions of modern social relations may none the less provide means of representation adequate to the complexity of those social relations. For it is with these conditions feminist practices contend at the level of the text, of the institution and of the social organisation of revolution.

Feminist artistic practices cannot pretend to a greater effectivity in political change than the relative position socially designated for such activities by the society as a whole. But equally they cannot be denied a strategic necessity within a broad spectrum of contemporary political activities. Not all feminist practices contend with these dominant discourses and institutions in the manner discussed in this section. But those which do operate upon this terrain will gain in political effectivity through the recognition and understanding of their procedures by the women's movement which is their necessary base. At the same time, however, it is important to assert the historically central place of feminist opposition to Modernism, not for any heroic purpose, but because of the way in which the structural sexism of cultural institutions in the present conservative climate actively denies the feminist tradition.

Notes

1 In this anthology we include essays by Mary Kelly (Section IV, 10), Rozsika Parker (Section III, 22), Judith Barry and Sandy Flitterman (Section IV, 11). Other studies include: Alexis Hunter, 'Feminist Perceptions', *Artscribe*, 1980 no. 25; Griselda Pollock; 'A Politics of Art or an Aesthetics for Women?', *Feminist Art News (FAN)*, 1981 no. 5; Laura Mulvey 'Interview' in *Wedge* (GB), 1978 no. 2; Lisa Tickner, 'Feminism, Femininity and Women's Art', *LIP* (Australia), 1984 vol. 8.

2 For more information see Martha Rosler, 'The Private and Public Feminist Art in Southern California', *Art Forum*, September 1977, vol. XVI, no. 1.

3 Raymond Williams, *Keywords*, Glasgow, 1976, pp. 34-5; see also *Culture and Society 1750-1950*, London 1958, Introduction.

4 Linda Nochlin, 'Why Have There Been No Great Women Artists?' (1971) in *Art and Sexual Politics*, ed. E. Baker and T. Hess, New York and London, 1973. Compare V. Woolf in *A Room of One's Own*, London, 1928, p. 105.

5 Rozsika Parker and Griselda Pollock, *Old Mistresses: Women, Art and Ideology*, London, 1981. See also Griselda Pollock, 'Vision Voice and Power; Feminism, Marxism and Art History', *Block*, 1982, no. 6.

6 Griselda Pollock, 'History and Position of the Contemporary Women Artist', *Aspects*, 1984, no. 28.

7 June Wayne, 'The Male Artist as Stereotypical Female', *Art Journal*, Spring 1973, pp. 414-16.

8 For a useful history of the development of cultural studies see Stuart Hall, 'Cultural Studies and the Centre: Some problematics and problems' in Stuart Hall et al (eds.), *Culture, Media, Language*, London, 1980.

9 *Riddles of the Sphinx* (GB 1976), script published in *Screen*, 1977, vol. 18, no. 2, p. 69.

10 For further discussion of this and its explanation in terms of art work see Susan Hiller, 'Interview', reprinted in Section IV, 5; and *Susan Hiller 1973-83: The Muse my Sister*, essays by Guy Brett, Rozsika Parker and John Roberts, London, 1984.

11 Sheila Rowbotham, *Woman's Consciousness, Man's World*, London, 1973, pp. 35-6.

12 Louis Althusser, 'Ideology and Ideological State Apparatuses' (1969) in *Lenin and Philosophy*, trans. Ben Brewster, London, 1971. See also Judith Williamson, *Decoding Advertisements: Ideology and Meaning in Advertising*, London, 1978. Stuart Hall, 'Culture, Media and the "Ideological Effect"', in *Mass Communication and Society*, ed. James Curran, London, 1977.

13 Rosalind Coward, 'Rereading Freud, The Making of the Feminine', *Spare Rib* May 1978, no. 70.

14 See also Francis Mulhern, 'On Culture and Cultural Struggle', *Screen Education*, 1980, no. 34, p. 32.

15 Anna Coote and Beatrix Campbell, *Sweet Freedom: The Struggle for Women's Liberation*, London, 1982, pp. 24-5.

16 Rosalind Coward and John Ellis, *Language and Materialism*, London, 1977, and Rosalind Coward, 'The Making of the Feminine', *Spare Rib*, May 1978, no. 70. Juliet Mitchell, *Psychoanalysis and Feminism*, London, 1974. Cora Kaplan, 'Language and Gender', in *Papers on Patriarchy* (London, 1976), Women's Publishing Collective, Lewes, Sussex, 1976.

17 Elizabeth Cowie, Claire Johnston, Cora Kaplan, Mary Kelly, Jacqueline Rose, Marie Yates, 'Representation v Communication' 1979, reprinted in *No Turning Back* ed. Feminist Anthology Collective, London, 1981, p. 239.

18 For a fuller analysis of this see Griselda Pollock, 'Artists, Media and Mythologies: Genius Madness and Art History', *Screen*, 1980, vol. 21, no. 3.

19 Annette Kuhn, *Women's Pictures: Feminism and Cinema*, London, 1982, p. 8.

20 Judith Barry and Sandy Flitterman, op. cit., p. 44. The quote is in fact differently worded from the cited source. It is taken from the manuscript originally submitted to *Screen*. The article was edited in ways of which the authors disapproved and in this anthology we have reprinted the version which appeared in *Screen*, together with the letter of complaint from the authors and with the original text of their introduction.

21 What art means is simply the totality of institutions, practices and representations in respect of which the word is actually used: art museums, art schools, art magazines . . . painting, photography, sculpture, art history, art theory, art criticism . . . right across to the representations of the artist in popular media: Kirk Douglas's Van Gogh, Charlton Hestons's Michelangelo; television documentaries about artists and so on. In this perspective we may see that 'art' is extensively a matter of institutional definition and the 'artist' is a culturally constructed stereotype.
Victor Burgin, statement in *Three Perspectives on Photography*, edited Paul Hill, Angela Kelly, John Tagg, London, Arts Council 1979, p. 72.

22 See Robert Hutchinson *The Politics of the Arts Council*, London, 1983. Su Braden, *Artists and People*, London, 1978.

23 Kenneth Robinson, *Punch*, 6 September 1978. Further examples of suppression of feminist art works by labelling them as obscene can be cited: the attempt to close down the exhibition 'Womanpower' (Monica Sjoo, Liz Moore, Ann Berg, Beverley Skinner) reported in *Spare Rib*, June 1973. In May 1971 Margaret Harrison's exhibition at the Motif Editions Gallery in London was closed down after one day by the police. She had used and altered pin-up and advertising material. In 1977 The Arts Council excluded from a touring show of Artists' Books a selected work, Suzanne Santoro's *Towards a New Expression* on grounds of obscenity (see *Spare Rib* 1977, no. 54, Rozsika Parker, 'Censored'.)

24 I am grateful to David Baggaley in whose analysis of independent cinema the notion of interdependence was usefully elaborated.

25 For discussion of the term see Stuart Hall, 1977 op. cit (note 11), and

Raymond Williams, *Marxism and Literature*, London 1977.

26 Lisa Tickner, 'Introduction', *Women's Images of Men*, London Institute of Contemporary Art, 1980, and Phil Goodall, *Feminist Artistic Strategies, Production, Consumption and Distribution*, Birmingham, CCCS, 1983.

27 As we have already seen (Introduction I), in 1980 the ICA housed three consecutive shows by women artists: '*Women's Images of Men*', '*About Time*', '*ISSUE, Social Strategies by Women Artists*'. The next major feminist event did not take place until 'Sense and Sensibility in Feminist Art Practice' opened at the Midland Group in 1982. Although there was an exhibition 'Light Reading' at the B2 Gallery in London in February 1983 showing work by Karen Knoor, Eve Lomax, Mitra Tabrizian, Susan Trangmar and Marie Yates), this was not reviewed by any major critic. Neither 'Beyond the Purloined Image' (1983) nor 'Difference: On Representation and Sexuality' (1985) received serious coverage in the press or the art journals. See Griselda Pollock's 'What's the Difference: Feminism, Representation and Sexuality', *Aspects*, no. 32 1986. There have been shows of women's collectives in Nottingham 1982 and Sheffield 1982 and in Leeds 'Anonymous Notes Towards a Show in Self-Image' St Paul's Gallery in February 1981 – whose only publicity has occurred in *Spare Rib* or Regional Art News Journals.

28 Lucy Lippard, 'Sweeping Exchanges: The Contribution of Feminism to the Art of the Seventies', *Art Journal*, 1980, vol. 41, no. 1/2, p. 362.

29 Ibid.

30 For the classic fomulation of this trajectory see Clement Greenberg's 'Towards a Newer Laocoon', *Partisan Review*, July-August 1940, vol. VII, no. 4. For an historical and textual reading see F. Orton and G. Pollock '*Avant-gardes* and Partisans Reviewed', *Art History*, 1981, vol. 3, no. 3..

31 C. Harrison and F. Orton, *A Provisional History of Art and Language*, Paris, Editions Fabre, 1982, p. 5.

32 There is a considerable literature on the relations between the Museum of Modern Art and Cold War cultural politics, beginning with M. Kozloff, 'American Painting During the Cold War', *Art Forum*, May 1973, vol. II; E. Cockroft 'Abstract Expressionism: Weapon of the Cold War', *Art Forum*, June 1974, vol. 12; J. de Hart Matthews, 'Art and Politics in Cold War America' *American Historical Review*, 1976, vol. 81, no. 4. F. Orton and Griselda Pollock have written a television programme and a radio talk for the Open University Course *Modern Art and Modernism* A 315 (1983-4) on this relation.

33 Raymond Williams, *Marxism and Literature*, Oxford 1977, p. 115.

34 See for instance Craig Owens, 'The Discourse of Others: Feminists and Post-modernism' in *The Anti-Aesthetic*, ed. Hal Foster, Port Townend Washington, 1983.

35 Frederic Jameson, 'Post Modernism or the Cultural Logic of late Capitalism', *New Left Review*, July/August 1984, no. 146.

36 Charles Harrison and Fred Orton, Introduction to *Modernism, Criticism, Realism*, New York, 1984.

37 Anne-Marie Sauzeau-Boetti, 'Negative Capability as Practice in Women's Art', *Studio International*, 1976, vol. 191, no. 979, p. 25.

38 Nicole Dubreuil-Blondin, 'Feminism and Modernism: Some Paradoxes', in *Modernism and Modernity: The Vancouver Conference Papers*, ed. Benjamin Buchloh *et al.*, Nova Scotia College of Art and Design Press, Halifax 1984, p. 197.

39 Brecht was used as a basis for the development of radical film culture and radical film studies. See 'Brecht Event' of the Edinburgh Film Festival in 1975, and two editions of *Screen* magazine devoted to Brechtian issues: 'Brecht and a Revolutionary Cinema', *Screen*, 1974, vol. 15, no. 2, and *Screen* 1975, vol. 16, no. 4, 'Transcript of the Brecht Event Papers'.

40 I am grateful of conversations with Heather Dawkins for drawing attention to the work of such artists as Daniel Buren and Marcel Broodthaers who in different ways questioned the definition of the museum and how a designated space defines its contents as art or not art.

41 These two postures are symptomatically represented in the two canonical views of Abstract Expressionist practice, Harold Rosenberg's 'American Action Painters', *Art News*, 1951 and Clement Greenberg's 'American-Type Painting', *Partisan Review* 1955. The term literalist abstraction refers to work in painting and sculpture (which often crossed these boundaries) which stemmed from one of the possible interpretations of the work of Jackson Pollock, wherein Pollock was claimed as the best abstract artist because his paintings derived this purpose from insisting upon the objectness of a painting and from the directness of the artist's relations to the materials. Classic examples would be Tony Smith's 'Cube'.

42 Mary Kelly, 'Re-Viewing Modernist Criticism', *Screen*, 1981, vol. 22, no. 3, p. 45.

43 Ibid., p. 57.

44 Clement Greenberg, 'Modernist Painting', in G. Battcock, *The New Art*, 1973, p. 68.

45 Opticality was explored in Clement Greenberg, 'Louis and Noland', *Art International*, 25 May, 1960 (with passing reference to Helen Frankenthaler).

46 Philip Leider, 'Literalism and Abstraction: Frank Stella's Retrospective at the Modern', *Art Forum*, 1970, April, p. 50.

47 Mary Kelly, op. cit., p. 57.

48 Mary Kelly discusses this complex issue in her article, pp. 51-6. An essentialist feminist practice exemplifying this use of sexuality as a truth of and for woman is that associated with Judy Chicago's projects, notably 'The Dinner Party' 1979; see also Suzanne Santoro 'Towards a New Expression', and a critical reading of such work in Judith Barry and Sandy Flitterman, op. cit..

49 Notably as a result of the impact of Michel Foucault's *History of Sexuality*, vol. I, (1976) translated Robert Hurley, London, 1979. See also Lucy Bland, 'The Domain of the Sexual: A Response', *Screen Education*, 1981, no. 39.

50 Statement printed in *Sense and Sensibility in Feminist Art Practice*, Nottingham, Midland Group, 1982, n.p.

51 Marie Yates, 'Notes to Accompany *Image/Woman/Text*' 1980 at the exhibition '*ISSUE: Social Strategies by Women Artists*', ICA, 1980. See further statement of this position in *Sense and Sensibility* catalogue.

52 Susan Hiller, 'Dedicated to the Unknown Artists', in Susan Hiller *Recent Works*, Oxford, Museum of Modern Art, 1978, p. 17.

53 David Elliott, ibid., Introduction, p. 6.

Keeping the records:
an historical anthology

Section I
Images and signs
Introduction

We learn ourselves through women made by men.
(Sheila Rowbotham, *Woman's Consciousness, Man's World,* 1973)

From the outset feminists recognised that images – in films, advertisements, women's magazines, paintings, the Venus de Milo or Wonderwoman – were a target of criticism. Yet it was also necessary to admit that we were profoundly shaped as women by these images through which we came to imagine what we were or might be. Initial opposition to what was perceived as the falsity of dominant 'images of women' and the attempt to produce positive images had a liberating but limited effectivity. The development of theories about the way meaning is produced, semiology in particular, and the expanded Marxist concepts of ideology, led feminists to a more complex appraisal of what came to be called 'representations'. No longer could images be treated as discrete reflections – good, bad, false, truthful – of real women. The use of the term 'representation', and later 'signification', marked the importance of the processes by which meanings are produced. The social manufacture of meaning occurs through both technical devices and codes and conventions, what came to be known as 'the rhetoric of the image'.[1] It was also argued that meanings depend on the relationships between a single image and its total cultural environment of images and social belief systems, between what is included in one particular image and all that is omitted. For any viewer to understand any image she must carry a whole baggage of social knowledges, assumptions, values. For instance, if we are familiar with the codes of drawing or of photography we may decipher certain red and green rounded shapes as apples. But the possible connotations of apple, as fruit, as emblem of Eve, as symbol of seduction, as epitome of Nature's bounty and so forth, depend upon internal clues as well as on the connotations of apples within a particular culture, class, race, gender group. What secures which connotations prevail as a preferred meaning is ideology, understood as a complex of meanings and practices which form the dominant order of sense,

a regime of truth for a particular culture or social group. Therefore notions of images whose meanings derive from the conscious intentions of their maker gave way to an understanding of the social and ideological networks within which meanings are socially produced and secured.

Meanings are therefore actually made in a social activity which involves the viewer. Representations are addressed to someone and are organised to win that someone's complicity with their preferred readings so that the image is experienced as a reflection of the natural order of things. Feminist theoretical analysis of ads, films, photographs, paintings, ceramics, sculptures, textiles have been important in producing strategies for feminist practice and vice versa. In many cases it has become clear that all 'images', whatever the intentions of the maker, enter into a public domain and are read in relation to other images forming part of dominant discourses and ideologies. What may seem like a critique of pornographic images can in a public space simply be assimilated to those images it is apparently seeking to undermine. Feminist 'difference' has to be calculated in the knowledge of the normalised connotational systems and patterns of spectatorship and address.[2] The articles included here are a selection of attempts made by feminist theorists and practitioners to provide the groundwork for that knowledge by analysis of some instances of how representation works.

Notes

1 Roland Barthes, 'The Rhetoric of the Image', in *Image, Music, Text*, ed. Stephen Heath, London, 1978.
2 The major essay on this is still Laura Mulvey, 'Visual Pleasure and Narrative Cinema', *Screen*, 1975, vol. 16, no. 3, pp.6–18.

Laura Mulvey

'You don't know what is happening, do you, Mr Jones?'

> *Allen Jones has a high artistic reputation for his paintings and sculptures of women (and he makes a pretty good living out of them). They are erotic, startling, fantastic and inspired the cafe female figures in the filmed version of 'The Clockwork Orange'. Laura Mulvey suggests his work is not about women at all, but illustrates Allen Jones' male fears. Now read on.*

'To decapitate = to castrate. The terror of the Medusa is thus a terror of castration that is linked to the sight of something. The hair upon the Medusa's head is frequently represented in works of art in the form of snakes, and these once again are derived from the castration complex. It is a remarkable fact that, however frightening they may be in themselves, they nevertheless serve actually as a mitigation of the horror, for they replace the penis, the absence of which is the cause of the horror. This is a confirmation of the technical rule according to which a multiplication of penis symbols signifies castration.' Freud, 'The Medusa's Head'.

In 1970 Tooth's Gallery in London held a one-man show of sculptures by Allen Jones which gained him the notoriety he now enjoys throughout the women's movement. The sculptures formed a series, called 'Women As Furniture', in which life-size effigies of women, slave-like and sexually provocative, double as hat-stands, tables and chairs. The original of *Chair* is now in the Dusseldorf home of a West German tycoon, whose complacent form was recently photographed for a Sunday Times article, sitting comfortably on the upturned and upholstered female figure. Not surprisingly, members of Women's Liberation noticed the exhibition and denounced it as supremely exploitative of women's already exploited image. Women used, women subjugated, women on display: Allen Jones did not miss a trick.

Since 1970 Allen Jones's work has developed and proliferated in the same vein. His paintings and sculptures are exclusively images of women. He has won increasing international acclaim, with exhibitions in Italy, Germany, Belgium and the United States, as well as Britain. He is one of the shining properties in the stable of Marlborough Fine Art, the heaviest and most prestige conscious of the international art traders. He has expanded his interests beyond painting and sculpture proper into stage design, coffee-table books, luxury editions, film and television. The Allen Jones artistic octopus extends its tentacles into every nook and cranny where the image of woman can be inserted and spotlighted.

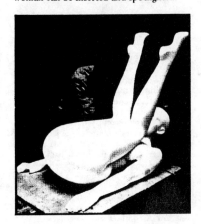

Familiar Woman

At first glance Allen Jones seems simply to reproduce the familiar formulas which have been so successfully systematized by the mass media.

His women exist in a state of suspended animation, without depth or context, withdrawn from any meaning other than the message imprinted by their clothes, stance and gesture. The interaction between his images and those of the mass media is made quite explicit by the collection of source material which he has published. *Figures* is a scrapbook of cuttings, out of magazines, both respectable (*Nova, Harpers Bazaar, Life, Vogue, Sunday Times* supplement, etc) and non-respectable (*Exotique, Female Mimics, Bound, Bizarre*, etc). There are also postcards, publicity material, packaging designs and film stills (*Gentlemen Prefer Blondes, Barbarella, What's New Pussycat?*). *Projects*, his second book, records sketches and concepts for stage, film and TV shows, including *Oh Calcutta!* and Kubrick's *Clockwork Orange* (some unfinished) and includes more source material as an indication of the way his idea developed. By publishing these clippings Allen Jones give vital clues, not only to the way he sees women, but to the place they occupy in the male unconscious in general. He has chosen images which clearly form a definite pattern, which have their own visual vocabulary and grammar. The

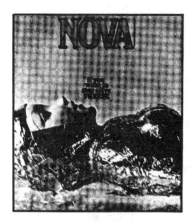

clearly in his books and art objects. First: woman plus phallic substitute. Second: woman minus phallus punished and humiliated, often by woman plus phallus. Third: woman *as* phallus. Women are displayed for men as figures in an amazing masquerade, which expresses a strange male underworld of fear and desire.

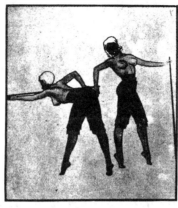

The nearer the female figure is to nakedness, the more flamboyant the distraction. The only example of frontal nudity in his work, a sketch for *Ob Calcutta!*, is a history of knickers, well-worn fetishist items, in which the moment of nakedness is further retrieved by the fact that the girls are carrying billiard cues and an enormous phallus is incorporated into the scenery. In the source material, a girl from *Playboy* caresses a dog's head on her lap; another, on the cover of a movie magazine, clutches an enormous boa constrictor as it completely and discreetly entwines her. Otherwise there is an array of well-known phallic extensions to divert the eye: guns, cigarettes, erect nipples, a tail, whips, strategically placed brooches (Marilyn Monroe and Jane Russell in *Gentlemen Prefer Blondes*), a parasol, etc, and some, more subtle, which depend on the visual effect of shadows or silhouettes.

popular visuals he reproduces, go beyond an obvious play on the exhibitionism of women and the voyeurism of men. Their imagery is that of a fetishism. Although every single image is a female form, not one shows the straight female genitals. Not one is naked. The cunt (yoni) is always concealed, disguised or supplemented in ways which distract attention from it. *The achievement of Allen Jones is to throw an unusually vivid spotlight on the contradiction between woman's fantasy presence and real absence from the male unconscious world.* The language which he speaks is the language of fetishism, which speaks to all of us every day, but whose exact grammar and syntax we are usually only dimly aware of. Fetishistic obsession reveals the meaning behind popular images of women.

It is Allen Jones's mastery of the language of 'basic fetishist' that makes his work so rich, and compelling. His use of popular media is important not because he echoes them stylistically (pop art) but because he gets to the heart of the way in which the female image has been requisitioned, to be re-created in the image of man. The fetishist image of women has three aspects, all of which come across

Belts and necklaces, with buckles and pendants, are both phallic symbols and suggest bondage and punishment.

The theme of *woman bound* is one of the most consistent in Allen Jones's source material: at its most vestigial, the limbs of pin-up girls are bound with shiny tape, a fashion model is loaded with chains, underwear advertisements, especially for corsets, proliferate, as do rubber garments from fetishistic magazines. Waists are constricted by tight belts, necks by tight bands, feet by the ubiquitous high-heeled shoe. For the TV show illustrated in *Projects* Allen Jones exploits a kind of evolved garter of black shiny material round the girls' thighs, which doubles openly, in one case, as a fetter. The most effective fetish both constricts and uplifts, binds and raises, particularly high-heeled shoes, corsets or bras, and, as a trimming, high neck bands holding the head erect.

Woman plus phallic substitute

Women without a phallus have to undergo punishment by fetish objects ranging from tight shoes and corsetry, through rubber goods to leather and torture. Here we can see the *sadistic* aspect of male fetishism, but it still remains fixated on objects with phallic significance. An ambiguous tension is introduced within the symbolism. For instance, a whip can be simultaneously a substitute phallus and an instrument of punishment. Similarly, the high heel on high-heeled shoes, a classical fetishist image, is both a phallic extension and a means of discomfort and constriction.

In *Projects* the theme of punishment can be seen in the abandoned plan for the milkbar in the film of *Clockwork Orange* (infinitely more subtle in detail than the kitsch design Kubrick finally used for the movie). The waitress is dressed from neck to fingertip to toe in a rubber garment

with an apron, leaving only her buttocks bare, ready for discipline, while she balances a tray to imply service. The same theme can be traced in his women as furniture sculptures and, in *Figures*, the background to these is made clear. Gesture, bodily position and clothing are all of equal importance. *Hat Stand* is based on the crucial publicity still from *Barbarella*, which unites boots, binding, leather and phallic cache-sexe, in the image of a girl captive who hangs ready for torture, her hands turned up in a gesture which finally become the hat peg. A similar design for a hors d'oeuvre stand derives from a Vargas drawing of a waitress who sums up the spirit of service and de-personalization.

Another aspect to the theme of punishment is that the subject phallus-less woman should suffer spanking and humiliation at the hands of the man-woman, the great male hope. Characterized in Eneg's drawings for *Bound* (reproduced in *Figures*) by tight belt, tight trousers, mask and constricted neck (while a female woman carries a soon-abandoned handbag), the

man-woman emerges with full force of vengeance in *Projects* as Miss Beezley in *Homage to St. Dominic's* ('to be played by a 7 foot woman — or a man would do. With 6 inch platform heels "she" would be 18 inches taller than the school "girls" ').

And again in *The Playroom* (another abandoned stage project) where the transvestite owner, 'an elderly "woman" ' chases the children. A whole series of paintings show sexually ambiguous images in which a man walks into female clothing to become a woman or male and female legs are locked as one.

Woman as phallus

Finally, in *Männer Wir Kommen*, a show for West German Television, which is illustrated in *Projects* by stills, notes and sketches, Allen Jones adds yet another dimension to his use of fetishistic vocabulary. The close-ups and superimpositions possible on television give him the chance to exploit ambiguities of changed scale and proportion. The spectator is stripped of normal perceptual defences (perspective, normal size relationships) and exposed to illusion and fantasy on the screen. As sections of the female body are isolated from the whole and shown in close-up, or as the whole body shrinks in size and is superimposed on a blown-up section, Allen Jones develops even further the symbolic references of woman to man and subjects her form to further masculinization.

His previous work preserved the normal scale of the female body physically, although it distorted it symbolically. *Männer Wir Kommen* contains some imagery of this kind: *Homage to Harley* uses the motorcycle and the nozzle in their classic roles as phallic extensions, with the women in natural proportion to them. (Women clad in black bands around their thighs, boots and bound necks). But by far the most striking image is that of

the entire figure of one girl, shrunk in scale though symbolically erect, superimposed as a phallic substitute on the tight black shiny shorts of another. A series of freeze-frames from the show, female manikins strategically poised, makes Allen Jones's point blindingly clear.

More close-ups in the television sketch carry the female body further into phallic suggestion. Girls supporting a boxing-ring like human pillars have bared breasts divided by a shiny pink material fastened to their necks. A single frame, from breast to neck only, gives the breasts a look to testicles with the pink material functioning as a penis. Female bodies and fragments of bodies are re-deployed to produce fantasy male anatomies. A similar emphasis on breasts divided by a vertical motif can be seen in the source material: the torture harness in the *Barbarella* still, Verushka's single-strap bikini in a fashion photograph. There is a strong overlap between the imagery of bondage and the imagery of woman as phallus built into fetishism. The body is unified to a maximum extent into a single, rigid whole, with an emphasis on texture, stiffness caused by tight clothing and binding, and a general restriction of free movement.

In *Figures* there is a consistent theme of women as automata, with jerking, involuntary, semaphore movements, suggestive of erection of the phallus. These automata often have rhythmic movements (Ursula Andress dancing in a series of stills, like an animated doll, the Rockettes, Aquamaid water-skiers in Florida), uniforms in which the conception of duty and service is combined with strictness and rigidity (for instance, a cutting from the *Daily Express* in which 'Six Model Girls Step Smartly Forward For Escort Duty') and, most important of all, the stiffness induced by wearing tight clothes which constitute a second slithery skin (rubber garments transforming the body into a solid mass from fingertip to toe, one-piece

corsets, synthetic garments ranging from perspex to nylon). An identification develops between the phallus and woman herself. She must be seen in her full phallic glory.

What is fetishism

To understand the paradoxes of fetishism, it is essential to go back to Freud. Fetishism, Freud first pointed out, involves displacing the sight of woman's imaginary castration onto a variety of reassuring but often surprising objects — shoes, corsets, rubber goods, belts, knickers, etc — which serve as signs for the lost penis but have no direct connection with it. For the fetishist, the sign itself is the subject of his fantasy — whether actual fetish objects or else pictures or descriptions of them — and in every case it is the sign of the phallus. It is man's narcissistic fear of losing his own phallus, his most precious possession, which causes shock at the sight of the female genitals and the fetishistic attempt to disguise or divert attention from them.

A world which revolves on a phallic axis constructs its fears and fantasies in its own phallic image. In the drama of the

male castration complex, as Freud discovered, women are no more than puppets; their significance lies purely in their lack of penis and their star turn is to symbolize the castration which men fear. Women may seem to be the subjects of an endless parade of pornographic fantasies, jokes, daydreams, etc, but fundamentally most male fantasy is a closed-loop dialogue with itself, as Freud conveys so well in the quotation about the Medusa's head. Far from being a woman, even a monstrous woman, the Medusa is the sign of a male castration anxiety. Freud's analysis of the male unconscious is crucial for any understanding of the myriad ways in which the female form has been used as a mould into which meanings have been poured by a male-dominated culture.

Mass media

Man and his phallus is the real subject of Allen Jones's paintings and sculptures, even though they deal exclusively with images of women on display. From his work we see how the mass media provide

material for a 'harem cult' (as Wilhelm Stekel describes the fetishist's penchant for collections and scrapbooks in his classic psycho-analytic study) in which the spectre of the castrated female, using a phallic substitute to conceal or distract attention from her wound, haunts the male unconscious. The presence of the female form by no means ensures that the message of pictures or photographs or posters is about women. We could say that the image of woman comes to be used as a sign, which does not necessarily signify the meaning 'woman' any more than does the Medusa's head: the harem cult which dominates our culture springs from the male unconscious and woman herself becomes its narcissistic projection.

Freud saw the fetish object itself as phallic replacement so that a shoe, for instance, could become the object on

which the scandalized denial of female castration was fixated. But, on a more obvious level, we could say with Freud in 'The Medusa's Head' that a *proliferation* of phallic symbols must symbolize castration. This is the meaning of the parade of phallic insignia born by Allen Jones's harem, ranging from precisely poised thighs, suggestive of flesh and erection, through to enormous robots and turrets. Castration itself is only rarely alluded to in even indirect terms. In one clipping an oriental girl brandishes a large pair of scissors, about to cut the hair of a man holding a large cigar. In another, a chocolate biscuit is described in three consecutive pictures: *c'est comme un doigt* (erect female finger), *avec du chocolat autour* (ditto plus chocolate), *ça disparaît très vite* (empty frame), then larger frame and triumphal return, *c'est un biscuit: Finger de Cadbury* (erect biscuit held by fingers).

Male fears

There is one exception to this: the increasingly insistent theme of women balancing. Female figures hang suspended, at their peak, on the point of coming

down (the phallic reference is obvious). Anything balanced upright — a woman walking a tightrope or balancing a tray or poised on the balls of her toes — implies precariously a possible catastrophe that may befall. The sculptures of women as furniture, especially the hat stand, imply erectness and suspension at the same time, hung motion and hanging in space. In addition, the physical structure of some of his earlier paintings — three-dimensional flights of steps leading steeply up to two-dimensional paintings of women's legs poised on high heels — in itself implies ascending to a point, erect posture and suspension and balance, fused into one image by the illusionistic effect.

In his most recent paintings, exhibited this summer at the Marlborough Galleries, Allen Jones develops the theme of balance much further. A number of the paintings are of women circus performers, objects of display and of balance. Here the equation 'woman = phallus' is taken a step further, almost as if to illustrate Freud's dictum that 'the remarkable phenomenon of erection which constantly occupies the human phantasy, cannot fail to be impressive as an apparent suspension of the laws of gravity (of the winged phalli of the ancients)'. In *Bare Me*, for instance, the phallic woman, rigid and pointing upwards, holding her breasts erect with her hands, is standing in high-heels on a tray-like board balanced on two spheres. She is on the way up, not down. Loss of balance is possible, but is not immediate.

But in other paintings in the same show this confidence is undercut. The defiance of gravity is more flamboyant than

convincing. The same devices — high heels, walking on spheres — which compel an upright, erect posture can also point to its precariousness. In the painting *Whip*, derived from a brilliant Eneg drawing of two women, castrator and castrated, a woman lassoed by a whipcord is slipping off a three-legged stool: in the painting we can see only the toppling stool, but there can be no doubt from comparison with the Eneg source, that her real absence — symbolic castration — is intended. In another painting, *Slip*, both figures from the same Eneg drawing are combined into one and loss of balance becomes the explicit theme. Dancers on points, waitresses carrying trays, women acrobats teetering on high heels or walking the tightrope — all are forced to be erect and to thrust vertically upwards. But this phallic deportment carries the threat of its own undoing: the further you strive up, the further you may fall.

The real scare

In *Männer Wir Kommen* the reverse side of the phallic woman, the true horror of the fetishist can be seen in one startling sequence. The female body, although still bound in a tight corset and with a snake necklace wound round her neck, has a flamboyant, scarlet scar over her genitals. The surrounding mise-en-scene consists of enormous eggs, containing bound women rising from a foetus-like position while, in another sequence, maggot-like women's limbs emerge from equally enormous

apples. The scar breeds the putrescence of pregnancy and nothing but decay can come out of the apple. The apple and the egg are the only non-fetishistic images of women to appear in Allen Jones's work. Infested by manikin maggots, they are the eternal companion of the scar.

Woman not there

Most people think of fetishism as the private taste of an odd minority, nutured in secret. By revealing the way in which fetishistic images pervade, not just specialized publications, but the *whole of the mass media*, Allen Jones throws a new light on woman as spectacle. The message of fetishism concerns not woman, but the narcissistic wound she represents for man.

Women are constantly confronted with their own image in one form or another, but what they see bears little relation or relevance to their own unconscious fantasies, their own hidden fears and desires. They are being turned all the time into objects of display, to be looked at

and gazed at and stared at by men. Yet, in a real sense, women are not there at all. The parade has nothing to do with woman, everything to do with man. The true exhibit is always the phallus. Women are simply the scenery on to which men project their narcissistic fantasies. The time has come for us to take over the show and exhibit our own fears and desires.

Laura Mulvey organised the Women's Film Festival in Edinburgh last year. ♣

Source: *Spare Rib*, 1973, no. 8, pp. 13-16, 30.

Griselda Pollock
'What's wrong with "Images of Women"?'

I want to address myself within this article to what I consider to be an unbridged gap within the women's movement between an awareness of the role of ideology in visual representations of women in our oppression and the level of critical and theoretical analysis developed by a small number of largely professionally involved women. The political interest in images is evidenced by the frequency with which courses are set up under the misleading title 'Images of Women' in a variety of educational establishments and at women's studies conferences. The theoretical analysis is more specialised and therefore only appears in small distribution journals of small study groups. I have found myself working within both camps and I would like here to both examine the practical problems of bridging this gap without failing to incorporate the important theoretical issues and also to explore some of those issues without losing sight of their practical exercise in teaching. Many of the points I shall raise below were originally developed by the collective work of a group of women over a long

period, collecting images and experimenting in different teaching situations. Limitations of space do not allow for a full elaboration of issues which are both complex and part of a much wider study of women and representations. For instance I cannot acknowledge properly within this article the full implications of the differences of media and qualities of photographs to be used as illustrations to the argument. Instead I shall try to outline the main points of our analysis and show certain images which we have found useful in teaching in this area.

In 1972 a group of women involved in art and media practice, art history and feminist criticism formed the Women's Art History Collecive in order to attempt some analysis of women's position in, and in relation to, the history of art and representations. Our starting point was firstly an identification with the direct relevance of the issue to ourselves and our work as part of a political movement of women and secondly a response to the still limited literature on the subject, for instance John Berger's *Ways of Seeing* (Penguin,

Fig 1

Fig 2

1972) and American publications which included the work of feminist academics like Baker and Hess *Art and Sexual Politics* (Collier, 1971) and Hess and Nochlin *Women as Sex Object* (Allen Lane, 1973) as well as documentary material in art magazines, notably *The Feminist Art Journal*. The literature highlighted many important problems but was not on the whole theoretically very rigorous or helpful. A third influence was the attempt made by certain feminist artists to provide what they termed an alternative and positive imagery of women which, though important in terms of the political solidarity it encouraged, in fact foregrounded the impossibility of challenging existing imagery without an adequate theory of ideology and representation.

Of all the areas to which the Women's Art History Collective addressed itself, that of 'Images of Women' has consistently proved itself the most difficult and resistant to satisfactory theory or practice. The problem can I think, be analysed on four major fronts: the confusion and mystification of the issue created by the title 'Images of Women'; the problematic and as yet undefined relation between so called High Culture and the Media or Popular Culture; the lack of theoretical definitions of what terms like sexist, patriarchal or bourgeois mean when applied to images; and finally what practice can be suggested in order to rupture dominant ideology and undertake a radical critique and transformation of visual imagery.

The first difficulty arises out of labelling the area of study as 'Images of Women'. The term implies a juxtaposition of two separable elements – women as a gender or social group versus representations of women, or a real entity, women, opposed to falsified, distorted or male views of women. It is a common misconception to see images as merely a reflection, good or bad, and compare 'bad' images of women (glossy magazine photographs, fashion advertisements etc.) to 'good' images of women ('realist' photographs, of women working, housewives, older women etc.). This conception represented by the title 'Images of Women' needs to be challenged and replaced by the notion of woman as a signifier in an ideological discourse in which one can identify the meanings that are attached to woman in different images and how the meanings are constructed in relation to other signifiers in that discourse. Thus rather than compare different kinds of images of women one needs to study the meanings signified by woman in images with reference, for instance, to man in images. A useful device for initiating this kind of work is the use of male/female reversals.

In 1973 *Women's Report* (v 1 n 6) published a reversal of the then current Bayer advertisement on the Seven Ages of Man (figs 1 and 2) posing a young man in exactly the same position as the ad had placed an adolescent girl and changing the gender of the pronouns in the accompanying copy which then read:

> 'Adolescence – a time of misgiving. Doubts about the site offered by parents to build a life on. Both head and heart subject to the tyranny of hormones. Youth under stress in search of an identity.
>
> B . . . is there to help *him* through this period of self-seeking. With textile fibres and dyestuffs for the fashionable clothes *he* needs to wear. . . . With raw ingredients for the cosmetics *he* uses to *create his own personality*. And simple remedies too. Like Aspirin . . . for the pain *he* will experience.' (my italics)

Fig 3

Fig 4

The advertisement was one of a series of seven, but it was both the only female image and the only nude. The reversal serves initially to make strange the original image in which femaleness and nudity are completely elided. The contrast between the actual photographs themselves also opens up space between the model and the nudity in so far as the original is soft-focussed, with smudged edges thus binding the image into the material of the photograph while the reversal is shot in sharper focus and the hard edged lighting emphasises the nakedness of the male model. The notion of woman as body which is thus made explicit is supported in the advertisement by the accompanying copy. By changing the original 'she' to 'he' the meanings become less automatic, denaturalised and a space is created between the signifier and the signified exposing the notion of the female as both subject to bodily processes and also the field of action for various products which will act on the body to complete the flowering of this bud-like creature.

The density of meanings signified by the female nude can be further shown by a comparison of two other advertisements taken at random from the thousands that assault us daily (figs 3 and 4). What is remarkable in this juxtaposition is the relative complexity of the advertisement for Lee Jeans and the startling economy of Levi's. To make this meaning clear, the Lee advertisement has to resort to a location on the wild pampas and the additional attributes in order to specify that which the Lee jeans will make of a man. Grotesque as this image is, it shows the necessary lengths to which one has to go to make a clear image of the desirability of purchasing the jeans when using a male model. The Levi's advertisement is of a completely different order – it simply offers its product for sale, but that it can do so merely by attaching the label to a nude portion of the female body depends on the identification of the female body and sale. A common critique of such an image simply condemns the exploitation of the female body in selling commodities. However the use of the female nude is not arbitrary or exploitative, for a study of the transformation of the female nude in the history of representations does show how the body has come to signify 'sale'. It is not possible to adduce here all the illustrative material necessary to elaborate that point but at the risk of sounding too speculative I would contend that that which recuperates a bottle of sherry or a car in advertisements from being read as still life with its traditional associations and indicates their status as purchaseable commodities, is the presence of

woman by virtue of that which the woman introduces into an image.[1]

In suggesting this I am laying stress on the active relationship between the visual vocabulary, or what art historians prefer to call the iconographic traditions of High Art and the Media which is the second point raised above. John Berger has already made some observations on the way in which contemporary advertisements 'borrow' their images from Old Master paintings by showing examples of advertisements that quote directly from an oil painting. The implications of this practice go beyond quotation as Berger states,

'The continuity, however, between oil painting and publicity goes far deeper than the "quoting" of specific paintings. Publicity relies to a very large extent on the language of oil painting. It speaks in the same voice about the same things. Sometimes the visual correspondences are so close that it is possible to play a game of "Snap". . . . It is not however on the level of exact pictorial correspondence that the continuity is important: it is at the level of the sets of signs used.' (*Ways of Seeing* pp 135–8)

The main thrust of Berger's argument is to show up the ideological meanings usually disclaimed for pure High Art. However his final statement can be taken further and his argument, in a sense, reversed. Returning once again to reversals, one can cite an example from the misconceived attempts by certain magazines to offer to women erotic images of men, for instance the photograph of a nude man running through the woods which appeared in the magazine *Viva* (fig 5).

The photograph bears comparison with the advertisement for Lee Jeans (fig 3) in so far as the male figure does not stand alone or in a slight setting but is similarly placed in an elaborate woody glade and is posed in conjunction with an animal, in this case the horse's head, whose position and shape is not only suggestively phallic but recalls the longstanding association of a horse and virility in early iconographic traditions. In attempting to construct an erotic image of man this picture foregrounds the difficulties of reversing erotic imagery and furthermore reveals a significant reliance on the images in European art, for this photograph is a fine paraphrase of the Hellenistic statue, the *Apollo Belevedere*.

One can read this image a number of ways in which it cannot be an equivalent of photographs of women in magazines for men. The figure is active, self contained, does not engage with the gaze of the spectator whose hypothetical position can only be as

Fig 5

Fig 6

some wood nymph catching a fleeting glimpse of this sylvan god through the blurred bushes of the foreground. What is absolutely lacking is any conceivable position of ownership or possession offered to the spectator. But in addition, the image inscribes into itself the contradiction inherent in the use of the Apollonian prototype which occurs in the severe disjunction between head and body and the bizarre relation of the almost phallic horse's head with the man's genitals virtually barred off by the reins. That which can be signified by the male figure is therefore curtailed by the historical specificity of the sign 'man' within patriarchal ideology whose synchronicity on the level of pre-presentations is ensured by the expansion of the art publishing industry and the production of so called popular art books as well as television serials like the now famous *Civilisation*.

But a further and more dangerous aspect of this process appeared recently again in the pages of a sex magazine. The appropriation of woman as body in all forms of representation has spawned within the women's movement a consistent attempt to decolonise the female body, a tendency which walks a tightrope between subversion and reappropriation, and often serves rather to consolidate the potency of the signification rather than actually to rupture it. Much of this attempt has focussed on a kind of body imagery and an affirmative exposure of female sexuality through a celebratory imagery of the female genitals.

The threatening implications of this undertaking is witnessed by a recent episode when the work of Suzanne Santoro (fig 6) who produced a small booklet of vaginal imagery was in fact censored by the Arts Council who, after some complaints, removed it from a travelling exhibition of Art Books on the grounds of

indecency and obscenity. However that the radical potential of this kind of feminist imagery can easily be reappropriated can be seen if one looks beyond the petit bourgeois ideology of the art establishment to the major conveyors of bourgeois patriarchal imagery in the big selling sex magazines where a profoundly disturbing development has taken place.

Fig 7

In the pages of a recent *Penthouse* (v 12 n 3, fig 7) vaginal imagery appears in all its force and decorative glamour, liberated from the traditional coyness of such magazines' sexual invitations by a directness that radically questions the psychoanalytically based analyses of images of women undertaken by Claire Johnston and Laura Mulvey and the notions of castration fears and the phallic woman. In some senses there is a similarity to the images of men illustrated above with the lack of engagement between model and spectator and the sense of self sufficiency which in the pages of *Penthouse* are underlined by the fact that these women are frequently engaged in private masturbation. The relation between spectator-buyer of these images and the picture of woman created in these photographs, is that of forceful intrusion or indeed possessive voyeurism inviting rape. While I can only remark at the present on the insufficiency of present theory in the analysis of this development, I want here to hypothesise on the direct relations between levels of representations from the High Art undertakings of feminists to the mass market sex magazines. I would argue the absolute insufficiency of the notion current in the women's movement which suggests that women artists can create an alternative imagery outside existing ideological forms for not only

is vaginal imagery recuperable but in that process the more sinister implications of sexual difference in ideological representations are exposed. However it must be acknowledged that certain feminist critics have been aware of these dangers, as for instance Lucy Lippard who comments in her essay on Body Art in her recently published book *From the Centre* (New York 1976):

'It is a subtle abyss that separates men's use of women for sexual titillation from women's use of women to expose that insult.'

Even so, such a comment reveals a certain lack of focus on that which determines this process (this not-so-subtle abyss) and serves to illustrate my third introductory point concerning the lack of clear definitions of the precise ideological system within which the signification of woman is recreated and maintained. Notions of patriarchal ideology engendered by a recourse to psychoanalysis are on their own inadequate and insufficiently historical and the issue must be located in terms of capitalism and bourgeois ideology for, as I have briefly indicated above, one of the dominant significations of woman is that of sale and commodity. The transformation apparent in the pages of *Penthouse* is the replacement

Fig 8

Fig 9

of willing transaction by what amounts to theft.

By way of conclusion and summary I would like to offer one final set of reversals which have proved useful in the exposition of such points by the Women's Art History Collective. In her essay on 'Eroticism and Female Imagery in Nineteenth Century Art' in *Woman as Sex Object* (pp 9–15) Linda Nochlin published a nineteenth century soft porn print entitled *Achtez des Pommes* (fig 8) and juxtaposed it with a photograph of a man she had posed carrying instead a tray of bananas (fig 9).

The usual reaction to this comparison is laughter, an embarrassed reaction to the recognition of that which we take for granted in the 19th century print. This does, of course, invite some comment on its 'sexist' nature but it is nonetheless so naturalised that it is hard to isolate the precise ideological implications of such an image. On an obvious level, as Nochlin points out, while there exists a long tradition of association between female breasts and genitals with fruit which renders the sight of breasts nestling amongst a tray of apples and the implied saleability of both unsurprising, no such precedents exist for a similar juxtaposition of a penis and its fruity analogue, the banana. However what is more significant in this comparison is precisely the failure of the reversal.[2] It

is clear that a bearded man with a silly expression, woolly socks and moccassins does not suggest the same things as the sickly smile of the booted and black stockinged woman not simply because there is no comparable tradition of erotic imagery addressed to women but rather because of the particular signification of woman as body and as sexual. There is a basic asymmetry, inscribed into the language of visual representation which such reversals serve to expose. The impossibility of effective reversal also exposes the mystification brought about by the attempt to isolate 'Images of Women' outside the total discourse whereby the meanings carried by male and female are predicated on difference and asymmetry.

Nochlin also adduces a painting contemporary with the print culled from the realms of High Art namely Gauguin's *Tahitian Women with Mango Blossoms* of 1899 (New York Metropolitan Museum of Art – fig. 10) in which a similar configuration of breasts and fruiting flowers is created within the idyllic setting of non-industrialised, pre-capitalist Oceania where all is natural and free.

The comparison not only indicates the inter-connections in terms of ideology of High Art and popular prints but demands a re-integration in cultural studies which does not falsely privilege mass forms

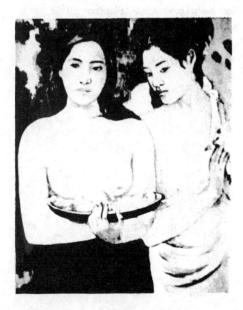

Fig 10

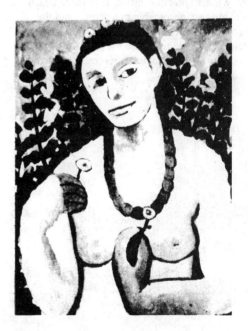

Fig 11

over what is often their source material in the more elite manifestations of dominant ideology in High Culture and finally necessitates the rescue of the discourse of art history from its recent practices that are untouched by a radical critique or theoretical analysis.

A final example related to these works can be used to address the fourth point made above which concerns the nature of the practice through which the ideological nature of the representations can be exposed and the ideology ruptured. Paula Modersohn Becker's *Self Portrait* (fig 11) painted under the influence of Gauguin's Tahitian paintings at the turn of the century and the combination of such a source with the attempt at self-portraiture foregrounds the contradictions under which women attempt to represent themselves. The tension lies between the naturalness of the image of woman as nude and the unnaturalness of the portrait of the artist as a young woman. Two separate traditions collide resulting in an image which neither works as a nude, for there is too much self possession, nor as a statement of an artist since the associations are those of nature not culture. The painting must be considered as a failure not simply because an alternative iconographic tradition did not yet exist (for that presumes the possibility of simply creating one) but rather, I would maintain, because of the inseparability of the signifier and the signified. It is that false separation which the notion 'Images of Women' precisely attempts to make which renders the term so inescapably mystifying, and the study engendered by it, so difficult, and which cannot be maintained if we are to expose the roles of the signifier woman within ideological representations.

Nor can a separation be maintained between various manifestations of these signifying practices for, in order to make any intervention in theory or practice, we require a soundly based historical analysis of the workings of ideology and codes of representation in their historical specificity and through the interrelated systems by which ideology is maintained and reproduced. It is precisely here that the gap I mentioned in the opening sentences of this article opens up between the direct relevance of this undertaking to women as we live out that ideology, seek to challenge it and the kind of analysis necessary to expose and rupture it. This article has only outlined some of the processes and examples which can be helpful in introducing this subject to students.

Although this piece has been written entirely by me, the ideas and work contained within it are the result of the collective work of the Women's Art History Collective.

1 This notion has to be carefully argued from the precise historical developments of bourgeois art and most importantly by a careful study of the transformations of the representations themselves. Verbal or purely theoretical argument without numerous illustrations would be disturbing. However since the point is important I make it here and can only suggest that anyone interested awaits the publication of a book co-authored by myself and Roszika Parker *Old Mistresses – Women, Art and Ideology*, 1978.

2 Nochlin does not acknowledge its failure nor did she attempt to produce comparable images in terms of the photographic methods used.

Source: *Screen Education*, 1977, no. 24, pp. 25–33.

I.3

Rosetta Brooks
'Woman visible: women invisible'

It is interesting to note the conspicuous presence of woman as the subject-matter of art historically and her conspicuous absence as producer. Equally one is aware of the dominance of the female image within the spectacle of bourgeois culture and the absence of her (house) work from that spectacle. The reality of housework is as invisible as the woman artist. Without wishing to overstretch the analogy, I would like to justify an interest in it within the context of an issue of *Studio International* devoted to the work of women artists, on the grounds that it poses a problem which is at the roots of understanding what I shall call the modes of visibility and invisibility of women.

I. Woman: Producer/Produced
Housework is the most characteristic form of female labour in modern Western industrial society. It also seems to be unique or exceptional in several different but related respects. Firstly, it is evaluated differently from the dominant forms of labour in a market society — it does not produce surplus value. Secondly, it is uncharacteristic of a service industry in that it is not explicitly orientated towards abstract demand but has, as its focus, the specific demands of husband and family. Thirdly, the housewife herself is not converted into a commodity in the same way as the factory worker: the latter sells his or her time at its value as fixed in the market, whereas the housewife is not subject to exchange-value. Fourthly, alienation induced by housework is not the familiar product of the division of labour — it is a sort of double-alienation, in that the integration of a variety of tasks yields no integral product. This is the sense of invisibility of housework, for in restoring things to a state of domestic normality its 'yield' can only be seen negatively. Fifthly, there is no clear quantitative definition of housework which can differentiate it from other activities and can demarcate a separate leisure sector in the housewife's life. This recalls the phrase 'a woman's work is never done', in that it is contingent upon all other activities which (like sex) are transformed into domestic duties; and, because of the lack of a definitive product, it is literally continuous with all other activities of the family.

Housework is the most deadening form of labour for these reasons and because, above all else, it is rendered invisible within a modern consumer society. Its yield lies outside the conspicuous forms of consumption — the spectacle of bourgeois society. But it is deadening in its effect upon housewives in one respect which encompasses all that has been attributed so far to housework — it is deadening in negative relation to all other activity in the family including one's own. Women's activity is divided into doing and clearing up afterwards. It is this which finally destroys all spontaneity, because every domestic action leads to another like an endless chain of domestic duties. You cannot eat without washing up afterwards in order to prepare the next meal, and so on. The illusion which is created is of a self-perpetuating activity with no relation to the outside world. The woman finds herself condemned to her own world in dealing with the perpetual ramifications of her own labour — right down to childbirth. The negative reflex to all forms of spontaneous activity is incorporated into the female consciousness, so that it informs on all activity.

The result is an extreme form of self-policing — a holding in check of any and every manifestation of spontaneity which invades women's attitudes to everything from food to sex. Not only do her actions and attitudes take on this feature of incorporating a negative corrective, but the sphere within which these actions occur also seems limitless and self-perpetuating. When women cannot see beyond the sphere of their own actions, and all work appears to be the resultant check on previous actions, they cannot *see* beyond the world demarcated by their role. Factory workers do not share the same problem: their activity lacks this dualistic reflexivity because theirs is a world of leisure beyond the world of work. The housewife, in facing the immediate realities of her work, can only see herself as the source and responsibility for every new task. She finally turns the world in on herself, making the identification of domestic privacy and self complete and suffering an invisibility equivalent to that of domestic labour.

II. Woman: Consumer/Consumed
If women are rendered invisible as producers, they are clearly visible as consumers. If what the woman does is invisible there can scarcely be anything more visible than what she *is* within (and in the terms of) a modern consumer culture. These two modes of visibility are related, i.e., as consumer and as the consumed.

Historically, the advancement of modern industrial capitalism involves a more and more accentuated division of labour, one product of which is the division between the work and leisure sectors of life and finally between the spheres of production and consumption. The more that these two sectors of the life of the worker are separated, the more extreme the forms of division of labour which he can tolerate in his productive capacity. A sector of the worker's life increasingly comes to be sacrificed as a duration of non-being, in which one awaits a sense of being or reality in one's leisure hours. Involved in the polarisation of production and consumption is the increasing division between activity and passivity, so that action and being become mutually exclusive realms. That the woman, as a part of her household duties, becomes the chief consumer is important in concealing the productive nature of her existence, in making the association between women and passivity, and in the value of being as opposed to doing. This is an important artifice in the stereotyping of women.

Indeed, the same movement (committed to the same ends) brings about the dualism of production and consumption, which also displaces women from involvement in the same work as men into the new sphere of domesticity. Without the development and architectural objectification of a domestic (private) realm, in the emergence of the nuclear family, which could be separated from the public (social) realm of work, the development of industrial capitalism would have been impossible. Of course, it is not modern industrial capitalism which, by itself, brings about the association of women with passivity. This model, as we shall see, is much older. What modern industrial capitalism does is to universalise and develop an ideology previously restricted to a minority.

The same tendency which stereotypes the woman as domestic consumer and displaces her activity from visibility (as production) also makes her visible as the *consumed*, so that not only her actions but also her very being are subordinated to men's. Housework, in representing an exception within capitalist forms of labour, resembles feudal work relations in its lack of freedom. (The fact that it does not enter the market in its evaluation, makes choice and the right to withdraw labour problematic and ill-defined). Woman's entry into the market is uniquely defined by her appearance—by her image. What is appropriated is not her labour but her appearance, and this equivalently defines the principal arena of emancipation encouraged by the market.

The exploitation of women within the market is clearly different from the exploitation of the worker. Whilst both appear as commodities on the market, only the woman appears as a consumer object. The worker's existence as a commodity is in terms of labour power evaluated abstractly as time; while even though the fashion model, for example, may be paid hourly rates, it is not her time but her *image* which is appropriated as commodity. One might say that the woman, as a result, becomes a more permanent commodity, in the sense that it is her being rather than a sector of her active life which is offered for consumption. Even though the woman is more conspicuously transformed into an object, in that she manifestly appears within the same realm of consumer objects, a different process of exploitation is involved. If the worker sells himself in the sense that he is selling his life by selling his time, the model is selling her time because she is selling herself. The resultant abstractions are equivalently different also. The worker as commodity is abstract labour or quantitatively *time,* whereas the woman as commodity is abstract, being qualitatively assessable as an 'ideal'. The visibility of the ideal and the invisibility of labour are crucial in understanding *both* spheres of production and consumption and its relation to the sexes.

One feature of the preponderance of the woman's image in a modern capitalist consumer culture which tends to be overlooked is the contradiction involved in a consumer culture's overall orientation towards the woman as chief consumer, and the apparent orientation of its individual images towards the man as abstract spectator. The effect upon women within the social production of 'womanhood' (i.e., the bombardment of woman by images) tends to be obscured by the most superficial condemnations of sexism. The fact that women are surrounded by their self-images is important in culturally dictating not only our self-perceptions but the whole context in which we perceive. The point is this: women are not surrounded by their own image as a by-product of the overall orientation of the realm of such images (culture) towards men; but this apparent orientation is built in, to disguise the fundamental orientation of such images towards women. In this sense the illusion of always looking through men's eyes is maintained. This 'self-image consciousness' encourages women to think of themselves as images, as appearances or as objects—the sense of otherness which within the social mythology of capitalist culture reduces women to the status of a reflection. It also encourages women to incorporate this sense of otherness into their subjective perception—there is the belief that in looking one is looking as though a man, or more accurately that one is spying on a spectacle ready-prepared for men. Incorporated into the context of perception is the woman's lack of presence—her invisibility as observer is countered by her visibility as perception. The effect of this is to deny her own reality and reinforce the reality of her appearance as reflected in the *man*-made image. The reflection is more real than what is reflected.

This is the more important when it is realised that, for the housewife, such cultural realities are the only source of social reality which is presented socially. The housewife's productive ties seem asocial, in the sense that they represent exceptions to socialised labour in a bourgeois society (i.e., the productive relation seems tied to individual husbands). Her only tie to a recognisable social reality is therefore through the connection of her image with the abstract individual created as universal male percipient of her own image. Belonging to society is not something that can be assumed by women. First and foremost they belong to their husbands. Further than this, the only ready-made social relations are the relations via their own idealised self-images to the abstract 'man'. Social aspirations are therefore channelled into aspirations towards the archetypes of physical beauty. The woman aspires towards her own reality. It is not just a sense of being surrounded passively by her own images, but the active aspirations to such objectification is a part of the context of encounter with such images.

For the woman, the polarity of the private and public sectors of her life is extreme. As has been indicated earlier, the housewife turns the world of her actions (production) *in* on herself, seeing herself as the source of everything—in the sense of every new domestic demand—and yet in such a way that her implosion into herself involves a deadening of her activity and sense of invisibility. On the other hand, outside her relation to the individual man, she confronts herself (her sense of being as opposed to her actions) in relation to abstract 'man', both in terms of her self-image and in terms of her subjective relation to the self-image. Paradoxically, here, in being surrounded by her appearance, she is everywhere excluded: firstly in that she is excluded from the sex of the universal viewer of her self-images, and secondly because of the exclusiveness built into the abstract ideal perceived as 'woman'.

Everywhere the woman's alienation seems to operate in reverse to the normative forms of alienation induced in a bourgeois society. Where for the worker the sense of being is opposed to the sense of activity, respectively in the private and public realms, this is inverted for women, as are their relations to these different spheres. (The worker enters the public sphere as quantitatively assessable activity. The woman enters the same sphere as qualitatively assessable passivity. The male worker enters the private sphere as passive recipient, whilst what is entered is the housewife's activity; her own privacy—at least as passive sense of being—is the more permanently denied her).

III. Woman-In-Herself; Woman-For-Man.

The further women are alienated by their self-images, the more encouragement they have to retreat from the realm of their objectification into the private realm of domesticity. This immersion in domestic tasks can seem like home-loving, and it can also be seen as a retreat from visibility by a sector of society permanently forced into self-apology in every mode of existence. The result is that both the actions and the consciousness of women take on a peculiar form of reflexivity. As has been seen, productive activity has its own counter-action within the run of housework incorporated into it, a negatively holding in check which deadens all spontaneity. Further consciousness, ostensibly directed beyond the productive realm, involves an equivalently negative self-consciousness which identifies self only as that which falls short of the complete woman represented as abstract ideal. It is more like self-doubt than self-consciousness.

Reflexivity of action makes private and de-socialises the reality of women (or at least reflexivity and privatisation are

mutually contributory and self-perpetuating features of the same situation). This puts it apart from the social normative teleological character of productive activity in a technological society. Reflexivity of consciousness involves a separation from action (as opposed to more abstract self-consciousness of 'behaviour') in the negative individuation of 'self'.

The combined effect of what here can only be vaguely described as 'reflexivity' in activity and consciousness is the social creation of woman both in image and in reality as a thing unto itself, which is in constant contradiction with the woman as thing for man. It is with the cultural manifestation of the contradictory images of women that the remainder of this article is concerned, i.e., the agency of men in the construction of the images and corresponding realities of woman.

The perpetual contradiction of the world as self-governing—nature as a thing-in-itself and as subject to the law of man, as a thing for us, the contradiction between objectivity and subjectivity—seemed to enter cosmology with the signs of the break-up of medieval Christianity (and the first manifestation of a powerful organised merchant class). The resultant anthropocentric cosmology of the Renaissance appears to entail both meanings of its 'man-centred universe'. For as pictorial convention became aimed at a representation of nature as a thing-in-itself (rather than as a mere representation of divine agency), the severing of ecclesiastical constraints on painting and a secularisation of subject-matter also singled out women as the subject representations with which the values (observed in nature as thing-in-itself, i.e., grace and beauty) become associated.

Perhaps the central contradiction upon which the new pictorial view of the world is based, is the insistence on portraying nature as a thing-in-itself and the individualisation of reality as equivalent to the unique perception of an individual onlooker (a reality whose source is in the individual). The way that the dominant pictorial representation of women inherits this contradiction seems finally to emerge in the dual conceptions of woman-as-thing-in-itself and as women-as-thing-for-man.

The view of nature as self-contained, harmonious and unified, involves a suppression of the relations to the onlooker (reality as *for* the subject), which is the context within which nature is presented. Thus where individual sensations become the basis of reality subjectively, the insistence on objectivity of naturalistic representation involves a commensurate insistence on the idea of separation from that reality. Distance becomes a precondition for the evocation of the ideals of grace and beauty which are associated with a unified and separate nature. The focus upon women as otherness would seem sexually natural, as would their characterisation with the attributes of nature. What then emerges is a genre of pictorial representation (the nude) in which the woman is presented as object and man is present as subject, both subject and object created in the pictorial relation being abstractions. The more that the woman is seen as a natural object, the less aware the onlooker is encouraged to be of the context—the individual vantage-point of perception, of 'presence'—and the more the woman becomes a symbol of the grace and beauty of natural autonomy. The representation of woman in this way becomes a naturalisation of the abstract values associated with nature.

It is interesting to survey contemporary representations of the sexes, and observe the heritage of the man-centred reality in which woman appears as visible phenomenon and man almost as 'invisible' source of context. In photographs, and especially advertisements, it is automatic to read female representations as objects, whilst it is difficult to exercise the same perception on representations of men. We tend to read representations of men not in terms of objects, but as events, i.e., in terms of agency (what is happening). Where we are contextually forced to read men as objects, the representational context becomes uncomfortable. The woman is presented as an object in a man's world. The context is given and assumed. Indeed, it is by a de-emphasis of the context that the representation is naturalised. The more that we see women as things in themselves (mysterious and autonomous), the less we question the contextual use of such representations as things-for-men and the implication of a corresponding reality for women. Women's agency is thus consistently under-emphasised, in keeping with the ideal of the thing-in-itself (beauty), by the ideal of grace (the reconciliation of agency, activity with being). Equivalently, man's agency is emphasised and his being (presence) represented as the potentiality of agency (power). This is what I mean by the visibility and the invisibility of women within the spectacle of a bourgeois culture. For women can be appropriated at the level of the visible—as phenomena; whilst the reality of men can only be deduced in terms of events—as agency.

Of course, what has been scrutinised here is the image of woman-as-thing-in-itself and as passive. As we have seen, this depends upon the suppression of the contextual relations within which the representation of woman-as-object occur, i.e., a suppression of the association of woman-for-men. The contradiction is ever-present, even in the older tradition of nude painting, in the imposed artificiality of 'female setting'—the (changing) conventions of which, if overstepped, have at different times historically been seen as a violation of femininity or as obscene. Paintings like Manet's *Olympia* have often been observed to traverse the boundary between the nude and the naked. But in the terms used here, they would be regarded as representations in which the context of the woman's existence as an object is evoked in the relation of the represented woman and the abstract onlooker, or where the self-contained passivity associated with grace is broken and an active relation to the context of a man's world, or the onlooker's perception, is suggested. Here woman-as-thing-in-itself comes into explicit contradiction with woman-as-thing-for-man. Subjection becomes explicit. This contradiction can never be resolved in its own terms but only suppressed in different forms; even so, for present purposes it is important in differentiating two contemporary kinds of representation of women. Both types involve as contextual presupposition the construction of an abstract male viewer, but are distinguishable in that the first kind is actually orientated to a female audience and the second kind orientated towards male consumption.

I am distinguishing, broadly speaking, the kinds of imagery used in women's magazines from that used in men's sex magazines, pin-up and pornographic photography. The characteristics of the first kind are essentially the same as those representations whose lineage can be traced to the emergence of the dominant pictorial form in the Renaissance and which, in spite of stylistic change, remain concerned with the pictorial integration of woman as visible self-contained unity. The relations of such representation are concerned to reduce women and their activity (within changing fashions and conventions) to a unity of appearance in an equivalent manner to the older idea of grace. If it is possible to specify a stylistic norm within contemporary modes of representing women, one might point to the widespread use of the fleeting, arrested moment as a literal reduction of activity to the phenomenal. Perhaps more revealing is the observation that this kind of representation objectifies woman as natural by suppressing the identity of

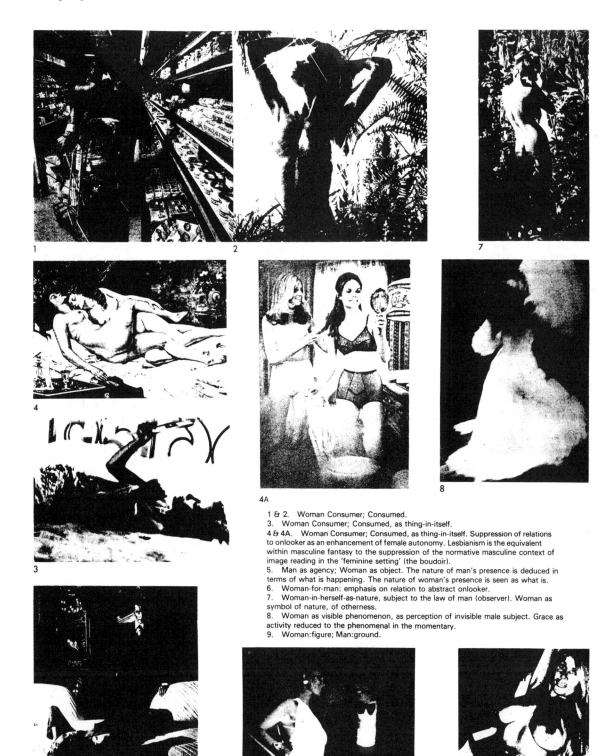

1 & 2. Woman Consumer; Consumed.
3. Woman Consumer; Consumed, as thing-in-itself.
4 & 4A. Woman Consumer; Consumed, as thing-in-itself. Suppression of relations to onlooker as an enhancement of female autonomy. Lesbianism is the equivalent within masculine fantasy to the suppression of the normative masculine context of image reading in the 'feminine setting' (the boudoir).
5. Man as agency; Woman as object. The nature of man's presence is deduced in terms of what is happening. The nature of woman's presence is seen as what is.
6. Woman-for-man: emphasis on relation to abstract onlooker.
7. Woman-in-herself-as-nature, subject to the law of man (observer). Woman as symbol of nature, of otherness.
8. Woman as visible phenomenon, as perception of invisible male subject. Grace as activity reduced to the phenomenal in the momentary.
9. Woman:figure; Man:ground.

the woman as object-for-man. It also emphasises the naturalness of pose and seeks to eliminate manifest relations to the abstraction of the male onlooker, so that represented behaviour looks as unself-conscious as possible. The emphasis is thus upon the spontaneous, immediate, natural and free.

The essential characteristics of the second genre of photographs of women which are designed for actual (as well as ideal) consumption by men—erotic photographs—differ in all significant respects from the first category of representations. By their very character, erotic photographs are aimed at enhancing the imaginary appropriation of women as objects by men. The context of the existence of the woman-as-object within the field of vision of man must be enhanced rather than suppressed, as the basis of erotic photography rests in an imaginary identification (as complete as possible) between the ideal male onlooker constructed by the picture and the actual individual male consumer. Thus the setting of a man's world, either literally or in terms of man as the source of the field of vision, must be emphasised in the relations of the picture. This usually involves an extreme artificiality of setting or highly exaggerated pose, or some suggestion of active engagement with the hypothetical spectator/participant which can make the necessary relationship between imaginary and physical participation. If, in the representations of women for women, there is an emphasis on the extreme of female autonomy as thing-in-itself, the erotic representation isolates the opposite and contradictory extreme—the woman as object for man.

It has been noted that the formation of women's activity (producer/produced) and consciousness (consumer/consumed) is uniquely characterised by a peculiar reflexivity. It is almost as if the housewife's work involves her in covering her tracks in the work. Perpetually involved in eliminating every trace of herself (as producer), the woman is condemned to invisibility.

Reflexivity of production puts the reality of labour into explicit relation only to the producer. Reflexivity of consumption is always attained *via* self-consciousness—the inescapable self-image. This means an equivalent form of

exclusion for women. Woman-as-subject must adopt the vantage-point of man; woman-as-object must become *for man*. But in the suppression of these relations in the woman-as-object-in-itself, as otherness—as reality or nature which resists man's subjective appropriation—this reflexivity is internalised. The woman is presented explicitly as consumer of her own appearance, as subject to her own object in the obsessive use of reflections. This is one way of constituting, as image, woman's private world. The 'feminine setting' as a suppression of the reality of woman's self-annihilation (the boudoir, the reclining woman) involves woman as consumer of her own production, as mistress to her own servant, similarly celebrating the private world as the reality of her own self-perpetuation. But the falsified woman's world is only a realm of fantasy and escape for men. Her modes of visibility define a subjective fantasy tie with the abstract 'man' as woman-for-man, and constitute an objective tie with men which is only the constitution of woman's independent reality as otherness-for-men.

Bearing in mind that it is the same economic force which ties the woman to an individual man (and transforms her into the invisible producer), it also renders her visible only in the tie to the abstraction 'man'. In this context we can assess the visibility of women-as-object-for-man as the social objectification of woman, and the woman-as-thing-in-itself as the reification of women. Woman's invisibility as subject to her image is, equivalently, the objectification within social ideology which similarly entails her reification as invisible producer.

IV. Postscript
A conclusion suggests that the conflicting forces have been satisfactorily resolved, i.e., understood within the plane of writing. I make no such claim for this article, so any conclusion must take the form of an apology for failing to keep the promises implicit in its formation. The article may seem unduly complex, and my only answer is that issues have been complicated historically. I hope that it may serve at least to break ground which may give some more definitive yield in the sphere of cultural production.

Source: *Studio International*, 1977, vol. 193 no. 987, pp. 208-12.

Rosalind Coward
'Underneath we're angry'

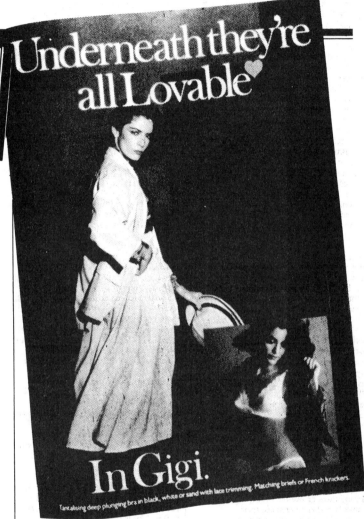

CRIES & WHISPERS

'We get a steady stream of complaints about the way women are portrayed in advertising,' the Advertising Standards Authority has finally admitted. In fact, the protests against the industry's representations of women have been so numerous that its self-appointed (and apparently toothless) watchdog has set up a special study to examine 'current attitudes among women of various ages and social groups throughout the country'. This is long overdue. Although the Authority occasionally upholds complaints about 'sexual titillation', not once has it insisted upon withdrawal of an advertisement on the grounds that an image is offensive, degrading, or exploitative towards women.

Nor does the proposed research project commit the Authority to actually do anything about sexist representations. When 11 members of the public complained about a Sniff'n'Tears LP ad in the *NME* depicting a 'semi-clothed woman in a state of terror, attempting to close the door against an intruder', the Authority ruled that 'in the weekly paper it appeared the advertisement would not cause grave or widespread offence to readers'. The ad, they said, simply reflected 'the pop music industry's predilection for the startling and the bizarre'. And last year the Authority rejected complaints from both the TUC and the Equal Opportunities Commission against the British Insurance Association. Their ad portrayed a half-naked woman in chains. Its caption ran 'A lorry load of goods—like a beautiful girl—will vanish if you don't look after it.' The ASA decided that the advertisement did not offend the group at which it was directed—lorry drivers.

Such responses would be laughable if the issues they dismiss weren't so serious. Women's daily experience of oppression is rooted in attitudes like that produced by these advertisements. Visual images,

An open letter to the Advertising Standards Authority from Rosalind Coward.

common speech, popular notions about women and sex, are all apparently nebulous phenomena. They nevertheless construct a climate in which women are intimidated and undermined by virtue of our gender. But such representations are regularly regarded as phenomena which are not manipulated, and therefore cannot be analysed.

The ASA shares the prevailing view

that images, idioms, customary forms of behaviour are either the product of an individual's spontaneous creativity or simply neutral reflections of attitudes and images which already exist out there in society. This view is particularly invoked about visual images. Yet our society increasingly uses visual images in acts of communication. And these acts of communication are rarely free from

persuasive intentions. There seems to be a clear need for visual as well as verbal literacy.

At present visual images are commonly exempted from social criticism. They are not treated as deliberately agitational or capable of constructing definite attitudes. The ASA's June 1980 report classifies complaints about the representation of women in a way which indicates that they agree with this treatment. Such complaints, say the ASA, 'tend to fall into three categories'. First there is the complaint from the 'sincere advocate of unfettered womanhood' who is indignant about any advertisement which doesn't conform to the tenets of 'women's lib'. Second comes the argument that 'if a woman is shown on an advertisement simply decoratively and not because she has any relevance to the product, then the advertiser must be using her for salacious purposes.' Finally there are criticisms about ads using women in 'a lewd or salacious' way.

The ASA is clear about the first. Images reflect what advertisers think is going on in society. It is not up to them to construct new images. But on the second and third, the Authority is more hesitant. They recognise a level of gratuitous nudity. But they turn at this point to their notorious test. Does a particular ad transgress an unwritten code of what a 'reasonable' person might take to be decent? They note that 'decent in our books is not limited to chaste but is rather defined as conforming to standards that are right and fitting'. By implication feminist complaints are made to seem 'prudish', confusing explicit sexuality with degradation. It's implied that such objections to the portrayal of women are simply objecting to any explicit representation of a woman's body. This mistaken attitude is mirrored all down the line. The slogan 'this degrades women' has spawned 'this degrades rabbits' on the 'Watership Down' poster, and on the 'Jaws' poster, 'this degrades sharks'.

The ASA's response to feminist criticism makes one thing clear. They cannot or will not understand what is meant by 'sexism'. They continue to insist that ads either reproduce what is already there or use the beauty of women's bodies to enhance their products in keeping with a general increase in explicitness. Advertisements, they argue, show reality with reality. The ASA refuses to consider that ads construct definite meanings and seek to make us share them.

Advertisers of course know differently. Their work is to create new and definite meanings and these meanings have to be understood. The more advertising becomes self-referential, the more it uses jokes and puns, the more explicit becomes the way that adverts produce their meanings. Take some innocuous examples. I was recently asked the meaning of the advertisement showing a toucan with its beak tied up. The caption runs, 'Have a quiet Guinness at home tonight'. Without the knowledge of previous Guinness ads, this one was totally bewildering. Similarly, until I too became a 'Dallas' addict, the Heineken advert using JR was meaningless to me.

In both these examples it is clear what the advertisement requires: an understanding of very distinct cultural references. Ads draw on very distinct codes to make their point—in these cases, codes produced by particular television programmes. But all ads work in more or less the same way. They produce meanings by putting elements together. These elements have definite and clear connotations. If you don't make the associations, the ads will be unintelligible.

Often ads employ verbal elements—catch phrases, slogans, puns or jokes—which fix the connotations in a definite direction. But even without such aids, the images are often intelligible. Far from reproducing reality, they use particular codes to produce their meanings and make us understand them.

We can call an advertisement sexist when it actively produces meanings which play into a whole spectrum of oppressive attitudes. One infamous example was the hoarding hailing the advantages of orange juice with the caption, 'Juicy, Fruity, Fresh and Cheap'. The visual image was an illustration of a fat woman exposing parts of her body in the style of a naughty seaside postcard. In order to understand this poster, we are required to share its meanings whether we like them or not. At the visual level, we immediately associate the illustration with a certain kind of stereotyped 'vulgarity', the culture of Brighton promenade. The woman's brash exposure is, by association, also surrounded by these connotations. She too is vulgar, cheap. The linguistic level fixes these associations. It decides how we must read this advert. Juicy, fruity—a ripe sexuality; fresh—bold and sexually suggestive; cheap—vulgar, working class, and, like a prostitute, sexually available for a small price.

If asked, the ad agency responsible would almost certainly insist that this is just a harmless joke. There's no hint that you'll get a prostitute or sex with every packet. Nor is the objection to the gratuitous use of a woman's body really relevant here. The ad could hardly be interpreted as a sexual come-on. It simply takes a traditional image and puns on it to suggest the merits of orange juice.

But this response misses the point. To understand the caption we are compelled to use a code which says a certain type of woman—a 'vulgar' woman who flaunts her sexuality—is like a prostitute. What's more, anyone like this is 'cheap', 'tarty', not 'classy' and therefore not worth much. So, even though we may be feminists, even though we would resist these definitions of women, even though we personally would never make such statements, we have been caught up in the meanings produced by the advert. A sexist idiom has been recast and promoted into wide circulation, and *everybody* who looks at that ad must make those associations.

This process is all pervasive. From every corner, advertisements reach out, calling on you to share their meanings. A stockings ad reads 'For girls who don't want to wear the trousers'. The accompanying image is always a pair of slender female legs surrounded by a horde of businessmen. Perhaps the ASA would want to treat this as another truly neutral ad. After all, it appears to be aimed not at all women but only a particular group, those who don't want to wear the trousers. But however much you dismiss that dead metaphor, you are forced to repeat the old idioms: 'Who's wearing the trousers?' or 'She's trying to wear the trousers.' Willy nilly we're forced into a position where we make certain definite associations. Feminine women don't try to be men, and men appreciate that.

The ASA would probably argue here that these idioms do, after all, exist. But no ad just reproduces old attitudes. How else would new meanings be given to new products? Ads may play on popular idioms and old stereotypes, but it is never a matter of just reproducing them. They recast them, put them into currency again, give them new life.

Let me close with a more sobering example, the advertisement for Gigi lingerie pictured on this page and captioned 'Underneath they're all lovable'. On a literal level this ad is no better or worse than most. Both the linguistic level and visual elements tell us that, although a woman may look business-like and be about the streets, she does need men after all, she is soft and sexy. But the meaning of the advert by no means stops here. The picture on the left also demands that we decipher it. The woman is alone at night. Instead of the inviting look characteristic of advertising, this woman is glaring into the camera. Immediately we go to work. What is she doing? Ah, yes. She's being propositioned by someone in the place of the camera and she's saying no. She may say no and be offputting but persevere, force her. Underneath they all want it. An invitation to rape.

I'm not suggesting that advertisers maliciously make up these meanings. The attitude that women will initially resist sex but when forced, enjoy it, is widespread within our society. Legal judgements frequently condone male violence on the grounds that a woman 'asked for it' however unconsciously. The media reinforces this. The activities of the Yorkshire Ripper became a matter of press concern only when he attacked 'respectable' women, those who didn't

'ask for it'. Doing so transformed him into a psychotic exception to the rule rather than a symptom of male attitudes towards women and sexuality. Even schoolboy rhymes share these understandings: 'When a lady says no, she means maybe. When a lady says maybe she means yes. When a lady says yes, she's no lady.'

Natural attitudes, good harmless fun. Unless, of course, you happen to be a woman. Unless you think it should be our right to walk about the streets without fearing male violence. Unless you believe that women have a right to active sexuality in which they take the decisions about when, where and who with. Unless, finally, you think that these ideas and the convictions they engender form the basis for some fundamental inequalities between the sexes.

Whether the ASA can be persuaded to rule against advertisements for such attitudes is another matter. At present communications which foster misogyny (unlike incitements to racial hatred) are considered above the law, a realm of personal choice. But sexism, like racism, is not a private matter. Anti-women attitudes underlie aggressive and oppressive actions. They create a climate of fear and antagonism—where to say that women are free can only be the expression of a wish.

Source: *Time Out*, 1980, 567, pp. 6-7.

Section II
Institutions
Introduction

All art is made within an institutional framework. By institution we do not mean merely actual buildings or establishments, but we are referring to the organisation of limits and possibilities which materially affect all social practices. In the case of artistic practice, education, exhibition, support systems, critical networks, the art trade, public funding are just some of the relevant institutions.

Over the 1970s feminists in art have questioned the dominance of men in art teaching as well as the art historical silence about women artists of the past and present. They have developed strategies which involved the creation of autonomous spaces and organisations (the Women's Free Arts Alliance, for instance); others entered into alliance with alternative art groupings on a broader front (such as the formation of the Women's Workshop of the Artists' Union). They have also intervened in dominant public institutions (see Dossier on the Hayward Annual 1978, in this section). The struggle has been uneven, rewarded by notable gains establishing feminist art practices within art schools and the art world. But the art establishment has also hit back, attempting to contain women artists and curtail their opportunities. Nevertheless, the existence of women's art groups throughout the country founding their own exhibition galleries, putting on collective shows, teaching each other, sharing skills and support – all attests to the continuing vitality of feminist interventions in the institutions of art making and consumption. The articles selected for this section are divided into four groups:

education,
alternative spaces for women's creativity,
interventions in the Public Sphere, and
the current situation.

II.1

Anthea Callen, Mary Crockett, Wendy Holmes, Linda Newington
'A beginning'

Above, 'Two Women' mixed media by Wendy Holmes
*Images of women, questioning the commercial idealised body.
"The first hurdle to cross is the gaining of respect and acceptance of your feelings towards your own work."*

In December 1975 I organised an exhibition of prints and drawings by three young women artists in the Arts Centre of Warwick University. There was no time to arrange a review of the show which could appear simultaneously with its brief ten-day span, so this postmortem is intended more as a discussion of the problems facing young women artists at the start of a professional life, than as a review of the actual exhibition. It is the product of group writing and discussion.

Mary Crockett, Wendy Holmes and **Linda Newington** studied at Winchester School of Art where they gained BA

Artists may be a privileged elite, but working as an artist is becoming an increasingly doubtful privilege. Anthea Callan, with three women just out of art college, looks critically at their training and the structure of the profession facing them.

Honours degrees in Fine Art. Since leaving college in July 1975 they have continued painting, Wendy and Linda sharing a studio in Winchester, Mary in a *Space* studio in the East End of London; *Space* is an organisation funded by the Arts Council to provide cheap space for artists to work in. They·are all doing odd jobs in order to live, Mary for example is working as a catering assistant, and finds the resulting boredom destructive to her art work.

Leaving college had made them face difficulties of survival from which they were protected there. Although they felt their progress stultified by the lack of privacy in open studios at the college, and by the pressure of often brutal criticism from both staff and peers, the present isolation also has its disadvantages leading most readily to a lack· of self-criticism: it is easy to lose your sense of comparative standards when suddenly isolated, and unprepared for that change. They are feeling the loss of college facilities, of ready access to advice and of the competitive stimulus of a group situation.

Wendy voiced the fears of many art students when she spoke of her anxiety over continuing creative work on her own, without the reassuring security of college. She is visited by younger students and finds them preoccupied not with her artistic progress, but with the simple facts of her existence: is she working? how many studio hours does she put in each day? what is it like with no one to tell you what to do, no outside discipline? Thus Wendy finds valuable opportunities to discuss her work are lost to friends seeking reassurance as to their own future prospects.

Below, 'Sandcastle' by Wendy Holmes
*Contrasting luscious magazine image with boyishness of the adolescent girl (figure in white vest).
"At college I was accused of having sexual problems and masturbating through my work."*

All three women feel strongly the need for two or three informed people with whom to discuss their work fruitfully. Mary in particular stressed her need for contact with other women painters; although she finds value in discussing her work with men with similar painterly concerns, women artists – regardless of their individual artistic interests – share a common experience of the particular problems facing women.

Their experience of college was of a place geared to producing theorists rather than practicing artists; an emphasis on the intellectual at the expense of

making art. They sensed a denial of emotion in the over-stressing of ideas and method. As women, they found still rife the sexist notion of art as a 'hobby' for females, a profession for men; a woman artist has to struggle for respect and appear tougher than her female counterpart to survive. In a department dominated by male staff they witnessed double sexual standards operating — young female applicants accepted on their physical rather than creative talents, resulting in lower artistic standards and an untenable position for the women concerned. Similarly, double standards in the criticism of their work reinforce women's traditional sense of inferiority while preconditioned expectations inhibit their development: 'she'll only get married anyway . . . '

Left, 'Untitled' oil on canvas by Linda Newington
"To continue to paint is important . . . even walking down streets influences my work, I am never separated from it. The physical doing of it is not separate from the mind or the emotion — it all makes up a wholeness. My drawings are influenced by my body actions and humour.

Below, 'Untitled' acrylic on canvas by Mary Crockett
"I found myself working in ways I know and getting into a stylization when I first left college. Now I am building up a bit more confidence and finding that the lack of audience has made me explore more recklessly and personally, and what I put in seems to give me back a lot more."

Above, 'Untitled' acrylic on canvas by Mary Crockett
"An entrenchment of ideas sets in when I have so little contact with fellow artists. Art magazines and most galleries simply frustrate my need for communication because they seem removed from the ideas and the actuality I'm attempting to describe."

All three feel the lack of self-confidence among women as a whole, and that their harshest critics are female; Mary remembers a typical female student's comment overheard in a lecture: 'I don't think women can think as well as men'. Wendy feels the traditional isolation of women was evident in the college environment; there was a tendency for the men to gang together and give mutual support and reinforcement, while the women tended to work alone and communicate less about their work — often for fear of not being taken seriously.

Mary found that her involvement in the women's movement, and the energy she spent trying to fight prejudices detracted from her creative work; Linda, less actively committed to the women's movement, feels she could not afford to think so consciously of those problems, but that she works them through her painting. Linda's is the most abstract of the three women's work, yet she describes its preoccupation with her emotions, the reflection of her bodily activities in the action of drawing; through her work she seeks the fusion of her mind and body. Wendy's direct use of the symbols of sexual politics in her painting confirm the extent of her disagreement with Linda on the issue of feminism and art. For Wendy the politics of female oppression provide the basis of her art, and her imagery centres around visual stereotypes of women in our culture.

Linda commented that few women in college seemed to take the initiative

in actively seeking support or reinforcement. Greater self-confidence was needed among women students, a greater sense too of shared experience and common problems; to this end they started a women's discussion group. Although expectations were higher than the results, and the group only lasted for six months, nevertheless a new atmosphere of growing awareness permeated the college.

Now on their own, Mary, Wendy and Linda face not only the difficulties 'of breaking into a hostile art establishment which has little sympathy for women, but also the personal transition from student to professional. These problems were highlighted for them by the exhibition; at the private view they found it difficult to see themselves as serious professionals able to socialize and discuss their work with strangers. They felt the show itself was a disappointment, and that the traditional exhibition structure provided for no feedback or response to their work. They would like to see the end of the present professional structure and the start of a more vital situation in which artist and public are actively brought together and learn from each other's experience of art. 'We are trying to start out and create our own disciplines and structures. It is a beginning time'.□

Anthea Callen, Mary Crockett, Wendy Holmes, Linda Newington.

Source: *Spare Rib*, 1976, no. 44, pp. 38-9.

Rozsika Parker and Margaret Priest
'"Still out of breath in Arizona" and other pictures'

By 1975 works by Margaret Priest will have been seen in most parts of the country. One June 4 - 22 an exhibition of her drawings opens at the Garage gallery in Earlham Street, Covent Garden. From August 10 - 21 her work will be on exhibition at the Arnolfini Gallery, Bristol, and three of her drawings will be included in the touring show, 'An Element of Landscape' - works purchased by the Arts Council. She talked to Rosie Parker about herself and the motivation behind her work.

M. I never feel that my work is successful; there is always something more to grasp; something more to dredge up. You see, on one level my work is about physical, formal workings of structure but it's also about spaces, places and times because I want to discover how much that absorbs me and makes me react is based on my background, and to convey visually these things that hover in the back of my brain.

R. Can you tell me a bit about your background?

M. Yes, I was an only child and my parents were relatively quite old when I was born, and consequently so protective and packed with fears where I was concerned that I was never allowed to do anything that might hurt me. There was a taboo on touching electrical things, crossing roads etc. But they let me play with what I wanted to, and gave me a tool set, which was quite enlightened.

R. So they were happy that you went to art school?

M. Oh no. They were both working class people. They'd both worked and studied to become clerical workers from being manual workers, and they expected me to take the next step and to become what they considered a professional person - they wanted me to be a teacher, a solicitor; and because I managed to get O Levels and A Levels there was nothing in my way. They were shattered that I wanted to go to art school.

R. I'm surprised that you had the courage and confidence to persist.

M. It's not courage, it's effrontry - there is a terrific effontry in deciding to become an artist. You decide that society is going to be rewarded for giving you a grant to study, and I see the fact that I can now teach part-time in art schools such as St. Martin's as a continuation of the grant.

R. Were you encouraged at school to go on to art college?

M. No, because the area I lived in - Dagenham - was a cultural wilderness. I went to the only grammar school in the area. And once you'd proved yourself to be clever, everybody expected you to go to university. I just had this terrible thing that I'd got to escape, I didn't know from what, but just to where I'd be valued, and I didn't feel I was valued there.

R. Not even by your contemporaries?

M. No, you see I developed late, was skinny, weedy and asthmatic; it was fifteen years ago and the height of the sweater girl. I became desperately physically insecure.

R. Do you suppose that you made up for your physical insecurity by establishing a sort of physical perfection on paper?

M. It's very easy to draw those kind of conclusions. It's an interesting parallel, my insecurity and my security of craft, but it's probably superficial, covering up layers and layers of other motivations. Still I was very physically insecure and the fact that I broke my nose five times didn't help. However, my attitude towards my physical appearance was modified within a year of going to art school. Some people actually said, 'May I draw you, you've got such an interesting face.' Whereas before they were always saying, 'Christ, look at that nose.' Maybe I knew all along that that was one area where I could function with the least amount of pain. But it was difficult to go to art school, knowing that you could go to university, and knowing that that was a way of changing your financial circumstances. I wanted classy things.

R. When you went to art school and began to accept your physical hangups, did you have a corresponding increase in overall confidence?

M. Not really because I had no cultural background. I had no idea at all what was going on in painting at that time, and in addition I hadn't done art at school. Most of the people who went to art school in a working class area were not the people who wanted to go, but the people who were good at art and weren't good enough at anything else. So many of the people at college had been doing art at school since they were eleven, while I had done nothing. I was terrified, and unable to do what I thought was required, I just used to do neat things which were at least not dirty. I was immediately type-cast as a graphic designer/illustrator.

R. Do you think that the same kind of equation would have been made if you had been a man?

M. No, and my appearance was against me at the time. I looked fashionable, wore all the right clothing, and that marked me down as superficial. A concern with appearance is imagined to preclude a woman from the depth of intensity and drive required of a painter. It wasn't until I'd left Walthamstow after a year of pre-diploma studies and had spent one whole term as a graphic designer that I actually realised that my motivation wasn't towards graphic design at all. I reapplied for a painting course, and burst into this kind of manly painting exercise; wearing jeans all the time and working on huge chunks of hardboard - throwing myself into it.

R. It's striking the extent to which your actions were effected by the prejudices surrounding women's appearance. Your experiences sound like the reversal of what Betty Friedan calls the 'frilly blouse syndrome' when women who do supposedly manly work feel compelled to adopt some ultra feminine item of clothing. Today you are doing small, exact pictures. Why did you abandon large scale painting?

M. Well, I enjoyed it, and it was very valuable. Things like that always sound pretentious, but it was very valuable; it was an experience and it was physically very stimulating. But I was making pastiches; it was coming off the surface of what other women artists were doing who were emulating men, and that's one thing I don't want to do - I want to make a woman's art that's of a woman and not of a woman mutated in order to make it in a man's world.

R. Your position is directly opposed to that of so many women art students who say that the stereotype of the woman as a small scale delicate worker is so entrenched that they are actually discouraged from painting on large canvases.

M. On the contrary I was consistantly encouraged to paint large. It was as if anything small scale was associated with the female stereotype and couldn't be the vehicle for anything universally meaningful. Anyone working on a small scale drew the comment, 'Oh, knitting again!' For a long time I was determined to do nothing that was considered typical of a woman. But I eventually realised that my strength lies in the end of my fingers. I don't have a relaxed body. I feel that the kind of person who eats a lot and yet remains thin can't do big relaxed paintings.

R. Are you saying that biology is destiny?

M. No, but for me fighting against experiencing myself as the sort of woman I am was very destructive. I turned against everything that's part of our conditioning - I didn't want to consider having children or getting married.

R. Did you begin to realise that you could work in a way which might be seen as conforming to the female stereotype because

Housebite *1971 pencil on Whatman's handmade paper 20.7 cm x 20.7 cm*

you felt able to do it in your own terms?

M. Yes, for example I eventually got married, and it's given me incredible freedom because I did it on my own terms. But I still play games, like very rarely wearing a wedding ring. I'm not sure whether it's a game, I mean how can you forget your wedding ring?

R. What do you suppose it symbolises?

M. I'm very happily married – I think everyday how lucky I am, I talk about my husband all the time which is a drag for everyone else but . . . I think losing my ring is not an attack on my own marriage but a defence against the labels society sticks on you with marriage. When I got married my parents thought, 'Ah she's in our camp after all.' My husband is a painter.

R. Does that create competition between you?

M. Obviously there's competition – how can there not be? You even compete over who has done the washing up. We talk about it though. I'd lived with someone else for five years and suffered all the pain of competition that remained largely unrecognised.

R. You mean that once you are conscious of competition you can deal with it? Do you think it spurs you on to work?

M. No. I don't think consciousness can be the solution but it can be a beginning; an area in which to negotiate, I certainly don't think competition with my husband or anyone else spurs me on to work. The greatest spur is having finished a piece – I immediately want to start another.

R. How do you react to working alone today?

M. When I was at the Royal College of Art I worked alone a lot because I suffered from something of a sense of isolation having changed departments. That made me think that I worked well alone but working alone in an institute is quite different from working on one's own at home. If work goes badly in my studio I find that I just end up sitting in the kitchen drinking mammoth cups of coffee and eating biscuits. My insecurities come back and I start to worry about housework; if I'm at home I don't feel comfortable when I'm just sitting and thinking because I still have the

remnants of childhood guilt – thinking is dreaming – dreaming is lazy. Going out to teach and being with people definitely stimulates me – just looking at people.

R. Yet the places you draw are deserted.

M. I don't find it easy to be friendly. I find it difficult to rush up smiling and say hello. I like people who are friendly to me but I can't reach out to people, and my work is the same. My work demands that people come to them, they demand effort on behalf of the viewer. But they are avoidable – they melt into printed matter.

R. They are so mechanically perfect that they resemble photos.

M. Yes, there is a superficial resemblance; it's intentional. I'm trying in pencil to get closer to the more immediate stamp of authority which the media has. Most of the information we receive comes second hand from books, T.V. etc. Years ago I was working in the Science Museum and a boy came up to me, looked at my drawing and said,'Did you do that or was it done?' My attitude is contradictory because on

153

Auditorium *1972 pencil on Whatman's handmade paper 17.2 cm x 20.7 cm*

one hand I'm hiding in media manifestation, and on the other, despite all I know of current style, I'm absorbed in using the craft aspect as a vehicle for emotion. During the ten years that I've been involved in painting there have been constant changes in approach, and having a craft has given me an anchorage and the freedom of having a direction. It's a narrow precise language. Some would call it crystallised, others would say ossified, and I think it would be fair to see in it both those extremes. Some men have even said that it's frigid. Nobody would have used the term if I hadn't been a woman. Perhaps women are expected to convey a kind of warmth or earthiness of emotions. In fact a great many of the pictures are of places I feel strong emotions towards. They are the equivalents of places I've dreamed about since I was a child. And I feel I'm a part of the places when I draw them. While I drew this one, "Auditorium", I felt that I had been there on some terrible October afternoon in an empty theatre with a cleaner sweeping up dog ends. And this one, "Still out of breath in Arizona" relates to the asthma I've had since I was a child. It has sometimes got to the point when I have to take cortisone. Then I take myself much too seriously and I'm a real drag. That's my other speciality; a goodline in dramatic acts. Anyway, as a child I was always told that unless my asthma improved I'd be packed off to one of those council run institutions in Switzerland, and as an adult I'm always hearing that all American asthmatics always live in Arizona. I imagined arriving in Arizona and still being out of breath – what could be worse.□

Margaret's drawings can be seen in 'Elements Of Landscape' at:
Blackburn September 21 – October 20
Newcastle November 30 – January 4
Plymouth February 15 – March 16
Dorchester March 26 – April 20
The show will be touring until November '75 and the above dates are subject to conformation.

Source: *Spare Rib*, 1974, no. 24, pp. 38-40.

II.3

Elona Bennett
'Venus de Milo: Virgin on the Rocks'

Elona Bennett—member of the newly
formed Artists Union, and Women's
Liberation for the last three years—
currently teaching at Maidstone College
of Art—writes about women artists.

VENUS DE MILO, VIRGIN ON THE ROCKS

I am a healthy, literate woman. When
I was eighteen I was full of ambition
and dedication. I wanted to be an
artist, a sculptor. I went to art school.
Very confused by the whole thing
I decided I would have to analyse what
I thought Sculpture was. The work I
did was cool and scientific. I didn't
want to 'express' myself, as that seem-
ed such a random way to work. Where
would I begin? So in the idealised
world of an art student, a world that
was my **real** world, I began to explore
space and form and how to commun-
icate in this medium. For almost four
years I was totally unaware of one
very important thing—I was a woman.
It wasn't until my final post-graduate
year that I was really confronted with
the idea. I went to a psychiatric
consultant due to emotional stress
and depression. I was wearing trousers
at the time because I had just come
from the studio. He said,
'Why are you wearing trousers?'
'I am a sculptor', I replied, 'and have
been working in the studio all day'.
'That's very interesting. Have you ever
wondered why you chose sculpture?
It's a very unusual thing for a woman
to do, you know'. Very annoyed by
his inference, I said that it had never
occurred to me that it was an unusual
thing to do. Why should being a woman
make any difference? I had chosen
entirely of my own free will, I was Me,
not just any woman.

From then on the light suddenly
dawned. Who were my friends? Who
did I work with? Had I ever taken any
of my women friends at art school
seriously? Did I regard them as serious
artists?

Women and Art

Women won't become artists until they
have wrested sexual supremacy from
the men; until inspiration ceases to be
titillated by 'the muse'. We have to
externalise the mutually exclusive
'artist' and 'woman' inside us, and
confront the world with the contradic-
tion.

The present problem for men artists
is different. Their sexuality is tradition-
ally 'sublimated into work'. Oppressed

by the stale, uninspiring '9-5 Bread-
winnerism' destined for them, they
rebel and react to become 'true artists'.
They call the world they have left,
'repressive' and 'bleak'—the world
they enter as acknowledged fantasy
(culture?), in their terms a 'redefinition
of reality'. But having opted for an
existence outside society, they have lost
touch with their subject matter: rather
their means of relating to subject
matter is so negative that style and
performance become the only criteria.
Creativity is formalised and abstracted.

Procreation, however, is an act all
women have as a birthright. We don't
have to reject anything in order to be
creative—our lives are dominated by
creating life: sewing, cooking, baby
minding, housework.

Even though on a national scale,
only one in a thousand women enter
further education, we have parity in
our art schools. But on closer scrutiny
it becomes apparent that men and
women still fall into traditional roles,
men dominating in the field of Fine
Art, women in Design.

Fine Art is essentially an elitist
activity. 'Talent' constantly question-
ed. Increasing self-doubt begins to
dominate the desire to make art. Bad
enough for a man you might say.

Women not only have to cope with
'artistic insecurity' but also the lack
of confidence caused by having step-
ped outside the traditional role to
begin with. We have to prove ourselves
equal in terms of our colleagues and
our art. At the same time we demand
approval of our femininity—after all,
there are limits!

The male art world sees us as a
threat, competitors from another world,
which they believed offered no
competition, ie, passive woman waiting
to be seduced. 'You're getting to be
butch' becomes the form of attack to
which we are most vulnerable since
we are conditioned to think of our-
selves basically in terms of our sexual-
ity. Social pressure too, is heavily
against us as professional women. So
it seems that under present conditions
creative activity and female sexuality
are a contradiction in terms.

Whistlers Mother, Desmoiselle D'Avignon

Consider the study of art history. The
perpetual gallery visits, the Internalising
of historical notions of beauty and
form (feminine) and masculine, We face
a contradiction.
1. The absence of women from history
as artists . . . (interpreting the world).

2. Our overwhelming presence in
history in terms of being portrayed by
artists . . . (being interpreted).

Certainly, the visual arts have had
no 'great women exponents' in West-
ern European culture since the sixteen-
th Century; to an extent that was
never true for literature or drama.
Writing was introspective enough to
be contained within the activities of
the drawing room and acting for
women always bordered on the realms
of prostitution. Recently I was read-
ing about the Kabuki Theatre which
began 300 years ago, and was originally
a show merely comprising dances by
women.

With the passage of time the Okuni
Kabuki came to be presented by
various groups of professional women.
However, as they gradually degenerated
with prime emphasis shifting from the
dancing art to prostitution, the
Tokugawa Government suppressed
and stamped out Okuni Kabuki on the
grounds it had an evil effect on public
morality. Who says they weren't just
having a good time! The physical
participation demanded by painting
and sculpture combined the 'lone wolf'
and the 'extrovert'; roles that had
been denied women by the sexual
mores that remained unchallenged
until this century. Women have been
absent from art history and will con-
tinue to be until we destroy the
paternalism that calls the tune.

So what is 'creative potential'?
Does it have a relationship with every-
day life or Fine Art? Notions of Art
with a capital 'A' have always been
regarded as absolute. Who sets the
standards?

Valerie Solanas, the girl who shot
Andy Warhol, has written an attack
on male-dominated culture in her
SCUM (Society for Cutting Up Men)
Manifesto. She sums it up in this way:
'The true artist is every self-confident,
healthy female, and in a female
society the only Art, the only
Culture, will be conceited, kookie,
funkie females grooving on each
other and on everything else in the
universe'.

Source: *Time Out*, 1972, p. 43.

Pen Dalton
'What is art education for?'

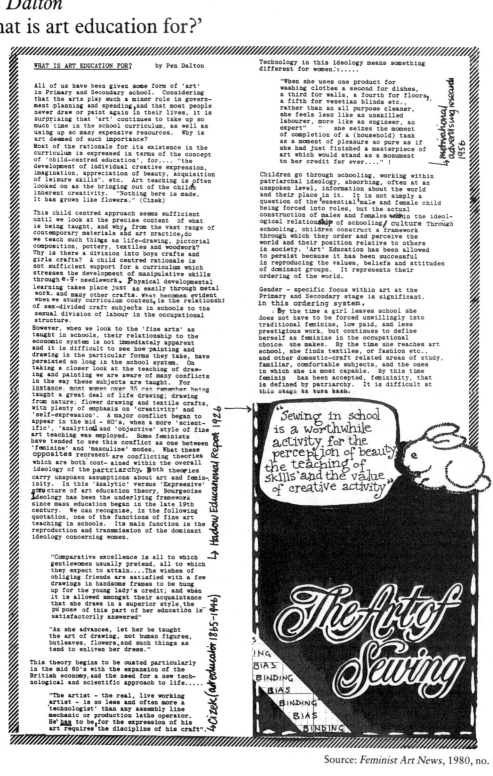

Source: *Feminist Art News*, 1980, no. 1, p. 4.

Rozsika Parker
'Women artists take action'

Finally women artists are joining together, exchanging ideas and solving the practical problems which face them today. Male artists have always benefited from group activity; since the time of the Guilds through the Pre-Raphaelite Brotherhood to the numerous predominantly male groups of our century such as the Futurists. It's a new move for women however, and the Women's Workshop of The Artists Union is proving how effective it can be.

In January 1972 a group of women artists met together at a studio in Southwark, where two of the founding members Elona Bennet and Tina Kean worked, to discuss joining the Artists' Union which was then in its formative stages. They believed that they should join the union as an organized group of women and so ensure that women's demands actually became part of the union's aims and plan of action.

The main activity of the Artists' Union is found within the workshops which are set up to deal with areas which members believe to be of special concern to artists. Workshops were initially created to cover education, art patronage and trade unions. The women's group succeeded in establishing a special workshop on women and they have been actively working in the union on that basis ever since.

The Artists' Union formed with the aim of seeking affiliation with the TUC and with this in mind they ratified a constitution and elected officers in May 1972. The Women's Workshop nominated members of their group for all positions in the union; Mary Kelly was elected union chairman and Carol Kenna and Margaret Harrison were elected to the Secretariat. Not content with having equal numbers of men and women as workshop convenors and officers, the group also demanded that the union should eventually aim to establish parity in the entire union membership.

Once members of the workshop were actively involved with the running of the union, women's issues were quickly brought to the foreground. Mary Kelly described the general reaction, "the women in the union were always supportive (not all of them are members of the workshop) but the men were sometimes suspicious and heated debates ensued". Nevertheless, a majority vote established "to end discrimination in the arts" as one of the union's major aims. And resolutions were passed supporting the women workers occupation at Fakenham and the Night Cleaners Campaign. While on a practical note the women succeeded in having "Do you need creche facilities" printed on union membership cards.

The Women's Workshop are seeking to establish links with women's sections in other unions, and they have a variety of impressive schemes for improving women's position in the art world. They plan to pressurise local councils into providing much needed studio space for women with children. They want to ensure that exhibitions put on by public galleries and national museums now include equal numbers of women artists. And they believe that retrospective exhibitions and historical surveys must include the work of women artists. We should all join with them in demanding that the Tate Gallery puts on the show "Old Mistresses" (the exhibition of female old master painters previously held in Baltimore)

Women artists' difficulties start at art school where nothing is done to encourage them to see themselves as potential practising artists or teachers. The female staff are nowhere near proportional to female students so the workshop is calling for an anti sexual discrimination clause applied in the hiring of art school staff. And they think that art school attitudes towards women students should be thoroughly investigated.

The workshop membership is about thirty but the average attendance is a manageable eight. They discuss the problems facing them as practising artists and they view slides of each others work, building up a strong sense of solidarity. Tina Kean described how stimulating she finds their meetings, "I get the feeling that I must go away and do something, instead of just thinking about it".

Members who discovered that they shared similar ideas formed affinity groups and started three different projects.

Su Madden, Alexis Hunter, Sonia Knox and Linda Price are working on "Project Woman House" based on an experiment which has been done by women in Los Angeles. They plan to work intensely for some months in a derelict house using it as both a studio and meeting place, and finally opening it to the public.

Jane Low and Tina Kean are working on "Playground Projects". Jane is designing an environmental piece for children to play in at 123 Dartmouth Park Road, while Tina is planning an environmental piece for both children and adults at Victoria Park.

Kay Hunt, Mary Kelly and Margaret Harrison are working together on a documentary about women sheet metal workers in Southwark factories, exploring the experiences of women doing so called man's work, their working conditions and the significance of the Equal Pay Act for them. Eventually they will assemble an exhibition out of photographs and interviews with the women. "Spare Rib" plans to follow up this introduction to the workshop with descriptions of the progress of all these projects.

Women artists have less to lose and much more to gain from creating an alternative to the present art world, so we can expect a lot from a union with women active in it. Anyone involved in the arts who wishes to join the union should contact The Secretariat, The Artists Union, 12 Carlton Terrace, c/o The I.C.A. and for information on the Women's Workshop contact Tina Kean, 60 Oxford Gardens W10 ∎

Source: *Spare Rib*, 1973, no. 13, pp. 39-40.

Rozsika Parker
'Exhibition at the Arts Meeting Place'

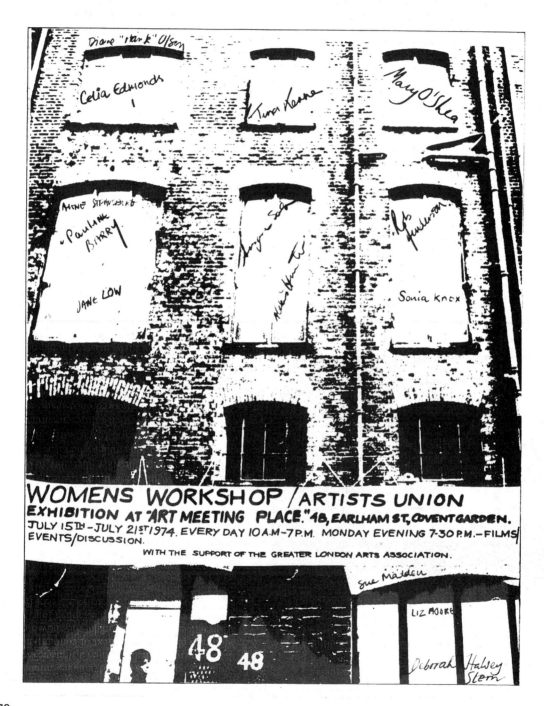

We continue our series on the alternative ways and means of working and exhibiting which women artists are organising today with a look at the recent activities of the Women's Workshop of the Artists Union. The Women's Workship was founded within the Artist's Union in 1972 (see S.R. No. 13), and members have met and worked together ever since. We asked them to use the arts section of the magazine as a catalogue of their recent exhibition at the Arts Meeting Place in London, and to provide statements and illustrations of their work. This should not be seen as a definitive description of the exhibition for two reasons, firstly because some members were away when we went to press and secondly because an article can't convey the exceptional atmosphere of the show. It became a women's meeting place – an international one as it was on during the tourist season – enabling the workshop to establish contacts with women in Germany, France, Italy, the USA, and many other places. ▶

The exhibition provoked many questions and much criticism; here some members of the group answer the most frequently asked questions.

Why didn't the work reflect a group identity?
We formed as a collective of women artists because of our common situation/condition. We share similiar, if not identical problems of isolation; both from other women artists and the general isolation of artists in a society which is alien to collective creative activity.

Why have a women's exhibition?
Why does a women's exhibition always create that response? Most exhibitions are single sex ones (i.e. all male), and for as long as that holds true we have to promote ourselves and each other in a very conscious way. We chose, and feel it necessary to exhibit together – though some of us exhibit individually and in other contexts – to counteract prejudice against women artists. Nobody else is going to do it for us.

What about the women's issue of 'Art and artist' or the exhibition of women conceptual artists organised by Lucy Lippard? Surely women's particular position is now being recognised and wrongs are being righted.
It's true that a token, fashionable interest has been taken in women artists.

Why weren't you more selective? Many of the works were not only different in terms of content but also in levels of competancy.
Who determines what is good? All artists share the experience of external definition - relying on external judgement. Women are particularly vulnerable, experiencing judgement within a male identified cultural context. Are we then to apply the same external definition to each other?

Much of the work seems unfinished.
What does a well packaged product convey? One can say things in a multitude of ways. It's really a question of conveying what one has to say in its most precise and economical way. It is this factor which should determine the image.

Your exhibition does not seem particularly feminist.
Feminism can be expressed on many levels - not just by the use of explicit imagery. And, as in any group of people, there will be varying levels of committment and consciousness which will be reflected in the work. We convey feminism not only in the content of our work but also in its context; in terms of how we go about finding space in which to exhibit, finding and sharing financial support - £200 from the Greater London Arts Council which was used collectively in organising publicity and supporting each other. We give mutual support not only in terms of the exhibition but also by discussing each other's work, offe ring feedback, and extending facilities

Mary O'Shea: *With thanks to Virginia Woolf.* Plastic bags, acetate off-cuts, tracing paper, silver wrapping paper, photographs and gr aphite.
In the process of making this collage, I realized that, as with any artist, the circumstances of my personal life and my situation as an artist in society determines the content of my work, the possible range and usage of materials, and the form which the object or image can take.
 Since I live on Social (in-) Security, my financial resources are nearly non-existent. More importantly, those non-existant resources necessarily imply very limited access (if any at all) to the more advanced levels of materials and technology.
 Making this collage, therefore, partly meant using existing materials (ie previously accumulated old work in the form of photographs and drawings) in order to create a new piece of work. It became necessary to find a completely new and different process, appropriate to the new piece, which would transform and transcend the meaning and content of the new material. I also turned, out of necessity, to cheap and if possible free or discarded materials such as tracing paper, wrapping paper, plastic bags, acetate and melanex off-cuts.
 Working in such a constricted context led me to think about the hierarchy of access to, and usage of, materials and equipment that exists in the "art world", which inevitably generates a heirarchy of object or image. Certain objects/images made of certain materials or with certain techniques acquire prestige merely by virtue of their level of technological complexity, and simply on that basis are considered more important, relevant, or significant by the arbitrators of culture (taste).
 There is clearly a relation between social and cultural privilege. In highly industrialized capitalist societies (ie the West), access to advanced stages of technology and the use of expensive materials are inevitably the prerogatives of a priviledged few (generally white middle-class males).
 Such an elaborately stratified society cannot possibly include many people at the higher levels of access and priviledge, and very few of those people are going to be women - even token women. We see again and again that when technology in a capitalist society reaches a certain level it is used to impose or reinforce exploitative social relations. One of the more vicious circles of such stratification and exploitation is that science and technology, and therefore 'culture', tend to remain male preserves.
 As a woman artist, I must question whether it is desirable for women artists to participate in and therefore perpetuate such social stratification, and ask whether it is just that the tools of society remain limited in use and availability to the priviledged few. If I am not to be a "token woman artist" with the disproportionate access to the higher levels of technology and equipment such a position would give me (and I am not going to be), it becomes imperative to challenge the existing hierarchy of objects, image making, and materials which is imposed on us and surrounds us.
 Given a situation at the moment in which my necessity and my principles are inseparable, it becomes clear that if I am to continue in creative activity with neither financial resources nor access to advanced technology and equipment, my only alternative is to concentrate on working with materials which are primarily cheap and easily available, or even free (an incidental benefit from the general idiocy of overpackaged goods), and to show how these materials can be used creatively, how their possibilities as materials can be expanded - not determined by or limited to economically exploitative factors. ○

Pauline Barrie: We must as women be extremely conscious of thinking within our time, and together be capable of predicting a future, so as to be able to accomodate ourselves to its demands, as this is the only way of reducing the hazards of being extinguished by it.

to one another. We meet regularly at each other's homes or studios – particularly at those of the women with children – to discuss problems and to work on activities. We provide for ourselves something which then gives us the strength to go on and to try to find space and to fight to extend our consciousness into the community or at least to other women.

Are you an open group?
We are considering having open meetings once a month.

Will your activities always be limited to gallery products?
If we could find the space we would like to start a women's arts lab which would house activities in all medias (film, theatre, music, dance, etc.), where we could pool knowledge, materials, tools and experience. ○

The Women's Workshop are looking for a space at the moment and would like to hear from anyone who has ideas, suggestions, offers, etc. Write to them c/o Spare Rib.

Tina Keane: *Collapsed Dream.* image/dream/illusion
image/language/illumine
Mirrorboard, bamboo poles and string. 9ft. high by 7ft. wide, 4ft. projection.
The mirrorboard the illusion of water, the bamboo poles elegence,
the string a tangled web.

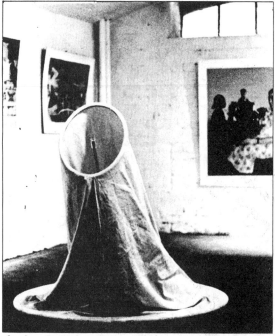

Jane Low: *The Madonna of Mercy.* Two perspex discs, canvas, polythene tubing to attach bamboo pole to support.

DEBORAH HALSEY STERN

Sonia Knox:
My work until recently has been concerned with exploring situations and the relationships that determine them. Situations that I have imposed on people, and situations that occur naturally and are determined by certain systems (eg transport system, postal system, etc. . .). These have mostly been environments or conceptual pieces, and I feel they have been very limited by the art school environment in which they have existed.

The situation in which the Women's Workshop exhibition was held was an open one, in whcih women were able to walk around and talk to women who had done the work, and in this way a feedback formed. This was the most stimulating aspect of the exhibition and I feel this is going to be reflected into any work I produce in the future. I think feminist art should reach all women, not only women in the movement, but women workers in the factories and housewives in their local communities, as women seldom get the opportunity to see that there is a women's culture of any importance. Working class women seldom get the chance to criticize their own culture, analyse it and work out the ways in which their culture under capitalism affects their lives. Feminist art is one way of opening up these channels of communication between groups of women, the working class and other oppressed sections of society. Also the places where one exhibits can determine the sort of feedback one gets, and this in turn can determine the process of the work and the materials used. At the moment the art world is feeding on itself and artists are only reaching and getting feedback from a small margin of society; and this in itself limits the devlopment of a whole different consciousness and the exploration of the relationship between materials and this form of consciousness which would be anti-everything the art world stands for today.

These two pieces are a very good example of how the situation in which one finds oneself determines the sort of work that is produced. The box, which one has to look into, then sees a mirror reflection looking out from behind steel bars, was made when I was most isolated and working for my Diploma show. The graffiti project, which is more to do with other people's experiences mingled with my own, was the outcome of my inter-action with the Women's Workshop.

I am not interested in becoming technically skilled with any one medium. Art to me is a learning process and a communication system. ○

Mary Kelly: Manicure- Pedicure Series (infant 4 months). Post Partum Document from *Primapara,* 1973-74.

"Primapara" is an attempt to document my first experience of pregnancy, childbirth and childcare. The Post - Partum section includes records of childcare tasks, i.e., actual corporeal evidence as well as written and photographic material. My previous involvement with women's work outside the home showed me to what extent women's status in the labour market is determined by the social function of reproduction. Women's unpaid work in the home not only maintains the labour force in the physical sense, but also, mediates the relations of production through the ideology of the family. In fact, mother-child relationship determines the whole process of socialisation, in so far as it constitutes the dominant factor in the formation of unconscious mental life. C.

If women are defined as "being confined" by pregnancy, are they then confined to being defined by pregnancy?

Question WOMEN

If art is defined (as investment or whateve), people are contained by this confinement, but when art is thus confined who can define people?

Question ART

Rob Henderson.

Blown Glass Cage

A Bird In The Hand. . .

Photograph by Priscilla Trench

Alene Strausberg: Description
1 Four small mounted collages of various dimensions
2 Three mounted industrial photographs measuring approximately 11in ×
16in
3 One tape cassette or 'Name' tape
The cassette contains an alphabetical list of popular songs featuring girl's
names, proceeded by imitation bird-calls. A similar list of songs which
include the names of 'boys', follows.

With the exception of two items ('China Reconstructs the Female 'and' 1948 Coca
Cola'), all the works included in the exhibition explore the theme of woman as a
'feathered creature'. I have taken a popular verbal analogy and portrayed it literally,
through a visual image. My intention was to turn the cultural archetype inside out, to
expose it, and to explore the myth behind the archetype.

The image of the bird-cage as a 'container' may be seen as a metaphor not just for
women's oppression but for oppression at various levels. By presenting the female
condition as *the* human condition I have attempted to reverse the usual pattern of
identification. In art as in all other aspects of western culture all human beings are
meant to identify with the pronoun, 'he'. ○

Photograph by Diane "Hank" Olson: *Brockwell Park Loo Lady.*

Source: *Spare Rib*, 1974, no. 29, pp. 37-40.

Su Braden
'Self-Exposure'

Su Braden previews:
'Sweet Sixteen and Never Been Shown'
at 1b King Henry's Road, Chalk Farm
(from February 14)
1b King Henry's Road is just over the
painted bridge from Chalk Farm tube
overlooking London's best decorated
railway sidings. The personal nature of
its immediate environment extends in-
side 1b. There on St Valentine's Day
an 'exhibition' may be approached
through a 'Tunnel of Softness', con-
structed with 'soft, silky, pink, flesh-
like material'. Once through, you're
in the hands of the Women's Free Art
Alliance, and then the soft, silky

pinkness gives way to more angular
juxtapositions.

The Alliance has involved over
200 women during the past two
years and enabled them to take part
in theatre, dance, yoga and therapeutic
groups. The purpose of their current
exhibition 'Sweet Sixteen and Never
Been Shown', is to draw attention to
this work and raise money for new
premises, an old piano factory, to
which they are planning to move. There
the Alliance will extend their activities,
provide women artists with individual
studio space and set up a range of
workshops.

'Sweet Sixteen' is bound to be a
strange show for anyone who has pre-
conceptions about art exhibitions. Apart
from the fact that all the work will be
by women, it will be almost impossible
to categorise it in the normal way.

I walked around the building with
members of the Alliance, discussing the
show and the dialogue which they hope
it will provoke about the role of art.
We looked at the route for the tunnel
and the plans for the musical environ-
ment which will be created with
'instruments of oppression', the pots,
pans and vacuum cleaners, all available
for tuning or just beating up by visitors
(drumsticks provided). Other work we
saw included Mary Sergeant's self-
portrait photographs and woven cos-
tumes, Linda Mallet's paintings and
prints of animals, Shirley Reed's etching-
like photographs of landscapes, Carol
MacNicoll's curious pots and Irene Kai's
erotic etchings. Hanging from the ceiling
were Kathy Nicholson's cloth and plaster
bodies, displaying every combination of
physical allure (red-head with small tits,
blonde with platinum pubes) to 'gratify'
each nuance of taste. Some things were
still plans — the American cheer-leading
event to be performed by a squad of
cheer leaders on swings, directed by
Joanna Walton — the Women's Rock
Band, and many more live events.

The Women's Arts Alliance is in
no way a defensive alliance, set up to
protect a particular style or school of
art. Rather it seeks to promote the idea
of working together. This is the point
behind the exhibition and what makes
the extremes of talent, ability and
development a strength rather than a
weakness. The exhibition, like the Free
Art Alliance, is about putting art back
into a community situation where
'professionals' don't feel their images
will be tarnished by showing alongside
'amateurs'.

Art critics will shudder at so much
healthy vitality, but everyone else
should go along between February 14
and 21.

'Self-Portrait' by Mary Seargent.

Source: *Time Out*, 1975, pp. 15-16.

Caroline Tisdall
'Women's Art'

The Women's Free Art Alliance was formed two and a half years ago to provide therapy counselling and group workshops. From the outset its policy, as a registered charity, has been unusually fluid and flexible: unaggressive is the word that comes to mind. Hopefully this represents the second stage in women's movements, the stage after the rage and the isolationist tactics. Certainly the mood set by this group in their exhibition and events is more conducive to their aim of encouraging self-awareness and creativity in women than other shows I have seen over the past few years.

Two things are particularly refreshing about the group's approach. One is the sense of humour, present for instance in Rose English's guying of the Country Life-type girl's horsey obsessions – and if Rose English isn't a pseudonym it could be. Irene Kai's drawings built out of six lines are outstanding for their delicately unnerving quality. The other quality is the amount of interaction between the disciplines of drama, music and art that goes on, and which will characterise the new arts laboratory that the group will be setting up with financial help from Camden borough council and the Arts Council.

Women's Free Art Alliance: 16 King Henry's Road, NW3, closing to-night.

Source: *The Guardian*, 3 March 1975, p. 8.

Griselda Pollock
'Feminism, femininity and the Hayward Annual Exhibition 1978'

Male artists are very likely to be on the defensive when this year's Hayward Annual opens next week. The show was proposed and organised by a group of five women artists, they have chosen 23 artists only seven of whom are men. (Last year's Hayward Annual showed just one woman.) 'I think we're fairer to the men than they were to us', comments Tess Jaray, one of the organisers. (Suzanne Hogart, *Sunday Times*, 13 August 1978)[1]

Thus was the first Arts Council sponsored exhibition in Britain organized by women and showing predominantly women's work introduced in the Lifespan section of the *Sunday Times* one week before the 1978 Hayward Annual (23 August–8 October) opened. The piece continues with statistics which show how poorly women have been represented hitherto in major exhibitions, and it emphasizes that this show would not have taken place had not a group of women proposed it, explaining that the women aimed to correct the bias against women by proving that there are women artists and that they are good. The main effect of the article is to present the show and its five organizers as moderate, sensible artists who want to right an easily proven wrong – the omission of women artists from major, public exhibitions.

However the piece is more interesting for the conflicts and confusions that emerge despite its smooth journalese. Why is the unexceptionable aim of these women likely to inspire 'male defensiveness?' The words themselves register an unexplained threat posed by the very idea of an event organized by women, largely on their own behalf. This threat is picked up again in the phrase, 'The five are braced for criticism, even in the planning stages there were whispered snide comments.' And it reappears in the slightly different form when we are told that although none of the organizers would claim the 'role of public feminist', their experiences in planning and preparing the exhibition has radicalized them in some way. Liliane Lijn said: 'We weren't part of a feminist group, but doing this has made us one.' Finally there is the strange construction 'They have chosen 23 artists, *only seven of whom are men*.' (my italics.) It is a revealing choice of words with which to inform us that an exhibition is coming on in which for the first time more than half the exhibitors are women artists. Why is women's *fairness* stressed within the first paragraph?

In no way was the Hayward Annual presented in this piece as part of a political movement, nor even as part of a strategy, an intervention by women. It is seen merely as an interesting event, which despite its potential threat, offers little to be defensive about. We need to understand why it *could* have been a threat and equally, why it never was.

In order to discuss this, I shall consider the event under three headings: its position in a British art context; its relation to women's art practices[2] in Britain; its critical reception. However my comments belong in a broader context of work on women and art undertaken initially with the Women's Art History Collective (1972–5) and extended in a book jointly written by myself and Roszika Parker, *Old Mistresses, Women Art & Ideology* (publication Sept. 1979). The position we take up is in conflict with most existing feminist literature on women and art, notably with the analyses proposed by American feminists. We do not believe that the major problems for women artists revolve around neglect of women artists in the past and discrimination against contemporary women artists. In opposition to this, in our work we have tried to establish that women have always been present as artists, but that a variety of positions have been ascribed to them at different periods, and their ways of getting into art practice have varied and been affected by different historical factors. Finally we have concluded that women artists and their art, although often slightingly discussed, occupy nonetheless a significant place in what for brevity I shall call the discourse of art and art history. This is a significant point of difference between ourselves and other feminist writers. We consider that the way in which art and its history are discussed, formulated, interpreted, categorized, constituted into a professional and academic discipline should be subject to analysis, as it is both historically determined and historically signfiicant. Art history as a discipline is not just a method of research but an ideological practice.

Its products, for instance books, and their arguments and conceptual frameworks constitute specific fields of meanings based on ideological positions, i.e. discourses. Thus we propose two strategies. The first is to recognise the significance in art writings of an insistent assertion that all women's art is homogeneous and 'feminine' by definition, and the second is to retrieve a knowledge of consistent but diverse, heterogeneous and historically specific work of women artists, to retrieve it from the discourses of art history and criticism, which are either silent on the subject of women artists, or submerge their work into the 'feminine' category of 'women's art' and set it apart from both the rest of art history and from history itself.

Women artists have never been excluded from culture, but they have occupied and spoken from a different place within it. That place can be recognised as essential to the meanings dominant in our culture, for the insistent stereotyping of women's work as 'feminine' makes women's art a kind of opposition, a structuring category constructed to ensure never-acknowledged masculine meanings and masculine dominance. Such a position is for women themselves problematic and contradictory, but also potentially radical. It is from this point of view that I shall consider the ramifications of the Hayward Annual as an intervention by women in the art establishment.

Hayward Annual II and the British Art Scene – A Sketch

The Hayward Annual II (HA II) opened on August 23 at the Hayward gallery under the auspices of the Arts Council. It was an event in the British art scene both as the second of a recently-instituted Arts Council annual survey of current British Art and as the first show to be organized by women with so many women exhibitors.

It was the first time the British Art Establishment has had to confront any aspect of feminism within its privileged preserves. In the United States women artists have been campaigning and organizing for many years. Not only have they established a substantial network of alternative galleries and exhibition circuits, but they have successfully focussed public attention and public money on women artists. The Whitney Biennial, comparable with and perhaps model for the Hayward Annual, is a survey of contemporary American art; and after picketing and demonstrating, women forced the organizers to raise the quota for women's representation from 4.5% to 25%. Not only did these women draw attention to and

marginally correct the biassed selections of the Whitney show, but provided the selectors with names, addresses and portfolios of works by women artists whom the selectors claimed did not exist.

The British women's movement has pursued a different strategy and has focussed little of its energy or attention on major establishment shows or institutions. However there is a history of protest aimed at the Arts Council which was initiated by the women's movement when in 1975 feminist groups demonstrated outside the Hayward Gallery in which the *Condition of Scupture* show was then on exhibition. (Thirty-six men, four women.) The demonstration continued outside the Arts Council offices and a petition was handed in which demanded:

a) 50% representation for women in all future state financed shows;
b) 50% representation of women on selectors' panels;
c) parity in bursaries, awards and grants made to artists.

Shortly thereafter, and unrelatedly so it is claimed, Liliane Lijn, an American artist living in London, suggested to the Tate Gallery that it should organize an exhibition of contemporary women artists. When this was not taken, up, she turned to the Arts Council, who were at the time contemplating bringing the large historical survey of women's art from Los Angeles to London. Lijn tried to persuade them to add a modern British section to this show. However, the Los Angeles loan fell through and with it Lijn's additional section. She then suggested an exhibition of British women's art of the twentieth century. This too was refused. During these negotiations the idea for an annual survey of British art to be held each summer at the Hayward Gallery was in the air and the decision was made to invite five women to organize the second of the Annuals. Lijn was joined by Rita Donagh, Kim Lim, Tess Jaray and Gillian Wise Ciobaratu.

Two considerations need to be borne in mind at this point. Firstly the situation of British artists has always been very difficult in Britain. Many artists are better known, receive better attention both critical and financial in Europe, except for those whom one is tempted to call 'the old boys' or the international celebrities, like David Hockney. The first Hayward Annual (1977) was bitterly attacked for its limited selection of artists, drawn from a well-established successful élite, many of whom came from one dealer's gallery – Waddington's. The controversy over the show led to a conference at the Institute of Contemporary Arts in February 1978 entitled 'The

Crisis in British Art'. One critic cynically commented that the first Hayward Annual had nothing much but the gimmick of fame and considered that this year's gimmick, 'women', would be just as good. Secondly, because of the fact that the British women's movement has not mounted a campaign directed at the art establishment as has been done in the States, there is not even a trace of public liberalism to be found in the establishment. It continues with its hearty sexism unabashed. But the other side of this is an often-expressed fear of feminism. The fact that women were invited to organize HA II reflects their desire to deal with the constant pressure from Liliane Lijn and her group and their hope to wipe their consciences clean with a one-off token gesture. Indeed Edward Lucie Smith, reviewing the exhibition in the *Evening Standard* commented that it was 'born from a *mating* of panic and compromise'. (My italics.) It was not a response to the 1975 demands for a thorough-going change of policy, a categorical commitment to end discrimination in state patronage. It was a public gesture based on confused motives. The critic Paul Overy described it: 'The confusion surrounding the *parthenogenesis* of this exhibition is typical of the muddle the British get themselves in when faced with a serious issue like feminism.' (My italics – it is worth noting that according to these critics this exhibition does not appear to have been actively organized but was given life, born indeed from unnatural matings in the Arts Council or spontaneous conception by women.)

In the context of the British art scene HA II has to be understood as a defensive manoeuvre on the part of the Arts council. However, it was also a useful occasion for women to get at least some public airing of important issues concerning their position in the art world. Yet in so far as the pressure for a women's show and the Arts Council manner of response focussed on the *numbers* of women artists exhibiting and sponsored, a confusion easily sprang up between discrimination against women artists and token gestures to right the wrong on the one hand, and, on the other, the debates about the kind of art women make, a confusion that made considerable problems for the organizers and for the visitors and critics.

It is clear that the main point of departure for the organizers was discrimination in exhibition practices. They wanted to show little-known or unknown women artists and they stressed at their press conference the statistics of previous shows. In 1972 the *New Art* exhibition showed the work of fourteen men and not a single woman. The *British Painting Today* exhibition

in 1975 sent to Milan work by 106 men and sixteen women. Last year's Hayward Annual had thirty-two male artists and one female on show. It is true that in general fewer women artists have regular dealers, are less frequently chosen for big survey exhibitions, have fewer one-woman shows and less space is devoted to their work in critical journals. But from the Hayward Annual II catalogue it would be hard to prove. Of the sixteen women included, eight held one-woman shows in major galleries in the last four years, eight received grants or bursaries, ten teach in London art schools. (However I should qualify that by saying that although these artists have established reputations in Britain, few are well known, or at all known in the international art scene, beyond the national, 'domestic' context.) Lucy Lippard claimed in her introductory essay that the show provided an opportunity to see under-exhibited, underrated women artists, but just a glance at the list of exhibitions and articles that accompanied the section on each artist in the catalogue reveals this to be a false assertion, or at best an unrealized intention. The majority of the women in the show are reasonably successful in establishment terms.

One is tempted to ask whether the Hayward show was a real step towards the rectification of wrongs, or a strategy to enable some women to get more firmly lodged in the establishment, to use Lucy Lippard's phrase – to get a larger slice of a rotten pie. Writing from an American point of view, Lippard sounded a warning to women on the occasion of the *Paris Biennale* in 1975. Discussing the improved ratios of male to female artists in these exhibitions, she wonders whether higher quotas are not merely new barriers,

> The great danger of the current situation in America . . . is that this barrier will be accepted, that women artists will be content with a piece of the pie so long dominated by men . . . rather than continuing to explore alternatives. It is crucial that art by women be not sucked back into the establishment and absorbed by it. If this happens, we shall find ourselves back where we started within another decade, with a few more women artists known in the art world, with the same old system clouding the issues, and those women not included beginning to wonder why. (Lippard, 1976: 139–40.)

In her catalogue essay for the Hayward show she uses the metaphor of fishing rights in a private brook and concludes 'In fact this controversial entrance of women into the mainstream . . . may be better for the British art world and public than for the women themselves.' (Hayward Annual 1978 Catalogue: 4.) I

do not entirely agree with Lippard's position, which runs the great danger of merely encouraging women artists to embrace of their own free will the separate sphere of operations to which they have been consigned since the nineteenth century by art history, critics and art organizations. However Lippard's warning does correspond with some of the facts of the case as does her conclusion that the British art establishment has more to gain from the discovery amongst women of new sources of energy and of relatively little-known artists, given the criticism for which they came in last year when they showed only the known faces of the art establishment. How we assess the significance for women themselves depends on our understanding of the current situation from the perspective of the women's art scene.

Women's Art Practice – A Variety of Feminisms

In 1977 a symposium was held on Women's Art in Britain at the Women's Free Art Alliance. Caroline Tisdall reported the meeting in *The Guardian* (28.2.77) under the title 'No Easel Answers'. By way of introduction, Tisdall listed a number of recent European exhibitions which for the first time in each respective country brought the work of women artists before the public in a major institution or museum, commenting 'It seems incomprehensible that we have had no such event in this country.' But she offered her explanation,

> Perhaps our most distinctive feature is that we have more women artists than any other country working in ways that can definitely be seen as alternatives to mainstream art, either in directly socially involved ways, or in a wider receptivity to cultural things that are usually dismissed as anonymous or 'sub-cultural'.

Three distinct positions were represented at this meeting and can perhaps be used to represent the present situation of women in art in Britain. This very schematic breakdown of positions can be studied in more detail in the issue of *Studio International* devoted to Women's Art (February 1978). Firstly, there is what I would call cultural feminism which is characterized by a commitment to alternative art practices. This means not only the rejection of establishment institutions, galleries, dealers, and so on, but also a refusal of existing exclusive definitions of Fine Art and of restriction to conventional art forms and media. The content or concerns of this kind of practice relates to specifically female experience, both physical and psychological as in body art, and social or political art.

A second group or position exists of women who already have a place of sorts within the establishment, who are concerned with the position of women artists in the present structures and who concur with existing definitions of art practice. It is from this group that the organizers of the Hayward show were mostly drawn. Their position reflects a difference of experience from the first group, since most of these women are not part of the women's movement and have not therefore been formed politically by the existence of the movement. Their work as artists is the main determinant, their sex of marginal significance in what they do, although it makes for certain admitted difficulties in opportunities, jobs, exhibitions, reputation. This is fully recognised, but is compromised by the dangers they perceive in identifying themselves first and foremost as women within a male-dominated art world.

In contrast to both these two tendencies, there is a third position adopted by feminists who argue that it is important to acknowledge the significance of being a woman and that it is necessary to engage with and intervene in the main currents and institutions of contemporary art practice. From this position, feminists situate themselves in radical art politics on two levels, in the kind of work they make and the concerns they address in their art, and, secondly, in the desire to exhibit their work as an intervention in the public gallery system.

The proposed Hayward Annual Exhibition presented a problem to the first of these three tendencies because of an inherent contradiction between the kind of art they make and the place of exhibition offered. For instance the organizers invited a mixed community art group from Liverpool to join in the Hayward show, but they declined because they could not see that their community-based work would make sense in the context of that mausoleum of a gallery, the Hayward, with its kind of audience. This presents certain problems for this group of artists. Although it is usually made and received in the context for which it is intended, its character and politics are such that it cannot be included in the official survey map of current art practices in the way in which that map is at present drawn up by annual survey shows. However, in addition to the Hayward exhibition, the organizers arranged a wide variety of discussions, seminars, performances and events which took place concurrently with the show and this enabled a number of alternative groups to appear and to raise exactly that issue of the marginalization of alternative art practices.

Sandra Blow (b. 1925) *Untitled* 1976

The second group I have mentioned, that amongst which the organizers themselves appear, was well represented in the exhibition, and they were able to fulfil one of their main aims which was to show women's art in the context of contemporary art practices. However, this very fact invited considerable criticism, for the exhibition did not look very different from any other selective survey of currents in British art. We had examples of colour field painting, constructivist sculpture, bricks, graphs, photomontage, found object assemblage, performance, and so on.

But the third tendency which was represented at the show in the work of Mary Kelly, Susan Hiller and Alexis Hunter, was doubly disadvantaged. Firstly it appeared out of one of the contexts from which it has stemmed, that is, feminist art debates. Superficially it could easily be and often was confused with work made by women in similar contemporary modes but uninformed by a feminist political position. This served also to diminish its importance because through the absence of examples of feminist art of the first tendency its intervention in feminist art practice was not made visible. On the other hand, within the context of an Arts Council survey of current art, the feminism of Kelly, Hiller and Hunter was muted by expectations established by the surrounding work which invited a traditional mode of reception and critical response. The show as a whole was dominated by an emphasis on visual aesthetic pleasure and avoidance of overt or representational content. In looking at the work, we are expected to attend primarily to its formal properties which may give rise to association, references and discussion of concepts, but do not directly represent things.

Moreover the aesthetic premises of much of the

work could be called 'romantic' and this was evident as much in work by men as by women. I use the word 'romantic' to refer both to ideas about the relation of people to nature and to the function of art as a means to establish a relation to nature; in a looser sense it conveys a belief in the power of art to transcend the real situation of people and their material and social conditions. In Sarah Kent's essays on the individual exhibitors this ideology recurs again and again in different forms. For instance Sandra Blow describes painting as 'the one love affair I have had throughout my life'. Kent comments, 'Sandra Blow describes herself as an academic abstract painter because she concerns herself primarily with the self contained problems of 'pure' painting such as balance and proportion, tension and scale, issues that have been important since art began'. (Hayward Annual 1978 Catalogue: 11.) In Deanna Petherbridge's work fantastic architectural constructions appear dense, detailed drawings which reveal both a fascination with and repulsion industrial and urban installations. Their scale and treatment call to mind the fantasy architecture of the nineteenth and twentieth centuries that derives from Piranesi and his romantic (late eighteenth-century) followers, Ledoux and Boulée for instance. The essay on Adrian Morris in the catalogue is introduced by a quotation from Erich Fromm which reads, 'Modern man is alienated from himself, from his fellow men and nature – human relations are essentially those of alienated automatons'. Morris's painting is predicated on the continually changing relation between what lies within the individual and what lies without. His work is based on the paradigm of landscape and the earth and it is an act of creative consolation. 'For me painting has been an attempt to create an environment in which life could exist.' (Hayward Annual 1978 Catalogue: 19.) I could go on giving many more examples but let it suffice that many of the works exhibited situate themselves as abstract embodiments of responses to the natural world and individual sensibility. One is tempted, in order to explain the kind of spectator response imagined by such painting, to quote Delacroix's dictum 'painting is but a bridge laid between the soul of the artist and the soul of the spectator'. In such a context the range of intellectual and political references in the feminists' work is either refused or not recognized precisely because they demand so different a response from the viewer; a response that demands work on the work of art rather than merely a response to an embodied response to the painting.

Moreover, the hanging of the exhibition further enforced the visual spectacle with its pristine surfaces, muted colours, glinting constructivist sculptures with optical boxes. The show was divided into separate self-contained spaces for each artist's work, thus reasserting the individualist notions of the artist and the artist's studio. One walked into these separate compartments to see the world in a private space, engage in a quiet communion in a slightly sacred, special environment. This format also prevented the work of different artists from impinging on each other while at the same time it encouraged the visitor to carry the expectations set up in the viewing of one artist's work over to the next 'study space'. Within this environment, it becomes virtually impossible to sustain an interventionist purpose, and the feminist work was laid open to criticism, particularly from within the women's movement, because it appeared to blend in too well with surrounding non-feminist art.

One final point needs to be made about the show in the context of women's politics – it was a mixed show. At first sight it seems strange that women, whose stated intention was to show little-known artists and correct a bias against women, should opt for an exhibition of only sixteen as opposed to twenty-three women artists. However, in order to understand this decision it is necessary to consider the historically determined position of the woman artist. For a decision either way about an all women's show or a mixed show was hedged about with difficulties and dangers. Let us sum up the pros and cons of an all-woman show first.

1. If they did an all-woman show it would be easy for the Arts Council et al to dismiss the whole event as a one-off good deed done.
2. Separating women from the mixed context in which the majority work, might merely serve to reinforce the historical notion of separate spheres for men's and women's art.
3. An all-woman show would invite speculation as to gender-determined characteristics shared by the women exhibitors and thereby obscure the diversity of women's work and its involvement with contemporary art practices.
4. An all-woman show with only twenty-three exhibitors could not be inclusive and represent sufficient examples of women's work and many tendencies, more especially because of the basis of the selection for the Hayward Annual. The artists chosen as organizers each select two artists of their own personal choice and the rest by panel discussion. It is therefore highly selective, artists choosing artists within a limited number and so one argument for not making it all women

was determined by the need to make clear the basis of selection.

The problem therefore was one of avoiding categorizing and separating women's art and appearing comprehensive. Some of these problems could have been avoided if it had been openly stated that the show was simply a token rectification of the establishment bias against women, and that it did not intend in any way to raise questions about the kind of work produced by women. But the clear distinction that needs to be made between easing the discriminating symptoms of the art world's more structural control of women's art and making an art that directly challenges the structures of patriarchal bourgeois art, is not evident to equal rights feminism. This was precisely because women artists established within the art world without a feminist perspective, frightened by the threat of being labelled 'woman artist', have no political position from which to recognize the historical sources of the stereotyping and dismissal of work by women. Nor do they fully perceive the crucial difference between art made by female artists and art made from a political recognition of one's position as a woman within patriarchal bourgeois society.

The solution found by the organizers was that of a mixed show which reversed the usual ratios of men and women, but without the usual laughable proportions. Seven men to sixteen women is however just under a third and 33% is a very generous proportion of men. In making this decision the selectors fully anticipated criticism from all sides. The feminists could easily attack them (and have done so) for selectivity. Some feminists have argued that the show should have been open rather along the lines of mid-nineteenth-century avant-garde independent exhibitions which allowed in any artist who could afford the hire of the wall space. Secondly, feminists have criticised them for failing to use the limited opportunity to show as many women as possible. Finally, they have been criticised for the extent of their selection of male artists. Moreover, because it was highly publicised as a show organized by women and exhibiting a lot of work by women, the exhibition did not in fact avoid labelling as a woman's show nor the dismissive condescension so characteristic of the art world when turning its full attention for a moment to the work of women artists.

The titles of the published press reviews of the show are very revealing in their coy belittlement and safe humorous superiority – The Female Twist, Wayward Gallery, Girls' Own Annual, No Deadlier than the Male, Ladies First, Ladies Night at the Hayward,

Distaff Side. Only one review was given a suitable descriptive title; in *Time Out* the review by Paul Overy appeared under the simple heading 'Women's Work'. Exhibitions that offend against or disturb accepted notions of art are often subject to ridicule by means of jokey titles, but there is here a particular and significant pattern underlying them all – threat. Adult women become anything but adult women; girls, ladies, distaff side, female. Relief is clearly sounded by *The Guardian's* title: No Deadlier than the Male.

Perhaps interesting also was the selectors' choice of male artists. The women said that they chose for the show work by artists with whom they felt an affinity. This produced a considerable similarity of concerns. In the critical reception of the show a tendency to perceive marks of femininity in art works even extended to the men's work. Indeed some critics mistook the work by men for work by a woman artist. This did not in fact bring into question sexually stereotypical responses to art and render them void by the fact that men as much as women exhibited signs of what is presumed to be quintessentially and definingly feminine. It merely served to envelop most of the men exhibiting in an overall view of the show predetermined in the critics' mind by the idea it was the 'Girls' Own Annual'. But the most significant problem raised by a mixed show with positive bias in favour of women is that it cannot keep clearly distinct three quite separate issues:

1. Women's position as a disadvantaged minority – the Hayward Annual II is then a *strategic* event.
2. Women's place in the context of contemporary art practices – this would make the show a *critical* event because it could try to establish that women's work is not necessarily different from men's, except in so far as difference is part of the stated practice.
3. Women's work versus feminist practice – this would have made the show a *political* event.

Thus, as the event turned out, it was the locus of a conflict of expectations and had unexpected results. The art world saw a show by women artists initiated as part of a 'feminist' inspired assault on the art establishment. Expecting the show therefore to be feminist, it experienced some relief when it was not so, which is evident in the reviews. It was, after all, 'no deadlier than the male'. Women's different situation in art practice was therefore obscured once again; women who did not rock the boat as expected were welcomed back as having offered a very good art exhibition. Feminists, on the other hand, saw an exhibition that did little more than show a few artists who happened

171

to be born female, and their response was that of betrayal at a wasted opportunity, of criticism for failing to address political issues in the art selected, and attack on the organizers as band-wagon jumpers and pie-eaters.

I do not think that within the framework of a Hayward Annual these conflicts were soluble because it was never part of an overall strategy, of a concerted campaign based on well-informed, thought-out political perspective. Such a perspective is only now beginning to emerge in Britain and it is desperately needed in order to understand the different levels on which feminism has to intervene in the art world and equally to understand the dangers of being unaware of the problematic and contradictory situation of women artists – a situation that requires a more complex strategy than that conceived of for the Hayward. However the event has served one good purpose which is to make that need obvious. An analysis of the critical response to the exhibition will elaborate that point, because it exposes one crucial and unforeseen effect – the main target of attack and the main casualties of the show were in fact the few feminists who were actually included.

Critics' Responses

A study of critical writing is crucial for our understanding of the position of women artists as well as for the ideological structures of art practice. The reception and critical response to art is as important a determinant on art practice as are the conditions of its production. Inattention to this fact has been one of the main weaknesses of feminist art history and critical literature to date. Instances of stereotyping and prejudice are often recorded and listed but the central question, why does this stereotyping occur, is never posed. Within the dominant conceptions that inform current feminist art history and criticism, the main explanation for the problems of women artists is one of *institutional* obstacles which have impeded women, for instance exclusion from the means of acquiring necessary skills and professional recognition, workshops, academies, the Life Class and so on. Critical stereotyping of women's art as 'feminine' is seen as a distortion and a symptom of discrimination. In the twentieth century these major institutional obstacles have been removed. Women can go to art schools without obvious prejudice, though what they encounter in art education remains a crippling pressure on their emergence as artists. Women are no longer impeded at the point of access to official art education, the point of emphasis in feminist writing,

but their overall position has not been radically altered. The notion of a slow steady progress against their exclusion from the mainstream institutions has obscured both the fact that women in the past practised art despite those official limitations, and the fact that the way their art is received has operated as powerfully as institutional discrimination, if not indeed been a determinant on that discrimination. Critics' and art historians' writing in the twentieth century holds women artists in their allotted place in the art world. In this century publicity is crucial to the artist's survival and silence on an artist's work is deadly. Silence is total in some art history books like Ernst Gombrich's *Story of Art* (1950 + 1967) which in its survey of western art from the Greeks to the present, refers to not a single woman artist. In a survey of American art periodicals in 1972, researchers found that on average 90% of words, and reproduction on their pages were devoted to the work of male artists. (Tamarind Lithography Workshop, 1972.)

Certain notions recur when women artists are discussed and these constitute the 'feminine' stereotype. This is not merely a prejudiced or distorted view which obscures women's art. Its significance lies in its stress on a biological or gender base for all women's work so that in so far as all women's work is the reflection of its author's femininity, work by women is seen as the natural result of their supposed nature, and, by extension their 'naturally' ordained roles as mothers. Hence women's art is seen as fertile, procreative rather than conceptual and creative. On this basis what women artists make is located in a space categorically different from that of art. Other aspects of the feminine stereotype reinforce this separation. Women's work is described as delicate, manually dextrous, graceful, elegant, intuitive and so on – terms which imply women's place in the domestic sphere and suggest its relation to craft or domestic art produced in the home in fulfilment of roles as mother and home-maker. Mention is often made of a woman for the sole purpose of denigrating her work, but the important thing is how often that negation has to be effected.

Although women are refused recognition in accepted terms as artists, their presence is always asserted in one way or another. It is a negative presence, a presence asserted in order to categorize it as 'other', and by this means the way in which women artists are placed in the discourses on art serves to define art and artists as masculine prerogatives. The assimilation of artistic creativity to the male sex is a process that has taken many centuries since the

Renaissance. It is concurrent with development towards the modern definitions of art and the artist. It resulted in institutional discrimination against women but it is articulated and disseminated in discourses by critics, artists, art historians.

Moreover because of this central but nonetheless negative and misrecognised place that women's art occupies in the ideologies and practices of art, women artists have a radical potential, both on their own behalf and in order to disrupt and expose the ideologies and structures of dominant art practice in production and reception. It is this that helps to explain both the threat intimated in the *Sunday Times* discussed at the beginning of this article, the relief at the outcome of the Hayward exhibition, its favourable reception by the majority of critics and also the almost universal hostility directed against Mary Kelly.

The main points under which I want to discuss the critics' response to this show are as follows:

1. The majority of reviews were favourable.
2. The feminine stereotype was asserted markedly associating women not so much with biologically determined essences as with their domestic role.
3. Only three reviews were outrightly hostile, and three mildly critical, but these attacked women artists for being untypically feminine, i.e., as too intellectual, not gutsy and non-saleable.
4. A consistent hostility to the feminist art was evident, even within favourable reviews.
5. A special emphasis was placed on three artists, Mary Kelly, Wendy Taylor and Michael Sandle.
6. The preference was for Alexis Hunter over Mary Kelly and Susan Hiller among the feminist artists.

That the majority of reviews were overall favourable to the event as an exhibition of art is surprising since this unanimity extends over papers and magazines as politically diverse as *The Times* and the *Morning Star* and as opposed as *Vogue* and the *Christian Science Monitor*. In the *Evening Standard*, Edward Lucie Smith wrote 'What a pleasure it is to be able to give a warm welcome to a survey show of contemporary British art. . . . The result is the most stimulating art event I've been to for ages.' In the *Arts Review* Frances Spalding gave slightly more indirect praise 'If it were possible to divorce this show from the political issue it arouses – the role of women artists in Britain today – it would still rate as one of the most exciting exhibitions of modern art for some time'. In the August issue of *Vogue*, William Feaver praised the show over its predecessor in 1977 for providing a better cross-section of British art. He liked its diversity. However he failed to make the necessary

links between the fact that last year's Hayward Annual was criticised and disliked because it showed well-known artists, almost all from one gallery's establishment modernists, and that this year's show inevitably *looked* different because so much of it was unknown to him since women so rarely get included in those prestigious shows. In the *Morning Star*, Emmanuel Cooper commented 'By any reckoning, it is a good exhibition, representing all mainstream styles and reflecting the concerns of contemporary artists, personal, political, abstract, figurative'. It is perhaps not surprising that the *Antique Collector* praised the show for its beautifully arranged gallery spaces, but the critic did go on to say that the 'works are uniformly sensitive as they are occasionally stimulating or outrageous'. Finally the *Christian Science Monitor* concluded its review 'Vague intuitions are not thick on the ground in this show: instead the art that is thorough, painstaking, methodical, brimmingly intelligent. This show is one of the most stimulating exhibitions of a collective kind seen in Britain for some time'. Although this critic betrays some gender determined expectations and praises the show for not living up to his meagre ideas, although one stumbles over painstaking, thorough and methodical (where have I heard that before?) the show is fulsomely praised, indeed all these warm words by many critics add up and confirm the notion that relief is being expressed, most often at the refutation of their apprehensions. In the *Sunday Times*, William Feaver makes that quite explicit,

> Last year's Annual, you may recall proved a convenient scratching post for those with itching prejudices. This year the whole affairs presents less of a target. True with five women picked as selectors, cynics have been predicting a pat feminist or somehow peculiarly womanly line-up. But the exhibition itself is *disarming*. At least it can't be construed as a herding of the usual Chosen, of whatever sex, into an OK corral. (My italics.)

A similarly backhanded compliment is made by John Russell Taylor in *The Times*, 'There is a very consistent level of achievement in this show, with no sign of the lame ducks who might have got in only because it is ladies' night'. Even though the evidence presented by the actual exhibited work confounded these sexist expectations, the spectre of the weak woman artist is summoned up and placed before us in the black and white of the newsprint. The oddest review in this group was by Bryan Robertson in *Harpers & Queen*. It is a long, serious consideration of the situation of women artists which concludes 'From

this diatribe, readers may gather that I take women in art seriously and welcome the idea of handing over the selection of the Hayward Show to a female committee'. But then comes the inevitable sting in the tail of this patronising liberalism. 'On the negative side, if there are proportionately fewer female artists than male artists, the number of really brilliant women is proportionately smaller. In America there's only one . . . in Europe it's hard to think of a woman artist of stature . . .' Thus may we with true generosity acknowledge the difficulties of the struggling and oppressed, but we must admit that it is from compassion we do this, not for a moment because they might measure up to our standards. Greatness seems such a natural concept, but is fundamentally a term we must reserve for successful men alone.

The reassertion of the feminine stereotype as we have known and loved it occurs in these reviews in a very interesting way. It constitutes the terms of greatest praise. So Burns is the author of 'Lyrically fine constructions', Farrer commended for 'delicacy' and 'refinement', Leapman is 'exquisite', Blow 'immaculate and rhythmic', Jaray 'decorative'. In *Artscribe*, Judith Marle praises delicately wrought works with personal content, but criticised the lack of guts, and considers the show too circumspect, audience-conscious and tentative. Spalding welcomes a feminine sensibility reflected in work she describes as gentle, delicate and painstaking.

Another facet of this critical coin occurs in the pleasure taken by critics in the way in which the exhibition was laid out. Michael Shepherd approved the use of individual spaces, 'I'd like to think this is because the home-maker aspect in woman understands the relation between space and substance and takes visitors into account'. The other side of this notion of the woman artist as kind hostess occurs in the comments of one critic who did not like the show. Although he considers that the artists and their work managed to make the austere Hayward look 'lived in', he knew clearly what should be done with such work and he advocated that the works and the artists go back to where they belong, the home.

Hostility to the show used the same overtly sexist assumptions but to different effect. Kenneth Robinson, from whom that last comment was taken wrote a piece in *Punch* entitled 'Wayward Gallery' casting over women artists the slur of deviance and delinquency. 'I didn't like the idea of all those liberated women artists at London's Hayward Gallery' he starts and explains that he chose to visit instead the exhibition of Victorian paintings at the Royal Academy where he found a painting by Frank Dicksee

called *The Confession* (1896) which showed him a strikingly emancipated woman. In the painting a dying but beautiful woman, nervously fingers her wedding ring as she confesses some sin to her anguished husband. 'It is marvellous to find that a woman of 1896 could have had such confidence . . . as she told her husband she was right to have done wrong'. Returning to the Hayward, Robinson found courage to swipe at Sarah Kent's 'uninhibited illiteracy' and of course at the feminist work of Mary Kelly:

> What this tedious woman has done is to cover several walls with framed statements of thoughts about a growing child, and the child's first precious questions about its parents' bodies . . . Still I don't want to knock at something that could brighten the waiting rooms of Queen Charlotte's (a famous maternity hospital), or the foyers of Mothercare. I just didn't expect to find it at the Hayward.

Under the heading 'Beleaguered', John McEwan of *The Spectator* provided one of the other two outrightly hostile reviews. He has considerable qualification as a critic, especially since three weeks after the Hayward opened his personal selection of paintings was exhibited at the Serpentine Gallery. This show, *The Critic's Choice* contained not a single work by a woman. He begins his review by praising last year's Annual which was 'an undeniable and critical success'. However there were many discontented artists who felt they should have been chosen, and prime amongst this group were women. He thus introduces a reading of the show that is taken up by another critic, Tim Hilton – the idea of a Salon des Refusées. (In 1863 there was an enormous outcry in Paris against the number of paintings rejected by the official Salon exhibition and the Emperor agreed that the refused works should be exhibited in a Salon of their own, so that there could be no doubt how bad they were. Of course amongst that rejected group were later famous artists like Manet, Whistler and Pissarro. But in 1863 the critics and public agreed that it was only the truly second rate who protested their exclusion.) McEwan continues slightly in this vein when he states 'The show, ironically, is rescued by men'. When he comes round in the final paragraph to comment on the women in the show, all he can say is, 'Elizabeth Frink at least exhibits none of the needle-threading eye and taste for detail that is so peculiarly the bugbear of women artists, when left to their own devices; a preoccupation that invariably favours presentation at the expense of content'. This statement can take its place in an established discourse on women's art in which women are associated with dexterity and craft, domestic spheres, lack of mental capacity and

intellectual content. Compare its basic ideology with this passage from an early twentieth-century history of Neolithic art,

> The geometric style is primarily a feminine style. The geometric ornament seems more suited to the domestic, pedantically tidy and at the same time, superstitiously careful spirit of woman than of man. It is, considered purely aesthetically, a petty, lifeless and, despite all its luxuriousness of colour, a strictly limited mode of art. But within its limits healthy and efficient, pleasing by reason of the industry displayed and its external decorativeness – the expression of the feminine in art. (Hoernes and Menghin, 1925: 574.)

In the *Spectator* review we have not only the idea that women artists are second rate, but belond in a separate sphere because their art is marked by its domestic femininity. However at the end, McEwan gives the final twist. Some work did please him; he took a 'voyeur's delight' in Ingrid Morris's installation, which 'unconsciously no doubt' alleviated the earnest constructivist section. And to end with a true liberal flourish as if even he could not quite dare to leave his position quite so blatant, he comments that it is a pity that the first show of women's art could not have included certain women, Prunella Clough, Bridget Riley, Mary Potter, Gertrude Hermes or Stephanie Bergman. That is to say women artists of quality do exist somewhere else, but in his opinion their inclusion would not have been good for the show because it would, it seems, have brought the exhibition back from its gimmick 'women' and just been about good art. Here again is one of the defensive positions when confronted with sexual politics in art. Artists may have problems and need gimmicks, but 'art exists free of such concerns' in a blessedly neutral sphere into which we can escape from anything as troublesome as politics.

It is against this intrusion of politics that Tim Hilton in *The Times Literary Supplement* takes up his cudgels. 'Art Politics are here again' he complains and continues to direct his attack against the art included in the exhibition which demands any mental effort. His piece is a dense weaving of many different strands – women's art is feminine because it has so little content and tends to the decorative. However if it introduces intellectual content it's not art, but art politics which have no place because art is purely a visual experience. 'In many respects one is encouraged to read this exhibition rather than experience it visually.' Thus the political art is twice asserted to be the weakest part of the show, weak here being in no way a quality judgment but an ideological difference of

opinion as to what art is. When women's art fails to conform to expectations and remain quietly in the sphere carved out for it by man, it can still be dismissed because it simply is not art. The organizers, he complains, 'have occasionally allowed militant feminism to triumph over artistic taste'. To complete the assault, the slur of the Salon des Refusées is cast over the show. The selection

> has clearly been made with much kindness, and they have gone out looking for art. At the same time, felled by their own penchant for the minor, they have necessarily excluded women whose work is of high quality and who belong by nature and inspiration to the fine art tradition. To have shown Katherine Gili and Jennifer Durrant, for instance would not only have shamed every other contributor; it would also have destroyed its unspoken rationale, that second-rate art deserves as much showing as first-rate.

Cutting across the favourable and the hostile responses to the show is a consistent attack on the feminist element of the show, on Mary Kelly especially. Almost echoing Hilton's 'The weakest part of the show is political art' is Lucie Smith's 'Militant feminist offered the weakest part of the show'. Kelly is however attacked for a variety of reasons. Sometimes it is over content – motherhood is not the right subject for art, it belongs in a maternity hospital or women's magazine. At other times it is her presentation that offends. Thirdly, she did not win love because of the intellectual demands her work makes on the viewer. For this Kelly was criticised as much by populist feminism as by Tim Hilton and Paul Overy. The former's attack however belongs to a political debate in the women's movement over the importance of psychoanalysis and theory, while Hilton and Overy are merely hostile to the intellectual demands made by Kelly's work and misrepresent its challenge as weakness. Here two things are operating. One is the hardly suppressed outrage against women daring to presume on privileged preserves of intellectual and theoretical work – daring to challenge male power. Secondly, and it is an observation made to me by Kelly herself, for which I am very grateful, the attack on Kelly shows how the feminine category used in art criticism operates as a construction of difference. I have said before that I think that the feminine stereotype exists as a construction through which to locate women's art as the 'other', by which masculine dominance in the art can be sustained. However the feminine stereotype is usually presented in art discourse as merely an observation of natural and biological characteristics of the female sex. Most critics

Mary Kelly (b. 1941) *Post Partum Document* (1973-9)

Detail: Documentation V: the specimens in this collection are significant for the mother because they are gifts from the child and because they coincide with his sexual researches which are set out in Fig. a and answered/not answered by the index in Fig. b.

Detail, Documentation III: the diaries are based on conversations which were recorded at weekly intervals during the child's first three months in nursery school. Each conversation was played back later the same day and again the following week with the mother's notations and revisions superimposed over the child's markings within a metaphorical perspective scheme.

Detail: Documentation IV: transitional objects refer to the hand imprints which constitute part of the mother's memorabilia and to the child's comforter fragments on which the diary text is inscribed.

found HA II easy enough to enjoy, probably because for the most part they found that the majority of exhibitors were doing nothing much very different from their male counterparts in contemporary art; in the context of an all-woman exhibition the necessity of establishing difference and excluding threatening art practices is reasserted not by distinguishing feminine from masculine, but feminist from feminine. Confronted with a 'feminine art show' (see back to the feminine praise section) that both salves the official conscience and offers no real threat, which can indeed

be endorsed and embraced as visually stimulating and pleasurable (that is serving the function of art as an untroubled world of pleasure and escape), it is the art that asserts a woman's discourse about her position that is then the object of exclusion, dismissal, denigration. If Kelly's work belongs in the foyer of Mothercare, Hiller's is not art because it is

Of the feminist artists, only Alexis Hunter's work was not subject to this categorization. This may be because her photographic montages of the theme of pain and fetishism, despite the feminist content, did

not demand the viewer a different posture in relation to the art work, nor displace the memory traces of a frisson of pain and masochism, voyeurism. This is not a comment on the work itself, but a reference to the comments I made above about the effect of the organization of the exhibition on the way in which the works shown were received and viewed.

Finally in reading the twenty or more reviews of the show, I noticed a preference for discussing three artists, Mary Kelly, Wendy Taylor (who had a number of large brick constructions on show) and Michael Sandle. It was his 'Twentieth Century War Memorial', a metal construction of a skeletal figure surmounted by the metal head of Mickey Mouse set in front of a machine gun, that saved the show for many critics. John McEwan devoted one third of his review to this piece; eleven other reviewers specifically discuss it; one reviewer described it lovingly as aggressive three times within one review. According to the critics it was powerful, brilliant, glittering, frightening and shocking. It was the only piece by a man in the show that a) did not get praised for its 'feminine' qualities of style, elegance and so on, and b) obliged the critics to employ the 'masculine vocabulary'. Judith Marle praises it simply, for its 'sheer presence'; presence and power, *the retrieval of the phallus*. Yet in another sense of the word Sandle's sculpture did have presence within the exhibition. Direct, metallic, visually striking as one entered the room it inhabited alone, it was quite different from the predominant abstractions, constructions and conceptual pieces in the rest of the show. Its appeal is popular, its meaning easily discoverable, its critique not of art, but of war, reassuringly identifiable, and for some identifiable with.

It must be one of the most remarkable features of the Hayward Annual that it did so signally fail to disturb. Rather than the controversial uproar created by last year's Annual, this show was by common consent a great boost for British contemporary art, a pat on the back for the Arts Council in these troubled times. But that means it probably did very little for women artists except to prove that they could get together a highly acceptable and enjoyable show of modern art and that women could stand beside their male colleagues and, at times, be more or less indistinguishable. But it is shocking that the main effect of this show was to attract hostility to feminist art, while, at the same time submerging their work in the overall structure of the exhibition.

However, I have to admit that there is a level at which the feminist work in the show resembled the appearance of the others – a tight classifying tendency, grids, graphs, careful drawing, pristine lines, subdued colour. For Kelly and Hiller make their work within avant-garde practices of contemporary British art and participate in its cultural climate and vocabulary. But the most important differences should not be obscured. Their art does not attempt a fantasy solution to contemporary problems, does not see art as the means to avoid the conflicts and meanings of our society by proposing an alternative, imaginative order (see the comments on Adrian Morris). Only Kelly and Hiller engaged with the fragmentary, the non-unitary and non-self-evident. Kelly most particularly radically displaces current ideologies of art by displacing the viewer's relation to an art object, and by demanding that the viewer work to participate in reconstructing the discourses set out in and through the artist's work. Kelly's work confronts one of the myths of patriarchy, Woman as Nature and Nurture, as Mother because of her so-called natural capacity to bear and raise children. This is the ideological basis used to discount women's artistic creativity. Kelly brings together in the gallery not only those historically separated roles, artist and mother, but also unites the public and private spheres, the domestic and professional whose categorical separation have served to maintain and define patriarchal bourgeois notions of what is and what is not art.

It becomes therefore easily comprehensible both why the show as a whole did not threaten the establishment and why Kelly got it in the back. The feminist presence in the show was the threat, the threat of an art that both disrupted the carefully constructed categories and exposed the ideological substructure of those categorizations. They proposed radical difference and this became the new 'other' that had to be contained by critical dismissal as weak.

Women's place in art is not natural, but historical; subjected to a categorization in order to contain their subversiveness of male categories and orders. The sociological and institutional arguments of American feminists fail to take this structural and ideological determination into account. Neglect or discrimination against women is not a central issue. A liberal policy of equal rights may slowly under pressure allow more women into the establishment, if their work does not constitute a woman's discourse, and therefore no disruption. In so far as it does, the structuring category will be reformed and reasserted to contain that threat, to contain and silence not artists who happen to be women, but women engaged in a politically radical art practice and intervention.

Michael Sandle (b. 1936) *A Twentieth Century War Memorial* 1971-8
This was the second most popular choice for illustration by the press and the two compliment each other.

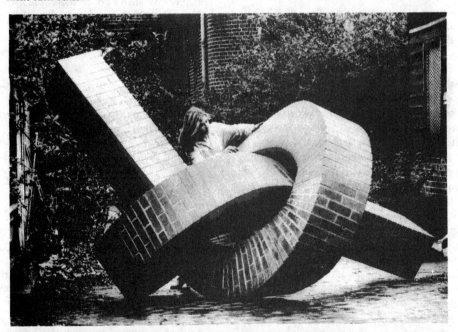

Wendy Taylor (b. 1945) *Brick Knot* 1978
The photograph illustrated here shows the sculpture, but not in the exhibition context. it was, however, the press photographs most extensively used by reviewers to illustrate the exhibition. Its setting, in the artist's home or backgarden and the landscape surroundings, its scale and the careful placement of the artist herself seen almost locked into the giant brick knot unwittingly illustrates the points I make in the text about the 'romantic' undercurrents of the whole exhibition.

179

I will conclude with a quotation, a comment and a warning. Frances Spalding concluded her review with this paragraph,

> The success of this show must mark a great step forward in the move to end the cultural repression of women. The indications of self-discovery, untapped energies recently discovered, of co-operation, of content that has direct political and social relevance suggest that women artists today have the potential to become the most explosive force in future British art.

Untapped sources of newly discovered energy may well be a great find for British art, a much needed injection of new talent, a new resource to exploit, exploding like North Sea oil into the faltering economy of British art. That is one of the reasons for Lucy Lippard's warning about women rushing for larger slices of the 'pie'. Partial absorption is not only possible but may be welcomed. The reasons for women's apparent 'exclusion' in the past do not lie in either their failure as artists or in discrimination exercised against them, but results from the particular place allotted to women in society and its discourses. It is against that placement that women have to fight, by forms of interventions through art practices based on a radical representation of that position both in social structures and discursive practices. The nexus of conflicts and contradictions that was the Hayward Annual in 1978 has made this a great deal clearer.

What is needed now is an exhibition of feminist work which will present and encourage debate around the issues of feminist and art practice which have emerged within the women's movement. But such an exhibition must take place in established institutions of art, conceived of and structured as a sustained political intervention. The Hayward event not only clearly exposes the problems and confusions resulting from a limited project of correcting bias in numbers of women exhibiting. But it also makes equally clear the dangers of the ideology of 'alternative' practice for women. By remaining outside public institutions and therefore invisible to them and their critical discourses, women endorse their place in the separate sphere historically created for their work, thereby colluding in their own marginalization. In effect they provide the perfect complement to the retrieval of the phallus so anxiously sought after by anti-feminist

critics of the Hayward show, re-presenting the 'feminist' in the place of the other, the excluded, the weak, the injured, in a word, the 'feminine'.

Notes

Griselda Pollock teaches the history of art and film at Leeds University.

1 Quotations and references are to the following reviews:
 Tim Hilton, *Times Literary Supplement* 27.8.78.
 Edward Lucie Smith, *Evening Standard* 24.8.78.
 John McEwan, *Spectator* 9.9.78.
 Paul Overy, *Time Out* 22-28.9.78.
 Kenneth Robinson, *Punch* 6.9.78.
 J. Russell Taylor, *The Times* 24.8.78.
 Frances Spalding, *Arts Review* 1.9.78.
 Antique Collector, October 1978.
 Artscribe, No. 14, 1978.
 Christian Science Monitor, 2.10.78.
 Harpers and Queen, September 1970.
 Morning Star, 19.9.78.
 Vogue, August 1978.
2 Art practice: a term used to assert that art is a process of production, a practice in the sense in which we speak of theory and practice, and political practice. 'Women's art' connotes the paintings or objects that are the product of the practice.

References

GOMBRICH, Ernst (1950 + 1967) *The Story of Art* London: Phaidon Press.
HAUSER, Arnold (1951) *The Social History of Art* London: Routledge and Kegan Paul.
HAYWARD ANNUAL 1978 CATALOGUE (1978) London: Arts Council.
HOERNES, H. and MENGHIN, C. (1925) *Urgeschichte des Bildende Kunst in Europa*, quoted in HAUSER.
LIPPARD, Lucy (1976) *From the Centre* New York: E. P. Dutton.
PARKER, Roszika and POLLOCK, Griselda (September 1979) *Old Mistresses: Women, Art and Ideology* London: Oresko Books.
TAMARIND LITHOGRAPHY WORKSHOP (1972) 'Sex Differentials in Art Exhibition Reviews' *Feminist Art Journal*, Spring 1972.

Source: *Feminist Review*, 1979, no. 2, pp. 33-54.

Rozsika Parker
'The story of art groups'

"Things are changing. Women artists are making contact with each other, coming out of their isolation," wrote Liz Moore back in 1972. "We are beginning to acknowledge the validity of our own and of each other's work; to learn to do without male approval, to be proud to show in company with each other. We are learning to provide each other with the confidence to explore and develop our own vision, born out of a new consciousness: and we believe that the existing male-orientated art world, distorted as it is into a sort of international stock market, needs the transformation of this vision and consciousness in order to survive."
(Towards a Revolutionary Feminist Art)

Liz Moore belonged to one of the first women's art groups to form in this resurgence of feminism. Together with Monica Sjoo, Beverley Skinner and Ann Berg she organised 'Womanpower' (*SR* 12), the show that had the porn squad steaming to London's Swiss Cottage Library to huff and puff in front of Monica Sjoo's painting 'God Giving Birth'.

At the same time other women artists joined the Artists' Union (*SR* 13) which formed with the aim of seeking affiliation with the TUC. As an organised group they hoped to ensure that women's demands actually became part of the Union's plan of action. They succeeded in establishing a special workshop on women which nominated members of their group for all positions in the Union. Not content with having equal numbers of men and women as workshop convenors and officers, the group also demanded that the Union should eventually aim to establish parity among the entire Union membership. Once members of the workshop were actively involved with the running of the Union, women's issues were quickly brought to the fore. A majority vote established "to end discrimination in the arts" as one of the Union's major aims.

The workshop itself researched the situation of women in the arts, calling for equal representation of women in public exhibitions, an end to discrimination in the hiring of art school staff, and that art school attitudes should be thoroughly investigated. Eight years on women are still making the same demands, but beyond the odd token

gesture, they fall on stunningly deaf ears.

At regular meetings the workshop also discussed each other's work and their own situation as artists. Collective projects started including the documentary exhibition by Margaret Harrison, Kay Hunt and Mary Kelly on women sheet metal workers in a Southwark factory (*SR* 40).

The workshop within the Union came to an end (though some members still meet today as the autonomous Women Artists Collective). But a pattern had been set for women's art groups. All over the country groups

started as discussion and support groups, to produce magazines, to show together, to share skills and to create collective art works like Feministo. Women exchanged art works through the post, often using traditional domestic craft techniques to express their feelings about children, housework, marriage. As *Spare Rib* pointed out, "The significance of Feministo goes way beyond individual art works: both form and content of the art takes up many of the criticisms the women's movement has levelled at established art practice, it undermines the idea of the isolated genius by revealing the collective basis

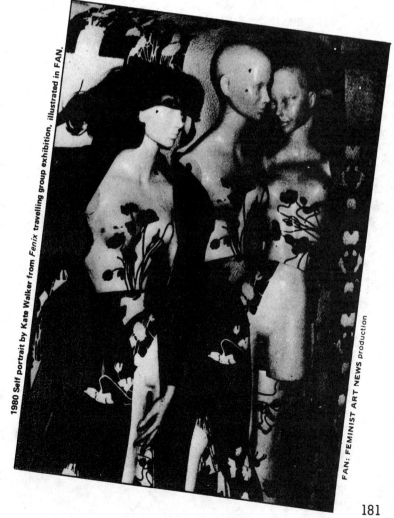

1980 Self portrait by Kate Walker from *Fenix* travelling group exhibition, illustrated in F.A.N.

FAN: FEMINIST ART NEWS production

of inspiration: 'images are re-iterated in different people's work, images and ideas aren't private property' " (*SR*60).

Co-operation not competition is the aim of the art groups — but everything is weighted against it. Artists, more than any other group, work in a highly competitive structure and for women artists it's even worse. The givers of grants and selectors of shows may make room for a couple of women, but then they will be constantly compared and measured against one another.

How, we wondered, are women's art groups faring today? We wrote to the ones we knew about (sorry if we missed yours out) and the replies we received suggest that the Women's Art Movement is still thoroughly alive, though it's lost that first flush of optimism. "I feel a bit disheartened about the art group," wrote one woman. "As soon as you start something like this it becomes apparent that you have very different ideas/positions on ART, WOMEN'S ART, WHO ARTISTS ARE . . . which I fear is what's baulking us at the moment

. . . we DON'T AGREE! Here's hoping something will bring us together in the near future." Feminists are attacking not only the psychological and institutional discrimination facing women artists, but every aspect of art practice (art education, the role of the artist, art form and content, ways of working, exhibition formats and more). So it's not surprising that groups limp, split or explode under the pressure of political differences. Should feminists exhibit in public galleries, challenging the system from within? Or should women concentrate on developing their own alternative spaces? Can abstract art be feminist art? Or does feminist art demand polemical content? Endless, endless arguments. But because the issues are so live, new groups form with apparently boundless energy.

Since 1972 the problems of group work have become clear: "The group needs a few guiding spirits to organise it and I'm busy guiding my own spirit away from areas of disintegration at the moment, never mind organising any one

else's life" (Fanny Tribble, *Manchester Group*). But issues of shared responsibility apart, group work still gives people courage to air their art: "One of the things that people have often said is, well how can you do it, how can you do it, how can you go in public and put all your dirty washing out? We're all scared of that, but people don't realise that fear is overcome by group support" (Sue Richardson, *Fenix*). And group work is still considered by some to be the appropriate form for feminist content: "The essential structure that we got from CR groups won't build into current art forms as they stand, I find my other, more traditional ways of working, less personally satisfying than the experimental group works because of this misfit between form and content" (Kate Walker, *Fenix*).

Some women from the early groups still work together. Women involved in 'Womanpower' at Swiss Cottage now exhibit as 'Woman-Magic'. In April, once again, their work was charged with being obscene and removed from the Lancaster Theatre cafe where it was exhibited. And though women from other groups have scattered, reverberations from their group activities continue. Individuals build on what the group began. Two members of the long defunct Women's Art History Collective are bringing out a book next spring on ideas which originated in the group.

So whatever the state of individual groups, the Women's Art Movement has had impact. In the early 1970's no public gallery would touch a show of women's art selected by Lucy Lippard — this autumn the Institute of Contemporary Arts in London happily houses her women's show, 'Issues'. And just as significantly, more and more young women come to *Spare Rib* when they leave art college, looking for a way to put their feminism into art practice.

The following is a partial list of existing groups — please send us details of any group we have missed out so we can complete it.○

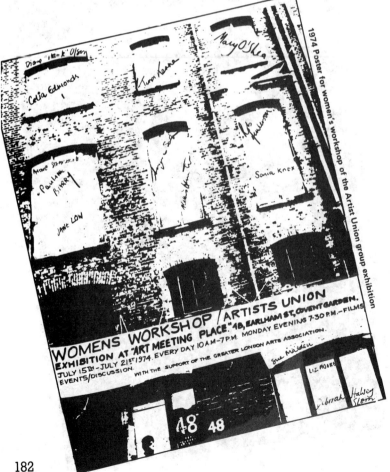

1974 Poster for Women's workshop of the Artist Union group exhibition.

MANCHESTER WOMEN'S ART GROUP
c/o F. Tribble, 12 Pine Grove, Manchester 14. Open, irregular meetings
SOUTH LONDON ART GROUP (SLAG)
c/o Chick Hull, 33 St Margarets Road, Brockley, London SE4. Open, regular meetings
IRIS SHEFFIELD WOMEN'S PHOTO-GRAPHY GROUP c/o Dais Cliffe, 70 Edgedale Road, Sheffield. Open, regular meetings
LEEDS WOMEN ARTISTS GROUP
c/o The Swarthmore, Woodhouse Square, Leeds 3. Organises a day school two or three times a year.
NOTTINGHAM WOMEN'S ART GROUP
c/o Nottingham Women's Centre, 32a Shakespeare Street, Nottingham. Open, irregular meetings

WOMEN IN ART SOCIETY c/o Psalter Lane Site, Sheffield Polytechnic, Psalter Lane, Sheffield. Open, regular meetings

LONDON WOMEN ARTISTS COLLECT-IVE c/o Women's Arts Alliance, 10 Cambridge Terrace Mews, London NW1. Closed, regular meetings

HACKNEY FLASHERS c/o 7 Archibald Road, London N7. "Dormant at the moment"

SOURCREAM COMIX c/o Sisterwrite, 190 Upper Street, London N1. Open, regular meetings

FAN: FEMINIST ART NEWS production group, c/o 79 Blenheim Road, Moseley, Birmingham 13. (subscription £2 for 4 issues)

FENIX c/o 79 Blenheim Road, Moseley, Birmingham. Travelling, evolving art work. Pamphlet/art work available for 65p inc. p&p (limited edition of 100).

WOMEN'S ARTS ALLIANCE 10 Cambridge Terrace Mews, London NW1. Women's art centre.

X FACTOR GALLERY c/o Arts Alliance

BRISTOL WOMAN-MAGIC GROUP c/o Monica Sjoo, 11 Durdham Park, Redland, Bristol 6.

ROYAL COLLEGE OF ART WOMEN'S GROUP c/o Students Union, Royal College of Art, Kensington Gore, London SW7

SLADE SCHOOL OF FINE ART WOMEN'S GROUP c/o University College, Gower Street, London WC1.

SLIDE LIBRARY OF WOMEN'S ART of the North East, c/o Carmen Wills, 25 Dursley, Whiston, Knowsley, Merseyside L35 3TB

WOMEN ARTISTS SLIDE LIBRARY c/o Flick Allen, 40 Lydgate House, Woodville Road, London N16

DEMOCRATIC WOMEN ARTIST'S SLIDE EVENINGS c/o 60 Auden Place, off Princes Road, London NW1. Open, irregular meetings, depending on need and opportunity.

We also heard from **Phil Goodall**, 14 Valentine Road, Kings Heath, Birmingham who has and will help organise exhibitions, publications and events.

Source: *Spare Rib*, 1980, no. 95, pp. 50-51.

Section III
Exhibitions
Introduction

Over the decade 1972–85 there has been a rich history of feminist exhibitions, many of which we document here, with eight dossiers. It is important never to underestimate what a significant and personally risky move it was for those women who first decided to exhibit together as women in an all-women show. It was also extremely difficult to find a venue that would even consider, let alone, accept an all-women show. Two exhibitions of 1973, 'Womanpower' and 'Three Friends' demonstrated the already diverse possibilities of the art by women. 'Womanpower' raised most vividly the issue of content, overtly insisting upon the singularity of women's consciousness and experience and the need for a specially fashioned iconography to celebrate it; 'Three Friends' was a show with less consciously articulated motivations, but none the less its effect was to raise the issue of a sensibility that was autobiographical and often formally suggestive of female experience.

These and other feminist exhibitions indicate a pattern of concerns and general lines of development, which started with the mere fact of women exhibiting together, but led to the identification and treatment of content, evolved and comprehended through consciousness raising and theory combined, which asserted what had hitherto been taboo topics. These taboo topics, suppressed and denied in art, were of course the commonplace of women's daily and working lives: menstruation, childbearing and rearing, domestic labour and so forth. These new contents have necessitated new forms of exhibition often involving the audience more actively in making their own sense of that which is on show. Some new forms of practice as well as of exhibition stress the active and visible role of the women as artist – in performance and live work, in the intimacies of video. Others have refused the separation of production and consumption and bring the working processes into the gallery. We can see in the history of feminist exhibitions the internal development and history of the Women's Movement's more and more complex understanding of women's oppression and of the role of cultural definitions in political struggle. We can trace how terms have

changed, how exposure of content now necessitates reflective and analytical dimensions as well, how links are made beyond the initial position of women artists becoming visible to the broader cultural and political struggle.

Most of the shows documented in this section have been of major significance as much in the history of British art in the 1970s as in the history of feminism. But the responses – from critics as well as from art officials – have unfailingly displayed the continuing fear which feminist cultural work generates in the masculinist establishment. Without our record these very recent events could easily not only be hidden from history but appear never to have entered it, never to have happened at all.

'Woman power'

In Spring three important exhibitions of women's art opened. They were group shows, and in all of them I sensed the excitement and stimulation of shared ideas yet each of the artists preserved a personal approach.

"WOMAN POWER"

Five feminist artists brought together by common aims were responsible for the controversial exhibition at Swiss Cottage library. Their styles vary widely from Ann Berg's bright colours and sinuous lines to Monica Sjoo's almost austere canvases, and their subjects range from Beverley Skinner's exploration of matriarchal mythology to Liz Moore's perceptive portraits. However, they share a determination to express their experiences as women, to portray the spirit of the Women's Movement and to challenge the male dominated art world with both the form and content of their pictures.

Everytime they exhibit they create an extraordinary response. Because of threats and complaints by the public, the police visited the exhibition bringing in their wake the critics and reporters who had virtually ignored the show until then. The porn squad was called in apparently because a number of the paintings show women giving birth. Monica Sjoo originally turned away from abstract art to feminism and figurative painting after the birth of her first child. She found childbirth both "dignified and incredible" and it led her to question societies view

of women. She began to paint pictures of women in childbirth as strong, dignified and immensely self possessed, in a style accessible to everyone. No-body could seriously consider such paintings obscene or liable to corrupt children.

The exhibition at Swiss Cottage was one of the most animated shows I have ever visited. I was constantly stopped by people eager to air their views on the pictures, and there was a queue waiting to write in the visitors book. Comments varied from "Right on sister", "This says it all" to "While you are burning your bra, burn your paintings too".

The artists believe that the hostile comments were not so much an attack on the paintings as a reaction against Women's Liberation. I am not sure. We have all become so accustomed to accepting a work of art as a cross between a toy, a stockmarket bond and a sacred object that many people were actually embarassed and bewildered by the frankly political and emotional nature of the women's pictures. Polemical art is such a rarity in England

that we feel uncomfortable and defensive. We expect art to provide only aesthetic pleasure and entertainment and certainly not to preach Women's Liberation. We are used to indoctrination in ads but not in art.

It's not surprising that polemical painting is rarely seen – there could scarcely be a more difficult medium. If a message is to be conveyed forcibly in two dimensional images it is hard to avoid cliches. I have nothing against polemical art, indeed the Women's Movement has already mothered the excellent Women's Street Theatre, but with painting the danger of being trite or being misunderstood is greater. The danger is well illustrated by Monica Sjoo's picture "God Giving Birth", it is certainly not a cliched image but it is misunderstood. She discusses ideas behind her work in the

pamphlet "Towards a Revolutionary Feminist Art" and anyone who has considered the implication of a matriarchal god appreciates what a strong symbol she has created in her painting. However, paintings provide images not arguments and some people accused her of blasphemy. At the public meeting to discuss the exhibition the five artists tried bravely to organize constructive discussion but it was impossible because there was so much rhetoric and so much anger about. Ann Berg attempted to explain that they were aiming to "raise women's consciousnesses to be aware of themselves as creative beings". Someone replied, "only by liberating the entire working class will women artists be free". Soon the meeting erupted into a chaotic variety of behavior with one man ripping up his T shirt and declaring "I may have a man's body but I have a woman's soul", while another man leapt to his feet with a tirade against his mother and someone else circled the meeting crying that we were all "moral vigilantes".

If you were a frustrated member of the meeting and really wanted to hear the artists views, read their pamphlet "Towards a Revolutionary Feminist Art" 10p from The Womens Workshop, 3 Shavers Place, Haymarket, Piccadilly, London W1.

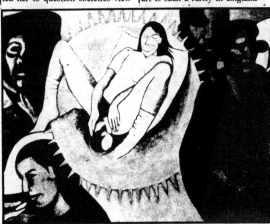

Creation Monica Sjoo

High Priestess Beverley Skinner

Source: *Spare Rib*, 1973, no. 12, p. 19.

III.2 1973 Dossier: 'Womanpower' (2)

Monica Sjoo
'Some thoughts about our exhibition of "Womanpower: Women's Art" at the Swiss Cottage Library'

Five of us took part: Liz Moore from London, Ann Berg from Manchester, Roslyn Smythe, Beverly Skinner and I from Bristol. (although I am Swedish and Bev and Roz Canadians.) Thanks to all the publicity we got as a result of the local Festival of Light (fascists) squad making complaints to the pornography squad of Scotland Yard (they decided to not do anything about it after duly investigating the exhibition) great numbers of people came to see the work, discussed it, wrote comments in the visitors' book and thoroughly enjoyed themselves. All classess, sexes and races of people came through the library ? which is after all a public place and not just an exhbition place.

We feel that we have done just a little towards throwing the whole question about what is 'art' open and its functions anyway, that we have launched an attack on the male business artworld where huge canvasses of abstractartt goes from dealer to dealer at enormous prices and profits and where you have to belong to the trendy 'in-crowd' to get anywhere .

Women artists are made to compete with male artists at the cost of their humanity and have toenonnuce motherhood and children to be taken seriously. There is a man-made myth in our society that once a woman has children she has fulfilled her creative or any other needs. I was personally just about told by somebody high up in the Arts Council hierarchy (when we wwere trying to get a show at the Arts Council owned Serpentine Gallery) 'what do you think you are doing trying an betist as well as a mother'. I was also told that 'it is us, poor men, who have to subliminate our needs in ART ' but in the next breath I was told that there is no discrimination against women in the artworld. Well that might be so if you behave as a 'decent chap' (ie. have balls) !

Anyway women are taken on at male-run artschools if they are either 'feminine' or 'butch' and all the standards, rules and ideals are set by middle class white males. In the artschool they do thousands of studies of nude females so called artists' models - who could just have well as been pieces of furniture, apples or any other 'thing' (by the way I worked myself for two years as an artists' model after leaving school at sixteen).

There has been a long tradition in European bourgeois painting of showing women as sexual or luxury commodities who are there simply to please the male spectator - the owner of both women and paintings. John Berger's book 'Ways of Seeing' illustrates this very clearly.

So ... when we have in our exhibition paintings of women, showing the rawness of sexuality and childbirth - the reality behing the passive facade of the 'happy housewife' (did you ever meet her?), women preoccupied with their own identity and women as mystic, high priestess, and a painting of 'God Giving Birth', then that is seen as a threat to the whole of patriarchal culture - and so it is.

The painting 'God Giving Birth' was the one that many of the complaints were about it was supposedly pornographic and blasphemous. I would say that because 'God' is seen as a nonwhite woman of great dignity, looking straight ahead unsmilingly, with a child coming out of her womb, between her legs.... it is disturbing. What I mean is that if it had been painted in bright colours, the 'God' had had long blonde hair and been pleasantly smiling that would have probably been okay because she would have at least been seductive to men. Also the image attacks the absurd myth that the creative force is male and phallic.

When an English artist Allan Jones does degrading sculptures of women as tables, on their knees wearing black stockings and garter belts, he has the nerve to call them female experiemnts and gets away with it
but then of course anyone can go down to the nearest London tube-station and find almost equally degrading images of women everywhere (adverts & posters) selling everything from toothpaste to cars. But when a woman states her belief in 'God Giving Birth' the same people who take these adverts and images of women as perfectly 'normal', will try to close our show down or threaten to deface the paintings.

The comments in the visitors' book from the exhibition is full of page after page of the most incredible either vicious comments like; 'when you have finished burning your bras why not burn your paintings too', 'these are obviously five confirmed lesbians and very unattractive women who cannot get anymann and this is why they do these ugly and aggressive paintings' or women writing very supportively 'Right On Sisters! I am right behind you' 'this is the most important exhibition I have ever seen and at last painting that talks about me'. There were a lot of very good vibrations and excitement and I felt particularly good when an elderly woman who does some some painting herself, came and said to me 'This show has given me a lot of courage, I no longer feel I have to apologise for doing women's painting, now I can go right ahead.'

Many men complained that the women in the painting were 'ugly' or 'aggressive' - this shows to me what degree the pleasing masks that women are forced to wear are seen as truly belonging to us while anybody who cares to look can see the real faces of women and they are by far he more beautiful, dignified, strong than anything seen on the plastic woman in adverts, in men's art. Which is of course the reason why it is so important hat we women start looking at each other and make images out of our own eyes out of what we honestly see and discover.

We feel that at this point in history to understand ourselves, our situation as women and to be able to use our art as a revolutionary act we have to do figurative, representational art (this is true for us but not other groups of feminist artists necessarily) about women's real lives, work , struggle and ambitions - which is an untapped an enormous sphere of of subject-matter and emotions.

We also refuse to separate ourselves, our lives (most of us are poor, some live on Social Security, some work at odd jobs) from that of our sisters. Three of us have children and share nappiewashing and household work with the majority of women. Some of us have never been through artschool training or had any further education and had to find our own means teaching ourselves.

Which women with children can go through years of artschool training or de devote her whole day to her work? that was the privelege of white middleclass men who had women and servants to do the shitwork, look after 'their' children.

Keeping the records

We feel that because our lives are involved in things that matter, our work will and does reflect this. When women start doing paintings about the actual reality of their lives, then things will start happening!

We are calling a meeting of WOMEN IN ALL THE ARTS including music, film, theatre, etc. on July 1st. in LONDON, 7.30pm AT THE LARGE HALL ST.-PETER'S CHURCH, BELSIZE SQUARE-NW3
to discuss possible action collectively, art and revolutionary action etc. TO ATTACK THE REACTIONARY MALE ART ESTABLISHMENTS ETC. TO SIMPLY COME TOGETHER, SHARE OUR VISION, LOVE, EXPERIENCE

written by MONICA SJOO
typed by ROSLYN, run off by MONICA
BRISTOL MAY 1973

Peter Cole
'Porn Squad eyes Women's Lib art'

The Director of Public Prosecutions is studying a report on an exhibition of Women's Liberation paintings after a visit to the exhibition by members of Scotland Yard's anti-pornography squad.

The exhibition, which has been running since April 7 at the Swiss Cottage public library, North London, and is due to close on April 28, has produced numerous complaints to Hampstead police that pictures of nude men and women should not be on show in a place where children can see them.

The exhibition was organised by Camden Council's visual arts manager, Mr Peter Carey, who said yesterday that about 3,000 people had already been to see the paintings. He had received two complaints and an anonymous telephone call from a man who threatened to deface some of the pictures.

For this reason Mr C a r e y decided to work in the hall where the pictures are on show. Standing among the controversial canvases yesterday he said: " I would defend the exhibition to the death. It is an important exhibition, and I can't imagine it corrupting any children. My own children are 12, 10, and eight, and I shall be bringing them to see the paintings this weekend. I don't believe children have a sense of shame. They are given one."

The centrepiece of the exhibition is " God giving birth " by Monica Sjoo, which depicts God, in the form of a woman, delivering a child. Yesterday afternoon, an elderly man carrying a brown paper bag walked into the gallery, stared at this picture for about a minute, loudly muttered " Christ," and walked out again.

The theme of the exhibition is clearly Women's Lib—one

poster carries the slogan " Women need not always keep their mouths shut and their wombs open."

Elizabeth Moore, one of the artists, believes that antipathy to the exhibition is largely a manifestation of anti-Women's Lib feeling. If the paintings had all been done by men, she was sure there would have been no fuss.

Mr Frank Dobson, leader of Camden Council and chairman of the libraries and arts committee, saw the exhibition on Tuesday and said yesterday that he saw no reason why it should be the subject of a prosecution. He could see that some people might find it obscene, and he did not like all the paintings himself, but that was no reason to ban it.

Source: *The Guardian*, 19 April 1970.

Clive Borrell
'Police see Women's Lib art show'

Scotland Yard's Obscene Publications Squad has sent a report to the Director of Public Prosecutions after complaints about paintings in a " Women's Lib " art exhibition at a London public library.

Soon after the squad went to Swiss Cottage library, Mr Peter Carey, the exhibition manager, said: " I do not think these pictures are obscene, and I will refuse to remove them if the police tell me take them down. In fact, I will be happy to stand up in court to defend my action to hang these pictures in the exhibition."

The show, by four woman artists, all claiming to be supporters of the Women's Liberation movement, contains several paintings and drawings, some depicting birth and sexual intercourse.

Since it opened on April 6,

local police have received many complaints. Mr Carey has received anonymous telephone calls from people threatening to smear the paintings.

Penny Radford writes: The exhibition is centrally placed in the library. Visitors are greeted by a large painting of a naked goddess giving birth. The picture, by the Swedish-born artist **Monica Sjoo, seems to be at the centre of the controversy.**

Miss Elisabeth Moore, another of the four woman artists, said: " Our intention is no primarily to provoke, but to make our own statement. If you want to see obscenity in London, go into the Underground stations and look at the advertisements.

" The image of woman has been debased for a long time. It's about time women started to explore and create an image for themselves which includes some

dignity and strength."

None of the visitors interviewed at the exhibition yesterday seemed to find the paintings obscene in any way. Mrs Sylvia Matheson, from Kilburn, said she would have no objections to her children visiting the exhibition. She felt they would understand better than she did some of the more puzzling images.

A comment in the visitors' book indicated another, and perhaps more realistic, reaction. " I feel saddened that the total output of ' four women artists ' is such a conglomeration of spite towards humanity ", one visitor wrote, presumably after studying the generally angry and miserable expressions on the faces of the women depicted.

The library plans to hold an open meeting on April 27 at which views can be expressed.

Source: *The Times*, 19 April 1973.

III.3 1973: 'Three Friends'

'Three Friends'

Three friends have broken the male monopoly on that enormous exhibition space, Gallery House. Carla Liss, Susan Hiller and Barbara Schwartz managed to assemble an exhibition of their work despite the fact that Gallery House was on the verge of closing and could offer no assistance. Originally they wanted to organize a huge exhibition of women artists' work but their idea was rejected. It's a pity because the series of exhibitions held last year at Gallery House called "Survey of The Avant Garde" gave us little clue what women are doing now as the series included the work of only one woman artist.

The "Three Friends" proved beyond doubt that no survey of the avant garde is worthy of the name without women's work. Carla Liss and Barbara Schwartz showed films. Susan Hiller exhibited the large tissue paper construction "Transformer" and, under her pseudonym Ace Possible (phonetic Spanish American for "it is possible") gave a slide show which cleverly opened our eyes to the high premium we place on the mindless assimilation of facts. Carla Liss created an entire environment with simultaneous projections on four walls. She calls her film "Dovecote" as it transports us into a dove's world in the centre of a stone tower. To the sound of doves cooing and beating wings she shows us a constantly changing bird's eye view of the dark inside of the tower and the bright trees and sky through openings in the stone work. Barbara Schwartz films included "Homemovie", a highly personal exploration of different techniques, and images that caught her eye.

You will have an opportunity to see their work this Autumn when, together with other women artists, they plan to take over a street of houses vacated for demolition and hold an open women's exhibition. The exhibition, to be called "Women's Work," promises to be an entirely new kind of show. Anyone will be able to submit anything they believe others might want to see and there will be discussions, documentation, events and more.

Susan Hiller Transformer

Source: *Spare Rib*, 1973, no. 12, p. 29.

'Handout about proposed exhibition "Women's Work"'

Organising Committee:

Helen Dracup	485 9509
Marilyn Halford	254 9211
Susan Hiller	229 5259
Signe Lie	267 1597
Carla Liss	254 9211
Christina Toren	289 2305

Too many women are 'secret' artists, reluctant to show the products of their work because it is, in many cases, largely functional, seen as an accessory to everyday living. WOMEN'S WORK is to be an exhibition of extraordinary and special objects, events, artworks, baked works, dances, films, works of love - in short anything which a woman may consider something to be looked at, or participated in, for the sake of its aesthetic rather than its purely practical relevance to her own life and the lives of others.

A basic function of this show is the re-evaluation of women's work and the eradication of the accepted barriers between the different intellectual stratas apparent in art. We want to exhibit the products of women's creativity on all levels, from the works of professional and committed women artists to those of women who are carrying on an old tradition in handicrafts such as pottery, carpet-making, tapestry and other home-making activities. We suggest that there is a continuity of intent and feeling in all the work done in love by women and we want all women to have a chance to see if this is so, to see their work in a new context. We make no rules as to what is and what is not acceptable as art. We want to see women's creativity acknowledged - by themselves and by men, women's diffidence about their own work is something we wish to see overcome.

We are inviting all women who are producing work which they feel is extraordinary, exciting, wonderful in its visual properties to submit this work to an open show - one in which we hope to see films and events shown and performed alongside exhibits of objects, paintings and other works, all by women.

Why women? Simply because the opportunities for professional women artists to show their work are rare and the temptation for all women to judge their own often very different work by masculine commercial standards is usually sufficiently discouraging to prevent that work being seen outside the context of the home. While it has always been recognised as man's proper role to strive to go beyond everyday existence into the expression and interpretation of it, to go beyond functional production to the creation of objects designed to be seen as well as used, women's work has never been looked at in this light. It is time for women to come out of their artistic purdah and share the products of their creativity with others. We expect the exhibition WOMEN'S WORK to be, at the very least, an experience from which all women (and men) can learn something about themselves and the nature of creativity.

Rozsika Parker
'Art has no sex. But artists do'

Laurie Anderson: *"I've always resented the 'Hey Baby' assaults because they usually come after I've passed by. They aren't attempts at communication. But ways of turning me into a thing to be coolly assessed. I decided to take my revenge by taking (stealing) their picture. One day in the middle of June I took the photographs of 9 men who made unsolicited comments to me. To my disappointment, most of them seemed pleased and flattered that I had wanted to take their pictures."* Laurie Anderson exhibited the photographs and records of the men's reactions.

Eleanor Antin: *"I live in California and from November 24 to December 15, 1971 a period of 17 days – I planned to visit New York City with my husband and small child. We planned to stay with my mother in her Manhattten apartment..."* Eleanor Antin recorded her conversations with her mother and the compromises she made to keep the peace between them. Her exhibit consisted of descriptions and graphs of the emotional contents of their talks, ranging from 'boredom' through 'agitation' to 'provocation'.

Mierle Laderman Ukeles: 'Maintenance Art' *"Development and Maintenance the sourball of every revolution: after the revolution, who's going to pick up the garbage on Monday morning? She requested that for one hour per day during the entire run of the exhibition, all maintenance work done by the regular maintenance people was, with their consent and awareness, considered art.*

Laurie Anderson, Eleanor Antin and Mierle Laderman Ukeles are 3 of the women included in the exhibition of 26 American conceptual artists which was shown in London during April. Lucy Lippard, the New York writer who organised the show, gives the following definition of conceptual art "in conceptual art, the idea is paramount – permanence, formal or decorative values are secondary or of no concern." The ideas, like the three described above, were exhibited in different ways; with photographs, texts, tapes, drawings, forms for visitors to fill in etc. The only factor they had in common was that each artist's work had to fit into a foolscap envelope to enable the show to tour Europe and the USA in a packing case and be seen by as wide an audience as possible.

The gory details

Last Summer, readers may remember, we mentioned that Roselee Goldberg was planning to exhibit the show at the Royal College of Art. In retrospect the announcement was premature. We should have predicted the mental and physical problems involved in mounting an all women's show in England. Sure enough, before the show arrived, the Royal College refused to supply the small space and meagre sum of money required for it. The Arts Council was asked for funds but they too rejected the idea. Finally, Garage gallery joined the struggle and approached the Arts Council who then miraculously found the money. But not enough. The show arrived,

and survived purely on voluntary labour. So ironically, the Arts Council, whose shows of conceptual art have excluded women, profited from our eagerness to see women's work.

Of course the danger is that the Arts Council will feel that they've now had their women's show, when the group of women who are trying to organise a large show of English artist's work are still finding it absolutely impossible to procure the space or the money for the project. Exhibitions like those organised by the Women's Workshop of the Artist Union – with the artists present to explain their decision to exhibit together – are badly needed.

An exasperated reply

But the show went on and provided, amongst other things, a focus for very good, productive discussions on women and art. The first question raised by people who appear not to have noticed the percentage of all male shows in London was, "why have an all women show?" Lucy Lippard, in her introduction to the catalogue, gave her reason:

"This fourth show includes only women artists, by way of exasperated reply on my own part to those who say 'there are no women making conceptual art'. For the record, there are a great many more than could be exhibited here. Inevitably there will be complaints about the sexual limitation of this show, to which I can only say that all curatorial limitations or whims ('German Art Since 1945', 'Color Painting', 'The Cat in Art', 'American Artists under 35' etc.) are equally ridiculous and, for the curator, equally necessary."

A cat may well respond more to 'The Cat in Art' than 'American Artist Under 35', and certainly as a woman spectator I found plenty to respond to in 'C.7,500' as the show was called (referring to the population of Valencia, California, where the exhibition originated). Lucy Lippard again suggests the reason why:

"All art no matter how 'rational' comes from *inside* the artist and the social and biological experience of any woman is very different from that of any man in this society. Art of course has no sex. But artists do."

In and out of uniform **Renee Nahum**

And so do spectators. However, there was a wide spectrum of vision and experience represented within the show - by no means all the women were feminists - and concerns varied from examination of role playing, to the nature of art, perception, communication, identity and change. The idea of change was an important component of the show. Caroline Tisdall, speaking recently on alienation and the artist, said that she wanted art to be an expression of a will to change society; "we lack a notion of art as an evolutionary activity", she said. The artists who confronted various facets of women's experience in 'C7,500' were presenting art as an 'evolutionary activity', but not in a preaching didactic manner - more in a spirit of inquiry, both humorous and inventive.

Analysing the saint

Laurie Anderson discovered during lectures on the History of Art that she had a talent for falling asleep in public. Together with a woman photographer friend she explored the taboo on public sleeping. Her friend photographed her sleeping and they recorded both her dreams and people's reactions to the sight. One of the few places where they were not hassled was in a women's lavatory.

Agnes Denes asked artists to fill in questionaires and she sent the answers to two different psychologists. The exhibit 'Psychograph' consisted of the questionnaires and the written analyses by the 2 shrinks. " 'Psychograph' she writes, "deals with approximate truth; its subject matter is artists and the aura they must, or feel they must create in order to exist and do their art. It also reveals the outside world's perception of artists, in this case the psychologists. It reveals them as well." It did. It showed walls of defensiveness interfering with understanding and communication.

In 'Fantasy, a group work', Ryan Canby wrote, "instead of brushes they use costumes, their environment and other people. Painting is a medium understood by and large by those trained in art schools; this new work by women artists can speak to all those who fantasize about themselves in new roles in order to stretch their identity." The group of women that she is talking about lived out and disected their fantasies using make-up, clothes etc. - manipulating the materials which women have previously only used in self defence. But it was Adrian Piper who presented the most thoroughly reasoned defence of using herself as material in 'Talking to Myself: The Ongoing Autobiography of an Art Object'. One reason, she says, for making and exhibiting a work is to induce a change in the viewer, and human confrontation has the greatest impact. Her argument covered 58 typed pages and I can't begin to summerise it. The art work actions that she has done include "coating my palms with rubber cement and then browsing at a newstand" and similar "catalytic" events. By becoming the art work herself she combined process and product and escaped the alienation of the art world.

Haube for a married woman **Ulrike Nolden**

Judith Stein in 'Anyone to tease a saint seriously' compiled descriptions of St. Bernadette ranging from the Press release for the film 'The Song of Bernadette' to an analysis of the saint's handwriting by Gini Glass Graphologist. It was a brilliant demonstration of subjectivity and how description alters according to the position, the relative knowledge and aims of the author.

"It stinks of the ghetto"?

But perhaps even more revealing of the biased nature of description was the press coverage of 'C.7,500'. Of course I'm biased and my description of the show is selective and distorted by preconceptions but I'm seen to be writing in an overtly feminist magazine while art critics are not seen as writing in male dominated publications. They are simply seen as The Critics.

London's last large exhibition of conceptual was all male, christened 'Art Now' and reverentially received. When women conceptual artists exhibit together it's greeted with outrage, "it stinks of the ghetto" with "a whiff of the second rate". Critics are entitled to their likes and dislikes and they are expected to pass value judgements, but one critic recently described their role as that of mediator between artist and audience. And as mediators they made a poor job of conveying to their readers the variety and diversity of this show - with the exception of Susan Smyth of Arts Review whose review revealed both the time and understanding she had put into it.

They fastened on the few artists who were dealing with traditional women's activities and dismissed the entire show as preoccupation with trivialities. But when men make art of activities not usually seen outside the factory, its Art not "the monitoring of a humdrum, self preoccupied existence."

"Self-preoccupied", "narcissistic", "self indulgent" were words constantly used in reference to the show, yet communication was a central theme - communication based on the

recognition of shared experience, and an implied need for change. But then once artist and audience communicate the critics role as mediator becomes obsolete.

Although critics attacked the artists for being self-preoccupied it didn't occur to them to ask why women artists should feel the need to question their identity as both artists and women, or whether there is a discrepancy between the stereotype of the artist and the female stereotype. Instead they viewed it in the light of established definitions – it wasn't conceptual art, it was second rate. "Nobody is going to be convinced that an injustice is being done if the works displayed to counter it are second rate", wrote Caroline Tisdall in the Guardian. But if, as she claims, the works are second rate then its *because of* the injustice being done to women. During the evening discussions in the gallery we heard repeated proof of the overwhelming discouragement and discrimination facing women in art schools and later in job opportunities. Men present pointed out that they too had a tough time as artists but there was little doubt as to who had the greatest incentive to look for alternative structures and new definitions of art and artist. ■

Source: *Spare Rib*, 1974, no. 25, pp. 34-5.

'Press Release'

An exhibition of conceptual art by 26 women artists, entitled "C. 7,500" (referring to the population of Valencia, California, where the exhibition originated) will open on Monday April 8th, at 48 Earlham Street, Covent Garden, London WC 2. Opening hours will be Monday to Saturday, 11.00 - 18.00. The exhibition will continue for three weeks, and close on Saturday April 27th.

The exhibition was organized by Lucy Lippard, a New York-based writer whose most recent book "Six Years: The Dematerialization of the Art Object" discusses many of the artists in the show. The exhibition was organized in part, as a reply to the comment 'There are no women conceptual artists." In conceptual art, the idea is paramount - permanence, formal or decorative values are secondary or of no concern.

This is the fourth in a continuing series of exhibitions organized by Ms Lippard since 1969, ("557,087" in Seattle, "955,000" in Vancouver and "2,974,453" in Buenos Aires) and is accompanied by a catalogue composed of randomly arranged index cards designed by the artists themselves.

Many media are used in this small scale exhibition: photographs, typed, printed or xeroxed sheets, cassette tapes, forms to fill out. For example, Mierle Ukeles' "Maintenance Art Tasks" shows the artist washing clothes and dishes, changing nappies, etc. Poppy Johnson's tape is a "play" in which the artist takes the part of both lovers. Jennifer Bartlett focuses on the life of Cleopatra with typewritten entries in a loose leaf book. Laurie Anderson documents dreams she has had while asleep in such public places as classrooms. Martha Wilson photographs breast shapes, while Athena Tacha photographs "finger positions".

A series of workshop discussions centred around issues raised by this exhibition will be held at 48 Earlham Street on the following dates:

Tuesday 9th April	"C. 7,500" Critics forum on the exhibition
Wednesday 10th April	Women and art education –
Thursday 11th April ·	Women students –
Tuesday 16th April	Women and film (Anna Ambrose)
Wednesday 17th April	Women and the Arts Council
Thursday 18th April	Women and Revolution (Cecilia Vicuña)
Tuesday 23rd April	Sex bias and criticism – Womens Art History Collective / Womens Workshop Artists Union
Wednesday 24th April	Sex and galleries (Susan Hiller)
Thursday 25th April	Women and art history – Womens Art History Collective – Mar

This programme is subject to alterations. For enquiries, please phone 836 9701/2

Caroline Tisdall
'Women artists'

"C.7,500," AN exhibition of conceptual art by women artists organised by the American critic Lucy Lippard, is a distressing disappointment. For one thing it stinks of the ghetto. Maybe Lucy Lippard wanted to demonstrate that this ghetto exists in the art world —a ghetto that discriminates against women as artists and relegates them at the most to the housekeeping jobs as critics and curators, or to the role of patient artists' wives. That's no news, even here where the whole issue is treated with more apathy and less heat than in New York. But nobody is going to be convinced that an injustice is being done if the works displayed to counter it are second rate.

And that's what most of the exhibits in the show are: just plain second rate. The ghetto sense comes partly from the feeling that many of the artists were included just because they were women, and not on the quality of their work. Quality and the need to express something should surely be the criteria for a woman artist, just as for any artist. But take a look at what is being expressed in a large chunk of the exhibits and you get another whiff of the second rate. There are too many gripes, too many problems that seem to equate superficial and real problems. Changes of cosmetics and clothes, switches of identity, how the outside world judges

the woman by such things, to what extent her personality is itself affected by such factors, all these are certainly problems and have been tackled in various media. But here they are presented as stupidly as I have ever seen them. The overall impression, which is certainly unrepresentative in some cases, is of a long, tedious gripe related to a downtown shrink.

C. 7,500: 26 Conceptual Artists, 48 Earlham Street, London WC2, until Saturday.

Source: *The Guardian*, April 1974.

'Unpublished letter to the Editor of *The Guardian*'

18, Roden Street,
London N.7.

27. 4. 74.

The Editor,
The Guardian
LONDON W.C.1.

Dear Sir,

Caroline Tisdall dismissed the exhibition 'C.7,500' as a distressing disappointment of second raters ('Women Artists' 24.4.74). She felt it would not convince people that women suffer injustice in the art world. She failed to mention the difficulties this show had in finding anyone to put it on or to finance it. It was hung, supervised and publicised by volunteers with minimal support from the Arts Council. She also underestimates the complexity of the injustice done to women which was fully discussed in a series of evening workshops that were held in the gallery in the weeks the show was on. The exhibition was a focal point for examination of the history of women as artists, prejudice in the art world, discrimination in art education, etc. Few exhibitions generate this kind of interchange about all the aspects of the art world which affect men and women alike. This contribution to the scene, which was an essential part of the idea of the exhibition was ignored by Ms. Tisdall.

The fact that an exhibition of women artists makes a critic react with the phrase 'stinks of the ghetto' is proof in itself of the need for such an exhibition. There is hostility to women identifying themselves as a group, exhibiting together for the purpose of giving their personal points of view as individual artists and for discovering if their work, seen collectively has anything in common because the exhibitors are all women. All male exhibitions are frequent and are seen as 'art'; sex is irrelevant. All female exhibitions are not treated in the same way, but are taken as a self conscious statement about women's art. This exposes the male norm of culture for what it is.

Finally Ms Tisdall dismisses women's experience as superficial. From her article one gets the impression that 'real' problems are what men show; women exploring questions of identity, which are peculiar to women because of the attitude in our society to women, make-up, dress, physical appearance, and the sexual objectifying of women's bodies, are 'superficial'. The sex bias is so clear. As a woman looking at this exhibition, I found the witty and ironic treatment of experiences with which I could so easily identify one of its most rewarding aspects. It was by no means a series of gripes; the content of the exhibits were full of humour and insight. Ms. Tisdall did a grave injustice to the show. She should examine her strong reactions against it and ask why women's work should provoke such hostility in the context of the art world in which she practices as a critic. The answers might explain to her the importance of this show.

Yours sincerely,

Griselda Pollock

Rozsika Parker
'Housework'

Bless my little kitchen, Lord,
I love its every nook ,
And bless me as I do my work,
Wash pots and pans and cook.

This verse was on a souvenir ceramic plate tacked onto the world of the kitchen at 14, Radnor Terrace, Lambeth –a kitchen knee high in garbage, old newspapers, half drunk coffees,milk rottingin bottles, fag ends and grubby plastic cartons. The kitchen was part of a project undertaken by six women. For two weeks they worked together on the South London Women's Centre, painting it, renovating it, and finally creating rooms which exposed the hidden side of the domestic dreams: "Rooms as images of mental states from unconscious basements to hot tin rooftops." (Kate Walker)

"A room as a chrysalis –using my appearance and the room as a projection of myself –positive and negative." (Sue Madden)

The house was on view during April and May. An orange front door opened onto a hall carpeted with artificial grass where a black stair case, covered in chalked poems and quotations, led to Kate Walker's kitchen -a nightmare kitchen, oppressive and cluttered. Footsteps on the floor marked an endless, persistant circle from fridge to basin to stove and back again. Out of the centre of the stove floated an enormous wedding cake complete with silver bells, lace and blossoms, while below it, half submerged in a heap of garbage lay a women's body. Scattered on the floor nearby were traces of a female childhood –dolls and the story of Cinderella written out in coloured crayons. In contrast to the general sordid chaos, the cupboards were obsessionally tidy with packets of food carefully balanced on top of each other and towels precisely piled and neatly folded.

silver beer bottles

If the basement reprents the instinctual, nurturing aspect of the home in its blackest form, the ground floor rooms dealt with the social and emotional expectations bound up with marriage. On one side of two adjoining rooms there was a bride swathed in white gauze who stretched out her arms to welcome an unseen groom. She was placed in an all white environment with chocolate box landscapes and collages of Princess Anne's wedding decorating the walls. On the mantlepiece, along with a copy of the Common Prayer book and Charles Dicken's Great Expectations, was a long line of silver beer bottles capped by baby bottle teats. The other room was all black and contained a corpse wrapped in a grey blanket. Dust surrounded the body, a pair of scuffed slippers lay nearby and a man's carefully folded grey shirt was placed in the grate. On the mantlepiece a black piece of paper read, "died. . . believed. . . had failed. . . half embalmed. . . road of love and unselfishness." And the room was presided over by a big, black leather chair. Kate Walker says that she purposely used the most trite, stale images associated with women in an effort to bring over their true implications. She stopped painting and began to create environments because she wanted to find a more immediate way of working; a method which brings quick result s. and reactions.She couldn't integrate painting , for her a slow, intense, isolated process , into the rest of life with her children. "I can't bear the idea of a one sided existance totally dedicated to my art," she says, "I'd rather think of myself as a housewife than an artist." Looking back at the Radnor Terrace project she regrets that she stopped work while the house was on view - her rooms evolve as she works on them and by presenting them as a finished product she thought the "human, tatty immediacy was a bit lost".

filming cleansing rituals

Upstairs was an all white, shaded, claustrophobic bedroom. Sue Madden called the room Chrysalis because she intended to use the room as a projection or a space in which "to grow and transform". She wanted to externalise and examine this process in a film using both the room and her appearance as an extension or reflection of her changing states of mind. She says that the following quotations were her starting points: *"A woman must continually watch herself. . . . From earliest childhood she has been taught and persuaded to survey herself continually. And so she comes to consider the surveyed and the surveyor within her as the two constituent yet always distinct elements of her identity as a woman."* (John Berger)
"Each sister wearing masks of revlon, clairol, playtex, to survive. Each sister faking orgasm under the systems very concrete bulk at night, to survive." (Robin Morgan)

With these ideas in mind Sue was going to start by filming removing rituals; plucking eyebrows, shaving armpits and legs, cutting toe nails, applying face packs, astringents etc. Working consciously through these activities "which wipe away women's identity", and moving on from them, she hoped to bring together the surveyed and surveyor within herself. Yet when it came to filming herself she couldn't do it: "As I started to wonder how I might explore these negative images I began to feel that performing these rituals yet again would be sacrificial and masochistic. For example I recently stopped shaving my legs after ten years, and it was a genuinely significant experience - in a way it made me begin to experience my body as integrated whole."

As a solution she made a "second skin" on which to perform the rituals; a model of her body complete even to embroidered moles, hairs and appendix scar. Making the model helped her to come to terms with her "first skin" but the film was never made. "The nature of my film," she says, "was to communicate to women how I was feeling about myself but this would have meant them being involved in the same kind of activity. I think for women to build up any significant working situation they must first commit themselves to developing close contact and communication between themselves." She believed that the Radnor Terrace project was premature because the women involved were working together without sufficient emotional commitment and contact.

breaking free

In the front room upstairs were some of the pictures Shireen, Clara, Joy and Martine have been working on. The group began to meet to paint and to discuss each other's work 5 months ago, and the exhibition included one canvas that they have been working on jointly. They also exhibited their note books and sketch books, which revealed the thoughts and motivation behind the house in the form of old essays, sketches, lists, postcards, plans, poems, cuttings, quotations and photographs.

As an exhibition it was light years away from the art market and conventional shows. It was initiated by the artists themselves not for profit but as an experiment in working together. In fact it was the way they got the show together as much as the content of the house which overturned the accepted idea of a women's relationship to the home. They worked on the home as a group instead of in isolation, creating a public instead of a private environment.

It was criticised for being too depressing and too propagandist. Yet patriarchal society has always used art to propagandise particular limited and limiting images of women; mother, muse and sex object. Both Radnor Terrace and Womanhouse in Los Angeles (S.R. No.14) are necessary steps towards breaking free of the stereotypes■

Working at Radnor Terrace

Source: *Spare Rib*, 1975, no. 26, p. 38.

III.8 1975 Dossier: 'Women and Work'

Rosalind Delmar
'Women and Work: A Document on the Division of Labour in Industry'

A visit to an art gallery can produce a variety of different experiences. You can discover a particular picture, which remains in your imagination; you can work through a whole series of related paintings or sculptures, the product of one artist or school. Often, for me, in representational art the most striking aspect of the artist's practice is the use of colour — all else can fade, but that remains. And, of course, the use of colour relates to the object of the artist's preoccupation.

If you start off from this point of view, a visit to *Women and Work* can be somewhat disconcerting, for the first impression is that it is colour-less. That turns out to be not altogether the case, however. In a darkened section of the gallery, an enclosed space, you find two colour films simultaneously projected, showing side by side the jobs done by women and by men in the Metal Box factory which is the location for the study on show. Accompanying the films are the sounds of the factory, the whirring, booming and clanging of the machines which are being tended. It is this segment of the exhibition which suggests, through the use of film camera and amplified sound, the flesh and blood of the process which the rest of the work attempts to analyse.

Women and Work is a show devised by three women artists, Kay Hunt, Mary Kelly and Margaret Harrison. It was on exhibition during May at the South London Art Gallery, and will be shown elsewhere throughout the country. The work on display is the result of two years collaboration between women who share a common commitment to the women's liberation movement. Their project was to combine research on the sexual division of labour in industry with the techniques of informational art.

The film material is, of course, one of the results of their study. For the rest, there are blown-up reproductions of charts and tables showing the different jobs performed by men and women and their different wages, a section showing the results of the job

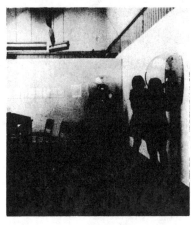

evaluation exercise carried out in the factory as a way of dealing with the Equal Pay Act, photographs of the hourly-paid women workers, a map indicating the location of the factory and where the workers live.

The theme of the sexual division of labour in production is played out in various ways. What comes across very clearly is the different demands made on the workers' physique. The male jobs tend to be mobile (often involving the movement of the whole body); the women's jobs tend to be static, fiddly and repetitious. This point is underlined in the section of photographs illustrating job description — they all require the camera to concentrate its attention on the women's hands.

The final section of the exhibition comprises books, documents and tape-recordings, including one of older women reminiscing about changes in the allocation of jobs into male and female. To meet the needs of this material one corner of the room is converted into a small reference section. Indeed, for the purposes of the show, the gallery is transformed into a mixture of sites — library, viewing theatre, display centre. And the mounting of the exhibition shows great

resourcefulness in the use of available space. But what raises most questions is the artistic position adopted.

It is obvious that aesthetic considerations are central from the careful positioning of the material. There is a formality and insistence in the almost geometrical placing of black, white and grey visuals against bare white walls. Its aura is one of a deliberate under-statement, an invitation to discovery rather than an overt declaration of findings. This low-key presentation led one group of leftist artists to dub the show a manifestation of a new offshoot of bourgeois ideology — 'aridism'. To the management of the factory, on the other hand, *Women and Work* didn't appear at all arid. Their reaction was to ban the women artists from visiting the factory again. It doesn't seem too fanciful to assume that they had in part recognised that the women had demonstrated the extent to which the job and wage differentials between male and female takes its place as a particular aspect of a general system of class exploitation.

All the same, it is the case that the artists have taken up a somewhat polemical position against other conceptions of avantgarde art. In *Women and Work* material from one situation — the point of production — is transferred firmly into the gallery, in a gesture which runs directly counter to those who argue that the purpose of revolutionary artists is to liberate art from the galleries — a sort of 'out of the galleries, on to the streets' position.

Moreover, it is the fact that the photographs, interviews, tables and charts are contained in a particular mode within the gallery which makes them into 'art'. The exhibits could be described variously as the tools in trade of the historian, the sociologist, the trades union militant or the women's liberation activist. It is in meeting the needs of the gallery and highlighting the aspect of visual perception that they are transposed into instruments of artistic production.

In that process too, the artists reveal the

sort of demands which they make on themselves and on their audience. Some artists want the visitor to take an active part in freely arranging what they have produced. By contrast, Mary Kelly, Margaret Harrison and Kay Hunt demand intellectual involvement and submission to the guidance and direction of the exl .bitors.

If the format and the thinking behind the show have any ideal objective it is that a learning process about the position of women in industry should be set up. This in itself puts extra demands on the artists — in particular the demand that the show be not just informative, but also explanatory. Although *Women and Work* does stand out for its clarity and lucidity of exposition, there is still the sense that its informational style is insufficiently backed by explanational guidance — the material, unfortunately doesn't 'speak for itself'. What could; and doesn't do the job of offering either additional explanation or some interpretation of the findings, is the catalogue.

That said, there is no doubt in my mind that *Women and Work* is a stimulating and thought-provoking experiment. As a form of alternative propaganda it raises questions about the nature of agitational art. As research it comes out of the need for a greater understanding of the issues involved in the struggle to liberate women from a narrow confinement to tedious labour.□

The exhibition was initially shown at the South London Art Gallery, the site of the research. It will be available during the coming year to trades councils and educational institutions, and then will become part of the permanent collection of the National Museum of Labour History.

GROUP A: AVERAGE ANNUAL EARNINGS UNDER £2000		GROUP B. AVERAGE ANNUAL EARNINGS UNDER £3000 BUT NOT LESS THAN £2000		GROUP C: AVERAGE ANNUAL EARNINGS OVER £3000	
MONTHLY PAID EMPLOYEES:		MONTHLY PAID EMPLOYEES:		MONTHLY PAID EMPLOYEES:	
Clerks, Cashiers, Secretaries, Typists, Office Machine operators, and Quality Measurement Inspectors	11 MEN 38 WOMEN	Administrators Personnel, Welfare and other professional staff Security officers, Supervisors, Charge-hands and Management Trainees	37 MEN 11 WOMEN	Managers, Directors, Heads of Departments, and other Managerial staff such as Branch Engineers and Accountants	22 MEN NO WOMEN
HOURLY PAID EMPLOYEES:		HOURLY PAID EMPLOYEES:		HOURLY PAID EMPLOYEES:	
Operatives, Assemblers, Packers, Inspectors and other employees including Cleaners and Canteen Assistants	131 MEN 168 WOMEN	Engineers, Electricians Machine setters, Drivers, Despatch planners, and Printers	71 MEN NO WOMEN	None	

FEMALE AGE 59	MALE AGE 20
FULL TIME	FULL TIME
DOUBLE SEAMER OPERATOR	MACHINE SETTER
GRADE 3	GRADE 5
AVERAGE WEEKLY HOURS 40	AVERAGE WEEKLY HOURS 52
AVERAGE WEEKLY WAGES 25.60	AVERAGE WEEKLY WAGES 41.08

6:00 AM: GET UP, MAKE BREAKFAST
6:45 AM: LEAVE HOME
7:30 AM: START WORK, GET LINES READY
8:00 AM: MACHINES START, KEEP MACHINES RUNNING
12:30 PM: LUNCH, RING WIFE
1:30 PM: START, INSPECTION, GENERAL SUPERVISING, LABOUR, PRODUCTION
9:30 PM: FINISH WORK
10:00 PM: GET HOME, LIGHT MEAL CHAT WITH WIFE
12:00 PM: GO TO BED

CLIFTON McKINSON, AGE 32
1 SON AGE 10 4 DAUGHTERS
AGES 7, 6, 4, 2

SECTION FOREMAN

7:00 AM: GET UP, GET FAMILY READY FOR SCHOOL & WORK
9:00 AM: WASHING, CLEANING
10.30 AM: GO SHOPPING
11:45 AM: PREPARE MEAL
12:30 PM: SERVE MEAL
2:00 PM: CLEAN WINDOWS
4:00 PM: PREPARE MEAL FOR EVENING
4:30 PM: MAKE TEA FOR SON
4:45 PM: LEAVE FOR WORK
5:30 PM: START WORK
9:30 PM: FINISH WORK
9:45 PM: GET HOME, WASH UP HAVE TEA
10:45 PM: GO TO BED

EILEEN SZMIDT, AGE 46
4 SONS 1 DAUGHTER
AGES 25, 24, 21, 19, 14

DOUBLE SEAM OPERATOR
PART TIME 5:30 PM - 9:30 PM

Source: *Spare Rib*, 1975, no. 40, pp. 32-3.

Laura Mulvey
'"Post Partum Document" by Mary Kelly'

Traditionally, the ability to produce children and the emotional relationship that ensues has been held up as the reason for women's lack of creativity. Now, with the women's movement, it is beginning to be possible to bring motherhood, with all the deeply traumatic emotion and unrecognised elements involved, into the kind of examination it desperately needs. Mary Kelly's exhibition *Post Partum Document* is a crucial contribution to this. As an artist she forces into public view the unacceptable combination of roles mother/artist — a slap in the face for old guard concepts of the artist as freewheeling genius; as a feminist she focuses on the contradictory emotions that necessarily come with motherhood, which have been almost taboo as a subject for art in male dominated culture.

It is quite clear from the attention Mary Kelly's exhibition has received in the establishment press that it was a direct provocation to conventional concepts of "art". It is the form of the exhibition, its emphasis on work rather than art-object-for-critical-evaluation that causes so much outrage. A painting of a mother changing her baby's nappy would be easily overlooked as kitsch, but not so with dirty nappy liners annotated and placed within a discourse that needs work to be unravelled, and refuses to place the figure of the mother on view.

The exhibition comes within a radical art practice which refuses to see art works as purely objects in themselves but rather takes an exhibition as space to give documentation the force of argument. It deprives the object of any market value and its meaning only truly emerges if the work put in by the artist is complemented by work put in by the spectator in reading the documentation and understanding the theories. But the complexity of the language in *Post Partum Document* and the many different ideas presented simultaneously did place a great burden on the spectator.

Mary Kelly described her previous exhibition *Women and Work* produced collectively with Kay Hunt and Margaret Harrison as "a document on the division of labour in a specific industry, showing the changes in the labour process and the constitution of the labour force during the implementation of the Equal Pay Act. At the same time we were discovering how the division of labour in industry was underpinned by the division of labour in the home and that the central issue for women was in fact reproduction." Real objects, records (written, taped, filmed, videoed) were collected together as evidence focussing attention on a particular economic situation. Individually they may have been disparate without meaning, but linked and organised by the artists, the whole could take on a new level of significance.

In the *Post Partum Document* Mary Kelly uses her relationship with her infant son as her raw material. The exhibition has two distinct parts: objects and records acting as factual evidence of the past, framed and hung on the gallery walls, and written, separate documentation using Freudian psychoanalysis to give a commentary and structure to the actual exhibits.

The first room contained the (now famous) nappy liners and baby's vests dating from the period in which the child's needs and the mother's work meet to produce a complementary relationship (the dyad). At this point the mother's frustrated anxiety and the child's frustrated helplessness can be soothed by pleasure, partly through the eroticism of physical interdependence and partly through narcissistic satisfaction at their completeness as a couple. The second room contained an infinitely more complex record of the child's gradual acquisition of language and the mother's notes as she tries to cope with the sense of loss that overcomes her as the child takes his first steps to social independence. The completeness of the two is broken as the father as authority and the nursery school introduce the child to another world of "law and culture".

In its appearance and presentation Mary Kelly's exhibition reduces the passion involved in this process to the minimum; her aim is to distance the emotion by putting the dilemma into a wider context: the way women's unconscious is shaped by the patriarchy. The exhibits themselves are touchingly reminiscent of women's traditional means of self expression (her diary showing so much self doubt, painfully collected and guarded memorabilia). She organises this material in an attempt to turn the most unspoken and culturally repressed of everyday experiences (mother-child relationship) into an art work inspired by feminism and psychoanalysis.

Mary Kelly's use of psychoanalysis is a direct result of recent work by feminists (Juliet Mitchell's book *Psychoanalysis and Feminism* and the conference on patriarchy held last May in London), and growing interest within the women's movement. This interest stems from the realisation that biological difference becomes overlaid by a cultural concept of sexual difference suited to the needs of a particular social order, which psychoanalytic theory can help us to understand. Thus "femininity" can be understood not as a natural essence but as a complicated edifice which the patriarchy demands in order to give "masculinity" meaning and strength. The little girl enters society "negatively"; her lack of penis gives the phallus significance and allows the male to fear castration.

Mary Kelly evokes the impact that producing a child has on women whose unconscious desires are formed within the confines of the castration complex: "During the ante partum period (gestation inside the mother's body) and continuing during the breast-feeding phase of early post-partum, the mother's negative place in the patriarchal order — more precisely the Symbolic — can be 'misrecognised' because in a sense the child *is* the phallus for her." (Experimentum 1. Weaning from the Breast). As the child grows through the various stages of increasing independence from his mother, she experiences a sense of loss that Mary Kelly describes as reliving her own previous Oedipal drama, undergoing castration for the second time and re-learning the fact of her negative place in the symbolic order. Within these terms, the mother has two possible roads open; recognition and acceptance of her secondary place or rebellion against it. Her rebellion takes the form of fetishisation of the child (as substitute phallus), clinging to the couple relationship and refusing to allow the child to emerge as an independent entity. Part of the fascination of the *Post Partum Document* lies here: the exhibition in all of its obsessive detail fetishises the child, but in this case, the mother has reconciled her "natural capacity" with her work as an artist. The art object as fetish replaces the child as potential fetish.

The exhibition throws a spotlight on the need to explore further the labyrinthine unconscious structures that lie behind the natural looking façade "motherhood", but Mary Kelly is limited by a theory biased — though not invalidated — by patriarchal assumptions. The influence of the French psychoanalyst Jacques Lacan is heavily apparent in the *Post Partum Document*. But one important aspect of the exhibition prevails: it gives a voice to the pain and pleasure women have lived as mothers, understood by each other, despised as domestic by dominant culture. Mary Kelly's work comes in the footsteps of some of the very few women in the past who managed to be "artists" and constantly returned to the mother-child relationship in their work, women such as Mary Cassatt, Berthe Morisot and Julia Margaret Cameron.

Source: *Spare Rib*, 1976, no. 53, p. 40.

"Mystifying theory'

Mystifying Theory

Dear *Spare Rib*,
Mary Kelly's exhibition, 'Post Partum Document', which was at the Institute of Contemporary Arts this autumn, aroused much publicity and some notoriety. We are concerned about some aspects of the exhibition which were ignored both by the media and by Laura Mulvey in her largely explanatory article (*SR* 53).

We recognise the importance of the issues Mary Kelly has chosen to treat as an artist (the mutual mother-child socialisation process in infancy), and the seriousness and ambitiousness of her project. However, we feel that the gap between her intentions and her actual achievements is so great that it has the very opposite effect of its apparent aims.

She draws on a relatively new area of psychoanalytic theory to transform selected moments of her relationship with her own child. Using a variety of framed objects —

nappy liners, vests, diagrams, charts, she demands an active participation from the viewer as part of the process of appreciation/comprehension/learning from the exhibition. At a superficial level it is possible to walk round the walls and either be turned on by the 'pictures' or not. But any deeper understanding, presumably meant to help provide a basis for women to theorise their own experience and struggle on the basis of that, cannot be got from the 'pictures' alone. Either the viewer must bring the psycho-analytical/linguistic knowledge with her, or make use of the folder of notes Mary Kelly provides.

However, the notes themselves are highly selective, and quite obscure to anyone unfamiliar with the concepts and terminology. While there's nothing wrong with pitching a work of art at a high intellectual level, surely Mary Kelly must be aware that such brief notes, far from extending

understanding and closing the gap between theory and art, serve to mystify theory even further.

The exhibition, free to anyone who wants to walk in, appears to be open and accessible; in fact it is opaque, and not so much participatory as excluding and exclusive. This mystification of the theory and the art, rebounds on the impact of the framed objects: they cannot carry the weight of significance attributed to them and become weak visual metaphors for an esoteric intellectualisation. At its worst they come across as disconnected visual clues to some academic discourse which do little more than expose the ignorance of the viewer.

We do not simply demand longer and better notes, but question the whole form of presentation Mary Kelly has chosen; such a heavy dependence on an inadequately presented theory can only distract attention from the

'artistic' nature of the work. And because of the inadequacy, we think the exhibition is in danger of provoking impatient and philistine anti-theory responses such as "this is a load of crap", or "look, the Empress isn't wearing any clothes". Two important related effects of this are firstly, the depoliticising of vital feminist issues, and secondly, a confusion about the nature of psychoanalysis, in particular the relationship between psychoanalysis as a theory and a clinical process.

These criticisms do not, of course, deal comprehensively with the exhibition, and we could expand on each of our points at greater length; we simply want to contribute to an important debate within socialist-feminist culture.
Yours
Margot Waddell,
Michelene Wandor,
London

Source: *Spare Rib*, 1977, no. 55, p. 4.

'Using psychoanalytic theory'

Using Psychoanalytic Theory

Dear *Spare Rib*,

Michelene Wandor and Margot Waddell's comment on Laura Mulvey's article and Mary Kelly's exhibition would be more of 'a contribution to a debate' had any of their points been argued. Instead, they present us with a series of assertions which we need to question and clarify in order to even begin discussion. In doing so we leave to one side two points that they raise. First, their speculations about Mary Kelly's 'intentions': only Mary Kelly can tell us about those. Secondly, their claims about the exhibition's 'difficulty' and 'obscurity' for the visitor: any exhibition, *Post Partum Document* included, will meet with a mixed response and to construct a single general response seems an unnecessary and unilluminating enterprise. There are however, other more concrete questions.

(a) One of the strengths of Laura Mulvey's article is that it treats the exhibition as a product of artistic practice. This dimension is entirely missing from Margot and Michelene's comments. What is also missing, therefore, is any indication of how they understand the relationship between the work of an artist and the theoretical position which informs that work. The relationship is by no means a simple one. Mary Kelly's exhibition exposes, rather than suppresses, the difficulties involved.

(b) Their account of her work consequently reduces it to a question of the 'issues' involved, simply and somewhat blandly described as 'the mutual mother-child socialisation process in infancy': a sociological categorisation which which misses an important point. Mary Kelly's work is original in that it deconstructs the assumed unity of the mother-child relation in order to give a place to the mother's phantasies of possession and loss. She links the exploration of the psychic forces involved to the social relation in order to indicate the way in which motherhood is a constructed meaning rather than a biological truism. But in her account this deconstruction is achieved through the work of uncovering the interplay of unconscious desire with the conscious activity and physical and mental labour demanded by childcare. This aspect is not even mentioned by Michelene and Margot.

(c) This brings us to the question of the 'relatively new area of psychoanalysis' — 'new' for the women's movement or 'new' within psychoanalysis? Two points can be made here. First, Margot and Michelene seem to see such a new position as an already constituted body of knowledge which people already have or do not have: 'the viewer must bring the psychoanalytic/linguistic knowledge with her, or make use of the folder. They advise the artist against the 'exposure of ignorance' which may arouse anger and the philistine response. But what is wrong with the exposure of ignorance, or indeed the exposure of the need for further work? It may cause discomfort, but might also be productive. And of course, the work *did* provoke a philistine response, 'a load of crap', unsurprisingly, since at a certain level that was what part of the exhibition literally was. Margot and Michelene make a connection between philistinism and anti-theoreticism, but then fail to explain why they think that Mary Kelly should have adopted a conciliatory stance. After all, it is not the work which 'depoliticises' the issues, but the response which, political in its own way, attempts to reduce the work to the level of sensational eccentricity. Their position appears to be one which evades the reality and consequences of ideological struggle.

(d) Perhaps Margot and Michelene could be more explicit about what they mean by 'a confusion about the nature of psychoanalysis'. Psychoanalytic theory is used to structure the exhibition but this contains no overtones of a 'clinical process'. It is not a psychoanalysis of Mary Kelly or her child. Laura Mulvey writing about Allen Jones in *Spare Rib* has shown how fruitful a psychoanalytic approach can be — there again with no question of psychoanalysing Allen Jones. The attempts to use the theory produce problems, but its use is important in that it emphasises the ideological positioning of women and explores the phantasy of the loss of the phallus: in *Post Partum Document* in the centrally important figure of the mother. If there is to be a debate it would be useful to know what specific importance Margot and Michelene attach to the movement towards the use of psychoanalytic theory as a means of exposing the mechanisms through which we are formed as women within patriarchy.

Parveen Adams,
Rosalind Delmar,
Sue Lipshitz.

Source: *Spare Rib*, 1976, no. 49, p. 5.

Phil Goodall
'"Feministo: Portrait of the Artist as a Young Woman"'

At the beginning of 1975 a group of women gradually started sending each other small art-works through the post. The originators, Kate Walker and Sally Gollop, involved their friends and this core has extended to cover people all over the Midlands and South of England. The aims of sending art-works to each other are to develop a visual language that is accessible to women in that it corresponds with their own experiences, and to break down our isolation. Often we learn to understand ourselves by making visible in some form aspects of our lives — our process of selection often leads to self-discovery. Each person replies to the art-work she has received by making either an image/object that reflects something of her perspective on life, or that responds directly to the image she has received. Of course work has to be small to be posted, but small scale has an added dimension. Women's lifestyles tend to contain small time-scales, brief moments — we need flexibility to deal with the tiny important moments that children, friends, lovers, present. This is often reflected in the work. And we are so busy with children, jobs, domestic life that time for art-work has to be slotted in between tea and the ironing or whatever.

This search for images to do with being a woman is, for many of us, an attempt to find a feminist perspective and to put art into a directly political sphere. We are trying, I think, to unite apparently disparate aspects — the private, domestic and personal with political and social understanding.

We have few physical resources which is reflected in the art-works; many of them use old packaging, clothing; we recycle lots of things. Ecological bunch! We use the skills we already have — "female", "domestic" skills — crochet, knitting, sewing as well as the more traditional "arty" skills. Not all of us are artists. We have neither the time, resources, nor I think the inclination to use the complex technology which has become an integral part of the established art scene.

Bubble Bath Suicide by Lyn Austin in Feministo postal event

Our reasons being that mystification in art has already made it nearly impossible for all but a few to work in art and design fields without a sense of inferiority. Also since this postal event is about communication we don't want to alienate the women we are hoping to involve. Most of us after all had a non-technical education. We ended up on the "domestic science" scale not the "pure science" one.

Our isolation is broken by recognising images that are instantly knowable as to do with women. Images are re-iterated in different people's work, images and ideas aren't private property. The strain of being creative is removed from the individual and begins to become a bit more collective.

Some of the things that have been made and sent fall into rough groups. There are things on food — boxes of chocs using parts of woman as the sweets, a plate of salad with the meat on the lettuce a little woman. Some work on childbirth and our ambiguous relationship with our children. Many images indicating the use of the female by the press and advertising world. Works expressing suffocation and isolation in a personal life.

We hope that people who go to see the exhibition of the postal event will feel free to respond to the images by joining in. Our notion of visual contact as a network of relationships is one we would like to see extending very widely.

To coin a well-known phrase "this is what you do":
1. Get excited at the idea of a postal visual communication event.
2. Write to Phil Goodall, 14 Valentine Road, Kings Heath, Birmingham 14, who will send you a list of people already started into this.
3. Pick a name.
4. Make an image, knitted picture, spaghetti sculpture, embroidered poem, what you will.
5. Pack it with a note, post it: please don't forget the stamp.
6. Soon you'll get a reply in the form of another piece of work, which will be the start of your collection.

Now there is the beginning of a dialogue — two people have got some clues about each other.

Phil Goodall
Birmingham: August 4—27, The Readers Lounge, Central Library, Paradise Circus, Birmingham 3.
Liverpool: October 4—18, The Academy Gallery, Renshaw Street.

A Woman's Work is Never Done by Penny Booth in Feministo postal event

Source: *Spare Rib*, 1976, no. 49, p. 37.

Rozsika Parker
'Portrait of the Artist as a Housewife'

"They had houses, children, lives of habit and habitation. They were trapped in an especially painful way. Their spirits yearning to travel, their bodies committed to men, to children, to houses."[1]

Feministo, the women's postal art event, could be described as a life-line for trapped women. Growing numbers are exchanging small art works through the post.

It began in 1975 when Sally Gollop, isolated on the Isle of Wight, and Kate Walker in London started sending other images which expressed the feelings of women confined by childcare and domestic responsibility. An early work from Sally, for example, took the form of a miniature kitchen dresser with shelves like bars across the window. Cups obscured the view and with the crockery hung hands and a brain.

The two involved their friends and the numbers have slowly increased. Some were inspired to join by shows of the work in England, Scotland and Germany, others heard about it on the radio or answered an invitation in *Spare Rib*. Maybe one day "Portrait of the Artist as Housewife", as they call exhibitions of the work, will become a vast, subversive international network.

The significance of Feministo goes way beyond individual art works. Both the *form* and *content* of the art take up many of the criticisms that the women's movement has levelled at established art practice.

It undermines, for example, the idea of the isolated genius (the artist who, whether they wish it or not, intimidates others from producing), by revealing the collective basis of inspiration: "images are reiterated in different people's work, images and ideas aren't private property".[2] And as each woman can reply directly to the work she receives, the division between art producer and consumer begins to be broken down. Art practice becomes a living process — more of a dialogue.

Perhaps because Feministo is like a visual discussion, a long distance consciousness raising session, it avoids simplistic polemics. The images are neither idealistic (women are strong, wonderful, invincible) nor despairing (women are helpless, hopeless, victims). Instead the work explores the complexity of our relationship to our sexuality, domesticity, motherhood and romanticism. It's often witty, irreverent and most subversive when, as in a consciousness raising group, a number of women contribute to the same theme.

The destructive conflict we experience between being a consumer, a commodity and a nurturer is analysed in images of food. A box of Black Magic chocolates opens to reveal fragments of women's bodies symbolizing the way women are portrayed as "something to be enjoyed", until we too accept our bodies as commodities, seeing ourselves through other people's eyes and believing that parts of our bodies are desirable and other parts are disaster areas. Another box, filled with smiling, pleasing mouths is titled "Keep Smiling Chocs".

Then there's the plate of salad with a reclining nude — the image of women which most directly conflicts with their activity as artists — lying instead of ham amongst cucumber, lettuce and tomatoes.

A golden, appetising, plaster pie bears the words "The Safe Way Humble Pie", which reading between the pie crust could spell adapt, conform, compromise. The hours consumed by shopping, cooking and feeding are symbolised by strings of knitted zippered sandwiches or a saucepan sawn in half and filled with crocheted cauliflower.

Nearly all the pieces manage to convey both the appeal of domesticity and the bitterness and disillusion. This is part of the show's political strength. Certain images predominate: butterflies impaled or escaping, masks reflecting the shifts of identity daily demanded of women, windows simultaneously forming prison bars and frames for domestic dreams.

I think the same ambivalence is reflected in the materials used. There's nostalgia as well as rebellion in the scraps of cloth, old photographs, packaging and supermarket trays — sterile, depressing yet seductive. The materials also reflect women's limited resources, and in some cases, a rejection of the "complex technology which has become an integral part of the established art scene". And because much of the work is flimsy it has an impermanence which the women value. Most want to make statements rather than consumer objects.

Techniques vary. The show contains a great deal of assemblage, some painting and drawing, but a lot is knitted or sewn. On one level the use of craft validates women's traditional skills and emphasises how much pleasure there is in, for example, crocheting. On another level it draws attention to the way our time and energy has been absorbed by our massive contribution to the domestic economy: knitting, sewing and furnishing the home.

Because all that work was done for immediate use in the home, not for the cultural market for love not money — its creativity has been discounted. A pink and blue knitted panel, still hanging from the needles, picks up this theme. It reads "Heart Not Art, Homemade I'm Afraid."

If craftwork is valued, it's out of nostalgia or out of admiration for an individual skill. The symbolic significance craftworks had or have for women is usually overlooked despite the fact that feminist art historians continue to draw attention to the content and social role of craft production. And like the 18th century women who sent each other Friendship Samplers, the women of Feministo exchange stitched messages, only their samplers read "Wife is a Four Letter Word".

But does this long distance communication break down the isolation of a woman at home with children? Some criticise Feministo saying it simply confirms women in their role as housewives, and like the Friendship Samplers, does little more than ease loneliness. It goes much further than that; in raising women's consciousness it also sustains their belief in making art of their own experience. As Tricia Davis points out, before Feministo she "made things, hid them, destroyed them and grew increasingly frustrated with the whole process."[3] And after Feministo? "I still sometimes feel self conscious or hesitant about making things . . . but I go on doing it. Partly because although art is by nature individual, I see myself as part of a large group of women working in different media, using different skills."

By providing audience and feedback, Feministo has given women who have abandoned art the incentive to start again, while women who've never seen themselves as artists gain the confidence to try making things. A postal event provides a relatively safe beginning for someone who may have reached the state Michelene Wandor

To Kate on Mothers Day. Crysetteus Prickum

Self-clown portrait

Mirror Mask

Christmas Tree

Crocheted Breakfast

Salad Plate

Sanctuary

Bound and gagged.

Black Magic Bodies

Keep Smiling Chocs

describes: "The security of the home and its deceptive freedom from immediate control operative in any work situation have their own backlash. You lose contact with any sense of the 'real' world, you think in frames of reference and a language looked down upon by most people. After a while you come to relish the misery of this isolation as a frying pan alternative to the fire of exposure as a possible failure; after years of being used to living in a home alone with your children, you become terrified of confronting the world of work and other people outside your family."[4]

Not all the women in Feministo wanted to risk showing the work in public, but most believe it is politically important. They are, after all, fighting both the art world and sexism by bringing domestic imagery into the open.

They try to create a new form of exhibition, showing the context of the work by pinning up the letters the women send to each other with the art works. Their aim is to unite "apparently disparate aspects — the private, domestic and personal with political and social understanding". Exhibiting homemade works begins to challenge the split between the public and domestic spheres, between "home and work", validating women's work in the home as "work".

Visitors pick up on the protest. "Miserable bitches," commented one man. "Bitter and twisted," said another. "I don't see what all the fuss is about." While North West Arts Association who housed their first show put up a notice reading "Unsuitable for Children".

That struck the women as particularly ironic. Most of them work on the kitchen table "in between making the tea and doing the ironing", constantly interrupted by children. "Anything you do is a threat to your child's security; the child knows that it's totally dependent on you and, in self defence, becomes a tyrant making petty compulsive demands to be reassured."[4]

A number of women artists are using domestic imagery usually polemically — to analyse or draw attention to woman's role as housewife and mother. Feministo, however, provides a way of overcoming some of the material difficulties a home worker has to contend with. It makes use of small scale art which takes up neither too much space nor time. Few women possess studios which partly explains why women's work tends to be more integrated with their lives. The materials the postal event women use and the images they create are part of their everyday reality. They want to "develop a visual language that is accessible to women in that it corresponds to their own experience."

Such a language has a long history in women's art even in oil painting. The sixteenth century painter Sofonisba Anguiscola invented the type of portraiture known as "domestic genre" with a picture of her sisters playing chess. But domestic genre was always considered a secondary art form to male dominated historical or mythological subjects. For "though the virtues of domesticity are upheld on a verbal level, social practice confers all prestige on man's achievement orientated role".

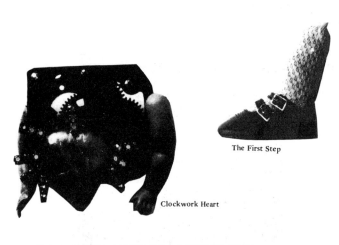

Clockwork Heart

The First Step

Rape cup and saucer

The Great Stuffed Baby

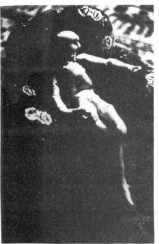

Part of the furniture

Feministo steers a course between "celebrating the area of domestic creativity and 'women's world' and exposing it for its paucity".

With much of the work, the spectator's response will be invoked by their personal experience, their fantasies and their relationship to the family and sexuality. It can be threatening. "You just want to make people as unhappy as yourselves," said one woman defensively. It's hard to predict whether feminist imagery will fill a woman with anger and insecurity, or with instant recognition and relief, but no one can remain unmoved by *Portrait of the Artist as "Housewife".*□

At the ICA, London June 10—July 20, then to Melbourne, Australia.

1 *How to Save Your Own Life* by Erica Jong
2 *Spare Rib* review by Phil Goodall
3 *Mama* feminist arts magazine
4 *Conditions of Illusion,* Michelene Wandor, feminist press
5 *The Great Divide* Open University Art and Environment Unit 6 by Michelene Wandor, Kathy Henderson, Maureen McCue and Susan Treisman

An article on Feministo by Rozsika Parker has appeared in the women's issue of *Studio International* magazine

Source: *Spare Rib*, 1977, no. 60, pp. 5-8.

III.14 1977 Dossier: 'Feministo' (3)

Monica Ross
'Portrait of the artist as a young woman: a postal event'

Early in 1975 one woman moved house, away from a close friend. They maintained supportive contact, not just by letter, but also by exchanging small art-works through the post. By May '76, at the time of the first exhibition, over a dozen women were exchanging artworks and had produced over 200 pieces of work. Since May we have exhibited this work four times; in Manchester, Liverpool and Birmingham.

It is a non-stop process, new work constantly emerges as visual conversation develops. The aim is communication, not perfect aesthetics.

The interchange of work means that we encourage and support each other. We are fighting isolation, inventing our own woman art. Unlike much contemporary work on the fine Art scene, the work is non-technological, non-academic. The content, materials and approach are related to our everyday lives. Here are visual statements about the condition of women. Materials are often household residue; cartons, brillo pads, underwear.

Skills are often those traditionally ours; a portrait is knitted, not painted, a sculpture crocheted, not cast. Scale is related to time, often short and fragmented; and to the event. Work is often done quickly (or not at all) and is light enough to post.

The content is women's life; our work, babies, sexuality, frustrations; and our exploitation – a common theme is the edible, canned and packaged sex object. A naked papier mache woman lies like a slice of meat, on a plate of green salad, or is dissected into juicy mouthfuls in a chocolate box.

Between us, we harbour many differences. Neither are we all Feminists or "Artists". Women of different ages, ideology, marital status; yet the same themes and images constantly recur to make an Exhibition which makes a coherent statement about Women's Oppression. This, despite some of us never having met.

We have the common enemy – a vast indifference to our creativity – to unite us. The history of women's creativity has been overlooked and unpreserved. Its existence has only recently begun to be re-discovered by feminist Art Historians. We have only each other to identify with. Till now, the prevalent influence has been male.

The problems of isolation and prejudice are those of all women. We are attempting to create our own image-language; to sew a cloth of identity that other women may recognise.

The contemporary Art scene is just another sphere where women have taken second place. Its elite and obscure nature has developed in the interests of capital. False standards, ethics and competition combine to isolate all artists and to inhibit the development of meaningful communication. Since "ideas" and "styles" have become prestigious products, these factors unite especially against women.

Our creativity derives from non-prestigious folk traditions. It is diverse and integrated into our lives; it is cooked and eaten, washed and worn. Contemporary standards either ignore our creativity or rate it as second-class.

We communicate, we don't compete. We share images

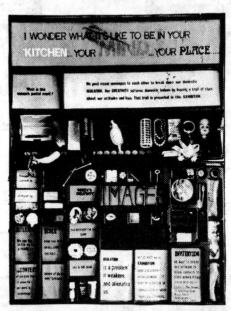

and experiences. The posting of one piece of work from one woman to another makes ownership ambiguous. Our creativity is valid. The exhibitions state this and demand recognition for it.

MONICA ROSS.

POSTAL EVENT CONTACT: Phil Goodall, 14, Valentine Rd., Kings Heath, Birmingham 14.

POSTAL EVENT POSTCARDS: Lyn Foulkes, 65, Livingston-Road, Kings Heath, Birmingham 14.

FROM LIQUORICE 'N' ALLSORTS. NOVEMBER '76.

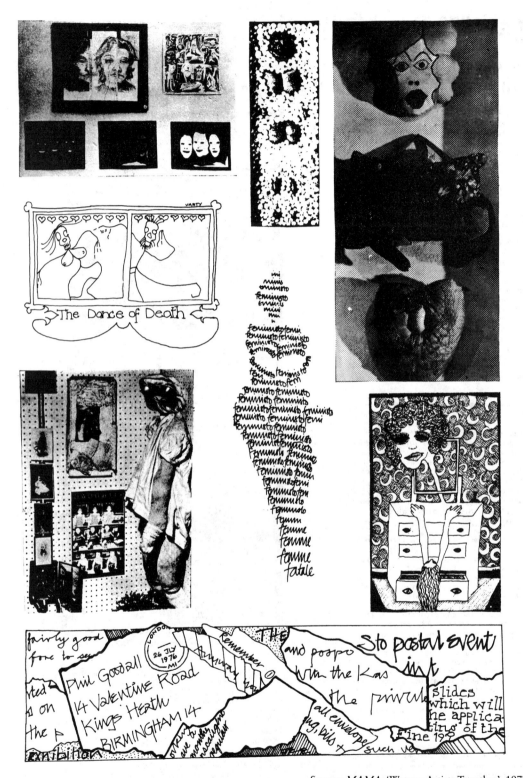

Source: *MAMA*, 'Women Artists Together', 1977, pp. 24-5.

Phil Goodall
'Growing point/Pains in "Feministo"'

CREATIVITY

Creativity involves physical, emotional and intellectual processes in varying degrees. In the visual arts Chagal might be described as a more emotional painter whereas Mondrian could be regarded as more of an intellectual. In philosophy creativity expresses itself in a largely abstract form, in architecture in a concrete physical form. I can't think of an area where the emotional type of creative process is so divorced from the intellect except possibly the "stream of consciousness" type approach to art, but that still involves conceptual play and manipulation.

For women creativity has been channelled into home-making and child rearing. So our creative powers are directly re-inforcing the centrality of the family as the source of reproduction of the labour force and the division of the sexes. For men, either their creative capacities must be expressed largely outside the personal sphere in work or men have virtually no source of creative expression in work (manual labour) or in the home (that is already taken up by the woman.) Their creativity is relegated to "leisure time". Our channelling is circular (we do at least have some outlets) starting from home, childhood, through school to a short period of work back home again. Because the opportunities are very limited for us to work in creative fields which are disconnected from our expected roles - this often leads to a hardening of the emotional arteries. We all know of women artists who say "Any woman with talent and guts can make it - what's all this feminism about?"

Women's Art.

Art is a process of integration.
For the most part we experience the making of art as an integrated process. Yet images are often understood only partially in relation to the viewer's own experience. The accusation is sometimes made that women's art is trivial, that it speaks only to women, that is not innovatory within the terms of art.
We know that the content of our work is highly significant, yet cultural blindness leads critics to raise objections to (a) the validity of content, ideology. "Surely politics should be separate. The conditions of life should be fought for in the political arena not in art terms". (b) the specifity of compositional elements and imagery of women's art being only apprehendable by some women and not by people in general.

In response to the question of ideological content in art, one could reply that there is a long history of such content - Goya to mention but one artist. It is precisely because ideological content is almost ever present, whether it be overt or hidden, vesting itself in the status quo or the revolutionary that visual images can be power-ful. The artist often expresses consciously or otherwise his acceptance of a whole range of values, as John Berger points out in "WAYS OF SEEING". Women artists are reinstating openly and consciously the centrality of social values in art.

In response to the second criticism about female compositional elements and imagery, the answer could be, if indeed there is a distinction to be made along gender lines between methods of composing pictures, and it seems that some women's work does reflect not just in imagery, but more deeply in mode of composition their female experience, then so be it. For a long time now our visual arts diet has consisted of so called male compositional elements. Perhaps its time the world re-connected with our means of making images. It takes time to learn to understand unfamiliar images, but heaven knows they are born out of the world's back kitchen, turn round world and look, we are real, we are valid, we are angry, we are trying to make a strong human art that integrates politics, social awareness, personal lifestyle, developing skills, the emotional, the intellectual and the visual. We are trying to make sense.

SOME THOUGHTS ON THE FEMINISTO/PORTRAIT OF THE ARTIST AS A HOUSEWIFE POSTAL EVENT.

Within the feministo postal event we have both celebrated the area of domestic creativity and "womans world" and exposed it for its paucity. The postal event seems to me to belong to the consciousness raising process. The fact that any woman can participate provides opportunities for self-exploration, communication and development of political awareness integrated into a development of skills. As the postal event is the sum of individual contributions it means that there is no expression of a consistant set of ideas. Though the degree to which images reflect shared awareness is remarkable. The bredth of the event, while being an advantage in terms of involving many disparate people can be seen as a disadvantage in that conflicts can be presented without a solution in the event. This is no surprise to women familiar and sympathetic with women's politics. However people outside that context can find it disturbing.

One problem that we face is that of fighting on two fronts, the art world and sexism. The gallery isn't the best place to present women's oppression to women. If, as we have done so far, we show our work in galleries, the justification would appear to be for changing the significance, content and basis of art. We are trying to do both things, (entirely consistant) but for the time being we ride uneasily on the back of the gallery bogey. Hopefully in the future if we haven't run out of energy we can find ways of presenting visual images to women in more accessible situations.

Another conundrum we have talked about is - is the postal event art? Opinions differ. It seems irrelevant, it is art, but more importantly it's visual communication. The word art is loaded with a patina of snobbery and mystification. Since the postal event is primarily communication we want to avoid alienating women, and the familiar cry "I'm not creative I can't do it". Any word would do, FART might be appropriate if not original. Immediacy is important to many of us, making things to do with whats happening now.

It seems that out of the postal event several possibilities could come. We could embark on them as individuals or as a group and hopefully with the help of other women.

(a) Keep the network extending until many, many women are communicating in visual terms.
(b) Decide whether or not to justify the sub-cultural aspect of women's art levelled at us, and if so how.
(c) Question the underlying values in existing art, through our own art.
(d) Work out a clear theoretical basis for women's art.

These things are already being attempted, but it is important to have available a medium such as this pamphlet for ideas to be passed around, argued over and worked on. I hope the pamphlet will become a regular edition.

Source: *MAMA*, 'Women Artists Together', 1977, p. 28.

Joanna Klaces
'Phoenix arising'

BERNARD MILLS

Exhibition in progress – one of the artists at work on a soft sculpture

Four feminist artists occupied the small space of the Holt Street Gallery in Birmingham's Arts Lab for three weeks. Sue Richardson, Monica Ross, Suzy Varty and Kate Walker displayed their work in progress, but not "finished". They "wanted to make the process open, with boxes for other women to write and draw in, and for us to learn from women's reactions to new work as we went along instead of presenting a finished object and then discovering it didn't communicate."

Every day for the first week the artists were in the gallery "with kids 'n' all, making this quadruple women's environment on the rough theme of women's lives." In the centre of the room was a black-walled, shed-sized box and the artists had worked outwards from this to the gallery walls. Domestic pictures were filtered through fine muslin from a projector in the box onto a screen made of old white clothes pinned to the wall. Outside the box several pairs of stuffed legs were lying around, and there was a large black and white mask series on another wall. Kate Walker's filing cards were waiting to be filled in by visitors with response to her questions on birth and marriage.

The work has not yet extended very far. They intend to add to it as they take it elsewhere.

Bluecoat Gallery, Liverpool from the end of January.

Source: *Spare Rib*, 1978, no. 76, p. 37.

"Fenix" Documents

Origins of FLIGHT!

THE FIRST POINTS WE DISCUSSED WERE CONCERNED WITH THE WORKING CONDITIONS OF WOMEN ARTISTS AND THE SMALL AMOUNTS OF TIME, SPACE AND MONEY AVAILABLE TO WORKING MOTHERS. WHAT METHODS HAVE WE ADOPTED TO FIND SOME ROOM FOR MANoeuVre IN THESE CONDITIONS?

K.W. I do various kinds of work. FENIX is one way of operating, because it fits in with the rest of my life.

S.R. You can collect stuff in the small amount of time that you have. Then you can use the gallery space as a studio when you get together.

K.W. Very few women have a proper studio anyway, unless they're reasonably mature/established and child-free or independently moneyed, middle class or aristos.

M.R. That whole pressure, if you have kids, of keeping the place habitable for them and clean and safe. If you paint big, it's really difficult for kids to find anywhere to play. For instance say we had tried to make the life-sized figures that we made for FENIX in the living room, which is the biggest area we've got, the place is dominated by our artwork.

K.W. I know lots of artists, female and male who might not mind that, they live in relative chaos. I always question the dominance of one persons standards and needs over everybody elses, especially those of very young children.

M.R. I think women feel that worry and guilt strongly. For instance, think of all the precautions you have to take even when painting a chair, if there's a baby crawling around. A bloke might not feel obliged to do anything, but women are conditioned to feel obliged.

K.W. Eventually held just get a studio away from the home. In the past these pressures made women want to stop doing their work. I think we're different, because we just make our work fit round the life.

S.R. This is a way of forcing a situation which will give us space to do large work. It's only this way that the average working woman would get a chance. She can't afford extra space.

WE GO BACK CONSTANTLY TO THE PROBLEM OF ACCESSIBILITY.
OUR AMBITION TO MAKE A POPULAR BASIS FOR ART.

S.R. One of the best ways we've found of getting people involved is through the use of slides. We've also used written contributions.

K.W. So far we've used file cards for women to write in their experiences of marriages, births, deaths; slides of our past FENIX show and slides of S.R.'s recent family history; music; audience-participation in events which we photograph; radio interviews; conversation in the gallery with the public; requests for assistance etc.

S.R. It has to be fun, buttons to push, things to play. Most people find it hard to write.

K.W. It imposes a style if they see what others have done.

S.R. We should make tapes of what everybody thinks about it, then it's not just the artists. - use it in the next show. One of the things that people have often said is "well how can you do it? How can you go in public and put all your dirty washing out? We're all very scared of that, but people don't realise that fear is overcome by group support.

ENGINEERING

niCe

niCe!!

niCe!!

"Do you want to have part in an ART event?"

"[Cut this out would you, please] [MICHAEL]"

"Ok, ready!"

"Please hold it up and look through"

"QUICK! Smile Please!"

"I feel like a voyeur"

[AUDIENCE APPLAUSE]

inFlight CHECKS

WORKING IN PUBLIC WE ARE CONSTANTLY CONFRONTING THE
WOMAN AS SPECTACLE/STEREOTYPE. WE OVERCOME IT BY
STRATEGIC MANIPULATION OF ARTWORLD EXPECTATIONS.

K.W. How far can you go with audience participation?
I think it's important that the dividing line
between audience and workers is somewhat blurred,
but I want to keep the group integrity. I want
our view of a woman's life to prevail because
it's funny and optimistic, changeable, peculiar
and difficult.

S.R. Not ending up with something that can be pinned
down.

M.R. It was difficult when men came to view us as
spectacle. It made it hard to carry on working.
(see captions to photos)

contrast
between my
usual lonely
work and
PHOENIX
black + white

travelling
lady
needs
group.

I painted
my friends
holding me
up

AViATiON

THERE ARE TIMES WHEN YOU CAN CARRY OPPRESSION LIGHTLY
AND SUCCEED IN THROWING SOME OF IT OFF, BECAUSE OF THE
ENERGY GENERATED BY THE GROUP.

M.R. It's important politically for women to be seen
working together and being successful without
destructive battles between ourselves. It's a
statement of strength in itself. It contravenes
the myth of women as competitive jealous bitches.

K.W. At the same time I'm wary of the Amazonian myth,
quite a different proposition. If you say
anything positive about your own life, you can
become personally idealised into Amazon woman.
It's an image of super woman which is dis-
couraging to other women and falsely appealing
to men.

M.R. The Womens Art Movement is so fragile here at
the moment, that's why the Postal Event was so
shocking to **those** feminists who wanted to
produce automatically, a positive image of
woman. They felt that the material used had
been worked through but of course it hadn't been
worked upon as visual art, in public. It's
very important to make these ideas visible as
a basis upon which to change art itself. There
are a lot of women artists who are not inter-
ested in changing art or inventing new forms,
but just interested in "getting a piece of the
poison pie" as Lippard calls it, and who can
blame them? (9)

beginning
PHOENIX
blank
white walls

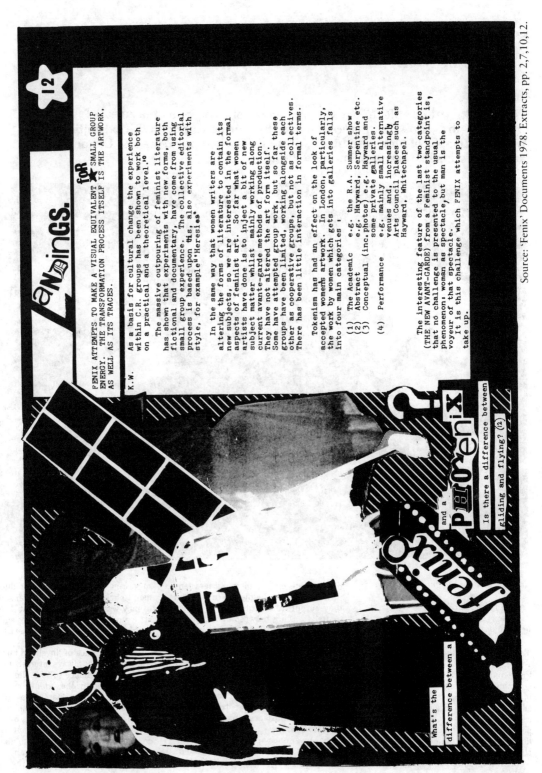

12

L☆ANDINGS for ☆ SMALL GROUP

FENIX ATTEMPTS TO MAKE A VISUAL EQUIVALENT for SMALL GROUP ENERGY. THE TRANSFORMATION PROCESS ITSELF IS THE ARTWORK. AS WELL AS ITS TRACES.

K.W.

As a basis for cultural change the experience within C.R. groups has been shown to work both on a practical and a theoretical level.[10]

The massive outpouring of feminist literature has shown that experiments with new forms, both fictional and documentary, have come from using small group experience. The collective editorial process is based upon this, also experiments with style, for example "Heresies".

In the same way that women writers are altering the forms of literature to contain its new subjects, so we are interested in the formal aspects of feminist art. So far what women artists have done is to inject a bit of new subject matter whilst mainly working along current avante-garde methods of production. They have not altered the art form itself. Some have attempted group work, but so far these groups have been limited, working alongside each other as cooperative groups, but not as collectives. There has been little interaction in formal terms.

Tokenism has had an effect on the look of accepted womens artwork. In London, particularly, the work by women which gets into galleries falls into four main categories :

(1) The Academic e.g. the R.A. Summer show
(2) Abstract e.g. Hayward, Serpentine etc.
(3) Conceptual (inc.photos) e.g. Hayward and some private galleries.
(4) Performance e.g. mainly small alternative venues and, increasingly Arts Council places such as Hayward, Whitechapel.

The interesting feature of the last two categories (THE NEW AVANT-GARDE) from a feminist standpoint is, that no challenge is presented to the usual phenomenon: woman as spectacle, but man is the voyeur of that spectacle. It is this challenge which FENIX attempts to take up.

What's the difference between a

and a PERFORENiX ?

Is there a difference between gliding and flying? (2)

fenix

Source: 'Fenix' Documents 1978. Extracts, pp. 2,7,10,12.

Rozsika Parker
'Images of Men'

The weak, vulnerable or sickly man has long been a feature of women's art. *Rozsika Parker* **notes his appearance in the exhibition 'Women's Images of Men', at the Institute of Contemporary Arts, London, and traces his history in women's fiction.**

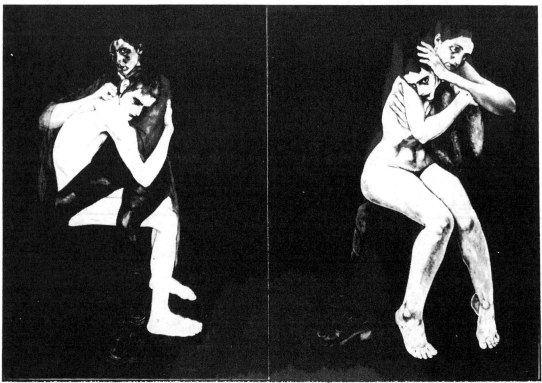

Deborah Law

How it pleased me to guide your slow, feeble steps
To feel your arm clinging tightly to mine . . .
Leaning on your strength, with my hand in yours.

These lines which the 19th century writer George Sand addressed to her lover conjure up a curious, highly contradictory picture of the man. He is incapacitated, hardly able to shuffle along, and yet he is a source of strength supporting George Sand. Obviously the poem is not to be taken literally, but it does indicate how women's writing about men (like men's writing about women) reveals women's fantasies and

desires, fears and defences, rather than providing a concrete picture of the man they purport to describe.

Relationships between men and women are unequal and fraught with antagonism. It is (perhaps) inevitable that women's images of men in art as much as in literature should be about the effects of differences of power between the sexes; about the fear and hatred it can generate, and about the desire to reveal, challenge, transform or destroy the imbalance. Take George Sand: she can only allow herself to lean on her lover once he is, so to speak, invalidated out of battle, and relying on her to guide his "feeble steps". I am not

suggesting that we all want to reduce men to helpless invalids (though some of us may want just that) but that through art women express the fantasies and desires engendered in us by a sexist society.

The recurrence of 'invalided men' in women's art has always interested me. When I had a chance to view slides of work destined for the exhibition, 'Women's Images of Men', I was struck how the theme emerged. The show, of course, encompasses numerous other themes but for this article I want to concentrate upon the 'invalided man' although, given that I have had no chance to ask the artists what the works

220

mean to them, what I write is necessarily generalised and subjective.

Women's Images of Men' says as much, if not more about women's response to a male dominated world than would an exhibition of women's images of women. It does not constitute 'wasting energy on men' — a useful slogan in the women's movement when addressed to the way women have traditionally serviced and privileged men, but entirely misplaced, in my view, if levelled at this show. For 'Women's Images of Men' marks an important development in feminist art which has long concentrated on images of women intended to challenge current definitions of women. Innovative and exciting work has been done, but frequently our efforts to give new meanings to women have been viewed through entirely traditional spectacles. For example, feminist photographs and paintings of our genitals are often received not as the intended celebration of women's autonomous sexuality but simply as titillation, or even as obscenity. Men's bodies have never stood simply for sex, rather they have represented a wide spectrum of emotion and experience, from defeat to victory, from suffering to strength. Take a look at Kenneth Clark's book *The Nude* and you'll find naked men in chapters on 'Energy', 'Pathos', and 'Apollo', while for women look under 'Venus I', 'Venus II' and 'Ecstasy'. So when we use men's bodies to reveal our perspective on society there is perhaps a greater chance that we will be heard — and understood.

Moreover, to take men as the objects of our fantasies and the subject of our art is to shift power relations within art. Since the 19th century women's bodies have provided the raw material for acres of canvases and tons of sculptures. The exhibition also demotes men from standing unproblematically for mankind; presented through women's eyes men can no longer be Man.

Looking at the slides I was reminded of a friend's exasperated remark that "all men are either bullies or cripples"; on reflection she added "and all bullies are basically cripples". Such phrases hold their own tyranny: the use of a physical metaphor — cripple — to signify an emotional lack reflects back on people who actually have physical disabilities. On top of the discrimination they already face, people with disabilities live in a society which uses physical weakness and disablement as a metaphor for being emotionally and intellectually incomplete. Also, any description beginning "all men are . . ." is unfair, but so is sexism, and a symptom of sexism is that it produces generalisations. Men divide us into madonnas and whores while women

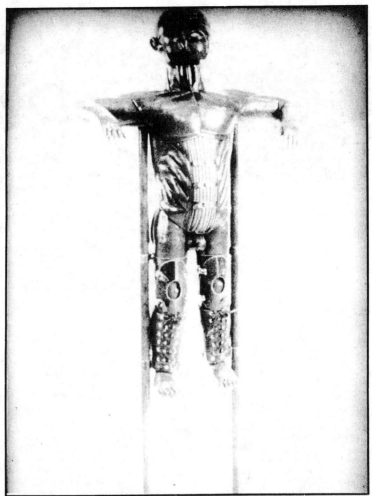

Mandy Havers *Icarus*

explain, excuse and shrug off the indignities they suffer at the hands of men by characterising them as little boys — helpless little boys. Given the sexual division of labour which produces domestically incompetent men, it is, in one sense, an accurate description. But the prevalence of 'invalided' men in women's art since the 17th century is no simple reflection of reality, but women's response to the unequal power relations between the sexes

Male critics detecting this tendency amongst women to blind, maim, sicken and render their male subjects unconscious, have to a man cried, "castration fantasies". It is, of course, infinitely more complex than that, for the crippled man is not only a constituent of women's art — we did not invent him. The male body has for centuries represented pathos with the crucified Christ as the archetypal crippled man. Women have merely employed the image to make meanings of their own,

and incapacitated men have meant different things in different women's art at different historical periods.

In the 17th century, for example, when violent women biblical figures were a dominant subject of European art, the theme was adopted with alacrity by countless women embroiderers. They stitched cream-coloured satin with Jael hammering the tent peg through Sisera's temples, and in delicate white work embroidery they depicted Judith decapitating Holofernes. By the end of the 18th century, however, neoclassicism and romanticism ushered in images of women weeping at tombs, and in fiction vigils at sick beds began. Mary Wollstonecraft parodied the genre in her novel, *Mary* whose heroine gloried in the "luxury of wretchedness" as she nursed her Henry.

The 19th century was the heyday for male invalids. *Jane Eyre*'s blinded Mr Rochester was the tip of an iceberg. Within fiction the male

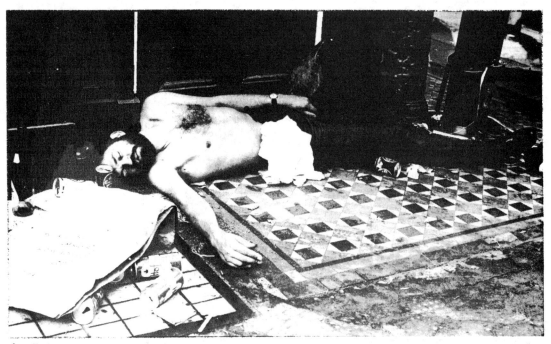

Anya Teixeira

invalid answered a number of needs. He gave women an excuse to abandon feminine passivity and reticence and to take action: "Every shadow of womanly shame vanished before the threatening shadow of death" (*Olive* by Dinah M. Craik). And he allowed the heroine to experience her unacceptable feelings of sexual desire as maternal pity: "He was trembling heavily, and his breath had visibly shortened. He looked very ill. Her heart leaped with a deep maternal yearning . . . flight would be either coquetry or cruelty; and of both she was incapable" (*Avis* by Elizabeth Phelps).

Pity was also a very useful emotion; it enabled the heroine to subscribe to the Christian Virtue 'love thine enemy' In May Sinclair's novel, *The Helpmate* a marriage bitterly disintegrates until the man is entirely paralysed. Then the woman stands beside his bed and realises "His body was once more dear and sacred to her as in her bridal hour".

And however much a woman may be tied to the sickbed, male invalids are so gratifyingly grateful for attention: "Beth used to wonder at the young man's uncomplaining fortitude, his gentleness, gratitude, and unselfish concern about her fatigue" (*The Beth Book* by Sarah Grand). The sick man clearly takes on the virtues associated with women. But not only does an invalided hero allow for the differences and divisions between the sexes to be emotionally and intellectually transcended, physical differences also in some way dissolve: "There was beauty in his pale, wasted features.

There was earnestness, and a sort of sweetness" (*Shirley* by Charlotte Bronte). "His whole face was softened and spiritualised, as is often the case with strong men, whom a long illness has brought low" (*Olive* by Dinah M. Craik). Soft, sweet, spiritualised, who do these sick men resemble, if not women? In order for men to appear desirable they have to resemble *the* objects of beauty and desire in our society — women.

Moreover, once a man is desperately ill, it suggests that he can empathise with women's sufferings, that understanding can exist between two sexes who sometimes seem like different species. In Charlotte Bronte's *Shirley* two of the major protagonists become deathly ill before there can be a meeting of minds. Then Caroline enters Robert's sick room and says, "I understand your feelings: I experienced something like it. I too have been ill."

Lying behind all the varied images of the male invalid is the desire to level off the power imbalance. Elizabeth Phelps in *Avis* gives these words to her male lead: "He felt, that, had he come to her again in the power of his manhood, he might have gone as he came. It was his physical ruin and helplessness which appealed to the strength in her." While in the *Tenant of Wildfell Hall* Anne Bronte's Mr Huntingford bitterly resents the power reversal he observes: " 'Oh, this is sweet revenge!' cried he, when I had been doing all I could to make him comfortable . . . 'And you can enjoy it with such a quiet consciousness too,

because it's all in the way of duty'."

Twentieth century medicine has changed not only the types but also the meanings of illness in our society. For 20th century artists and novelists illness takes a different form. We find impotent heroes who suffer breakdowns, often destroyed and laid low by their own blind insensitivity: "How gripped by fear he was, how possessed by pain and sexual energies gone haywire" (*Torch Song* by Anne Roiphe).

'Women's Images of Men' contains a fair variety of 'invalided men'; blind men, men with amputated limbs, tortured bodies, male bodies literally muscle bound by masculinity, passive men asleep or unconscious, men dependent on the props of machismo to provide the semblance of strength. Deborah Lowensburg's double image of a couple with the woman on the man's knee reminded me of traditional images of suffering men. Although the woman is in the powerless position, held like a little girl upon the man's knee, he is the pale and fearful member of the couple. She cradles him. Yet her expression is entirely tragic as she gazes over the top of his head. She is the Seer, the Mother, the Pieta — the Virgin Mary holding the dead body of her son.

Traditional power relations are tenacious — casting the man as the invalid almost inevitably transforms the woman into his mother. Another artist, Elena Samperi, reveals what an ambivalent, oppressive role it is to be the feeder of 'invalided' men. She depicts a solid, stalwart madonna figure, her face

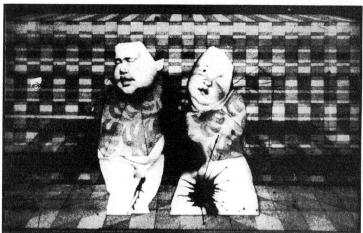

Jane Lewis *Eunuch*

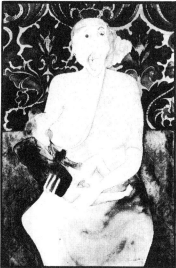

Elena Samperi *Madonna*

hideously contorted as she breastfeeds a particularly nasty city gent, the size of a baby.

Other artists avoid showing where the 'invalided' man puts the woman in terms of power relations by absenting women from the image. By keeping women out of the picture they present weak, vulnerable men without placing women in the maternal, protective role. Instead they place men in the positions usually occupied by women in art — naked and on display. Helen White photographs a man in his bath, limp, vulnerable, eyes closed, with rubber alligators ranged round the rim of the tub. Anya Teixeira shows a man half stripped, out cold on a pub floor in a litter of beer cans. Then there's the photograph of a naked man prone on a Persian carpet in a shaft of light. But male bodies refuse to be turned into passive, available nudes. These photographs suggest irresistibly that the man is caught between actions; the drunk will come to, the man in the bath will dry himself.

Artists who work with traditional images of men, subverting them or providing a fresh perspective upon them, manage to convey their meanings more forcibly than those who attempt role reversals. And artists who use the techniques of surrealism and expressionism are particularly successful. The violent lines and fractured forms of expressionism permit women to portray anguished men as well as their own suffering and anger, while dream imagery and the humour of surrealism allow women to represent their fears and desires.

Several women present highly surreal, symbolic images of men with no eyes. (Cries of "castration" again.) Mr Rochester walks once more. Some provide their men with blank spectacles, others just close their eyes, or bury their faces in beer mugs. No doubt each image has a particular meaning for the artist who made it, and indeed scores of

meanings could be attributed to the images. For example, the man with the extinguished eyes can no longer evaluate, dominate and control women with his gaze. But equally the image suggests that although men observe women constantly they do not *see* us, do not perceive who we really are. It could be argued that the construction of masculinity — the process that turns boy babies into men with the characteristics valued by our culture — does 'blind' men.

Perhaps it's stretching my argument to place works like Mandy Havers' rigid leather bodies or Jo Brocklehurst's machismo bully boy in the 'invalided' man category, but I do believe that is where they belong. They suggest that machismo is skin deep — an ugly defence mechanism against fear and weakness. Lill Ann Chepstow–Lusty, for example, exhibits a photograph of a city gent looking arrogant and unconcerned, but beneath his bowler he is entirely naked, clad only in a copy of the *Times*, a brolly and a huge phallic tie. Jo Brocklehurst displays two types of power posturing — the cowboy; all bulging biceps and black stetson, and the immaculate young man propped up by his well cut green suit and pink shirt. Mandy Havers' sewn, stuffed leather figures give concrete form to the expression 'muscle bound'.

Some artists hint that it is possible to transcend differences and divisions — or, at least, that the effort should be made. They emphasise that both men and women are damaged by a sexist society. Jackie Morreau draws the two sexes locked together inside an apple. Jane Lewis provides what I take to be a surreal representation of the oedipal moment when, according to Freudian theory, castration fears erupt and the child takes his or her place in society as a sexed being; two truncated doll-like male and female figures stand beneath a flight of steps, both with blood-stained

genitals. Robin Richmond's 'Love' stretches his arm, tatooed with bright flowers, out through prison bars.

Only one artist, Philippa Beale, seemed to deal directly with love and desire for a man. She displays suggestive, sensitive close-ups of parts of her lover's body. A tendency to isolate bits of man's body rather than recreating the desired body as a whole is quite common in women's writing and painting. For example in Mary Gordon's novel *Final Payments* the heroine fragments her lover so completely in her fantasies that she ". . . had difficulty remembering who he was. Not that I had forgotten him; I had thought of him in those days with a constancy it embarrassed me to acknowledge . . . I had thought of his hands and his walk . . . and his eyes, and his back . . . I had thought of having those arms around me . . ." More manageable in pieces?

'Women's Images of Men' contains numerous themes and individual works which I have no space to mention. There are portraits of famous men, photographs of men in their separate sphere, and paintings of male violence, and urban landscapes as an indictment of patriarchal capitalist values. Only a visit to the show itself can reveal the diverse ways women convey what lies between the sexes, challenging power relations. Virginia Woolf commented that men need women to reflect themselves back to themselves twice as large as they are. The show reflects women's determination to reflect men no larger than life.○

'Women's Images of Men', *Institute of Contemporary Arts, The Mall, London SW1. October 4 — October 26. Then at the Arnolfini Gallery, Bristol, in November/December, and the Bluecoat Gallery, Liverpool in March, 1981.*

Source: *Spare Rib*, 1980, no. 99, pp. 5-8.

III.19 1980 Dossier: 'About Time' (1)

Sarah Kent
'Pretty promises, happy traps'

Whether as model, mistress or muse, the woman's role in the arts has largely been a supportive one. Nowadays you will also find her in the service industries as a critic, dealer, historian or exhibition organiser — more active but still, by and large, fostering the male practitioners.

The female image that comes closest to that of the potent and predatory male artist is the performer or artiste — the woman who displays herself on stage with her talents. But in offering themselves to men as a spectacle, both artiste and model confirm the social expectations according to which: 'men act and women appear. Men look at women. Women watch themselves being looked at. This determines not only most relations between men and women but also the relation of women to themselves... she turns herself into an object — and most particularly an object of vision.' (John Berger)

The major problem for women as artists has been to make the transition from observed to observer, and to give up the role of the caring female to become the self-seeking and ambitious protagonist. It's a question of dropping the 'e' from artiste, or as Elona Bennett wrote 'to externalise the mutually exclusive artist and "woman" inside us and confront the world with the contradiction.'

Emmy Hennings, a cabaret performer, helped to set up the Cabaret Voltaire in Zurich, during World War I, as the first venue for regular performance art. It was the birthplace of Dada, an anarchic movement that established performance as a political tool and a means of attacking the bourgeois values responsible for perpetrating the war. Emmy Hennings, however, has not gained acceptance in the history books as an artist along with her male colleagues. Nor have the female collaborators in the happenings of the fifties and sixties in America and Germany. But since then, more and more women have been attracted to the medium as solo or group performers and have modified it to become less theatrical or illusionistic — concerned with activity rather than with acting and with live exploration and experience rather than with transformation.

Roberta Graham 'Short Cuts to Sharp Looks'.

For the current season of performance, video and installation at the ICA women were invited to submit proposals that would 'indicate the artist's awareness of a woman's particular experience within the patriarchy'. Sarah Kent previews what promises to be an important event – 'About Time'.

Traditional female skills have been introduced such as conversation, story telling, flower arranging and interior decor, sewing, make-up and diary keeping. Performance allows women not to separate the domestic from the professional and not to disentangle the artist from the model within her, but to present herself to the public as her own subject — a duality of passive and active forces. It allows an analysis to be made of the traditional images of her sex at the same time as enabling new ones to emerge. Who am I? and How was I constituted? can be explored while fresh options are also uncovered. In performance, women walk along a knife-edge, knowingly presenting themselves as spectacle, while simultaneously unravelling and making public their internal experiences. In 'Rubber Gloverama Drama' Silvia Ziranek satirises the veneer of glamour which advertising gives to the dullness of life in the suburban home, creating a sense of inadequacy in the housewife when the emptiness wells up inside her. Sometimes I am alone', croons the languishing

heroine decked up like Barbara Cartland, 'desperately alone at the sink dripping with diamonds'. Further investment in commodities and more attention to appearance are prescribed as the panacea: 'Maybe I should take more hair care Am I wrong to want the spring-time freshness that says I love you.

Several artists concentrate on the domestic role of the woman as provider and consumer. Julie Sheppard pinpoints the shocking, valium-numbed reality which lies behind the glamourised twaddle of the commercials.

With the help of a hideously graphic soundtrack, Roberta Graham probes into the horrors of plastic surgery and the philosophy which allows men and especially women to accept an ideal of beauty to which they must conform.

In her cookery demonstrations of how 'to wash fruit whilst observing the beauty of falling water', Bobby Baker knocks at the distinction between art and traditional home crafts, emphasising the fine but watertight line between the masculine and feminine zones. This distinction

is tested by marketing a limited edition print of her edible display taken by a professional, male, food photographer.

Probing those taboo areas of daily female experience which conflict with the fetishised male idea of woman is an important aspect of performance work. In her menstruation piece Judith Higginbottom collates information from 27 women about their thoughts, feelings and menstrual dreams in which images of blood red flowers and the sea recur. Susan Hiller has documented the swelling of her belly during pregnancy and recorded her apprehensions at impending motherhood.

But the most crucial and most unwieldy issue to tackle is that of one's upbringing and socialisation, especially through the mother-daughter relationship, explored by Tina Keane in 'See-Saw' and by Cate Elwes who gradually fills in a portrait of the response of three daughters to their mother's 'happy trap' of illusions and dreams: she built an admirable fortress, a fabulous fable — a happy trap lined in soft pink comfort and loving words: It caught her too, even as she pulled us in sweet innocents as we were up to our necks in sticky sentiments...

The parable offers three possible modes of action: to rebel, but finally to be ensnared by 'pretty promises and self-deceptions'; to analyse the emotional entanglement to 'unpick the fables, attack the fortress, slip past the happy trap and spit out the clap trap' — seen as the analytic feminist approach and the response of conventional success by which one takes the good things offered and rejects the bad — seen as the insensitive approach that lacks the dimension of self-awareness.

The strongest element shared by these performances is one of self-analysis coupled with political probing to elucidate the feminist motto that 'the private is political'. Crucial issues such as 'What do I wear?' 'How do I speak' 'Who am I' become the subject of exploration in art for application to life.

Source: *Time Out*, 1980, no. 550, p. 23.

III.20 1980 Dossier: 'About Time' (2)

Kate Elwes and Rose Garrard (editors)
'"About Time" at the ICA'

Introduction

Two years ago a group of feminist artists, Joyce Agee, Catherine Elwes, Jacqueline Morreau and Pat Whiteread initiated an exhibition of art by women to be held at the ICA. Their hard work and enthusiasm inspired such a large response from artists that it soon became evident that one exhibition would not be enough. In order to ensure that all work selected could be adequately shown, their original concept was extended into two separate exhibitions. The main committee concentrated its efforts on "Women's Images of Men", an exhibition of painting, sculpture and photography. Catherine Elwes also took particular responsibility for video, performance and installation works, and was joined by Rose Garrard and Sandy Nairne in the selection and organisation of "About Time".

All the works in this exhibition were about time. All the artists exhibiting their work were women. These two facts are the simplest link between the twenty-one art works seen during the ten day exhibition. Selection was made from an open submission of new works or proposals for work by women artists involved in this area of art. Decisions were based firstly on these works being of recognisable merit rather than on the name of previous reputation of the artist. Another more complex linking factor which governed both the submission and selection procedures was that "all works should indicate the artist's awareness of a woman's particular experience within the patriarchy". Although the final selection was intentionally inclusive of a wide range of styles and forms of art, and diverse individual attitudes and ideas, we did not feel that we could adequately represent women's work in theatre, dance, music or documentary video. We considered that these were often closely associated to the work we chose, but was less appropriate for the gallery situation available to us. The concerns expressed in the form and content of each selected work has raised many questions which can form the basis of discussion in and beyond the gallery. We hope that this will be the first of many exhibitions of women's work and that the whole range of time-based activity in the visual arts will be given the space and interest that it deserves.

Catherine Elwes, Rose Garrard

Rose Garrard "Beyond Still Life"
30th October

The audience assembling for **Rose Garrard**'s performance came into an area with a pre-arranged installation. In the centre there was a video camera; towards the periphery, at each of three cardinal points from the centre, a carved figure resembling the artist; at the fourth point there was a spot-lit still-life composed of three items: a book, an alabaster vase and a dead bird. The figures were in themselves identical but each held a plaster replica of one of the three items. Already a question was posed: the relationship between the **real** and the **imitation**.

The performance began with a recording describing the waiting audience: but this description was in the past tense. The artist, pre-recording in the recent past anticipated the now/our present as already in the past. Simultaneously, we **were**, and we were looking back at the unfolding present from the future. To the question of **reality** and **mimesis** was added a complex perspective of layered time.

As the performance continued, the recording revealed that the book and vase were the ones used by the artist for a still life attempted many years ago. (Were we, then, looking at a **real** still-life or a copy?) Using a camera, the artist produced on the monitor a flat picture as nearly as possible identical in appearance to the original painting. At this point we heard her recall her exact feelings when working on the painting. Later, the mode of Still-life was explored: to the art historian still-life is a genre which can be appreciated technically, culturally as form, and also culturally in terms of the complex of significance historically attached to the depicted objects. The artist as composer/image maker must be competent and conversant with cultural language. She knows the cultural significance of the objects; but their meanings to her are additionally loaded with contingencies of personal history and linked in her memory in ways which a painting could never reveal. True, the items, Book (culture, authority), Vase (art, culture; also container, womb), Bird (independent spirit; also fragile, vulnerable) have obvious links. But the visible appearance of the still-life would be unlikely to reveal that the book lies open at the story of Pandora. And even if it did, it is even less likely that this is the version of the myth in which Pandora carries a vase wherein, when the manifold troubles have escaped, only the Bird of Hope remains. Finally, no way could the actual cause of the bird's death be deduced.

The **real** artist picked up each item in turn, took it to a figure, and sat so that momentarily her image on the monitor merged with her replica. Then the **real** was exchanged for the copy, and the copy put in place in the still-life. Meanwhile, the memory of the items was told, adding layers of private and intense experience, and questions of reality proliferated. We were left with a cacophony of her questions as she, to expose her reality behind the objects, had to step out of the role of her image maker and undertake herself, in person, in real time to release her private memories.

Tam Giles

Catherine Elwes "Each Fine Strand"
31st October

A symmetrically placed long table faces the waiting audience. A small yellow light illuminates a white table-cloth and tape deck flanked by two speakers. Three cassette tapes sit in a row in front of the deck. Beyond, three towering black easels stand in the shadows, a tryptich, each supporting a large identical image of a woman's face. The outer edges are clear, distinct, but their drawn features are blurred, hardly there.

Slowly, the artist walks down the central aisle dividing the spectators, towards the table. She pauses, switches on a tape and moves towards the first image. She slowly illuminates the drawing with a black angle-poise lamp attached to the top of the easel. As the face emerges, a girl's voice begins to read a poem "You stand somewhere in the middle, turning and looking, but each direction you find seems to point back to the beginning . . ." The sound of a family meal fades in and a second voice takes up the story: "She built an admirable fortress, a fabulous fable—a happy trap, lined in soft pink comfort and loving words. It caught her too, even as she pulled us in. Sweet innocents that we were, up to our necks in sticky sentiments . . ." **Catherine** begins to weave a web of black wool across the drawing as the daughter tells how she rebelled against the matriarch only to be caught within the same self deception. As the voice argues her case for conformity and strength within the maternal alliance, the performer gradually defines a pencil smile on the expressionless face before her. Her task completed, the first story told, she now changes the tape for the next episode.

At the second easel, two taped voices, sisters, repeat the poem in unison: ". . . You retrace your steps, but your memory fails you, so you piece her back together again, borrowing from friends . . ." A pair of eyes and glasses are being positioned across the blank face. "Unpick the fables, attack the fortress, slip past the happy trap and spit out the clap trap . . ." The image seems clear, it has been identified and the inherited pressures which created this archetypal mother are beginning to be understood.

At the third central easel and with the last tape, Catherine begins to speak in unison with the two recorded voices. Once again the poem is heard ". . . In all the tangle, you look for her as if she were lost and somehow could be found . . ." The artist draws in a pair of gazing eyes under aggressive eyebrows and colours the lips bright red. This daughter takes the world as she finds it and attacks it head on. She learns how to ". . . Take what's good and leave the rest . . ." Three alternatives have been explored. There is no perfect answer, no simple solution. Slowly, the performer leaves the space, repeating the now familiar "chorus". From a distance, beyond the space, we hear her last words: ". . . She never really leaves and likes to tease you with clues that defy you to try. But you speak just too loud for her words to be heard and run a little too fast for her stride." The web of shifting identities has been woven, each fine strand trying to discover how to survive the limitations imposed by a mother's conditioning without destroying her. A loving trap from which few daughters are ever able to free themselves.

Rose Garrard

Silvia C. Ziranek "Rubbergloverama Drama"
1st November

A green plastic apple, two irridescent feather dusters, a pair of gold shoes, a pair of handcuffs, a pink champagne glass decorate one wall. Two raffia seated bucket chairs, a carpet golf gadjet, a miniature ironing board, a pile of white china plates, backed by a thirty foot long curtain of cut-out pink gloves suspended across the space . . . The stage is set, the drama is about to commence, the audience is ready and waiting, Ms Ziranek makes her entrance. She pauses, coughs and with a flourish begins: "Who took the if out of life? Who took the ache out of bake? Who put the us into house? And who put the love into rubber glove? Sidney, I want more diamonds . ."

The audience is mesmerised by the effervescent performer, dressed in a black and pink check creation, her hair in huge curlers, rings on their fingers, diamante around her neck, this larger than life personification of the middle-class housewife confidently ridicules the stripped-pine values of stereotyped suburban life. Beside her Sidney, in red wool cardi, smoking his pipe and reading the paper, completes the domestic scene.

"Sidney likes to read radical journals about experimental gardening in the suburbs, don't you dear. I was five when I discovered that you don't have to be in love to go shopping. Tell me, Sidney, does pacifism alternate with pate de foie. How brave to dislike the sound of music."

The audience, bemused, bedazzled has already fallen as willing prey to the irrepressible humour of the artiste. The monologue continues interrupted only by the occasional grunt from Sidney, combining with self-consciously stylish gestures to encourage increasing waves of laughter from those watching. These deliberately frivolous actions, superficial bourgeois values, play a clever game which transports us into the pink plastic world of Silvia C. Ziranek. The aesthetics of souffle is the rock upon which this house has been built. Laughter is the only way out of the imprisonment of her gilded cage.

We are complicit in this game, smiling broadly as Silvia mischievously reveals that many of her lines are written on props, she reads a plate then nonchalantly hurls it over her shoulder to shatter on the floor. Another plate, more laughter, a third and the laughter grows louder . . . The entertainment ends with rapturous applause, and shouts for more. Ms Ziranek returns with a flourish to deliver a precisely aimed encore: "SIDNEY HAS NEVER YET PROCLAIMED MY SOUFFLE AS A STRUGGLE AGAINST CIVILISATION!"

The majority of the breathless spectators smilingly acknowledge the undeniable charisma of this theatrical performer, the seductive power of this glittering myth, created, celebrated, and lived out by the artist. As the excitement subsides the questions begin—Is she ridiculing or questioning the lot of the suburban housewife? Are we laughing at her, or at the role of the dedicated home-maker? Does the performer reinforce the prejudice that a woman's world is filled with trivia? Who did take the if out of life?

Rose Garrard

Rose Finn-Kelcey

Mind the Gap

JOYCE A. AGEE

Rose Finn-Kelcey "Mind the Gap"
2nd November

Rose brought together a diverse collection of objects to create a strange and evocative environment for her performance: two parallel running tracks were marked out on the floor, heading in opposite directions, each into a dead end. Facing each other across the tracks were a large block of ice and a treadmill/moving carpet. The ice, supported by two white plinths, was dripping slowly in a cool blue light. The treadmill sat silent, in the recess of an adjacent room. It resembled a crouching animal, vaguely threatening, barely visible in the glow of ultra-violet light. A small flickering tongue of electric light on a stand, a Marconi radio facing a microphone, rows of chairs for the audience, these completed the scene.

We took our seats and were soon enveloped in the sound of numbing musical platitudes, supermarket muzak, absurdly contrasting with the formal beauty of the installation. This disjunction jarred me out of my contemplative mood and gently mocked my reverence. Rose's recorded voice periodically overlaid the music. Each insertion described a working idea generally discarded, occasionally carried out. "The steam from six kettles against the energy produced by her running on the treadmill. Could she outlast the evaporating water? She wanted to dance on a pile of black grapes, treading the juice through a sieve."/"She wanted to sandwich ectoplasm between 2 sheets of transparent perspex, but didn't want a substitute for the real thing. And she wondered if there were any recordings of the sound made by woodworm while damaging property."/"She considered giving the audience a hot water bottle each as comforters." These fragments were interspersed with perhaps overlong periods of *musical opiate. Was the artist ever going to appear?* Her recorded voice had claimed she would not. A child voiced the question most of us were silently considering. As I was concluding that she would not appear, Rose emerged from the darkness dressed in loose white trousers and white shirt. She was carrying two silver weightlifter's dumb bells linked by a fine wire. With great care, she hung them over the block of ice and left them to rotate gently. "She wanted to try an experiment where you place a block of ice between 2 supports, lay a wire over the middle of the ice and tie a brick to the free ends. Pressure should make the ice melt as the wire glides through, leaving the ice to reseal itself".

The insistent canned pulp continued to cushion Rose's artistic offerings. They invited us to try them out in our imaginations, and make our own choice. A man's voice on the tape read a passage from Mary Shelley's Frankenstein in which the inventor faces his own creation. Here we can identify the artist exhausted as her creation comes to life and she can see that it has inherited all the imperfections of its creator's intentions.

The treadmill at last came into lumbering life. Rose

climbed onto the machine. At first she walked smoothly and slowly as if testing her ground. Then she broke into a slow jog which was maintained for several minutes. Being dressed in white, Rose became a ghostly figure, headless and handless as the ultra-violet light picked out only her clothes. The white figure then disappeared. The tape ended with the shattering sound of an earth rift and the all clear siren – the final irony of a nuclear conclusion, in the face of which all issues seem trivial. Rose reappeared for the last time and took up the crouched position of the sprinter – on her marks. She remained motionless until discomfort forced her to stand up and walk away.

Rose's work raised many questions about the nature of performance itself. Its difficulties and its contradictions. The conflicting impulses of wanting, yet not being able to perform. The moment of crisis that is reached which ultimately frees the artist to perform. The paradoxes are transposed entire and unresolved into the work. The doubts are given equal substance to the certainties in the realisation of the piece.

For me, the most striking single image in the work was that of the runner. I experienced an immediate identification with its physical vitality and delighted in the image of a woman actively using her body, showing its strength. The pace lacked the more masculine (short-lived) drama of the sprinter, but evoked stamina and endurance – the limitations and strengths of the physical female. I caught the irony of running and getting nowhere. Racing oneself, a recurring nightmare but a familiar reality of the artist's struggle with inhibitions, contradictions, disillusionment, political and personal isolation. Each new step, each new possibility inevitably retreats into old solutions and is discarded. But it wold be impossible to stop. One has to run the risk, in spite of the odds.

I sense the danger of continually focussing on the hardships and contradictions facing the woman artist, but in this image of the runner, Rose Finn-Kelcey has been able to create a positive, powerful work which sacrifices nothing to truth but in the use of ambiguity, irony and sharp observation, has been able to transcend what can so easily become a self-defeating pessimism.

Catherine Elwes

Celia Garbutt "Supermarket"
4th November 1980

In *Supermarket*, **Celia Garbutt** showed false breasts and buttocks like commodities arranged on a shelf. Her piece was witty, revealing just how ridiculous are society's ideals of the female form, the spurious notion of perfection which reduces the feminine to a product like any other. The damage that such assumptions can cause was graphically illustrated in Roberta Graham's tape-slide presentation *Short Cuts to Sharp Looks*. Here, the horrifying techniques and self imposed agony of plastic surgery were exposed. The **restylings** and **modifications** of eyes, noses and mouths were revealed as brutal exercises in moulding flesh to conform to an ideal.

JOYCE A. AGEE

Rose Garrard *Beyond Still Life*

In Celia's performance, she followed instructions given by a taped male voice, which took her through the paces of removing six packages from a set of shelves, the whole process described as if it were some obscure branch of calisthenics. The packages contained false breasts and buttocks, three sets of each, green, pink and **flesh-coloured**. Removing her transparent plastic raincoat, Celia attached all three sets of breasts and buttocks to her leotard clad body.

I watched Celia's performance sitting next to a man. I began to smile as the work, often very funny, progressed. But as I heard him laughing at my side, I stopped smiling, and looked at him. What Celia referred to in her performance, what Roberta illustrated in her tape-slide piece was the devastating effect on the self-regard of women of a particular world-view—a male world view. In such a world, experienced by all women, everyday, she is forever fantasy and sexual package, never person. Her very flesh is remouldable, at whatever cost, to serve an alien but all powerful ideal. And the man beside me laughed.

Lynn MacRitchie

Sonia Knox "Spring 1980"
5th November

The space is brightly lit. An old sewing machine sits on a simple black table beside its companion stool A video camera lies next to the machine, focussed on the wall. The image is relayed to a colour monitor at some distance from the sewing machine. Three small cassette recorders are placed on the ground forming a triangular arrangement of sounds. **Sonia** appears wearing a brightly patterned dress. She switches on the tape recorders. From an adjacent room, the artist produces a plain grey dress and hangs it on the wall beside the machine. The dress was worn in an earlier work. She adds two more dresses, identical to the one she is wearing. The monitor now shows us a close-up of the colourful material.

The performer sits down at the sewing machine and attaches the camera to the handle that operates the wheel. This she turns. The rhythm of the machine is echoed in the shifting image on the screen. The sound is strangely soothing but the peculiarly gutteral noise of a photocopying machine is soon overlaid. Gradually the layers build up as the recorders transmit their material: intermittent fragments of a country and western song—"Blanket on the ground"—and periodic texts read by Sonia. These are often drowned by the other sounds, but snatches can be heard and they give clues to the concerns of the work: "The performance of a woman trying to fragment herself through sound, through video, and that effort will be recorded, documented . . . this is merchandise. This is a woman selling herself"./"There were three patrols within the hour. The rifles passed by the net curtains."/"Tenderness, mother, whore."

Sonia now swings the camera round to point out another part of the room—sideways on. She takes the third patterned dress and lays it on the ground within the camera's range to complete the triangular arrangement of monitor, sewing machine and dress. She draws a chalk outline around the dress and returns to the machine. With the sound created by its turning, she builds rhythms to work in with the other sounds in the space. Sonia now places the camera on the ground and curls up into a foetal position in such a way that her head and shoulders appear on the monitor. The classic

Celia Garbutt — *Supermarket*

JOYCE A. AGEE

fragment of the newsreader—but on its side. ". . . A video that picks up head, or cuts out a head as it goes by . . ." She unfolds a piece of paper and begins to read with the help of a small microphone that relays her voice to the monitor. In the confusion of sounds, only a flavour of that speech can be retained. A manifesto is suggested, an academic lecture, fragments of James Joyce in a lilting Irish accent, art jargon, political jargon.

The mechanics of video give the text the authority of media while the arrangement of sounds allows it no clear reading. This device suggests the difficulties of speaking as a woman and as an artist in a clear, authentic voice through the fog of ideology inherent in much of verbal language. The medium of video and of the work itself, seems to act as a catalyst for the diverse elements that the work contains: the labour of woman, exploited by capitalism and seduced by the media into sewing together an acceptable image of herself – inadvertently building her own trap./The sentimental song linking marriage and romance into a self-perpetuating myth./ The blanket of the song ironically making a reference to the plight of Irish political prisoners./The repressed hatred of man towards woman being chanelled into an all-encompassing tenderness--". . . He put his hand over her mouth and sai said he wanted to kill her – but he kissed her instead . . ."/ The English presence in Ireland as it affects the daily lives of ordinary people ". . . She pulled back the curtains and shouted out to one of the squaddies— you're too young to be here, you ought to be home at school . . ."/The vulnerability and sensuality of the artist in her foetal position. Her jargon-ridden speech coming across like the babblings of a child./ The personal, the political, the power of the media, the powerlessness of the oppressed, the predicament of art, the relationships of all these elements fused and shifted. They

229

were held together by the tremendous tension created by Sonia's total involvement in the process and content of the piece. I found this work one of the most moving of the series.

Catherine Elwes

Bobby Baker "My Cooking Competes"
6th November

Food preparation and serving is a universal female task. Men may work with food as professionals – highly paid chefs for example, whose creations are admired – but ordinarily, domestically, cooking is done by women. Skill in baking and cooking is usually passed down from mother to daughter. An unusual aspect of what is normally a private task is the tradition of the show of baking, jam and preserve making at venues such as the Women's Institute, church fete or agricultural show. **Bobby Baker** drew on this reference in her piece "My Cooking Competes".

A long trestle table covered in white was set with an array of dishes, each with a rosette, blue, red, yellow or green according to the grade of the award. Bobby came in, dressed in a spotlesswhite overall, and addressed the audience. After welcoming us and enquiring after our comfort, she moved behind the long table and began to describe each dish in turn. What made this different from an ordinary cookery display was the particularity of the detail which Bobby chose to describe. Thus, in dealing with a coffee-break snack, she included a hand rolled cigarette. From these precarious cylinders some strands will always spill, necessitating wiping the table with a J cloth. Enthusiastic about a TV dinner of pasta and salad, (served in bowls fitted with rubber stickers so that they would not slip from the tray when it was carried upstairs) she worried about guests grating their fingers along with the cheese. A supper party for four had the guilty inclusion of "Smash" potatoes and frozen peas. Sunday breakfast, a full fry-up with croissants and Sunday papers on the side, was more of a dream than a regularly achieved reality. When attempted, the sputtering fat from the frying sausages necessitated the constant wiping of the stove and wall with a J cloth in warm water. Perhaps the point that set most heads nodding (and nods and little smiles of delighted recognition kept breaking out, rippling among the women in the audience) was the description of pouring icing sugar into a bowl. During this, always, a fine cloud of sugar particles will rise into the air, settling eventually on the storage jars ranged on the shelf. A collar of sugar crystals and dust is thus inevitably, inescapably formed, and the jars must be removed from the shelf, washed and dried, the shelf dusted and prepared for their return . : .

Perhaps what made this piece so appealing, even touching, was the sense it conveyed of shared experience. The audience knew that this presenter had actually performed all these tasks, that they had taken up her time, just as they wear away the time of countless women, day after day. Those women who in all their frustration will still take a blue ribbon to decorate that despised iced bun, because, after all, it's an "anniversary tea". Cooking is indeed one of the ways, however damaged, in which we experience love. Bobby finished the performance festooned in the rosettes from her creations. She managed to look at the same time both bashful and wise.

Lynn MacRitchie

JOYCE A. AGEE

Carlyle Reedy *Woman One*

Carlyle Reedy "Woman One"
7th/9th November

Carlyle Reedy is a veteran of performance art, poetry and events. A mistress of timing and the well-turned phrase, a poet with a gleam in her eye, having **Hung in there for twenty five years** she is still full of surprises.

Carlyle presented two different pieces. The first was relayed on video to those of us unable to crowd into the packed performance space. The "set" made a striking composition – a dangling lightbulb traced ghostly lines over the TV image and flashed in a suspended mirror. The performer was wrapped waist down in a vilene sheet, and vilene panels marked off the space. The sound was unfortunately rather unclear and many of Carlyle's words were lost. She decorated her face and examined it in the mirror, talking about time. Tracing its surface, with a graceful swoop she shaved an eyebrow clean away. Suddenly I had a flash of what it might have been like at a Dada event so long ago – intrigued, surprised – what could come next? An ironing board was "improved" with a hand plane until it crashed to the floor. Tin cans rolled and Carlyle stamped on one with a firm, strong foot, declaring "This is miserable". There was some percussion, some gamelin-like music, and lastly, seen in negative, the projected image of a baby's face, crying, open-mouthed, demanding.

Sunday's performance was more elaborate, with five other women taking part. For much of it, Carlyle lay feigning sleep, first in a "bed" with vilene sheets, then curled up on

230

the floor. As she "slept", other women entered. First, one went to a crammed dressing table, where she began to work on her face, then slipped behind a screen to change from one feminine outfit to another, then returned to the mirror. Two more women entered, climbed into the bed which Carlyle had vacated; they made each other up. Then one filled envelopes with knives, then forks, while the other, lying face hidden, poured out an endless stream of tea. On the wall behind, a slide of a mannequin dressed as a bride was presented. Eventually Carlyle got up, donned a rafia head dress and brocade coat and began to dance. "Welcome to the Samoan Republic. No more of that ack ack", she declared. More dancing, some drumming on beer cans and dishes, a sign which read "old hippy". Then, silent, Carlyle lay back over a plinth in the corner. Her hair streamed down. A woman in a white dress entered from the audience. She moved up next to Carlyle, and passed her hands over her body and hair. Carlyle got up again, and danced through the audience bearing her old hippy sign, and demanding to know where it was at.

The slide had changed to a collage showing a bomb superimposed over pop images. There were animal noises – sheep on the sound track. And then the Rolling Stones. All the women were now holding signs reading *Woman One*. Shirley Cameron entered from the audience wearing an extraordinary hat, like a pyramid of screwed up paper. Gradually she released its fastenings, and the paper slowly showered down. Carlyle thanked the audience, and the piece was over.

The first piece was unusually powerful – chaos, time and fertility as the eternal companions of woman, never truly one. *The space* as Carlyle wrote on the screen in a final gesture, is too crowded. The second piece showed women together, sharing an opportunity, a venue, an idea. Not perhaps so clear in its images, perhaps more powerful by showing that that "One" can be, and is, many.

Lynn MacRitchie

Hannah O'Shea "A Visual Time Span (a visual diary) Towards a Sound Track"
8th November

Two tables were set in the space containing the tools of her practice: splicer, film reels etc. and an 8mm. projector. The films were silent, consisting mainly of "home movie" material (children's birthday party, woman breast feeding baby etc.) and private performances (mainly of women acting-out mythical/fantasy roles) which appeared to have been carreid out (made public) especially for the film. These sequences were collaged together in a seemingly random manner – one set of images having no direct relation to the next – thereby denying any notion of a narrative and an "easy" reading on the part of the spectator. Hannah O'Shea manipulated the projector, slowing down, stilling as she felt necessary. Once during the performance dust gathered in the projector. she calmly stopped the equipment, cleaned the gate, cut and spliced the film. It was unclear whether this was a pre-conceived action (a de-mystification of the mechanics of film production?) or an unpremeditated technical hitch.

The most interesting part of the performance was when she stopped the film and explained that what she had intended to show (on the film) had been carried out by a friend who had requested that it not be shown. Hanna

Silvia C. Ziranek *Rubbergloverama Drama*

O'Shea then mimed the actions of her friend, describing how she had removed a tampon from herself, smelled, tasted and smeared her body with her own menstrual blood, finally writing her name on the window. In doing this she managed to bridge the difficult gap between private and public with great delicacy and sensitivity, avoiding the voyeuristic aspect of film but at the same time raising questions about "the acted" and "the real" experience.

Her stated aim was to show and de-mystify as many aspects of woman as possible and the eclectic nature of her imagery ensured her success on that score. However, the apparently arbitrary nature in which they were filmed perhaps made it difficult for the audience to generalise beyond their appreciation of one woman's particular self expression.

Maggie Warwick

About Time is touring to:

Arnolfini, Bristol	9-20	Dec. 1980
South Hill Park, Bracknell		Feb. 1981
Liverpool Academy, Liverpool	7-28	Mar. 1981
Project Arts Centre, Dublin		Apr. 1981
Third Eye Centre, Glasgow		May 1981
Birmingham Arts Lab		Jun. 1981

Source: *Primary Sources*, 1980, no. 6, pp. 8-9, 14.

Griselda Pollock
'"Issue": An Exhibition of Social Strategies by Women Artists'

Griselda Pollock looks at **Issue**, questioning our assumptions about art ('truth and beauty'), the artist ('born genius'), and the political ('not art').

(to emerge;
to be born;
outcome;
event;
the point in question):

Over the last decade *Spare Rib* has played a vital role in supporting, recording and spreading information about feminist art. This doesn't surprise me. Art has been an important area of feminist activity. But there have been genuine difficulties for the magazine in presenting the issues in feminist art practices in an accessible way to a non-specialist readership. For feminist artists may well be very interested in feminist art, but are feminists interested in art, feminist or otherwise? The limited audience for and the apparently marginal importance of art in most of our lives might easily suggest to many that women's art practices have little or no relevance to our political struggle as women.

Art as protest

Yet there are several constituencies within the movement who argue otherwise but with different emphases. There are of course women who want to make art but encounter at college or in the world of exhibition and criticism typical forms of discrimination and prejudice against women's equal participation. Remember it was only last September that the major grant giving body, the Awards Panel of the Arts Council, published their list of awards for this year and did not include a single woman artist. As in many areas of employment women as artists have to organise and campaign for their rights to pursue their chosen work and get what they produce shown.

Art can also be defined as an important form of communication and one to which we at least have access, unlike the major media. Art can therefore be used to record or articulate feminist points of view about the world, experience of, and protest against oppression. It has been used in this way to express the 'personal' feelings of women, to depict a female experience of the world. But it can also be defined as a device to spread knowledge. Art can be made in a more overtly propagandist or agitprop manner, to provide different kinds of information to that which either the media or traditional art practices produce and purvey. Finally it can be argued that however remote or insignificant high art appears to be, it none-theless has an effect which extends beyond its own limited boundaries. To an important extent, the seemingly specialised fields of high art contribute to, and reproduce ideas, attitudes, images of the world and especially definitions of woman and gender roles. These 'ideologies', systems of ideas and beliefs, shape us and our identities and help to make the patterns of domination and subordination characteristic of our society appear 'natural', obvious, commonsensical because they are validated by the claims that art offers universal human truths. So in addition to the obvious and immediate levels of political and social struggle we can talk about cultural struggle – opposition to the ruling ideas of our society aimed at the very places where those ruling ideas and ideologies are generated.

It seems to me that we are usually more willing to accept some of these arguments for a feminist cultural practice when applied to novels and films because they seem more accessible and widely disseminated. Some women at least buy or borrow books; few go to art galleries. This is arguable. But I suspect the prejudices against the visual arts (painting, sculpture, photography and so on) are founded on the belief in their narrow appeal and limited public. (This has of course to be questioned in the light of the large number of visitors to the *Images of Men* show in London and now elsewhere around the country.)

Yet despite the fact that many of us have little to do with art as such in our lives, we all carry about with us ideas about what art is, and about the artist, which are derived from the traditions and ideologies of the visual arts. I'm thinking about ideas of creativity, genius, eccentricity, about the artist being born a special kind of person, different from the rest of us, ideas about art expressing someone's individual feelings and inner being, art being an expression of emotion, spontaneity, intuition . . . Current popular definitions of art and artist are the very *opposite* of the socially involved, the politically analytical, the outwardly oriented, the collective. And these ideologies of art and artist can also be challenged as well as the meanings usually conveyed in art. This is what the exhibition ISSUE: *Social Strategies by Women Artists* at London's Institute of Contemporary Art tried to do. And it was around the validity of these challenges that debates grew up at the concurrent conference, Questions on Women's Art.

Just what is at ISSUE?

It has of course been an amazing autumn for feminist art with three successive shows of work by women artists, a festival of women's films, panel discussions of literature, poetry and feminist cultural theory and finally a two day conference. The third and final art exhibition of the series opened in mid-November. It was an international exhibition organised by the American feminist, Lucy Lippard, who has done a great deal to promote knowledge of women's art in America and also, importantly in Britain. This is not mentioned out of national chauvinism, but in recognition of Lucy Lippard's inspiration to feminists involved in art in this country. In 1974 a show she had organised, *Ca. 7,500*, of works by women conceptual artists was exhibited in London. Then in 1978 Lippard wrote the catalogue essay for the Hayward

One morning while glancing at the newspaper, we were horrified to see the naked body of a dead woman on the front page, the ninth woman raped and murdered by the Hillside Strangler. We had to do something about the way news had made entertainment out of it. So we created IN MOURNING AND IN RAGE, (L.A. '77), a memorial performance on the steps of city hall as an expression of our grief and rage transformed into political action. The images of 7 foot tall women profoundly affected the consciousness of the media audience.

These three images are a part of *Performance Art and Social Change*: Suzanne Lacy & Leslie Labowitz

Annual II, the first publicly funded exhibition in England to be organised by women and which had a majority of women artists. Now she has arranged ISSUE. But it is a very different kind of exhibition. Lucy Lippard's position has changed over the last six years. Although much of the work was feminist in content, *Ca. 7,500* conformed to the format of a typical modern art show and subscribed to the display function of an exhibition. By 1978 Lippard was expressing doubts about the wisdom of women artists focussing energy on merely overcoming discrimination and winning admittance to the privileged circuits and exhibition spaces of mainstream institutional art.

Now Lippard has brought to England, with British artists included, a show which raises questions about the new kinds of job art can do, the new ways it can be used within our feminist social strategies.

The new kinds of job art can do

The exhibition is explicitly addressed to feminist art practices, thus stating that there is a clear difference between art made by women and art made from a political perspective by women. (A political perspective can mean either its content, the context for which it is made, or the general political overview which informs the work.) The show does not just display works of art. It demonstrates the variety of current political art strategies used by feminist artists who deal with such issues as rape, racism, militarism, political intimidation, imperialism, health care, childcare, housework, service work, migrant workers, torture, the media and, indeed, the ideologies of art and their intimate connection with conventional notions of women. The exhibition collected works together, or, as importantly, presented information in a documentary form about work that was being done

which could not be exhibited — records of performances which were part of a campaign against violence and rape in Los Angeles, or examples of the work of an artist who sends out through the post messages and stories which in a popular way analyse and raise consciousness about rape or American political and cultural imperialism.

Thus the exhibition can be seen itself as a political intervention in the

art gallery because it refuses to display art objects. Its purpose is to propagate information about feminist art strategies, about work being done in ways that are not aimed only at conventional art gallery audiences, or if they are, do not pander to the idea that art is merely an aesthetic or exclusively visual experience. The artists involved are different in that they are not making art for aesthetic consumption so much as making art which contributes to knowledge about issues that are central to feminist political practice. Lucy Lippard hoped that the exhibition would prove that art making had a place within feminism and socialism:

ISSUE is of course a pun on generation and topicality. It is about propagation, spreading the word that it is possible to think of art as a functioning element in society.

This is the claim made in the very important statement Lippard makes in the catalogue essay. She continues:

While all art should to some extent act as provocation, as a jolt or interruption in the way social life and sensuous experience

are conventionally perceived, the work shown here attempts to replace the illusion of neutral aesthetic freedom with social responsibility by focussing — to a greater or lesser extent — upon specific issues.

Making art *and* propaganda

So instead of the conventional associations of art with truth and beauty, the show posed questions about art and truth and politics, about power, knowledge and social action. To say

that, however, doesn't imply that those who produce this work are not really making art but merely propaganda. This is a common complaint against art that addresses real social questions or engages with political human experience. It's not art, it's politics, it's said, as if these are mutually exclusive. Such a complaint was being made at the conference against the ISSUE show because, I think, the dominant ideologies of art and the expectations they incite about what can and can't be art still prevail within the women's movement and the women's art community. Art is visual, it is often claimed, and speaks to us through non-intellectual modes of communication. It can of course be that and do that. But art can also be rigorous, analytical, mindful, thought-provoking in its use of juxtaposed words and images, or human speech and action recorded on video, for instance. Lucy Lippard anticipated debates around such issues and in the catalogue she wrote:

I hope the web of interconnections and disagreements cross the boundaries of medium, aesthetic and ideology in order

to facilitate dialogue with the audience. The conference that is taking place in conjunction with the sister shows *Images of Men* and *About Time* will be a still more effective factor in this process.

But at the said conference, while many aspects of women's struggle to make art and get their voices heard were discussed, the issues raised by the ISSUE show were largely ignored — except for a few personal attacks on individual artists for their way of working, for using words, for asking us to read statements in words in the exhibition. The artist most attacked for this, Martha Rosler — attacked most unjustly because her major work in video was not shown — was able to raise a central problem in her statement to the panel, 'The Diversity of Women's Art: Is the personal political?' To say yes to this question meant acknowledging a real difference between merely

claiming that it is so and recognising the social factors that act upon and constrain those parts of our lives that are called the personal. She stressed this because there is a particular danger in the realm of art making for feminist ideologies of the personal to play directly into and thus be appropriated by the existing ideologies of art as the expression of the personal. According to that rubric a woman artist makes art and thus expresses herself, and her art is then claimed as political, as feminist, simply because a woman has given expression to her woman-self. This is not enough argued Martha Rosler. We have to make the personal political in terms of a larger collective struggle, to demand freedom and change in all aspects of our lives as part of the campaign to win control over the direction of society as a whole.

Breaking the tabus

At the conference there was a collision of ideologies. Some women present were concerned above all with finding a place, a genuine one, within the existing definitions of art, its production and uses. From the ISSUE show there were women who as feminists wanted to elaborate new kinds of art practices. These new forms and means and audiences which resulted from feminist and socialist concerns would sometimes take their art 'outside', either literally outside the gallery, or metaphorically outside the conventional notions of art.

In her catalogue Lucy Lippard described this new movement:

> In challenging notions of genius, of greatness, of the artist as necessary nuisance that are dear to the hearts of the institutional mainstream and the general public, the artists in ISSUE have also challenged some fundamental assumptions about art. They are in a good position to do so because feminist art has had to exist for the most part outside the boundaries imposed by the male-dominated art world. While these artists do exhibit in that world they maintain support systems outside of it and many have established intimate connections with different audiences. Having watched so many politicised artists reach out only to fall by the wayside or back into the acceptable modernism fringed with leftist rhetoric, I have the heartiest respect for those with the courage to persist in the nobody's land between aesthetics, political activism and populism. The tabus against doing so however bears some looking into along with the ways some artists have broken them.

It was because of this attempt to negotiate new spaces and purposes for art, both looking outward to popular arenas and back into the centres of high culture, that I found the exhibition so

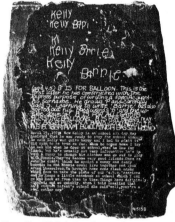

From Mary Kelly's *Post-Partum Document: the Name . . . an institution, an author and a text*

exciting and inspiring. I saw art works about things that matter and which gave me new insights into them, new understanding. It would be impossible to describe adequately the effects of this variety of work from a video document on the FBI's political persecution of the actress Jean Seberg, who committed suicide last year as a result of their smear campaign, to a sculptural homage to the life and fast disappearing culture of Bedouin women and their people now being moved into concrete townships, from a series of photo and word portraits of women of twelve different ethnic or national backgrounds made for and displayed on Los Angeles buses, to the more familiar looking paintings by an artist attempting to confront racial violence in the States and who, in order to overcome young black people's assimilation of media images employed the less familiar techniques of painting on canvas, but hung these pictures with vicious looking ropes and barbed wire. Other kinds of work addressed the question of the media itself and how to use it ourselves; another piece worked to deconstruct the 'reality of woman' that is represented and defined by words and images in photographic practices for instance, and how the claim to be able to present the truth about a woman in the photograph overlaps with artistic ideologies which claim that art can offer a direct visual truth when it is, in fact,

manufactured, constructed, partial and ideological. Thus the piece insisted on a political strategy at the level of radical art practices and not merely alternative images or new content. The predominant characteristic of the exhibition was the diversity of media and methods deployed in diverse strategies addressed to varying audiences both inside and outside the usual public for art, feminist or otherwise, the usual audiences for politics, feminist or otherwise.

The personal is *not* all

Yet the experience of the conference left me feeling saddened and concerned. So long as women making art have to continue to battle on the front of discrimination in art education and exhibition, and so long as feminists in general continue to think the visual arts are irrelevant to our movement we will miss out. The ISSUE show demonstrated the potential for feminist political art with its rigour and careful concern with art theory and political theory to make a powerful contribution to the women's movement's struggle to raise political consciousness for radical social change. What is worse than that loss is to find that this kind of art is either overlooked or ignored by feminists as it was at the conference, or picked at for silly reasons as it has been by some critics since, simply because it does not conform to the traditional definitions of art, in which the personal is all and the political belongs somewhere else. ●

The women whose work was included in ISSUE were:
Ariadne: A Social Network (Suzanne Lacy and Leslie Labowitz)
Nicole Croiset and Nil Yalter
Fenix: A Cooperative Travelling Installation (Sue Richardson, Monica Ross, Kate Walker)
Margaret Harrison
Candace Hill-Montgomery
Jenny Holzer
Alexis Hunter
Maria Karras
Mary Kelly
Margia Kramer
Loraine Leeson
Beverley Naidus
Adrian Piper
Martha Rosler
Miriam Sharon
Bonnie Sherk (The Farm)
Nancy Spero
May Stevens
Mierle Laderman Ukeles
Marie Yates

Source: *Spare Rib*, 1981, no. 101, pp. 49-51.

Rozsika Parker
'Feminist art practices in "Women's Images of Men", "About Time" and "Issue"'

In 1974 no public gallery in London would accept an exhibition of 26 women conceptual artists, 'C.7,500',* selected by Lucy Lippard. In 1980 the ICA housed three major feminist exhibitions, a women's film season, a series of panel discussions and a week-end conference 'Questions on Women's Art' involving artists from all these shows as well as those from the related venture 'Eight Artists: Women: 1980' at the Acme Gallery.

Why the shift? It cannot be viewed as a token gesture, a way of accommodating feminist demands before the door is closed behind us again. The time span, the broad spectrum of events — too insistent and varied in form and content to be organised in one kind of exhibition — counteracted that danger.

A complex set of factors determined the events at the ICA. At one level they signified the great change of consciousness brought about by the women's liberation movement since the early 1970s. For example, though public critical response to the shows continued to negate and contain feminist art practices, no-one outrightly dismissed the shows with the levels of abuse aimed at 'C.7,500' ('It stinks of the ghetto'). But most importantly the shows were the result of diverse strategies by feminist artists. Since 1974 they have continued to campaign for equal access to art-world structures, while simultaneously organising alternative exhibition spaces and producing small magazines. And women working within the system — in art schools, galleries, universities, art centres and regional arts associations — have purposefully supported women's endeavours, while independent networks of women artists' groups have developed throughout the country. Panel discussions, feminist conferences and workshops have repeatedly addressed the issue, 'What is feminist art?'

The answer produced by the ICA shows was, 'It doesn't exist'. Instead we were presented with a multiplicity of feminist art practices, deliberately intervening in the main currents and institutions of contemporary art practice — or equally deliberately raising questions about them. The achievement of feminists over the last decade has been not only to break the silence on women's specific experience, but to question the basic assumptions about art and the artist that have worked to establish the dominance of white, male, middle-class art. I want to look at some of the strategies that emerged at the ICA shows, and identify a few of the approaches developed so far, their problems and potential.

Brush Painting by Mikey Cuddihy, March 1979, exhibited in the Acme Gallery's 'Eight Artists: Women: 1980'

'Women's Images of Men' was primarily concerned with transformation at the level of content. The organisers advertised widely for work, asking 'Women, how do you see men?' From the submissions they selected a show of narrative painting, sculpture, drawing and photography. Figurative work, they believed, would be above all accessible: 'To reach beyond, but including, the women's movement and the usual visitors to galleries' was one of their major aims.

The show aspired to make visible the invisible; to confront women's oppression by revealing hitherto repressed or censored aspects of our lives. 'Like any colonized people they want to first know who or what they are — to strengthen a sense of themselves as Subject rather than Other', wrote Lisa Tickner in the catalogue. It demoted men from standing unproblematically for mankind; presented through women's eyes, men can no longer be Man. The women returned the gaze that is usually turned upon them and refused to be objectified. It was a subversive act. In Lisa Tickner's words, 'How threatening, how disruptive, to return the scrutiny; to attempt at least to stay author of one's own look; coolly to appraise the male not just in himself, but as bearer, rather than maker of significance'.

The makers of significance hurriedly marshalled their forces and made out the show to be simply women making spectacles of themselves. The organisers deliberately sought publicity in order to draw a wide audience, therefore it is important to examine critical response to the show; moreover, the genuine lack of understanding and/or profound anxiety with which the show was received is in itself illuminating.

Work providing a far-ranging appraisal of women's experience of a patriarchal society was viewed entirely mistakenly as a querulous demand for role reversal. This was partly due to the fact that since the 19th century the figurative tradition has been dominated by the female nude. Visitors may thus have expected to find ranks of naked men. The few penises on show multiplied in anxious minds — and debate descended to the level of a numbers game.

Critical discourse worked to contain the discomfort provoked by the show. On the one hand it was entirely denied — the exhibition was 'fair', 'interesting', 'not particularly Amazonian', even 'highly flattering to the male ego'. In other words it was seen to conform comfortably to the feminine stereotype. But the exhibition was as often characterised as the aggressive outpourings of unrepresentative neurotics: an endeavour 'sabotaged by anger'. It was seen to conform to the feminist stereotype — ugly and extremist, able to be dismissed and denigrated. Griselda Pollock has pointed out that whereas critical discourse has traditionally placed a feminine stereotype like a blanket over all women's art, with the appearance

of today's feminist art 'the necessity of establishing difference and excluding threatening art practices is reasserted not by distinguishing feminine from masculine, but feminist from feminine and making the former the object of exclusion, dismissal and denigration'. (*Feminist Review,* No 2, 1979 'Femininity, Feminism and the Hayward Annual'.)

However, with the proliferation of feminist art practices, new critical strategies are appearing, exemplified by Waldemar Januscek. Instead of posing feminine against feminist he created two categories of the feminist. Declaring himself in sympathy with those *reasonable* feminists who simply claim equal rights, he felt safe to lambast 'organisers of shows like this one — shows which sit back and wait for the scratching and biting to begin'.

Although misread and misrecognised as a demand for role reversal — something all feminists entirely reject — the show was provocative and popular. Indeed it broke all previous attendance records at the ICA. And many women, including myself, found that the work provided absorbing evidence of patterns in the way women have seen men. Recurrent themes in the exhibition related to a tradition of women's representation of men. (See *Spare Rib* No 99 'Images of Men'.)

The reception of the exhibition indicates why some feminists consider that introducing a novel content is in itself insufficient. For example, somewhat bitter experiences have shown feminists that so-called 'positive images of women', though an important means of consciousness raising amongst women, have not been able to radically challenge the narrow meanings and connotations of 'woman' in art. Because meanings depend on how the art is seen, from what ideological position it is received, the most decisively feminist image of a woman can be recuperated as body, as nature, as object for male possession. Therefore some feminist artists turned to radical art practices other than the traditional fine arts of paintings, sculpture and photography. Some are exploring performance art and video to investigate novel ways of presenting women's experience. They are not attempting the impossible — the creation of a new language untouched by existing expectations — but rather to show how representations of women are reproduced in our culture. 'To unlock the power of imagery, to decode its mystery, to make the impossibly evocative also a moment of dissection and comprehension'. That is the aim of

A work by Margaret Harrison show in 'Issue' at the ICA

feminist performance art, wrote Sally Potter in the catalogue for 'About Time; Video, Performance and Installation by 21 women artists'.

The selectors requested work which 'indicated the artist's awareness of a woman's particular experience within patriarchy'. So this too was a theme show, but less tightly defined, and interesting because of its stress on particular media. New media is not essential for feminist art practice but it does offer possibilities for working directly with the artist-audience relationship, and exposing multiple, complex, overlapping meanings within the same piece — useful for feminists determined to challenge the certainties of our society.

Most work went beyond presenting women's experience within patriarchy to show how that experience is constructed; through the mass media, the family, education, advertising, consumerism, fashion, domestic labour and styles of art. Within installations, mixed media was juxtaposed to powerful effect. The artist's intention or personal experience was conveyed on tape, in a text or in person and juxtaposed to photographs, slides, objects, drawings, or video which interacted with her words, sometimes revealing the power of media to transform meanings, or indicating contradictions and conflicts between a woman's subjective experience and the cultural expectations and definitions within which she works.

It is dangerous, though, to generalise about the diverse work contained in 'About Time' and even more dubious to attempt to sum up the different approaches contained within the performances. Feminist performance today is, I

think, determined by two developments within the recent history of feminism. Firstly, a growing understanding of the role of audiences in producing meanings makes performance art appealing in that it can allow an artist to engage directly with her audience; secondly, feminists have always placed importance on collective work. Initially feminist performances invariably involved several performance artists — a device for questioning the notion of artist as isolated, purely self-expressive, exceptional being. Today, however, the emphasis is more on collaboration between individual artists and audience, not in the sense of direct audience participation, but in that audiences are rarely allowed to simply 'appreciate' the work. Offered elliptical fragments of sounds and images, we had to draw out connections and form meanings, within a framework nevertheless carefully determined by the artist, calculated to raise issues about women in a partriachal society.

One of the problems facing feminist performance artists is the tradition of female performers as spectacle for an audience. How, asked Sally Potter in the catalogue, can women avoid appearing simply as an object on display positioned always in relation to male desire: 'Women performance artists who use their own bodies as the instrument of their work, constantly hover on the knife edge of the possibility of joining the spectacle of women'. A variety of methods were employed to focus the audiences' attention from the artist as object to the subject of her work. The artist herself was distanced though video, lighting and recorded voice. She rarely, if ever, engag-

ed directly with the audience, she worked with her back to the audience, sometimes altogether 'off stage', leaving the audience with a curious assemblage of objects — the traces of her presence.

The drawback to all performance art — the number of people who can manage to see the work — is particularly acute for women who are fighting institutional discrimination. Installations relating to the performances were on show in the gallery, but the problem was exacerbated by the brevity of the exhibition. It lasted only ten days and there was a different performance every evening.

The next show 'Issue', unlike the others which were selected by participants, was put together by the American critic Lucy Lippard. She has played an important and useful role in Britain. She was responsible for 'C.7,500' mentioned above, she introduced the catalogue for the 1978 Hayward Annual selected by women, and now she has brought 'Issue' over here. The exhibition was conceived of from an overtly political perspective and it demonstrates 'the contributions of feminist art to the full panorama of social-change art'.

All three shows were placed in the gallery — not, as some have suggested, to gain acceptance from the establishment, but to *change* it. 'Women's Images of Men' with the publicity it received outside the usual reviewing channels brought a wider public to the gallery. Artists in 'About Time' claimed that their working methods criticised conventional use of a gallery as a 'clean white space', while 'Issue' brought evidence of art-making in very different contexts straight to the heart of the system.

All of the artists in 'Issue' challenged the idea that art is ever simply a visual experience. They raised questions about how art can be used to produce knowledge of

Work by Emma Park, 1979-80, shown at Acme

structures of power. The practices and media they employed were those most appropriate to each artist's objectives and her intended audience. There was no pure painting, sculpture or photography.

Lucy Lippard described the feminist art practices in 'Issue' as ' "moving out" into the world, placing so-called women's issues in a broader perspective and/or utilizing mass production techniques to convey its messages about global traumas such as racism, imperialism, nuclear war, starvation, and inflation to a broader audience'.

She uses the term 'moving out'. In one sense this means going beyond the stage of feminist art practice characterised as 'looking for shared images' in women's art — to consider those issues loosely defined as socialist feminist. But the term can be profoundly misleading if it is taken to mean that feminists are just identifying with other struggles. On the contrary, once feminists realise that as women they are positioned in the world by social and political forces all the institutions of society become subjects for scrutiny. The most powerful works in the show revealed the

chain of connections from the artist's personal recognition of oppression to 'global traumas'. The issues examined in 'Issue' were shown not simply to be either the result of capitalism or of patriarchy but of their intersection. After an exhibition like 'Issue', overtly political art which excludes a critique of partriarchy will, I think, appear incomplete.

The work could roughly be divided into two categories. Some artists directly addressed the gallery context. They presented their ideas in such a way that it fulfilled the audience's expectations of visual pleasure — yet challenged complacency with intellectually-demanding or emotionally-distressing content. Those who cynically characterise such work as 'gallery socialism' would perhaps prefer feminists not to disturb the easy tenor of gallery life. Other artists exhibited records of art practice in other sites. They revealed how they had worked with a chosen audience developing appropriate means of communication from bus-cards to post-cards, utilizing the mass media in such a way as to avoid their ideas being distorted in the process. They were accused by critics of simply providing documentation. That is exactly what they *were* doing; showing one public their work with another. How else were we to see it?

The co-existence of the two types of work in one show, and the varied approaches in the other exhibitions, underlines the point I made initially — there is no feminist art, but a multiplicity of practices, ever developing, and undoubtedly pushed forward by the events at the ICA.

(Thanks to Griselda Pollock and Ruthie Petrie for comments and criticisms.)

* 'C.7,500' was finally exhibited at The Artists' Meeting Place, Earlham Street, London.

Source: *Art Monthly*, 1981, no. 43, pp. 16-19.

Griselda Pollock
'Feministry?'

FEMINISTRY?

The photos and text illustrated here document that exhibition which was called ANONYMOUS: NOTES TOWARDS A SHOW ON SELF IMAGE, by women involved in the Leeds Women's Art Programme.

The work was produced by a collective of women who had been working together for four months. They were: Barbara Birks, Jackie Callis, Cat Clark, Dinah Clark, Diana Compton, Kay Cooper, Liane Kordan, Helen Kozich, Shirley Moreno, Annie Smith, Caroline Taylor, Toni Villanueva, Jan Wallis.

The show was made up of twelve panels all the same size, 3ft x 4ft, each painted a different colour and treating a distinct but interelated theme. They had no titles but dealt with the following concerns:

Women's Creativity (a textile work about women making-people, life, art)

Female Faces (photos of one woman and of advertising stereotypes collage and inter-secting each other)

Fetishism (a huge jigsaw of advertisement visions of women's endless ruby lips and stilleto heeled legs)

Feminist Frolics (a pinball machine rewritten in terms of women's lives- winning and losing being born and dying)

I DO (huge pink stuffed hands embroidered with all the work and fun women do with their hands)

Feminist Friendships (Photos of Women by Women)

Menstruation Cycles (a celebration of them)

IN THE PINK ('ghastly' pink network of baby gear, laundry, cookery exploring the contradictions of being in the pink as a mother and being in the thick of domestic labour)

Making Up and Making Art (using instructions for making up a face and for preparing a surFACE for a painting and applying the latter to a photo of a woman's face)

Compulsive Eating (drawings of faces expressing the several stages of desire and disgust while eating)

The Family Album (juxtaposes several typical moments from the family album with reconstructions of the scenes which expose the power relations within our smiling or romantic snaps)

Genetics and Inheritance (a collage of photos of the generations of women in a family dedicated to an overlooked scientist who worked on the discovery of DNA)

Here is the text published to accompany the show: ANONYMOUS: NOTES TOWARDS A SHOW ON SELF-IMAGE This show is the result of work that a group of women began at a Saturday morning art class at the Swarthmore run by Caroline Taylor, as part of the Leeds Women's Art Programme. The work is on the theme of self-image, a concept that, as the course progressed, appeared to us to be more and more complex. We chose this theme because of the paradoxes that have to be negotiated in order for a woman to identify herself as an artist, a term that in our culture is gender specific, i.e. male. To begin with most of us had thought that self-image was the

same as self-portraiture, and that this was merely a seeing clearly of the reflection in the mirror. However it became apparent to us that our seeing was affected by the multiple and contradictory views that we had of ourselves. These 'selves' are socially produced in representation, relationships and institutions, and although we are each 'individuals', as

women we share, in varying degrees, certain aspects of these selves. This then positions us, particularly in representation, as part of the category female and in difference to that other, the male. This difference, operating as it does in a society of hierarchies, cannot be recuperated as positive or dismissed as neglible. This is why although the exhibition is on self-image, we have spent so much time looking at how 'woman' as a general category is represented within a variety of discursive practices. For example, we have looked at the construction of 'femininity' in advertising and produced work that tries to examine the way that these 'perfect' images construct within the female viewer certain responses. There is no equivalent to this for men. A reason for this, at a very simple level, is that men are represented as controllers and producers and women as consumable and consumers. This division may not necessarily correspond to biological definitions, (e.g Margaret Thatcher) but it usually does. There are other dominant/subordinate constructions in western culture, of which class and race are the most obvious. These are of crucial significance but in this show we have concentrated on gender divisions.

Part of the importance of this show is that it concentrates on the manner in which the work was produced, both formally and conceptually. Much feminist work to date has used similar formal devices and looked at related areas; in this way the work is not innovative. But this approach, that challenges certain fine art assumptions about the medium of art, by using other media that use 'women's skills', and the content of art, by re-presenting hitherto trivialised subject matter is important. Thus the individual panels focus on different skills;knitting, embroidery, the application of make-up as well as collage, painting and photography, without any craft/art division between them. Also the content of the work, how I see myself through work, through advertising, as a fetished object, within the family album, are presented as aspects of the construction of ourselves as subjects. Some of this work attempts to fracture the illusion of there being a unified subject; a real self. Other work posits the notion of a reunified subject constructed in direct opposition to patriarchal definitions.

The group of 15 women is not homogeneous in that their backgrounds, experiences and understandings of both art and feminism are quite different. The show is based on the productivity of this difference. Most of the work has been communally produced, but all of it has been discussed and produced in relation to the group. This kind of communality breaks down the mythology of the individual genius, which functions so perniciously in our art institutions. This is why the work is not exhibited under any individual names but shown communally, under the title 'Anonymous' - throughout history 'anonymous was a woman'.

The diversity of the group and the approaches to the subject has defined, to some extent, the form of the exhibition. We chose not to employ either the documentary or the modernist traditions of contemporary art, for they bring with them connotations we wished to avoid. We have utilised various skills and concerns

that normally fall outside the definitions of art. By using a sort of diaristic element in the show, we have tried to bring up various questions relating to the production of images and the construction of self-image, whilst also stressing the process of artistic production rather than the end product.

A RESPONSE

In 1971-2 Judy Chicago and Miriam Schapiro, American feminist artists, started a Feminist Art Programme at Cal Arts in Los Angeles. They worked with a group of women art students, initially consciousness-raising about being women and doing art in order to find out how to explore the first through the second. The result was a collaborative project called WOMANHOUSE for which the class took over and renovated an empty downtown house and remade each of its rooms as a dramatic representation of women's experiences of childhood, home, menstruation, marriage, eroticism, nurture and fantasy.

WOMANHOUSE was one of the first feminist art-projects to stress the importance of collective work and the relationship between discussion and making. It was an exercise in women's solidarity and support to forge new kinds of art work and through them new understanding. It opposed the cult of the star individual genius and reclaimed the history of women's creative relationships contained in the phrase 'Anonymous was a woman'.

In Leeds in 1981-2 such a project has been revitalised. A group of women have extended the idea to start up a programme of linked activities which will bring women together as makers of things, as viewers, critics, students, i.e., as participants at all levels. There is to be a photography centre with workshops, exhibition space and an educational programme.

This last item has already begun with several courses that were put on in conjunction with local adult education facilities. The aim is to create a feminist context for work, to make new kinds of work, to build a new kind of audience for feminist activity in this field.

The exhibition documented here is the first fruit of this programme. It was not a college project with Artist-Teachers and women students so much as a collective process utilising the resources available to the thirteen women who came together from different backgrounds. They felt it was important to work towards making an exhibition - coming out and going public. They wanted to occupy a typical downtown art gallery with this kind of feminist presence. It has also been shown in other contexts, more community-based and woman-based. This strategy enabled them to realise several different aims. It is important to take feminist practices into mainstream institutions where - backed up by support at the open seminar and in the visitors' book - feminist challenges to typical assumptions about the artist and about what art is can be highly visible and make a compelling argument. Equally important however is the contribution this project is making to the now substantial feminist tradition of 'art' making. ANONYMOUS addressed familiar themes - childcare, advertising, images of the family and so forth, but what they did to these concerns was new and exciting. Few shows provide both so adequate an introduction to feminist debates in feminist art and so vital and fresh a development of the debates. It actually moves us on. Too often isolated individuals or groups find themselves as feminists beginning at stage one because we haven't pushed on or, more usually because no one knows what others have done.

Take their theme - self image. Chicago

and Schapiro and the womanhouse event belong to a period of feminism when the assertion of the special character of women's experiences was made in the belief that we were the silenced majority and we needed our own spaces and each other's encouragement to come out and be ourselves. Ten years and more of feminism has made us all aware of the intricate pattern of forces which keep us silenced - however much we shout. We have had to scrutinise more carefully the effects of what is called ideology - not just ideas and beliefs falsely held, but the very way we see the world and live in it, the attitudes that are held so deeply that they become 'common sense' and can only very slowly be rooted out. Instead of merely asserting ourselves against the (false) male-dominated way of seeing us, we have had to analyse the way of seeing as something which actually produces us, i.e. constructs femininity. We have to admit that we all peak in and out of this social identity; it is meshed into our very sense of self.

The ANONYMOUS exhibition was a very subtle and impelling response to the ten years of discussion of feminist ideas about ideology and the social construction of female subjectivity. The ideas and arguments have been worked through in discussion and the show makes them visible, locating the concrete instances where they arise. Theory has been used but transformed into a lively and revealing set of visual objects. The series of panels invite the viewer to explore the many layered relationships between experiencing the world as a woman and the contradictory messages about women as she is represented to us. We are invited to reconsider the way we experience the tempting but inconsistent offers of images and ideals to identify with through which we imagine we will find our true selves and an identity as a woman. The argument is not that there is a monolithic false image of woman from the ad man, Woman's magazines, art, whatever and that feminists offer a true, authentic picture. Rather the show stresses firstly the active role played by all sorts of pictures of ourselves and of woman in general which we encounter throughout our lives and these have to be demystified. Secondly the show stresses that these images don't add up; they are themselves contradictory and incoherent. The show can make us forcefully conscious of the mismatch between notions of Woman offered to us and how we live them out; and we still have to look in these mirrors to find out what we are not.

For example take the two panels Feminist Faces and Fetishism. Feminist Faces repeats the photo of one woman's face, so that we get to know it. Then it is intercut with a series of other photos, each representing an advertising stereotype - and they are indeed a mixed bag, from active career woman, to zany schoolgirl as well as glamorous model to countercultural trendy. The juxtaposition of the original photo and the advertisement forces create the impression of a fractured image of woman, sometimes trying to see out from behind a superimposed mask, sometimes incorporating parts of the ad image. The panel graphically portrays the way we live ourselves in this motley array of personae through them, under them, with them, always in tension. Such a broken up yet multiple concept of how we experience ourselves is pursued in the Fetishism piece which is about the predominant representations of woman's bodies. As an exercise the group collected pictures from magazines of parts of women's bodies and then tried to reconstruct a woman - mapping the 'fragments' onto a drawn outline figure. They found that the overwhelmingly majority of items collected were fixated obsessively on two areas,

241

lips and legs. Woman is fetished; i.e. parts of her body are taken out of context and made to function both as erotic thrills and threatening dangers for the male viewer. But however many lips and legs you collect you will never be able to put 'woman' together again. The group decided to deal with this area by making a giant jigsaw puzzle with the pieces bearing the ad images of legs and lips. The pieces are scattered behind a window frame with a net curtain you can push aside. You look in and are made to feel a voyeur. You struggle anxiously to reassemble the fragments but discover that the wholeness is not possible in this game.

Other sections, while each exploring particular themes, also comment back on these points and on each other. The cumulative effect of the show results from a dialogue within it. Self image is not its starting point but the result of the collective labour - by those who made it and those who see it - of both deconstruction and reassembly, distancing and recognition.

One of the most metaphysically complex pieces in the show was about women making themselves. In rainbow colours used symbolically to recall the Creation Myth, comprising knitting, weaving and patchwork the panel represented the creativity of women both in terms of cultural skills and in terms of reproduction. Further it also initmated the way relationships between women construct women as women. A scarf of blue and white trailed across a notional sky turning to earthy greens and browns to form the head of one female figure who is knitting a face. Continuing hair-like down the figure it curled again to form the torso of another female figure engaged in sewing patchwork pieces from which the first figure's body is made. Nestling in its folds were tiny crouching bodies, foetuses and babies. This piece seemed to transcend the all too familiar feminist strategy of revalidating women's craft skills and traditions by using

these very materials so often dismissed as mere manual dexterity to convey so mythic and complex a theme. Its maker employed materials and techniques, colours and arrangements - the real thrill of these forms of making - to make symbolically visible an idea or set of ideas with many layers of meaning, this within the context of the whole show - which exploited a variety of media. This panel made a telling point about a range of meaning possible in this form of creative activity.

In an entirely different format, a collage of photographs, drawings and photocopies the relatedness of women was explored in another dimension. The Genetics and Inheritance piece traced the generations of one women's family from grandmother to daughter to mother and once again to grandmother. This "ordinary" story was footnoted by a reference, a hommage even, to another woman, Rosalind Franklin who played a vital part in the discovery of DNA, the chain of genes which determine our inheritance and bodily structures. This offered therefore another level of understanding women's creativity and reproduction which, co-existing with the other, prevented any simplistic reading of celebration of tradition (female) versus science (male). Together they used different means to place in the foreground the many facets of their theme.

We make ourselves through what we eat. There was a panel dealing with compulsive eating, its impulses and self-hatred, which made use of the expressive possibilities of drawing. Large faces in varying degrees of completeness as drawing floated on a dark brown surface each expressing a different stage in the unhappy sequence of an apple being consumed. Here the mouth and face of a woman are made to function differently from the other advertising panels. The mouth is made - drawn - by a woman and shows

a woman experiencing herself as a mouth, a bottomless
insatiable pit of need, a painful fullness which
is not satisfaction. It was thus an anti-dote
to the fetished image of woman and her face and
mouth are made to represent woman as demand, as
feeling and experiencing subjectivity.

What I have been trying to convey with these
examples from the show was the way in which the
group exploited the inherent qualities of all
the materials to hand, privileging none, but making
them all speak together to form not a single sentence
with a single meaning, but more a complex story,
a discussion which operated on several levels
from visual pleasure to politcal analysis. All
that they have done is recognisable from the preceding
decade of feminist work and argument about art
and craft, imagery and advertising, ideology and
knowledge. But what is most important is that
they have moved this tradition on by daring to
synthesise it in a new way, weave these often
separated strands together in a single piece composed
of different threads and embroider new significance
onto familiar materials. All was done without
pretentiousness or awkward seriousness. Discomfort-
ing, surprising,yes, but offering the pleasure
of a really successful feminist achievement.

Source: A Response to 'Anonymous Notes Towards a Show on Self-Image'.

Griselda Pollock
'Theory and pleasure'

I do not intend to treat sense and sensibility as opposites in contention with one another. Not only would such an exercise distort the art on show but it would falsely polarise the admittedly diverse but interrelated projects of feminist artists. Moreover there is a danger of offering a merely critical classification which with its '-isms' and groups and tendencies never attends to the important questions about why art works are produced, for whom they are produced, to do what kind of job they are produced. Some earlier feminist exhibitions such as the show in Holland in 1979 *Feministiche Kunst Internationaal*, have tried to create critical categories into which work generated from different premises could be slotted for easier consumption by the audience, as an example of this '-ism' or that school.[1] More recently, in 1980, the exhibition *ISSUE: Social Strategies by Women Artists* at the Institute of Contemporary Arts in London laid before the audience the heterogeneity of feminist art practices whose unities did not lie in imposed classifications but rather in their contributions to the important debates within feminism and within art.

The relevant debates which have emerged within the women's movement concern the efficacy and function of art within a political movement. Is it valid and how is it useful? To whom should it be addressed? Where should it be displayed? How should it be made and about what topics? There has also evolved within the women's art community a debate at a more specific level about the relation of feminist art practices, notable in their multiplicity, to the dominant modes of art. Should we intervene in the main institutions or disassociate ourselves and build alternative bases? Should we work in the public or the commercial sector? What kinds of work should we produce? Should we use traditional art forms or traditional domestic and feminine materials, or neither, but seek out the overlooked indices of forgotten subgroups in an expanded notion of culture? Should we use theoretical material or the personal voice?

This exhibition with its title may be taken as both reference and contribution to these debates within the women's art movements in different countries.

I am personally familiar with some of the work in this show. About others' work I do not feel confident to write from either ignorance or lack of pre-

vious time to study the work and talk with the artist. I am afraid therefore that this essay will seem partial where my aim is feminist and inclusive. I hope therefore that my remarks, when made of specific artists and pieces, may serve not as typical critical publicity but rather as a springboard for readers/visitors to look at all the work with some questions and some points of entry into the debates which are being carried on by all the participants.

What do we mean by sense and sensibility? I would like to substitute the word theory for sense. For we are not, I imagine, concerned as Jane Austen was, with the conflict in modes of personal behaviour between classical decorum and restraint versus Romantic self-indulgence in feeling and refusal of social conventions as rules for conduct. In her statement for this catalogue May Stevens defines 'Theory' as,

> A proposed pattern to understand the world by. We look for patterns (meaning) in the world. When we see one that works (fits our experience) we apply it for as long as it holds up. When it begins not to fit, we re-examine the pattern, correct it, refine it – if it is salvageable. Mystification of theory prevents its organic development; anti-individualism prevents users of mystified theory from matching it to their own experience. Theory is for *us*, not the other way round.

Theory does not imply an abstracted, imposed, remote, cold, rationality. It refers to our means to gain systematic understanding of the world we live in, our condition in it and the possibilities for its change. It is, as May Stevens insists, a provisional instrument constantly subject to correction in the interaction with new material, new insights and collective political work. It is initially a means to take hold of experience, revising it and articulating its connections with large patterns in order to produce knowledge of its nature and causes.

Some feminists adopt an anti-theoretical stance. Their argument indicts theory as male-dominated in content and as a generically male occupation. They are right to stress that existing theory is masculinist be it sociological, biological or artistic. Most current forms and bodies of knowledge are oppressive to women by virtue of rendering women invisible, or marginal, or biologically determined. Take art history for instance which as

an established discipline has systematically obliterated women artists from the historical record, belittled those women it admits and has created out of this partial fiction a celebration of the exclusive masculine possession of genius and creativity.

Non feminist art historians – women as often as men – may now write about women artists 'on commission' and 'without passion' but they wonder whether or not women constitute a real historical subject.

No political movement, however, can do without theory. Feminists have, therefore, had to construct new theories in order to produce new patterns of understanding a world in which women are as much as men the actors and victims in social history. We have had to draw new maps of a landscape and make new images of the world. Often this has meant wrenching from apparently oppressive male oriented theories such as Marxism or psychoanalysis a radically different reading which will serve our ends. This is a necessity for feminist historians, sociologists, philosophers and all of us involved in the political struggle. But what special pertinence has theory in this sense to art, which is clearly a different order of knowledge, perhaps rather a matter of sensibility?

Alerted by feminist work on the ideological nature of most theories about art, certainties which begin with phrases such as 'art is...' have become particularly suspect. Furthermore feminist art practices have radically expanded the possibilities for art to become, in Lucy Lippard's words, 'a functioning element in society'.[2] By this she did not mean that art was reduced simply to 'agit prop' or community art, but was concerned with communication, community, knowledge and political effectivity. Feminist artists have used all the media of conventional high art, painting, sculpture, video, film, posters, textiles, scriptovisual formats, collage, photography etc. Some reject dominant forms, abstraction for instance in favour of accessible realism, while others suggest that abstract forms provide a potent and evocative language of, for instance, erotic humour and sensuality. Some seek to intervene directly into mainstream practices, utilising consciously avant-gardist techniques in order to wrest radical possibilities for a real, political effect. What makes the difference is that feminist artists traverse the fields of art making with a specific orientation – a primary concern for the production of meanings for women and an emphasis on communication and knowledge. It is impossible and wrong to give priority to any one strategy especially on the basis of apparent accessibility or familiarity. This is where the notion of sensibility is most delicate and potentially misleading.

What is sensibility? Some women would embrace it as a way of perceiving the world and claim sensibility as an alternative to sense, to rationality, the opposite of theory. Indeed we should validate many forms of perception and modes of understanding as against the official (patriarchal) rational systems as part of our resistance to masculine domination. The women's movement still critically depends upon our courage to insist upon our own experience and perceptions in opposition to those dominant interpretations which invalidate the specificity of women's position. But we also want to avoid being trapped in the man-made category of woman as repository of feeling, subject to the tyranny of emotions. This is particularly acute for women artists whose products have been treated as emblems of this image of trembling femininity and described exclusively in terms of sensitivity, delicacy, grace, charm and other intended derogatives.[3]

Sense and sensibility need to be seen as ideological constructions permeated with gender specific connotations. Rationality and feeling have been fixed as opposing images and attributes of masculinity and femininity. As feminists we must appropriate both, as theory and as feeling in order to make the personal political and the political in line with the individuals who constitute the movement. In our adoption of both we recognise the ambivalence we feel towards both. Yet we cannot avoid the debate that these terms invite us to consider, a debate that becomes immediate in relation to feminist interventions in, with and by means of art.

I have suggested that the word theory can be substituted for the term sense. Now I want to argue that pleasure should replace sensibility. Pleasure has become a political issue. Feminists have been made painfully aware of the oppressiveness to women of the socially validated pleasures from the voyeurism of male-dominated cinema to the sexist norms of sexual behaviour. But we also recognise that repudation and hostility alone are insufficient and that a negative politics often finds feminists incorrectly linked with repressive purity movements. The project is therefore to construct new, emancipatory pleasures. But we are formed by and often unwittingly compliant with the current regimes of pleasure – they are normalised and obvious even if we begin to recognise intellectually their insult to women. So we are often slow to acknowledge the potential of new pleasures based on rigorous understanding of and active participation in a world of our collective remaking, where we are asked willingly to engage in both the complexity of social processes and support the diversity of human potential. This latter point is

pertinent to art where new feminist works are aggressively dismissed precisely when they disrupt our expected pleasures of simple consumption and easy recognition. In this essay I can only touch on two aspects of this larger issue of feminism and pleasure; in relation to representation and images; and in relation to the pleasures supposedly peculiar to art – the aesthetic effect. Both are sites of feminist debate, new work and redefinition.

Much feminist theory has helped to warn us that the material of our feelings, our most intimate experience of identity and of sexuality are socially permeated, if not constructed and constrained by determinations outside out control and consciousness. Our feelings are political precisely because they are not private, innocent or pristine. They are material, historical and sites of social struggle. Theory has also taught us about the power of the image in the construction of our identities and even sexualities. Marie Yates's work has been concerned precisely with the way images function in the construction and reproduction of 'sexual difference', particularly because of the way images depend upon the work of the viewer, activating her, drawing her in to make the meanings for the image. But whose meanings do we produce, our own? Or do we reproduce those 'constructed according to definite and familiar conventions and means of representation?'

In catalogue notes accompanying the exhibition of her major piece, *Image – Woman – Text* in *ISSUE* (1980) Marie Yates explained,

> Within these representations we see womanness or man-ness; we locate what we identify as a clue, and decide on the basis of it that we have discovered as 'real' sexual difference located as a property within the discrete person captured in the 'reality' of the photograph. This 'location of difference' then becomes the full presence required by the question of the image [What do I see in the image?], and narrative takes hold and is constructed which places the subject of the image within a framework of events and details, and their precise ordering. Further, because so much personal reference is required in this production of meaning through involvement with the image, *we entail ourselves within the recognition.* (my emphasis)

Marie Yates is drawing upon the arguments about the workings of ideology and the effect of the means of representation within it. These arguments have offered a way to refine initial feminist perceptions of how deeply we were implicated in the oppressive system, which was often expressed in terms of 'conditioning'. Consciousness-raising is the political instrument we use collectively to work over our own experiences, to question why

we submit, and to come to understand the considerable social pressures and forces by which we are 'socialised' as girls at home, at school, at work. Feminist interventions in psychoanalysis enabled us to include the study of *unconscious* formations and the psychic structures of our culture which are instituted in each individual in the learnt relationships of the family and in the acquisition of language itself. (This relation of the stages of feminist analysis, from the level of immediate personal experience, to the question of socially produced subjectivity and finally to a way of understanding unconscious processes is not only evident in the structure of Mary Kelly's *Post Partum Document*, but is inscribed in the historical evolution of the piece over several critical years in the development of feminist theories). Psychoanalytical theory was coupled with new understanding of the phenomenon ideology. Ideology means more than merely a set of ideas or beliefs. It now also refers to the actual practices and institutions through which we 'live' our relation to the world and through which our place within it is re-presented to us. Feminist studies of the working of major apparatuses such as art, film, advertising and so forth alerted us to their manipulation of our formative obsessions through playing to and on visual pleasure and desire. These cultural apparatuses work to relocate us and fix us in given, gender positions which are unstable because they are not natural but socially produced. In their work Marie Yates and Yve Lomax interrogate these processes of identification and inclusion in the photographic image but also by new strategies of composition, juxtaposition and play with image and language they are also producing for women a new language of desire, the other side of theory. As Anne Marie Sauzeau Boetti wrote in 1976 about women's practice in art,

> Woman's exclusion is historical not natural. She has (seemed to be) absent from history because she has never given meanings of her own through a language of her own to culture (and to herself as part of it). The new meanings cannot be conveyed through an 'old' language ...But what is of greater importance is that these new meanings cannot be affirmed at all through any alternative positive management of the artistic language, because these meanings refer to a scattered reality...The actual creative project of woman as a subject involves betraying the expressive mechanisms of culture in order to express herself through the break, within the gaps between the systematic spaces of artistic language...This kind of project offers the means of objectivising feminine existence: not a positive avant-garde subver-

sion but a process of differentiation. Not the project of fixing meanings but of breaking them up and multiplying them.[4]

The work of Aimee Rankin shares some of these concerns with deconstruction of the construct, femininity, in and through representation, striving to show that femininity is not a primordial, singular essence but a social product erupting across 'the layered surfaces of representation'. However, she also considers a problem which in fact results from the role of reception in the structures of meaning. Viewers bring to the viewing of art many preconceptions about art, which as a system of signs produces not only meanings but '"visual pleasure", beauty as well. Thus art operates primarily on the basis of a seduction for the artist as well as the spectator'. The question she poses is, does this 'surplus of pleasure' circumvent her critical intention, 'deflecting meaning in favour of an aesthetic evaluation'?

Aimee Rankin has identified two substantive issues. The first concerns the extent to which the aesthetic effect operates as a regressive force, as a 'seduction' which displaces the radical distancing of the spectator from the material and mechanics of representation which the artist aims for. The second issue is whether or not the audience is prepared to share those concerns and work against seduction in favour of participation in the production of new meanings.

To counter the first danger some feminists have pursued Brechtian strategies encouraged by parallel experiments in film making where the aim is to break the spell of illusion and insist upon making the audience both critical and aware of the social and the real. Sometimes these have been criticised for being unduly difficult; we resist becoming critical spectators when we are used to the passive pleasures of aesthetic consumption.

Other feminists have contended with the problem by insisting upon the 'fetishistic' nature of art and representation, i.e. that both are always substitutions of some thing which is invested with the potency, the meaning that in fact belongs to or is aroused by an absent, forbidden or repressed object. Alexis Hunter's photo-narratives exploit the fetishistic style and content of glamour advertising, reproducing its time scale for viewing and reading, echoing its themes of auto-eroticism and violence. However, this is subverted by an edge, an ambiguity and an excess which is too incisive to sit within the parameters of the genre and thus both arrests the spectator from passive consumption to more troubling speculations and, at the same time, exposes the undercurrents which motivate advertising imagery and its effects.

Susan Hiller makes the beauty of objects she uses work for her to a different end, thus belying the mystification of experience which occurs in the aestheticised form of representation. In her piece *Monument* (1981) Susan Hiller reproduced in 'beautiful' photographs 41 plaques commemorating the deaths of ordinary people who had died in an act of heroic self-sacrifice. As Tim Guest explained in the catalogue which accompanied the exhibition at A Space in Toronto,

> For Hiller the problem, and indeed the key to this work, is in the function of representation. Representation is a kind of distancing, a substitution, a reduction and most apparently in 'Monument', a romanticisation.

Each plaque tells an individual story; none the less they all follow not only a similar pattern but are there because each act conformed to society's moral standards.

> Moreover it is a strange paradox that their entire lives are reduced to the spectacle of their deaths. These monuments are alien to these peoples' lives, as well as from our own.

The very form of the seductive presentation registers the gap between the romanticisation of martyrdom and the horror of sudden death. In *Sentimental Representations* (1982) this theme of representation, record and remembrance is continued in an even more compellingly seductive format. Composed of a grid of meticulously collected and laboriously placed rose petals, some laid over photographs and inscribed, this piece underlines the gap between representation and what we want to present or reflect. The scrupulous working method reclaims the traditions of women's labour and crafts, often painstaking in their detail and dexterity and always sensitive to materials. A general connection with women's tradition is rendered a more specific exploration of a female lineage by the fact that the piece commemorates the artist's two grandmothers, both named Rose. It asks, however, how well can any process of representation, be it sentimental/personal or official/archival (plaques, stamped passport photographs etc.) do credit to those they attempt to recapture and record. The gap, the failure cannot be allayed by the object, and if it is used as such, its function as a substitute, a record of a loss must be acknowledged.

In Mary Kelly's *Post Partum Document* (1976-80) each section witnesses the processes of substitution and displacement which is formative upon and reflective in the fetishism of art. Documenting the twin processes of the loss of the child and the location of the mother in the position of lack, of maternal femininity, this occurs not only through the use of 'trace' objects, the nappy liners, and vests, the comforter and plaster cast of a hand, the gifts and drawings, the words of the child. It is demonstrated in the actual formal presentation.

Each format echoes some larger social and cultural mode of representation/substitution – clinical (medicine, scientific entymology), artistic (perspective), personal (diary, mementoes), educational (alphabet rhymes) which culminate with the inscribed stone tablets. The stone tablet both documents the final severance of the child by its assimilation to society and culture through language and naming; it also remarks upon the institution of language itself, that system of signs which forever separates us from direct access to the real.

Let me deal now with the second point – about audience. As I have suggested feminist artists have explored the possibilities of new pleasures in deconstruction, in producing new knowledge, in appreciating the significance of representation itself, in offering new patterns of identification for women spectators. This often requires active and imaginative work on their part. But are audiences ready to do this? Most of us are not privy to the 'conversations' out of which the debates and practices have evolved. Conditioned, moreover, to meet art as a consumer pleasure, audiences may be ill-prepared to take on the challenge of these new, active and critical pleasures, these emancipatory invitations to tread beyond the normal positions and expectations of what art will be about and how they will feel in front of it. This is aggravated by the extreme division of labour in artistic production wherein the artist is the remote producer, brought to the public by the exhibition – organiser/ entrepreneur, where critic acts as mediator and interpreter and audience stands by to consume. Feminist art like all radical and democratic cultural movements necessitates a more open relation to artistic practices in which informed participation breaks down the specialist/consumer involve for us. It may not be easy to change but our cooperation is a vital part in the attempt to make an expanded and vivid art function socially.

It would be wrong to consider the aesthetic only from the point of view of something to be resisted, part of the distracting ideological apparatus of consumerism. A definition of the aesthetic that is in tune with the feminist political project occurs in Rudolf Bahro's case for a cultural revolution in Eastern Europe. By cultural is meant the transformation of a whole way of life and social relationships. As a fundamental part of his programme Bahro advocates an expanded and comprehensive education for all which must include both an artistic and a political-philosophical practice.

To put it another way, they must be able to appropriate, *as tools for some use*, the means of patterning and the concepts that allow them to differentiate and synthesise both the small world and the wide world.[5]

Theory and feeling these are crucial partners but where does aesthetics fit in?

Knowledge of human affairs that is taught and accepted without aesthetic emotion must be basically untrue, and particularly so for the individuals involved. Aesthetics as a method of education means simply the attempt to present all knowledge that we require in such a way that it appeals to our own selves and receives subjective meaning for us.[6]

The material or the content of feminist art is very broad, as this exhibition will surely demonstrate. Whatever its topic it concerns the relationship between understanding the social processes which work upon us and the subjective meaning these experiences have for us. In terms of sense and sensibility in feminist art practices, we are dealing with the way in which the meanings, the patterns of understanding which we are struggling to produce can be made vivid for the audience. It is futile to split theoretical work and feeling or aesthetic sensibility for it is in the making of art works that sense can be made of both the small and wide worlds, that subjective validity can be given to knowledge, developing out of the traps and closures of dominated society through appropriate theoretical work.

This aesthetic dimension of knowing – in sharp distinction from mere aesthetic evaluation and consumerism – evokes and represents new kinds of sensibility. These are special to women, not because they speak to any female essence or nature, but because we claim them as ours as a result of the way they articulate our distinct experiences and position within social relations. Whether we consciously use what we call the 'feminine' as a position or as a subversive voice, or whether we interrogate and deconstruct the social production of femininity, it must always be a strategy of liberation. There is no retreat from the difficulties – for artists and audiences alike – of the debates with which feminist art practices of necessity engage and which they expand within the larger cultural and political struggle for full human emancipation.

Notes

1. The Dutch exhibition was divided into essentialism, realism and their fusion.
2. Lucy Lippard, 'Issue and Tabu', *ISSUE: Social Strategies by Women Artists*, London, ICA, 1980.
3. See R Parker and G Pollock, *Old Mistresses, Women, Art & Ideology*, London, Routledge & Kegan Paul, 1981.
4. Anne Marie Sauzeau-Boetti, 'Negative Capability as Practice in Women's Art', *Studio International*, 1976, Jan/Feb, Vol 191, no 979, p 25.
5. Rudolf Bahro, *An Alternative in Eastern Europe* (1977), trans D Fernbach, London, Verso, 1981, p 286.
6. ibid p 285.

Source: 'Sense and Sensibility in Feminist Art Practice', Preface to catalogue, The Midland Group, Nottingham, 1982.

Mary Kelly
'Beyond the purloined image'

Roland Barthes has said that those who fail to re-read are obliged to read the same story everywhere. Perhaps by a similar default, we are obliged to see the same exhibition time and time again.

Considering that, when I was asked to curate yet another 'women's show', I saw it instead as an opportunity to go beyond, exactly to 're-read' the biological canon of feminist commitment and situate the question of gender within a wider network of social and aesthetic debates. Specifically, I wanted to show how recent developments in photographic practice, initiated by artists in London, had gone beyond the more reductive quotational tactics of their New York equivalents, precisely by extending a feminist theory of 'the subject' to a critique of artistic authorship.

I am not, however, exploring 'the truth' of my intentions here, in order to create a unitary 'author' for the exhibition/text. Beyond its title, there is no explanation; there is, rather, a set of intentions, a group of diverse statements, a practice of selection and collaboration that could be called a *discursive event*. Inasmuch as a fragment of this event concerns the 'naming' of it, I should say that my thematic emphasis is an attempt, not simply to purloin, but to re-work and extend the notion of 'appropriation'. It is one that has been used, predominantly by New York critics, to describe the work of artists who take their images from the so-called mass media and re-present them 'in visual quotation marks'.[2] Their aim in doing this, (the part that interests me), is to contest the ownership of the image, and dispel the aura of genius, madness, originality and maleness that surround the artist-*auter*.

Olivier Richon *The proper names* 1983

Like their American counterparts in a show such as The Stolen Image and its Uses, the artists in Beyond the Purloined Image refuse to retreat into the esoteric realms of pre or post modernism.[3] They are passionately, but critically, committed to the contemporary world; yet they are not content merely to pilfer its cultural estate. Instead, they are exploring its boundaries, de-constructing its centre, proposing the de-colonisation of its visual codes and of language itself. They are adopting what I would call a strategy of *de-propriation*.[4] Point of view and frame, use of caption and narrative sequence; all are subject to investigation as Peter Wollen has emphasized in *Photography and Aesthetics*; 'This is not simply a 'de-construction', but rather a process of 're-production' which involves a disorientation and reorientation of the spectator in which new signifieds are superimposed disturbingly on the memories/ anticipations of old presuppositions.'[5]

Mitra Tabrizian for instance takes the concept of 'documentary' and turns it inside out by exposing the fabricated 'reality' of the subjects she photographs – designers, photographers, agents, executives. In *Governmentality*, she unmasks not only the codes of the magazine image, but also the function of advertising as an institution. In contrast Karen Knorr appropriates the lush genre of traditional portraiture and transforms it into what she calls 'non-portraiture', that is, an acid commentary on the manners, gestures and social values of a particular class; in this case, those who frequent *Gentlemen's Clubs*. For both artists the problem of 'politics' is posed rather than prescribed, as Victor Burgin advocates 'new forms of politicisation' within the institutions of art (and) photography must begin with the recognition that meaning is perpetually displaced from the image to the discursive formations which cross and contain it; . . .'[6] Olivier Richon, too, takes a similar stance, imbricating the discourses of Science, Politics, Technique and Literature in a series of tableaux-comme-critiques he calls *The Proper Names*. Richon purloins the pages of collector's catalogues and academic books on Orientialist painting and uses them as backdrops for a Sybergergian re-staging (ie method of front projection) of the European colonialist's exotic spectacle of antiquity. His ironic 'mis-en-scene' calls into question the representation of origins, as well as commenting on the origin of representation in the psychoanlytic sense of the term. He makes this intriguing statement, 'The etymon- the proper meaning, the origin of Names – is *oriri*: to (a)rise; Orient and Origin are then just a point on the

Mitra Tabrizian *Governmentality*

western horizon, where the sun rises, East of the dividing line. It is a technicolour sunrise, a post-card, a card which comes after . . . Thus it is the representation of origins, of the orient, which constructs the memory of it; representation never gives access to a primary vision but to a constant secondary revision.'

Judith Crowle's re-visions of the past are startling and direct. She confiscates stereotyped pictures of men and women from the Photography Annuals of the 1930's and then subjects these historicised images to a ruther distortion by using a mirror. Crowle is not 'making strange' as an end in itself, but as a means of effectively shattering our traditional

view of sexual roles. Ray Barrie embarks on a parallel enterprise, but uses radically diverse sources such as graffiti, advertisements, holiday snaps and popular literature to map out the still uncharted terrain of male sexuality. His aim is not to locate a fixed site on that route, but rather to observe the constantly shifting landscape of fantasy and reminiscence that shapes our sexual identities. the implicit reference is Freud: '. . . but we shall, of course, willingly agree that the majority of men are also far behind the masculine ideal and that all human individuals, as a result of their bi-sexual disposition and of cross-inheritance, combine in themselves both masucline and feminine

Karen Knorr *Gentlemens clubs* 1982

characteristics, so that pure masculinity and femininity remain theoretical constructions of uncertain content'.[7]

In a piece entitled *Screen Memories,* we trace the man's desire for status, for property; his fear of punishment, his fantasised revenge and finally the absurdity of this vicious phallocentric cycle. Barrie makes a pointed comment, 'Men are obsessed with femininity. Consequently, they have seen feminist theory merely as a means of unravelling that 'enigma'. Feminism also offers clues to understanding how masculinity is formed; but this has generally been resisted since it would require us to deal instead, with the absurdity of the phallus. (Men never tire of looking up the proverbial 'ladies skirt', but they don't like being caught with their pants down.)'

Marie Yates also pursues 'the subject' of sexual difference, but in the occupied territory of language. She deploys a complex juxtaposition of jewel-like images or icons, symbols and indexical signs to engage us in a multilayered reading of her *Dream of Personal Life.* Visually, the work is unified by the

Judith Crowle *Untitled*

Judith Crowle *Untitled* 1983

technique of montage, but then fragmented into a series of objects. Similarly, there is the unifying pull of the narrative towards some resolution; but this is again refused, revealed to be 'fictitious', in order to open rather than close the text. Seeing her work reminds me of Jane Gallop's provocative metaphor, 'The notions of integrity and closure in a text (or image) are like that of virginity in a body. They assume that if one does not respect the boundaries between inside and outside, one is 'breaking and entering', violating a property'.[8] In a sense, Yates is 'asking for It', that is, a reading which re-positions, even deletes the author herself.

The re-positioning of spectator and author alike is a persistent undertaking in the work of Yve Lomax and Susan Trangmar as well. Lomax borrows the rhetoric of *film noir* to manufacture a 'plot' between a mysterious fragment of media melodrama and another equally ambiguous personal interlude. Her tactic's resemble Cindy Sherman's insofar as they urge us to search for hidden relations, explanations or 'meanings', but there is a crucial difference, she breaks the story line, opens the ring of identification and pushes a 'third term' onto the stage in the guise of 'lack'; that is, a space between the two images which queries the photographs assumed finitude, rather than solving the enigma of the subject's identity. Describing the work, aptly titled *Open Rings and Partial Lines,* she says 'I have attempted to bring into play the basic assumptions of the classical model of communication i.e. subject/object, sender/message/receiver. In short: to open up these assumptions and

Ray Barrie *(Voice-over) at Chankpe Opi Wakpala* 1979

not to take them for granted. So . . . in the work I have attempted to produce an assemblage where a 'middle' or 'third' term neither unifies nor fragments or divides which in turn calls into question the position of the two sides as two sides. It is this play of neither/nor which excites me '.

Yve Lomax Open rings and partial lines 1983

Trangmar's refusal of logic, her 'excess', so to speak, takes another form. She pilages, literally shreds, a seemingly infinite reserve of simulated media images and repetitious written phrases, and transforms them into a monumental continuum of sensations which is generally called collage. In this case, it is more like an archaic, yet poetic recycling of the visual debris that exudes from a technologically engorged social body. Trangmar makes this probing remark: 'Everywhere we seek the image's reality; we turn the camera movement into a prayer and seek the passion between black and white. If we take technology as an extended or detachable part of a human whole, if we take the lines of communication and knowledge as instruments or media along which the human whole may be projected or represented, then will we not always be returned to lack?'

In summary, but certainly not in conclusion, it is evident that the artists who are engaged in a depropriative practice take their cue from Brecht and Godard, rather than the situationists. They are concerned with the image but not consumed by the spectacle; critical, but not moralistic; obsessed with pleasure, but with the kind to which Barthes referred when he wrote 'knowledge is delicious'. Moreover, and crucially, *depropriationists* are not afraid to pose the question of subjectivity and of sexuality together with, across or even against the 'allegorical' imperatives of a politically correct art. The depropriative text is heterogeneous, disruptive, open, pleasureable *and* political. Finally, it also goes (almost) without saying, that the artists' intentions reach far beyond the curatorial confiscation of their imaged effects. So let us 'proceed analytically', as Brecht suggested and 'transform finished works into unfinished works'. In this way, we will make *meaning* possible and our pleasure in it unpurloined.

Susan Trangmar *Life-guard* (detail) 1983

1 Title of an exhibition of photographic work by Ray Barrie, Judith Crowle, Karen Knorr, Yves Lomax, Olivier Richon, Mitra Tabrizian, Susan Trangmar and Marie Yates, which I curated for *Riverside Studios,* London, August 3-29, 1983. This article is an extended version of the catalogue introduction.
2 See for instance Douglas Crimp, "The Photographic Activity of Post-Modernism", *October 15,* 1980; also Benjamin Buchloh, "Allegorical Procedures: Appropriation and Montage in Contemporary Art", *Art Forum,* September 1982, and Kate Linker, "On Richard Prince's Photographs", Arts Magazine, November, 1982.
3 *The Stolen Image and its Uses* included work by Bikky Alexander, Silvia Kolbowski, Barbara Kruger, Sherrie Levine and Richard Prince. It was curated by Abigail

Solomon-Godeau for *Light Work/Community Darkrooms,* Syracuse, N.Y. March 16 – April 15, 1983.
4 Stephen Heath uses the term *depropriation* to describe the film practice of Straub, Oshima and Godard in "Lessons from Brecht" *Screen,* Summer, 1974.
5 Peter Wollen, "Photography and Aesthetic", *Readings and Writings* Verso, 1982.
6 Victor Burgin "Photography, Phantasy, Function", *Thinking Photography,* Macmillan, 1982.
7 Sigmund Freud, "Some Psychological Consequences of the Anatomical Distinction between the Sexes", 1925, *Collected Papers,* Vol.5.
8 Jane Gallop, *Feminism and Psychoanalysis,* Macmillan, 1982.

Source: *Block*, 1983, no. 9, pp. 68-72.

Ann Cullin
'Sculpture by women at Ikon, Power plays at Pentonville'

"No time for flowers" writes Sarah Kent in the 'Power Plays' catalogue. Too right it isn't; they were all at the Ikon's 'Sculpture by Women'. I was struck at first that two all-women shows could be so different, but on reflection maybe it's obvious (isn't it?) that there are as many shades of art by women as there are by men. It was an essential component of both shows that the artists are female. 'Power Plays' was about power in all its guises (power that is most often masculine and/or partriarchal), both in the private and the public (Big Politics) domain; 'Sculpture by Women' explored personal obsessions, also from a female perspective. But it was the differences between the two shows that were more outstanding, and let me say at the outset that I am not disputing the artistic quality and skill of any of the work: all the artists are very competent craftswomen in their various media. What I want to talk about is what the art did and didn't do, its accessibility (or not) and its consequent value, its usefulness.

Is it sufficient still to make art with "feminine" or female-specific subject-matter, materials and techniques, and to assume that this makes it into a feminist/positive female statement? "The personal is political" – OK, I'm all for it, but something's wrong if the result is so introverted and private that it fails to communicate anything to men or to women (including feminists, who presumably start from a privileged position for reading feminist art). I did not find my "privileged position" much use at 'Sculpture by Women'. Ten or fifteen years ago it was felt that female critics had to support female artists purely because they were women trying to achieve recognition in a male-dominated art world. (So were the female critics, for that matter). Whilst around 1970 this was, I think, a correct and useful political stance to adopt, in 1983 I'm not sure that it's either necessary (there *are* quite a large number of shows by women now) or helpful. I don't see how feminist art can progress if it knows it

can always rely on a supporters' club to endorse it on the sole basis of its being 'feminist art', regardless of how individual artists interpret that feminism. Surely it would be more invigorating for feminist art to be subjected to as rigorous a criticism and evaluation as other art(s)? This would also alleviate the burden on the feminist critic who is made to feel that she must praise feminist art or else "betray the cause". I would hope that a feminist criticism would be not destructive but supportive and constructive, and would eventually result in a stronger art practice.

'Sculpture by Women' was a closed affair. So is some art by men, don't let us forget, but if you are a woman raising personal/political issues, isn't it important that they should be readable, or at any rate that they provoke speculation? They weren't and they didn't; it was visually pleasing art, skilfully made, that didn't go anywhere. Sheila Clayton's careful presentations of make-up, manicure equipment, wax sanitary towels, giant shiny-wrapped sweets; Janet Hedges' catapult structures with stones and wishbones, broken pots and bandaged sticks; these were all very mysterious but didn't accommodate enough ideas (or rather, hid those that were there), making speculation not particularly fruitful. Elona Bennett's smoothly-carved wooden heads and faces were not assisted by the accompanying definitions of Hysteria, Narcissism and Goddess, and the déjà vu "I wanted to make a positive image of woman" statement. Cornelia Parker's *Manna for Birds*, a group of tall and leaning white forms, was evocative of standing stones, providing more food for thought than some of the other things here, but the most enjoyable work was by Lois Williams. *Nine Crumpled Seas* and *Sea of a Thousand Creases* were tough, solid and warm, mattresses or carpets made from tightly-packed pleats of old newspaper. Her large Eva Hesse-like hessian pieces were statuesque: statuesque rather than monumental for they

seemed to allude to figures, especially *Ladder* which I mistook for two people embracing. I particularly like *Keepsake*, an old wooden box with little compartments in which nestled tufts of hessian and coarse wool.

'Power Plays' was about as far as you could get from such treasured and safe cosiness. It wasn't a "nice" exhibition, it didn't make me feel good all over, I can't really say I enjoyed it. I hope that the three artists (Sue Coe, Jacqueline Morreau, Marisa Rueda) will take these as the compliments they are intended to be. Of course some art must be spiritually uplifting, we need that, but 'Power Plays' depicted the world we long to be lifted up from and it succeeded in making me uncomfortable, guilty at my complacency, and communicated the artists' rage at what those in power do to those who are not. It was accessible too, in that meanings were comprehensible without (on the whole) being banal or obvious. Coe's pictures of urban and moral decay are nasty, disturbing and real – this isn't what we expect of art and that's why they're so disconcerting. Rueda's fat, grotesque judge, the society lady, the informer had many richly suggestive connotations: the judge with his chicken's head and show-girl's red satin bodice. Morreau's work is not about a sentimental mythology (no dreams of rosy New Matriarchy), but a reappropriation of the old stories made relevant now. *If Mary came to Greenham* she'd be arrested for breach of the peace; *The Divided Self* burns a midnight candle to write by while nearly incapacitated by her nurturing-half, bare-breasted and suckling three babies.

After 'Sculpture by Women' I despaired over the state of feminist art in Britain. It was becoming too pretty: reclaiming the feminine as positive had been going on too long. I still think that's regrettably true in too many cases, but 'Power Plays' restored my faith. □

Source: *Artscribe*, December 1983, no. 44, pp. 64-5.

Roberta McGrath
'Sculpture by women'

Ikon Gallery, Birmingham

This is an interesting exhibition. However, I am less certain that we can share in the optimism of the catalogue introduction which claims 'a new confidence on the part of women' to enter into traditionally male preserves such as sculpture. If anything we are in fact witnessing the reverse as more women lose their jobs and face increasing pressures to return to the home. Such optimism is liable to separate one group of privileged women from their less fortunate sisters.

The title has been carefully chosen to minimise the chances of the exhibition being referred to as 'women's sculpture'. But, have we ever seen an exhibition entitled 'sculpture by men'? It still therefore, leaves a nagging doubt that there is Sculpture (with a capital S) and sculpture (by women). It is for these reasons that Antonia Payne (director of the Ikon) is hesitant about over-stressing the feminine qualities of the work. Nonetheless, such concerns seem to be at the very heart of much of the exhibition. If there is a common thread, then it is at the level of material: a tendency to use natural materials such as cloth, wood and paper, or materials which are fluxual such as wax, or materials which conduct energy such as copper. All these materials imply a certain warmth. There is little in the exhibition which we could consider as heavy, solid or immovable and on the single occasion when this does occur it has a specifically male reference. Gone are solid blocks of stone and welded sheets of metal. There is also a tendency to combine materials – a pluralistic approach in opposition to male homogeneity. It is by these manoeuvres that women have managed to subvert the maleness of sculpture. By embracing the very means of their imprisonment – craft-work, the fragile, the natural – they have managed to turn this to their advantage. A good example of this is the work of Sheila Clayton. In her piece entitled

'Weighing/Good Fortune Kit' we are invited to make connections between a number of objects, made from a variety of materials: the giant box of chocolates; the dishes filled with symbolic food; the measuring rods. The image produced is of women within the home; woman as the provider and preparer of food who simultaneously must remain slim and attractive. Thus the giant box of chocolates lies in wait as both traditional reward and temptation to which we must not fall. Against this we have the giant charm bracelet oversized and heavy, resembling something akin to a ball and chain. It reminds us of those bracelets which weigh increasingly heavily around the wrists of women who are shackled by these pretty trinkets – another one being added with each anniversary or birthday. Much of her other work makes reference to cooking ware: paper doylies and fluted paper cases. In 'Manicure/Medical Kit' and 'Make-up/Suppository Kit', she forces us to make connections between the instruments of beauty and the instruments of medical torture.

In a more formal manner, Cornelia Parker brings together disparate materials. The traditional medium of cast plaster is connected to cloth. Solidity is brought together with flexibility. A white plaster column opens on to a virulent green fan.

In contrast Lois Williams and Elona Bennett reject colour. Lois Williams' work is reminiscent of the work of Eva Hesses and Jackie Windsor. She makes the familiar object unfamiliar. Two functional objects are changed: a chair wrapped in hessian which one cannot sit upon, a ladder similarly covered which leads nowhere. However, perhaps more interesting are paper carpets which seem to subvert the make-do and mend ethos of weaving rag mats. The newspaper replaces rags. Is this a play upon the fireside scene, she sewing while he reads the paper?

Elona Bennett's work is clearly concerned with the representation of women by men. She presents us with a

Sheila Clayton: 'Make-up/Suppository Kit' 1982. Wax, wood, paper. string and silk. 4 × 24 × 24.

Lois Williams: 'Nine Crumpled Seas' 1981. Newspaper, string. 4 × 78 × 70.

Source: *Aspects*, Winter 1983-4, no. 25.

series of heads: the hysteric, the narcissist, the goddess. She states: 'we must remove the masks and know ourselves – but what are we then?' This is an important question to ask, avoiding any idea that there is some womanly 'essence' waiting to be revealed. What woman *is* depends on how she is described. At the same time as we dismantle their representations of women we must formulate a langugage about and for ourselves. Less successfully, however, is the medium on which the heads are carried out. She returns to a traditional skill, that of wood-carving. Her interest stems from the tactile qualities and therefore touch as a sense attributed primarily to women or the blind. But, this material seems to be at odds with the content. It is too homogeneous and it becomes difficult to view them as anything other than beautiful.

Lastly, Janet Hedges examines the relation between matter and energy, between solidity and movement and the way in which these are fused together in constant interchangeability. This is perhaps the split in woman herself: comforting and stable coupled with a desire to move forward on to new things. Moreover, it is a split which is lived unevenly amongst women. This is why women who are practising artists must not divorce themselves from other women. They should be fighting for all women and not just for women artists. We would be foolish to believe that we can be artists first, and women second.

Exhibition dates: 8 October – 12 November

Janis Jeffries
'Women and Textiles'

The social and political context of their work has, in recent years, been a major pre-occupation for some textile artists. An exhibition and conference, Women and Textiles: Their Lives and Their Work, *held at Battersea Arts Centre in November, helped to consolidate opinions. Janis Jeffries, one of the organisers, reports*

Women and Textiles – Their Lives and Their Work was a collaborative venture between three women textile artists and the Women Artists Slide Library (administered by Battersea Arts Centre). Our intention was to show the diversity of past and present textile practices, and the different ideological positions of their makers.

As textiles are products of complex social relations, it was felt that most of the successful works in the exhibition exploited the tensions between a feminist statement (significantly, most exhibitors were from the Fine Art and Textile departments of Goldsmiths' College, London) and craft skill. Some of the works intervened in the established tapestry tradition, others were environmental installations. Each work, however, attempted to expose the "value system" or set of views held within our culture with regard to women's role within textiles. Each of us brings to our work the social, psychological, economic, political and cultural attitudes which have been transmitted to us for generations. The shifts that we have made and are making rupture this transmission. One of the roles of this exhibition was to address itself to these changes from private to public, from personal to political, from craft to art.

The complementary part of the exhibition was to show the economics of organised manufacture and the economics of textile production. The Inner London Education Authority lent a mobile exhibition which examined, photographically, the plight of women homeworkers in England, whilst photographic panels represented Dutch homeworkers and Indian self-help groups. These examples, which illustrated how women's textile skills can be exploited and oppressed, contrasted with the collective resistance displayed in the patchworks made by women from Soweto in South Africa and Chile.

Here, textile skills and materials have been used specifically for political protest and social change.

A women's banner (*c*1935) and two recent peace banners (generously lent by the Fawcett Library, the Birmingham women's self-image group and Kate Walker respectively) were shown together. The Blackie Community Centre from Liverpool were invited to install their textile garden, *Baa Baa Blackie*, made by people of all ages as part of their Easter scheme last year.

We believed that by reclaiming these different histories, all the works displayed would be relevant to people's lives and experiences. In addition to the exhibition we arranged a series of seminars, performances, films and a weekend conference to further the debate around women's textile work.

Pennina Barnett, until recently Crafts Assistant at Yorkshire Arts, quoted Margaret Mead (from *Male and Female*) in her talk: "In every known society, the male's need for achievement can be recognised. Men may cook or weave, or dress dolls, or hunt humming-birds but if such activities are appropriate occupations of men, then the whole society, men and women like, votes them as important. When the same occupations are performed by women they are regarded as less important."

This view was constantly reiterated throughout the conference and seminars. Audrey Walker, Head of the Department of Embroidery and Textiles at Goldsmiths' College, traced her background and education to ask why and how. Much of her creative and professional life in many areas of art education has been spent challenging the prejudice and boundary of textile practice.

Barnett concluded that the preponderance of women in the textile arts is integrally related to the position of women within the hierarchical structure of the fine arts (fully discussed by her in *Crafts* No. 54). This relationship was questioned by June Freeman's seminar. Her research (and the exhibition which she organised, *Quilting, Patchwork and Applique 1700–1982*, subtitled *Sewing as a Woman's Art*) revealed the extent to which patchwork, as only one example, has developed separately but parallel to "high" culture and the fine arts. Not only were these sewn items the only memorial that many women, of all classes left

behind, but they were made as part of a shared experience within a socially defined community. The varieties of pattern, motif, colour and symbol are used to express social meaning. The boldness of design argues against these patchworks being seen as examples of "innate femininity" and stylistic, "modernistic" conventions.

A showing of the film of Judy Chicago's *Dinner Party* reminded us that our work is about "writing *in* the history." Not only of women who have achieved in the past, but to make visible the present struggles of those who have limited means of articulating their position. Writing in their *own* history is exactly what the courageous black women of Soweto did. Their moving film *Awake from Mourning* (1980) was made in memory of the children who died during the 1976 riots. The Soweto patchworks, inspired by the struggles of the Chilean women who made their rag pictures out of remnants to depict the brutalisation and sufferings of ordinary people, speak a message of survival and resistance, of determination to achieve their human rights (see *Crafts* No. 32). Terri Bullen used the example of these women and their patchworks in her talk on *Patchwork: Women and Politics*.

For many women attending these events, much of the theoretical and visual material confirmed, reaffirmed and extended their own experiences: their rejection and eventual

rediscovery of textiles either by accident or reasoned choice. There were many questions. Not so many answers. No history is finite, but the excavation work is helping all of us to find other ways of linking the fragments for ourselves.

We did not only exchange our similarities of experience but were often critical and argued our differences; each of us was able to voice our hopes, aspirations, doubts, confusions and our commitment to textiles, in a supportive environment.

Textiles can be an area which constantly challenges our pre-conceptions and renews our responsibilities. Other societies have made work which warns, confronts, soothes and rejoices. Guy Brett in his article *Patchworks from Chile* (*Spare Rib*, October 1977) quotes the words of a Chilean woman: "We have lived through much and we must explain it . . . we must find a way to say it. I can't keep silent because I have lived it."

Where do *we* go from here?

The exhibition catalogue, with full statements by exhibitors, is available, £4.50 plus 95p p&p from: Women Artists Slide Library, Battersea Arts Centre, Old Town Hall, Lavender Hill, London SW11 5TF.

Special issue (No. 9) of FAN (Feminist Arts News) on Textiles & Fashion is available, £1 + 17p p&p, from: Michele Fuirer, 34 Clarence Road, Birmingham 13

Source: *Crafts*, March-April 1984, p. 44.

Moremi Charles
'Beyond labels'

'Five Black Women Artists' is the title of an exhibition at the Africa Centre. But is it about precious, 'minority group' politics? MOREMI CHARLES takes a look.

Art by 'minorities' is vulnerable to being viewed with a typecast eye. For some, especially those from 'minorities', the news of an exhibition of work by five black women at the Africa Centre might even be an invitation to stay away.

But although they are right to be suspicious of precious politics, here at least they would be wrong.

Houria Niati (Algeria), Lubaina Himid (Tanzania), Claudette Johnson, Sonia Boyce and Veronica Ryan (Caribbean/British) are the five artists. Veronica Ryan creates small sculptures and paintings which seem naturally formed rather than artificial and recall calabashes, stones, things washed up on beaches, in undramatic but evocative colours.

Houria Niati's canvasses are formless masses of bright, dazzling colour which give a contradictory impression of panic, neurosis and fear. People-images drown, nails come through, evoking the brutality of torture.

Sonia Boyce shows huge pastels of black women eating, doing their hair—domestic things—in strong colours and with larger-than-life distortions. Hours after I still had a strong impression of a woman's head-tie, an orange comb, the patterned fabric of a sofa.

But most striking is the work of Claudette Johnson. Dark, strong colours into which elusive images of women are completely absorbed. They radiate independence, strength and, curiously, friendship.

Lubaina Himid's cartoon-like drawings and sculptures are startling and funny. They show white men as they like to see themselves but with twists that debunk the self-image of power. There is Superman and an absent questioner pondering on a long strip of paper which curls through the frame—what is it? Or there is a lifesize, male, plywood cutout gazing loftily into the middle distance after noble, artistic ideals, apparently unaware that the paintbrush he grasps is an extension of his penis.

Lubaina Himid is organising an exhibition of black women's art called 'Black Women Time Now', to be held at the Battersea Arts Centre in November. She does not feel there is anything which necessarily groups black women's art together. To her, an exhibition of this kind is simply a way of countering the racism of the art world, which makes it impossible to exhibit without labels.

Five Black Women Artists continues until October 14. See Visual Arts for details.■

ANNE CARDALE

Sculpture by Lubaina Himid—'white men as they like to see themselves'

Source: *City Limits*, 1983, no. 103, p. 13.

III.30

Maud Sulter
'Houria Niati, "Black Woman Time Now"'

Africa Centre Gallery
London
Black Woman Time Now,
London

Houria Niati's solo exhibition at the Africa Centre is the first by an Algerian artist. The work was created between summer and winter 1982 in a tiny cramped bedsit in Croydon.

The Outcome of the Mysterious Delerium is the theme. Her philosophical interpretation of North African/Algerian folklore transports us through a labyrinth of vivacious images. Everywhere symbol overrides representation.

In L'Oiseau Rare de l'Anthropologie, a black mask, eyes, hands, head, stickwoman, juxtapose in front of our eyes jarring our sensibilities as they are laid over greens, pinks and orange. Six panels stretched over most of one wall of the gallery. It pained me to see the savage way the panels had been gouged to fit the picture around the cornicing on the wall. Unfortunately it emphasised the impression of a rushedly staged exhibition.

The large scale and vibrant colours of these works contrasted interestingly with Houria's work at the *Black Woman Time Now* exhibition last year. There a trilogy of small works; *Midnight, Morning, Evening*, impressed me by their clean lines, deep jewel-like colours and simplicity of content. These seemingly straightforward paintings, accessible and easy on the eye played on the mind stimulating our imaginations by their very provocation.

I left the Africa Centre pleased to have seen another phase of this immensely talented woman's work but hoping that it would not be long before we see yet more of her work from a broader timescale.

It is heartening to know that the young women at Fulham Cross School for Girls in South London can look forward to Houria Niati taking up a three month residency soon. A useful way of increasing the visibility of Black women's creativity in the wider community.

Source: *Spare Rib*, April 1984, no. 141, p. 48.

259

Section IV
Strategies of feminism
Introduction

All feminist strategies aim to transform women's relation to art practice. They are based on assertions that woman is no longer the mere object of art but its producing subject, and is so as a woman. This could take the form of practices which claimed to express an essential female creativity. It can also imply that within a sexually differentiating society all our experiences are shaped more or less by socially determined gender positions. Therefore the articulation in a patriarchal society of women's specific point of view can be subversive of existing orders of knowledge. The 'feminine' position, presented by the dominant order as the negative or inferior Other to the masculine, can be re-articulated to challenge that hierarchy of difference.

The strategies of feminist art practice are not simple novelties of form or style. They are complex negotiations at the level of representation and signification of the positioning of women. Take for instance the body of woman: colonised, appropriated, mystified, defined by male fantasy, this figure is reclaimed in feminist art, though it is a difficult and equivocal project. The body of woman can represent fertility, childbearing, or sexuality for an audience of women, but how is that representation to be differentiated from sexist usage? By conceptual forms of art some feminist artists have attempted to avoid the difficulties of same image/new content. They have attended to devising means of making us reclassify ordinary experiences and systems of knowledge of the world so as to expose the patriarchal assumptions embedded within what we so often take for granted as common sense, as normal and obvious. But the question is raised as to how we can insist on other potential ways of seeing and feeling without merely being positioned once again as the other. This is a point made powerfully by Sauzeau-Boetti in her insistence on the strategy of breaking up coherent systems of meaning instead of merely trying to offer a singular 'feminine' alternative. Performance has been a major area of practice, attractive to feminists because it seemed untrammelled by tradition and it also allowed for a woman's immediate power over and contact with – even confrontation with – the audience. But

how can the female performer subvert the way women are so often viewed by audiences, as visual objects, as a spectacle? The strategies in this area have tried to produce for women a different kind of 'presence' so as to ensure that the liberating possibilities of direct access to audience and assertion of immediate, personal activity are realisable.

The complexity of the strategies in feminist art have generated analysis and assessment by feminists themselves. In the absence of supportive criticism from the usual orthodox quarters, feminists have had to produce their own terms of analysis and criticism, to assess the progressiveness or lack of resolution in the practices that have emerged. Often feminist artists themselves have broken down the division of labour between maker and writer. But one of the characteristic features of feminist art practices has been the full use being made (in art making as much as in commentary about it) of the body of evolving feminist theory about language, subjectivity, social relations of gender, ideology, and our formation in culture as sexed subjects.

The removal of barriers between artist and critic, or rather between theory and practice operates also at the level of the media used in feminist practices. Feminist artists have eroded the hierarchies that have existed between types of media, painting and sewing for instance, or kinds of skill, traditional fine art versus those considered craft and even those called housework. In the mixing of media and the utilisation of all available or appropriate materials and skills, feminist strategies have also striven to reconcile the desire to make art works that are vivid and potent as art but are also accessible to the constituency they primarily (though not always) address. That means not just other artists but the community of women.

IV.1 _____

Lisa Tickner
'The body politic: female sexuality and women artists since 1970'

The recent work of a number of women artists has taken as its starting point the human body. This paper is concerned to pursue some of the implications that arise from this; to suggest some categories for the material; and to investigate its significance in the light of Linda Nochlin's observation that

> The growing power of woman in the politics of both sex and art is bound to revolutionize the realm of erotic representation.[1]

It does not appear to me possible, at this moment, to discuss the work of women in this field *without* sketching an outline of the many pressures and contradictions bearing upon it. These need to be discussed, firstly in relation to the tradition of Western erotic art and the nude (man the maker and spectator, woman the passive object of desire);[2] and secondly in relation to the last phase of the feminist movement, beginning in the 1960s, with which women's body art has been largely co-incident.[3]

It is possible to divide the western tradition of erotic imagery, if not into two exclusive categories, at least into two polarities which might loosely be labelled the 'fantasist' and the 'realist'. In discussing the superior merits of Rops over Rowlandson Huysmans also, by implication, defined the difference.

> It must be admitted, however desirable she may be, Rowlandson's woman is altogether animal, without any interesting complications of the senses. In short he has given us a fornicating machine, a substantial sanitary beast, rather than the terrible she-faun of Lust.[4]

The expression of erotic fantasy is characteristic of Romanticism and Decadence, but it is not to be exclusively identified with them. The images are frequently of woman alone (thereby isolating her into a more effective symbol); woman dominant over man or submissive to him; or woman masturbating or engaged in lesbian love-play. The images are usually in some way fragmented, distorted, or otherwise fetishized, and the range runs from the spied-on innocent (Susannah and the Elders, Diana and Actaeon), to the sexually conscious Fatal Woman who, as Circe, Medusa, Delilah, Judith or Salomé is perhaps the typical embodiment of the *genre*. Huysmans' 'interesting complications of the senses' have operated in different ways and on different levels in the work of artists like Fuseli, Burne-Jones, Moreau, Klimt, Munch, Beardsley, Lindner and Allen Jones, but the associations are generally those of violence, fear and death.

It is not difficult to see both the sadistic and the masochistic elements in this imagery as projections of male fantasies and fears, compounded by guilt or an exaggerated awe,

and, in Freudian terms, these can be recognized as dependent on displaced castration anxieties and a repressed homosexuality. This aspect of the tradition emphasizes above all the *mystery* of woman (appropriately, in so far as she is the receptacle for those psychic forces and contradictions the artist does not understand): an enigma to be approached with fascination or with fear.[5]

The 'realist' aspect of the tradition, on the other hand, appears to pay more attention to Woman as sexual partner. Romano's 'Aretino' prints, Rowlandson, Picasso, much pornography and otherwise 'underground' imagery depicting copulating couples seems to accommodate woman as an equal and even active partner in mutual sexual enjoyment.

Such *apparent* openness about female sexuality should not, however, be mistaken for its direct expression. Such an image is also produced by a male artist for a masculine audience, and here too, as Berger had indicated, 'the spectator-owner will in fantasy oust the other man, or else identify with him'.[7] In coitus, the male is Everyman. Not so the woman, whose chastity has been prescribed by a patriarchal and Christian society, and who is at one and the same time the embodiment of virtue and the instigator and repository of sin. Erotic art is centred upon the depiction of Eve rather than Mary – the courtesan and not the wife – and this is emotionally the case even when the painting is nominally concerned with Venus, Diana, or the toilets of Bathsheba and Susannah. The wife and mother is erotic only in the context of an implied rape of domestic virtue (such as provides the *frisson* to all those Victorian caucasians in the barbarian slave markets).

Once we have questioned the *nature* of the woman who is a sexual partner, we can see that the 'realist' tradition, too, is often concerned in a subtler way with fantasy: with the dream of the unthreatening and sexually available woman. Female lust is insatiable and provocative, only in so far as that is arousing to masculine desire, and often only as a prelude to her submission before the phallus. Huysmans' 'fornicating machine, a substantial sanitary beast' is here no more attractive, or to women recognizable, a stereotype than the 'terrible she-faun of Lust'.

The conventions of the erotic tradition range from the plausible to the absurd, from the flattering to the misogynist, and so, in a sense, inevitably cancel each other out. Surveying the images of women in Surrealist art, Xavier Gauthier concluded that she was both a symbol of purity and transgression, one and multiple, the embodiment of repose and movement, victim and executioner, the nourisher and the destroyer of man, his protector and his protégée, his mother and his child, sky and earth, vice and virtue, hope and despair, death and Satan.[8] What can we possibly deduce from this fact that she can be everything, but the knowledge that she is nothing? She seems everywhere present in art, but she is in fact absent. She is not the expression of female experience, she is a mediating sign for the male.

INTRODUCTION TO THE WORK

It is clear that women's sexual roles and expectations have changed dramatically in the last 70 years, and that Freud, Kinsey and Masters and Johnson have all marked stages in

the re-evaluation of female sexuality. [9] The greater social freedom for women which we have witnessed in the last 20 years or so is often attributed to the 'permissive society', which has been in fact as much effect as cause, and as much a curse as a blessing. It has sanctioned the increasingly public exploitation of female sexuality, especially in the areas of advertising and 'soft' pornography. Women's bodies are used to sell to men *and* women, who are thereby encouraged to collude in their own reification, and to identify with the characteristics of exhibitionism and narcissism. Through advertising and newspaper photographs the glamorized nude becomes accepted by both sexes as part of the natural language of the media.

It is now widely assumed that in the wake of these changes, women will find a cultural voice to express their own sexuality, and that in doing so they will add without modification to the existing tradition of erotic art and literature, thereby rendering it 'complete'. The fallacy here exists in the implication that there is a definitely defined male sexuality that can simply find expression and an already existent female sexuality that simply lacks it. Women's social and sexual relations have been located within patriarchal culture, and their identities have been moulded in accordance with the roles and images which that ideology has sanctioned. It will be necessary to differentiate between true and alienated desire. For the moment we should not be surprised to find that the much vaunted collections of women's erotic fantasies are hauntingly familiar, and inclined to reflect traditional images of sexual relations between men and women. The most famous female erotic novel is, after all, the *Histoire d' 'O'*, Pauline Réage's account of masochism and submission, which ends with the heroine's masked entry to a ball, naked, and on a leash slipped around a ring through her genitals. Similarly, Nancy Friday's *My Secret Garden* sets out to reveal 'a whole new realm of sexual experience', and yet the majority of the fantasies belong under the headings of exhibitionism, rape, masochism and domination, and lesbianism. We have, as Mary Ellmann wrote, accommodated our alienation; we are saddled with men's view of us and cannot find our true selves – in art, in literature or often in life.

> Those who have no country have no language. Women have no imagery
> available – no accepted public language to hand – with which to express their
> particular viewpoint. [10]

and so the problem is firstly to manufacture one out of the materials to hand, and secondly to decide on what is to be said.

Women artists *do* live in a culture still dominated by patriarchal values, but within this their experience of life – and eroticism – *is* differentiated from that of men. The double standard has distinguished their sexual roles on both the psychic and the social levels.

There *could* be no role-reversed equivalent to Degas' and Lautrec's brothel scenes, no 'keyhole' art recording the intimate and perhaps homosexual moments of the off-duty *male* prostitutes. It is at this moment impossible to imagine a woman artist in the situation of Picasso's late prints: 89–90 years old, recalling with affection and nostalgia both creative and coital moments from her youth. And what of the male muse, doubling as cook, housekeeper and emotional support system? What would be the iconography of Man where women made the imagery, what parallels or alternatives to the virgins and

venuses, mothers and whores, *femmes fatales*, vampires and Lolitas with which we are familiar? Nor is there any parallel to the masculine preoccupation with the pubescent girl, which runs from Lewis Carroll to Balthus, Bellmer and Ovenden. Fantasies of seduction by older females are almost always written by men, where they are to be interpreted as thinly veiled allusions to the incestuous desire for the mother. Voyeurism, and even more fetishism, which have both provided the impetus for large quantities of erotic art and literature, are both rare amongst women.[11] The question is how, against this inherited framework, women are to construct new meanings which can also be understood.

Women's body art is currently to a large extent reactive, basically against the glamorous reification of the Old Master/Playboy tradition, but also against the anti-academic convention in so far as that, too, continued to see the female body as a special category of motif.

Living *in* a female body is different from looking *at* it, as a man. Even the Venus of Urbino menstruated, as women know and men forget. Breasts, the womb, ovarian secretions, menstruation, pregnancy and labour, as de Beauvoir has reminded us, are for the benefit of others and not ourselves.[12] Woman is the natural prey of the species in a way which man is not, and these experiences are perhaps closer to their re-expression in the work of Martha Wilson and Judy Clark, than to an eighteenth-century nude.

Given, as it were, this double alienation: the body as occupied territory in both culture and nature, women artists have only two consistent courses of action. One is to ignore the whole area as too muddled or dangerous for the production of clear statements; the other is to take the heritage and work with it – attack it, reverse it, expose and *use* it for their own purposes. The colonized territory must be reclaimed from masculine fantasy, the 'lost' aspects of female body experience authenticated and reintegrated in opposition to its more familiar and seductive artistic role as raw material for the men.

Paradoxically then, the most significant area of women and erotic art today is that of the *de*-eroticizing, the *de*-colonizing of the female body; the challenging of its taboos; and the celebration of its rhythms and pains, of fertility and childbirth. Narcissism and passivity must be replaced by an active and authentic sexuality, and we must cease to accommodate, in Ellmann's terms, the 'canopied bed' of our alienation:[13]

I have divided the work into the following categories, which are not of course mutually exclusive. Each could be substantiated by a quantity of material, but I have had to be highly selective in my examples.

1. the male as motif
2. 'vaginal iconology'
3. transformations and processes
4. parody.

1. THE MALE AS MOTIF

There was until the twentieth century no tradition, because no opportunity, for *women* to paint the male nude. The Surrealist artist Léonor Fini has done so, in ways that begin

to prefigure more recent attempts, but her iconography remains largely dependent on that of the fatal sphinx-woman, and her power over the unconscious male. She is 'in favour of a world where there is little or no sex distinction',[14] but her view of woman is ultimately reactionary, since the femininity which she celebrates is an archetypal image of the Romantic movement: she accepts the definition of woman as 'other' and elevates it, without questioning the meaning of the sign.

Although she paints women and group portraits as well, Sylvia Sleigh is best known for her pictures of nude men, many of which invert famous examples of the female nude – such as Botticelli's *Venus and Mars (October)*; Ingres' *Turkish Bath*; and Velazquez' *Rokeby Venus (Philip Golub Reclining)*. The traditional references provide a degree of continuity with the past, but at the same time they provide a witty and ultimately subversive reminder of the extent to which the values of that tradition are non-transferable, and of the modifications that she has chosen to make. One key distinction is that she combines the portrait genre with the nude, and her sitters are therefore highly individualized male friends rather than anonymous women.

Philip Golub Reclining (plate 44) depicts a dreamy adolescent boy in a typically 'feminine' recumbent pose on a satiny draped sofa. Behind him is the mirror in which the artist is reflected: a small but briskly energetic figure of indeterminate age, in contrast to his relaxed and expressionless, youthful passivity. Similarly, the *Double Image: Paul Rosano* (plate 45) accommodates the 'violence' that Berger suggests results from the substitution of a male, for a female nude. The male/female clues are ambiguous, and the resulting sensuality of the body is therefore partly androgynous – graceful but with plenty of 'virile' body-hair; delicate features and a mass of carefully arranged hair but well developed genitals – in fact the back pose with its concentration on the configuration of bone and muscle and the potential energy in their tension is itself a contrast to the more languid passivity of the front.

Women generally like Sleigh's paintings, finding them both sensual and affectionate, and appreciating their solution to the 'problem of gentling the male without destroying his – at least potential – potency'.[15] Male reaction has been less favourable, and *Double Image* brought in hundreds of complaints when exhibited in 1975. 'Woman gets even by painting nude men'[16] ran a headline on another occasion; and yet Sleigh's paintings are chiefly remarkable for *transcending* such crude reversals, and since the subject is so uniquely 'present' in his portrait, the body, though celebrated, is not objectified.

Colette Whiten is a young Canadian artist who also uses men as part of her subject matter, but in a less traditional figurative fashion. She makes casts of men, but in a process which entails the construction of elaborate machines to hold them in place, the assistance of helpers at the casting itself which is almost a 'performance' (certainly a rite), and the eliciting of 'testimonies' from the subjects[17] (plates 46 and 47). Since the process demands an enforced passivity, and since the men have to be depilated and vaselined for it, and since once locked in the stocks they are dependent on female ministrations for sympathy, water and cigarettes, the overtones of erotic domination are extremely strong, and startlingly explicit. At the same time Whiten denies any conscious 'feminist revenge', the men are usually her friends and unpaid volunteers to the painful eroticism of the process.

Perhaps what these unlikely images of Sleigh's and Whiten's have in common is best summed up by the phrase which Joan Semmel used to describe her own paintings, 'sensuality with the power factor eliminated'[18] (or perhaps in Whiten's case, reversed). The same thing is true of Betty Dodson's copulating couples – the significance lies in giving back the woman her sexuality, her potency and her desires – and in freeing those from the power relations of a patriarchal society.

Judith Bernstein's interest in phallic imagery grows out of a preoccupation, first with calligraphy, and then with graffiti, which she pursued into the men's lavatories of the Yale Graduate art school. Her current work consists of huge and hairy charcoal drawings of punningly phallic, mechanical screws – monumental in scale but sensuous in touch (plate 48). What she seems to intend is the celebration but also the reappropriation for *women* of a heroic image, and its re-sensualizing for their pleasure. They are metaphors for women ready to acknowledge the masculine elements in themselves, and who are 'ready to admit things hidden for a long time – that they have the same drive, the same aggressions, the same feelings as men'.[19] This would seem to suggest an echo of Freud's concept of the libido as 'masculine' in men *or* women; and its reclamation – incorporating the masculine into our female creativity in the way in which male artists have popularly drawn on their 'feminine' sensibilities.

2. 'VAGINAL ICONOLOGY'

Greer: 'Women's sexual organs are shrouded in mystery. . . . When little girls begin to ask questions their mothers provide them, if they are lucky, with crude diagrams of the sexual apparatus, in which the organs of pleasure feature much less prominently than the intricacies of tubes and ovaries. . . . The little girl is not encouraged to explore her own genitals or to identify the tissues of which they are composed, or to understand the mechanism of lubrication and erection. The very idea is distasteful.'[20]

The acceptance and re-integration of the female genitals into art has thus been a political, rather than a directly erotic gesture. Like the associated violation of the menstrual taboo, it celebrates the mark of our 'otherness' and replaces the connotations of inferiority with those of pride. It is a category that promotes self knowledge (like the self-examination health groups by which it has probably been influenced), and as Barbara Rose has pointed out it refutes at least rhetorically both the Freudian concept of penis envy and the notion of women as 'The Dangerous Sex'.[21]

Judy Chicago and Miriam Schapiro have suggested an *unconscious* use of the 'centralized void' in female imagery, and have drawn on the work of O'Keefe, Hepworth and Bontecou amongst others in support of their case.[22] This has caused considerable controversy, and it is not altogether clear whether Chicago was insisting on such imagery as biologically innate (though often disguised to accommodate itself to the demands of masculine culture), or politically appropriate as a way of asserting femaleness in an area where it has conventionally been denied. East coast feminists reacted strongly to the idea of womb-centred imagery as just the old style biological determinism in a new guise.

But the point in either case is not only to 'express' femaleness in some nebulous fashion, but to redefine it, and this is where familiar symbols can be useful in the construction of new meanings, particularly where they are used in association with less familiar attributes. In *Let it all Hang Out* for example, Chicago aimed to express the ability to be feminine and powerful simultaneously;[23] but the problem here is to maintain the challenge, and not just rework an existing set of associations (plates 49 and 50).

Shelley Lowell's *Rediscovery* (plate 51), an apple with a vagina as its core, is a powerful image which celebrates a subject that is still largely taboo, and suggests through its title the feminist connotations of exploration, understanding and re-integration so important to Chicago. At the same time it evokes the old connections between women and delicious passive consumables, between female sexuality and the theme of temptation and sin, and arouses a very similar set of responses to those provoked by a Sam Haskins photograph of an apple/breast. It may have *intended* a reference to such visual puns, but the irony is double-edged, because the clichés are not challenged but indulged.

Betty Dodson is an erotic artist who has developed a positively missionary attitude towards masturbation as 'a meditation on self-love',[24] seeing it as the 'sexual base' from which women can achieve sexual and hence political liberation. Deciding that there was no contemporary aesthetic for the female genitals, she decided to help create one, and at the 1973 N.O.W. Sexuality Conference in New York she presented a series of slides: firstly of her earlier work; secondly of anatomical diagrams from medical and educational sources, frequently as ugly as they were incorrect; and finally pictures of the individuals in her own body workshops, their genitalia affectionately categorized as 'Baroque', 'Danish Modern' 'Gothic', 'Classical', 'Valentine'[25] (plate 52). A thousand women, many of whom had never seen their own vaginas, let alone anybody else's, gave her a standing ovation.

Susanne Santoro, an American living in Rome, has been similarly moved to comment on, and rectify the absence of female genitals in masculine culture:

> When I saw how this subject had been treated in the past, I realized that even in diverse historical representations it had been omitted, smoothed down, and in the end, idealized.[26]

Santoro's intention in her book *Towards New Expression* is to find a way of 'understanding the structure of the female genitals' (when she had taken a cast of her own in 1970 she had been amazed by the very precise construction and form), and to produce 'an invitation for the sexual self-expression that has been denied to women till now, and . . . not . . . to attribute specific qualities to one sex or the other'[27] (plate 53).

The Arts Council withdrew this book from their 1976 exhibition of 'Artist's Books' (for which they had originally requested five copies), 'on the grounds that obscenity might be alleged'.[28] They *did*, however, include Allen Jones' *Projects*, thereby inadvertently endorsing the views of Laura Mulvey[29] and Suzanne Santoro, that whilst the image of woman as fetishized object, repository for male sexual fantasies and fears, is 'acceptable' in our society, the image of the vulva itself which the fetish seeks to displace, is 'obscene'.

Only in western culture, however, can the point be made and the image reinstated in this way. Nowhere has the vagina been depicted in *more* graphic detail than in the Vaginal Albums of the Japanese Ukiyo-e tradition. Many of these belong to the genre of the 'courtesan-critique' – guides to the famous courtesans of the day giving details of their beauties and faults, their location and price, and sometimes complementing a facial portrait with a genital one (plate 54). If the vagina has been anaesthetized or omitted as part of the de-sexualizing of women and the fetishization of their image, then an emphasis on genital imagery as a parallel to women's reclamation of their sexual identity is fine. The implications are fairly clear. But if vaginal imagery, however beautiful, exists in this way within a male-dominated society – in association with the courtesan critique which identifies the woman with her genitals in a relationship of bought possession – that is another matter, and the symbol is not open to 'reclamation' as in the West.

3. TRANSFORMATIONS AND PROCESSES

Women are arguably closer to bodily processes and transformations than men: their physical cycles are more insistent, and they are used to treating their bodies as raw material for manipulation and display. Women are never acceptable as they *are*, as de Beauvoir has suggested they are either the raw material for their own cosmetic transformations, in which nature is present but fetchingly 'culturized', or for the artist's.[30] Alternatively, and at a deeper level, they (we) are somehow inherently disgusting, and have to be deodorized, depilated, polished and painted into the delicacy appropriate to our sex.

Investigating the make-up process is a way of re-investigating one's identity. Cosmetics pieces were fairly common in the early 1970s, and one of the first was *Lea's Room*, inspired by the bedroom in Colette's *Chéri* as 'the boundary of female life', which was part of the Cal. Arts Womanhouse programme. A woman dressed in pink silk and antique lace sat at a mirrored dressing table in an opulent, satiny and perfumed room, repeatedly putting on make-up, wiping it off in discontent, making up again. . . .[31] (plate 55).

The English artist Sue Madden, in planning a 'cleansing ritual' took as her texts Berger's comment on women as both the surveyor and the surveyed, and Robin Morgan's reference to 'Each sister wearing masks of revlon, clairol, playtex, to survive.' She intended to film 'removing rituals', plucking eyebrows, shaving armpits and legs, applying face packs and astringents – which she sees as activities 'which wipe away women's identity' – and by thus working through them to bring together the surveyor and the surveyed within herself.[32]

These examples, eccentric as they may at first seem, question the cost and the meaning of woman as sexual object in the world, in the same way as Sleigh's more artistically conventional paintings of male nudes foreground the issue of woman as object in art. They attempt the investigation of an identity which is assumed to be separate from, and hidden by, external appearance: Adrian Piper speaks of an 'awareness of the boundaries of my personality', and Antin of 'moving out to, into, up to, and down to the frontiers of myself'.

Women who work directly *on* their bodies, not just to emphasize the transforming process but to make of that material 'art', are concerned with both issues – i.e. woman as object in life *and* art – at the same time; and also with a conflation of the roles of the artist, the model and the work (plate 56). Take for example Eleanor Antin's *Carving: a Traditional Sculpture*, which consisted of 144 photographs of her naked body, front, back and both profiles, documenting a weight loss of 10 pounds over 36 days.

> This piece was actually done when the Whitney Museum asked me to tell them what I intended to have for one of the Annuals . . . since I figured the Whitney was academically oriented, I decided to make an academic sculpture. I got out a book on Greek sculpture, which is the most academic of all. (How could they refuse a Greek sculpture?) This piece was done in the method of the Greek sculptors . . . carving around and around the figure and whole layers would come off at a time until finally the aesthetic ideal had been reached.[34]

The other transformations are those of bodily processes, including ageing and decay (e.g. Athena Tacha's ongoing catalogue of the effects of time on her body);[35] and of a calculated disgust that is cultivated in defiance, and as an exorcism of the prescribed female role.

Betty Dodson feels that women will not live easily in their bodies until they have learnt not to suppress its less 'feminine' physical processes. It would be difficult to find a fuller expression of that, or a more extreme/satirical rejection of all veneer and polish than the *Catalysis* series of performances by Adrian Piper. In *Catalysis I* for example she 'saturated a set of clothing in a mixture of vinegar, eggs, milk, and cod-liver oil for a week, then wore them on the D train during evening rush hour, then while browsing in the Marboro bookstore on Saturday night'; and in *Catalysis V* replayed tape-recorded belches at full volume while researching in the Donnell Library.[36]

Menstruation has been so concealed as to *invite* the violation of the taboo[37] ('The blood jet is poetry / There is no stopping it' as Plath wrote) – partly for the sake of public recognition and re-assessment; partly as an emblem of celebrated femineity, the embracing of our inferiority; partly as the hinted at resurrection of ancient matriarchal powers;[38] and partly in reaction against what Ellmann has called 'the insistent blandness of modern femininity'.

Menstruation images have been even rarer in art than in literature: in that form they can scarcely be discreetly alluded to, or veiled in metaphor. Judy Chicago's notorious *Red Flag* photo-lithograph (plate 57), a self portrait from the waist down showing the removal of a bloody Tampax, was made deliberately 'to introduce a new level of permission for women artists' and 'to validate female subject matter by using a "high art" process'.[40] (Cf. also the *Menstruation Bathroom* in Womanhouse, which set out to explore the dichotomy between the secrecy, the discomfort and the mess, on the one hand, and its gauzy packaged denial on the other.)

Gina Pane is a rare example of a woman body-artist who actually damages her own body. She talks a lot about 'reaching' people in an anaesthetized society, and she is prepared to suffer to do that, although she insists that she does not enjoy pain and is really an optimist (plate 58). In a performance in May 1972 she had been cutting her

back with a razor blade whilst turned away from the audience, when

> suddenly I turned to face my public and approached the razor blade to my face. The tension was explosive and broke when I cut my face on either cheek. They yelled 'no, no, not the face, no!' . . . The face is taboo, it's the core of human aesthetics, the only place which retains a narcissistic power.'[41]

Except perhaps in the specific instance of what Barbara Rose first termed 'vaginal iconology',[42] it is impossible for women to assert their identity directly through their appearance. They already *have* a reputation for narcissism. Since women are not *expected* to be disgusting, the violation of certain established taboos, like that on public reference to menstruation, symbolizes a disrespect for the social order, and a rejection of the normal patterns of domination and submission which are enshrined within it. Vulgarity can be a means of enhancing dignity 'when the obscenities are merely signals conveying a message which is not obscene'.[43]

4. PARODY: SELF AS OBJECT

The following quotation from John Berger has already been mentioned by several of the artists discussed, and it is central to a consideration of the subject/object contradictions which face women working with the female body. This seems the moment to quote it in full:

> A woman must continually watch herself. . . . From earliest childhood she has been taught and persuaded to survey herself continually. And so she comes to consider the surveyed and the surveyor within her as the two constituent yet always distinct elements of her identity as a woman.[44]

Carolee Schneemann is an artist who has used her own body in her work, and appeared nude in performances of her own, Oldenburg's and others since the early 1960s. Personal, sexual and artistic freedom are mingled in 'a determination to incorporate the nude body in all my work' – i.e. performance, film, paintings and collages.

> In some sense I made a gift of my body to other women: *giving our bodies back to ourselves.* The haunting images of the Cretan bull dancers – joyful, free, bare-breasted, skilled women leaping precisely from danger to ascendancy, guided my imagination . . .[45]

a timely reminder that in rejecting men's view of us, we cannot afford to lose also an authentic joy in the very *real* pleasures of the body, particularly if by some such exorcism we can heal within ourselves the split between the surveyor and the surveyed.

Hannah Wilke's *Starification Object Series* includes a performance in which she provides the audience with bubble gum to chew, and then flirtatiously takes it back, forming it into tiny vaginal-like loops and sticking them in patterns over her naked torso. In the 1974 video *Gestures* she manipulates her flesh and features and converts her mouth into a vaginal metaphor by exposing its inner labial structure.[46] For Lil Picard's *Life Sculpture* she enacted the roles of sex kitten and Venus, and ended her own *Soup and Tart* performance in a crucifixion gesture which, like the vagina/mouth metaphor, Penny Slinger has also used.

Lynda Benglis is an established artist who has for some time divided her work between abstract, if sensual, poured-foam sculpture and more directly autobiographical and auto-erotic video pieces. In 1974 she deliberately parodied the still-bohemian image of the West Coast sculptor in four consecutive published photographs which appeared as exhibition notices and/or advertisements. The last, and most controversial, was a full page colour advertisement in *Artforum*[47] showing an aggressively sexual image of a greased nude body with just a pair of sunglasses and a huge latex dildo as accessories (plate 59). Benglis apparently intended it as a 'media statement . . . to end all statements, the ultimate mockery of the pinup and the macho'[48] (and the dildo image is a bizarre blend of the two). Reactions were mixed. A group of the editors condemned the advertisement as 'an object of extreme vulgarity . . . brutalizing ourselves and . . . our readers'[49] thereby playing into her hands by proving, according to the critic Lucy Lippard, 'that there are still some things women may not do. . . .'[50]

At the same time those who claim an art form out of being 'intentionally' exploited like Cosey Fanni Tutti of the COUM group, or supplement their activities with the odd nude pose in *Knave* (Penny Slinger), shift the meaning of the work, however serious its original or possible intentions, from parody to titillation.

The depiction of women *by* women (sometimes themselves) in this quasi-sexist manner as a political statement grows potentially more powerful as it approaches actual exploitation but then, within an ace of it, collapses into ambiguity and confusion. The more attractive the women, the higher the risk, since the more closely they approach conventional stereotypes in the first place.[51]

It is difficult to see what the most useful conclusions might be, especially when we are so clearly in the *middle* of a process of change (and one which could yet be reversed). There are, however, a number of points to be made.

The female image in all its variations is the mythical consequence of women's exclusion from the *making* of art. It is arguable that, despite her ubiquitous presence, woman as such is largely absent from art. We are dealing with the sign 'woman', emptied of its original content and refilled with masculine anxieties and desires. Nowhere is this more evident than in the area of eroticism, and women see themselves reflected in culture as through a glass darkly.[52]

Yet paradoxically the tool for objectifying their experience *is* culture, *is* the process which already distorts it and which is not itself value-free.

The only solution is to grasp and reconstruct it, through the exposure and contradiction of the meanings it conveys. We cannot pull out of thin air a new and utopian art – or a new and utopian sexuality: both must be arrived at through struggle with the situation in which we find ourselves. Art does not just make ideology explicit but can be used, at a particular historical juncture, to rework it. There seems to me every reason to believe that feminism, and ultimately the overthrow of patriarchal values, will transform art in just as dramatic a fashion as the bourgeois revolutions.

In one way, women do not need to be 'sexually' liberated in order to produce erotic art, they need to be liberated into the art-making process itself – many of the reasons why they have not produced an erotic imagery being the same as those which have

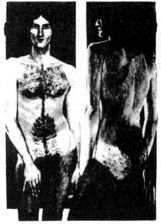
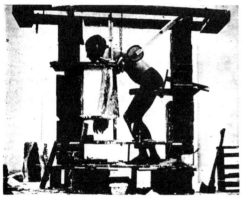
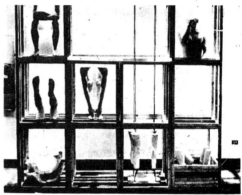

44 (*top left*) Sylvia Sleigh, *Philip Golub Reclining*, 1972

45 (*top right*) Sylvia Sleigh, *Double Image–Paul Rosano*, 1974

46 (*centre left*) Colette Whiten, *Untitled*, 1971–2

47 (*centre right*) Colette Whiten, *Untitled*, 1971–2

prevented them from making art at all. Desirable as the free expression of human sexuality may be, it is not *per se* a precondition for the making of art, or we might have had precious little of it; but the making of art *is* a precondition for the expression of even a confused or repressed sexuality such as Moreau's or Beardsley's. Both these questions have arisen simultaneously for women because broadly speaking they only entered art in large numbers at the same time as they sought to redefine their sexual relations, and for much the same reasons. They are able to express their sexuality only at the point of changing it, and it is from a restructuring of their sexual situation (bearing in mind that this is quite a different thing from generalized 'permissiveness'), that we may expect that revolution in the realm of erotic representation of which Linda Nochlin has spoken.

48 (*above left*) Judith Bernstein, *Horizontal*, 1973

49 (*above centre*) Judy Chicago, *Female Rejection Drawing* (from the Rejection Quintet), 1974

50 (*above right*) Judy Chicago, *Let it all Hang Out*, 1973

51 (*left*) Shelley Lowell, *Rediscovery*, 1972

The process, here as elsewhere, is perhaps best seen as a dialectical one. The thesis is represented by the erotic art of a male-dominated culture, and the antithesis by women's current response to that – an attack on the patterns of dominance and submission within it, a rejection or parody of the standards by which women are judged sexually desirable, a repossession for our own use of the 'colonized' and alienated female body, and tentative steps towards the expression of a sensual appreciation of the male. The synthesis is yet to come, and apart from the fact that one obviously hopes for a truly androgynous human culture, and the kind of authentic erotic expression that would be its corollary; to discuss it at this stage would clearly be premature.

Middlesex Polytechnic

52 (*above left*) Betty Dodson, Vaginal drawing (untitled) from a series, 1973

53 (*above right*) Suzanne Santoro, Untitled double page spread from *Towards New Expression*, 1974. Photographs

54 (*left*) Utamaro, Two views of a courtesan. Late eighteenth-century woodblock print from a guide to the prostitutes' quarters

55 (*above left*) Nancy Yondelman, *Leah's Room*. Environment and performance (Karen le Cocq acting) from 'Womanhouse', Los Angeles, winter 1971–2

56 (*above right*) Eleanor Antin, *Representational Painting* with herself, video piece, 1972

57 (*far left, top*) Judy Chicago, *Red Flag*. Photo-lithograph, 1971

58 (*far left, bottom*) Gina Pane, Photograph from *Psychic Action* performance, April 1974

59 (*left*) Lynda Benglis, Photograph of the Artist, *Artforum*, November 1974

Source: *Art History*, June 1978, vol. 1 no. 2, pp. 236-49.

IV.2 Dossier: Letter from Lisa Tickner and *Apollo* editorial

Attitudes to women artists

The *Apollo* editorial for October 1978, devoted to a review of the new magazine *Art History,* may well have escaped your readers' attention. It was brought to mine, however, since several paragraphs attempt some heavy-footed sport with my paper for the 1977 Conference of the Association of Art Historians (*Art History* June 1978 vol. 1 no. 2).

Now a feminist analysis of women in relation to erotic art can still expect to draw some fire, and the editor is entitled to his opinions; but his privileged position requires a standard of professionalism sadly lacking in this uncritical, misleading and offensive account.

I expected the right to some sort of reply, but after three months have not even been granted the conventional courtesy of an acknowledgement. In the circumstances I would be grateful for an opportunity to publish my letter here instead — in defence of my politics, rather than specifically this paper.

There follow: 1) the paragraphs from *Apollo*, 2) my letter to *Apollo* of October 18.

Lisa Tickner
Middlesex Polytechnic
London N8

'The second issue contains one novelty — Miss Lisa Tickner's article 'The Body politic: female sexuality and women artists since 1870'. At first reading this might be interpreted as a spoof, but it is clearly meant to be taken seriously; it could well provide rich material for Tom Stoppard. Miss Tickner's piece presents some rum folk. There is Miss Judith Bernstein. Her interest in phallic imagery, we are told, 'grows out of a preoccupation first with calligraphy, and then with graffiti, which she pursued into the men's lavoratories at the Yale Graduate Art School'. The dear creature evidently emerged unscathed. Then there is another female explorer, Miss Betty Dodson, she has 'developed a positively missionary attitude towards masturbation as "a meditation on self-love" ' and has produced a series of slides of female genitalia

affectionately categorized as "Baroque", "Danish Modern", "Gothic" and "Valentine". Lovers of the *ancien regime* may well ask — 'what about "Rococo" '?

All this is good knockabout fun; in any event, we dare say that it makes a change for hard pressed students as they plough through some of the more highbrow stuff. It may even make some of the male art historians eager to scrape acquaintance with Miss Lisa, Miss Judith and Miss Betty, and the Editor has rather let us down by not adding their photographs to the illustrations. One, Figure 59, shows saucy Miss Lynda Benglis whose striking pose might well have delighted some old hands at Le Sphinx and at Chabanais's!

A male chauvinist Fascist-pig may be tempted to wonder if women have been either quite such demure little misses or such vampires as Miss Lisa Tickner and her patron saint, Mistress Linda Nocklin, like to pretend; what about Mrs Caudle and her curtain lectures and Mrs Proudie? As for the sex war, does this not add a touch of spice to the art of the alcove?'

My attention has been drawn to the October editorial, and to your remarks on my paper 'The Body Politic: Female Sexuality and women artists since 1970'. (i.e. *not* '1870').

These are so confused, irrelevant and/or prejudiced that they scarcely merit a response, and on that score the bait is resistable; but the innacuracies of content require correction, and the offensiveness of tone some comment.

By selective (and rather careless) quotation you conflate me with my material, and trivialize the important issues I attempted to raise — and indeed manage to convey an impression directly opposed to the main effort of my paper, which was *precisely* to provide that critical and interpretive context, without which the artists might well be too easily dismissed as 'rum folk' by the uninformed.

Ironically, your remarks bear out many of my own points about the kind of opposition that women artists and critics

have to negotiate. I have listed a few varieties below but they are all, of course, inter-connected.

1. A patronizing facetiousness is more likely than head-on conflict. This is sneakier: it ridicules from a position of assumed urbanity whilst avoiding the main issues. Alex Potts' piece contains 'unfamiliar material' — mine is a 'novelty', and 'good knockabout fun'.

2. Physical comment is substituted for intellectual argument: 'It may even make some of the male art historians eager to scrape acquaintance with Miss Lisa, Miss Judith and Miss Betty, and the Editor has rather let us down by not adding their photographs to the illustrations'.

3. Counter-criticism is disarmed by a cosy, self-confessed chauvinism. This has the added strategic value of ridiculing the opposition by an exaggeration of its position. 'A male chauvinist Fascist-pig may be tempted to wonder . . .'

4. Blatant misrepresentation may be resorted to (although I suppose it occurs here simply through carelessness). Neither I nor Professor Nochlin, for instance, have ever divided women into vampires and venuses. We have, however, not been alone in remarking a strong tendency in the Romantic movement to represent them as one or the other.

5. Emphatic use of gendered titles, Christian names, and other reminders of the subject's sex is adopted as both effectively dismissive, and amusing in itself (Why else the smirking reference to 'Mistress Linda Nocklin' (sic) — would 'Master Anthony Blunt' reflect well on its writer's spelling and wit?)

And so on . . . but I trust the point is made. In short Sir, your comments are not worthy of you; nor of the traditions of *Apollo,* which whilst it is open to criticism and debate, does not normally stoop to the facetious sneer.

Yours faithfully,
Dr Lisa Tickner.

Source: *Art Monthly*, 1979, no. 23, pp. 22-3.

IV.3

Anne-Marie Sauzeau-Boetti
'Negative capability as practice in women's art'

'I would call "feminine" the moment of rupture and negativity which conditions the newness of any practice.'

Julia Kristeva

'Let's be careful to remain in the margin: on this side of it, ideology catches us again, but beyond it, archangelism threatens to catch us.'

Alain Robbe-Grillet

In Italy, like anywhere else, many women artists still deny the idea of a female art. They feel either offended or frightened by a hypothesis which seems to imply a deliberate fall back into the gynaeceum. If the word 'feminine' frightens these artists it is because they are not confident about the possibility of filling it with a reality which is different from the metaphorical womanhood invented by men. They say, and they are convinced, that art is good or bad, but has no sex. It is a fact that their artistic research is often so perfectly in line with the cognitive order of male culture, that their work (at its best and its worst) has no substantially different connotation from man's art. If we assume that culture is an asexual absolute, it means that women have just one problem, historical backwardness, which will be overcome with time, with the general social evolution and the demonstrative anticipation of an emancipated female élite. Between this theory and women's traditional docile reverence, there is no opposition but a great deal of agreement: male humanism remains the yardstick of value and strength.

In Italy today we frequently find male art critics or amateurs who make a great show of accusing themselves of having excluded women from the mainstream of artistic activity. They exalt the consecration of great women artists who had been either forgotten (for instance Marisa Merz) or eclipsed after a brilliant first stage of their career (Carla Accardi); they exalt the entry or re-entry of these artists into the economy of artistic expression.

There is still no declared group situation in Italy among the artists who are aware of their historical condition as women, and their awareness is much more of a private identification than a move towards self-vindication and promotion (as it appears in the radical politics of USA feminist artists). These Italian artists who behave differently within their profession (whether because they are forced to do so by discrimination, or whether they do so through a genuine difference in their way of being), evince many different approaches to their experience of life and to the process of art. I don't mean 'different' in the context of the dominant artistic situation (as a pluralist reference to 'schools' such as Optical, Pop, Conceptual,

Narrative, 'Wild', etc), but inside their more or less concealed but communal incongruence, that is in their relationship to a different experience of the world (existence in the feminine and assimilated male culture).

The primary approach is connected to the rediscovery and exploration of the body (specific biology, physical boundaries, sexuality) conveyed through privileged and recurrent materials, shapes, colours, rhythms, gestures, internal/external spatial relationships. The body theme has not as yet become too explicit, it is not 'translated' into a codified imagery – a conditioning and ambiguous iconography, on the verge of mythology – as has been happening in California in the Womenspace situation (see Judy Chicago's book *Through the flower*). The biological and uterine themes are ambiguous, because they exalt a 'natural' identity, whereas woman's history is mainly cultural and it is in the name of 'nature' that she has been kept away. In Italy (let us say in Europe) this body matter can be traced in many women's work, but usually as a substratum of their artistic expression, and far less gratifying than the explicit female iconography. This characteristic appears particularly clearly in body-art: it deals with blurred figures and the confused roots of woman's physical and mental lack of identity – with narcissist pleasure and self-denial, with silence and fragmentation. (About women's art and body, see the section on Iole de Freitas, p 26).

Another approach (I am schematic) to existence and art deals with woman's ancestral second nature: the oppression and negation which are also self-oppression and self-negation. An historical example of conjunction between the expressive/repressive impulse: the thousands of lace doilies, more maniacal than modest, that always radiate like spiderwebs . . . It is not a question of reproposing lace doilies but of recalling them as examples of the atrophied expression of a culture which remains authentic (although smothered). Women's art sometimes starts on this pilgrimage of rediscovery and vindication of traditional gestures. Having been rescued in art mechanisms, some memorized gestures free themselves from atavism and obsession; they are actually exorcised from a spell and become a free inventive activity, once their matter-of-fact function has been cancelled and their value, as a trace of some deep intimacy between body and mind, has been restored. Here, 'free' does not mean perjury, it implies respect and a sense of belonging to the obsessive pleasures of some feminine moves and rituals (such as knitting, patch-working, candle-melting, fable-telling and warding off the evil eye . . .), an occult space now open to free imagination and invention. (About women's art and traditional gestures, see the section on Marisa Merz, p 27).

Other artists tackle the difficult task of the most rarefied cognitive and creative processes in male art, the least existential and for that reason particularly

demanding for women (emancipation as a third nature?). I am alluding to the activities that require the greatest mobilization of the abstracting and sublimating faculties (abstract art in the fifties, programmed and optical art in the sixties, conceptual art starting in the late sixties). Now, when the woman artist lives profoundly as a woman in her profession and strongly enough in her mastery of the means she is managing, it is my belief that a gradual differentiation from this 'father' art occurs. It does so in the daily dialectic between intuition and cognitive mobilization, between desire and intellectualism, between the female and male polarities existing in her as a human being. Her relationship with the technique and artistic field she deals with, her very language, changes when she reaches the point of exercising her ability to symbolize areas of life which have been historically unexpressed (and sheltered) for so long. In this case she enters the double space of *INCONGRUENCE*, by which I mean that she can still be read and appreciated through the cultural criteria of the avant-garde, formal quality and so on, BUT also through another criterion, as a landmark of an *ALIEN* culture, with reference to other values and mind schemes (a Fourth World, Susan Sontag would say). This represents an indirect and difficult path through the territory of art (with the risk of getting lost), a certain appropriation/negation of languages and expressive media. (About this 'traverse' practice of art, see the section on Carla Accardi, p 26.)

Some young artists and feminist supporters think that feminist art can exist as a new artistic language. I remember a small show in Trieste last spring called 'Feminists'. In the presentation, such art was praised as 'accusatory, violent, hard, crude' (in contrast to the gentle conciliating tradition of women). Indeed, a woman is liable to feel violent and crude (if not alien and lost) when she 'seizes the word,' since the daily abuse of her existence has been violent and crude. It is also true that her redeemed creativity cannot exist in a pure state, outside history, all shadow-cultures or exiled cultures being related to the revolution which prepares their return home. Nevertheless, ideological and pamphletarian matter as such cannot build up a creative expression. The explicit figurations or references to feminist themes (anger, body expropriation, body rediscovery, etc) are by themselves no guarantee of a diverse relation with the instruments of expression. What is more (and worse for art), ideology is reassuring: as a political project it supplies a goal and gives a positive validity to accusation; when applied to artistic expression it is usually anti-revolutionary whenever it does not succeed in being IMPLIED in the very language, since it directs expressive research into the didactic and illustrative processes we all know

(all the party and state forms of art). So, when women's art explicitly accuses and vindicates, it re-enters the LEGIBLE cultural space as militancy; and in order to be antagonistic (a type of dialogue), it has to recompose itself artificially (for instance through a 'provocative' use of Pop technique), which means betraying the basic disunity, 'negativity' and *OTHERNESS* of woman's experience. I do acknowledge feminist group expression as a rich militant instrument, in the way Chilean and Portuguese 'murales' are a renewed political praxis; but I don't believe in 'feminist art' since art is a mysterious filtering process which requires the labyrinths of a single mind, the privacy of alchemy, the possibility of exception and unorthodoxy rather than rule.

Woman's exclusion is historical, not natural. She has been absent from history because she has never given MEANINGS OF HER OWN through a LANGUAGE OF HER OWN to culture (and to herself as part of it). Instead, she has assumed those established by man (for instance she has complied with his metaphorical vision of her real self). The new meanings cannot be conveyed through an 'old' language (for instance the explicit and coherent reference to these meanings – the bad joke of filling a smelly pot with fresh water). But what is of greater importance is that these new meanings CANNOT BE AFFIRMED AT ALL through any alternative positive management of the artistic language, because these meanings refer to a scattered reality, to a subject in the negative who wants to displace the horizon, not to alter it; who wants to go through all the resources of *'NEGATIVE CAPABILITY'* (Keats and Duchamp let their own feminine identity bloom quite freely). The actual creative project of woman as a subject involves *BETRAYING* the expressive mechanisms of culture in order to express herself through the break, within the gaps between the systematic spaces of artistic language. This is not a matter of accusation or vindication, but of *TRANSGRESSION* (closer to madness than to reason). The cuts and waves in the braided transparent material (Carla Accardi), the waiting needles around the curled void knitting (Marisa Merz), the absent and broken body reflected back from the other side of life (Iole de Freitas), the quivering hands that 'embroider' their own shape with calligraphy and attempt to save themselves from metaphor and unreality (Ketty La Rocca), are examples, among many others, of such languages in the 'negative'. This kind of project offers the only means of objectivizing feminine existence: not a positive avant-garde subversion but a process of differentiation. Not the project of fixing meanings but of breaking them up and multiplying them.

Source: *Studio International*, 1976, vol. 191, no. 979, pp. 24-5.

IV.4 Judy Clark

Rozsika Parker
'Body works'

*Judy Clark's recent exhibition aroused
extreme reactions. While several women
critics were swept into pseud's corner by
their enthusiasm for the exhibition and the
Tate was buying one of her works, many
others were appalled. Judy makes works of
art out of matter that is usually hidden or
thrown away. She takes dust, urine, nail
parings, menstrual blood etc., and mounts
them with clinical care, creating an effect
not unlike a museum cabinet. Her self
portrait consisting of hairs from all parts of
her body and fluids from her nine orifices
could hardly be further from the sweet
plastic image of women celebrated in pop
art. Rosie Parker asked her about her work.*

R. Much of the material you use is seen as dirt
by most people. Do you think that dirt lies in
the eye of the beholder?
J. On one level, yes – in fact I was thinking of
creating a series of situations which would
actually be considered dirty in subtle ways; an
obsessively carefully laid table with milk in a
bottle instead of a jug – showing the arbitary
nature of good manners and ideas of dirt. I
probably won't do it.
R. The milk bottle in itself isn't dirty, only in
the context of an immaculately laid table?
J. Yes, dirt is really disorder, matter out of
place – Mary Douglas in her book 'Purity and
Danger' articulates what I feel about dirt. She
says that we consider objects or ideas to be
dirty and unclean when they interfere with the
order we impose on our lives and environment.
R. Its true that our view of dirt isn't always
based on hygiene. Food as such isn't dirty but
it's dirty when spattered on our clothes; cat
hairs are clean on the cat but dirty on the sofa.
J, But then hair off the body can be acceptable
if it is in a locket. I've seen brooches with hair
woven and plaited in the most incredible
designs, and its acceptable like that. But
tangled, in a disordered mass in Mary
Douglas' terms, it is not acceptable.
R. Because then it isn't under our control. All
your work strikes me as impeccably ordered;
every nail paring mounted according to size
and shape, each of the hairs you collected from
your bed laid out horizontally. Do you do it
consciously?
J. Yes, one of the reasons it is put out in an
ordered way is that it is so dangerous that if it
was out of control it would be totally
unacceptable. It would be obscene and
revolting and nobody would look at it. But
because it is laid out so carefully it creates a
dualism between unacceptability and
acceptability. That is one of the things that a

Judy Clark

lot of people commented on. They said, "It's
so beautiful but Oh! isn't it awful."
R. There is a further dualism between the
intensely personal material you work with,
your own menstrual blood, dust from your
home etc., and the cold, detached, clinical way
you lay it out.
J. I think if I had been a man I would have had
to impose more of myself on the lay out.
Malcolm, (who she lives with), and I deal
with very similar ideas – all centred around the
body and our day to day occupations – only his
are more autobiographical and less scientific
than mine. He wanted to do a skin print of me,
as if it had been peeled off and flattened. He
wanted it to look like a real skin. I did the same
sort of thing except that I just wanted to
compare all the different textures and things.
But Malcolm said that if he had been doing it
he would have to do a positive thing - to make
a positive impression of the skin. I would have
been quite happy to take footprints whereas he
would have had to create a foot.
R. All the material you use comes from your
body. Are you very aware of your body?
J. No, I don't think anymore than anyone else.
In fact, I take less exercise and trouble than
most people. I think that living here (an old
house above a shop in Hackney) made me
much more aware of grooming and cleansing.

(One of Judy's pieces consists of soiled cotton
wools collected and mounted). I had never
lived without a bathroom before, and having to
make an expedition for a bath brought into
focus things that I hadn't bothered to consider.
R. Had you never used the body as a subject
before?
J. I did my thesis at college on body images in
the environment. Houses and the way we
design our environment are related to the
structure of the face and the body. The body is
a very rich source of symbolism. As Mary
Douglas points out, its boundaries can
represent any boundaries which are threatened
or precarious - a society's attitude to the body
mirrors its social organization and anxieties.
R. How does the idea of the body as analogous
to the structure of society link to the taboos
surrounding blood, urine, or shit.
J. Different cultures view dirt in different
ways and the way they view it tends to reflect
the way their society is structured. Tribes
which are very secure in their boundaries have
less hangups about bodily taboos than tribes
that were constantly attacked from the outside.
The Jews are an example of a threatened
society who create a structure and framework
for their lives out of dietary and sex pollution
laws.
R. Notions of purity are also linked to status

Soft Surfaces

J. I'm breaking men's isolation too. Women are the one's who usually have to deal with it; clean things up. But it's aimed as much at men as it is at women in that women are aware of it but don't think about it; whereas men are not even aware of it.

R. But you are publicising private rituals.

J. Yes, and I think one of the things that really intrigues people about my work is 'how on earth did she do it' or 'what a thing to do'. They are obsessed with the image of me doing it – particularly the semen pieces (semen stained tissues arranged in wood and glass boxes). Is as if people were more obsessed with the artist mixing the colours than the actual painting. Which is nice because the process is as important as anything else.

R. I think the menstrual pieces are more radical. You are breaking deeply entrenched taboos by exposing menstrual blood and transforming it into a work of art.

J. Yes, funnily enough it became the central work which was not how I originally saw it. Once I started doing it, it became very powerful. I found it very touching to do. In fact I wrote down all the taboos associated with menstruation: You must not walk between two men. You must not enter a holy place. You must not cook food. You must not poke the fire. You must not scratch. Keep out of sight.

R. All these taboos are built on fear of defilement, of pollution. If the women broke the taboos disaster occurred – the two men she walked between died, or the crops failed if she entered the field. Pollution laws drastically curtailed women's activities didn't they?

J. Though they seem to be built on fear of women, fear of the unknown. S trangely the men in some societies cut themselves to simulate menstruation. They believe that menstruation is a cleansing process.

R. Where male dominance is absolute and maintained through physical violence, sex pollution laws are non-existant. Yet where the position of women is ambivalent, when they have some rights and privileges, sex pollution laws flourish. Doesn't Mary Douglas say that sex pollution laws are used to impose a system

aren't they? In a caste society, the lower castes deal with dirt, allowing the higher castes to remain 'pure'. Does your work relate to the idea that beliefs about cleanliness maintain divisions in society?

J. Well, that raises a sort of side issue. I don't really know why I did the work. I just did it. All the social and the female implications came as a by-product.

R. What female implications do you mean?

J. I think men particularly are rather horrified by my work. Because it doesn't fit in with their idea of what women do. It's never publicly admitted that women bleed. Its OK to talk about men's sub-life but you can't talk about women's sub-life.

R. So in a sense you are breaking down women's isolation?

Menstruation

Small Wounds

on society by exaggerating the differences between within and without, male and female... etc.

J. Menstruation is still hidden and horrific for little girls today. When I started menstruating I thought, "Oh my God, is it going to go on for 30 years; was it never going to stop?"

R. Shame and embarrassment are part of the feelings women are made to feel about dirt and dust as well. Is your work connected to housework?

J. Yes, it is. I did much more housework when we first moved here than I do now. It took a long while before I started not to bother about it. I was very conscious and resentful of housework. But it also made me aware of how much dust there was. The sheer volume of it – I couldn't understand where it all came from.

R. I think that some intolerance of dirt is normal. After all, animals naturally clean themselves and each other. Dirt avoidance can become pathological because of all it symbolizes, I mean if dirt is disorder – matter out of place, as you said, then for many women housework is the only way of demonstrating some control over the environment, some self determination. But it gets incredibly complicated with the 'cleanliness is next to godliness' concept and the Protestant association of dirt with the devil and corruption.

J. I find the 'House and Garden' compulsive cleanliness really alienating. To me it's showing the world an image of what you want to be, rather than what you are. My work may be ordered but it's showing what's behind the facade. I saw a TV ad for furniture - people were shown huddled up on an old sofa and when they brought their new set of chairs they appeared scattered and isolated.

R. So your work is a comment on housework?

J. No, I wasn't consciously critising housework, or even trying to make a creative activity out of the materials of housework. Housework is just part of my life; most creative activity comes out of things you do, things you look at. Housework made me aware of that there are things going on all the time that we are unaware of – an invisible rate of consumption that I saw in the mountain of dust (it's mostly skin) which is cast off everyday.

R. What do you mean by consumption?

J. It's a question of passage and process. Like food going in and being shitted out or urinated. The whole process of constant flux is one we never notice.

R. How do you relate that to your work?

J. It relates to my interest in time and change. One of the things I've been doing recently is drinking a fixed amount of liquid every day and eating dry things. I measure how much I urinate, taking time photographs of the flasks of urine and organge juice. As one goes up the other goes down over the period of a week.

R. Are you doing these things to learn about yourself?

J. No, the reason I do a lot of these things is simple curiosity - not knowing the answers. I didn't know how many hairs are shed in a bed over a week, so I collected them. I didn't know whether or not we have intense periods of cutting ourselves. So I collected and dated old sticking plasters. I've only recently become interested in rhythms and cycles. Again it's a metaphorical thing; if there are rhythms in the body that you can understand, then maybe you can understand social rhythms, cosmic rhythms, historical rhythms - one system can reflect all sorts of other systems. It's so easy to build analogies with the body. ■

Source: *Spare Rib*, 1974, no. 23, pp. 37-8.

IV.5 Interview with Susan Hiller

Rozsika Parker
'Dedicated to the unknown artist'

Feminist artists are working in any number of ways from up-front poster art, to thoroughly researched documentary exhibitions, to avant-garde art practice which is where Susan Hiller's work belongs. She was trained as an anthropologist but in the mid 1960s began working as an artist. She pursues her initial fascination for objects like seaside post-cards, fragments of Pueblo Indian women's pottery, photos from automatic machines, analyses them and classifies them. She wants to bring out the cultural meanings hidden within the images, to raise questions about ways of seeing and ordering experience in a patriarchal society. In April three exhibitions of her work opened in Oxford, Cambridge and London.

DAVID COXHEAD

Susan Hiller working on her most recent piece, "Fragments".

During April three exhibitions of your work opened in relatively conventional galleries, yet you are highly critical of the 'Art World' structure.

I would say that my using the gallery context at the moment is strategic. I am trying to insert a kind of world view smack into the middle of patriarchal notions of what art is. When I was younger I experienced real difficulty in placing my work within this very hostile structure, but at a certain point you have to face up to the necessities. If you want to communicate you are impelled to insert your work into the art of your time. I think you have a responsibility towards your work, and it's a heavy burden to have it sitting around unseen by everyone but a few friends. Once you've been working for a fair period, once you feel fairly confident about your work, you have to make a decision about what to do with it. The decision to place your work within the contemporary art context causes incredible stress. I don't know any women artists who are not stressed.

I can understand that putting your work up for public judgement would be stressful, but why is it particularly acute for women?

Well, your work won't be seen properly, it won't be seen clearly. And no matter how much validation I receive from the mainstream, I can only

see my presence within it as intrusive. And the difficulties that I get into are, I believe, the difficulties of communication and language based on a totally different perception of the world.

I'd agree that the way people see your work is indelibly coloured by the fact you are a woman, but how does your experience as a woman — your perception of the world — affect your relationship to the male art establishment?

Take for example the arts grant aiding committee that you and I served on. It had initially been all male but gradually over the years more and more women were invited to serve as members. As soon as there were several women on that panel the language of discussion changed from being the formal and strategic language of the committee room to being a language of feeling and a language of confrontation. Rows broke out that had formerly seethed unmentioned, and those rows were about absolutely basic issues concerning the whole problem of grant aiding the arts. But they had not been made explicit in all those years of funding the arts in this country. Who made them explicit? The women on the panel.

Don't you think that happened because we were already politicised rather than because we were women?

No. Look, recently there's been a lot of trouble because there are not enough women teaching in art colleges and the students are finally getting to the point where they are demanding that more women be hired. In a staff meeting at the college where I teach I said that this request of the students should be listened to, I think it's important because I respect the students, not just because that specific demand might be in my interest. A male member of the staff stood up after me and said he totally agreed with everything I said, he thought we should have at least 50% women teaching at the college and ended up by saying "Of course that would mean the end of art education as we know it." He's absolutely right. (laughter)

But surely a lot of art administrators, people running galleries and so on, are women and they change nothing.

Because administrators who are not feminists are often people who fit themselves into the male structure. They can therefore only give credibility to the existing value system. But this is really so complicated we could talk about it for the entire interview.... I'm speaking about aspects of our conditioning which when made conscious can be a constructive force in your life, but unconscious can be pretty damned destructive.

Examples of Rough Sea postcards from Susan Hiller's work "Dedicated to the Unknown Artist".

Hastings

Blackpool

Hastings White Rock

Scarborough

Hillsboro Beach Ilfracombe

Brighton

Torquay

What do you mean?

You see a woman is mute, right?

No.....

A woman is mute within our culture in that when she speaks she speaks as a man. This is a point I think Cora Kaplan' made brilliantly about the first person ir. poetry. Women poets come up against important difficulties when they get outside the area of expressing personal feelings. When they try to speak as I-the-poet-speaking-for-humanity, a false note often enters their work and one feels a kind of inauthenticity. This is a problem we all face. For example, you may speak well in public, but is it really you? You can seem articulate and feel alienated. You have to supress your alienation in order to remain articulate.

And that becomes personally destructive

Exactly. When I was talking at Cambridge about the work I showed there, the only hostile member of the discussion was a woman art historian whose speciality was the Renaissance. She attacked me because she said I was calling into doubt ideas about art that she held dear. I was saying that soup ladles were as important as Rembrandts and she didn't think soup ladles were as important as Rembrandts. I replied that in terms of personal meanings to her Rembrandt's work might be more important than soup ladles, but in terms of telling us things about ourselves, soup ladles were just as important. Then she did a sudden about face, she looked as though she was going to cry. I could see some sort of pressure building up inside and she started to mumble. The mumbling, all the

inarticulate stuff, was what she really thought. Suddenly she said, "You're absolutely right, soup ladles are important," and dashed out of the room. I never saw her again. One of the reasons she was able to be initially articulate was that she was dealing with the accepted frameworks and categories. It's when we try to deal with the contradictions arising from our experience within these frameworks that we have no language.

So one of the reasons why I think some women arts administrators — who aren't feminists — are hostile to women artists without recognising their own hostility is that they resent the fact that there are at least a few women around who are attempting to speak and to create a language in which they feel at home.

How does your work challenge conventional ways of seeing reality?

In the three shows on in April, the components of the works are cultural artifacts.... post-cards, fragments of pottery, photographs from automatic machines and clippings from popular encyclopaedias. Now conventional art materials (canvas, paint) are mute, it's only when work is put into them in terms of presentation and analysis that they say anything. So by extension what I'm trying to do in my recent work is to

make articulate that which is inarticulate. I'm interested in these cultural materials for the unspoken assumptions they convey.

Could you describe a work.

Take "Enquiries/Inquiries". I present a series of slides which are photographs of texts taken from popular encyclopaedias, one British and one American. They purport to give information about questions of fact and what first intrigued me was that they gave this data in the form of a catechism, in other words the questions are rigidly followed by the correct answers. That indicated to me that there was some effort towards imprinting these notions indelibly on the mind. And I discovered by looking at the sets that they carried inbuilt assumptions which are extremely curious. After a while just observing the repetition of certain ways of asking questions indicates that there is a very rigid mental set involved. As an American I feel personally embarrassed by the details of the American set, but I understand that the British set can be just as excruciating. It has a great deal of hierarchical thinking built into it. But both cultures share the same symptom — the lived experience of a person is cut off by a kind of verbal formulation of that experience.

284

Did you make the piece from an awareness that as a woman you are negatively positioned in culture by language?

When I wrote about the piece I said that to examine the givens of a culture implies to some extent that you are separated from it. Now I didn't say that I am separated from the language of my culture *because* I am a woman. I don't want to make those kind of statements, I want the art to speak. I don't want to label it — here is the work of a feminist artist. That notion has been very much degraded; to call people feminist artists is to box them off into an area which cannot insert itself, cannot contradict mainstream notions of art. Feminists are shunted off to a little side-track called "Feminist Art".

And it's characterised as being utterly unconcerned with notions of what art is and only concerned with making strong, direct statements about the position of women in our culture. In fact I'm not sure that work such as yours which examines language, social structures and art forms would be stamped as "Feminist Art".

I think there are radical implications in a more subtle form of intervention. By, for example, looking at notions of sexuality in a popular image to expose our underlying cultural assumptions.

Let's talk about your piece called "Dedicated to the Unknown Artist" in which you collected and presented hundreds of seaside postcards, all titled Rough Sea.

What they are saying is paradoxical and contradictory as I believe our notions are. In most cases the images show a turbulent sea encroaching or threatening human structures, and we get the impression of nature as threatening, wild and terribly thrilling. Some of the postcards show people standing like voyeurs watching some sexual act — watching the waves crashing towards them. I include a quote from Marie Corelli (best-selling Victorian novelist) in which she speaks of "earth the beautiful and her lover the sea" because her images of the sea are tempestuous and sexy and male. Yet normally the sea is referred to as female.

But natural disasters like hurricanes are called female, maybe a rough sea viewed from the shore is characterised as male because it's seen as powerful rather than uncontrollable and destructive.

We attribute characteristics to the sea or the land depending on whether we value them positively or negatively. And so you have a number of terms colliding in supposedly ordinary seaside postcards. If you were an anthropologist dealing with another culture you would pick up on the pattern of gestures, artifacts, eating — you would try to make a coherence out of it — but we are so

Pueblo Indian women's pottery shards in "Fragments"

demented with our own culture that we simply discard these manifestations of our own complexity, perplexity and conflicts. And we dismiss them as only postcards.

My conviction is that popular formats may well be art. A postcard is after all a miniature picture. In some of the postcards where the original image is photographic, hand tinting has been added. We tend to think of this sort of thing as a mechanical process, but by comparing several examples based on one initial image, it is easy to see that each painter painted the image completely differently. Aspects of imagination, fantasy or whatever enter the process inevitably. Human beings are not machines; they express their creativity in their gestures, in their ordinary, mundane working gestures. And it's those sort of things I am trying to bring out in that piece.

A lot of male artists work with discarded fragments of every day life. Do you think your work differs from theirs?

Yes, they usually make new wholes out of fragments. They don't see their work at all as I see mine. They see it as sculpture. I present the idiosyncratic nature of each individual unit as a sign. Without being sentimental, I think it's a kind of cherishing of things as they are, rather than trying to make them into other things. I deal with fragments of everyday life, and I'm suggesting that a fragmented view of the world is all we've got. Take that high chair over there, we only see it now and for a short time, we're not seeing its entire history.

As women we have a particularly fragmented view of the history of our art. Do you think that has affected your ideas about the role of the artist?

Yes. I've always been interested in investigating the origins of ideas and

images, and my assumption is that they are collective and not individual. I worked from 1968-74 with other people in various kinds of group structures to allow people to see for themselves that this was so. Perhaps as a woman I had to make explicit the notion that the ideas I had were not idiosyncratic — in a sense I was forced into that position in order to enable me to feel strong enough to state them.

You no longer work collectively but always make it clear how your work depends on other people's, whether it is the postcard artists or the Pueblo Indian women potters whose shards you work with in "Fragments". You point out that the Pueblo women say they draw inspiration from their art history, from a tradition of pottery making handed down for over two thousand years from mother to daughter, as well as basing their painted pots on designs that they have dreamed at night. Are you saying our culture makes too rigid a distinction between rational and irrational thought?

Yes, our culture more than most makes a distinction between the rational and irrational, between empiricism and intuitive ways of apprehending the world. In my experience those kinds of distinctions don't have any validity. In my work I'm trying to approach a kind of reconciliation of rational and irrational factors which seems to me a lived truth for many people — particularly for women. For myself, speaking as a woman, I can say that this is part of the way that I see things.

It is true that a comparatively large number of women became involved in Surrealism which as an art movement aimed to unite the rational and irrational, conscious and unconscious, and which supported the notion of the artist as medium rather than a domineering, ordering force.

It has been argued that the subjugation of women has strengthened certain faculties because in order to survive women had had to develop resources to judge the nature of people and situations. Our culture, however, has laid great stress on the development of rational, thinking faculties in people and dismissed or minimised the irrational, calling these qualities feminine, negating them, calling them *extra-sensory* perception.

Except when male artists draw on irrational mode of thought or dreams and then it's termed inspiration provided by The Muse — the female, silent, representative of the unconscious and the dream.

Yet there are numerous instances in the history of science of great insights coming to people in a way that our culture dismisses. In other words when you study the history of science, you study it as a history of empiricism,

experimentation and the formulation of hypotheses, but in fact so many important insights of science have come through what are called irrational means that we have to conclude that the way science describes itself is not value free.

Our culture does use the kinds of insights that dreams bring at the same time as dismissing these insights as unreal, feminine and mystical. Whereas other cultures acknowledge that information or solutions to problems come to people through dreams. For example in Malaysia a shaman had a dream that insisted women be integrated into the ceremonial structure of the tribe — a situation that did not exist prior to the dream, either in the shaman's inherited context or in the social structure of the groups that surrounded his tribe which were predominantly Moslem and even more patriarchal than his group.

Now I think that because of the situation of women in our society, they may have a kind of privileged access to those ways of knowledge, and I don't see them as antithetical to, or less significant than the more dominant, rational modes. ●

Susan Hiller's work will be in Hayward Annual Exhibition, London August 23 to October 8.
● *"Language and Gender" by Cora Kaplan in* **Papers on Patriarchy** *1976.*

Source: *Spare Rib*, 1978, no. 72, pp. 29-30.

IV.6 Tina Keane

Natasha Morgan
'Shadow Woman'

Performance art is the result of a cross-fertilisation of dance, the visual arts—painting, sculpture, etc—and the theatre. It's a contemporary form used by artists with different art training who are interested in working live before an audience. Tina Keane, feminist and visual artist, was drawn to performance art because of its immediacy and flexibility. She has been working for over a year on a performance called Shadow Woman, a piece about the influences passed down through generations of mothers and daughters. Natasha Morgan watched Tina and her six-year-old daughter Emily perform Shadow Woman, and afterwards asked Tina about her ideas.

When I saw the performance it was done in a constructed artifical garden, upstairs at the Acme Gallery in London's Covent Garden. There was an audience of about 30 people, mostly fellow artists, who sat quietly on the ground or stood at the back of the room attentively watching. There was no announcement made to indicate when the piece was to begin or what to expect.

The piece begins with a young girl—Emily—playing Hopscotch on her own in the garden. Meanwhile Tina begins to lay 13 small mirrors across the Hopscotch numbers; on the mirrors is written a poem, which Tina reads out as she lays the mirrors down:

The shadow of my daughter
becomes the shadow of my life
as I will become the shadow of hers
as my mother
grandmother, and
great grandmother.

As the child plays her shadow is projected on to a large white screen.

Tina: "As I place the mirrors over the numbers, my shadow, larger than the child's, totally dominates hers, and I move away again, leaving the child free. As the poem goes on and the mirrors are placed around her, the area of movement becomes restricted—smaller—because as life goes on you get more and more restricted."

Watching the beginning of Shadow Woman I remembered the amazing feeling of freedom as a kid, playing in a garden in the evening, thinking maybe the grown-ups in the house had forgotten me, had forgotten it was long past my bedtime.

Tina: "Yes, 'Out in the garden, Go and play.' So you are shoved out into your own world. That's why I thought to use the Hopscotch game in Shadow Woman. It's universal and totally classless, coming right through the ages. Everybody knows it. It's the same ritual over and over again. And the Hopscotch I chose was the one which goes to thirteen—the beginning of being a teenager. When you

first menstruate, everyone gets worried—my god, my god, the boys, the boys. Restriction. My daughter is becoming a woman and goodness me, goodness knows what might happen.

The girl notices her freedom begins to diminish as the boy becomes free-er and free-er. 'Where are you going? What are you doing? What time are you coming back?'—that's why she gets smaller. Meanwhile the shadow of the mother gets larger and looms over her because of her fear of and for her daughter's sexuality—because of the repercussions of society and all that implies. And that fear goes on until a woman gets married. Then the mother feels safe. She can relax.

The whole thing began with the sudden realisation one day, looking at Emily, that if I wasn't very careful I'd be putting things on her of myself—maybe things I disliked intensely; things my mother planted in my head, ways of doing things. One is part of a chain and it goes right down the line. So, I was looking at Emily and wondering how does one ever break that consciousness—not wanting to break it in such a way that one becomes fanatic about it, but wanting her to think of herself not just as a girl, and boys are boys, but as a human being, living and growing."

After the Hopscotch sequence, the focus shifts from the outside to the inside. The outside was the garden and the game—for Tina, symbolising fantasy, growth, mystery, potential.

Tina: "And the inside is the restriction we spoke of, and takes place behind a large white screen. The lighting changes, Emily goes off and you can just see my silhouette, a shadow projected from me as I sit, veiled as it were, behind it. This I call the waiting section."

Here Tina reads *Waiting*, a long and hypnotic poem by American poet Faith Wilding, which is about the passivity of waiting from the time of one's birth as a baby girl till the day of one's death as an old woman—waiting to be pretty, waiting to be old enough to make-up, to date, waiting for one's wedding day, for orgasm, waiting for a child to be born . . .

Tina: "And I feel we've got to break away from this. We have the opportunity as women now to change the rules of the game; to make it more open for us. It's not that we don't like being women—it's that we don't like the restrictions of being women.

In the first performance I left it at that, although I felt the ending was a bit negative. So when I came to the second performance I decided to use an open-ended film sequence of waves that I'd taken in Scotland earlier this year. And then over that someone read a descriptive bit from Virginia Woolf's book The Waves.

Using the film of the waves gave the performance a much more optimistic feeling—I made it on a boat going from Skye to Harris. To me it was a magical journey. The sun was in the right place, the boat was the

right size, and I looked down and saw time moving in amongst the shadows. I got my camera out and I just intuitively began to film these waves. One thing the film had — it had optimism, it had the universe and it had energy, constant energy. That's what I like about the film, and the fact that those shadows on the water could be you, they could be me, they could be anyone. People coming, or people who have been. It could be a hundred years ago — anywhere, anybody.

You see, the whole idea of male art is very much tied to the idea of making art that will last for ever. So, in a sense they become monuments. I think that the art that comes from women is organic and not particularly lasting. I don't think women are thinking of trying to make themselves great artists with works that will last after their death, that will put them on a pedestal. It's to do with the whole NOW and LIVING."

Did you choose The Waves passage because you identify with Virginia Woolf?

Tina: "Not so much her, no, but her work. I like the idea of using other women's work that has influenced me. She's a very visual writer and has always been a progressive thinker — always urging women to be creative, understanding their needs."

How do you feel when you are performing?

Tina: "Beginning a performance I feel very insecure. I find performance art one of the hardest ways of working. You have to put yourself on the line."

Why don't you use actors to perform the words?

Tina: "It wouldn't be the same. I suppose it's directly to do with the whole thing of sound being part of the texture. It's me putting over my experience as me, and people seeing my insecurity and identifying their own insecurities — if people can see others who are also insecure doing things it breaks through the mystique. That's a criticism I have of theatre — the mystique.

All you have to have is a positive feeling about something that you want to say. And then you need a structure — the rules of the game. The danger is either being too spontaneous or too formal . . . I've tried to combine the two — to mix the intellect with the intuitive part so that one has a structure within which one can be fairly spontaneous. The importance of not having a total script is actually trying to respond to the audience — see who is there. Different places you go you might slightly change it."

Do you rehearse?

Tina: "No. It's not fixed in that way — but it's still very formal, the precise drawing out of the hopscotch lines, the well-made screens. It's very disciplined. And that's important — to have self-discipline, but within that to know no boundaries."

I wanted it to be even more formal, more deliberate — or else I wanted to know it was *deliberately* not deliberate.

Tina: "One has to guard against being too rigid, too mechanical — because if one learns one's lines incredibly well, then after a while the meaning of the lines starts to disappear and the person saying the lines starts to be too mechanical. The main thing about performance art is, I think, sincerity. If I don't think the person is sincere then I can't believe in their performance.

The film at the end, and the performance itself, is not meant to tie anything up, to give the final word, to conclude anything. It

PHOTOS BY ROSE FINN-KELSEY

is continuous. Because even if I don't finish it . . . people pick up on things . . . someone else might.

The piece I'm doing next is going to be on the streets, where I'll write texts on the walls and use the streets as a labyrinth and do the Hopscotch on the pavements. That's communicating outside. But I have to start inside—like in your own home—where I feel secure."☐

Tina Keane will be performing Shadow Woman at the Women's Festival, at the Drill Hall, Cheyne Street, London WC1 on Saturday December 14.

Source: *Spare Rib*, 1977, no. 675, pp. 26-7.

IV.7

Natasha Morgan
'A litany for women artists'

Hannah O'Shea, in her programme notes, describes her Litany as "a sound poem for unaccompanied voice . . . chosen as a means of celebrating the lives and activities of women artists of the past, to make 'visible' their names and to encourage . . . present day women artists."

Within a single spotlight, Hannah O'Shea, in formal dress, carefully positions her music stand. She strikes a tuning fork and gravely intones in measured plainsong, the names of 600 deceased women artists.

The stream of alphabetically ordered names, changing in texture with the various foreign pronunciations, develops a powerful hypnotic quality. Amongst the 600, the few names that we recognise remind us of the many who lived and worked in obscurity.

The 40 minute performance at the Camden Women's Centre was a strengthening experience for at least one feminist who arrived in a foul mood on a cold and rainy night and went away feeling less isolated.

The Litany has been performed in Berlin and Frankfurt, and elsewhere in London. It will be done again as part of a programme by Women Performance Artists within the Women's Festival at The Drill Hall, 16 Chenies Street, London WC1 on 17 December.

Source: *Spare Rib*, 1977, no. 65, p. 35.

IV.8

Sally Potter
'On shows'

My intention is to raise questions that need to be asked by and about women working in performance. What follows of course arises out of my experiences working variously as a dancer, choreographer, musician and filmmaker. At times I have also worked, somewhat reluctantly, under the label 'performance artist'. Why this reluctance on my part? Why the anxiety experienced by so many working in these fields about what they 'really' do, and what terms describe their work best? I have found it helpful to examine the history behind the terms and so that is where I am choosing to begin.

Naming yourself

In the nineteenth century during the consolidation of class difference to serve the new industrial capitalism, the word artist became distinct from both artisan (craftworker) and artiste (performer) – the difference implying not only one of form but also one of class position. Artisan implied a skilled manual worker without intellectual, imaginative or creative purposes (qualities that the bourgeoisie were busy naming as their own) and artiste implied entertainer; for women this usually meant a connection with prostitution, for the display of the female body in performance was considered a form of sale. The word artist was reserved for painters, sculptors and eventually also for writers and composers – part of a culture defined, funded by and mostly serving the middle and ruling classes. So to name yourself artist embodies a history of class meanings. How do people choosing this kind of work tackle this history and what does it mean to them?

For some, the work becomes criticising art itself and the prescribed role of the artist: a continuous form of self-referential protest (followed by criticism of how the protest is transformed into saleable artifact). For others the priority is to destroy the definition as it is understood; to show that the manual worker also thinks, that the housewife creates, that art practice is a life practice and not the property of an elite. But for some people, using the name artist implies seizing the right to something which has been systematically denied them: the right to work with ideas on a large scale within a form of production over which they have complete control.

And what does it mean to call yourself a performance artist? At its most simple level it means to be an artist who performs. How is this different from other kinds of performance and entertainment? Does it imply that it has somehow been 'elevated' to the status of an art form? For the Dadaists, Futurists and Surrealists to perform was in itself to dissolve and revolutionise the function of art – to disinvest it of the deadening aura of 'high culture'. The actions and events often borrowed from other forms of performance (eg cabaret) and from the polemics of political practice (manifestos etc) but the contempt for bourgeois values was often more redolent of the aristocratic prankster exercising a privileged form of protest than of the struggles of the revolutionary; and, most importantly, their work was always designed to be seen in the context of the history of art.

What reasons lie behind contemporary performance artists' choice of self definition and anxiety to distinguish and separate their work from anything to do with theatricality? Any implication that the entertainer deals with less important issues and in compromised ways would seem to arise from the class stereotyping founded in the artist/artiste split described above. But not all performance artists think along these lines. The emphasis placed on difference arises out of a criticism of the functions of pleasure in the theatre (plays, opera, dance, music etc). Performance art becomes a framework for this criticism through a combination of formal and structural strategies.

Performing versus Acting

Some performance artists might describe their work as a kind of anti-skill, to differentiate their way of performing from the acting skills of characterisation. Performance is seen as 'doing' – an activity which is being watched rather than a part being played. Characterisation is seen as a technique founded on a literary tradition heavily reliant on the written and spoken word and intimately connected with the aesthetics of illusionism which transport the spectator by a series of identificatory processes to another place and time. Theatre is caricatured as a place of catharsis where you vicariously emote and rarely think. You may 'lose yourself' in the displays of virtuosity of another, or via the structuring mode of the story, of realism, of narrative continuity.

Some see this process of engagement as itself the site of reactionary formation. Theatrical timing, developed to its ultimate finesse by comedians with a split-second appropriateness of word and gesture that delicately juggles the desires of an audience and orchestrates their response (often on the borderlines of repression and expectation) is rejected in favour of 'real time'. The time it takes to execute a certain task, read a certain text, and so on. The audience may be free to come and go during a piece; its duration is not necessarily determined by the conventions of the 'show'.

The performance artist is often concerned to alert the audience to the shifting constructions of the performance, to be both inside and outside it, commenting on it. Similar reasons motivate the painter who moves out of the rectangle onto the wall, drawing attention to the act of framing; the filmmaker who works with the surface and plastic qualities of film and draws attention to the structuring device of the splice. The theoretical context is that of post-linguistic structuralism in which emphasis is thrown on how meanings are formed (the 'language' of the medium) rather than on what is being said. The intention is to destroy the 'innocence' of representation, to expose its mechanics. However this strategy can be counterproductive when the enemy is wrongly named as the story, identification and pleasure. Many comedians and others working in theatre tread an extraordinary line that engages an audience on many levels at once; not in a soporific way that prevents thinking but in a way that allows precisely the opposite to happen. The audience can laugh or cry and think. The function of the joke (when its not at the expense of an oppressed group) can be to shout people out and stir up those places in people where thinking has stopped. "I cracked up" describes the experience of a good laugh.

In any case live action, be it in a theatre, gallery or wherever, inevitably also produces its own kind of distanciation. It can never achieve the perfection that explains the power of cinema for there is never a perfect blackout (indeed some shows happen in broad daylight) and there is never a truly empty space. The performer is at the mercy of possible mechanical failure if using lights or tapes and is constantly exposed to the hazards of accidental sound. This erosion of the perfect statement and of precise artistic control is often used as the basis for questioning both the myth of the absolute correlation between intention and realisation and as an acknowledgement of present time.

The female performer

For women the implied difference with theatricality has also more complex meanings because of women's relationship to entertainment, stereotype and spectacle. Once outside of the fine art context women have joined the tradition of the female performer: women as actresses, singers, dancers, strippers, music hall artistes. One could argue that even within a gallery or other self defined art venue this history is implied. Woman as entertainer is a history of varying manifestations of female oppression, disguised, romanticised (but savingly, contradictory, of which more later). The glittering phantom ballerina wilting in her lover's arms; the burlesque queen playing with and overtly conceding to her male audience's fantasies; the singer crooning about unhappy love and her victim

relationship to her lover. These are the conditions under which the female performer has been visible; positioned always in relation to the male construction of femininity and in relation to male desire. Women performance artists, who use their own bodies as the instrument of their work, constantly hover on the knife edge of the possibility of joining this spectacle of woman. The female body, nude or clothed, is arguably so overdetermined that it cannot be used without being, by implication, abused. But of course it is unthinkable that the only constructive strategy for women performers would be their absence. So steps are taken to build a new presence. How is this done?

It becomes necessary to examine what the presence of the female body means, what it means to be looked at. As a female performer you embody both the representation of a woman and you are a woman. The distinction is important, even if it seems academic, for it can illuminate why most women experience themselves in everyday life as a kind of living continuous performance, distanced by the constraints of femininity from themselves (let alone choosing to perform in the accepted sense of the word). It is like a split, being both inside your body, unable to transcend gender identity, fixed as the 'other' to man's central position in patriarchy, and yet also outside of your body in the very act of thinking, of using language.(The terms used to explain this phenomenon in psychoanalysis are very dense and need lengthy definition. In the context of this piece of writing that would be inappropriate so a form of extreme precis will have to suffice; that woman as performer represents for men a fetishistic replacement of the phallus as a way of dealing with the women's symbolic 'lack' and the implied threat of male castration.)

How can the female performer begin to dismantle this construction?

Strategies

For some it means using a feminist conception of subjectivity as the basis for the work as part of an overall strategy to reclaim on new terms what has been negatively caricatured as the realm of the feminine. An obsession with personal experience and relationships, an unwillingness to generalise, prioritising emotional over intellectual life: look differently at these characteristics and you find that what has been designated trivia has in fact profound political significance.

The women's movement has demonstrated that ideology is not merely reflected but produced in the context of the family and in personal relationships – that political structures are not just 'out there' but are manifest in the most seemingly insignificant actions, words and conditions. We have also shown how a society with power relations based on sexual, racial and class differences fixes these differences in early childhood in such a way that they are experienced as being almost outside of rational explanation – so that they seem 'natural'. Any form of objectivity based unthinkingly on the position of the white middle class male is therefore bound to be partisan and irrational, acting as a form of disguise of its authors' real and subjectively experienced sex, race and class interests. In an art practice dominated by men this has led to an emphasis on formalism, 'purity', art for art's sake, the de-signified image. The raising of female subjectivity to the status of objective significance is then for some women artists a priority. So how is this subjectivity approached and worked with?

For some it means building an imagery based on the female body – on menstruation, reproduction and female sexuality; on tackling what has been endlessly portrayed as female mystery from the other side – the inside. This might be on the level of documentation of the unmentionable or its traces, or on the level of myth, taboo and a cult of the mother in opposition to the patriarchy. For others it might mean reversing the gaze, breaking the silence of centuries and getting the female nude and muse to speak.

For some women a useful step is to look at female stereotypes and how they function; in some cases to turn them against themselves. For others the key is to find and use modes that contradict the stereotypes – ways out of the representation of women as passive and incompetent. Here the contradictory aspect of the female performance tradition can be used to good effect, for women have found positive and ingenious ways in which to sidestep or criticise their impossibly prescribed roles. The ballerina's physical strength

and energy which is communicated despite the scenario; the burlesque queen whose apposite and witty interjections transform the meaning of what she is doing and reveal it for the 'act' it is; the singer who communicates through the very timbre of her voice a life of struggle that transforms the banality of her lyrics into an expression of contradiction. All these can work against the pessimism of female 'absence', and also suggest a new way of looking at skill and its subversive potential.

Skill

'Femininity' demands the appearance of lack of skill and emphasises nurturance and appreciation of the skills of men. Women have therefore often been denied access to the skills they want and have also had their own skills undervalued or denigrated. In reaction to this some have seen virtuosity as the extreme example of skill that 'oppresses' by virtue of its display of superior difference. The performer becomes a symbol of privilege, of work that is valued while other kinds of labour are denigrated. Both the specialness ascribed to individual performers and the performer/audience divide itself are seen as unhealthy symptoms of a class divided society, the performer taking an honorary or symbolic position of power. The strategy then becomes to break down the divide and emphasise audience participation as a way of saying 'anyone can do it'. However, enforced participation can become a rather self-conscious and counterproductive event if it is not handled, paradoxically, with some skill.

It is this sort of realisation that leads many of us to differentiate skill defined as appropriateness of ability to meet a need, from the solidification of skill into a rigid system of technical excellence with its own insulated and self fulfilling ways of measuring and rewarding success. This 'success' for women often means gaining the precarious position of token achiever in a male dominated profession. This position is circumscribed in such a way that as more women achieve in a given area they are forced to compete with each other for the same space rather than the space itself expanding. In the women's movement there has been an emphasis on skill sharing, on teaching other as a way of breaking down the mystiques of professionalism and working towards the realisation of each persons 'genius'.

Working process

What of the mystiques attached to the 'creative' working process? How, in practical terms, does a performance artist set about working? This can be quite idiosyncratic, but usually reflects the starting points learnt in some form of training or practice. The sculptor turned performance artist might start with making or finding an object and working outwards from there; in some sense activating it in time, or giving it a space, a room or set, which suggests a scenario. The painter turned performance artist might take an existing painting or a painterly principle (such as Renaissance space), and use its formal and ideological components as the basis for a "script". Others might use their own dreams as the starting point for assembling images, or some other kind of writing such as notebooks, diaries etc. A dancer might use a sequence of movements, a tableau or a memory of the hidden aspects of the dancer's training as a basis. Apart from in improvisation, which is a discipline in itself, even very minimal performances usually have some kind of script. Sometimes the physical form of the script – the sheet of instructions, the diagram, the trace that the performance will leave, is considered more important than the performance and the event is designed as a forethought to the act of documentation. For others the performance is itself the antithesis of documentation. It is intended to strip itself of every vestige of artifact, to be purely temporal, to be the activation of an idea that then destroys itself. This is considered part of the struggle against capitalist recuperation.

Working processes of course become more systematised when people work together with the desire that each person's ideas will transform the others. Some performance artists work together side by side but continue to identify what they do individually as their own work. The fact of performing in the same space or in a series together may imply a connection, or suggest an argument. For others, such as myself, collaboration became part of a politics that questioned

notions of individual ownership of ideas and of the pursuit of originality. Working with others made it possible to discuss the implications of the work, of its politics and realisation at all stages; it forced one to be conscious of what one was doing. It was also a way of combining areas of relative expertise and the lessons brought from them; and on a practical level was a way of sharing tasks. One could try out ideas physically on each other, having the opportunity to step outside the piece and look at it. Exercises would be borrowed from various sources, theatrical and otherwise, designed to focus on performance itself. To find not a right way or a wrong way of doing something, but a conscious way. It provided a way to strip vestiges of self consciousness, to experiment with different kinds of voice, movement etc and above all to discard, to work through the first stages of an idea towards its full realisation and, hopefully, towards a new imagery.

Imagery

Images cannot be spoken of as if they float free of formal embodiment. A painted image obviously works quite differently from a photographic one. How do you begin to define what an image is in performance? A starting point would be to consider it as a compositional unit. In this way a movement or sequence of movements can be seen as an image, as can a tableau or a combination of layers such as light, action and object; the unit functions as an entity of visual meaning. However, this meaning cannot be seen as absolute or fixed. The varying approaches to the production of images determine at least in part how they can be understood.

Some would define the image maker's task as one of selection from a store of images received in that person's lifetime via artifacts, the media and in everyday life. The problem is seen as one of appropriateness and accuracy in the illustration of an idea – to make something 'in the image of' – a pursuit of 'truth' through likeness. The image in and of itself is seen as relatively unproblematic, having a kind of transparency and essential neutrality that will be transformed into meaning by the purpose of its user. But for the feminist performer, the impossibility of neutrality arises at every turn. How, for example, do you choose what to wear in a performance? It becomes clear as you sift through the options that there is no neutral costume, that every garment for women is imbued with feminine and class specificity. That the boiler suit, so often chosen as a suitably functional basic garment by performance artists during the last decade could be seen in much the same way as Marie Antoinette and her shepherdess scenarios – the appropriation of images of labour for the purposes of bourgeois leisure.

The experience of actually producing images also raises other questions. The sensation can be that of an ordering or letting through of a subrational area. The images seem to pop into ones head; when the 'right' one is there it appears to have arrived without conscious design. This process is conventionally defined as the use of the imagination, of intuition. Where do these images come from and how do they work? Archtypal images, myth and symbolism sometimes suggest the existence of a residual or collective unconscious, and that the image maker learns how to organise and produce from this place outside of verbal constructs in much the same way as a person can learn to produce dreams to order. The surrealists and dadaists considered the liberation of the imagination from sense to be a political act. The apparent randomness of the unconscious was emphasized, chance operations and arbitrariness became fetishised. The destruction of the order of the rational by giving in to 'chaos' seemed to them to be the clue to unlocking repression. But a more useful approach now seems to be to understand the order behind the apparent disorder. To unlock the power of imagery, to decode its mystery, to make the impossibly evocative also a moment of dissection and comprehension.

As a part of this project it becomes important to look at the principle of juxtaposition to see how the proximity of one image to another transforms its meaning. This is similar to the principle of montage in the cinema, but in performance, certain kinds of juxtaposition are uniquely possible. Juxtaposition through time, in space; visual and aural – the performer can simultaneously mobilise all the senses of the spectator. For a feminist, the fact of being able to work at the level of organisation of the unconscious (images and music) and in juxtaposition to rational speech offers the possibility of entering and re-entering consciousness in order to change it.

In a wider sense this dialectical principle can also focus on how performance as a whole is transformed by the environment it is shown in – by its physical characteristics, the associations it triggers, the politics it embodies and by the audience it generates. Understanding the role of the audience in *producing* the meaning of the performance, rather than just absorbing a given one, demands responsibility to them and respect for their needs (which may, within any one audience, be quite contradictory). It means finally abandoning all vestiges of alienated posturing (the 'nobody understands me now but will in posterity' syndrome) and instead finding or inventing ways of working that are effective here and now. The question is not so much one of making difficult ideas accessible, which somehow implies diluting or transforming in a patronising way for the benefit of a supposedly less able audience, as one of appropriateness of strategy. It means discovering what specific functions this work can have as part of a wider collective strategy to transform the structures and conditions under which we live.

Source: *About Time*, London ICA, 1980, pp. 7-9.

IV.9

Tricia Davis and *Phil Goodall*
'Personally and politically: feminist art practice'

Tricia

Phil

Between summer 1977 and spring 1978 we worked together on an exhibition called *Mother's Pride: Mother's Ruin*, which was shown first at the British Sociological Association annual conference and later at the New Arts Festival, Hebden Bridge and Saltley Community Centre, Birmingham.

We came to this exhibition from different directions, Phil Goodall as a trained artist and Tricia Davis as an historian and social worker. Phil was one of the first members of the Birmingham Women's Art group which started in January 1975, initially concerned to bring feminist artists and women interested in visual communication together into a working group. As a result of contact with Kate Walker at the Women Artists Conference in June 1975, the group took up the idea of establishing a visual communication network by post. This network, involving women from many parts of the country, became known as *Feministo*. It was based on developing relationships visually between women and exploring our lives as women, artists, mothers and domestic workers. Tricia, when she moved to Birmingham, initially made contact with the women's movement and became involved with *Feministo* and the Women's Art group after seeing the Arts Lab. exhibition in Birmingham.

Feministo was shown in Manchester, May 1976; Birmingham Central Library; Liverpool; Coventry; Kunstlerinnen 1877 to 1977, West Berlin; ICA, London; and Melbourne, Australia, December 1977.

During 1977 the Women's Art Group produced *Mama*, a collage of recent Feminist art events in the UK. Whilst working on *Feministo* the idea evolved of making a film based on that experience. The Women's Film Collective was formed for this purpose and initially eight of the Art Group worked on the 'ideas' phase. Then Tricia, Phil and one other woman from the group worked in what had to become a mixed group, since there were few women in the area with film experience. The film, in Super 8mm., is still at the cutting stage and has gone through a series of changes, due to the complex issues of women's art and the problems of exposing these visually-filmically. The Women's Art Group stopped meeting by the end of 1977 due to changes in people's lives and different emphases on ways of working in art. However, the interests of the two of us coincided through activity in other groups such as the socialist-feminist reading group, and we felt we have sufficient common ground to work together on *Mother's Pride: Mother's Ruin*.

The work – photographs, film, collage, installations of furniture, toys and clothes – sets out to explore visually some of the ways in which our experience as women is structured through education, employment and domesticity, and some responses to these structures. At this thematic level we have tried to convey that at some points the different areas reinforce each other – the typist (Figure 1) is made up of photographs of babies, small children, nursing mothers, the collage of a pregnant woman (Figure 2)

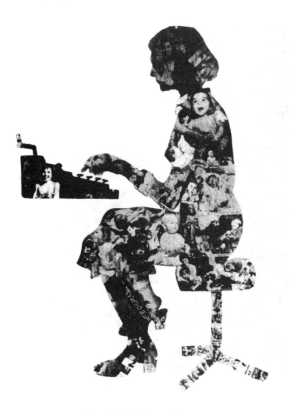

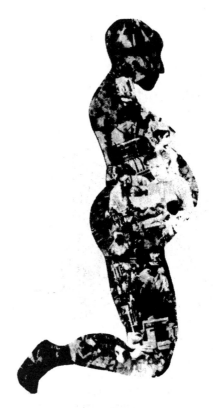

Typist. Photo-collage,
black and white, 49″ by 31″.

Pregnant Woman. Photo-collage,
black and white, 48½″ by 26″.

of photographs of women in different job situations.
There is also, however, at some points very real
conflict between the different structures and ideologies
of femininity, and between them and femininity as a
lived reality. The desk (Figure 3) for example, is also a
dressing-table – but the mirror is shattered. The cot
(Figure 4) sets up associations with motherhood but is
painted black, and behind the bars is not a baby but a
doll woman, reduced to size by the lack of adequate
socialized child care. Yet the points of conflict between
different ideologies create a space for women to
understand and organize around their oppression. We
tried to create a positive ending to the exhibition to
show how women are not passive victims of their fate.
We also wanted to convey how women's experience is
cut across by class and some of the work shows, for
example, how many working class women must also
work outside the home, holding together their dual
role with safety pins, clothes pegs and, above all, with
love.

We do not aim here to give a comprehensive review
of our work, but to set out some of the issues we

wanted to raise – a transitional process between this
work and the next. We describe our art as feminist
and understand feminism as political practice, our art,
therefore, is political art. Yet we are aware that these
connections are not simple and it is at the points of
tension that the most important work remains to be
done, and that the major potential lies. To describe
feminism as political practice without exploring these
complexities is to beg a crucial question about the
relationship between personal experience, theoretical
knowledge and the struggle for change. It is, in
particular, to sidestep the question of how class cuts
across women's experience. It is to place women's
experience within a universal and a-historical context,
to deny it the specificity which allows us to analyse the
contradictions and organize from the reality of our
oppression and exploitation. To call feminist art
political without exploring its own particular set of
complexities is to ignore a parallel question about the
relationship between form and content, to leave art
where it is and use it descriptively whether of female
oppression and exploitation or of female strength.

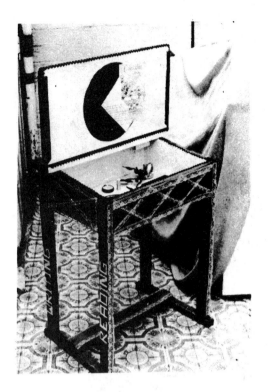

Desk. Real desk, lace, Letraset, plastic flowers, congratulations card, dried flower seeds, 29″ by 23¾″ by 16¼″.

Cot. Black painted cot, pink satin sheets, silvered cloth doll, icing, pink paper rabbits, toy, medicine bottle marked 'Drink Me'. 47½″ by 39¾″ by 24½″.

By using a female figure (Figure 5 Prime British Womanhood) which is recognisably a stocky ordinary woman, we tried to set up a contradictory set of associations – 'But aren't pictures of women normally sexy, voluptuous. . ?' In addition we used a grid division of the parts of the body, as well as the title of the work (Associations with butcher's meat charts), captions used outside their normal contexts, quotes from reports by the National Council for Civil Liberties and the Equal Opportunities Commission on the ways in which women are deprived of their rights. We attempted, thus, to shift the emphasis of the female nude as sexual in order to expose the reality of the female under oppression.

In the women's liberation movement, and this is to generalize about work which is quite specific, we are struggling for a more dynamic relationship between what we feel, what we know and what we do about it. We are trying to move away from that compartmentalization which prevents us from using what we learn for changing our own lives and those of other women, and from using what we experience to

raise questions about what we know, how we know it and what we do about it. We are working towards new conceptions of experience, knowledge and politics, each one shaped by the others.

The notion of creative activity in the visual arts is conceived as individual activity. Often in the past, art criticism has not taken into account the social and economic conditions under which a work is produced. We have attempted, although we do not know how far this is possible under existing conditions, to break away from individual creative production, taking into account that production is dependent on a host of sources, not least the contact between the minds and imagery of co-workers. To what extent can the perceptual, emotional, intellectual capacities of two minds really collaborate when the habit of individual activity has been the norm? The question arises as to the nature of creative activity, which starts to be seen in a different framework when working with somebody else. Problems arose in visualizing each other's ideas on occasion, and it was not until a piece of work was well under way that we grasped its

Caged. Photo, black and white,
constructed 16" by 20".

Prime British Womanhood. Sprayed
water colour on lining paper 66" by 24".

significance. Interestingly such influence on the overall direction of the exhibition that was largely visual came from seeing the progress of the work, as much as from discussing, analysing and planning in advance.

We worked both individually and together. Working alone usually arose both because we could not synchronize our timetables and because the idea originated from one person and was clearly formulated, though we discussed all the work together before and during the making. When we needed to swap skills, one would provide an outline, the other suitable written/visual material, as with the collages; and we did some whole pieces together. Phil learned basic photography at night class and passed this on to Tricia; we then had joint photography and printing sessions. Since we wanted to link the imagery firmly in reality, ours and other women's, we felt it important to contain some of the material in a medium normally read as realist. Thus we used the photo not only in a realist context, but also through constructed scenarios, as in 'Caged' (Figure 6). Tricia collected a wealth of written material which we both used in different ways. Thus authorship was blurred. To some extent the

individual works reflect our existing skills – Tricia embroidery, Phil drawing – and the joint work reflects the swaps or skills acquired specifically to do this exhibition.

As feminist artists we did not want only to take a theme relation to women and deal with it in a way which made it as accessible as possible to other women, though this seemed and still seems important. We wanted also to raise the possibility of a political art in which the art is not grafted onto politics, serving the cause; nor the politics, as content, poured into art. Instead we wanted the art form and political content to work together to change our understanding of each, and to create new ways of understanding political art. Our concerns, as they ultimately resolve themselves around the viability of art, its meaning and value, its need to relocate itself more firmly within the wider framework of social relations, are not new. We have in a sense, moved into the space made possible by the artist who blocked out the windows of the gallery with mud and stared back in through a small cleared area; or the space created by the artist who exhibited posters about capitalist possession both in the streets and in

Breadbin. Photo, black and white constructed 16″ by 20″.

Think of your home as a tea-pot. Print paper montage, coloured inks
13¾″ by 10½″.

Following in Mother's Footsteps. Ribbon, photos of men at work, dolly clothes pegs, lace, ironing board 48″ by 21″ by 12″.

2.4 into 1 won't go. Photo, black and white constructed 10″ by 8″.

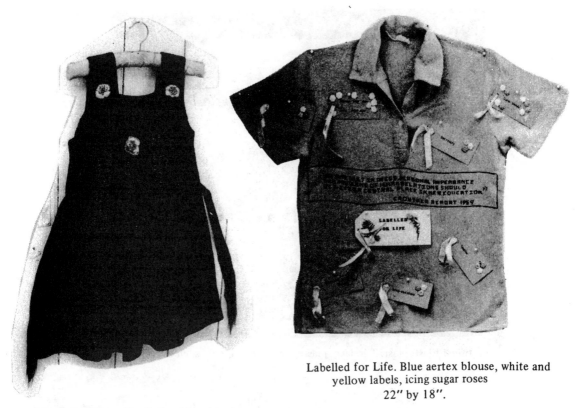

Ideological Gymslip. Embroidered text
on brown tunic, appliqué 32″ length.

Labelled for Life. Blue aertex blouse, white and
yellow labels, icing sugar roses
22″ by 18″.

the gallery. In using familiar objects and skills in unfamiliar contexts and to convey unfamiliar messages, we have taken up the issue of the threshold of legibility, the need to create a shared world of references to that

> Contact can be made on a number of levels. These levels are not calibrations of merit seen on a popular fine art thermometer (aesthetes look at this, social scientists note that) but one aspect seen in terms of another. (Smith, 1963:48).

Our debt is enormous. We have, however, tried to move into these areas with concerns and concepts that are specifically feminist. That is, our concern is to understand the relationship between our experience as women artists and the possibility of accessible art; our concept is the dialectical nature of the personal as political.

Our material existence as women has contributed to our absence or marginality as artists. Although this is being looked at more closely in its historical context (and again we acknowledge our debt, this time to feminist art historians) in general terms it can be argued that lack of access to some kinds of training and equipment and the practical demands of women's domestic role have contributed to the position of women in relation to the arts. Women's visual creativity seems to have been channelled into crafts, both useful and decorative. At the same time the distinction made between art and craft has prevented an examination of the ways in which the form of female creativity and its content speak together. The appropriation of female crafts by the art world has been achieved through a failure to focus on this relationship between form and content. Judged against works of art produced in the studio by full-time artists, there has been no space in which to understand as anything more than incidental the processes whereby these artefacts have been produced, their usefulness and the ways in which they represent a serious challenge to some of the underlying concepts on which fine art operates.

We have, therefore, used skills and objects more usually associated with the domestic environment –

299

Emotional Elastoplast. Tin, lace, plasters with inked texts such as "I need you", 2″ by 4″.

Chicks. Photo of baby inserted into page from children's book. 12″ by 9″.

Nude Cooking, Nude Gardening, Nude Walking. Thumb-nail sketches.

Anatomical Woman.
White paper, ink, plastic doll face, wool,
23½″ by 16½″.

Badges Woman. Red card, badges,
cut-out quotes and symbols
57″ by 29″.

both within the context of other skills, such as photography and film and together with or in contrast to other skills. In specific pieces of work and as an overall strategy we have tried to set up a dialogue between the use for decorative effect, between the public exhibition space and the intimacy and claustrophobia of the domestic environment. For instance, we implied a domestic scene by having an armchair in one corner of the exhibition with an antimacassar, cushion, newspaper and a pair of men's slippers. On the wall behind were embroidered samplers, some of which described the situation of homeworkers, whilst others were in the tradition of the 'Home Sweet Home' idiom. The space was used to include tight enclosed domestic sets as in the above example, and more open areas which allow one to stand back and look at panels of photographs documenting women's lives, or larger images such as the collage women (Figures 1 and 2).

A set of paper feet on the floor was used to guide people, since the sequence was important. On the feet were extracts of diaries we had kept for four months. These served as an opportunity to search for clarity about the work and its processes, both thinking and making. In the diaries we made a space for working at different levels on our concerns over our children, daily living patterns, relationships, visual ideas, political consciousness, analysis and theory, and use of skills including seeing these as ongoing, interrelated, open to development, even if not worked out.

We have described the processes whereby the work was produced in diaries and photographs, its place within other aspects of our lives, such as childcare, the shift into co-operation if not collectivity, in these areas and some of the possibilities for extending this.

Our objective has not been to validate these skills as art nor as parallel to fine art forms. In art as elsewhere, equal but different means unequal. Instead we have tried in some reasonably accessible way to ask questions about our experience as women and artists; and both through these questions of content and the form in which they are presented, to challenge some basic assumptions of fine art, its preoccupation with individual skills, personal vision and an enclosed value system.

References

LIPPARD, Lucy (1967) *Pop Art* London: Thames and Hudson.
SMITH, Richard (1967) in LIPPARD (1967).

Source: *Feminist Review*, 1979, no. 1, pp. 21-35.

IV.10

Mary Kelly
'On sexual politics and art'

First of all, I'd like to make a distinction between 'feminist practice' and 'the feminist problematic' in art, (problematic in the sense that a concept cannot be isolated from the general theoretical or ideological framework in which it is used).[1] For one aspect of the problematic is the absence of a notion of 'practice' in the way the question is currently phrased, i.e. 'What *is* feminist art?' It provokes moralistic answers like 'it is this, not that, etc.'. These answers define essences; they are unified, non-contradictory and exclusive. They are grounded in the classic subject/object structure of knowledge, which implies that the subject, through experience, recognises the object in its represen-tation, which in turn implies that art forms represent social classes, (the art = ideology equation which we have inherited from the early seventies). But no ideology, including socialism and feminism, is homogeneous. Rather, the 'ideological' is a non-unitary complex of social practices and systems of representation which have political consequences.[2]

This may seem like a hair-splitting distinction but I think it is crucial to understanding women's practice in art. It is exactly the tendency of homogenising the notion of the revolutionary which relegates feminism to the realms of economically given class positions, (i.e. bourgeois, middleclass, non-revolutionary). Furthermore, I think that a socialist theoretical practice which does not include a critique of patriarchal (as well as capitalist) social relations has the political consequence of ghettoising the issue of sexuality. This, in turn, has a determining effect on the ideological forms of feminism. For instance, there is the inversion of patriarchal attitudes in cultural feminism (a tendency within the Women's Movement), which seeks to identify in the present, excavate from the past, or invent for the future a self-contained set of social practices, in fact a separate symbolic system altogether, (again unified, non-contradictory and exclusive). This merely has the effect of confirming our negative place in political practice, which still ghettoises women but allows us to mis-recognise it. It gives a place to the fantasies of Amazons, matriarchs and virginal mothers, who contain all good things, as well as babies, and of course the phallus, the privileged signifier of the patriarchy.

(Right now you are probably thinking, Oh no, she's not going to
reduce the whole issue to penis envy.) No, not exactly. I think
it can only be a reduction if your notion of the subject (human
subject, female subject, yourself as subject) is a unified, discrete,
ultimately transcendental subject somewhere outside of the social
totality but acting on it. If this subject, who knows through
experience, hasn't experienced penis-envy, then it doesn't exist.
But I would rather think of the subject as dynamic, as socially
constituted, and moreover to think of the 'speaking subject' as
fundamentally divided; for example by the conscious/unconscious
split which has operations characteristic of both sides, and by the
signifying processes (drives) on the one hand and social constraints
such as family structures or modes of production on the other.[3] Why
did I say 'speaking subject'? Because it is at the moment of our
entry into language that we take up a feminine or masculine position
in the symbolic structure of our society.

Learning to speak is dependent on the ability to conceptualise
absence and establish differences. The phallus becomes the
privileged signifier in language not simply because society is
patriarchal but also because the recognition of the presence or
absence of the penis at this moment is infused with the meaning of
a whole series of presences and absences which preceded it, for
example, the breast, the mother, and all of the child's 'good objects'.
I would say that femininity is synonomous with our 'negative
signification' in the order of language and culture. It begins
even before you're born, when you're given your father's name.
It is structured at the moment of your entry into language by
the castration complex, i.e. anxiety concerning the penis for boys,
and envy of the penis for girls, which underlies the later equation
penis = baby. If the phallus (not the penis, but a kind of
symbolic plenitude) represents the ability to please the loved
object, originally the mother, then a threat to the phallus is an
enormous threat to the child's narcissism (a pleasure-seeking
instinct which is later shaped by the ego through various identi-
fications).[4] This is, I would say, of special relevance for
women, because it is precisely in trying to make sense of this
threatening symbolic 'lack' that she carves out the characteristic
features of feminine narcissism, i.e. the need to be loved and the
fear of losing her loved objects, in particular her children. Freud
maintains that a person's choice of love-object is constituted
either according to the anaclitic (dependent) type (the woman who
tends or the man who protects); or according to the narcissistic
(feminine) type (what she herself is, what she once was, what she
would like to be, or someone who was once a part of herself).[5]

I realize that out of the context of his article on Narcissism

this might sound vaguely like a horoscope, but since it has a special appeal to women – via narcissism – I would like, at least metaphorically, to relate these positions to various forms/means of signification employed in women's art practice now.

1. Female culture (mother art): identification with the woman who tends; i.e. the mother who feeds you. She produces milk and therefore all 'good things'. There is a valorisation of all her products (her labour of love): patchwork quilts, candles, bread and assorted magic rituals. She is the phallic mother, the uncastrated 'parthenogenator' of the pre-oedipal instance. But there is also the castrated and (unconsciously) despised mother of the Oedipus complex. Her labour of love is signified as 'women's work', a kind of inconography of victimisation. It includes 'installations', and more frequently performances of obsessive activities like scrubbing, ironing and above all preparing food, possibly a reference to the cannibalistic relationship between mother and child or to the totem meal, in which ingestion of the father signifies appropriating his name and status.

9. Kate Walker, 'The Other Side of the Blanket' 1977. 'I refute absolutely that domestic imagery always has to expose the bitterness of oppression. We have the future to think of and we have the past. It's all there waiting to be tapped and that's a thrilling prospect. You know it's a whole culture that we're demolishing and rebuilding from the other side: it's a whole new view.'

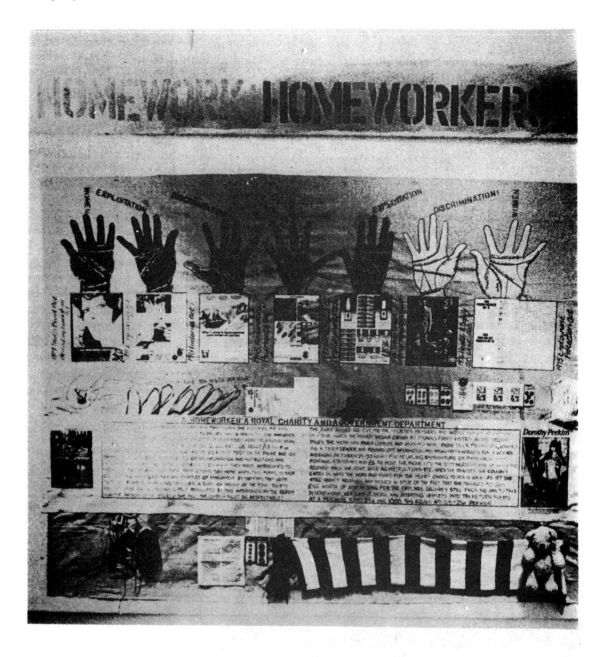

10. Margaret Harrison, 'Homeworkers' 1978. 'In working on this
project, I discovered I related to the situation very personally:
not only do I have children and find it a constant battle to organise
nurseries, etc. in order to work, but as an artist the situation was
very familiar. The work is done in between other responsibilities,
from the home, with no protection and, as far as Social Security is
concerned, no profession.'

2. Female anatomy (body art): identification with herself, or what she herself is. It seems to correspond to the way in which representations of the female genital recapitulates a kind of primordial autoeroticism. The vagina is documented in film or photograph or monumentalised as painted or sculpted metaphors. She has chosen as her model not her mother but herself, and loves herself with an intensity comparable to the mother's love for her.

]]. Rachel Finkelstein, 'Three Short Episodes']979. 'Although the film is in three parts, there is one underlying theme, i.e. my personal dissatisfaction with the kind of sexual relationships men impose on women. The continuity of the film is found in my search for a new female sexuality. Part three (above) is a discovery of my vagina and a lyric loving relation with my body by myself.'

3. Feminine 'experience' (ego art): an identification with an
 image of what she would like to be underlies the affirmation
 of 'feminine experience' in art, but paradoxically what *she*
 would like to be is usually what *he* wants her to be, the desired
 object. Currently in women's art practice there is a prolifer-
 ation of forms of signification where the artist's own person,
 in particular, her body, is given as object, as signifier of the

*12. Rose Garrard, 'Surveillance' 1978. 'The key object in this
installation is the portrait, which becomes both the subject matter
and the content of the work ... The mannequin figure is a portrait
of me dressed to look like the model in the painting. This serves
at least a dual function; as formally representing 'Sculpture' but
functioning in the performance as a prop, thus extending the trad-
itional evaluation of this category; and as a visual link between
my own physical appearance and that of the portrait model, allowing
a transference of identity to take place.'*

13. Alexis Hunter, 'Domestic Warfare' 1979. 'The Wedding Anniversary is concerned with people who are so dependent on material possessions that they end up destroying the very things which led them to believe they needed these possessions in the first place. Each object has its own symbolic meaning representing masculine or feminine role playing, emotional blackmail to manipulate the guilty partner, or the consumer economics of the nuclear family. Continuous slide projection was used to show the cycle of such a performance, that it repeats itself again and again.'

man's desire. As object she is also his symptom, because he
is judged through her. (Men exchange women, not vice-versa.)
She is seen; he is the 'look'. The literal mirror or video
screen as mirror often signifies a narcissistic structure
grounded on the return of her image to herself in a moment of
pseudo-totalisation, or it can signify the alienating function
of this mis-recognition in the fracturing, fragmenting or
violating of the mirror/video which is often carried out in
conjunction with attacks, visible or verbal, on her own person,
a kind of exorcism of her negative signification.

But there is also an inversion of this identification,
with 'what she herself would like to be', which negates
'feminine experience' as such. She can explicitly valorise
the phallic women with gun, flag or scythe in hand, and
occasionally with a baby in the other hand or an enemy underfoot;
or she can implicitly valorise the phallus, by adopting exclus-
ively and uncritically the dominant forms of signification in
the art practice of men.

4. Feminine 'discourse' ('Other' art): identification with the
 'Other' can take up any one of the aforementioned narcissistic
 positions but is primarily what she herself once was or was
 once a part of her, because self-analysis in a sense is always
 retrospective. In her practice she articulates the inter-
 subjective relationships which constitute her as a female
 subject, not object. She is usually not present, visibly, in
 the work or if she is then some forceful means of distancing is
 employed, for instance a text (a frequent device in film making).
 Such work is usually scripto-visual precisely because feminine
 'discourse', is trying to articulate the unsaid, the 'feminine',
 the negative signification, in a language which is coincident
 with the patriarchy; but for this reason her work is always
 in danger of being subsumed by it.

In summary, I think that feminine narcissism is an essential
component of the feminist problematic in so far as it includes a
symptomatic reading of our visual inscriptions, a reading based as
much on absences as on presences; that such a reading suggests the
way in which heterogeneous signifying processes underlie and often
erupt into a signifying practice; that because of the coincidence
of language and patriarchy the 'feminine' is (metaphorically) set on
the side of the heterogeneous, the unnameable, the unsaid; and that
in so far as the feminine is said, or articulated in language, it is
profoundly subversive.[6] And further to the radical potential of art
practice in general and women's art practice in particular, I think
that the notion of the problematic resists the prescriptive answers

(age 3.5) X IS FOR X. He calls it "a cross". He substitutes different letter names for the same marks. It seems to mean writing in general. X is arbitrary but not indifferent. X is the body-repressed, represented, enjoyed. X IS FOR ALLIGATORS X-ING X'S. X IS FOR A XENURUS HAVING A X-RAY. GOOD NIGHT LITTLE X. XENOPHON XERXES XIPHOSURA. GOOD NIGHT LITTLE X.

January 25, 1977: Parents(i.e. mothers) are required to help supervise children at the playgroup once a fortnight. How I dread it, I don't really want to know what he's like at school. I'll only worry about it if he doesn't get along with the supervisors or the other children. Today, I noticed they blamed one boy constantly for starting trouble and I felt sorry for him. Two little girls(twins) seemed to need special attention but the supervisors usually became impatient with them, no wonder, there were just too many children. Another little girl (barely 3 yrs. old) was trying to write her name. I was amazed. I told her how clever she was and made quite a fuss over her. Kelly watched very intensely and that evening he asked Pauline to show him how to write.

3501X

14. Mary Kelly, 'Post-Partum Document' 1978. 'In the Post-Partum Document I'm trying to show how maternal 'femininity' is constructed within the discourse of the mother-child relationship. In Documentation VI (detail above), each inscription (in a series of 15) is divided into three registers analogous to the Rosetta Stone; my son's 'heiroglyphic' letter-shapes are in a sense 'deciphered' by my comments, including excerpts from his alphabet books, and 'translated' or contextualised by the diary describing events at nursery and infant school which had particular significance for me.

required by the father/daughter duet of 'what is revolutionary/ feminist art?'. It requires formulating the problem of representation as the product of a practice of signification which will generate questions like 'How do the means of signification in a given art practice function?' and only then 'What is signified and with what political consequences?'.

Notes

1. Althusser, Louis, <u>Pour Marx</u>, translated by Ben Brewster, Allen Lane, 1969, Glossary (definition of problematic) p.253.

2. Hirst, Paul Q., 'Althusser's Theory of Ideology', <u>Society and Economy</u>, vol.5, No.4. (on 'representation') pp. 407-411.

3. Kristeva, Julia, 'The System and the Speaking Subject', <u>Times Literary Supplement</u>, Oct.12, 1973.

4. Laplanche, J., & Pontalis, J. B., <u>The Language of Psychoanalysis</u>, Hogarth Press, 1973, (definition of Narcissism) p.255.

5. Freud, Sigmund, <u>On Narcissism: An Introduction</u>, 1914, Collected Papers Vol. IV, Hogarth Press, 1971, p.47.

6. Kristeva, Julia, 'Signifying Practice and Mode of Production', translated by Geoffery Nowell-Smith, <u>Edinburgh Magazine</u>, No.1, 1976, (see introduction).

ⓒ **Mary Kelly**

Source: Conference on Art and Politics, 15-16 April 1977. Published in *Art and Politics*, ed. B. Taylor, Winchester School of Art, 1980, pp. 66-75.

IV.11

Judith Barry and *Sandy Flitterman*
Textual strategies: the politics of art making

In order to develop a feminist artistic practice that works towards productive social change, it is necessary to understand representation as a political issue and to have an analysis of women's subordination within patriarchal forms of representation. This article emerges from the need for a feminist re-examination of the notions of art, politics, and the relations between them, an evaluation which must take into account how 'femininity' itself is a social construct. We have come together, a feminist film theorist and a feminist artist, to discuss these issues, and more specifically to consider the limitations of current definitions of art as a political activity.

Initially in the women's movement feminists emphasised the importance of giving voice to personal experiences; the expression and documentation of women's oppression as well as their aspirations provided women's art with a liberating force. However, a radical reconceptualisation of the personal to include more broadly social and even unconscious forces has made a more analytical approach to these personal experiences necessary. The experiential must be taken beyond consciously felt and articulated needs of women if a real transformation of the *structures of* women's oppression is to occur.

While we recognise the value of certain forms of radical political art, concerned to highlight feminist issues generally submerged by dominant cultural discourse, this kind of work, if untheorised, can only have limited results. More militant forms of feminist art such as agit-prop, body-art, and ritualised violence, can produce immediate results by allowing the expression of rage, for example, or by focusing on a particular event or aspect of women's oppression. But these results may be shortlived. A more theoretically informed art can contribute to enduring changes by addressing itself to structural and deep-seated causes of women's oppression rather than to its effects. A radical feminist art would include an understanding of how women are constituted through social practices in culture; once this is understood it would be possible to create an aesthetics designed to subvert the production of 'woman' as commodity. We see a need for theory

that goes beyond the personal into the questions of ideology, culture, and the production of meaning.

To understand better the point at which theory and art intersect it might be useful to consider women's cultural production in four categories.[1] Our attempt here is to describe a typology rather than criticise these positions for their shortcomings. In evaluating these types of women's art, our reference point will be the recognition of the need for a theory of cultural production. When we talk about culturally constructed meaning we are referring to a system of heterogeneous interacting codes. The meaning we derive from any interaction is dependent on our knowledge of a set of conventions affecting every aspect of our lives, from the food we eat to the art we like. Every act (eating an orange, building a table, reading a book) is a social act; the fundamentally human is social. Theory both enables us to recognise this and permits us to go beyond individual, personally liberating solutions to a *socially* liberated situation. The culture of any society will impose a certain selection of priority of meaning upon the multiplicity of meanings inherent in a given situation creating an apparently given and enduring ensemble. A theoretical approach, systematically considering the range of cultural phenomena, can produce the means for examining the political effectiveness of feminist art work.

Each of the four categories in our typology of women's art-making implies a specific strategy. Through examination of each of the categories we can ascertain the assumptions that characterise these relations. From doing this it should be clear that sets of assumptions do not constitute a theory, although they may be sufficient to establish a particular type of artistic practice. When we speak of the political in discussing art work we must ask the question, 'Action, by whom, and for what purpose?' Each of the four categories will propose different answers to these questions, because they each have different goals and strategies.

I

One type of women's art can be seen as the

glorification of an essential female power. This power is viewed as an inherent feminine artistic essence which could find expression if allowed to be explored freely. This is an essentialist postion because it is based on the belief in a female essence residing somewhere in the body of women. It can be found in the emphasis on 'vaginal' forms in painting and sculpture; it is sometimes associated with mysticism, ritual and the idea of a female mythology. It is possible to see this type of art which valorises the body as reversing the traditional Western hierarchy of mind over matter. This form of art could be seen as an aesthetics of simple inversion. Feminist essentialism in art simply reverses the terms of dominance and subordination. Instead of the male supremacy of patriarchal culture, the female (the essential feminine) is elevated to primary status.

Much of the art work in this category has as its aim the encouragement of women's self-esteem through valorisation of female experiences and bodily processes. This art seeks to reinforce satisfaction in being a woman in a culture that does the opposite. By glorifying the bodies of women in art work, an identificatory process is set up so that the receivers of the art work (the women for whom the work is intended) will validate their own femaleness. This type of art work is sometimes concerned to redefine motherhood as the seat of female creativity. In a society which isolates women and inspires competition it seeks to encourage solidarity amongst women through emotional appeal, ritual form, and synaesthetic effects in performance.

One such example is the work of Gina Pane, the French body artist whose performances for the last ten years have involved self-mutilation and the ritualised drawing of her own blood. She defines the incision of her face with a razor blade in one performance as a 'transgression of the taboo of the sore through which the body is opened, and of the canons of feminine beauty'. At least on critic has praised her work because it 'privileges the signifier on the side of pain'. Complications arise, however, when the assumptions underlying this type of art are examined. To counterpose an aesthetics of pain to the assumed pleasurable discourse of dominant artistic practice, already accepts as given a pleasure/pain dichotomy. By confronting one half of the dichotomy with its opposite, Pane's work offers an act of artistic contestation, but within the dualistic tradition of Western metaphysics.

By elevating pain to the status of an oppositional artistic force, it would seem that Pane is simply reinforcing a traditional cliché about women. Even if women are assumed to be outside the patriarchal discourse, would the first rumble of self-expression take the form of pain or self-mutilation? Pane's comments about her work seem to indicate that she feels that in wounding herself she is wounding society. However, because her wounds exist in an art context, they are easily absorbed into an artworld notion of pain as beautiful. The solidarity in suffering that this work seems to want to promote is actually a form of solidarity that has been imposed on women for centuries. It is bondage rather than bonding.

Gina Pane *Psychic Action*, 1974

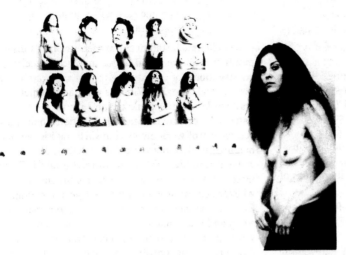

Hannah Wilke with
*S O S Starification
Object Series* 1975

Hannah Wilke, an artist based in New York, adopts a related strategy of body art in creating an art work that has as its aim 'that women allow their feelings and fantasies to emerge, so that this could lead to a new type of art'.[2] In her 'SOS Starification Object Series' (1975) she says, 'I am my art. My art becomes me.' She sets up an equivalency between her body's poses and its alteration after vaginally shaped pieces of chewing gum are attached to the exposed areas on the one hand, and language, where the meaning of a word or series of words is transformed by a slight change or modification in the letters composing it, on the other. Sacrification becomes starification. Wilke explains 'my art is seduction'. Often her poses take on the characteristics of a centrefold, her eyes directed to the assumed male spectator of nude paintings and *Playboy* magazine. In *Ways of Seeing*, John Berger points out 'Men look at women. Women watch themselves being looked at. The surveyor of the woman in herself is male; the surveyed female. Thus, she turns herself into an object.' In objectifying herself as she does, in assuming the conventions associated with a stripper (as someone who will reveal all), Wilke seems to be teasing us as to her motives. She is both the stripper and the stripped bare. She does not make her own position clear: is her art work enticing critique or titillating enticement? It seems her work ends up by reinforcing what it intends to subvert. In using her own body as the content of her art, in calling her art 'seduction', she complicates the issues and fails to challenge conventional notions of female sexuality. Consequently it permits statements like the following from male critics: 'By manipulating the image of a sex

kitten (female sex object), Wilke manages to avoid being trapped by it without having to deny her own beauty to achieve liberation.'

Wilke's and Pane's work represent two, very divergent, types of women's art in our first category. Yet they enable us to draw some conclusions about this type of art-making. Because this kind of art has no theory of the representations of women, it presents images of women as unproblematic. It does not take into account the social contradictions involved in 'femininity'. In much of this art, women are proposed as the bearers of culture, albeit an alternative one. In this way what is assumed to be a progressive position is actually retrograde. Being-a-woman is the essential presupposition underlying this art work: what this notion entails is assumed to be generally accepted, uncontradictory, and immutable. Whether the art focuses on pain (immolation) or pleasure (eroticism), it does not challenge a fixed and rigid category of 'femininity'.

II

A second strategy in feminist artistic practice views women's art as a form of sub-cultural resistance. It presents a kind of artisanal work, often overlooked in dominant systems of representation, as the 'unsung province' of women's art activity. An example of this type of work is the valorisation of crafts, such as patch-work quilts, and the activities of women in the home. It proposes the development of a feminist counter-tradition in the arts, reconstructing a 'hidden history' of female productivity. This strategy has the effect of stimulating women's creativity to discover new areas of expression. By redefining art to include

315

crafts and previously neglected skills, it avoids the ideological distinction between 'high' and 'low' cultural forms. In so doing, it emphasises that this patriarchal distinction that has served to restrict creative avenues for women.

However, this is also an essentialist position in as much as it views women as having an inherent creativity that simply goes unrecognised by mainstream culture. It therefore has limited ability to transform the structural conditions which both produce definitions of 'art' and oppress women. This is not to say that this kind of art-making is unimportant, but simply to point out the limitations of an untheorised strategy.

Although Jackie Winsor is not usually considered a feminist artist, she does fit into our second category of women's art, and in fact at least one critic considered her a feminist artist when she first came to national attention in 1970-71. Her constructions of wood, hemp and other 'natural' materials convey a post-minimal fascination with geometric forms and the imposition of order and regularity. While she lists her concerns as repetition, weightiness, and density, there is in her work-process itself careful attention to craft-like details, particularly in the spinning-like monotony of some of the hemp and wood pieces and even of the actual carpentry itself. In *From the Center*,[3] Lucy Lippard characterises her work in the following way:

Repetition in Winsor's work refers not to form, but to process, that is, to the repetition of single-unit materials which finally make up a unified, single form after being subjected to the process of repeatedly unravelling, then to the process of repeatedly binding or to the process of repeatedly nailing into wood or to the process of repeatedly sticking bricks in cement or to the process of repeatedly gouging out tracks in plywood.

Jackie Winsor's work is considered much 'tougher' than the work of other women who one might place in this category, for example the 'pattern painters' such as Harmony Hammond. Winsor's work includes skills such as carpentry usually reserved for men. Discussing her work Winsor often ties the origin of a particular sculpture to an early childhood experience, as in 'Nail Piece'. When she was a child, her father planned a house which her mother built while he was away at work. At one point, says Winsor,

My father gave me an enormous bag of nails and left, saying to nail them down to keep the wood in place. I did . . . and used the whole bag of nails to do it. The part he told me to nail down needed about a pound of nails. I think I put in about twelve

pounds. My father had a fit because I'd used up all his nails. They made such a fuss about it that it left quite an impression on me.

But like much traditional women's work, Winsor's pieces conceal the actual labour involved in their construction.

One might parallel Winsor's work and women's craft work in quilts or baskets, for instance. Patriarchal culture traditionally functions to negate the complexity of work involved in such traditional handiwork. By foregrounding this 'other' of conventional high art, the art work that falls into our second category emphasises that there is another art, which has a history, and which has been repressed. The 'alternative tradition' approach emphasises the social and functional aspects of activities such as weaving or pottery-making in communities. We agree that this type of contribution to feminist art-making is an important one; however it is equally important to point out the limitations of a form of self-contained subcultural resistance, one which does not work in a dialectical relation with the dominant male culture. A possible consequence is the ghettoisation of women's art in an alternative tradition.

III

Our third category of women's art derives also from this aspect of potential isolationism. It views the dominant cultural order as a monolithic construction in which women's cultural activity is either submerged or placed entirely outside its limits. This position can be regarded as an antidote to feminist essentialism in that it recognises that what has traditionally been known as the 'form' and the 'content' of culture both carry meaning. However, ironically, it is also the basis of *both* 'separatist' (artists who do not identify with the artworld) and non-feminist (women artists who maintain that they are people who 'happen' to be women) discussion. Thus this category includes two groups of women at opposite ideological poles. The strategy of the first group is to establish their own society, so women will be able to combat the patriarchy. However, it fails to theorise how women are produced as a category within the social complex, or how femininity is a social construction.

The example of Los Angeles artist Terry Wolverton presents both the advantages and the limitations of the separatist strategy. As co-director of the Lesbian Art Project (which provides a programme of Sapphic Education) and producer-co-director of a feminist science fiction theatre. Wolverton's art work is informed with the desire to shape an alternative female culture. This takes the form of validating craft projects

Jackie Winsor *30 to 1
Bound Trees*, 1971

such as bread-dough sculptures and costumed happenings because they are produced by lesbians in the community. One positive consequence is that this type of art allows women to explore their feelings and attitudes, enabling them to develop self-esteem and pride in the discovery of their love and trust for one another. The productive result is an attack on the destructive *dis*satisfaction with being a woman that patriarchal culture fosters. However, the separatist position seems to be an example of this self-validation gone awry: the very notion of positive (lesbian) images of women relies on the already constituted meaning of 'woman'. Again, this unproblematic notion of

'femaleness' does not take into account that meaning is a dialectical process which involves an interaction between images and viewers. By failing to theorise how this meaning is produced within the social complex, this art considers the notion of femininity as unproblematic and positions women's culture as separate and different from mainstream culture. This can produce very disturbing results, as in the case of some of the art work validated by Wolverton, in which the prominence given to the exposed breasts of the subjects of the art work is strikingly similar to that in the photography of Les Krims, an artist noted for his particularly virulent expressions of misogyny.

317

The second group of women within our third category cannot be said to have a feminist strategy because they do not view themselves as artists engaged in the feminist struggle. Women who have been favoured through more strident forms of careerism make the assertion that women's art has outgrown its need for feminism. For these women, feminism is no longer useful, primarily because it is seen as a means to an end. Artists falling into this category, such as Rosalyn Drexler ('I don't object to being called a woman artist as long as the word woman isn't used to define the kind of art I create') and Elaine de Kooning ('We're artists who happen to be women or men among other things we happen to be – tall, short, blonde, dark, mesomorph, ectomorph, black, Spanish, German, Irish, hot-tempered, easy-going – that are in no way relevant to our being artists')[4] simply deny that their work is embedded in a social context, or that art-making is a form of social practice.

IV

A final type of artistic practice situates women at a crucial place in patriarchy which enables them to play on the contradictions within it. This position regards artistic activity as a *textual* practice which exploits existing social contradictions. This position intersects with other social practices foregrounding many of the issues involved in the representation of women. In these works the image of women is not accepted as an already produced given, but is constructed in and through the work itself. This has the result of emphasising that meanings are socially constructed and demonstrates the importance and function of discourse in the shaping of social reality.

In discussing our fourth category of feminist art-making, we can clarify the issue of theory by underlining the difference between women making art in a male-dominated society and feminist art working against partiarchy. Activism in itself in women's art has limited effects because it does not examine the representation of women in culture or the production of women as a social category. We are suggesting that a feminist art evolves from a theoretical reflection on representations: how the representation of women is produced, the way it is understood, and the social conditions in which it is situated. In addition to specific artistic practices that fall into this category we should point out that important critical work is being done in theoretical journals such as *m/f, Camera Obscura*, and *Discourse* all of which contain articles analysing cultural production from a feminist perspective.

In 'Post-Partum Document' Mary Kelly deconstructs the assumed unity of the mother/child dyad in order to articulate the mother's fantasies of possession and loss. By mapping the exploration of psychic processes, she indicates the ways in which motherhood is constructed rather than biologically given. One section ('Documentation III'), displayed in a series of transparent boxes, is a record of 'conversations' between mother and son at the point when the chlid is leaving the family to enter school. Each box contains a drawing done by the child, remarks by the child, the mother's reaction, and the mother's diary. This information is supplemented by a Lacanian psychoanalytic text describing the constitution of the mother's subjectivity under 'motherhood' (patriarchy). This method allows the spectator to construct several positions simultaneously.

In a September 1976 press release Mary Kelly described her work in the following way:

I am using the 'art object' explicitly as a fetish object in order to suggest the operations of the unconscious that underly it. The stains, markings and word imprints have a minimum sign value in themselves, but a maximum affective value in relation to my lived experience. In psychoanalytic terms, they are visual representations of cathected memory traces. These traces, in combination with the diaries, time-tables and feeding charts, constitute what I would call a discourse which 'represents' my lived experience as a mother, but they are consciously set up in an antagonistic relationship with the diagrams, algorithms and footnotes, thereby constituting another discourse which 'represents' my analysis as a feminist, of this lived exprience.

Martha Rosler is a Los Angeles-based artist, who works in a variety of forms, often with a verbal and written text. Her video tapes address the ideology of bourgeois culture. In 'Semiotics of the Kitchen' an 'antipodean Julia Child demonstrates the use of gourmet cooking utensils within a lexicon of rage and frustration' alluding to a less civilized time when preparing the meal had more to do with survival than commodity fetishism. In 'Losing – A Conversation with the Parents' an at-home TV interview style is adopted as two middle class parents describe the death of their daughter by anorexia nervosa, the self-starvation disease that afflicts (mostly) teenage women from middle class families. In the attempt of the parents to present a 'coherent narrative' of their misfortune, many of the social contradictions contained in their position(s) are indexed, most specifically, 'starvation in the midst of plenty'.

Rosler's bound volume of three post-card novels is

Mary Kelly,
Documentation III,
detail

entitled 'Service: A Trilogy on Colonization'. Each novel, 'A Budding Gourmet' (about a middle class housewife who takes a gourmet cooking class because she feels 'it will enhance [her] as a human being'), 'McTowers Maid' (about a woman employee who organises the workers in a fast-food chain), and 'Tijuana Maid' (about a Mexican woman who comes to San Diego to work as a maid in a middle class household – the novel is in Spanish with the translation appended in the trilogy), deals with women and food in relation to issues of class, sex, and race. Originally Rosler sent these food novels through the mail as postard series, one card about every five to seven days. As she makes clear in an introductory note in the trilogy, the spectator or reader of an art work is an integral part of the part of the piece itself.

Mail both is and isn't a personal communication. But whether welcome or unwelcome it thrusts itself upon you, so to speak, and must be dealt with in the context of your own life. Its immediacy may allow its message to penetrate the usual bounds of your attention. A serial communication can hook you, engaging your long-term interest (intermittently, at least). There was a lot of time – and mental space – around each instalment of these novels, time in which the communication could unfold and reverberate. So they are long novels, and slow ones.

When various representations are placed in a crisis in a work of art, the work has a fissuring effect, exposing the elements that embody its construction. This is important to Judith Barry (our third example of art work in this category)

in considering how women are represented by art, particularly in performance art where diverse conventions/disciplines intersect making possible a natural dialogue within these cultural conventions.

In 'Past Present Future Tense' woman's position as icon is juxtaposed to a disparate psychological and social narrative detailing the question of women as subject. The format of this piece calls into question the assumption of a unified 'ego' of the woman, making apparent her heterogeneity. 'See How To Be An American Woman' situates feminist social theory clichés informing seven horror stories of women's existence, via a pre-recorded multi-track (rape, childbirth, abortion, marriage, divorce, old age, etc) against the naked, immobilised body of a woman in an Italian arcade and museum. Several dualities are telescoped: American feminism's relationship to the body of the woman/European body art (including another duality: nudity/pornography), women as individual subject/popular history, performer/spectator, and the art world/larger social world. These dualities are readily identifiable, yet because they are not resolvable they remain in a contradictory stasis.

'Kaleidoscope', a series of eight five-minute scenes employing conventions from TV, cinema, and theatre, explores the relationship of middle class feminism as it shapes the private and public lives of a heterosexual couple. The contradictory positions exhibited by the two protagonists (both played by women) as they attempt to live their beliefs, underscores the unresolvable contradictions contained in even the most

319

```
PEANUT BUTTER & JELLY SANDWICH          EMPAREDADO DE JALEA Y MANTE-
                                        QUILLA DE CACAHUATE
Butter 2 slices of bread. Spread        Unte de mantequilla 2 reba-
one slice generously with peanut        nadas de pan. Unte generosa-
butter and top with a layer of          mente 1 rebanada con mante-
jelly. Cover with remaining             quilla de cacahuate y luego
slice of bread; cut in half.            con la jalea. Cúbrala con la
Serve with a large glass of             otra rebanada de pan y corte
milk for a hearty lunch.                a la mitad (diagonal). Sirva
                                        con un vaso grande de leche.

    El libro contiene una lista de frases en inglés y en español:
Sweep the kitchen floor.                Barra el piso de la cocina.
scrub                                   Estregue
wax and polish                          Encere y saque brillo
We like breakfast served at----.        Nos gusta que nos sirva el
                                            desayuno a las-----.
Have you ever shopped in a              Ha ido usted al super-mercado?
    supermarket?
etcetera, etcetera, y contiene una frase que oía siempre:
    Will you cook a Mexican dinner for us sometime?
    Nos cocina una comida mexicana para nosotros alguna vez?
```

Martha Rosler,
Tijuana Maid, unit 4

progressive views of social organisation. In a November 1979 press release Barry says of this piece,

> It is in trying to come to terms with the world as perceived (a perception which is ideological) that psychoanalysis intervenes. As dreams, jokes and neuroses indicate, the unconscious does not describe a one-to-one relationship with the world. Jacques Lacan has shown that this unconscious is produced in language, hence the identity of the individual as speaking subject is fictional. Consequently, ideology's arbitrary nature within the domain of this fictional subject becomes apparent and yet simultaneously must remain unknown on some levels.

From our descriptions of the work of these three artists it should be clear that an important aim of the art in this category is the critical awareness (both on the part of the spectator, and informing the work) of the construction of femininity. For it is only through a critical understanding of 'representation' that a *re-presentation* of 'women' can occur. We do not want to simply posit a definition of 'good women's art', for at this historical moment such a definition would foreclose the dialectical play of meaning that we are calling for; our intention is to be suggestive rather than prescriptive. One strategy of this fourth type of art transforms the spectator from a passive consumer into an active producer of meaning by engaging the spectator in a process of discovery rather than offering a rigidly-formulated truth. Moreover, the art work strives to produce a critical perspective that questions absolute or reified categories and definitions of women. Both the social construction of femininity and the psychoanalytic construction of sexual difference can be foregrounded if the art work attempts to rupture traditionally held and naturalised ideas about women. Finally, a theoretical approach implies a break with the dominant notion of art as personal expression, instead connecting it with the social and the political and placing the artist as producer in a new situation of responsibility for her images.

Notes

1 An initial formulation of these categories has been made by Laura Mulvey in an interview in *Wedge*, no. 2, Spring 1978.
2 *Flash Art*, May 1975, pp. 54-5.
3 Lucy Lippard, *From the Center*, New York 1976, p. 203.
4 *Art and Sexual Politics: Why Have There Been No Great Women Artists?* edited by Thomas Hess & Elizabeth C. Baker, Collier, New York 1973, both quotes from p. 57.

Source: *Screen*, 1980, vol. 21, no. 2.

Sandy Flitterman and Judith Barry write:
As authors of 'Textual Strategies: The Politics of Art-Making' (*Screen* vol 21, no 2 1980), we would like to express our dissatisfaction with the fact that we were not consulted on editorial or stylistic changes made to our article. The copy-edited article simply went to press without our ever having seen it.

While the basic thrust of our discussion remains intact, the published article appears in a style that we cannot possibly feel comfortable with. The introductory paragraph was intended to *contextualise* the notion of feminist art among other critical discourses, and to emphasise the *political* necessity of theory. The opening paragraph should have read as follows:

> To say that there is a crisis in contemporary criticism might seem like overstating the case for a situation in which critical definitions and methods merely lack precision and rigour. Yet it cannot be disputed that in terms of the feminist issue of the representation of women and the figuration of female sexuality in art, a crisis does exist. In order to develop a truly effective feminist artistic practice, one that works toward productive social change, it is necessary to understand the question of representation as a political question, to have an analysis of women's subordination within patriarchal forms of representation.

Changes of a less serious nature abound, 'an artworld notion of beautiful pain, distanced suffering, and a whole legacy of exquisite female martyrdom' reads simply 'an artwork notion of pain as beautiful' in the published article. Some changes simply produce instances of bad writing (unnecessary commas, pronouns without antecedents in the text, repetitious phrasing). Others, by eliminating the major line of argumentation, make some discussions sound like prescriptive jargon.

Without necessarily subscribing to a division (which is always ideological) between form and content, we would like to point out that while changes of this sort do not seriously alter the *meaning* or political position of our article, they substantially change its *style*. We would therefore like to suggest that authors be shown copy-edited versions of their articles *before* publication.

We are sorry that we were not able to consult Sandy Flitterman and Judith Barry about the editorial changes to their article. Our usual practice is to clear major changes of the kind they refer to before proceeding to typesetting. Just before going to press an accompanying and contextualising piece did not appear. In this new situation we thought some changes necessary, but there was not sufficient time to contact the authors.

[MN]

Source: *Screen*, 1980, vol. 21, no. 4.

Jean Fisher
'Object of fetishism'

Women's legs continue to be amongst the most persistent images displayed by advertising distributors in the Underground — an ideal location to catch the gaze of the commuter as s/he waits in those captive limbo moments between home and work. Currently on view are several stocking ads: one from Aristoc ('Say knickers to panties'), and two from Pretty ('They beat the pants off trousers') Polly. In one image the model bends over at an acute angle exposing the product from hips to toes, addressing our gaze with vivacious complicity; in the other two the legs are disembodied from the personality of their owners. As our eyes slide from the 'glistening thighs' ('Gloss over your best features') down the slim calves ('Pretty Polly brings back lovely legs'), they come to rest at a pair of feet each clad inevitably in one of the principle icons of male fetishism, the outrageously impractical high-heeled shoe, cut-away to reveal the toes, and/or strapped at the ankles.

The advertisements appear to be addressed to women (women, after all, are the wearers of the product), but it is not so straight-forward. An adjacent image advertises women's underwear. The repressive ideology underlying this particular image has already been succinctly dealt with by Rosalind Coward ('Underneath we're angry') in Time Out earlier this year. The inscription, 'Underneath they're all Lovable', is itself, however, not without significance. Who is 'they' and to whom is the message speaking? Assuming that 50% of the commuter population are women, the use of 'they' (rather than 'we') clearly alienates the female sector in a two-fold manner: either 'they' are women other than 'we' but whom 'we' are encouraged to emulate, or 'they' refers to women (us), but the caption is couched in terms that imply that the reader, the conspirator in the message, is male.

In a painstakingly researched book recently published by the Women's Press, *Pornography. Men Possessing Women*, Andrea Dworkin, drawing on the statements of (male) psychologists, discusses the way in which man has used objects 'to feel his own power and presence'. Objectification has traditionally included women, whose function as 'chattels' — objects of possession, and therefore exchangeable and disposable commodities — still prevades attitudes within society. Advertising remains complicit with these attitudes through its persistent use of images of women which focus primarily on sexuality. The film *Lipstick*, recently screened on TV, purported to examine the after-effects of the rape of a fashion model. In general, it fell far short of discussing the important issue of representation, but in the courtroom sequence the model states that she projects the image of overt sexuality because this is the way that women would like to look. This undoubtedly has some truth, but it nevertheless begs the question of why this should be so. The image of woman propagated through the media is an idealisation of 'beauty' and 'femaleness' defined historically by man focusing on the *otherness* of female sexuality; and historically to transgress this standard through 'ugliness' or 'wilfulness' resulted in punishment (restraint, ridicule, social ostracism, or mutilation). Not surprisingly, being without power, women conformed.

Representation is double appropriation: firstly the possession of the object by the image-maker himself; and secondly by the spectator, who through theft and possession of the image perpetrates a further act of violence. What was subversive about the Seventies fashion images of Helmut Newton and Guy Bourdin (for example, the latter's hit-and-run auto-accident which advertised Charles Jourdan shoes), was that they made explicit the sexual violence covertly inscribed in much fashion imagery — of which the 'Lovable' ad. is a currently good example (when 'they' say no, what 'they' really mean is yes). Nevertheless, culture's ability to neutralise the publicity unutterable is seemingly boundless: witness the fate of punk's appropriation of the iconography of S&M and prostitution. All this is well-covered ground. What remains important is that the way we use language and present images is instrumental in the construction of meanings within society. Consequently, if violence against women, or any other group, is not to be perpetuated, then women must reclaim the images of themselves. This is one of the most important objectives of women's art.

Two artists, Ana Godel (whose work is currently at Angela Flowers) and Alexis Hunter (whose work was recently seen at

Alexis Hunter, Totah Gallery, Oct 1-Oct 31 and **Ana Godel** at Angela Flowers Gallery, Nov 4-Nov 28.

Alexis Hunter *Soho Square*, 1981 (detail)

Ana Godel *Connections,* 1981

the Edward Totah Gallery) both return consistently to the image of the high-heeled shoe. Their use of this image contrasts sharply to that of Andy Warhol whose 'Shoe' prints were also recently on show at Waddington Graphics. Although his bland and direct presentation appears to deny specific connotations, shoes nevertheless are icons of culture and therefore not without significance. There are two versions of shoes, both richly screened with diamond dust, in which the objects are either presented in a row, or presented scattered — in other words, 'displayed' or 'discarded'.

If woman-as-object serves the primary function of arousal of male sexual desire, than any other object which can evoke the 'woman-object' could serve the same function. The substitution of one object of arousal for another constitutes the basis of fetishism. The reasons why a particular style of shoe should be a key fetish may include the fact that it encases like a second skin that part of the body furthest removed from the head, and therefore the personality, of the owner; that excessively high heels are a form of shackling through inhibition of movement; that ankle straps suggest bondage; and that there is the excitement of danger — the stiletto heel can be turned as a weapon.

In Godel's drawings the focus is on shackling: the feet and shoes become organically inseparable, bound together by prehensile vines *The Vase,* bolted *The Choice* or tied to the floor *Blue Lady,* or plugged into an electric socket (The Connection). Women are fixed within *The Walk.* The image is of cruelty.

Hunter's shoes are used to symbolise freedom from bondage. In an early series entitled *Approaches to Fear* (1977) she presents us with serial photographic images: in 'Pain — Solace', a hand removes the offending object, a silver high-heeled shoe; in 'Pain — Destruction of Cause', the shoe is burned and rendered ineffectual. This concept is returned to in a more recent work, *Soho Square* (1978/81) in which a two feet progressively liberate themselves. Both artists address themselves primarily to women, but the importance of their work in terms of its engagement with the meanings of cultural images cannot be overstated. Culture 'launders' violence through the way it presents its images. There is a pressing need for us all to re-name and re-draw those repressive structures that society has 'normalised', and expose them for the divisive strategies that they really are.

Source: *Art Monthly,* 1982-3, no. 52, pp. 13-14.

IV.13 Alexis Hunter

Cheryll Sotheran
'Uncovering struggles'

Photographic Narrative Sequences and Drawings by Alexis Hunter, at RKS Art, 41 Victoria St West, until March 27.

The art of Alexis Hunter is challenging. It is unlike the sort of art produced by most local feminist women artists, who are more inclined to biography, to explorations of stereotypes without much explicit anger, to use of more traditional techniques in paint, fibre, collage.

Hunter uses complex serial arrangements of colour-Xeroxed, reworked photographs with harsh colours and dense images.

Her work deals with feminists, racial, and human struggles that New Zealand seems to have been always protected from, or at any rate that rarely surface in our art, the racial struggles of last year being an obvious exception.

But she does not revel in this brutality. This isn't sensational art, it's penetrating and intensely humane.

The works at RKS have been drawn from a number of shows in Britain and there is something of an anthology feel about the show, but the unified vision of the artist and her stylistic clarity draws the works together.

Hands appear a great deal, disembodied, engaging in not immediately obvious activities. The hands in *Gander Confusion* are ambiguous like the theme, caressing and invading.

In *Conversation with an Englishman* they are a metaphor for sexual involvement. In *Rape Sequence* they float indistinctly behind the street scene in a way that is both threatening and humanising.

These disembodied hands come from advertising imagery — the manicured hands of the model demonstrating beauty or efficiency or an impossible combination of both, the strong masculine hand holding a cigarette, stroking a bare bit of skin — never with a body attached, allowing the viewer to attach her/his own body, indulge her/his fantasies, buy the product.

Hunter provides for viewer participation too, but makes it an uncomfortable experience. The hands of the

Study for *A Young Polynesian Considers Cultural Imperialism Before She Goes to The Disco* by Alexis Hunter.

Cheryll Sotheran at the galleries

couple in *Conversations* are daubed with red paint (blood?). This interferes not only with the words they are offering each other as an (ironic?) accompaniment to the more real business of establishing sexual contact, but also with the nature of the contact itself.

In *Objectification of a Stranger* a hand takes liberties with a face, and the exploration is made more shocking because the gestures made by the manicured hand are those reserved in media experience for erotic encounters between intimates.

There is a brutality about the contact that characterises her ability to reverse roles visually. Her treatment of the stereotypes of female oppression is so far from cliche as to be, at its most extreme, almost too difficult, too shocking to accept.

This does not happen often, but it's

evidence of a problem of communication with which she has struggled. This political feminist art extends to the wider politics of racial oppression, destructive role-playing in marriage relationships in which both men and women are implicated (*Domestic Warfare*), the exploition of human responses by media oppression (which she illustrates principally by stylistic devices that disarrange the viewer's expectations) even perhaps to an exploration of male stereotyping (in *The Spider Tattoo*).

The only work in the show that is specifically about New Zealand is *A Young Polynesian Considers Cultural Imperialism Before She Goes To The Disco* a complex statement about race relations especially in comparison to the very explicit images we've seen since the tour.

Not only does the work comment on the stifling influence of white bourgeois culture, while avoiding false heroics about Maoris (the girl is going to the disco, she does put on the ear-rings before she rejects them, her defiance is more sullen than splendid), but Hunter weaves in

feminist awareness, and a refusal to use banal images.

The ornaments have primitive associations in their appearance, and provide a comment on whites offering back to Polynesians objects which may have once had cultural significance, and have become debased by the workings of that insidious aspect of Western culture, fashion.

Hunter has accepted that her works are not easy to read. They need time, but they repay in full and even in immediate confrontation they produce responses which are familiar in an almost subliminal way.

The cyclic or serial nature of the works reflects female life patterns, but also the on-off images of the TV ads, as does the mechanical clarity of the colour Xerox technique.

What she presents is visual complexity and ambiguity — hard to read, but so is experience. There are no easy answers to oppression.

She gives us a glimpse in paintings and early sketches of the hard personal road she took before she could work in the demanding objective images of the serial works, which have been all but purged of biographical reference.

Even in *Rape Sequence* which is a work based on a personal experience, the woman is not specified as the artist: Woman is everywoman in these works.

Hunter's acceptance that she is preaching to the converted, the middle-class audience that goes to galleries, seems a sorry waste. It seems vital that the artist's vision should reach out, that viewers who can learn from her insights, as Lucy Lippard suggests, "complete the image sequences in their own lives."

For us, her New Zealand audience this has particular relevance. Her art has a toughness that is unusual here. She is aware of the difference, and speaks of the "ogre of normality" that we all live with here.

I hope a lot of people will spend the time necessary with these works, avoid that well-known New Zealand paranoia about those who choose to leave, and let the insights penetrate their lives.

Source: *Auckland Star*, 22 March 1982.

IV.14

Chila Kurmari Burman and *Bhajan Hunjan*
'Mash it up'

WHY DID YOU BECOME INTERESTED IN ART?
Coming from a very strict/traditional Indian family it was very important to have an education, to have a degree so that I could marry a man of equal status. My family did not mind what subject the degree was in. I went to art school to be educated, and once I was there I began to find out more about myself, about where I came from and to question myself through my work.

CAN YOU EXPLAIN EXACTLY WHAT IS YOUR IDEA OF ART?
I do not start with an idea and see the idea through. I usually give my work a title after I have done it. I use different images to put across different feelings and emotions, which create symbols in my work. One has to be fully aware that a 'symbol' cannot be fully explained or translated — similarly I can only partly explain what my work is about.

In 'Unity', the two shapes in the half left-hand side confront each other, they are related, attracted, yet they are in their own respective spheres — represent female and male. In the middle a spiral-like shape (that is ever-growing, ever-evolving, ever-decaying, unfolding) could represent growth and time. This shape is enclosed by snares, thorns, taboos, restrictions which give it hardly enough air to breathe and survive. On the extreme right an organic structure of growth, death, continuation, sensualness, continues through from top to bottom. It represents nature. In 'Female and Male', the figure of a woman and a man are overshadowed by a thorny, evil-shaped, sharp structure pointing upwards and downwards while in a horizontal position. The snake-like shape within the woman's womb could represent her as a body for reproduction. It is her womb that projects her outwards and inwards. It is the physical medium between her physical inside and the outside

The image of a man exists along-side as part of existence.

It is my search into myself, into my unconscious. I question my dreams when I work as they are an inlet into my unconscious. I feel driven to express myself when I am undergoing emotional crisis personally and especially when it is something to do with women. I feel that I have an emotional outlet, doing what I do makes me think I can solve things.

WHAT WAS ART SCHOOL LIKE? DID YOU MEET WITH ANY RACISM?
I did my graduate course at Reading University and a post-graduate course at the Slade School of Art in London. I was the only Indian girl on the graduate course. It was very strange and cold in the first two years, I often felt left out. At the time I felt it was due to my shyness. Later on I realised that generally the English are very reserved and cold even within their own society, though there are exceptions. I have a difficulty in explaining my experience of racism, I am ignorant of it directly affecting me, though I can see it in a historical context and understand why it occurs. The nearest I have come to it has been on holiday jobs where I have come across people who have stereotype ideas and false interpretations about immigrants and their way of life. It would help if people had open minds and hearts.

HOW DOES YOUR FAMILY FEEL ABOUT YOU STUDYING ART? DID THEY EVER OPPOSE YOU?
They are pleased that I will be able to support myself. My mother comes from a very small village and has undergone many changes in her life. She cannot understand what I do, but is happy for me

◀ *Unity*

because she knows I can take care of myself. As far as my father is concerned, his ambition to see all his children educated has been fulfilled. He does see a woman's role as a housewife and bringing up a family. I come from a large family with elder brothers and an elder sister. They normally all see a woman as a housewife, married and with a family, as she is an 'asset' to the reputation and prestige of the family. I can only communicate with them on a certain level. On the whole they are pleased that I can continue working. It's strange, before I started studying art they had a certain idea about what art should be, but now they are more accepting to the idea that art can be what you want it to be.

There is something which I feel is very important to understand with Indian girls who have had a strict upbringing, that is a concept of fear. It is so inbuilt within you that you can never be fully yourself, never let go. You are so paralysed with this fear that you can rarely make a decision for yourself. You are conditioned to always respect and consult Indian elders. For instance, if I were anywhere accompanied by a man (irrespective of my relationship with him), I would be conscious and somehow scared, in case somebody in the community saw me! I have made a conscious effort to conquer this fear in my work. For instance it has taken me a year to come to terms with the image of a naked man. It's like a challenge to myself. Am I being morally wrong and untrue to myself?

Female and Male ▶

DO YOU FEEL AS IF YOU ARE BETWEEN TWO CULTURES?

I feel I am between two cultures, yes, and I feel I have every right to be there. I do not know what it feels like to belong to a culture. I was born and brought up in Kenya, as an 'Asian' in Kenya. I never ever felt I belonged there. When I came to England I never felt the need to belong. I wanted recognition as an individual, I wanted to feel comfortable, within my own community and the other. Talking about two cultures, I must tell you something which happened in a classroom situation.

There was a project for the class to do their own self-portrait. One Indian girl did her self-portrait in which she had blonde hair and blue eyes. It was an incredible and pitiful experience for me. Was it because she wanted the rest to see her as part of them or was it her thriving wish to be accepted as one of them? I wish there was more understanding from other people and just a little more awareness. Some white people do care, so do a very small proportion of teachers in schools, but others don't even try a little.●

Bhajan Hunjan — **Presently doing a Postgraduate Certificate in Art Education.**

Hiya Sisters...

When asked to be interviewed by *Spare Rib*, I thought to myself, 'Well, you ask the questions, and I'll answer after you.' I first started making prints when I was at school. There weren't any facilities, but you could still manage to make mono prints from old spuds or even by inking different parts of your body and then pressing against the paper or screen . . . magic. Right from my early days I was printmaking, early wood-block printing, etching and engraving. They really fascinated me. And at art school there was space to experiment with new ideas.

Me Mum and Dad are traditionally Hindu-Punjabi, and weren't really into the idea of me going away from home, because of what all the relatives and the community would say. But 'cos me dad worked all his life as an ice-cream man and me mum worked hard to bring us up healthy and strong in this strange land, they wanted us to have a good education, 'cos they never had the opportunity to go to school. Me Dad's a brilliant tailor too and a very gentle man — he teaches me about respect. And me mum is a really amazing, strong woman. They're both very loving and caring. There were hassles at home, like when I wanted to bring English friends home, and go out.

There was racism at school and university: comments were passed like, 'you are like curry with a suntan', or 'all you Pakis take our jobs'. There is a helluva lot of ignorance and stupidity. I did have some hassle with some tutors and students. There were of course the difficulties with 'class', which really stood out. So, you see, through my work I'm trying to expose some of these

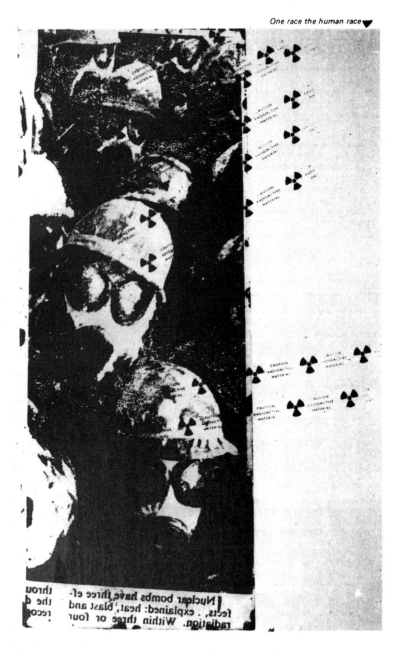

One race the human race ▼

Nuclear bombs have three effects . . . explained: heat, blast and radiation. Within three or four

◀ *Self-portrait*

things. It also helps me to understand what is going on in the world. I use different sorts of print techniques. The infinite possibilities intrigue me, it's kinda orgasmic!

Many different thoughts flow into my works; my feelings -- political, spiritual, philosophical; women's issues, sexism, racism and the media's con. None of these are developed exclusively. They all interact and change. My work doesn't encompass any rules or regulations. It's about freedom. A lot of my ideas flow from happenings and emotions. Other ideas come from the environment, love, compassion, dear friendships, respect, knowledge and discipline, (that's hard sometimes), and, above all, mostly through living. Being aware and conscious of the women's movement has taught me a lot of what I am doing now.

Some of the most recent stuff, is what you could say social, political, if you want to give it a label, 'cos sometimes art should have a social and political function. The recent stuff comes from within, naturally. It describes what I feel, the desires, fears, suffering and anger as shown in the image, 'One Race the Human Race'. The gas mask is used to symbolise war and it's all about anti-nuke stuff.

The images shown are different. Indian women, women under apartheid and as mentioned, anti-nuke stuff. The ideas/issues/subjects, plus my own culture have determined the content and form. They represent a consciousness and a culture. When I express personal thoughts, I try and create something which is more direct and harmonious. I try to bring about an awareness of what is going on. It sort of reflects the changes the women's movement has attached to the personal in the political world. They both merge. Other ideas come from music, eating, sleeping, thinking, Zen, friends, reading, Miro,

Uprisings — summer '81.

Mum and Dad, brothers, Billy, Sean and Peter (Achar, Ashan, Ashok), Ashra and many other sisters, especially Meena.

I don't always use images of men — if I do, I try and subvert them or to put a new perspective on them. It would be good to move towards a demystification of art within the present system. Everyone should be given the space and opportunities to realize their full potential, not just the privileged or those who go through the system.

When asked by *Spare Rib* to define art, I thought well, 'ere goes. First of all I'd like to say that art is an activity, a development of oneself in this mad world. It never seems to be understood, allowed nor appreciated. There's some good stuff around, exciting, in performance, video, film, painting and music. Art is a way of getting in touch with

Peace, love and unity, one of a series of four prints.

Militant women

oneself, with the visible world and nature. You could go on forever and ever. But here is a really nice quote from a book called The Zen of Seeing and Drawing. Here goes: 'Art is the unspoilt core in everyone, before being choked by schooling, conditioning, and training, until the artist within shrivels up and is forgotten.' Even artists who go to art school can still be damaged by becoming competetive or in a rush towards a personal style, or to be ''in''. It can be easy to let this happen to you unconsciously. 'You gotta be aware', 'Natural Progression'.

Sona from *Spare Rib* asked me what I felt about being between two cultures. I don't think I am between. I hate that phrase, it's more like beyond two cultures. All this labelling is something the media has conjured up. The media doesn't arf go on about stereotyping us: 'Mash the Media Up'. We have to entangle all this and take control of our lives. Challenge and transcend, transform and reveal these issues — like the imbalance of power relations that exist between men and women, and violence against women. We must do this through whatever medium, films, writ-ing, talking, print, sound, science and living . . . the world would be a better place to live in then.

To other sisters, it ain't easy. We can stand up for our rights. Be strong. The world is full of shit and pollution. Let's clean it up Sisters. Challenge and transform and become aware of what is going on. We are strong and dynamic. ●

Namesta Benji's

Chila **studied at Leeds Polytechnic and the Slade School of Art.**

Source: *Spare Rib*, March 1983, no. 128, pp. 52-5.

IV.15

Suzanne Davies
'Private and public: points of departure – the work of Margaret Harrison'

The point of departure for my work is that of experience, the issues arise from my sense of experiencing situations.[1]

That Margaret Harrison's work is based on experience strikes one again and again. Yet it is often the experience of others, mediated by her own. Experience objectified. This is 'experience' which is firmly located in culture and place.

Thus, as we explore Margaret Harrison's work, we are not thrust into a world of privatised signs or secret and obscure emotions, but rather, are confronted with that which is normally hidden by ideology as it works to preserve existing social formations.

To again quote Harrison, 'The interconnectedness and permeation of the public into the private, and the private into the public is probably the best way to describe work'.[2]

The correspondence between two private experiences — others and her own — is manifested in the work with the specific purpose of bringing them into the public (political and cultural) domain. This then is the relationship between the private and the public. We can go further by stating that work based on personal experience and that which is socially engaged, are *not* mutually exclusive.

There is a public rewriting or recontexturalizing of personal experience apparent in the quoting from diaries, novels and other sources in those works concerned with geographical location (*Dorothy Wordsworth & Land/Landscape: Australia/England*) as well as in the overtly 'issue' works (*Anonymous is a Woman, Rape, Craftwork, Homeworkers*).

However, on closer reading, such a division of the 'issue' orientated work from others may, in fact, be false, because despite the more polemical nature of *Rape, Homeworkers* and *Craftwork* **all** the works are concerned with issues, even where the subject matter is apparently focusing on the relationship between two people — Dorothy and William Wordsworth or between persons and a place — Wordsworth and Harrison to the Lakes District.

Significantly, there is a model in feminism for this kind of relationship between broad public issues and the individual and the shift from private experience to public enunciation. It is no less significant to note that Margaret Harrison is English and her politics are feminist.

Before embarking on a discussion of the work, it may be useful to point out some key features of feminism, specifically as applied to art practice in the last decade. While feminism has held and continues to hold a plurality of attitudes, the dominant tactics of visual arts feminism have centred around (and this list implies no ordering of priorities) first, the identification of a female sensibility; secondly the acknowledgement of women's history and validation of experience; thirdly the establishment of women's groups, organizations and venues for consciousness-raising, support and exhibitions and fourthly, the seeking of equality of representation in exhibitions, on and before funding bodies and in educational institutions.

These four broadly sketched tactical undertakings — true for both England and Australia — require the addition of a fifth, more recently significant one, which is the utilisation of theory — Marxian, psychoanalytic and linguistic.[3] These tactics are in fact aspects of a larger strategy to expose and counteract that dominant ideology defined through theory as the patriarchy, which denies, suppresses or trivialises women's experience and work. Such tactics as outlined are interwoven, all still maintaining currency, and operating on different levels.

There is evidence via her work, that Margaret Harrison has utilised all these tactics and, while she is not a theorizing artist, it is through theory that her work has become more publicly responsible and communicative.

In general terms, it is largely through theory that the lessons and gains of the last decade have shown their limitations: that marginalization may attend the *singular* pursuit of female experience through such tenuous notions as a 'feminine sensibility'. It has now become essential to broaden the analysis while not denying previous feminist work. Within this new context of placing women's issues in a wider, more public perspective, embracing cultural, economic, psychological and class concerns, we can locate this body of work.

In an article in *Studio International* 1977, Harrison documented some key activities for British visual arts feminism. Her own involvement with these activities and the issues arising out of them are clear. She, along with others formed the first London Women's Liberation Art Group in 1970, the year the Equal Pay Act was introduced. Women artists contributed their skills in examining the range of issues confronting the Women's Movement in general.

When she challenged advertising's cynical and exploitative use of women in her 1971 one-woman exhibition, the police closed the show. The 'offending' work made 'comments about current advertising, equating women with juicy tasty fruit [a soft-drink advertisement] and included a drawing of Hugh Hefner as a Bunny Girl with Bunny Penis.'[4]

Rape, Two pieces, Wall assemblage on canvas, 240cm x 180cm, Acrylic on canvas, 240cm x 30cm.

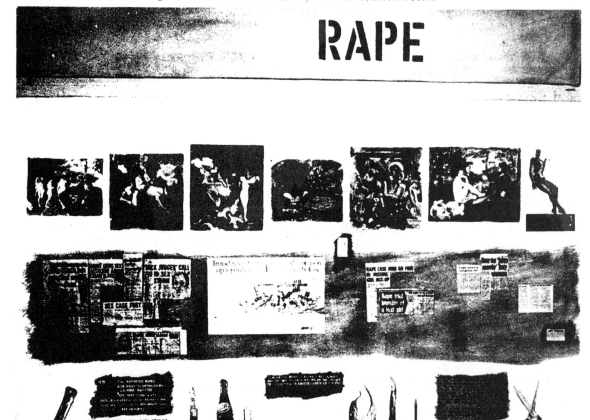

Harrison was amongst a number of women who joined the Artist's Union in 1972 (a union of professional British artists), which lead to the Union adopting as one of its aims, 'to end discrimination in the arts'. The union also ratified a Women's Workshop which supported three actions by women workers outside an art context, including a factory strike and a campaign for women night cleaners.

In 1975, she organized an all women group exhibition titled 'Sexuality and Socialization'. The same year Margaret Harrison with Mary Kelly and Kay Hunt participated in the 'Women & Work' exhibition at the South London Art Gallery which presented documentation of women workers in a South London metal box factory. The exhibition '. . . concentrated on the division of labour within the factory, examining the new problems facing women as industry adjusted to the Equal Pay Act and re-organized the workforce into double day and evening shifts unsuitable for women with children. The exhibition used photos, sound tapes, documentation and a short film'.[5]

The observation has been made elsewhere, that in England at least, feminist art is thought by some to be 'utterly unconcerned with notions of what art is and only concerned with making strong direct statements about the position of women in our culture'.[6] The adjustment required to this kind of claim is that it is our *perceptions about art* which are altered when artists approach such topics. Art is not made in an Art vacuum. The politics of the Women's Movement has been, to a large extent a politics of information — to know more about women's position in order to act upon it and it is through these

kinds of actions that Margaret Harrison has made the transition from formalist painter, trained at the Royal Academy. At that time (late 1960's) painting, within the context of formalism, was incapable of dealing with subject matter, specifically political subject matter. During the early 1970's it became necessary over the dilemma of content, for many women and men to virtually withdraw from 'mainstream' art practice. In 1977 Harrison noted (in fact in retrospect) that:

. . . the temporary abandonment of art practice has brought a new understanding for many women returning to their work. Feminist work is at present reflecting deep involvement in defining self and relationships to this new way of seeing . . . [7]

What we see before us is the work resulting from the reuniting of self within an engaged art practice.

The Work

Land/Landscape: Australia/England is the most recent work, the most different within Harrison's *oeuvre*, and for us perhaps the most accessible. The eight paintings were produced in Australia while artist-in-residence at Griffith University. Each canvas features a single gum leaf motif both described by and overlayed with impressionistic brushstrokes, and each canvas has a different hue — colouration as signifier of seasonal change and state. What didacticism exists in this work, is hidden within the paint, in that the texts (quotations) must be read through the painterly surface. These Australian paintings form a tentative bridge to understanding the historical significance of the landscape which includes both white and Aboriginal history. The Aboriginal words 'Pama' and 'Parra' on one canvas are used to 'crystallise relationships to place'. 'Pamma' refers to Aboriginal people who possess a cultural distinctiveness bound up with their land/roots/lives/family/tribe/place. 'Parra' in turn, refers to the Europeans who through their late migration are thought not to possess this cultural distinctiveness 'belonging' to the Australian continent. D. H. Lawrence's novel *Kangaroo* (which Harrison read while in Australia) also offers a distilled attempt at adjustment to place — the Australian landscape as experienced by an Englishman . . . 'the strange, as it were, invisible beauty of Australia which is undeniably there, but which seems to lurk just beyond the range of our white vision . . .'.

Yet another discourse elaborated in *Land/Landscape: Australia/England* is that of the challenge to the notion of landscape as a source of natural beauty, a place of escape and regeneration. The idea that this grand raw land exists unmediated and unconstructed, and that artists 'naturally' respond to such qualities. A position we are all to familiar with in Australian landscape painting. *Dorothy Wordsworth* shares with *Land/Landscape: Australia/England* the concern to challenge the ideological construction of the poetic emphasis on the beauty and simplicity of the country/landscape by counterpointing through selected texts, the conveniently ignored reality of people being dispossessed of their land

and livelihood. On this issue, Margaret Harrison has included in *Land/Landscape: Australia/England* a quotation from Raymond Williams' *Country & City* . . . 'Poets have lent their tongues to Princes, who are in a position to pay or reply. What has been left to shepherds, and at what rates of interest, is much more in question. It is easy to forget that Sidney's "Arcadia" which gives a continuing title to English neo-pastoral, was written in a park which had been made by enclosing a whole village and evicting the tenants.' [8] The implications for Aboriginal landrights are obvious.

A deliberate strategy apparent in these works is the setting up of contradictory discourses both within and across works. In *Dorothy Wordsworth* (as Wordsworth sets out in her diaries) it is a personal, romantic feeling for nature and place set against the harsh fact of a ruptured rural economy, spoken through the texts and images; the impressionistic painting against careful, botanically accurate details. Dorothy Wordsworth's relative obscurity against her brother's prominance; her diary minutia (those famous daffodils) serving as a source for this universally applicable poetry. From such contradictions it becomes possible to see the lie in landscape as a fixed entity; and in creativity as the possession of individual artists.

Other contradictions reside in the duality of the romance of the picture with its anticipated formal niceties set against the priority of the real content of the work. In the case of *Land/Landscape: Australia/England* the unstretched, unprimed canvas moves the work towards a materialist reading by stressing the very process of production. This challenge to finish, even more apparent in *Anonymous is a Woman*, *Rape*, and *Craftwork* and the obvious anti-illusionism ensure that the process of production is neither mystified nor ignored. In *Craftwork*, the women whose experiences are being examined speak through the texts and images along with Margaret Harrison as she redefines herself through and with these other voices. Thus the unity of the reader is disrupted by discouraging identification with a unified subject. Here, fragmentation serves as a structuring device and as a metaphor for the dislocation of women from their traditional skills as a consequence of increased industrialisation. Such skills, once the proud and useful possession of working class women have been supplanted by factory production where the same or similar objects are 'made in the factory by working women and sold back to them'. 'Home made' becomes a symbol of poverty, while equivalent craft activities become intriguing hobbies for middle-class women.

Homeworkers has particular relevance to Australia. The work draws attention to the circumstance of women workers who function outside the trade union movement.

Homeworkers are 99% women who work at home either making a product or finishing the process in some way. They are the most exploited of workers in Britain today. This work, which examines those structures, was done in recognition that my own personal struggles in everyday life

are part of the stem from the point of exploitation in the lives of other women. So a piece of work which examines the plight of Homeworkers is done from a subjective/objective point but its priority is the revealing of those invisible structures of exploitation.

It involved looking at the law, unions, the power of the state, advertising, international and multi-national movements of profits and employment and the power these elements had over your very own socialisation and ultimately your psychology.

***Homeworkers** was made with a number of specific contexts in mind – as consciousness-raising within the trade union movement, for a broadly non-art audience in regional towns and finally within the gallery network.*[9]

In Australia, such people are referred to as 'outworkers' As in Britain, Australian outworkers are predominantly women. These women work in their own homes for employers in the clothing and textile industries. Being outside the Clothing and Allied Trades Union, they receive no benefits, supply their own equipment, pay their own overheads, may be layed off without notice and earn well below the award rates. Frequently, they are migrants who cannot get work because of either prejudice, language difficulties or the relatively high cost of childcare.

Their cheap labour represents one-third of those employed in the industry. They are effectively used as buffers against fluctuating prices by being picked up or layed off without the need for notice or redundancy pay. 'As a result, the big manufacturers reduce production costs, overcome seasonal production peaks and lift production cheaply.'[10]

Different codes of representation are employed to serve different functions. In *Anonymous is a Woman* representation of objects in a pictorial sense is used to ensure symbolic recognition, as a way of pointing something out, for example the image of the head of Janis Joplin refers directly to the pop star. Whereas representation is used in a different sense in *Dorothy Wordsworth* and *Land/Landscape: Australia/England* where forms such as the gum leaf become metaphors within a representational schema.

Each of the works in this exhibition arises out of a specific set of personal concerns or genuine avenue of enquiry. *Rape* draws on Margaret Harrison's experience working at the Rape Crisis Centre, on the fact that she is a woman and a mother of two daughters living in an area where rape is a daily occurrence.

Based on these facts, her concern with the representation of woman as sex objects and with the military equating of sex, masculinity and violence, is a natural one. Her art practice develops, building on previous understandings, never reiterating in the same way. There is no stridency

Margaret Harrison in front of Land/Landscape: Australia/
England.
Acrylic on stretched canvas, 190cm x 110cm, 1982.

here, no hint of propaganda, no artful, constructed response. The display of virtuoso skills sometimes deemed necessary for painting are noticeably absent, and intentionally so, to ensure that they do not detract from the clear enunciation of the subject of concern which is treated in a purposeful and sympathetic manner.

I leave the final statement to Margaret Harrison (made in relation to the *Issue* exhibition but equally to her own):

. . . It seems to me that in order to achieve an art practice which transcends time and geographical boundaries and thus be universally understood, it only has a chance of doing so through an examination and an understanding of particular circumstances. The women's movement has made [an intrusion] on politics by a continuous insistence that sexual politics and the lived experience of women be a conscious consideration in party/group politics – in organization, activism and theory . . .[11]

I am indebted to Richard Dunn for his critical contributions in the formulation of this article.

1. From a taped discussion between Margaret Harrison and the author, Melbourne — June 1982.
2. Margaret Harrison, 'Art in Life: A Feminist Model'. Women's Forum Seminar Papers: *The Growth of Women's Art: from Manifesto to Polemics*, Women and Arts Festival, Sydney, October 1982.
3. Specifically Lacanian and post-structuralist. See the writings of Roland Barthes, Jean Baudrillard, Gilles Deleuze, Michel Foucault, Julia Kristeva, Jacques Lacan, Laura Mulvey and Griselda Pollock. For general, introductory material see also Barbara Creed, 'Feminist Film Theory: Reading the Text', *Lip*, no. 7, 1982/3.
4. Margaret Harrison, 'Notes on Feminist Art in Britain 1970-77', *Studio International*, vol. 193, no. 987, 3/1977.
5. ibid.
6. Quoted by Lucy Lippard in the introductory essay 'Issue & Taboo' for the exhibition *Issue* at the ICA, London 1980. The words are those of Roszika Parker talking to Susan Hiller, published *Spare Rib*, no. 72, 1978, p.30. The view expressed was a prevailing one rather than that of either participant.
7. Margaret Harrison, op.cit., p.220.
8. These quotations are taken from the paintings, not from the original texts.
9. Harrison, 'Art in Life: A Feminist Model', p.10.
10. Margaret Simons, 'Poor relations of the rag trade', *The Age*, Wednesday 6 April, 1983.
11. Margaret Harrison, 'Statement', *Issues* Catalogue, ICA London, 1980.

Source: *LIP Feminist Arts Journal*, 1984, vol. 8, pp. 20-4.

Notes to 'The body politic: female sexuality and women artists since 1970, by Lisa Tickner, pp. 263-76.

This is a slightly modified version of my paper for the 'Erotic Arts' section of the 1977 A.A.H. Conference. I should like to thank Iain Bruce and Mike Dawney for their encouragement, and for a critical reading of earlier drafts.

1 Linda Nochlin, 'Eroticism and Female Imagery in Nineteenth-Century Art' in *Woman as Sex Object, Studies in Erotic Art 1730-1970*, Ed. Thomas B. Hess and Linda Nochlin, Allen Lane, 1973, p. 15.

2 Basically, I am arguing from the premises of writers like John Berger and Linda Nochlin: that in the European nude, ownership is primary and the sexuality of the subject is not her own but that of the owner/spectator; and that the very term 'erotic' implies 'erotic-for-men', even (especially!) where the subject is lesbianism or female masturbation, in reflection of social and hence cultural relations between the sexes. See for example Berger *et al.*, *Ways of Seeing*, B.B.C. and Penguin Books Ltd, 1972, and Nochlin, *op. cit.*

3 Two aspects of this are particularly relevant here. Firstly a renewed interest in, and valuation of, female sexuality, with concomitant attempts to experience it as 'authentically' as possible; and secondly the emergence of a women artists' movement, emphasizing and encouraging the use of specifically female experience, especially the domestic and sexual, conventionally considered too trivial or inappropriate as creative material. It is perhaps worth emphasizing that these two aspects are linked not only in the feminist theory from which they derive, but also in the practice of many women making erotic art (for example in the expressive and therapeutic activities of Betty Dodson); and that such work is therefore at least as political as it is sensual in effect, and usually quite intentionally so.

Useful information on the genesis of the American women artists' movement is contained in Jacqueline Skiles and Janet McDevitt (Eds), *A Documentary Herstory of Women Artists in Revolution*, revised 2nd ed., KNOW Inc., Pittsburgh, 1973. See also Lawrence Alloway, 'Women's Art in the '70s', *Art in America* May/June 1976, pp. 64 ff.

4 Huysmans, 'L'Œuvre Erotique de Felicien Rops', *La Plume* no. 172, 15 June 1896, pp. 390-1.

5 Cf. Fellini's remark that women are 'the darkest part of ourselves, the undeveloped part, the true mystery within'. Quoted in Mary Ellmann, *Thinking about Women*, Harcourt Brace Jovanovich, Inc., New York, 1968, p. 22 (where she suggests that there is something 'digestive, even bilious, about this remark . . .').

6 I regret not having space to do more than mention in passing Carol Duncan's stimulating essay on 'Virility and Domination in Early 20th century Vanguard Painting', *Artforum*, December 1973, pp. 30-9. She suggests that the painting of the decade before World War I 'was obsessed with such confrontation between female nudity and the sexual-artistic will of the male artist'. Meanwhile the (female) nude remained the primal aesthetic 'object', partly out of habit and long tradition, and partly because it had become such a useful basic theme by which to practise a formal language or to authenticate a new and major statement. It permitted the display of dazzling variations precisely *because* it was otherwise such a conservative motif. Not wanting to invent his abstract shapes subjectively De Kooning used instead the substructure of a woman's body: 'I thought I might as well stick to the idea that it's got two eyes, a nose, a mouth and a neck'. (From an interview with David Sylvester, 30 December 1960, quoted in Thomas B. Hess, 'Pin Up and Icon' from *Woman as Sex Object*, Eds. Hess and Nochlin, Allen Lane, 1973, pp. 228-9.)

7 John Berger *et al.*, *op. cit.*, p. 56.

8 Xavière Gauthier, *Surréalisme et Sexualité*, Editions Gallimard, Paris, 1971, p. 194.

9 At the same time that it has been deemed necessary to protect women from exposure to erotic material, they have paradoxically been assumed

indifferent to it. Kinsey concluded (*Sexual Behaviour in the Human Female*, Saunders 1953) that very few women had produced what might be called erotic figure drawing; that few were interested in graffiti at all, let alone explicitly sexual graffiti in the male vernacular tradition; that very little erotic literature had actually been written by them, although a large proportion purports to be; that they do not often use sexual material for masturbatory stimulation; and that female fetishism was extremely rare. He was, however, puzzled by curious inconsistencies – for example, women claimed to find erotic films *more* stimulating than men did – and these may well have been due to the breaking down of established taboos. More recent experiments have suggested that his results reflected in part what women felt they were *expected* to experience, and also what they were prepared to reveal to interviewers. *The Report of the U.S. Commission on Obscenity and Pornography* (Bantam, 1970, p. 28) concluded that

> Recent research casts doubt on the common belief that women are vastly less aroused by erotic stimuli than are men. The supposed lack of female response may well be due to social and cultural inhibitions against reporting such arousal and to the fact that erotic material is generally orientated to a male audience.

One might also point out that there is no visual equivalent for the sub-tradition of explicit female eroticism in the Blues; e.g. Bessie Smith's 'I'm wild about that thing', 'You've Got to Give Me Some', and 'Empty Bed Blues'.

10 Linda Nochlin, *op. cit.*, p. 11.

11 Since in strictly Freudian terms the male, fearing castration, sets up a fetish that will substitute for the 'missing' phallus of the woman it is not surprising that, being already 'castrated' fetishism among women is extremely rare. However, although schematically we would therefore *not* expect to find it in quite the same way, it does seem possible that – perhaps through male identification – some women might at unconscious levels hallucinate the phallus and embody it in a fetish. It remains unlikely that a woman artist would produce any real equivalent to the fetishistic imagery of Allen Jones, except for purely political purposes. Nancy Grossman has perhaps come the nearest; see Cindy Nemser, *Art Talk: Conversations with 12 Women Artists*, Charles Scribner's Sons, New York, 1975, pp. 327-46, for a useful interview.

12 Simone de Beauvoir, *The Second Sex*, Penguin, 1972, p. 64.

13 Mary Ellmann, *op. cit.*, p. 199.

14 Leonor Fini, quoted in Constantin Jelenski, *Leonor Fini*, La Guilde du Livre et Clairefontaine, Lausanne, 1968, p. 15.

15 Linda Nochlin, 'Some Women Realists. Painters of the Figure', *Arts Magazine*, May 1974, p. 32.

16 *Feminist Art Journal*, Spring 1975, p. 36, and headline from an unidentified Washington newspaper cutting, in the collection of Ms Sleigh (1974).

17 John Noel Chandler, 'Colette Whiten: her working and work', *Artscanada*, Spring 1972, pp. 42 ff, and Connie Hitzeroth, 'Colette Whiten', *Artscanada*, May 1973, pp. 45-9.

18 Joan Semmel, quoted in Dorothy Seiberling, 'The Female View of Erotica', *New York Magazine*, February 1974, p. 55.

19 Cindy Nemser, 'Four Artists of Sensuality', *Arts Magazine*, March 1975, pp. 73-5, and also *Feminist Art Journal*, Spring 1975, p. 49 – brief notes by Rose Hartman, referring to the Philadelphia Civic Center's refusal to show Bernstein's work in the Focus exhibition. The director John Pierron excluded and dismissed her work as 'simply a penis without redeeming social value'.

20 Germaine Greer, *The Female Eunuch*, Paladin, 1971, p. 39.

21 Barbara Rose, 'Vaginal Iconology', *New York Magazine*, February 1974, p. 59. Perhaps by implication this category also rejects the idea that phallic

energy is required for the culturally creative act – as expressed in Mailer's assertion that 'a good novelist can do without everything but the remnant of his balls', and the claim variously attributed to Van Gogh, Gauguin or Renoir: 'I paint with my prick'.

I have kept Rose's rather loose and general application of 'vagina'; the proper distinction between internal vagina and external vulva is increasingly blurred in non-medical writings.

22 See Judy Chicago and Miriam Schapiro, 'Female Imagery', *Womanspace Journal*, Vol. 1, no. 3 (Summer 1973), pp. 11-14; and Judy Chicago, *Through the Flower*, Doubleday and Co. Inc., 1975, pp. 142-4.

23 Judy Chicago, *Through the Flower*, pp. 181-2:
I had never seen those two attributes wedded together in an image. I felt ashamed – like there was something wrong with being feminine and powerful simultaneously. Yet I felt relieved to have finally expressed my power. I could never have shown it comfortably if it were not for the growing support of the female art community.

24 Betty Dodson, *Liberating Masturbation, a Meditation on Self Love*, Bodysex Designs, New York, 1974.

25 *Ibid.*, pp. 25-7.

26 Suzanne Santoro, *Per Una Espressione Nuova/Towards New Espression*, Rivolta Femminile, Rome, 1974. (Italian and English text), un-numbered pages.

27 *Ibid.*

28 Robin Campbell quoted by Roszika Parker in 'Censored', *Spare Rib*, January 1977, no. 54, p. 44.

29 See Laura Mulvey, 'You don't know what is happening do you, Mr Jones?', *Spare Rib*, February 1973, no. 8, pp. 13-16.

30 Simone de Beauvoir, *The Second Sex*, Penguin Books, 1972, pp. 190 f.

31 Lucy Lippard, *From the Center. Feminist Essays on Women's Art*, E. P. Dutton & Co. Inc., New York, 1976, p. 129; and Judy Chicago, *Through the Flower*, p. 162.

32 Rosie Parker, 'Housework', *Spare Rib*, no. 26, p. 38.

33 Quoted in Lippard, *op. cit.*, p. 105. One might add to her examples of 'expanding identity', Carolee Schneemann's *Up to and Including Her Limits* – an 8-hour performance work with film and video presented at the Berkeley Art Museum in April 1974, and subsequently self-published as a book, 1975.

34 Cindy Nemser, *Art Talk: Conversations with 12 Women Artists*, p. 281.

35 Lucy Lippard, *op. cit.*, p. 130

36 Adrian Piper, quoted in Lippard, *op. cit.*, p. 167.

37 The aspects of shame and pollution survive in a rich variety of menstrual euphemism (those used by women tend to be coy, those used by men tend to be sexual and derogatory); in varying degrees of commitment to the traditional taboos on swimming, bathing and intercourse; and in the advertisements for sanitary aids which perpetuate the embarassment in order to reassure women that their products will minimize the humiliation. It is interesting to note that amongst a wealth of public sexual imagery, advertisements for sanitary protection are prohibited by the I.B.A., in part because of the public outcry that greeted a discreet experiment several years ago. The only exceptions are a few pilot advertisements on selected radio stations, carefully vetted for 'tastefulness' and subject to timing restrictions. A similar American ban was lifted towards the end of 1972.

38 E.g. Mary Beth Edelson's *Blood Mysteries*, which invited the direct participation of women in the sharing and reworking of menstrual experience. The figure of a powerfully built nude woman with a circle around her abdomen and flowing hair around her head, was drawn on the wall above a real wooden box with four compartments: *Menstruation Stories*, *Blood Power Stories*, *Menopause Stories*, and *Birth Stories*.

39 Mary Ellmann, *op. cit.*, p. 142.

40 Judy Chicago, *op. cit.*, pp. 135-7.

41 Gina Pane, interviewed by Effie Stephano, *Art and Artists*, April 1973, p. 23. See also Lucy Lippard 'The Pains and Pleasures of Rebirth: Women's Body Art', *Art in America*, May/June 1976, pp. 73-81. Reprinted in *From the Center, op. cit.*

42 Barbara Rose, *op. cit.*, p. 59.

43 Shirley Ardener, *Perceiving Women*, Malaby Press, 1975, p. 47.

44 John Berger *et al.*, *op. cit.*, p. 46.

45 Carolee Schneemann, *Cézanne she was a great painter*, The Second Book, January, 1975. Tresspuss Press, p. 24; 'unbroken words to women – sexuality creativity language art istory [*sic*].'

46 Lucy Lippard, *op. cit.*, p. 135. See also Cindy Nemser, 'Four Artists of Sensuality', *Arts Magazine*, March 1975, *passim.*

47 *Artforum*, November 1974, p. 5.

48 Lynda Benglis quoted in Lucy Lippard, *op. cit.*, p. 105.

49 *Ibid.*, p. 104.

50 *Ibid.*, p. 127.

51 There are still very few ways in which a woman is as *unequivocally* appreciated as she is for her physical and sexual beauty – or can earn as much as the £60,000 for an advertisement of Farrah Fawcett-Majors. There is very little self-parody to be found in that.

52 Simone de Beauvoir:

 Representation of the world, like the world itself, is the work of men; they describe it from their own point of view, which they confuse with absolute truth.

Index